THE CREATIVE IMPULSE

Third Edition

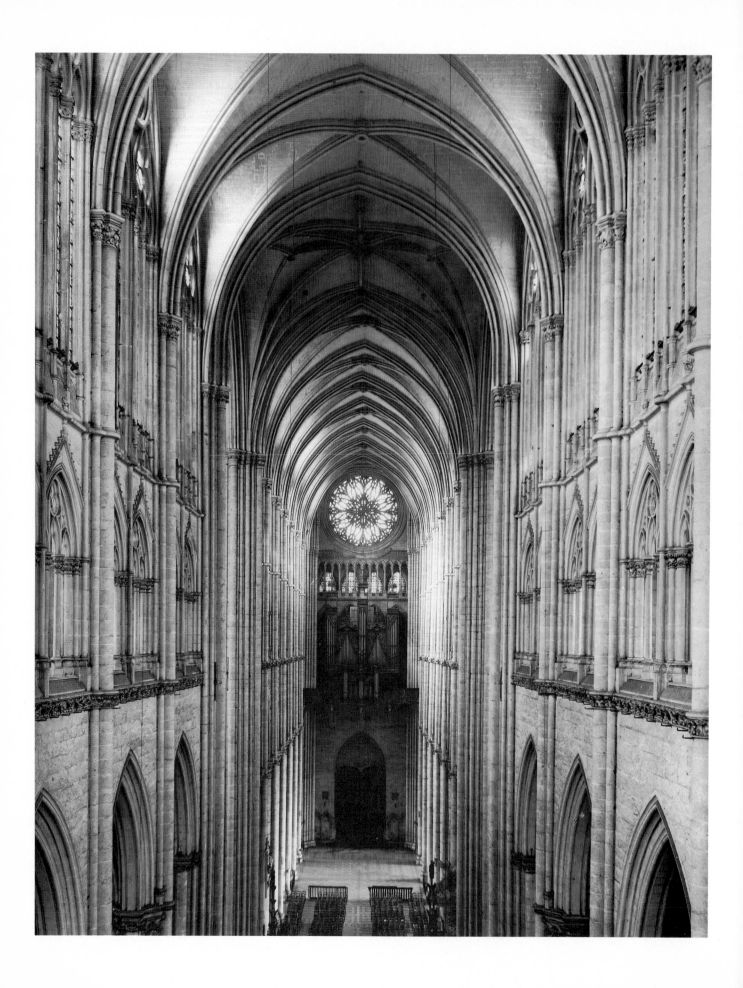

THE CREATIVE IMPULSE

An Introduction to the Arts

Volume One

DENNIS J. SPORRE

Ball State University

Third Edition

Prentice Hall, Englewood Cliffs, NJ 07632

© 1993, 1990, 1987 by Prentice Hall, Inc.
A Division of Simon & Schuster
Englewood Cliffs, New Jersey 07632

10 9 8 7 6 5 4 3 2 1

ISBN 0–13–189812–4

This book was designed and produced by
CALMANN & KING LTD
71 Great Russell Street, London WC1B 3BN

Designed by Karen Osborne
Literature research by Val Glenn
Typeset by Wyvern Typesetting, Bristol, England
Printed and bound in Hong Kong

Front cover: Detail of *Lady Playing the Cithara*, c.50 BC.
Wall painting, 6 ft 1½ ins (1.87 m) square.
The Metropolitan Museum of Art, New York (Rogers Fund,
1903).

Back cover: St Matthew, from the Lindisfarne Gospels, before
AD 698. 13½ × 9¾ ins (34.3 × 24.8 cm). British Library, London.

Frontispiece: Amiens Cathedral, France, nave looking west,
c.1220–36.

Acknowledgements

The author, the publishers and Calmann &
King Ltd wish to thank the museums, galleries,
collectors and other owners who have kindly
allowed their works to be reproduced in this
book. In general, museums have supplied their
own photographs; other sources are listed
below:

James Austin, Cambridge: 9.17; Bridgeman Art
Library, London: 8.7, back cover; Bulloz, Paris:
8.10; CNMHS/SPADEM, Paris: 1.18, 1.21, 8.21,
8.26, frontispiece; Centre Nationale de
Prehistoire Dordogne (photo Norbert Aujoulat):
1.8; Deutsches Archäologisches Institut,
Athens: 4.5; Deutsches Archäologisches
Institut, Rome: 6.36; Jean Dieuzaide, Toulouse:
8.17; Dumbarton Oaks (Byzantine Photograph
Collection), Trustees of Harvard University,
Washington DC: 7.17; Egypt Exploration
Society, London: 3.27; Fotografica Foglia,
Naples: 6.10; Alison Frantz, Princeton, New
Jersey: 5.23, 5.32, 7.18; Sonia Halliday, Weston
Turville, UK: 5.1, 7.25, 7.28, 9.25, 9.26; Clive
Hicks, London: 8.18, 8.32, 9.22, 9.24, 9.27;
Colorphoto Hans Hinz, Allschwil, Switzerland:
1.1, 1.17, 1.19, 1.20; Hirmer Fotoarchiv, Munich:
2.6, 2.8, 2.19, 2.30, 3.1, 3.9, 3.10, 3.12, 3.13, 3.14,
3.15, 3.16, 3.17, 3.18, 3.19, 3.32, 3.39, 4.15, 4.16,
4.17, 4.20, 5.8, 5.19, 5.30, 5.31, 7.6, 7.7, 7.12,
7.24, 7.29, 9.21, 9.21; Michael Holford, London:
1.9; Angelo Hornak, London: 9.37; A. F.
Kersting, London: 3.2, 3.3, 5.29, 5.33, 8.22, 9.1,
9.20, 9.28, 9.30, 9.31, 9.34, 9.35, 9.36, 9.38, 9.39;
Lauros-Giraudon/Bridgeman, London: 9.13,
9.14, 9.15, 9.23; The Mansell Collection,
London/Alinari: 5.4, 5.9, 5.10, 5.17, 6.9, 6.17,
6.18, 6.19, 6.21, 6.27, 6.29, 6.30, 9.10; Bildarchiv
Foto Marburg, Germany: 8.34; Jean Mazenod,
L'Art De L'Ancienne Rome, Editions Mazenod,
Paris: 6.13; Ann Münchow, Aachen: 8.31, 8.33;
Musée D'Art et D'Histoire, Auxerre: 8.24; Musei
Capitolini, Rome/Barbara Malter: 6.33; Courtesy
of the Oriental Institute, University of Chicago:
2.12, 2.27; Österreichische Akademie der
Wissenschaften-Mosaikenkommission, Vienna:
7.8; Photoresources, Canterbury: 4.4; Josephine
Powell, Rome: 7.5; Réunion des Musées
Nationaux, Paris: 2.29, 4.7, 7.13, 7.15, 8.27, 8.28;
Scala, Florence: 2.1, 4.1, 7.1, 7.11, 7.21, 7.23, 8.1,
9.12.

CONTENTS

CONTENTS

MAPS

TIMELINES

PREFACE

The purpose of this book is to present an overview of the visual arts, literature, music, theatre, dance, film, and architecture by focusing on selected developments in the context of the philosophy, religion, aesthetic theory, and political events surrounding them. It is an historical introduction to the humanities. The reader of this text should gain a basic familiarity with major styles, some understanding of the ideological, chronological, and technical implications of those styles, and also a feeling for the historical development of individual arts disciplines. In addition, this work attempts to provide the humanities instructor with a helpful textbook for courses which touch upon the arts in an inter- or multi-disciplinary manner. To achieve these ends I have necessarily been selective. This text should not be considered an attempt to develop a profound or detailed history. It gives an overview from prehistory to the present day, treating all the arts as consistently as possible.

The Creative Impulse is not a completely self-contained humanities course. It cannot substitute for the classroom teacher, whose responsibility it is to shape and mold a course according to the needs of local curricula and to assist the student to focus on what is important for the thrust of that particular course. No textbook can be relied upon to answer all the students' questions and include all key points. A good text can only suggest the breadth of the offerings available.

Material is organized vertically and horizontally. One may isolate any subdivision, such as the general history or sculpture sections, and study the overview of that area from ancient to modern times. Or one may read entire chapters so as to gain a basic understanding and comparison of events and elements within a particular era.

On the multisided debate concerning how a teacher should approach the arts, of course, this text takes a definite point of view. My focus, format, and choice of materials are based on the belief that one ought to be able to describe before attempting to theorize. The issue is not a matter of right or wrong. Nearly all approaches have some merit. The issue, which is up to the individual instructor, is how and when a particular approach is applicable.

In discussing artworks I have for the most part kept to description and compositional analysis. By so doing I hope to assist readers in polishing their skills of technical observation. By avoiding meaning and relationships I have left room for the classroom instructor to move discussion in whatever direction is deemed appropriate to the course. At the end of each chapter there is a section

entitled "Synthesis." Here I have narrowed my vision to one specific location whose arts (or, in two cases, art) provide us in some way with a microcosm of the period or part of the period. Here we may gain a fuller understanding of interrelationships than the broad treatment in the remainder of the chapter allows.

A significant problem in developing any inter- or multi-disciplinary arts text is balancing thematic, chronological, and practical considerations. A strictly chronological approach works fairly well for histories of single or closely related disciplines because major movements tend to be compressed. When all the arts are included however, we find a progression of shifting, sliding, overlapping, and recurring fits and starts which do not conform to convenient chronological patterns. A strictly thematic approach, on the other hand, tends to leave the reader in limbo. Chronological guideposts simply cannot be ignored. So I have tried to maintain a broad and traditional chronological framework within which certain liberties have been taken to benefit thematic considerations.

Basic to this discussion is a belief that teachers of arts survey courses should assist students to view the arts as reflections of the human condition. A work of art is a view of the universe, a search for reality, revealed in a particular medium and shared with others. Men and women similar to ourselves have struggled to understand the universe, as we do; and often, though separated by centuries, their concerns and questions, as reflected in their artworks, are alike.

Therefore, I trust that those who read this text will go beyond its facts and struggle with the potential meanings of the artworks included or suggested here. They should ask questions about what the artist may have been trying to accomplish; draw relationships from the social and intellectual contexts and concepts as they relate to the artworks; and, finally, seek to understand how they as individuals see these creative expressions in relation to their understanding of the universe.

To keep the text as flexible as possible I have not drawn detailed cause and effect relationships between the arts and history. Significant uncertainty exists in many quarters as to whether art is a reflection of the society in which it is produced or whether it derives entirely from internal necessity, without recourse to any circumstances other than artistic ones. I believe that both cases have occurred throughout history and do not consider it within my purpose here to try to argue which or where. I also find continual linkages of general events to six (or seven) arts

disciplines problematically repetitious. Therefore, I begin each chapter with a brief historical summary to provide a context for the arts of that period. Some relationships of style to political, philosophical, literary, and/or religious developments are obvious; others are not entirely clear, or may be questionable.

One further point is implicit in my approach. Artworks affect us in the present tense. Whatever the current vogue, the art of the past can stimulate meaningful contemporary responses to life and to the ideas of other people who tried or try to deal with life and death and the cosmos. Nonetheless, discussing dance, music, painting, sculpture, drama, film, and architecture falls far short of the marvelous satisfaction of experiencing them. Black-and-white and even color reproductions cannot stimulate the range of responses possible from the artwork itself. No reproduction can convey the scale and mystery of a Gothic cathedral or capture the glittering translucence of a mosaic or a stained-glass window. No text can transmit the power of the live drama or the strains of a symphony. One can only hope that the pages that follow will open a door or two, and perhaps stimulate the reader to experience the intense satisfaction of observing actual works of art, of whatever era.

I have tried to keep descriptions and analyses of individual artworks as nontechnical as possible, but technical vocabulary cannot be avoided entirely. For that reason a Glossary is included. I have endeavored to define technical terms either in the text or in the Glossary. (Instructors using this book might wish to consider *Perceiving the Arts* [Prentice Hall, 4th ed., 1992] as a collateral text.) In addition, my approach sometimes varies from discipline to discipline and era to era. Although that variation creates some inconsistency, I have tried to let the nature of artistic activity dictate the treatment given. Sometimes a broad summary of a wide-ranging style suffices; at other times an ethnographic separation is necessary; at still other times a more individualized or subdisciplinary approach is required.

I have separated the visual arts into architecture, sculpture, and two-dimensional art. The first two are fairly obvious, but the third is less so. At all stages in the history of art, pictorial art has encompassed more than easel painting. Drawing, printmaking, manuscript illumination, vase and mural painting, photography, and mixed media have also played a role, and I note this where appropriate. Traditional painting, however, has formed the backbone of the discipline, and is the primary focus.

Theatre as an artform or discipline must be seen as a live performance, which actuates a script with live actors in a physical environment. So the descriptions of theatre try to illuminate production, with a ready acknowledgement that the script is the basis, the style of which often determines the production style. As theatre is examined, I focus on the contemporary production of plays, but occasionally revivals of earlier plays give strong indications of the idea or style of production in that period.

Dance presents a problem because, although it has been an intimate part of creative expression since the dawn of history, it is also an ephemeral art and a social activity. Even though I have a fundamentally relativistic approach to the question "What is art?", for the purposes of this text I have tried to limit dance to what we may call "theatre dance," that is, dance which involves a performer, a performance, and an audience. Such a limitation, still, is not entirely satisfactory: certain dances may, in some cases, be theatre dance; in other cases, social dancing; and in still other cases, both or neither. However, I hope the reader will understand that my choices are more or less practical, and that my purpose is to provide a general overview and not to argue for or against any particular theory.

Architecture and sculpture raise only a few minor problems in definition and description. Both disciplines have the properties of longevity and, in general, have excellent examples to draw upon, even from the earliest days of the human race. Music, though also ephemeral, poses few problems, at least from the Middle Ages on. Finally, Chapters 14 and 15 present a new subject—film. A 20th-century discipline, film has developed its own aesthetics and form, and is fully a part, if only a recent one, of western arts history. So I include it as such.

I am guilty, as are most textbook writers, of robbing the arts of much of their excitement and rich interrelationships by using neat, taxonomical divisions in each chapter. A history of the arts should read like a complex novel, because this is a lively story—a story of humankind—full of life, breath, and passion. The ebb and flow of artistic history has created intricate crosscurrents of influence from society to individual to art; from other arts, to individuals, to society or societies, and so on, in infinite variety. I would challenge those who use this book, again, to go beyond its covers to try to capture that excitement.

It should be clear that a work such as this does not spring fully from the general knowledge or primary source research of its author. Some of it does, because of my long-term and close affiliation with the various arts disciplines. Much is the result of notes accumulated here and there as well as research specifically directed at this project. However, in the interest of readability and in recognition of the generalized purpose of this text, copious footnoting has been avoided. I hope the method I have chosen for presentation and documentation of others' works meets the needs of both responsibility and practicality. The bibliography at the end is a comprehensive list of cited works. I am indebted to many of these authors, to my colleagues around the country, and specifically to John Myers, Sherrill Martin, and David Kechley.

D.J.S.

PREFACE TO THE SECOND EDITION

In this second edition I have made two major changes in format, and a number of additions to the text and illustrations, in response to suggestions from those who have used the first edition. I have expanded the analysis of artworks in the text and in the new "Masterworks" sections, which focus on individual works of art in each chapter. I have eliminated the listings of artists and artworks not discussed in the text, as some individuals found them frustrating for students. "Focus" sections have been added at the end of each "Contexts and Concepts" section, to help students to focus on important terminology and key questions, such as People to Know, Dates to Remember, and so on.

Additional material has also been provided to assist those whose approach to humanities includes musical description and/or reading of literary examples. Musical works have now been included among the artworks featured in the new "Masterworks" sections, and some analyses of musical works have been added to the general discussion. For ease of access to recordings of these works, musical examples analyzed are included on a cassette available from Prentice Hall. In the case of literature, I have placed the literature and theatre sections together within the main body of each chapter, and added much new material, including several extracts from the literary works discussed. Further extracts can be found in The Literary Spirit (Prentice Hall, 1988), an anthology which was designed to accompany this text.

Finally, I have learned over the years that, despite care and a battery of copy editors and professional proof readers, mistakes do find their way into final copy. We've corrected this edition to the best of our ability, but I have no doubt that it still falls short of perfection. The best I can do is apologize and hope that any occasional error will not mar the overall value of the work.

D.J.S.

PREFACE TO THE THIRD EDITION

This is the third edition of a book that has, in its previous editions, received acclaim around the world. It has enjoyed separate editions in Britain and Australia. All of this has been highly gratifying for me as an author. Nonetheless, times change and expectations change. As a result, we have undertaken a complete rewrite of the book, from beginning to end. The style is, I hope, reflective of the transparency that the current generation of students and faculty expect. We have also improved the maps and charts, added new color plates, brought the modern era up to date, added more material on Aegean civilizations (thereby creating two new chapters), and paid further attention to the issue of cultural diversity.

The most obvious change, however, is the expansion of the book to two volumes by adding over 70 pieces of literature—extracts and complete works—which encompass the earliest known texts of the Gilgamesh Epic to contemporary poetry.

Any book of this scope is far more than the work of its author, and I want to acknowledge at least some of the individuals who have made major contributions to this edition. First is my wife, Hilda, without whose patience, advice, and editing the project could not have been completed. Next is Cheryl Kupper, whose perception, knowledge, and copy editing brought the manuscript to its final form. Ursula Sadie provided the oversight, expertise, and coaching necessary to put together the thousands of pieces that comprise the final product. Always present in the background were Bud Therien, Publisher of Art and Music, at Prentice Hall—friend and mentor for nearly 15 years—and the entire staff at Calmann & King in London, who, through three editions of The Creative Impulse and Reality Through the Arts, have come to seem like a second family.

D.J.S.

INTRODUCTION

This book is a story about us. It is a story about our perceptions of the world as we, the human race, have come to see it, both cognitively and intuitively. It describes how we respond to it and communicate our understandings of it to other people. We have been doing this as part of our humanity since the great Ice Age more than 35,000 years ago. We have not developed human qualities since then—archeological and anthropological evidence from the past 100 years shows that the characteristics of "being human" have been with us from the earliest times. Certainly we have learned, in a cognitive way, more about our world and how it functions. We have changed our patterns of existence and interdependence. But we have not changed in our humanity. Art illustrates this in terms that are inescapable. So a story of human ventures down the millennia is our story.

I hope that this book's content will suggest to the reader that creativity in the artistic sense is an intrinsic part of being human, and so we are all led by a basic "creative impulse." Try as we may in these modern times to escape from the suggestions of our right cerebral hemisphere to the absolutes of the left part of the brain (the cognitive part), we cannot escape the fact that we can, and do, know and communicate at an affective or intuitive level. The mistake of insisting only on cognitive knowing and development may already have robbed us of something of our capacity for being human.

Courses entitled "an introduction to the arts" exist widely, and this text is directed at them, together with all general readers interested in the arts and their history.

THE HUMANITIES AND THE ARTS

The humanities can very broadly be defined as those aspects of culture that humanize, that look into the human spirit. But despite our desire to categorize, there really is no clear boundary between the humanities and the sciences. The basic difference lies in the approach, which separates investigation of the natural universe, technology, and social science from the sweeping search of the arts for human reality and truth.

Within the educational system, the humanities have traditionally included the fine arts, literature, philosophy, and, sometimes, history. These subjects are all oriented toward exploring what it is to be human, what human beings think and feel, what motivates their actions and shapes their thoughts. Many of the "answers" lie in the millions of artworks all round the globe, from the earliest sculpted fertility figures to the video art of the 1990s. These artifacts and images are themselves expressions of the humanities, not merely illustrations of past or present ways of life.

How can one define what is, and what is not, an artwork, without imposing one's own subjective, 20th-century view? Here is a possible definition: a work of art is some sight, sound, or movement (or combination), intended as human expression. This is wide-ranging enough to accept as art whatever is intended as such, without placing it on a pedestal. It encompasses the banal and the profound, the simple and the sophisticated, the comic and the tragic—these adjectives are not limiting factors, but serve to describe artworks.

Styles and schools and conventions are the stuff of art history. But change in the arts differs from change in the sciences in one significant way: new technology usually displaces the old, new scientific theory explodes the old, but new art does not invalidate earlier human expression.

Obviously not all styles and forms can survive indefinitely, but a Picasso cannot do to a Rembrandt what an Einstein did to a Newton, nor can the serialism of Schoenberg banish the tonality of Mozart as the evolutionary evidence of Darwin banished the 18th-century world of William Paley. The arts, even more than literature, survive by direct impact, and continue to swell the evergrowing reservoir of human manifestations. Times and customs change, the passions that shaped the artist's work disappear, his cherished beliefs become fables, but all of these are preserved in the form of his work. "All the assertions get disproved sooner or later," Bernard Shaw observed, "and so we find the world full of a magnificent debris of artistic fossils, with the matter-of-fact credibility gone clean out of them, but the form still splendid."[1]

Works of art also remain, in a curious way, always in the present. We react *now* to the sound of a symphony, or to the color and composition of a painting. No doubt a historical perspective on the composer or painter, a knowledge of the circumstances in which the art was created, enhance the understanding and appreciation. But it is today's reaction that is important when it comes to the arts.

Beyond the immediate reaction, there is a complex web of questions and interrelationships. How does the artwork relate to the artist? To society? To nature? Why was it created? What is its focal point? Does it have a message or not? Many more questions could, of course, be asked, some concerning the work itself, and others

concerning its relationship to external factors. And they could be asked of any work of art, from a child's effort to an acknowledged masterpiece. It may be best to avoid such questions as "Is it really art?" or "Will it survive the test of time?" More constructive is "What can we get out of it now?" Look for your response, and avoid giving everything a label of good or bad. This relativistic approach may enlarge your understanding, as the parameters of art constantly shift. History has shown that there is no reliable way of knowing what artforms will survive. In our ignorance of the future, it is probably wisest to leave the widest possible range of options open. Our descendants may well still appreciate Shakespeare, Michelangelo, and Mozart, but we cannot guess how their art will take shape.

The arts can be approached with all the subtlety we normally apply to human relationships. We learn very young that people cannot simply be categorized as "good" or "bad," as "friends," "acquaintances," or "enemies." We relate in a complex way. Some friendships are pleasant but superficial, some people are easy to work with, others (but few) are lifelong companions. Similarly with art—and when we have gone beyond the textbook categories and learned this sort of sensitivity, we shall find that art, like friendship, has a major place in our growth and quality of life.

THINGS COGNITIVE AND AFFECTIVE

Language and communication come in many forms. Most familiar to us is the language of the written and spoken word, followed by the signs and symbols of science and mathematics. In addition there exists the language of sound, that is, music, and the language of gesture, which we could call dance, although gesture or body language in fact occurs all the time in circumstances other than dance. Nonverbal modes of communication comprise significant and meaningful avenues for our understanding of the world. In coming to grips with the variety of means of communication available to us, we often separate these not only into verbal and nonverbal categories but also into cognitive and affective realms. The term cognitive connotes generally those things which are factual and objective; affective connotes feelings, intuition, and emotions. Each of these areas—that is, the cognitive and the affective—represents a separate way of coming to understand or to know, as well as a way of communicating. They appear to be directly related to activities of either the left or right cerebral hemispheres. Roger Sperry, among others, has shown that

The left and right hemispheres of the brain are each found to have their own specialized form of intellect. The left is highly verbal and mathematical, and performs with analytic, symbolic, and computer-like sequential logic. The right, by contrast, is spatial, mute, and performs with a synthetic, spatioperceptual and mechanical kind of information processing not yet simulatable in computers.[2]

Sperry tells us that there is a scientific basis for our assumptions that we can know and communicate through affective experiences, which do not conform to verbal, mathematical, or sequential cognitive systems.

Finally, let us consider one further, related concept. That is the concept of aesthetic knowledge—the total experience surrounding our involvement with a work of art and/or its creation. Aesthetic knowledge stems from a unique synthesis of affective and cognitive, of emotive and intellectual skills that deal with the relationships between colors, images, sounds, forms, and movements. As we move through the material ahead of us in this textbook, we need to keep in mind that the facts and descriptions presented here are only the beginnings of an experience with our cultural heritage. We really must go beyond these facts and try to discern meaning. In the classroom that task will require discussion and some help on the part of the instructor. For those reading this book purely for pleasure, it will entail some additional reading.

WHAT IS STYLE?

Our discussion of arts history will focus to a large degree on style. So before we begin, we need to understand some of the things the term "style" implies. A standard dictionary definition would indicate that style refers to those characteristics of an artwork that identify it with a period of history, a nation, a school of artists, and/or a particular artist. We might say, too, that style is the individual personality of the artwork. That definition is fairly concise, but how does it affect us? How do we use it? When we look at a painting, for example, or listen to a piece of music, we respond to a complex combination of all the elements that make up the work—elements of form and of content. In the painting we see, among other things, colors, lines, and even perhaps the marks made by the brush as the paint was applied. In the musical piece we hear melodies, rhythms, harmonies, and so on. No two artists use these elements of their medium identically. Each artist has individual preferences and techniques. So when experts compare several paintings by more than one artist, they can tell which paintings were painted by which artists. Experts extract clues from the artwork itself: are the colors bright, dull, or some combination of the two? Are the lines hard or fuzzy, the contrasts soft or hard? Are the rhythms simple or complex? These individual clues help to indicate the artist's style, a style which may or may not be a reflection of society or philosophy, of biographical or artistic considerations.

Groups of artists often work in close contact with each other. They may study with the same teacher, or they may

share ideas of how their medium of expression can overcome technical limitations or more adequately convey the messages or concerns they all share. As a result, their artworks may show characteristics of such similarity that trained individuals can isolate them as a "school." The similarities which allow for such identification comprise the style of the group. Further expert examination could also identify the works of individuals within the group. This same process of isolation and identification can be applied to artworks from certain nations, and even to rather large slices of history, as we shall see.

Finally, how does a style get its name? Why is some art called classical, some pop, some baroque, and some impressionist? Some styles were named hundreds of years after they occurred, with the definition accruing from extended common usage or from an historical viewpoint. The Athenian Greeks, whose works we know as classical, were centuries removed from the naming of their style. Some labels were coined by artists themselves. Many stylistic terms are attributed to individual critics, who, having experienced the emerging works of several artists and noting a common or different approach, invented a word (sometimes a derogatory one) to describe that approach. Because of the influence of the critic or the catchiness of the term, the name was adopted by others, and commonly used. Thus, a style was born.

We must be careful, however, when we use the labels by which we commonly refer to artworks. Occasionally such labels imply stylistic characteristics; occasionally they identify broad attitudes or tendencies which are not really stylistic. Often debate rages as to which is which. For example, Romanticism has stylistic characteristics in some art disciplines, but the term connotes a broad philosophy toward life in general. Often a stylistic label is really a composite of several styles whose characteristics may be dissimilar, but whose objectives are the same. Terminology is convenient, but not always agreed upon in fine detail. Occasionally experts disagree as to whether certain artworks fall within the descriptive parameters of one style or another, even while agreeing on the definition of the style itself.

In addition, we can ask how the same label might identify stylistic characteristics of two or more unrelated art disciplines, such as painting and music. Is there an aural equivalent to visual characteristics, or vice versa? These are difficult questions, and potential answers can be troublesome as well as debatable. More often than not, similarity of objectives, as opposed to directly transferable technical characteristics, results in the use of the same stylistic label for works in quite different disciplines. Nevertheless, some transference is possible, especially in a perceptual sense. For example, undulating line in painting is similar in its sense-stimuli to undulating melodic contours in music. However, the implications of such similarities have many hidden difficulties, and we must be careful in our usage, regardless of how attractive

similarities in vocabulary may seem.

Styles do not start and stop on specific dates, nor do they recognize national boundaries. Some styles reflect deeply held convictions or creative insights; some are imitations of previous styles. Some styles are profound; others are superficial. Some styles are intensely individual. However, merely dissecting artistic or stylistic characteristics can be dull. What makes the analysis come alive is the actual experience of artworks themselves. What are our reactions to the work of art; what is the deepest level of meaning we can find? Within every artwork lies the reflection of another human being attempting to express some view of the human condition. We can try to place that viewpoint in the context of the time or the specific biography that produced it and speculate upon why its style is as it is. We can attempt to compare those contexts with our own. We may never know the precise stimuli that caused a particular artistic reflection, but our attempts at understanding make our responses more informed and exciting, and our understanding of our own existence more profound.

CREATIVITY AND CULTURAL DIVERSITY

The desire, in fact the need, to create is a part of our humanness. Creativity and its expressions can be found in every culture in every time. Our examination of the creative impulse in the pages that follow focuses on essentially what has been called "the western or Euro-centered tradition." That focus has practical reasons at its center. But all of the cultures not included in this volume have their own rich and deep traditions, and we shall now briefly glance at Asian and African art.

Asian art

In East Asia, the cultural tradition emerges from the social heritage of China, wherein the concepts of family subordinate the individual and result in particular political and ethical systems. From approximately 1400 to 1100 BC, verifiable Chinese history was beginning, with the emergence of the Shang dynasty. In the third or Zhou (Chou) dynasty, from approximately 1100 to 256 BC, accurate documentation of Chinese history begins. The earliest Chinese books date to early in the first millennium BC. They weave a pattern of ethics, philosophy, and mythology. From this strong sense of history came an ideal of political unity and a belief in the uniqueness of the "Central Country," or *Chung-kuo*.

Shang bronzes from approximately 1400 BC fall into two categories: weapons and ceremonial vessels. Both are frequently covered with elaborate designs, either incised or in high relief. The craftsmanship of the design

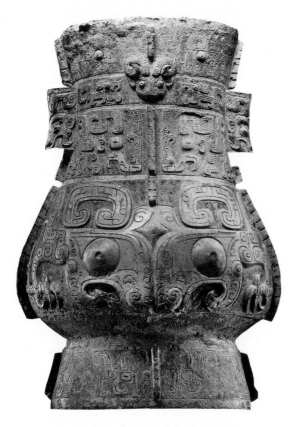

0.1 Ritual wine vessel or *hu*, Shang dynasty, c.1300–1100 BC. Bronze, 16 ins (140.6 cm) high, 11 ins (27.9 cm) wide. Nelson Gallery, Atkins Museum, Kansas City.

is exquisite and surpasses the quality of virtually every era, including the western Renaissance. Each line has perfectly perpendicular sides and a flat bottom, meeting at a precise 90-degree angle. This contrasts, for example, with incision, which forms a groove. The approach to design seen in animal representation illustrates a vision unlike that of western culture, and similar to later East Asian and Pacific Northwest Indian design, in which the animal appears as if it had been skinned and laid out with the pelt divided on either side of the nose. A rigid bilateral balance occurs. The bronze ritual vessel of the shape known as *hu* (Fig. **0.1**) exhibits grace and symmetry, with subtle patterns carefully balanced and delicately crafted.

0.2 Elephant feline head, Shang dynasty, c.1200 BC. Jade, 1⅝ ins (4 cm) long. The Cleveland Museum of Art, Anonymous Gift, 52.573.

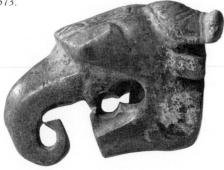

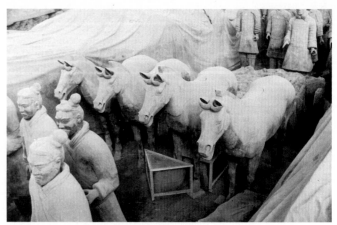

0.3 Terracotta warriors, Qin dynasty, third century BC. Life-size. Courtesy, People's Republic of China.

The graceful curves of the vessel are broken by deftly placed ridges and gaps, and while the designs are delicate, the overall impression exhibits solidity and stability.

Another innovation of the Shang culture is stone sculpture in high relief or in the round. Most numerous are small-scale images in jade. They represent a broad vocabulary, from fish, owls, and tigers, for example, as single units, to combinations and metamorphoses such as the elephant head of Figure **0.2**. This design expresses a simplicity of form with incised, subtle detail. We can easily see the metamorphic intention of the piece as we note the feline head with large, sharp teeth, elephant's trunk, and bovine horns.

Although the Qin dynasty lasted less than 50 years, during the third century BC, the emperor spent that entire time preparing his palace and mausoleum. Over the years, minor pilfering and excavation have occurred, since the location of the underground vaults was well known. In March 1974, however, a major discovery was made during the digging of a well near the vaults. Life-size and lifelike pottery figures were unearthed from vaults containing terracotta warriors, horses, and bronze chariots. In one vault (measuring 760 by 238 feet) alone, 6000 terracotta warriors and horses were found. A total of three vaults contain over 8000 figures (Fig. **0.3**).

African art

For thousands of years, African artists and craftsmen have created objects of sophisticated vision and masterful technique. The modern banalities of so-called primitive "airport art," sold to tourists, belie the rich cultural history of the African continent. Africans were trading with the Middle East and Asia as early as AD 600, as documented by Chinese Tang dynasty coins found on the maritime coast of East Africa. Climate, materials, and the very nature of tribal culture doomed much of African art to

extinction; only a fraction remains. Nonetheless, what has survived traces a rich vision which varies from culture to culture and which has a style that runs from abstract to naturalistic. Its purposes range from the magical to the utilitarian, adding layer upon layer to its potential meaning. It portrays levels and visions of reality that we may be ill-equipped to understand, inasmuch as our culture views reality differently. Nonetheless, if we know how to look, we can find profound human statements and great satisfaction in these works.

During the first millennium BC, on the Jos plateau of northern Nigeria, the Noks, a nonliterate culture of farmers, entered the Iron Age and developed an accomplished artistic style. Working in terracotta, they produced boldly designed sculptures (Fig. **0.4**) apparently nearly as sophisticated in firing technique as the Qin dynasty terracotta warriors of China. Some works represent animals in naturalistic form and others portray life-size human heads. Although stylized, with flattened noses and segmented lower eyelids, for example, each work reveals individualized character. Facial expressions and hairstyles differ, and it is this unusual combination of human individuality and artistic stylization that gives them their peculiar power. Probably these heads are portraits of ancestors of the ruling class. The technique and medium of execution seem to have been chosen to ensure permanence and for magical rather than artistic reasons. The Nok style appears seminal to several West African styles.

The level of skill achieved by the ninth and tenth centuries AD can be seen in a ritual water pot from the village of Igbo-Ukwu in eastern Nigeria (Fig. **0.5**). Cast using the *cire-perdue* or lost-wax process, this leaded bronze artifact is amazing in its virtuosity. The graceful

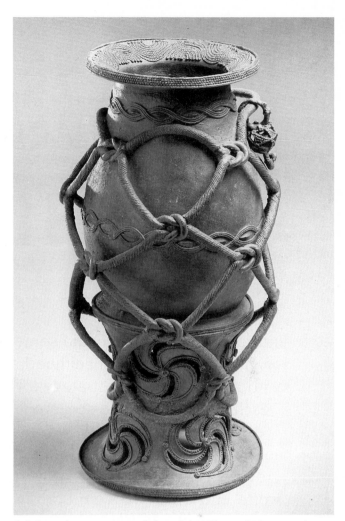

0.5 Roped pot on a stand, from Igbo-Ukwu, ninth to tenth century AD. Leaded bronze, 12½ ins (32 cm) high. The National Museum, Lagos.

0.4 Head from Jemaa, c.400 BC. Terracotta, 10 ins (25 cm) high. The National Museum, Lagos.

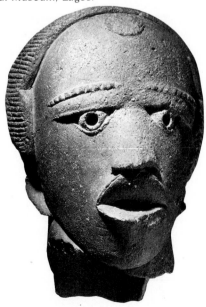

design of its recurved lines and flaring base are in themselves exquisite, but the addition of the delicate and detailed rope overlay reflects sophistication of both technique and vision.

Whatever cultural roots we may view as our own, we are part of a human search for understanding of our own and infinite reality. One of the ways we can pursue this search is through our creative impulses. We seek to reflect and interpret our human reality—however we may ultimately view it—in a myriad of objects that we call "art." We make and experience art in a variety of ways, some of which carry with them broader contextual relationships with society, politics, science, and philosophy. Others are personal and direct—our own subjective responses to a work of art which we experience for the first time, and without much thought about what brought it about. This book tries to assimilate some of that vast outpouring of human creativity.

CHAPTER ONE

PREHISTORY

In the Upper Paleolithic era some 50,000 years ago, *Homo sapiens* began to grasp the notions of selfhood and individuality. We began to make symbols as part of our strategy for comprehending reality and for telling each other what we discovered. We learned to make art in order to express more fully what we believed was our unique essence. We thought. We became aware of death, and buried our dead with care and reverence. We realized that we had a complex relationship with the world into which we were born in mystery, where we lived in mystery, and which we departed in mystery. In short, we became fully human. Our progress since that early time in technological and socio-economic sophistication has been immense—but we are no more human now than we were at the first.

1.1 Black bull, detail, c.16,000–14,000 BC. Paint on limestone, total length of bull 13 ft (3.96 m). Lascaux, France.

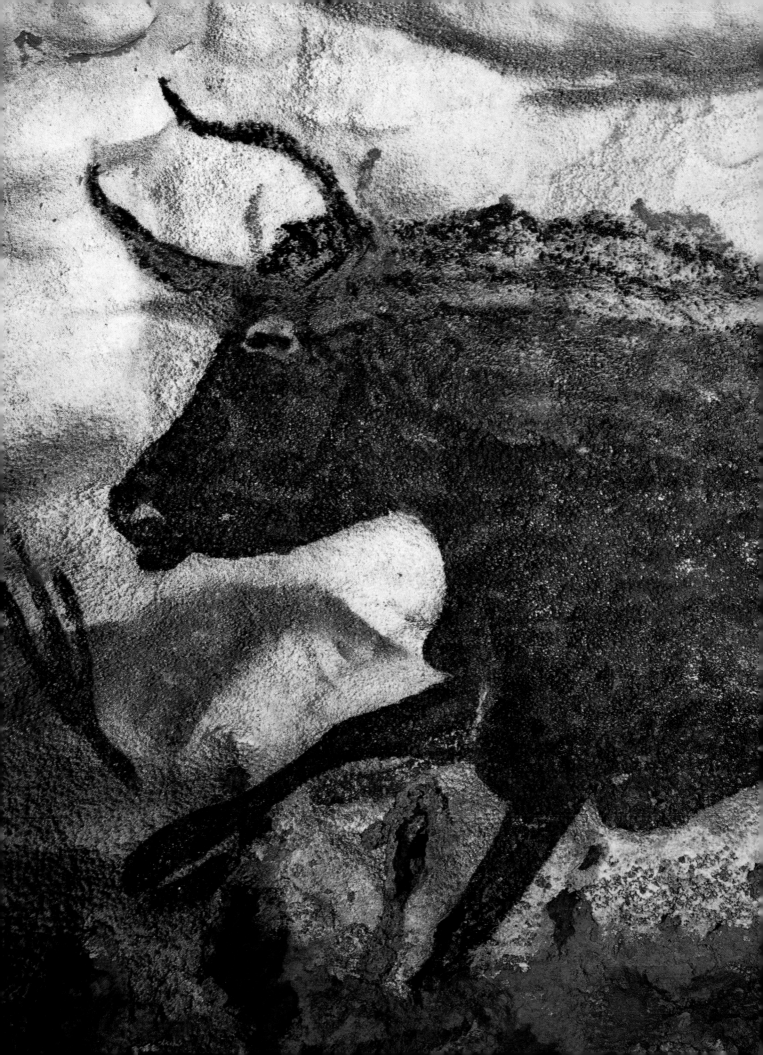

CONTEXTS AND CONCEPTS

If we have any tendency to think of our prehistoric predecessors as somehow less human than ourselves, we have only to consider the profundity of their art to set our thinking straight. Yet because the period we are about to examine is prehistoric, that is, before recorded history, we can make only the broadest of conjectures, based on the slimmest of evidence. Studies of prehistoric art and prehistoric societies leave us without a unified consensus on which to build. But if we cannot accurately grasp the whys or wherefores of the ARTIFACTS that remain for us to study, we cannot escape the power of the human spirit that they express.

The task of describing those wonderful, and in some cases contemporary-looking, works of Ice-Age art at first seems rather straightforward. But remember that we are dealing with prehistory. The context, and therefore the meaning, of these works eludes us. Of course, we can examine these artworks in terms of line, form, color, and so on. But what of meaning? Alexander Marshack's book, *The Roots of Civilization*, has served as a primary guide to this partial exploration of that question.

SOCIAL AND NATURAL ENVIRONMENT

We begin our study of this very long period of human creative activity with a brief look at the social and natural environment in which these earliest artists lived. We need to return to that time known as the Pleistocene Period, the beginning of which is dated variously between 500,000 and one million years ago. Great shifts of climate, ranging from temperate to arctic, occurred in the Pleistocene Period. During that time four glacial periods, separated by three interglacial periods, wrought tremendous changes on geography and animal life. During the glacial periods in northern Europe (Fig. **1.3**) glaciers at the pole and those in mountain ranges such as the Alps expanded to occupy huge areas. When the ice-sheets were at their maximum extent, they averaged approximately 1000 yards in thickness. This resulted in a drop in the levels of the oceans of nearly 90 yards. During the last glaciation, the sea level dropped so far that the British Isles and the Scandinavian peninsula were joined to the European continent. During the interglacial periods the glaciers contracted and the sea rose to 20 or 30 yards above its present level. Stretches of Pleistocene beaches containing shells from tropical seas can still be found in

the cliffs high above the Mediterranean shores. Between 10,000 and 8000 years ago the climate changed drastically. The Ice Age ended. The ice receded and the seas rose. Forests sprang up where only TUNDRA had existed.

From the Pleistocene glacial and interglacial periods come some of our most fabled animals. The *Machairodus*, or sabre-toothed tiger, the *Elephas meridionalis*, or southern elephant, the hippopotamus, Merk's rhinoceros, and the *Elephas antiquus*, or ancient elephant, were succeeded by creatures more adapted to cold climates as glaciation occurred: the long-haired, thick-furred pachyderms called mammoths, or *Elephas primigenius*, and the woolly rhinoceros, *Rhinoceros tichorhinum*. Fossilized remains of mammoths have been found throughout Europe, and in Serbia complete carcasses have been retrieved from the frozen earth. However, these animals are, so to speak, brought alive to us through the vibrant images in the caves of our prehistoric ancestors.

Compared to the span of recorded history, the Pleistocene Period is enormously long. Even the relatively brief period of Paleolithic art, from roughly 35,000 BC to 10,000 BC, is five times longer than all of recorded history, which starts with the ancient Mesopotamians and Egyptians only 5000 years ago.

HUMANS AND SYMBOLS

The predecessors of *Homo sapiens* shaped stone weapons as early as one million years ago. The rough chipped tools of the pre-human period led to more fully developed hand axes of flint or similar stone shaped to create a cutting edge (Fig. **1.2**). Tools from the Middle Pleistocene era are about 250,000 years old.

Some scholars speculate that it was about this time that early humankind developed the ability to create SYMBOLS, the requisites of language and of art. No other

1.2 Hand-axe from Swanscombe, Essex, England, c.25,000 BC. Flint, 6⅜ ins (15.8 cm) high.

creature has this skill. For example, when an ape wishes to warn of danger, let us say an approaching lion, it screams. However, the ape does not have the ability to make or communicate any symbol for "lion" when no lion is present. Symbol-making of this sort involves a cognitive sophistication unique, and basic, to humanity.

Our early ancestors moved slowly to the acquisition of artistic capacity. Stereoscopic vision, manual dexterity, communicative ability, conceptual thought, symbol-making, and AESTHETIC intuition all contributed to this development. A further 200,000 years of development brought us to the last Ice Age and an ancestor of far greater complexity, self-awareness, and clearer artistic gifts. Marshack believes that "as far back as 30,000 BC the Ice-Age hunter of western Europe was using a system of notation that was already evolved, complex, and sophisticated."[1] Scratched and engraved in bone and stone, examples of human notation appear across Europe, from Spain to Russia, and emerge from every period of the Upper Paleolithic.

Neanderthal man may characterize for us the physical type that lived into the relatively warm period after 40,000 BC. Male and female specimens of *Homo neanderthalensis* were clearly more intelligent than their ancestors. They created tools by striking stone against stone. They were aware of death and created specific burial places. The posture of these individuals was reasonably erect, although they stood on somewhat bowed legs, carrying their weight on the outward sides of their feet. The neck was short and squat. The low, slanted forehead had massive suborbital ridges. A broad jaw and receding chin completed the facial characteristics of this rather beast-like being. *Homo neanderthalensis* could probably speak, in an embryonic language, but did not, as far as we know, produce any art. *Homo sapiens*, completely evolved and distinguished by a defined chin and high, smooth forehead, appeared in Europe at the same time.

Homo sapiens

Around 27,000 BC, south of the great ice-sheet across the middle part of Europe from Czechoslovakia to Poland and eastward to Siberia, herds of mammoths migrated across a barren tundra of rivers, streams, and rolling hills. *Homo sapiens* hunted the mammoth and built huts, even constructing large houses of skin, bone, wood, clay, and stone. (Caves were rare in this part of Europe.) These people buried their dead with CEREMONY and ORNAMENT. They wore leather and skin clothes, some of which seem to have included a hood, and decorated themselves with

rings, bracelets, necklaces, and carved ivory headbands.

Homo sapiens comprised several sub-groups. The best known of these are the Cro-Magnons, some of whom grew to six feet four inches tall, with powerful builds and high foreheads. They did not differ much, in fact, from many Europeans of the 20th century. Another variety of early *Homo sapiens*, the Combe Capelle, had a smaller stature, more delicate bones, and a general appearance similar to contemporary Mediterranean peoples. These "modern" people made new types of tools as well as retaining some tools of the Neanderthals. Most important, as Marshack points out, these people appear, "apparently for the first time, with a skill in art, a skill for making images and symbols, that soon blossomed in every form: painting, sculpture, decoration, drawing, and engraving." They also seem to have had skill in music, as excavated bone whistles and flutes from the early Upper Paleolithic indicate.[2]

The cranial capacity of *Homo sapiens* remains the same today as when our species first appeared in Europe. It is logical, then, to assume that the basic functioning of the brain was the same then as it is now. Ice-Age people may have lacked our world-view and technological achievement, but they were no less human than ourselves in their feelings and in the ability to perceive and respond. In capacity, ability, functioning, and intelligence, Ice-Age men and women were our peers.

During the entire Pleistocene Period, agriculture and herding were unknown. Our ancestors appear to have lived on game and wild fruits and vegetables. They made weapons and tools from wood and bone. But it is because they also chipped out stone tools that this era is called the Old Stone Age, or Paleolithic era (see Fig. **1.4**). Some scholars divide this age into three periods, Lower, Middle, and Upper; others talk about only the Lower and Upper. Our study centers on the latest, or Upper, period, which begins around the middle of the final glaciation.

ICE-AGE CULTURE

Ice-age or Paleolithic art may be the product of a technologically and economically unsophisticated or "primitive" people, but it is not the product of "primitive" human beings. According to Marshack, even in the Ice Age human culture existed at a modern level, at least in terms of the use of art, symbol, RITE, and story. "Art and symbol are products that visualize and objectify aspects of a culture"[3] and "art, symbols and imitation imply a structure, continuity and periodicity in the economic and cultural life of the Upper Paleolithic hunter."[4]

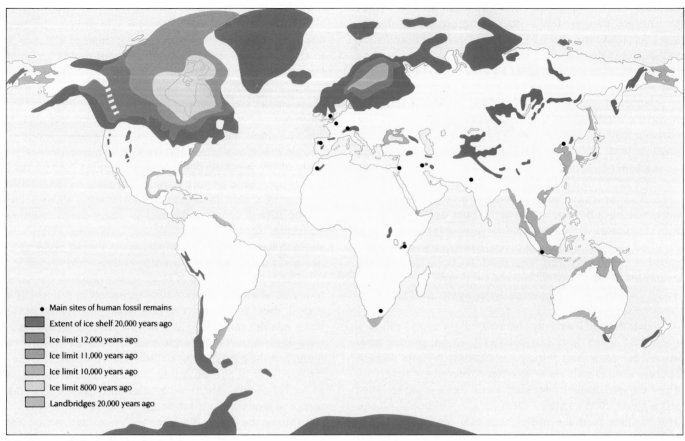

1.3 Extent of glaciation in the Ice Age.

1.4 Timeline of prehistoric eras.

BC	ERA	PERIOD	GLACIAL PERIOD	GENERAL EVENTS	LITERATURE & PHILOSOPHY	VISUAL ART	THEATRE & DANCE
1,000,000	Lower Paleolithic			Stone weapons			
600,000 540,000 480,000 380,000	Lower Paleolithic	Early Middle Pleistocene	1st glacial				
			1st interglacial 2nd glacial				
240,000 180,000 120,000	Middle Paleolithic	Late Middle Pleistocene	2nd interglacial 3rd glacial 3rd interglacial	Flint axes	Human symbols		
95,000	Middle Paleolithic						
40,000				Homo neanderthalensis			
30,000	Upper Paleolithic	Aurignacian	4th or last glacial	Tool making Homo sapiens	Human notation system	Woman from Willendorf (**1.13**) Man from Brno (**1.10**) Animals from Vogelherd (**1.14**)	
25,000	Upper Paleolithic					Woman from Dolní (**1.12**)	
20,000	Upper Paleolithic	Solutrean				Venus of Lespugue (**1.11**) Horse from Gargas (**1.7**) Bison from La Grèze (**1.8**) Cave of Lascaux (**1.16–21**)	
15,000 12,000 10,000	Upper Paleolithic	Magdalenian		Domestication of the dog Pottery		Cave of Altamira (**1.9**)	Dancing figures (Fig. **1.15**)
8000	Meso-lithic			Mining and quarrying			

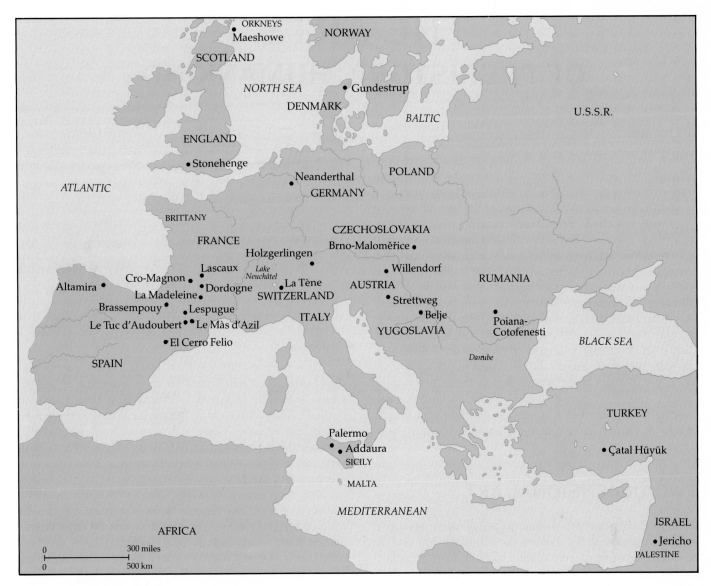

1.5 Sites of prehistoric importance in Europe.

FOCUS

TERMS TO DEFINE

Ice Age

Pleistocene Period

Neanderthal

Homo sapiens

Primitive

Paleolithic

QUESTIONS TO ANSWER

1 What kinds of animals lived during the Pleistocene period?
2 When did humans begin using tools?
3 What qualities make up basic artistic capacity?
4 How did Paleolithic humans compare to ourselves in appearance and ability to think?

THE ARTS
OF PREHISTORIC HUMANKIND

The material that follows presents neither a comprehensive picture nor any detailed archeological explanations. Rather, we sample some of the fascinating artifacts produced by our ancient ancestors. Their vision of the world around them may span the thousands of years between us and thus improve our awareness of our own vision.

These so-called "primitives" certainly express some amazingly "modern" and sophisticated insights. If you did not know that the Ice-Age SCULPTURE and painting at the Museum of Natural History in New York dated from over 20,000 years ago, you might suspect that you were in a gallery of the Museum of Modern Art 25 blocks downtown. The remarkable perception and execution of many prehistoric works have raised profound questions about early humans' psychological development. Scholarly interpretations of these sophisticated representations are many. But our direct responses to these prehistoric images can go beyond historic and anthropological speculation and lead us to an enhanced understanding of that former world, as well as of the world in which we now dwell.

TWO-DIMENSIONAL ART

Western European art probably began approximately 25,000 to 30,000 years before the Christian era, at its earliest, consisting of simple lines scratched in damp clay. The people scratching these lines lived in caves and seem, eventually, to have elaborated their simple line "drawings" into the outlines of animals.

This development from apparently idle doodling into the sophisticated art we have just described seems to have come in three phases. The first consists of black outline drawings of animals with a single colored filler. Next came the addition of a second color within the outline, so as to create a sense of light and shade, or MODELING. As we shall see, these depictions often incorporated projecting portions of the cave walls, adding three-dimensionality to the drawing. In many cases it appears as though the artist picked a rock protrusion that would fit into a drawing of a particular animal. In the third phase of the development of Ice-Age art, exciting multicolored paintings appeared, which show an impressive NATURALISTIC STYLE with highly accurate, lifelike details. In this category are the well known paintings of Altamira (Fig. **1.9**). Here the artists have captured detail, essence, MASS, and a remarkable sense of power and movement, using only basic earth colors and charcoal.

1.6 Animal's legs, vulva and dots, c.30,000–27,000 BC. Engraving on stone, 26½ ins (67.5 cm) long. Musée des Eyzies, France.

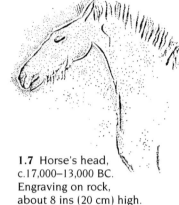

1.7 Horse's head, c.17,000–13,000 BC. Engraving on rock, about 8 ins (20 cm) high. Gargas, France.

Early in the 20th century, Henri Breuil traced the development of Paleolithic art over a period of 20,000 years. According to Breuil, art began with simple animal outlines and progressed to the multicolored animals just noted. Stylistically, depiction moved from naturalistic towards greater abstraction until, in the Mesolithic period (see Fig. **1.4**), an animal was represented by only a few characteristic strokes.

The first known drawings date from approximately 30,000 to 15,000 BC. Figures were scratched on stones which have since been found in deposits on cave floors, among tools and weapons which scholars have used to date them. Figure **1.6** shows a rock found at La Ferrassie, France. Probably carved with a flint burin, such drawings represent female sexual organs and animals. Figure **1.7** depicts a horse engraved on a cave wall at Gargas, France. The strong, curving outline captures the grace and strength of the horse. In this smooth and sophisticated depiction the artist uses realistic proportions and captures details like the hair under the muzzle. Although the use of line is economical, the essentials of the subject are nevertheless there. The caves at Gargas were occupied by much later peoples and this raises some questions about the date of the drawings there. But they still provide us with a remarkable illustration of the perceptions and style of our prehistoric ancestors.

The same may be said for a bison drawn on the wall of the cave of La Grèze in the Dordogne (Fig. **1.8**). Here we find a representational drawing situated on the rock wall in such a way as to suggest the three-dimensional contours of the bison's rib cage and flanks.

In general, however, Paleolithic artists seem to have shied away from the difficulties of suggesting three-dimensionality, keeping their subjects in profile (as,

1.8 Bison, c.23,000–17,000 BC.
Engraving on rock,
24 ins (60 cm) long.
La Grèze, France.

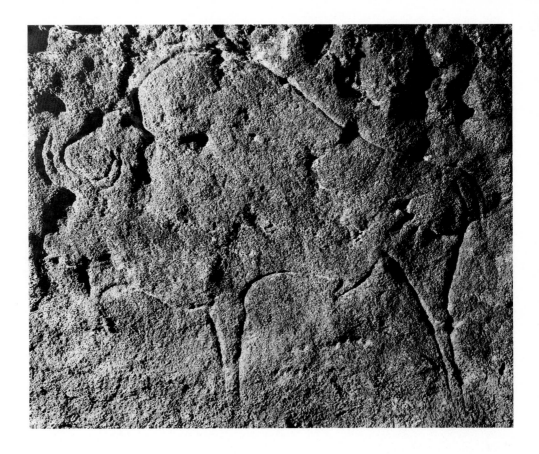

much later, the Egyptians were to do). Only an occasional turning of head or antlers tests the artist's skill at dimensional portrayal.

SCULPTURE

The first known sculpture created by our ancestors apparently predates any drawings, although it likewise dates from the period between 30,000 and 15,000 BC. The head and body of a man carved from mammoth ivory (c.27,000–20,000 BC) were found in a burial site at Brno, Czechoslovakia (Fig. **1.10**). Although many body parts are missing, we can see that the head, in contrast to the body, shows a remarkable degree of VERISIMILITUDE. The hair is closely cropped, the brow is low, and the eyes are deeply set.

Venus figures

Venus figures have been found on burial sites in a band stretching approximately 1100 miles from western France to the central Russian plain. Many scholars believe that these figures are the first works in a REPRESENTATIONAL style. The figures share certain stylistic features and are remarkably similar in overall design. They may be symbolic fertility figures or they may have been no more than objects for exchange. Whatever their purpose, all the figures have the same tapering legs, wide hips, and sloping shoulders.

The best-known figure is the Woman from Willendorf (described in the "Masterwork" section and shown in Fig. **1.13**), which is CARBON-DATED to as early as 30,000 to 25,000 BC. Remarkable similarity can be seen in two later Venus figures from elsewhere in Europe. Figure **1.11** shows the restored Venus of Lespugue, carved in mammoth ivory. The sweeping, bulbous quality of the Woman of Willendorf is also apparent in this figure. Its symmetrical PROPORTIONS give a much less naturalistic portrayal, however: whereas an actual woman might have the obese proportions of the Willendorf figure, the Lespugue figure is clearly a STYLIZED ABSTRACTION. The faceless, neutral head looks eyelessly downward, leading our own eyes to focus on breasts, belly, and *mons veneris*, all of which have been placed in close proximity. The artist has given us an image of sexuality and fertility, using sweeps of CURVILINEAR mass to establish a magnificent COMPOSITIONAL unity.

A third, more GEOMETRIC treatment of the same theme is shown in Figure **1.12**. Although less sensual than the other two examples, the similarities are obvious. The obese spread of waist, thighs, and breasts tapers into highly stylized appendages for legs, indicating what features are important—and unimportant—to the meaning of this figure. Here, as with the Lespugue figure, the

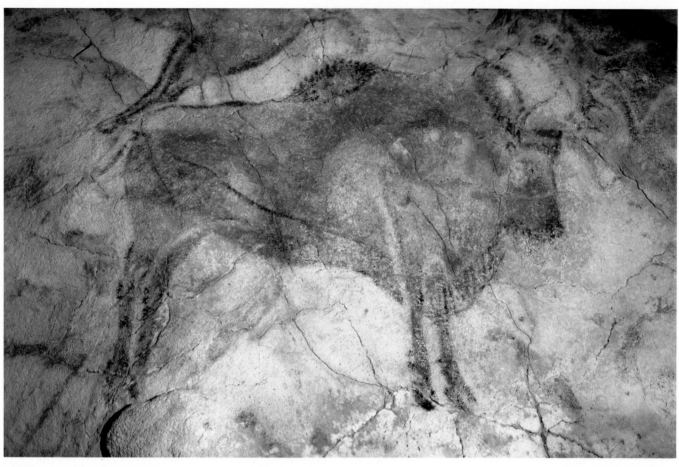

1.9 Bison, c.14,000–10,000 BC. Paint, 8 ft 3 ins (2.5 m) long. Altamira, Spain.

1.10. Man from Brno, c.27,000–20,000 BC. Ivory, 8 ins (15 cm) high. Moravian Museum, Brno, Czechoslovakia.

1.11. Venus of Lespugue, France, c.20,000–18,000 BC. Ivory, 6 ins (15 cm) high. (Restored.) Musée de l'Homme, Paris.

1.12 Woman from Dolní Věstonice, c.23,000 BC. Baked clay, 4½ ins (11.5 cm) high. Moravian Museum, Brno, Czechoslovakia.

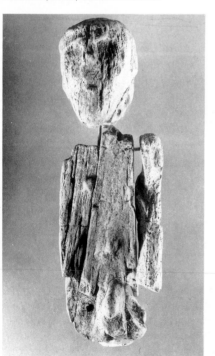

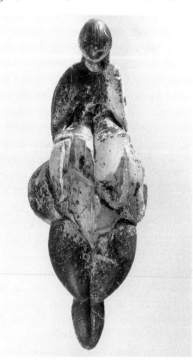

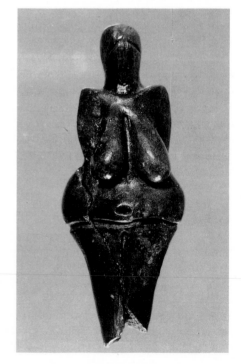

MASTERWORK
The Woman from Willendorf

The Woman from Willendorf is the best-known example of the Venus figures. Like the others, she is a recognizable, or naturalistic, portrayal within a stylized framework. The emphasis on swollen thighs and breasts and prominent genitals leaves no doubt that the image is a fertility symbol. Some have suggested that such works reveal this as an obsession of their makers. Carved from limestone, the figure was originally colored red, the color of blood, perhaps symbolizing life itself. Corpses were painted red by many primitive peoples.

The Willendorf Woman is remarkable in several respects. The figure is complete, with the legs finished off, intentionally, at the calves. The hands and arms are laid casually across the breasts. The head is tilted forward, in a similar fashion to other Venus figures. Obesity lends the figure a certain vitality; the REALISM of the folds and contours of flesh strikes a sophisticated balance with symbolic overstatement. The bulging fat of breasts, sides, belly, and thighs creates a subtle repetition of line and form which moves the eye inevitably toward the reproductive organs. She may be pregnant. She may very well be an Earth Mother, or goddess of fertility.

She is generalized in her facelessness, yet her form strongly suggests an individual woman rather than an abstraction, however grossly exaggerated her torso. Why, then, does the woman have no face? We know that artists at this time were able to render facial features; so the sculptor deliberately decided to leave them out. T. G. E. Powell suggests that "the face, being unessential to the achievement of luxuriance and propagation, found no place in the magical purpose of the figurine."[5] Or perhaps the conventions of the form itself predate the carving, coming from a time when artists lacked the skill to depict faces. Alternatively, the facelessness may reflect an idealized quality of the goddess handed down from the past.

Although faceless, these Venus figures usually have hair, often wear bracelets, beads, aprons, or waist bands,

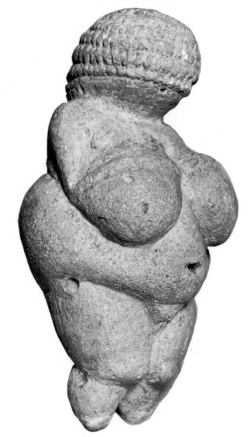

1.13 Woman from Willendorf, Lower Austria, c.30,000–25,000 BC. Limestone, 4⅓ ins (11 cm) high. Naturhistorisches Museum, Vienna.

and often show markings that may represent tattoos. These details are interesting for what they reveal about female ornamentation. In addition, although the culture would have been dominated by the male hunting ethos, the statues we have largely represent females and emphasize their sexuality. The mystery and apparent miracle of birth, along with the seemingly exclusive female role therein, must have held great importance for these people. Thus, the Venus figurines, which seem to blend women's practical and symbolic roles, undoubtedly had a powerful, if unnameable, mystical significance.

composition is BALANCED by carrying the line formed by the legs into the geometric shaping of the shoulders. A slight outward curve of the arms reinforces the taper of the legs. The bulbous waistline also gracefully picks up the reverse curves of the legs and joins the line of the arms. All this creates a central focal area in the pendulous breasts whose swell is repeated and reinforced by the curves of the waist. Finally, the eyes in the helmet-like head are simply slits like those of a mask. Their oblique

slant leads our eyes downward to the line of the shoulder and arm and returns us to the breasts.

This Venus lacks the innate sexuality of the other two. But in all three works we are surely communicating with artistic vision and technique of great aesthetic sophistication. The compositions of these three pieces exhibit the control and self-contained qualities we might find, although in a more naturalistic style, in the High Renaissance.

Animal carvings

The same period produced animal carvings (Fig. 1.14). These examples give us a sense of the vision and skill of Paleolithic artists. The works exhibit sensitivity to the grace, power, and spirit of the animal. Well modeled and proportioned, they are the product of sensitive and perceptive human beings.

The animals appear to be more realistically portrayed than the Venus figures. We can only speculate why such a difference may exist. One reason might be a difference in intent: a less realistic treatment can signify a more mythical, or magical, purpose, that is, a desire to explore a different level of "reality."

Artistic vision changes frequently in the way it treats its subjects, as noted in the section on two-dimensional art. (For a more familiar example, see the difference between the "realism" of Manet, Chapter 13, and the cubism of Picasso, Chapter 14.) In each case the artist seeks to reveal something of his or her understanding, or vision, of the universe. Each of these visions is different and will take a different form even if the subject matter is relatively similar. Thus the form of the object makes a statement about its meaning. In the case of these examples of Ice-Age art, whereas forms can be seen to differ, meanings remain hidden in the original intent of the artist, whose purpose is obscured to us by time.

HUMAN FIGURES IN PALEOLITHIC ART

Human images often accompany animals in Upper Paleolithic art. Interestingly, none of the human images appears with weapon in hand. Usually the image depicts a man, naked or robed in animal skins; posture and attitude suggest a ritualistic or ceremonial relationship with the animals.

Only later, after the Upper Paleolithic era, when the ice had receded and a considerable change in culture had taken place, do humans appear with weapons. Even then, it is not clear whether the paintings depict an actual hunt or a ceremonial one.

DANCE

We can, though with some hesitancy, conclude that a number of Upper Paleolithic art objects portray dancing of some sort. Marshack presents a line rendition of both faces of a broken engraved bone disc or plaque (Fig. 1.15) which he describes as showing "human figures in dance-like stances before the paws of a standing bear."[6] One side shows a masked dancer; the other, a "dog-faced" dancer.

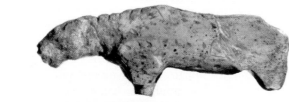
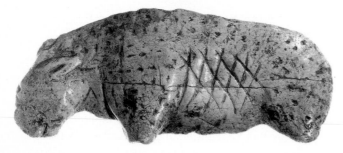

1.14 Animals from the Vogelherd cave, c.26,000 BC. Bone and ivory, lion $3\frac{2}{3}$ ins (9.2 cm) long. Institut für Urgeschichte, Universität Tübingen, Germany.

1.15 Two faces of a broken disc from Mas d'Azil, France, showing human figures and bear's paws, c.12,000 BC. Engraving on bone, $2\frac{1}{8}$ ins (5.4 cm) high.

SYNTHESIS
The Cave of Lascaux

We cannot study the earliest known art without considering what many believe to be the most significant repository of works from the dawn of humanity, the Cave of Lascaux in France. It lies slightly over a mile from the little town of Montignac, in the valley of the Vézère River. The cave itself was discovered in 1940 by a group of children who, investigating a tree uprooted by a storm, scrambled down a fissure into a world undisturbed for thousands of years. The cave was sealed in 1963 to protect it from atmospheric damage. Visitors now see Lascaux II, an exact replica, sited in a quarry 200 yards away.

Here we find ourselves in the undeniable presence of our early ancestors. There are hundreds of paintings at Lascaux, adding to those found elsewhere in France, Spain, and the remainder of Europe. The significance of the Lascaux paintings lies both in the quantity and the quality of the intact grouping of works. The diagram in Figure **1.16** helps to orient us to the wealth of paintings in the cave.

An overwhelming sense of the power and grandeur of Lascaux emerges from the Main Hall, or Hall of the Bulls (Fig. **1.17**). The thundering herd moves below a sky formed by the rolling contours of the stone ceiling of the cave, sweeping our eyes forward as we travel into the cave itself. At the entrance of the hall, the eight-foot "unicorn" begins a MONUMENTAL montage of bulls, horses, and deer, up to 12 feet tall. Their shapes intermingle one with another, and their colors radiate warmth and power. These magnificent creatures remind us that their creators were fully capable technicians who, with artistic skills at least equal to our own, captured the essence beneath the

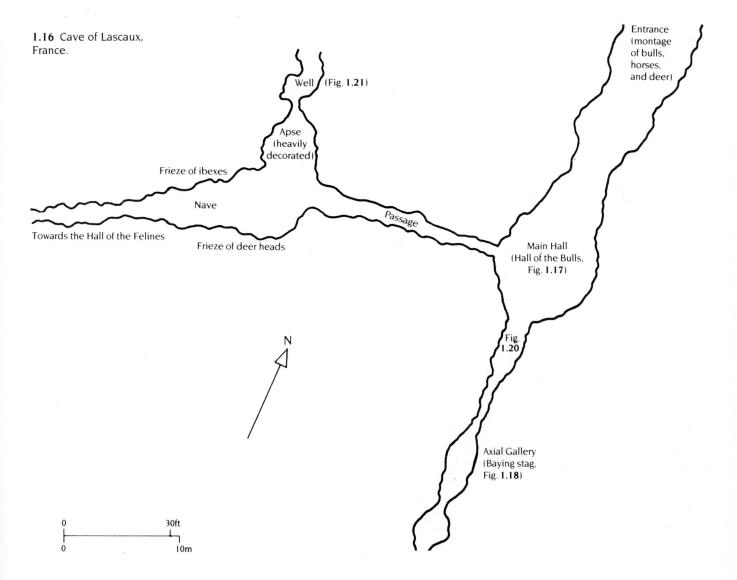

1.16 Cave of Lascaux, France.

Well (Fig. **1.21**)

Apse (heavily decorated)

Frieze of ibexes

Nave

Towards the Hall of the Felines

Frieze of deer heads

Passage

Entrance (montage of bulls, horses, and deer)

Main Hall (Hall of the Bulls, Fig. **1.17**)

Fig. 1.20

Axial Gallery (Baying stag, Fig. **1.18**)

N

0 30ft
0 10m

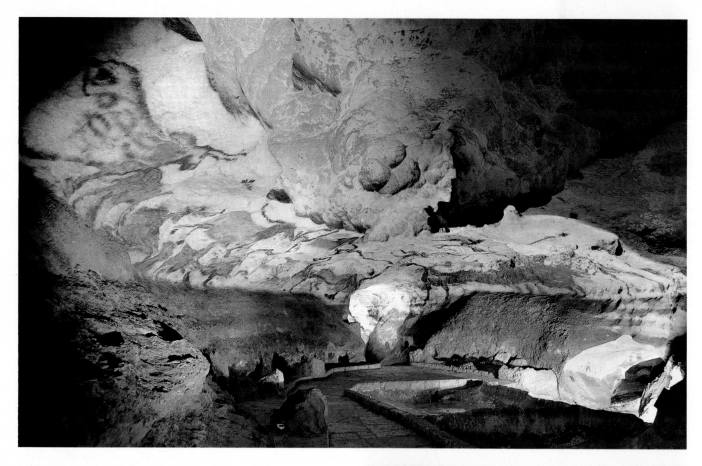

1.17 (above) Main Hall, or Hall of the Bulls, Lascaux.

1.18 (below) Head and back of deer, the 'baying stag',
c.16,000–14,000 BC. Paint on limestone, 4 ft 11 ins (1.5 m) high.
Lascaux.

1.19 (right) Geometric figures at the feet of a cow, left square
about 10 × 10 ins (25.4 × 25.4 cm). Lascaux.

1.20 (opposite) Entrance to the Axial Gallery from the Main
Hall, Lascaux.

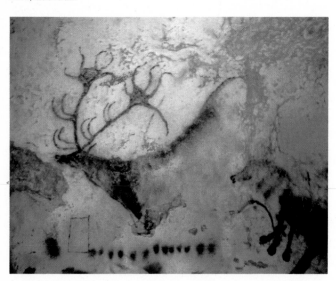

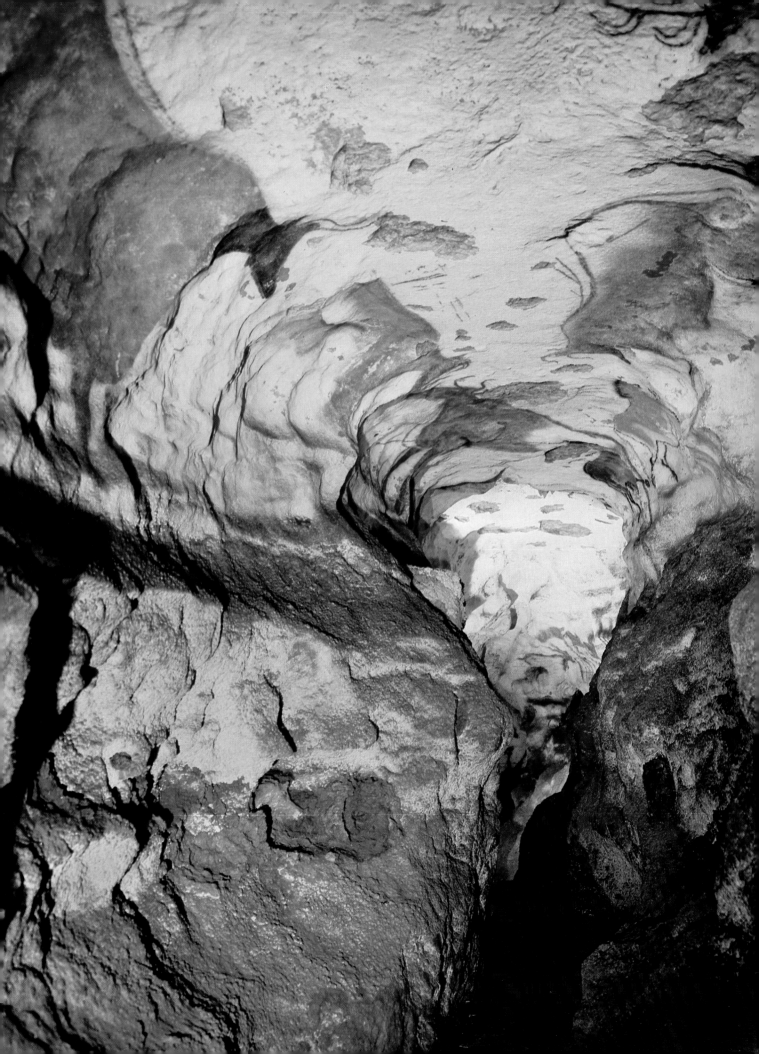

visible surface of their world. The paintings in the Main Hall were created over a long period of time and by a succession of artists. Yet their cumulative effect in this 30-by 100-foot DOMED gallery is that of a single work, carefully composed for maximum dramatic and communicative impact. We must remember, however, that we see the work, illuminated by electric floodlighting, very differently from people who could only ever see small areas at a time, lit by flickering stone lamps of oil or animal fat.

From the Main Hall one can move straight ahead to the dead-end Axial Gallery, whose walls and ceiling swirl in colorful and profuse images, alive and vital. The effect is breathtaking (Fig. 1.20). Rich in texture and color, the walls teem with horses, ibexes, cows, and bulls, amidst which we find the head and back of a baying stag (Fig. 1.18). Here the figures are much smaller than in the Main Hall, and are detailed with great delicacy. Like the Main Hall, the Axial Gallery seems to form a remarkably unified design. Its parts, like those of a BAROQUE design, stand on their own, distinct, yet rationally assembled into an emotional complexity which overwhelms the viewer.

From the Main Hall, a turn to the right leads through a small passageway to the Nave and the Apse. In the high-vaulted Nave, the paintings are spaced further apart. On one wall are a FRIEZE of ibexes, two groups of horses, three bison, and a very large black cow which dominates the wall. On the opposite wall a frieze of deer heads appears to show a swimming herd.

Swelling out from the Nave is a chamber called the Apse. Every surface of it is decorated, often with paintings layered one over the other, indicating immense activity over many years. Two additional spaces, the Well and the Hall of Felines, complete the areas that comprise the Lascaux Cave. Descending into the Well, we encounter a remarkable scene which dates back 15,000 to 20,000 years (Fig. 1.21). At the left, a remarkable portrayal of a rhinoceros captures the weight and power of the beast. The artist's choice of thick color areas to define the perimeter of the figure, rather than a simple outline, reveals a sophisticated use of PIGMENT. At the same time, the edges blend and recede to suggest the three-dimensional form of the animal. The sketch of a wounded bison on the

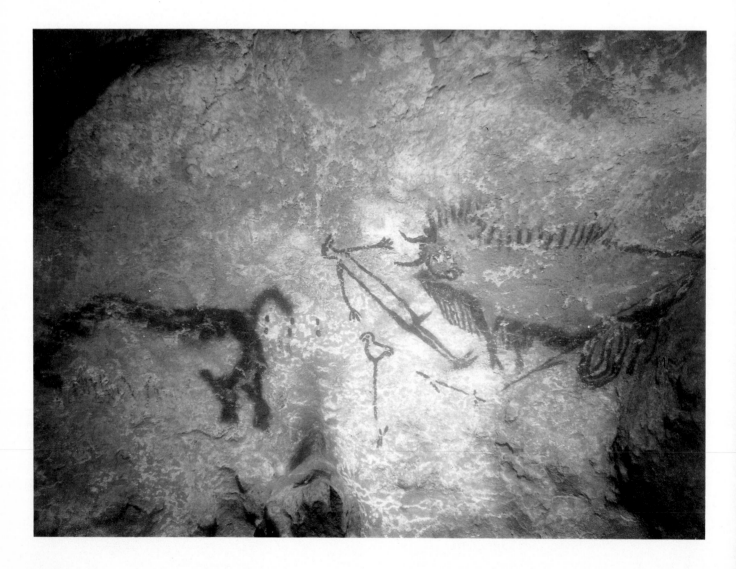

right is more rudimentary, although it too conveys a vivid impression of the actual beast. The human figure in the center is the least complete, and its meaning, even if it is interpreted as "bird-headed" and "dead," remains hidden. The "bird-topped rod" is also an enigma.

Another of Lascaux's enigmas is the series of geometric figures, or symbols, which occur throughout the cave (Fig. 1.19). Scholars have suggested numerous interpretations for these figures, but the mystery remains. We do not, and probably cannot, know their meaning. Elsewhere in the cave appear what seem to be arrows, or at least lines. Abbé Breuil attributed them to hunting magic and called them flying arrows.

There is some disagreement concerning the dating of the Lascaux paintings, but it is clear that through this whole sweep of time, human beings used art to help them cope with life and death, with hunting, with magic, and with the mysterious forces of nature around them. The paintings of Lascaux communicate these visions of our ancestors with a power and immediacy that threaten to overwhelm the modern viewer.

SUGGESTIONS FOR THOUGHT AND DISCUSSION

The artworks from humanity's earliest times reveal a human being who may have been fully developed in mental capabilities, and perhaps in communicative capabilities as well. If Marshack is correct in his analyses of these works, our earliest ancestors were not only artistic, but literate as well. Their vision was profound, and their technical ability was occasionally masterful. In visual art, they seem to have moved from the naturalistic style into the abstract.

■ What characteristics of Paleolithic art seem similar to other artworks you have experienced?

■ Express your own reactions to the examples in this chapter.

■ How do you react to the suggestion that Paleolithic people were equal in mental ability to us?

■ Is Ice-Age art more or less sophisticated than other so-called "primitive art" you have experienced, for example, African art?

■ What meanings can be transmitted through abstract, as opposed to naturalistic, images?

■ Some peoples believe that image and reality are the same. If such a belief existed in Paleolithic times, what practical results might Paleolithic humans have expected to occur from the representations we have seen in this chapter?

■ Do you think that Paleolithic people might merely have painted the walls of their caves for the pleasure of decoration, in the same way that we hang pictures on the walls of our homes?

■ What does the art of the Paleolithic period tell you about the humans who lived then?

■ Why might Paleolithic artists have chosen the deep, inaccessible parts of caves for some of their artworks?

1.21 Rhinoceros, bird-headed "dead" man, bird-topped rod, long spear and wounded bison, 6 ft 16 ins (1.98 m) long. The Well, Lascaux.

CHAPTER TWO

MESOPOTAMIA

The mythological Tower of Babel rose to connect heaven and earth. In much the same way the arts of the Mesopotamians symbolized people's relationship to their kings and, through them, their gods. Bridging prehistory and history, the cities and empires of the Fertile Crescent, the land "between the rivers"—the Tigris and the Euphrates—were our prototype civilizations. Here, for the first time, agriculture, metal technology, literacy, the specialization of labor, and a hierarchically organized urban community were combined. Kingdoms rose and fell as one power plundered its enemies, obliterated their cities, and was, in turn, itself plundered and obliterated. Finally, spilling out of the Crescent north into Asia Minor and south as far as Egypt, the vast empires of Mesopotamia reached outward in space and forward in time to clash with and influence the Greeks.

2.1 Head of an Akkadian ruler, from Nineveh, 2300–2200 BC. Bronze, 12 ins (30.5 cm) high. Iraq Museum, Baghdad.

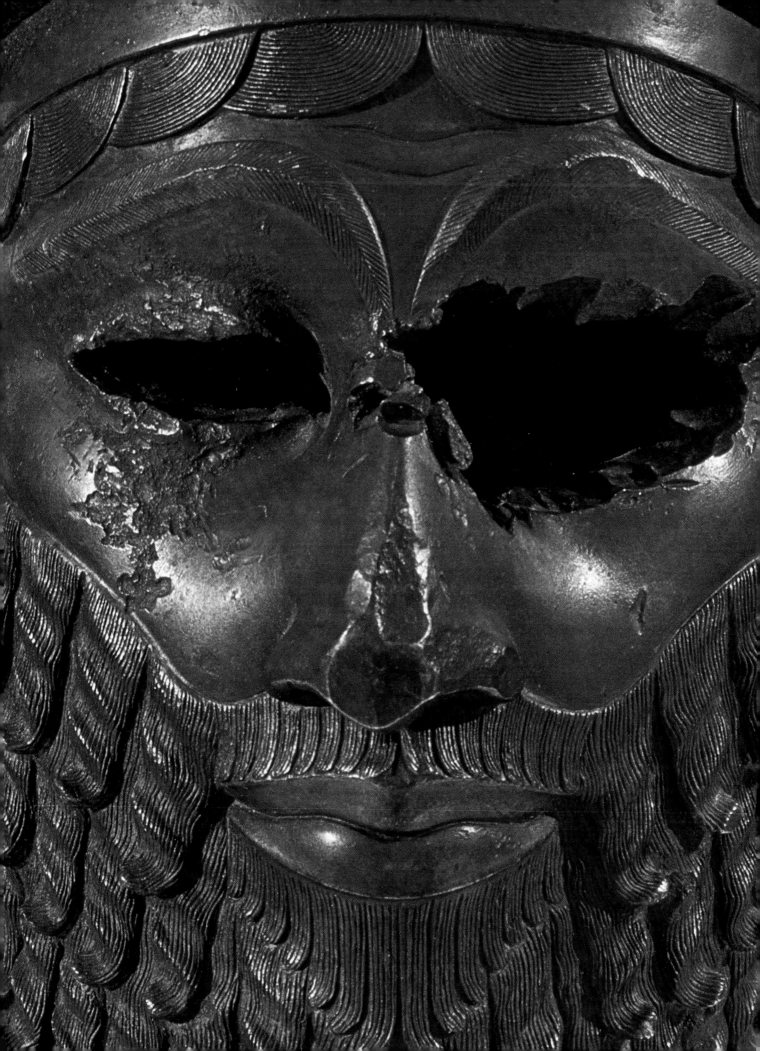

CONTEXTS AND CONCEPTS

FROM PREHISTORY TO HISTORY

Although we are studying cultural, not social, history, cultural history does not exist outside its social context. We must, therefore, be as careful with our general terminology as we are with our artistic terminology. The terms "prehistory" and "history" mark watersheds, not so much in our development as human beings, as in the development of the social arrangements under which we live. Humanity did not emerge into history from prehistory at some single point, however. Nor did it suddenly become "civilized" after having been "primitive." What terms, then, do we need to understand before we can move on to what historians call the "ancient, historical, civilized world"?

Archeologists talk about a Paleolithic Age (the Old Stone Age), which is followed by a Mesolithic Age (the Middle Stone Age), in turn followed by a Neolithic Age (the New Stone Age). Only in the last of these did our ancestors provide the beginnings from which a truly literate civilization could arise.

The word "history" implies a conscious and intentional recall of the past as a vital tradition that is handed down from one generation to another. In order for this to happen, a continuous organization must exist "which has reason to care for transmitting the historical traditions to future generations."[1]

"Civilization," on the other hand, implies the existence of something more. Before civilization could begin, human beings had to produce an economic surplus beyond their daily needs, so that some people could take up "non-productive" activities such as trading. To reach such a stage, they had to progress, from hunting and gathering, to agriculture. As our ancestors moved out of the Neolithic Age (an age that began and ended at widely separated times across the ancient world) and into the Age of Metals, they also moved from hunting to agriculture (this, too, at slightly different times). Societal complexity, perhaps the basic quality of civilization, could then emerge. At some time around 6000 BC, the first recognizable civilization appeared in the part of the Near East that we call Mesopotamia (see Figs **2.3** and **2.4**). The word Mesopotamia means "land between the rivers." It encompasses the entire geographical area centered on the Tigris and Euphrates Rivers, but does not denote a specific country. It is a term scholars use out of convenience to describe a large area and an amalgamation of cultures, as we shall see.

A SUCCESSION OF CULTURES

In a strip of land some 700 miles long and 150 miles wide between the Tigris and Euphrates Rivers, there is evidence of a cluster of very early farming villages. The oldest of these appeared in Neolithic times in the extreme south of the Fertile Crescent, where drainage from the uplands and annual flooding deposited a rich topsoil in which crops flourished. There was no significant rainfall, but water was plentiful, and wheat harvests appear to have been abundant. A surplus emerged. This enabled the people to improve their productivity further with techniques such as diking and ditching to raise the marshy flood plain above river-level. Individual irrigation and drainage projects came to be jointly organized, in collectively managed areas, and this resulted in the development of complex social and administrative structures.

At some point these increasingly sophisticated organizational units must have contended with each other over various opportunities. The resolutions of such conflicts would have been either conquest or cooperation. Undoubtedly both solutions were tried, and the wiser choice appears to have been further conglomeration and organization. Larger units of government then emerged. Towns were established and mutual defenses were erected. In one specific location, these factors appear to have coalesced more effectively than in others. The result was Sumer—the first truly urban settlement, and the first true civilization.

Sumer

The Sumerians had a way of life similar to that of the other peoples in the region. They lived in villages and organized themselves around several important religious centers, which grew rapidly, and in time became cities.

Religion
Religion and government shared a close relationship in Sumer. Religion permeated the social, political, and economic, as well as the spiritual and ethical life of society. From a long EPIC poem, the Gilgamesh epic, we gain an insight into this religion around which Sumerian society was organized. The list of gods is a long one. By about 2250 BC, the Sumerians worshipped a well developed and generally accepted PANTHEON of gods. Temples were

erected throughout Sumer for the sacrifices necessary to ensure good harvests. It appears that each individual city had its own god, and these local gods had their places in a larger HIERARCHY. Like the Greeks later (see Chapter 4), the Sumerians gave human forms and attributes to their gods. The gods also had individual responsibilities. Ishtar was the goddess of love and procreation, for example. There was a god of the air, one of the water, one of the plow, and so on. Three male gods at the top of the hierarchy demanded sacrifice and obedience. To those who obeyed the gods came the promise of prosperity and longevity. The elaborate and intricate rituals focused on cycles involving marriage and rebirth: a drama of creation witnessed in the changing seasons.

Sumerian religion was concerned with life and seems to have perceived the afterworld as a rather dismal place. Nonetheless, there is evidence to suggest not only the practice of ritual suicide, but also the belief that kings and queens would need a full complement of worldly possessions when they entered the next world.

Sumerian religion had important political ramifications as well. It ascribed ownership of all lands to the gods. The king was a king–priest responsible to the gods alone. Below him, an elaborate class of priests enjoyed worldly power, privilege, and comfort. To this class fell responsibilities for education and the writing of texts. And it is writing that undoubtedly represents the Sumerians' greatest contribution to the advancement of general civilization.

Writing

Various primitive peoples had used picture writing to convey messages. Sumerian writing, however, initiated the use of pictorial symbols that were qualitatively different: the Sumerians (and later the Egyptians) used pictures to indicate the syllabic sounds that occurred in different words rather than simply to represent the objects themselves. Sumerian language consisted of monosyllables used in combination, and so Sumerian writing came to consist of two types of sign, one for syllables and one for words. Writing materials were an unbaked clay tablet and a reed stylus which, when pressed into the soft clay, produced a wedge-shaped mark. The wedges and combinations of wedges that made up Sumerian writing are called "cuneiform," from the Latin *cuneus*, meaning "wedge."

Written language can cause many things to happen in a society, and it also reveals many things about that society. While opening up new possibilities for communication, it has a stabilizing effect on society too, because it fixes the past by turning it into a documentable chronicle. In Sumer, records of irrigation patterns and practices, tax-collections, and harvest and storage details were among the first things written down. Writing was also a tool of control and power. In the earliest times, the government and the priestly class of Sumer held a monopoly on literacy, and literacy served to strengthen their government.

But literacy also led to literature, and the oldest known story in the world comes to us from earliest Sumer. The Gilgamesh epic, an episodic tale of a hero's adventures, is from this era, although its most complete version dates from as late as the seventh century BC. Gilgamesh was a real person, a ruler at Erech (or Uruk), and one fascinating part of this epic describes a flood which parallels that in the story of Noah's ark in the Bible. Other epics too, and even love songs, have survived from the literature of ancient Sumer.

Everyday life

Domestic life in Sumer provides us with an additional insight into the human beings who made up this ancient civilization. Marriages were, apparently, monogamous, and they depended upon the consent of the bride's parents. Once a marriage occurred, a new family unit was established, governed by a formal contract. Its head was a patriarchal husband who ruled his relatives and his slaves. Nonetheless, evidence suggests that Sumerian women held high position in family life and society as a whole. This seems to reflect the importance of women's sexual power in Sumerian religion. Women also held important rights, including rights granted to female slaves who had children by free males. Divorce accorded fair treatment to women, although a wife's adultery was punishable by death.

The people of Sumer, like people today, were curious about the world around them. They sought answers to basic questions about the nature of the universe. In some cases these questions found intuitive answers, through artistic reflection. In other cases, the questions found scientific answers. Insofar as the Sumerians were capable of discerning scientific knowledge, they were also capable of applying that knowledge as technology. Sumerian mathematics employed a system of counting based on 60, and that system was used to measure time and circles. The invention of number positioning (for example, 6 as a component of 6 or 60) gave Sumerian mathematics an unusual level of sophistication. Mathematical calculation formed the basis for architectural endeavor which, in turn, gave rise to higher levels of brick-making technology. Pottery was mass-produced, making the first known use of the potter's wheel. The wheel itself appeared as a transportation device in Sumer as early as 3000 BC. By the third millennium BC, Sumerian technology had accomplished the casting of bronze and the invention of glass.

All these technological advances created a need for raw materials. This, in turn, encouraged the growth of trade and commerce, which took the ancient Sumerians to the far reaches of the Middle East.

Sumer comprised a dozen or so small cities and the lands around them, often within sight of one another. The feudal nature of Sumerian society constantly pitted one

city against its neighbor. Conflicts among these independent cities usually developed over water and pasture rights. But in spite of this, Sumerians shared a common language, customs, religion, and an intolerance of non-Sumerians.

The Archaic period

History provides us with a constantly changing scenario. To gain a clear overview of the changes in Mesopotamian civilization, we must consider certain periods in turn. The first of these is the Archaic period, from 3300 to 2400 BC, which saw numerous wars and conflicts between the cities.

Remember that the Sumerian city–states each had a ruler, or king–priest. The king was obliged to build temples; he also built roads. In addition, he was a warrior. Various carvings from the period depict kings leading troops into battle, conquering enemies, and receiving tribute from fallen foes. We find pictures of chariots and infantry. Chariots had solid wheels and were drawn by a special breed of ass. Charioteers carried javelins. Infantry soldiers wore uniforms and wielded short spears, pikes, and axes. Interestingly, with all the conflict among the city–states of Sumer, there does not appear to have been any attempt by the Sumerians to extend their territories to the north, where another civilization, that of the Akkadians, had grown up.

Nevertheless, the proximity of these civilizations was a catalyst for change. The distance between them was tiny by our standards. In fact, the distance from the Sumerian city of Kish to the Akkadian city of Babylon was only ten miles, a distance well within the limits of most modern cities. But these were different times, and the fastest means of transportation was not even the horse but rather the donkey. Contact did occur, however, and the Akkadians became interested in things Sumerian. In many of the border regions, Akkadians lived and dressed like Sumerians. Sumerian culture permeated Akkadian

2.2 Timeline of Mesopotamian culture.

BC	PERIOD	GENERAL EVENTS	LITERATURE & PHILOSOPHY	VISUAL ART	THEATRE & DANCE	MUSIC	ARCHITECTURE
8000	Neolithic	Mesopotamian farming villages Sumer		Ritual-painted vases Stamp seals	Religious dances		
3300				Head of a goddess (2.10) Lambs sacred to E-Anna (2.8, 2.11)			
3000	Archaic	Invention of the wheel Bronze casting		Cylinder seals Tell Asmar statues (2.12)			Ground level temples Sin Temple at Khafaje (2.21) Tell Asmar Temple (2.22)
2600				Royal harp (2.14) He-goat from Ur (2.15)			
2400	Akkadian	Sargon I Composite bow					
2300		Naram Sin	Sumerian pantheon well developed	Stele of Naram-Sin (2.16)			
2200	Neo-Sumerian		Early Gilgamesh Epic				
2100		Ur	Epics, love songs				Ziggurat at Ur (2.24)
2000		Abraham					
1900	Babylonian		Babylonian literature Rage of the God Ezra Love songs				
1700	Hittite	Hammurabi				Musical instruments: kissar, harps, lyres, dulcimers, asor	
900	Assyrian Empire		Old Testament		Social and religious dances		
800				Winged bull (2.27) Basalt reliefs (2.28–29)	Fire festival		
700		Sargon II					Citadel at Dur Sharrukin (2.25)
600	Neo-Babylonian	Nebuchadnezzar II Darius I	Gilgamesh Epic complete version				
500	Persian Empire	Xerxes I					
400							

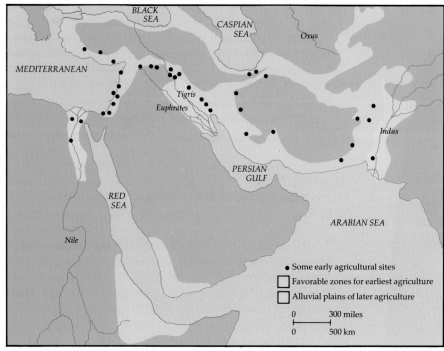

2.3 The ancient Middle East.

2.4 Mesopotamia.

civilization, which also adopted the Sumerian script. Curiously, though, as the Archaic period came to a close, it was the "Sumerizing" of the Akkadians that brought the latter to a position where they could conquer their older neighbor to the south.

The Akkadian period

Between 2400 and 2350 BC, Sargon I of Akkad led his people to victory over the Sumerians and thereby gained supremacy for Akkadian civilization. Sargon's empire stretched from the Mediterranean Sea to the Persian Gulf. Known for 1000 years as the King of Battle, he is known to us through inscriptions written in both Sumerian and Akkadian.

The reign of Sargon I is significant because he created a truly united empire, with a centralized government. A division between secular and religious authority was maintained, but the king was believed to rule by the authority of the gods. In the east, Enlil, the supreme god of Sumer, granted his authority. In the west, Sargon paid obeisance to the god Dagon. Sargon also ruled with the authority of the army, and the essence of Akkadian dominion was force. Military supremacy stemmed largely from two innovations. One was the composite bow, made from strips of wood, which could shoot arrows faster and further than the non-composite bow. The other was a military maneuver which proved effective in the wars between Athens and Sparta, when it was called the "Dorian phalanx." Its use required discipline and

professionalism: thousands of soldiers, ranked together in a tight formation with shields overlapping and spears projecting, formed a solid and impenetrable wall, which then moved steadily and forcefully forward, dispersing or crushing whatever stood in its path.

Sargon's grandson, Naram-Sin, called himself King of the Four Regions and seems to have been a fierce warrior. Depictions show him as standing taller than those around him, leading his loosely arranged soldiers to victory. Yet in spite of such strong leadership, the Akkadian phase was relatively brief by ancient standards. Within 200 years a mountain people, the Guti, overthrew Sargon's great-grandson, and a third phase, the neo-Sumerian period, began.

The neo-Sumerian period

This period, which lasted until approximately 2000 BC, brought to ascendancy the city–state of Ur. The rulers of Ur called themselves the kings of Sumer and Akkad. The art of the period indicates an even more exaggerated tendency to exalt the ruler of the land. The area from the Persian Gulf to the Zagros mountains was united. Government was centralized and the economy flourished. New temples appeared, and architecture reflected in its scale the vigor and pride of the society and its rulers. Ziggurats, great terraced towers, inspirations for the biblical Tower of Babel, rose skyward.

The neo-Sumerian period ended as more powerful neighbors, the Elamites, conquered Ur and turned the

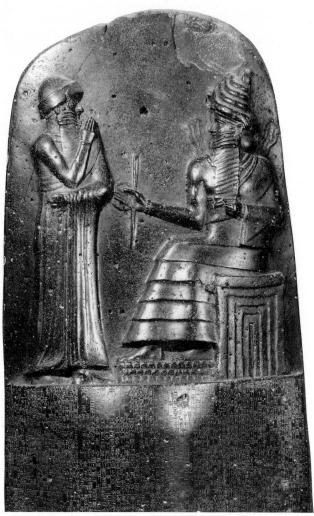

2.5 Upper part of stele inscribed with the legal Code of Hammurabi, c.1760 BC. Basalt, 7 ft 4 ins (2.235 m) high. Louvre, Paris.

empire once more into a conglomeration of city–states of reasonably equal status. This was the end of the Sumerian civilization.

Hammurabi and the law

As Sumerian civilization coalesced, corresponding developments took place among the surrounding peoples. But the region, which by this time had begun to feel the influence of the Egyptian civilization, remained in flux until the next great ruler emerged in the early 1700s BC.

This ruler was Hammurabi. His capital was Babylon, and Babylon became the hub of the world—at least for a while. The first Babylonian empire encompassed the lands from Sumer and the Persian Gulf to Assyria. It included the cities of Nineveh and Nimrud on the Tigris and Mari on the Euphrates, and extended up the

Euphrates to presentday Aleppo (see Fig. **2.4**). This empire, of approximately 70,000 square miles, rested on an elaborate, centralized, administrative system. It maintained its order through a wide-ranging judicial code we have come to call the Code of Hammurabi (Fig. **2.5**). These laws consist of 282 articles which address the legal questions of the time.

Foremost in importance among the articles was the precept of "an eye for an eye." Before Hammurabi's time, damages for bodily injury were assessed on a monetary basis, for example, a lost eye would be assessed at 60 shekels. Under Hammurabi, the monetary system was retained only for an injury inflicted by a free man on one of lower status. If, however, the parties were of equal status, exact retribution was called for: "An eye for an eye, a tooth for a tooth," and so forth. We do not know what retribution was exacted for injury inflicted on a person of higher degree, but the penalty in such a case was undoubtedly very severe. Hammurabi's code was pragmatic and clearly based on a rigid class system. Only the rich were allowed to escape retributive mutilation by monetary payment. A sliding scale, based on ability to pay, determined compensation for medical expenses and legal fees.

The rights and place of women, likewise, were specifically spelled out. The purpose of a wife was to provide her husband with legitimate sons and heirs. The penalty for adultery (by a wife) was drowning for both wife and paramour. Men were allowed "secondary" or "temporary" wives as well as slave concubines. On the other hand, beyond the area of procreation, women were largely independent. They could own property, run businesses, lend and borrow money. A widow could remarry, which allowed greater population growth than was possible in cultures where the wife had to throw herself on her husband's funeral pyre.

In essence, the Code of Hammurabi dealt with wages, divorce, fees for medical services, family matters, commerce, and land and property, which included slaves. Hammurabi, like the rulers who preceded him, took his authority from the gods, and also his law. Thus the concept of law as derived from extraordinary and supernatural powers continued unchallenged.

The Assyrians

Hammurabi reigned for only 42 years, but he achieved much in that time. Cuneiform writing saw further development and spread widely throughout the Near East. Astrology stimulated the observation of nature. The patron god of the Babylonians, Marduk, surpassed his rivals to assume supremacy in the pantheon. One hundred and twenty-five years after Hammurabi's death, his dynasty ended as yet another power from Asia Minor and northern Syria, the Hittites, plundered Babylon. The conquerors

apparently maintained control until nearly 1100 BC, but no notable figures emerged.

By the year 1000 BC a new power had arisen in Mesopotamia—the Assyrians. These were northern peoples from Ashur on the Tigris River. Their military power and skill enabled them to maintain supremacy over the region, including Syria, the Sinai peninsula, and as far as Lower Egypt, where they destroyed Memphis. For nearly 400 years they appear to have engaged in almost continuous warfare, ruthlessly destroying their enemies and leveling their cities. Finally, they too felt the conqueror's sword and all their cities were utterly destroyed.

The neo-Babylonian period

The neo-Babylonian period lasted for less than 100 years, but it produced some notable accomplishments and individuals. After the destruction of the Assyrian Empire by the combined forces of two local peoples, the Scythians and the Medes, a new ruler rose in Babylon. (Although politically impotent, the city had retained its cultural centrality.) Nebuchadnezzar II restored order and built a palace with a ziggurat which we know from biblical accounts as the Tower of Babel.

The Persians

The Persian Empire unified the Middle Eastern world from approximately 539 to 331 BC. Nomads by tradition, the Persians nonetheless kept a tight administrative hold on a vast empire that stretched from Mesopotamia to Syria, Asia Minor, Egypt, and India. Under Cyrus the Great, Darius I, and Xerxes I, the Persian Empire occupied an area nearly twice as large as any previous empire in the region. Had not the Greeks of the Delian League turned them back at the battle of Marathon in 490 BC, the Persians would have marched into Europe as well. Carefully organized into provinces called satrapies, the empire functioned smoothly under kings who regularly moved the administrative capital, but whose great palace was located at Persepolis. The Persians worshipped Ahuramazda, the god of light. Their places of worship were marked by outdoor fires, and so, unlike their predecessors, they left no notable temples or ziggurats.

The Jews

The ancient Jews shared a common ancestry with the Mesopotamian civilizations of Sumer and Ur. Around 2000 BC, the Jewish patriarch Abraham migrated, with his people, into Canaan from the land between the Tigris and Euphrates. Later, the Jewish culture overlapped with those of Egypt and Persia, and became reentwined with those of Babylon and Nineveh. Thus, the Jews shared with surrounding peoples a body of myths regarding such events as the Creation and the Flood. They diverged radically from their neighbors, however, in their adoption of MONOTHEISM, or the worship of one god.

FOCUS

TERMS TO DEFINE
Prehistory
Sumer
Cuneiform writing
Ziggurat
Persian Empire

PEOPLE TO KNOW
Sargon I
Hammurabi

DATES TO REMEMBER
The Archaic period
The Akkadian period
The Assyrian Empire

QUESTIONS TO ANSWER
1 What was the relationship between Sumerian government and religion?
2 How did the Sumerians regard the afterworld?
3 How did writing affect Sumerian culture?
4 What role did women play in Sumerian culture?
5 What were the responsibilities of the Sumerian/Akkadian king–priest?

THE ARTS
OF MESOPOTAMIA

TWO- AND THREE-DIMENSIONAL ART

Early Sumerian art

The majority of artworks surviving from Mesopotamia prior to 3000 BC consists of painted pottery and round or square stamp seals. The decoration of pottery served to satisfy the creative urge to give functional objects an aesthetic appeal. Stamp seals, for embossing clay tablets, went beyond the status of mere tools: clearly they came to be regarded as surfaces ideally suited to the artist's creative ingenuity.

Later, for reasons unknown to us, the cylindrical seal came into being. A carved wooden roller was applied to wet clay to produce a ribbon-like design of indefinite length. The creative possibilities for individuality of design in the cylinder seal were far greater than those of the stamp seal. Figure **2.6** shows a cylinder seal and its impression. The possibility of infinite repetition of an intricate design beginning and ending at the same point must have fascinated the Sumerians.

Monsters seem to have provided inspiration for the Sumerians, and many characteristic designs involve them. One reason for the popularity of monsters may have been their emotive and decorative potential. In Figure **2.6** a snake-necked lion combines two symbols of fertility: the lioness and the intertwined snakes. This fertility-based design and the infinitely repeating cycle it represents exemplify the cyclical Sumerian religious philosophy, and

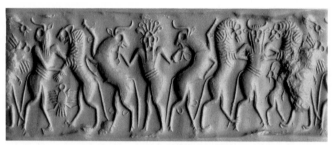

2.7 Sumerian cylinder-seal impression, showing a hero figure with bulls, surrounded by bull–men fighting lions, c.2500 BC. Aragonite seal, 1⅝ ins (4.3 cm) high. British Museum, London.

appear again and again in Sumerian art. Another later example of the cylinder seal explores the subject matter of raging beasts, making use of the repeating pattern imposed by the MEDIUM (Fig. **2.7**). Here intricate line patterns move through elaborate interlocking forms as bull and man wrestle for supremacy, both symbolically and in terms of design. Scenes of sacrifice, hunting, and battle all appear in the examples of cylinder-seal art that have survived. Throughout the early periods of Sumerian art there seems to have been a conflict, or at least an alternation, between symbolism and naturalism in the depictions in cylinder art.

The LOW RELIEF art of the early Sumerians provides further insights into Sumerian life. In works such as the relief vase shown in Figures **2.8** and **2.9**, we find a preoccupation with ritual and the gods. This alabaster vase, which stands three feet tall, celebrates the cult of E-Anna,

2.6 Mesopotamian cylinder seal and impression, showing snake-necked lions, c.3300 BC. Green jasper seal, 1¾ ins (4.5 cm) high. Louvre, Paris.

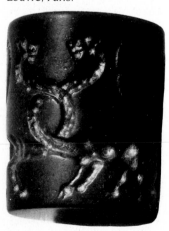

goddess of fertility and love. The vase is divided into four bands and shows the marriage of the goddess, which was depicted in order to ensure fertility among the people. The bottom band has alternate stalks of barley and date palms; above it are rams and ewes. In the third band naked worshippers carry baskets of fruit and other offerings. At the top the goddess herself stands before her shrine, two coiled bundles of reeds, to receive a worshipper or priest, whose tribute basket brims with fruit.

The composition exhibits an alternating flow of movement from left to right in the rams and ewes, and right to left in the worshippers. The figures are stylized but not rigid. Bodies are depicted in profile, as are heads, and the representation of the torso is fairly naturalistic. Anatomical proportion, however, especially in the torso, displays varying degrees of realism. Yet the muscular little men seem to show the strain of their burdens. The faces are clearly generalizations and not portrayals of individuals.

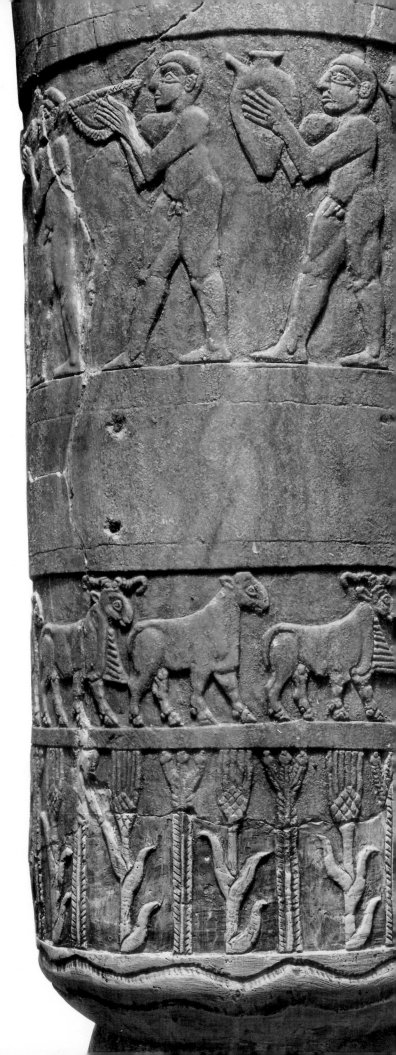

2.8 Vase with ritual scene in relief, from the E-Anna precinct, Uruk (Warka), Iraq, c.3500–3100 BC. Alabaster, 36 ins (91.4 cm) high. Iraq, Museum, Baghdad.

2.9 Detail of Uruk vase, showing tribute bearers and rams and ewes.

2.10 Head of a woman (female goddess) from Uruk, c.3500–3000 BC. Marble, 8 ins (20.3 cm) high. Iraq Museum, Baghdad.

2.11 Carved trough from Uruk, showing animals of the "sacred herd" of the mother goddess, E-Anna, with a reed-built byre, c.3500–3100 BC. Alabaster, $7\frac{7}{8}$ ins (20 cm) high. British Museum, London.

The mother goddess also emerges as the central focus of the works shown in Figures **2.10** and **2.11**. The head of a goddess (Fig. **2.10**), carved from white marble, may originally have adorned a wooden statue. Lapis lazuli eyebrows, lapis and shell pupils, and gold sheeting over the hair undoubtedly completed the work in its original form. The modeling of the mouth is remarkably sensuous, gentle, and lifelike.

In Figure **2.11**, a carving on a stone trough depicts a byre, the symbolic shrine of the goddess, from which lambs emerge on either side. The composition represents the "sacred herd," whose regeneration by the goddess symbolizes the restocking of its earthly counterparts each spring. The motion and countermotion of the design exhibit a fair degree of life and vitality, as the rams and ewes move toward the shrine, while the young lambs emerge from it.

The Archaic period

In the years from 3000 to 2340 BC, persons and events depicted in art became less stereotyped and anonymous. Here we find kings portrayed in devotional acts rather than as warlords. We also grasp a sense of the cylindrical nature of much Sumerian sculpture. The famous statues from Tell Asmar and the Temple of Abu illustrate this well (Fig. **2.12**).

But if crudity marks the depiction of the human figure in these votive statues, grace and delicacy are evident in two other works from this period (Figs **2.13** and **2.14**). These works illustrate the golden splendor of the Sumerian court. Inlaid in gold, the bearded bull symbolizes the royal leadership of ancient Sumer. Also laden with the symbolism of masculine fertility is the equally dazzling golden goat from the royal graves at Ur (Fig. **2.15**). Here we glimpse an idea basic to Sumerian culture: the wisdom and perfection of divinity embodied in animal power. In this case the goat is the earthly manifestation of the god Tammuz, and his superhuman character is crisply and elegantly conveyed.

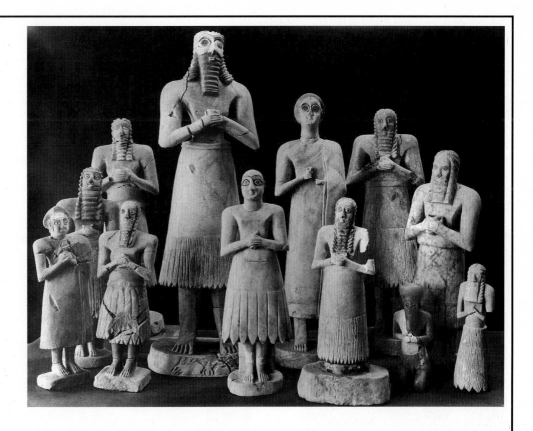

2.12 Statues of worshippers and deities from the Square Temple at Tell Asmar, Iraq, c.2750 BC. Gypsum, tallest figure 30 ins (76 cm) high. Iraq Museum, Baghdad, and The Oriental Institute, University of Chicago.

MASTERWORK
The Tell Asmar Statues

Undoubtedly the most striking features of these figures are their enormous, staring eyes. In contrast to the head shown in Figure **2.10** they are intact and rivet our attention with their dramatic exaggeration. Representing Abu, god of vegetation (the large figure), a goddess assumed to be his spouse, and a crowd of worshippers, the statues occupied places around the inner walls of an early temple, as though they were at prayer, awaiting the divine presence. The figures have great dignity, despite the stylization and somewhat crude execution. In addition to the staring eyes, our attention is drawn to the distinctive carving of the arms, which are separate from the body. The lines of each statue focus the eye of the viewer on the heart, adding to the emotion suggested by the posture. The composition is closed and self-contained, reflecting the characteristics of prayer.

Certain geometric and expressive qualities characterize these statues. In typical Sumerian style, each form is based on a cone or cylinder. The arms and legs are stylized and pipe-like, rather than realistic depictions of the subtle curves of human limbs.

The god Abu and the mother goddess can be distinguished from the rest by their size and by the large diameter of their eyes. The meaning in these statues clearly bears out what we know of Mesopotamian religious thought. The gods were believed to be present in their images. The statues of the worshippers were substitutes for the real worshippers, even though no attempt appears to have been made to make the statues look like any particular individual: every detail is simplified, focusing attention on the remarkable eyes, which are constructed from shell, lapis lazuli, and black limestone.

Looking back to the Head of a Woman from Uruk (Fig. **2.10**), we can see that large and expressive eyes appear to be a basic CONVENTION of Sumerian art —though it is a convention found in other ancient art as well. Its basis is unknown, but the idea of the eye as a source of power permeates ancient folk-wisdom. The eye could act as a hypnotizing, controlling force, for good or for evil, hence the term "evil eye," which is still used today. Symbolic references to the eye range from "windows of the soul" to the "all-seeing" vigilance of the gods.

The Sumerians used art, like language, to communicate through conventions. Just as cuneiform script condensed wider experiences, and simplified pictures into signs, so Sumerian art took reality, as it was perceived by the artist, and reduced it to a few conventional forms which, to those who understood the conventions, communicated the larger truth.

2.13 (below) Soundbox panel of the royal harp from the tomb of Queen Puabi at Ur, Iraq, 2650–2550 BC. Detail of **2.14**. Shell inlay set in bitumen, 13 ins (33 cm) high. University Museum, University of Pennsylvania.

2.14 (right) Royal harp from the tomb of Queen Puabi at Ur. Wood with gold, lapis lazuli, and shell inlay. University Museum, University of Pennsylvania.

2.15 (opposite) He-goat from Ur, c.2600 BC. Wood with gold and lapis lazuli overlay. 20 ins (50.8 cm) high. University Museum, University of Pennsylvania.

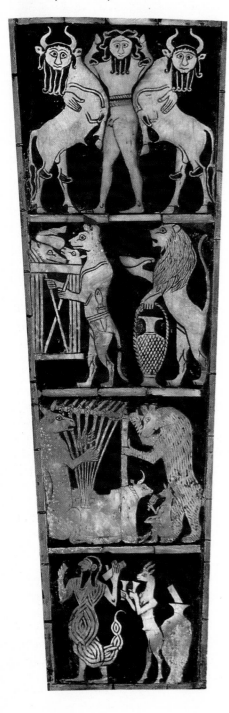

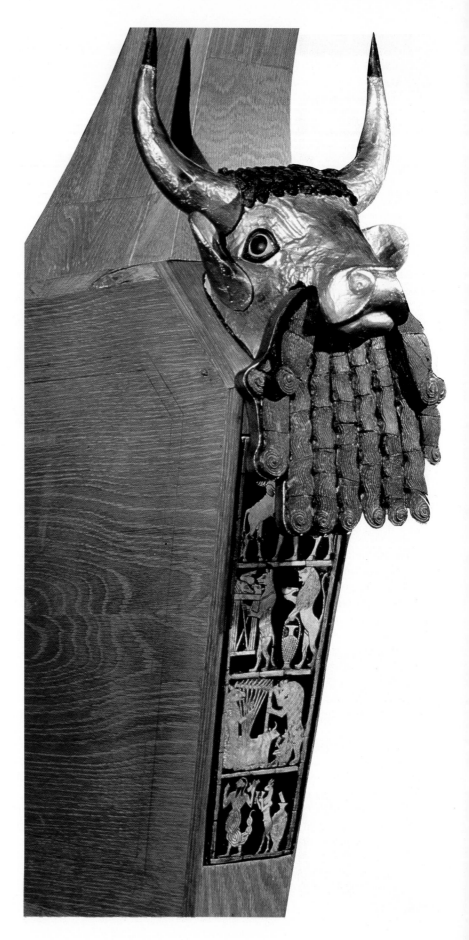

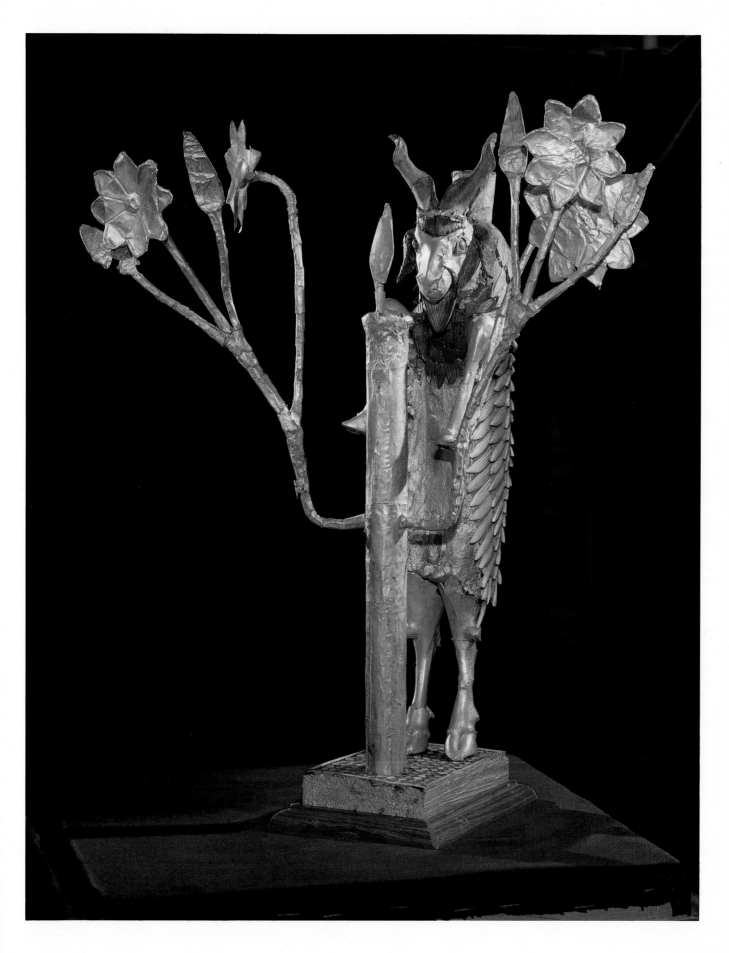

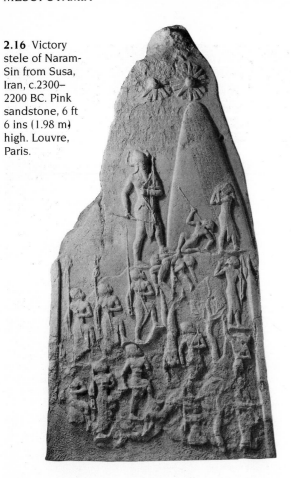

2.16 Victory stele of Naram-Sin from Susa, Iran, c.2300–2200 BC. Pink sandstone, 6 ft 6 ins (1.98 m) high. Louvre, Paris.

The Akkadian period

From the Akkadian period (2340–2180 BC) comes a uniquely dramatic and dynamic portrayal, high in emotion, yet conventional in the depiction of figures. The stele of King Naram-Sin (Fig. **2.16**) commemorates an historical event and, unlike the earlier works we have seen, records a strictly human accomplishment. Organized to fit the shape of the stone, the composition seems to rise and fall in RHYTHMIC spasms: one figure moves our eyes upward while another brings them down. The king, in his horned helmet, towers over his enemies and establishes the FOCAL AREA of the work.

LITERATURE

The Sumerian scribes began recording literature at some point between the years 2700 and 2100 BC. Their texts ranged, as we have seen, from epics—usually long rehearsals in verse of the feats of an indigenous hero, or of the tribe—to love songs. Since reading and writing were rare skills, however, most stories remained in the oral tradition. By 1900 BC, literature in Babylonia was more developed. But, true to the spirit of their civilization, the Babylonians tended to produce it for some practical purpose. A poem about the rage of the god Ezra was

a charm against pestilence. Lyrics for love songs, which arose from fertility rites, exhibited a frankness that left nothing to the imagination.

A great many literary texts have come down to us on school tablets. Students copied classic texts in order to learn spelling and style. In the Gilgamesh epic we find universal human themes such as the quest for immortality and the effects of wanton pride.

Elsewhere in Mesopotamia, scribes copied the myth of Adapa-Oannes, the wisest of men, who ascended into the heavens and yet failed to attain immortality. The Sumerian tradition is strongly evident in later Mesopotamian literature; almost all gods, heroes, and men, especially those of Akkadian classical literature, are Sumerian.

The Bible

Among the Mesopotamian peoples, in around 2000 BC, were the Jews, otherwise known as the Hebrews because they spoke the Hebrew language. They were descendants of Abraham, an inhabitant of Ur. He is an important patriarchal figure in Judaism, and also in Christianity and Islam. The Hebrews traced their story and chronicled their monotheistic religion in a series of texts which came to be called the Hebrew Bible. The earliest surviving text source is dated to approximately 1000 BC.

The Bible, a term that simply means "books," is a collection of works held sacred by Jews and, much later, by Christians. The Christian Old Testament comprises, with a few exceptions, the same material as the Jewish scriptures—that is, the Law, the Prophets, and the Writings. The Old Testament presents a sweeping history, along with detailed laws, teaching on ethics, poetry, psalms, and wisdom literature. The New Testament is the story of the life and teachings of Jesus and of the establishment of the Christian Church.

The Psalter, the book containing the psalms, is the hymnal of ancient Israel. Most of the psalms, or sacred songs, were probably composed to accompany worship in the temple. They can be divided into various types, such as enthronement hymns, songs of Zion, laments, songs of trust, thanksgiving, sacred history, royal songs, wisdom songs, and liturgies. Here we include Psalm 22 (a song of David), and Psalms 130 and 133 (songs of ascent). Dating the psalms has been difficult and controversial, but it seems clear that some of them—for example Psalms 29 and 68—are among the earliest texts in the Hebrew Bible.

Aside from their poetic imagery, many of the psalms invoke a very personal and individual entreaty to God. In general, the psalms stand in contrast to the rest of the Bible, in that they represent the people talking to God, rather than *vice versa*. Both Psalm 22 and Psalm 130 speak in the first person and appeal to the Lord. They open with a statement of agony and move toward a conclusion of

hope and assurance, representing strong statements of faith and hope. Psalm 22 provides for some Christian theologians a source for Jesus' seemingly desperate exclamation from the cross, "My God, my God, why hast thou forsaken me?" (Matthew 27:46; Mark 34:36), which, although it begins with an accusation, ends in affirmation and assurance. This would support the contention that Jesus did not feel abandoned by God in his crucifixion. Psalm 33 is a brief and upbeat expression of trust: the comparison of brotherly unity to "the precious oil upon the head, running down upon the beard," provides not only a rich poetic image, but also a cultural reference to the practice of anointing the head with oil (a valuable commodity).

Psalm 22

1 My God, my God, why hast thou forsaken me?
 Why art thou so far from helping me, from the words of
 my groaning?
2 O my God, I cry by day, but thou dost not answer;
 and by night, but find no rest.

3 Yet thou art holy,
 enthroned on the praises of Israel.
4 In thee our fathers trusted;
 they trusted, and thou didst deliver them.
5 To thee they cried, and were saved;
 in thee they trusted, and were not disappointed.

6 But I am a worm, and no man;
 scorned by men, and despised by the people.
7 All who see me mock at me,
 they make mouths at me, they wag their heads;
8 "He committed his cause to the LORD; let him deliver him,
 let him rescue him, for he delights in him!"

9 Yet thou art he who took me from the womb;
 thou didst keep me safe upon my mother's breasts.
10 Upon thee was I cast from my birth,
 and since my mother bore me thou hast been my God.
11 Be not far from me,
 for trouble is near
 and there is none to help.

12 Many bulls encompass me,
 strong bulls of Bashan surround me;
13 they open wide their mouths at me,
 like a ravening and roaring lion.

14 I am poured out like water,
 and all my bones are out of joint;
my heart is like wax,
 it is melted within my breast;
15 my strength is dried up like a potsherd,
 and my tongue cleaves to my jaws;
 thou dost lay me in the dust of death.

16 Yea, dogs are round about me;
 a company of evildoers encircle me;
 they have pierced my hands and feet—
17 I can count all my bones—

they stare and gloat over me;
18 they divide my garments among them,
 and for my raiment they cast lots.

19 But thou, O LORD, be not far off!
 O thou my help, hasten to my aid!
20 Deliver my soul from the sword,
 my life from the power of the dog!
21 Save me from the mouth of the lion,
 my afflicted soul from the horns of the wild oxen!

22 I will tell of thy name to my brethren;
 in the midst of the congregation I will praise thee:
23 You who fear the LORD, praise him!
 all you sons of Jacob, glorify him,
 and stand in awe of him, all you sons of Israel!
24 For he has not despised or abhorred
 the affliction of the afflicted;
and he has not hid his face from him,
 but has heard, when he cried to him.

25 From thee comes my praise in the great congregation;
 my vows I will pay before those who fear him.
26 The afflicted shall eat and be satisfied;
 those who seek him shall praise the LORD!
 May your hearts live for ever!

27 All the ends of the earth shall remember
 and turn to the LORD;
and all the families of the nations
 shall worship before him.
28 For dominion belongs to the LORD,
 and he rules over the nations.

29 Yea, to him shall all the proud of the earth bow down;
 before him shall bow all who go down to the dust,
 and he who cannot keep himself alive.
30 Posterity shall serve him;
 men shall tell of the Lord to the coming generation,
31 and proclaim his deliverance to a people yet unborn,
 that he has wrought it.

Psalm 130

1 Out of the depths I cry to thee, O LORD!
 Lord, hear my voice!
2 Let thy ears be attentive
 to the voice of my supplications!

3 If thou, O LORD, shouldst mark iniquities,
 Lord, who could stand?
4 But there is forgiveness with thee,
 that thou mayest be feared.

5 I wait for the LORD, my soul waits,
 and in his word I hope;
6 my soul waits for the LORD
 more than watchmen for the morning,
 more than watchmen for the morning.

7 O Israel, hope in the LORD!
 For with the LORD there is steadfast love,
 and with him is plenteous redemption.
8 And he will redeem Israel
 from all his iniquities.

Psalm 133

1 Behold, how good and pleasant it is
 when brothers dwell in unity!
2 It is like the precious oil upon the head,
 running down upon the beard,
 upon the beard of Aaron,
 running down on the collar of his robes!
3 It is like the dew of Hermon,
 which falls on the mountains of Zion!
 For there the LORD has commanded the blessing,
 life for evermore.[2]

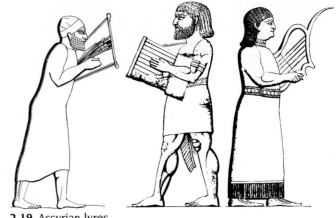

2.19 Assyrian lyres.

MUSIC

The early Sumerians made music as an essential and lively part of their culture, and they had many musical instruments. Lyres, pipes, harps, and drums all figured prominently in Sumerian music. These instruments appear in the art of the later Babylonian period and, more especially, in that of the Assyrian cultures. We have already seen one (reconstructed) example of a musical instrument in Figure 2.14.

Such illustrations as we have yield a fleeting picture of Mesopotamian music. Assyrian and Babylonian sculpture depicts musicians playing harps similar to the ancient kissor (Fig. 2.17). This instrument has a movable slant bar that anchors the strings. Thus, by simple pressure, the player can change the pitch of the strings. The Assyrians had a variety of instruments, wind, string, and percussion. They apparently used stringed instruments for solo performances, in ensembles, and as accompaniment for the voice. Stringed instruments show evidence of finger boards, and this indicates some degree of sophistication in musical development.

The harp was a basic instrument in Assyrian music;

Figure 2.18 illustrates its nature. The sounding board is at the top. Hanging from the bottom are tassels and strings, which make the instrument seem larger than it actually is. As pictured in extant sculpture, the lyre appears to have taken at least three different shapes (Fig. 2.19). There is also evidence of a dulcimer-like instrument and another stringed instrument, also apparently played with a stick, called the asor (Fig. 2.20).

In the category of wind instruments the Assyrians had a double pipe and also some variety of straight trumpet, which appears to have been a military instrument. Percussion instruments included the usual variety of hand-held drums, bells, cymbals, and tambourines.

Music fulfilled a variety of functions in Mesopotamian life. It seems to have been most popular as secular entertainment, but religious ceremonies also employed music. One low relief in the British Museum shows a king standing in front of an altar offering a libation for two lions he has just slain. Musicians with asors stand on the opposite side of the altar. Solo performances, instrumental ensembles of single and mixed instruments, and solo

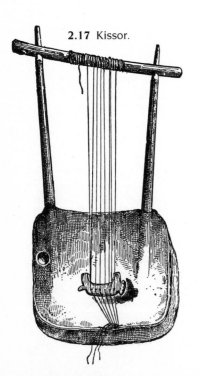

2.17 Kissor.

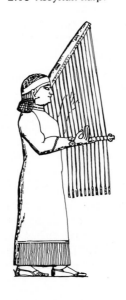

2.18 Assyrian harp.

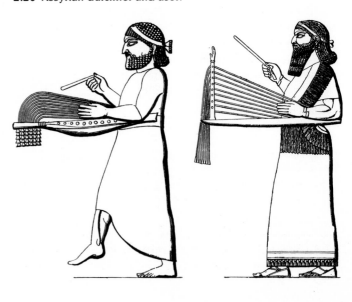

2.20 Assyrian dulcimer and asor.

and choral vocal music with instrumental accompaniment, are all documented.

We can only speculate on what Mesopotamian music would have sounded like; on its RHYTHMS, SCALES, and TEXTURE. We can, however, imagine something of its TIMBRE and DYNAMIC range from the scant evidence we have. Clearly, stringed instruments were predominant. Percussion and rhythm instruments seem to have been less popular, and the trumpet was mainly military in application. So we may assume that Mesopotamian music favored lyrical, soft, restrained tones, rather than loud, brash ones.

DANCE

Dance evidently played some part in ancient Mesopotamian culture, although we know little about its precise form. In Sumer we find various forms of sacred dance. One type seems to have required a procession of singers, moving slowly to music played on flutes. Another kind employed dancers prostrating themselves before an altar. In Assyrian low-relief sculpture, depictions of dancers are fairly common, in both religious and secular contexts. The fire festival of the goddess of fertility, Ashtoreth, apparently included drunken, orgiastic dancing involving self-mutilation with knives.

ARCHITECTURE

Evidence about Mesopotamian architecture dates back to well before Sargon I unified Sumer and Akkadia in the 24th century BC. A group of temples from around 2700 BC have been termed ground-level temples because, unlike later temples, they were not built on raised platforms. The Sin Temple at Khafaje (Fig. **2.21**) exemplifies this early style. It follows a plan typical of Sumerian temples. A long, rectangular sanctuary focuses on an altar at one end. An entrance and cross-axis occur at opposite ends of the sanctuary from the altar. Chambers were added on each side of the sanctuary.

The Tell Asmar Temple (Fig. **2.22**), which yielded the group of statuettes we examined earlier (Fig. **2.12**), is from the same period. Its plan is similar to that of dwelling houses of the time, in that the various rooms are grouped around a central courtyard. Here, the chambers include a priest's room, three shrines, the entrance hall, and an ablution room.

Sumerian buildings were constructed of mud that had been sun-dried in brick-shaped molds. In early buildings, courses were laid horizontally. Later, bricks were made larger and with convex sides; these were placed on edge. Successive courses leaned in opposite directions and created a herringbone pattern (Fig. **2.23**).

From the neo-Sumerian period, dating from 2120 BC,

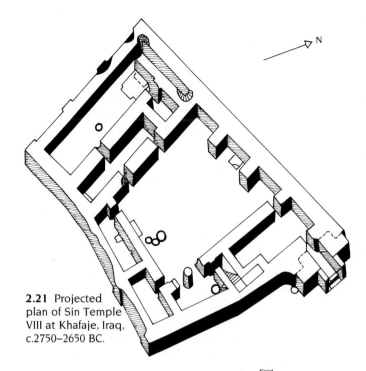

2.21 Projected plan of Sin Temple VIII at Khafaje, Iraq, c.2750–2650 BC.

2.22 Projected plan of the Square Temple at Tell Asmar, c.2750–2650 BC.

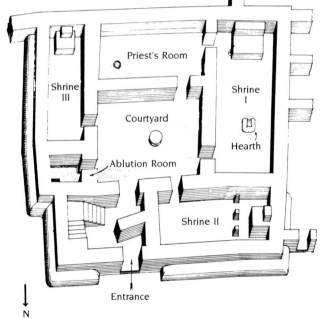

2.23 Diagram of Sumerian method of brick laying, used c.2750–2250 BC.

we have the surviving structures of Ur, which was the capital of the empire ruled by the kings of Sumer and Akkad.

Inside the city walls lies the colossal ziggurat built by Ur-Nammu and completed by his son Sulgi (Fig. **2.24**). (It was next to this very ziggurat that the Iraqis parked some

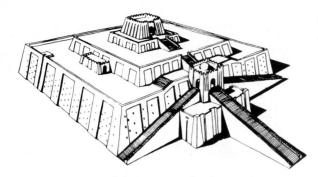

2.24 Reconstruction of the ziggurat of Ur-Nammu at Ur, c.2100 BC. Base 200 × 150 ft (61 × 45.7 m).

of their newest warplanes to save them from attack during the Persian Gulf war of 1991.) The structure rises in three stages from a mud-brick core. The lowest and largest stage measures approximately 190 by 138 feet and rises to a height of approximately 45 feet.

It is worth noting that, although brick was used in the ancient Near East, two factors militated against the survival of buildings. Over 5000 years separate us from some of these architectural works, and people constantly need new buildings to replace old ones. Space being at a premium, old buildings were often simply torn down or built over. Furthermore, incessant warfare and the practice of destroying conquered cities gave the buildings of the area a short life-expectancy.

SYNTHESIS
Sargon II at Dur Sharrukin

Under Sargon II, who came to power in 722 BC, the high priests of the country regained many of the privileges they had lost under previous kings, and the Assyrian Empire reached the peak of its power. Early in his reign, Sargon II founded the new city of Dur Sharrukin (on the site of the modern city of Khorsabad), about nine miles northeast of Nineveh. His vast royal CITADEL, which occupied some quarter of a million square feet (Fig. 2.25), was built as an image not only of his empire, but also of the cosmos itself. This citadel, a reconstruction of which appears in Figure 2.26, synthesizes the developments in Assyrian architecture and demonstrates the priorities of Assyrian civilization. In Sargon's new city, secular architecture clearly takes precedence over temple architecture. The rulers of Assyria seem to have been far more concerned with building fortifications and imposing palaces than with erecting religious shrines. This message is clearly readable here, as it is not at other Assyrian sites where later rulers have repeatedly added to the early construction. Dur Sharrukin was, like Akhenaton's Tell el Amarna (see Fig. 3.36), a city built, occupied, and abandoned within a single generation and today its integrity remains intact.

2.25 Plan of the citadel of King Sargon II's capital city, Dur Sharrukin, at Khorsabad, Iraq, c.721–705 BC.

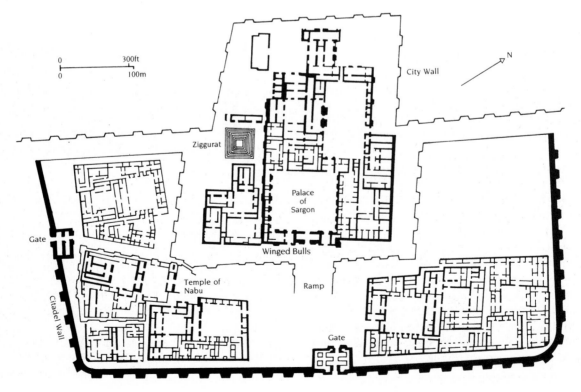

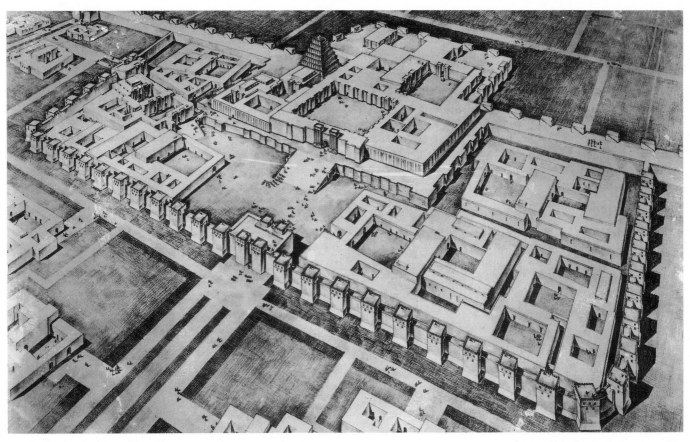

2.26 Reconstruction of Sargon II's citadel at Dur Sharrukin.

2.27 Gate of Sargon II's citadel at Dur Sharrukin (during excavation) with pair of winged and human-headed bulls. Limestone.

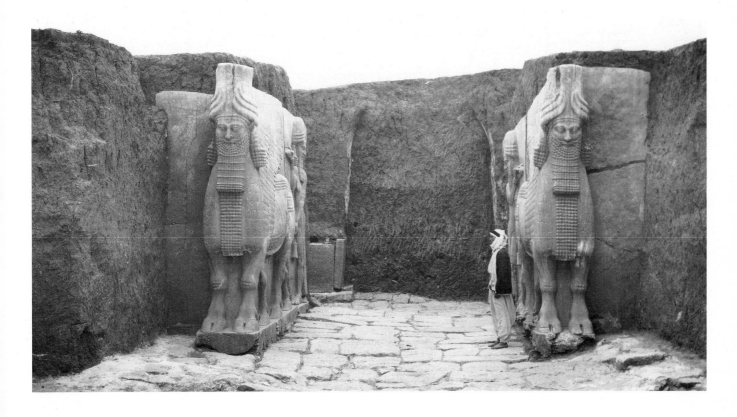

The citadel was a microcosm of the ordered world. It rises like the hierarchy of Assyrian gods, from the lowest levels of the city, through a transitional level, to the king's palace, which stands on its own elevated terrace. Two gates connect the walled citadel to the outside world. The first was undecorated; the second was adorned with and guarded by winged bulls (Fig. **2.27**).

Remarkably, excavations at the site have shown architectural planning to have been minimal. Buildings are arranged haphazardly, and the terrace is asymmetrical. Near one gate, a temple to the god Nabu sits at an awkward angle to the wall and adjacent buildings. Raised on its own terrace, the temple was connected to the palace by a bridge over the street. Within the inner walls, five minor palaces were crowded with obvious difficulty into the available space.

The main palace consists of ceremonial apartments arranged around a central courtyard. The entrances to the throne room were guarded by winged bulls and other figures. The walls of the room itself stood approximately 40 feet high and were decorated with floor-to-ceiling MURALS. Three small temples adjoined the palace, and beside these rose a ziggurat with successive stages painted in different colors and connected by a spiral staircase. The construction of the palace complex was of mud brick, laid without mortar while still damp and pliable, and of stone, dressed and undressed. Some roofs had brick BARREL VAULTS, although the majority appear to have had flat ceilings, with painted beams.

Great guardian figures, of which those in Figure **2.27** are representative, correspond, in their vast scale and impressive aspect, to the buildings. Undoubtedly symbolizing the supernatural powers of the king, these colossal hybrids have a majestically powerful stature and scale. Carved partly in RELIEF and partly in the round, they are intended to be viewed from front or side. Because each figure has a fifth leg, the viewer can always see at least four legs. These MONOLITHS were carved from blocks of stone upwards of 15 feet square. Roughly shaped in the quarry, the blocks were transported to the site and the final carving was done in place.

The subject matter of the murals and relief sculptures consisted mainly of tributes to the victorious campaigns of the king; the onward press of chariots predominates in many works. Warfare tended to be a seasonal activity, and the intervening time was, apparently, spent in hunting. Thus we find the sovereign engaged in the alternating slaughter of men and beasts, punctuated by some cult ceremonies. The scenes tell stories, and while the events in them are probably more symbolic than real, the "historical" treatment appears to have resulted in a more natural style than we have seen previously.

Significantly, the concept of space in works from Sargon II's palace is treated in a way quite different from the abstract space in other Mesopotamian art. As we examine reliefs such as those in Figures **2.28** and **2.29**, we recognize a treatment of pictorial space more like that seen in the medieval period. Here we see the artist attempting to portray deep space, that is, to free the image from the surface plane of the work by suggesting PERSPECTIVE. Of course, the understanding of VANISHING POINTS and HORIZON LINES, which was to revolutionize

2.28 Mural relief from the palace of Sargon II at Dur Sharrukin. Basalt, 5 ft 10 ins (1.78 m) long. British Museum, London.

2.29 Mural relief from the palace of Sargon II. Basalt, 4 ft 2 ins (1.27 m) high. Louvre, Paris.

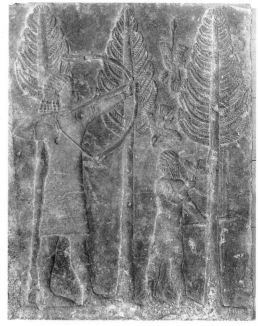

2.30 Relief from a façade of the throne room in the palace of Sargon II at Dur Sharrukin. Alabaster, 15 ft 5 ins (4.7 m) high. Louvre, Paris.

SUGGESTIONS FOR THOUGHT AND DISCUSSION

Mesopotamian culture perhaps extends over too great a time, with too few surviving examples, to represent anything other than a geographically related sampling of the work of several disparate peoples. Nonetheless, we can identify a certain characteristic style. As one people conquers another, cultures overlap and interact. Despite changes in the realism of figure depiction and spatial arrangement, the visual art of the area, whether Sumerian, Akkadian, or Assyrian, remains recognizably Mesopotamian.

Try to summarize the characteristics of the artworks we have examined to see if you can determine precisely what factors make such recognition possible.

■ How are the religious and political characteristics of Sumer and Akkad reflected in their arts?
■ Trace the changes from stylized to realistic portrayal of the human form as they appear in the examples shown in this chapter.
■ If the eyes are the windows of the soul, what meaning can be attributed to the Tell Asmar sculptures?
■ Explain the role of kingly authority in Mesopotamian religion, politics, and art.
■ How was the king glorified in Mesopotamian art?
■ What possible influences on art and architecture might derive from the fact that many peoples in Mesopotamia were nomadic?
■ Given the warlike character of Mesopotamian civilizations, to what would you attribute the apparent softness of their musical timbres?
■ Suggest how Dur Sharrukin might represent the late Assyrian concept of the structure of the universe.

visual art in the Renaissance, is absent. Nonetheless, the attempt to portray distance through diminution stands out clearly in both murals.

A hurried roughness haunts the works, and the stylization of the figures counteracts the attempt to represent space realistically. Yet these lively and charming depictions show some individuality among the figures. And, if attention to detail is any indication of interest, the Assyrian love of animals and the animal spirit shines through.

Yet, throughout, the king is still protector and lord. In Figure **2.30**, for example, Sargon himself subdues a lion whose reduced size further emphasizes the king's majesty and power. Finally, we should note the new convention of depiction whereby the body and head are portrayed frontally while the feet remain in profile.

LITERATURE EXTRACTS

Gilgamesh Epic

Tablet I Column 1

The one who saw the abyss I will make the land know;
of him who knew all, let me tell the whole story
. . . in the same way . . .
|as| the lord of wisdom, he who knew everything,
 Gilgamesh,
who saw things secret, opened the place hidden,
and carried back word of the time before the Flood—
he travelled the road exhausted, in pain,
and cut his works into a stone tablet.

He ordered built the walls of Uruk of the Sheepfold
the walls of holy Eanna, stainless sanctuary. 10
Observe its walls, whose upper hem is like bronze;
behold its inner wall, which no work can equal.
Touch the stone threshold, which is ancient;
draw near the Eanna, dwelling-place of the goddess
 Ishtar,
a work no king among later kings can match.
Ascend the walls of Uruk, walk around the top,
inspect the base, view the brickwork.
Is not the very core made of oven-fired brick?
As for its foundation, was it not laid down by the seven
 sages?
One part is city, one part orchard, and one part claypits. 20
Three parts including the claypits make up Uruk.

Find the copper tablet-box,
slip loose the ring-bolt made of bronze,

Draw out the tablet of lapis lazuli and read it aloud:
How Gilgamesh endured everything harsh,

overpowering kings, famous, powerfully built—
hero, child of the city Uruk, a butting bull.
He takes the forefront, as a leader should.
Still he marches in the rear as one the brothers trust,
a mighty trap to protect his men. 30
He is a battering floodwave, who knocks the stone walls
 flat.

Son of Lugalbanda—Gilgamesh is the pattern of strength,
child of that great wild cow, Ninsun,
. . . Gilgamesh, dazzling, sublime.

Opener of the mountain passes,
digger of wells on the hills' side,
he crossed the ocean, the wide sea, to where Shamash
 rises,
scouted the world regions: the one who seeks life,
forcing his way to Utnapishtim the remote one,
the man who restored life where the Flood had
 destroyed it, 40
. . . peopling the earth.

Is there a king like him anywhere?
Who like Gilgamesh can boast, "I am the king!"?

From the day of his birth Gilgamesh was called by name.

Column 2

Two-thirds of him is divine, one-third human.
The image of his body the Great Goddess designed.
She added to him . . .

On the sheepfold of Uruk he himself lifts his gaze,
like a wild bull rising up supreme, his head high.
The raising of his weapon has no equal; 50
with the drum his citizens are raised.
He runs wild with the young lords of Uruk through the
 holy places.

Gilgamesh does not allow the son to go with his father;
day and night he oppresses the weak—
Gilgamesh, who is shepherd of Uruk of the Sheepfold.
Is this our shepherd, strong, shining, full of thought?
Gilgamesh does not let the young woman go to her
 mother,
the girl to the warrior, the bride to the young groom.

The gods heard their lamentation;
the gods of the above |addressed| the keeper of Uruk: 60

"Did you not make this mighty wild bull?
The raising of his weapon has no equal;
with the drum his citizens are raised.
He, Gilgamesh, keeps the son from his father day and
 night.
Is this the shepherd of Uruk of the Sheepfold?
Is this their shepherd and . . .
strong, shining, full of thought?
Gilgamesh does not let the young woman go to her
 mother,
the girl to the warrior, the bride to the young groom."

When |Anu the sky god| heard their lamentation 70
he called to Aruru the Mother, Great Lady: "You, Aruru,
 who created humanity,
create now a second image of Gilgamesh: may the image
 be equal to the time of his heart.
Let them square off one against the other, that Uruk may
 have peace."

When Aruru heard this, she formed an image of Anu in
 her heart.
Aruru washed her hands, pinched off clay and threw it
 into the wilderness:
In the wilderness she made Enkidu the fighter; she gave
 birth in darkness and silence to one like the war
 god Ninurta.
His whole body was covered thickly with hair, his head
 covered with hair like a woman's;
the locks of his hair grew abundantly, like those of the
 grain god Nisaba.
He knew neither people nor homeland; he was clothed
 in the clothing of Sumuqan the cattle god.
He fed with the gazelles on grass; 80
with the wild animals he drank at waterholes;

with hurrying animals his heart grew light in the waters.

The Stalker, man-and-hunter,
met him at the watering place
one day—a second, a third—at the watering place.
Seeing him, the Stalker's face went still.
He, Enkidu, and his beasts had intruded on the Stalker's
　　place.
Worried, troubled, quiet,
the Stalker's heart rushed; his face grew dark.
Woe entered his heart.　　　　　　　　　　　　　　90
His face was like that of one who travels a long road.

Column 3

The Stalker shaped his mouth and spoke, saying to his
　　father

"Father, there is a man who has come from the hills.
In all the land he is the most powerful; power belongs to
　　him.
Like a shooting star of the god Anu, he has awesome
　　strength.
He ranges endlessly over the hills,
endlessly feeds on grass with the animals,
endlessly sets his feet in the direction of the watering
　　place.
For terror I cannot go near him.
He fills up the pits I dig;　　　　　　　　　　　　100
he tears out the traps I set;
he allows the beasts to slip through my hands, the
　　hurrying creatures of the abandon;
in the wilderness he does not let me work."

His father shaped his mouth and spoke, saying to the
　　Stalker:

"My son, in Uruk lives a man, Gilgamesh:
no one has greater strength than his.
In all the land he is the most powerful; power belongs to
　　him. Like a shooting star of Anu, he has awesome
　　strength.
Go, set your face toward Uruk.
Let him, the knowing one, hear of it.
He will say, 'Go, Stalker, and take with you a love-
　　priestess, a temple courtesan,　　　　　　　110
[let her conquer him with] power [equal to his own].
When he waters the animals at the watering place,
have her take off her clothes, let her show him her strong
　　beauty.
When he sees her, he will come near her.
His animals, who grew up in the wilderness, will turn from
　　him.'"

He listened to the counsel of his father.
The Stalker went to Gilgamesh.
He mounted the road; he set his face in the direction of
　　Uruk
[to speak to] Gilgamesh [the knowing].

"There is a man who has come from the hills.　　120
His power is great in the land.
Like a shooting star of Anu, he has awesome strength.
He ranges endlessly over the hills,

endlessly feeds on grass with the animals,
endlessly sets his feet in the direction of the watering
　　place.
For terror I cannot go near him.
He fills up the pits I dig;
he tears out the traps I set;
he allows the beasts to slip through my hands, the
　　hurrying creatures of the abandon;
in the wilderness he does not let me work."　　　130

Gilgamesh said to him, to the Stalker,

"Go, Stalker, and take with you a love-priestess, a temple
　　courtesan.
When he waters the animals at the watering place,
have her take off her clothes, have her show him her
　　strong beauty.
When he sees her, he will come near her.
His animals, who grew up in his wilderness, will turn from
　　him."

The Stalker went, taking with him a love-priestess, a
　　temple courtesan.
They mounted the road, went their journey.
On the third day, in the wilderness, the set time arrived.
The Stalker and the woman sat in their places and
　　waited.　　　　　　　　　　　　　　140
One day, a second day, they sat at the watering place.
Then the wild animals came to the watering place to
　　drink.

Column 4

The animals came; their hearts grew light in the waters.
And as for him, Enkidu, child of the mountain,
he who fed with gazelles on grass,
he drank with the wild beasts at the watering place
and with the hurrying animals his heart grew light in the
　　waters.

The woman saw him, the man-as-he-was-in-the-beginning,
the man-and-killer from the deep wilderness.

"Here he is, courtesan; get ready to embrace him.　　150
Open your legs, show him your beauty.
Do not hold back, take his wind away.
Seeing you, he will come near.
Strip off your clothes so he can mount you.
Make him know, this-man-as-he-was, what a woman is.
His beasts who grew up in his wilderness will turn from
　　him.
He will press his body over your wildness."

The courtesan untied her wide belt and spread her legs,
　　and he struck her wildness like a storm.
She was not shy; she took his wind away.
Her clothing she spread out, and he lay upon her.　　160
She made him know, the man-as-he-was, what a woman
　　is.
His body lay on her;
six days and seven nights Enkidu attacked, knowing the
　　priestess.
After Enkidu was glutted on her richness
he set his face toward his animals.

Seeing him, Enkidu, the gazelles scattered, wheeling:
the beasts of the wilderness fled from his body.
Enkidu tried to rise up, but his body pulled back.
His knees froze. His animals had turned from him.
Enkidu grew weak; he could not gallop as before. 170
Yet he had knowledge, wider mind.

Turned around, Enkidu knelt at the knees of the
 prostitute.
He looked up at her face,
and as the woman spoke, his ears heard.

The woman said to him, to Enkidu:

"You have become wise, like a god, Enkidu.
Why did you range the wilderness with animals?
Come, let me lead you to the heart of Uruk of the
 Sheepfold,
to the stainless house, holy place of Anu and Ishtar,
where Gilgamesh lives, completely powerful, 180
and like a wild bull stands supreme, mounted above his
 people."

She speaks to him, and they look at one another.
With his heart's knowledge, he longs for a deeply loving
 friend.

Enkidu says to her, to the temple whore:

"Come, courtesan, join with me, [travel]
to the stainless house, the temple, dwelling of Anu and
 Ishtar,
where Gilgamesh is, completely powerful,
and like a wild bull stands supreme mounted above the
 people.
I, I will call to him; I'll shout with great force."

Column 5

"I will cry out in Uruk: 'I, I alone, am powerful. 190
I am the one who changes fates,
who was born in the wild, might of strength belongs to
 me.'"

["Let us go, then, that he may see] your face.
Whoever there is [to know] I know.
Come, Enkidu, to Uruk of the Sheepfold,
where people are resplendent in wide belts,
and every day there's a festival,
and where strings and drums are played
and the holy courtesans beautify their forms,
radiating sexual prowess, filled with sex-joy. 200
At night they force the great ones into their beds.
Enkidu, pleased with life-joy,
I will show you Gilgamesh the joy-woe man.
Gaze at him—observe his face—
beautiful in manhood,
his whole body filled with sexual glow:
he is stronger than you,
endlessly active day and night.
Enkidu, make yourself an enemy to your anger.
As for Gilgamesh, the justice god Shamash loves him. 210
The sky god Anu, the storm god Enlik, and the word god
 Ea have widened his mind.
Even before you come out of the mountains

Gilgamesh, in the heart of Uruk, will have seen you in
 dreams."

Gilgamesh rises, speaks to Ninsun his mother to untie his
 dream.

"Last night, Mother, I saw a dream.
There was a star in the heavens.
Like a shooting star of Anu it fell on me.
I tried to lift it; too much for me.
I tried to move it; I could not move it.
Uruk, the land, towered over it; 220
the people swarmed around it;
the people pressed themselves over it;
the men of the city massed above it;
companions kissed his feet.
I myself hugged him like a wife,
and I threw him down at your feet
so that you compared him with me."

The mother of Gilgamesh, skilled, wise, who knows
 everything, speaks to her lord;
the goddess Ninsun, skilled, wise, who knows everything,
 speaks to Gilgamesh:

"The star of heaven is your companion, 230
like a shooting star of Anu he falls on you;
you tried to lift it; too much for you;
you tried to move it; you were not able to move it;
you lay him down at my feet
so that I compared him with you;
like a wife you hugged him."

Column 6

"This means: he is a powerful companion, able to save a
 friend;
his strength is great in the land.
Like a shooting star of Anu his strength is awesome,
whom you hug like a wife. 240
He is the one who will take leave of you.
This unties your dream."

A second time Gilgamesh speaks to his mother.
"Mother, I saw a second dream.
Over the assembly of Uruk of the Sheepfold an axe fell.
Uruk, the land, towered over it.
The people thronged before it;
the people pressed over it;
I lay him down at your feet
and I hugged him like a wife, 250
so that you compared him with me."

The mother of Gilgamesh, skilled, wise, who knows
 everything, speaks to her offspring;
the mother, wild cow, goddess Ninsun, skilled, wise, who
 knows everything, speaks to Gilgamesh:

"The axe you saw is a man.
You loved him and hugged him like a wife
and I treated him as your equal.
Go [,find him], I say; this is a strong companion able to
 save a friend, strong in the land; power belongs to
 him.
Like a shooting star of Anu he has awesome strength."

Gilgamesh speaks to her, to his mother. 260
"May a great piece of luck fall to me.
May I acquire as my friend a counsellor.
[. . . Let me go,] I, myself."
[Even as Ninsun untied] his dreams
the temple prostitute was casting her spell on Enkidu
where they two sat.

The Bible

Genesis

1

In the beginning God created the heavens and the earth.
²The earth was without form and void, and darkness was
upon the face of the deep; and the Spirit of God was
moving over the face of the waters.

3 And God said, "Let there be light"; and there was
light. ⁴And God saw that the light was good; and God
separated the light from the darkness. ⁵God called the
light Day, and the darkness he called Night. And there was
evening and there was morning, one day.

6 And God said, "Let there be a firmament in the midst
of the waters, and let it separate the waters from the
waters." ⁷And God made the firmament and separated the
waters which were under the firmament from the waters
which were above the firmament. And it was so. ⁸And God
called the firmament Heaven. And there was evening and
there was morning, a second day.

9 And God said, "Let the waters under the heavens be
gathered together into one place, and let the dry land
appear." And it was so. ¹⁰God called the dry land Earth,
and the waters that were gathered together he called Seas.
And God saw that it was good. ¹¹And God said, "Let the
earth put forth vegetation, plants yielding seed, and fruit
trees bearing fruit in which is their seed, each according to
its kind, upon the earth." And it was so. ¹²The earth
brought forth vegetation, plants yielding seed according to
their own kinds, and trees bearing fruit in which is their
seed, each according to its kind. And God saw that it was
good. ¹³And there was evening and there was morning, a
third day.

14 And God said, "Let there be lights in the firmament
of the heavens to separate the day from the night; and let
them be for signs and for seasons and for days and years,
¹⁵and let them be lights in the firmament of the heavens
to give light upon the earth." And it was so. ¹⁶And God
made the two great lights, the greater light to rule the day,
and the lesser light to rule the night; he made the stars
also. ¹⁷And God set them in the firmament of the heavens
to give light upon the earth, ¹⁸to rule over the day and
over the night, and to separate the light from the
darkness. And God saw that it was good. ¹⁹And there was
evening and there was morning, a fourth day.

20 And God said, "Let the waters bring forth swarms of
living creatures, and let birds fly above the earth across
the firmament of the heavens." ²¹So God created the great
sea monsters and every living creature that moves, with
which the waters swarm, according to their kinds, and

every winged bird according to its kind. And God saw that
it was good. ²²And God blessed them, saying, "Be fruitful
and multiply and fill the waters in the seas, and let birds
multiply on the earth." ²³And there was evening and there
was morning, a fifth day.

24 And God said, "Let the earth bring forth living
creatures according to their kinds: cattle and creeping
things and beasts of the earth according to their kinds."
And it was so. ²⁵And God made the beasts of the earth
according to their kinds and the cattle according to their
kinds, and everything that creeps upon the ground
according to its kind. And God saw that it was good.

26 Then God said, "Let us make man in our image, after
our likeness; and let them have dominion over the fish of
the sea, and over the birds of the air, and over the cattle,
and over all the earth, and over every creeping thing that
creeps upon the earth." ²⁷So God created man in his own
image, in the image of God he created him; male and
female he created them. ²⁸And God blessed them, and
God said to them, "Be fruitful and multiply, and fill the
earth and subdue it; and have dominion over the fish of
the sea and over the birds of the air and over every living
thing that moves upon the earth." ²⁹And God said,
"Behold, I have given you every plant yielding seed which
is upon the face of all the earth, and every tree with seed
in its fruit; you shall have them for food. ³⁰And to every
beast of the earth, and to every bird of the air, and to
everything that creeps on the earth, everything that has
the breath of life, I have given every green plant for food."
And it was so. ³¹And God saw everything that he had
made, and behold, it was very good. And there was
evening and there was morning, a sixth day.

The Bible

Job

1

There was a man in the land of Uz, whose name was Job;
and that man was blameless and upright, one who feared
God, and turned away from evil. ²There were born to him
seven sons and three daughters. ³He had seven thousand
sheep, three thousand camels, five hundred yoke of oxen,
and five hundred she-asses, and very many servants; so
that this man was the greatest of all the people of the
east. ⁴His sons used to go and hold a feast in the house of
each on his day; and they would send and invite their
three sisters to eat and drink with them. ⁵And when the
days of the feast had run their course, Job would send and
sanctify them, and he would rise early in the morning and
offer burnt offerings according to the number of them all;
for Job said, "It may be that my sons have sinned, and
cursed God in their hearts." Thus Job did continually.

6 Now there was a day when the sons of Gods came to
present themselves before the LORD, and Satan also came
among them. ⁷The LORD said to Satan, "Whence have you
come?" Satan answered the LORD, "From going to and fro
on the earth, and from walking up and down on it." ⁸And
the LORD said to Satan, "Have you considered my servant

Job, that there is none like him on the earth, a blameless and upright man, who fears God and turns away from evil?" ⁹Then Satan answered the LORD, "Does Job fear God for nought? ¹⁰Hast thou not put a hedge about him and his house and all that he has, on every side? Thou hast blessed the work of his hands, and his possessions have increased in the land. ¹¹But put forth thy hand now, and touch all that he has, and he will curse thee to thy face." ¹²And the LORD said to Satan, "Behold, all that he has is in your power; only upon himself do not put forth your hand." So Satan went forth from the presence of the LORD.

13 Now there was a day when his sons and daughters were eating and drinking wine in their eldest brother's house; ¹⁴and there came a messenger to Job, and said, "The oxen were plowing and the asses feeding beside them; ¹⁵and the Sabeans fell upon them and took them, and slew the servants with the edge of the sword; and I alone have escaped to tell you." ¹⁶While he was yet speaking, there came another, and said, "The fire of God fell from heaven and burned up the sheep and the servants, and consumed them; and I alone have escaped to tell you." ¹⁷While he was yet speaking, there came another, and said, "The Chaldeans formed three companies, and made a raid upon the camels and took them, and slew the servants with the edge of the sword; and I alone have escaped to tell you." ¹⁸While he was yet speaking, there came another, and said, "Your sons and daughters were eating and drinking wine in their eldest brother's house; ¹⁹and behold, a great wind came across the wilderness, and struck the four corners of the house, and it fell upon the young people, and they are dead; and I alone have escaped to tell you.

20 Then Job arose, and rent his robe, and shaved his head, and fell upon the ground, and worshiped. ²¹And he said, "Naked I came from my mother's womb, and naked shall I return; the LORD gave, and the LORD has taken away; blessed be the name of the LORD."

22 In all this Job did not sin or charge God with wrong.

2

Again there was a day when the sons of God came to present themselves before the LORD, and Satan also came among them to present himself before the LORD. ²And the LORD said to Satan, "Whence have you come?" Satan answered the LORD, "From going to and fro on the earth, and from walking up and down on it." ³And the LORD said to Satan, "Have you considered my servant Job, that there is none like him on the earth, a blameless and upright man, who fears God and turns away from evil? He still holds fast his integrity, although you moved me against him, to destroy him without cause." ⁴Then Satan answered the LORD, "Skin for skin! All that a man has he will give for his life. ⁵But put forth thy hand now, and touch his bone and his flesh, and he will curse thee to thy face." ⁶And the LORD said to Satan, "Behold, he is in your power, only spare his life."

7 So Satan went forth from the presence of the LORD, and afflicted Job with loathsome sores from the sole of his foot to the crown of his head. ⁸And he took a potsherd with which to scrape himself, and sat among the ashes.

9 Then his wife said to him, "Do you still hold fast your integrity? Curse God, and die." ¹⁰But he said to her, "You speak as one of the foolish women would speak. Shall we receive good at the hand of God, and shall we not receive evil?" In all this Job did not sin with his lips.

11 Now when Job's three friends heard of all this evil that had come upon him, they came each from his own place, Eliphaz the Temanite, Bildad the Shuhite, and Zophar the Naamathite. They made an appointment together to come to condole with him and comfort him. ¹²And when they saw him from afar, they did not recognize him; and they raised their voices and wept; and they rent their robes and sprinkled dust upon their heads toward heaven. ¹³And they sat with him on the ground seven days and seven nights, and no one spoke a word to him, for they saw that his suffering was very great.

3

After this Job opened his mouth and cursed the day of his birth.
²And Job said:
³"Let the day perish wherin I was born,
 and the night which said,
 'A man-child is conceived.'
⁴Let that day be darkness!
 May God above not seek it,
 nor light shine upon it.
⁵Let gloom and deep darkness claim it.
 Let clouds dwell upon it;
 Let the blackness of the day terrify it.
⁶That night—let thick darkness seize it!
 let it not rejoice among the days of the year,
 let it not come into the number of the months.
⁷Yea, let that night be barren;
 let no joyful cry be heard in it.
⁸Let those curse it who curse the day,
 who are skilled to rouse up Leviathan.
⁹Let the stars of its dawn be dark;
 let it hope for light, but have none,
 nor see the eyelids of the morning;
¹⁰because it did not shut the doors of my mother's womb,
 nor hide trouble from my eyes.

¹¹"Why did I not die at birth,
 come forth from the womb and expire?
¹²Why did the knees receive me?
 Or why the breasts, that I should suck?
¹³For then I should have lain down and been quiet;
 I should have slept; then I should have been at rest,
¹⁴with kings and counselors of the earth
 who rebuilt ruins for themselves,
¹⁵or with princes who had gold,
 who filled their houses with silver.
¹⁶Or why was I not as a hidden untimely birth,
 as infants that never see the light?
¹⁷There the wicked cease from troubling,
 and there the weary are at rest.
¹⁸There the prisoners are at ease together;
 they hear not the voice of the taskmaster.
¹⁹The small and the great are there,
 and the slave is free from his master.

20 "Why is light given to him that is in misery,
 and life to the bitter in soul,
21 who long for death, but it comes not,
 and dig for it more than for hid treasures;
22 who rejoice exceedingly,
 and are glad, when they find the grave?
23 Why is light given to a man whose way is hid,
 whom God has hedged in?
24 For my sighing comes as my bread,
 and my groanings are poured out like water.
25 For the thing that I fear comes upon me,
 and what I dread befalls me.
26 I am not at ease, nor am I quiet;
 I have no rest; but trouble comes."

4

Then Eliphaz the Temanite answered:
2 "If one ventures a word with you, will you be offended?
 Yet who can keep from speaking?
3 Behold, you have instructed many,
 and you have strengthened the weak hands.
4 Your words have upheld him who was stumbling,
 and you have made firm the feeble knees.
5 But now it has come to you, and you are impatient;
 it touches you, and you are dismayed.
6 Is not your fear of God your confidence,
 and the integrity of your ways your hope?

7 "Think now, who that was innocent ever perished?
 Or where were the upright cut off?
8 As I have seen, those who plow iniquity
 and sow trouble reap the same
9 By the breath of God they perish,
 and by the blast of his anger they are consumed.
10 The roar of the lion, the voice of the fierce lion,
 the teeth of the young lions, are broken.
11 The strong lion perishes for lack of prey
 and the whelps of the lioness are scattered.

12 "Now a word was brought to me stealthily,
 my ear received the whisper of it.
13 Amid thoughts from visions of the night,
 when deep sleep falls on men,
14 dread came upon me, and trembling,
 which made all my bones shake.
15 A spirit glided past my face;
 the hair of my flesh stood up.
16 It stood still,
 but I could not discern its appearance.
 A form was before my eyes;
 there was silence, then I heard a voice:
17 'Can mortal man be righteous before God?
 Can a man be pure before his Maker?
18 Even in his servants he puts no trust,
 and his angels he charges with error;
19 how much more those who dwell in houses of clay;
 whose foundation is in the dust,
 who are crushed before the moth.
20 Between morning and evening they are destroyed;
 they perish for ever without any regarding it.
21 If their tent-cord is plucked up within them,
 do they not die, and that without wisdom?'

5

"Call now; is there any one who will answer you?
 To which of the holy ones will you turn?
2 Surely vexation kills the fool,
 and jealousy slays the simple.
3 I have seen the fool taking root,
 but suddenly I cursed his dwelling.
4 His sons are far from safety,
 they are crushed in the gate,
 and there is no one to deliver them.
5 His harvest the hungry eat,
 and he takes it even out of thorns;
 and the thirsty pant after his wealth.
6 For affliction does not come from the dust,
 nor does trouble sprout from the ground;
7 but man is born to trouble
 as the sparks fly upward.

8 "As for me, I would seek God,
 and to God would I commit my cause;
9 who does great things and unsearchable,
 marvelous things without number:
10 he gives rain upon the earth
 and sends waters upon the fields;
11 he sets on high those who are lowly,
 and those who mourn are lifted to safety.
12 He frustrates the devices of the crafty,
 so that their hands achieve no success.
13 He takes the wise in their own craftiness;
 and the schemes of the wily are brought to a quick
 end.
14 They meet with darkness in the daytime,
 and group at noonday as in the night.
15 But he saves the fatherless from their mouth,
 the needy from the hand of the mighty.
16 So the poor have hope,
 and injustice shuts her mouth.

17 "Behold, happy is the man whom God reproves;
 therefore despise not the chastening of the Almighty.
18 For he wounds, but he binds up;
 he smites, but his hands heal.
19 He will deliver you from six troubles;
 in seven there shall no evil touch you.
20 In famine he will redeem you from death,
 and in war from the power of the sword.
21 You shall be hid from the scourge of the tongue,
 and shall not fear destruction when it comes.
22 At destruction and famine you shall laugh,
 and shall not fear the beasts of the earth.
23 For you shall be in league with the stones of the field,
 and the beasts of the field shall be at peace with you.
24 You shall know that your tent is safe,
 and you shall inspect your fold and miss nothing,
25 You shall know also that your descendants shall be
 many
 and your offspring as the grass of the earth.
26 You shall come to your grave in ripe old age,
 as a shock of grain comes up to the threshing floor in
 its season.
27 Lo, this we have searched out; it is true.
 Hear, and know it for your good."

6

Then Job answered:

[2] "O that my vexation were weighed,
 and all my calamity laid in the balances!
[3] For then it would be heavier than the sand of the sea;
 therefore my words have been rash.
[4] For the arrows of the Almighty are in me;
 my spirit drinks their poison;
 the terrors of God are arrayed against me.
[5] Does the wild ass bray when he has grass,
 or the ox low over his fodder?
[6] Can that which is tasteless be eaten without salt,
 or is there any taste in the slime of the purslane?
[7] My appetite refuses to touch them;
 they are as food that is loathsome to me.

[8] "O that I might have my request,
 and that God would grant my desire;
[9] that it would please God to crush me,
 that he would let loose his hand and cut me off!
[10] This would be my consolation;
 I would even exult in pain unsparing;
 for I have not denied the words of the Holy One.
[11] What is my strength, that I should wait?
 And what is my end, that I should be patient?
[12] Is my strength the strength of stones,
 or is my flesh bronze?
[13] In truth I have no help in me,
 and any resource is driven from me.

[14] "He who withholds kindness from a friend
 forsakes the fear of the Almighty.
[15] My brethren are treacherous as a torrent-bed,
 as freshets that pass away,
[16] which are dark with ice,
 and where the snow hides itself.
[17] In time of heat they disappear;
 when it is hot, they vanish from their place.
[18] The caravans turn aside from their course;
 they go up into the waste, and perish.
[19] The caravans of Tema look,
 the travelers of Sheba hope
[20] They are disappointed because they were confident;
 they come thither and are confounded.
[21] Such you have now become to me;
 you see my calamity, and are afraid.
[22] Have I said, 'Make me a gift'?
 Or, 'From your wealth offer a bribe for me'?
[23] Or, 'Deliver me from the adversary's hand'?
 Or, 'Ransom me from the hand of oppressors'?

[24] "Teach me, and I will be silent;
 make me understand how I have erred.
[25] How forceful are honest words!
 But what does reproof from you reprove?
[26] Do you think that you can reprove words,
 when the speech of a despairing man is wind?
[27] You would even cast lots over the fatherless,
 and bargain over your friend.

[28] "But now, be pleased to look at me;
 for I will not lie to your face.
[29] Turn, I pray, let no wrong be done.

Turn now, my vindication is at stake.
[30] Is there any wrong on my tongue?
 Cannot my taste discern calamity?

7

"Has not man a hard service upon earth,
 and are not his days like the days of a hireling?
[2] Like a slave who longs for the shadow,
 and like a hireling who looks for his wages,
[3] so I am allotted months of emptiness,
 and nights of misery are apportioned to me.
[4] When I lie down I say, 'When shall I arise?'
 But the night is long,
 and I am full of tossing till the dawn.
[5] My flesh is clothed with worms and dirt;
 my skin hardens, then breaks out afresh.
[6] My days are swifter than a weaver's shuttle,
 and come to their end without hope.

[7] "Remember that my life is a breath;
 my eye will never again see good.
[8] The eye of him who sees me will behold me no more;
 while thy eyes are upon me, I shall be gone.
[9] As the cloud fades and vanishes,
 so he who goes down to Sheol does not come up;
[10] he returns no more to his house,
 nor does his place know him any more.

[11] "Therefore I will not restrain my mouth;
 I will speak in the anguish of my spirit;
 I will complain in the bitterness of my soul.
[12] Am I the sea, or a sea monster,
 that thou settest a guard over me?
[13] When I say, 'My bed will comfort me,
 my couch will ease my complaint,'
[14] then thou dost scare me with dreams
 and terrify me with visions,
[15] so that I would choose strangling
 and death rather than my bones.
[16] I loathe my life; I would not live for ever.
 Let me alone, for my days are a breath.
[17] What is man, that thou dost make so much of him,
 and that thou dost set thy mind upon him,
[18] dost visit him every morning,
 and test him every moment?
[19] How long wilt thou not look away from me,
 nor let me alone till I swallow my spittle?
[20] If I sin, what do I do to thee, thou watcher of men?
 Why hast thou made me thy mark?
 Why have I become a burden to thee?
[21] Why dost thou not pardon my transgression
 and take away my iniquity?
For now I shall lie in the earth;
 thou wilt seek me, but I shall not be."

8

Then Bildad the Shuhite answered:
[2] "How long will you say these things,
 and the words of your mouth be a great wind?
[3] Does God pervert justice?
 Or does the Almighty pervert the right?
[4] If your children have sinned against him,

he has delivered them into the power of their
 transgression.
⁵If you will seek God
 and make supplication to the Almighty,
⁶if you are pure and upright,
 surely then he will rouse himself for you
 and reward you with a rightful habitation.
⁷And though your beginning was small,
 your latter days will be very great.

⁸"For inquire, I pray you, of bygone ages,
 and consider what the fathers have found;
⁹for we are but of yesterday, and know nothing,
 for our days on earth are a shadow.
¹⁰Will they not teach you, and tell you,
 and utter words out of their understanding?

¹¹"Can papyrus grow where there is no marsh?
 Can reeds flourish where there is no water?
¹²While yet in flower and not cut down,
 they wither before any other plant.
¹³Such are the paths of all who forget God;
 the hope of the godless man shall perish.
¹⁴His confidence breaks in sunder,
 and his trust is a spider's web.
¹⁵He leans against his house, but it does not stand;
 he lays hold of it, but it does not endure.
¹⁶He thrives before the sun,
 and his shoots spread over his garden.
¹⁷His roots twine about the stoneheap;
 he lives among the rocks.
¹⁸If he is destroyed from his place,
 then it will deny him saying, 'I have never seen you.'
¹⁹Behold, this is the joy of his way;
 and out of the earth others will spring.

²⁰"Behold, God will not reject a blameless man,
 nor take the hand of evildoers.
²¹He will yet fill your mouth with laughter,
 and your lips with shouting.
²²Those who hate you will be clothed with shame,
 and the tent of the wicked will be no more."

9
Then Job answered:
²"Truly I know that it is so:
 but how can a man be just before God?
³If one wished to contend with him,
 one could not answer him once in a thousand times.
⁴He is wise in heart, and mighty in strength
 —who has hardened himself against him, and
 succeeded?—
⁵he who removes mountains, and they know it not,
 when he overturns them in his anger;
⁶who shakes the earth out of its place,
 and its pillars tremble;
⁷who commands the sun, and it does not rise;
 who seals up the stars;
⁸who alone stretched out the heavens,
 and trampled the waves of the sea;
⁹who made the Bear and Orion,
 The Pleiades and the chambers of the south;

¹⁰who does great things beyond understanding,
 and marvelous things without number.
¹¹Lo, he passes by me, and I see him not;
 he moves on, but I do not perceive him.
¹²Behold, he snatches away; who can hinder him?
 Who will say to him, 'What doest thou'?

¹³"God will not turn back his anger;
 beneath him bowed the helpers of Rahab.
¹⁴How then can I answer him,
 choosing my words with him?
¹⁵Though I am innocent, I cannot answer him;
 I must appeal for mercy to my accuser.
¹⁶If I summoned him and he answered me,
 I would not believe that he was listening to my voice.
¹⁷For he crushes me with a tempest,
 and multiplies my wounds without cause;
¹⁸he will not let me get my breath,
 but fills me with bitterness.
¹⁹If it is a contest of strength, behold him!
 If it is a matter of justice, who can summon him?
²⁰Though I am innocent, my own mouth would condemn
 me;
 though I am blameless, he would prove me perverse.
²¹I am blameless; I regard not myself;
 I loathe my life.
²²It is all one; therefore I say,
 he destroys both the blameless and the wicked.
²³When disaster brings sudden death,
 he mocks at the calamity of the innocent.
²⁴The earth is given into the hand of the wicked;
 he covers the faces of its judges—
 if it is not he, who then is it?

²⁵"My days are swifter than a runner;
 they flee away, they see no good.
²⁶They go by like skiffs of reed,
 like an eagle swooping on the prey.
²⁷If I say, 'I will forget my complaint,
 I will put off my sad countenance, and be of good
 cheer,'
²⁸I become afraid of all my suffering,
 for I know thou wilt not hold me innocent.
²⁹I shall be condemned;
 why then do I labor in vain?
³⁰If I wash myself with snow,
 and cleanse my hands with lye,
³¹yet thou wilt plunge me into a pit,
 and my own clothes will abhor me.
³²For he is not a man, as I am, that I might answer him,
 that we should come to trial together.
³³There is no umpire between us,
 who might lay his hand upon us both.
³⁴Let him take his rod away from me,
 and let not dread of him terrify me.
³⁵Then I would speak without fear of him,
 for I am not so in myself.

10
"I loathe my life;
 I will give free utterance to my complaint;
 I will speak in the bitterness of my soul.

²I will say to God, Do not condemn me;
 let me know why thou dost contend against me.
³Does it seem good to thee to oppress,
 to despise the work of thy hands
 and favor the designs of the wicked?
⁴Hast thou eyes of flesh?
 Dost thou see as man sees?
⁵Are thy days as the days of man,
 or thy years as man's years,
⁶that thou dost seek out my iniquity
 and search for my sin,
⁷although thou knowest that I am not guilty,
 and there is none to deliver out of thy hand?
⁸Thy hands fashioned and made me;
 and now thou dost turn about and destroy me.
⁹Remember that thou hast made me of clay;
 and wilt thou turn me to dust again?
¹⁰Didst thou not pour me out like milk
 and curdle me like cheese?
¹¹Thou didst clothe me with skin and flesh,
 and knit me together with bones and sinews.
¹²Thou hast granted me life and steadfast love;
 and thy care has preserved my spirit,
¹³Yet these things thou didst hide in thy heart;
 I know that this was thy purpose.
¹⁴If I sin, thou dost mark me,
 and dost not acquit me of my iniquity.
¹⁵If I am wicked, woe to me!
 If I am righteous, I cannot lift up my head,
 for I am filled with disgrace
 and look upon my affliction.
¹⁶And if I lift myself up, thou dost hunt me like a lion,
 and again work wonders against me;
¹⁷thou dost renew thy witnesses against me,
 and increase thy vexation toward me;
 thou dost bring fresh hosts against me.

¹⁸"Why didst thou bring me forth from the womb?
 Would that I had died before any eye had seen me,
¹⁹and were as though I had not been,
 carried from the womb to the grave.
²⁰Are not the days of my life few?
 Let me alone, that I may find a little comfort
²¹before I go whence I shall not return,
 to the land of gloom and deep darkness,
²²the land of gloom and chaos,
 where light is as darkness."

11

Then Zophar the Naamathite answered:
²"Should a multitude of words go unanswered,
 and a man full of talk be vindicated?
³Should your babble silence men,
 and when you mock, shall no one shame you?
⁴For you say, 'My doctrine is pure,
 and I am clean in God's eyes.'
⁵But oh, that God would speak,
 and open his lips to you
⁶and that he would tell you the secrets of wisdom!
 For he is manifold in understanding.
Know then that God exacts of you less than your guilt
 deserves.

⁷"Can you find out the deep things of God?
 Can you find out the limit of the Almighty?
⁸It is higher than heaven—what can you do?
 Deeper than Sheol—what can you know?
⁹Its measure is longer than the earth,
 and broader than the sea.
¹⁰If he passes through, and imprisons,
 and calls to judgment, who can hinder him?
¹¹For he knows worthless men;
 when he sees inquity, will he not consider it?
¹²But a stupid man will get understanding,
 when a wild ass's colt is born a man.

¹³"If you set your heart aright,
 you will stretch out your hands toward him.
¹⁴If iniquity is in your hand, put it far away,
 and let not wickedness dwell in your tents.
¹⁵Surely then you will lift up your face without blemish;
 you will be secure, and will not fear.
¹⁶You will forget your misery;
 you will remember it as waters that have passed away.
¹⁷And your life will be brighter than the noonday;
 its darkness will be like the morning.
¹⁸And you will have confidence, because there is hope;
 you will be protected and take your rest in safety.
¹⁹You will lie down, and none will make you afraid;
 many will entreat your favor.
²⁰But the eyes of the wicked will fail;
 all way of escape will be lost to them.
 and their hope is to breathe their last."

12

Then Job answered:
²"No doubt you are the people,
 and wisdom will die with you.
³but I have understanding as well as you;
 I am not inferior to you.
 Who does not know such things as these?
⁴I am a laughingstock to my friends;
 I, who called upon God and he answered me,
 a just and blameless man, am a laughingstock
⁵In the thought of one who is at ease
 there is contempt for misfortune;
 it is ready for those whose feet slip.
⁶The tents of robbers are at peace,
 and those who provoke God are secure,
 who bring their god in their hand.

⁷"But ask the beasts, and they will teach you;
 the birds of the air, and they will tell you;
⁸or the plants of the earth, and they will teach you;
 and the fish of the sea will declare to you.
⁹Who among all these does not know
 that the hand of the LORD has done this?
¹⁰In his hand is the life of every living thing
 and the breath of all mankind.
¹¹Does not the ear try words
 as the palate tastes food?
¹²Wisdom is with the aged,
 and understanding in length of days.
¹³"With God are wisdom and might;
 he has counsel and understanding.

[14] If he tears down, none can rebuild;
 if he shuts a man in, none can open.
[15] If he withholds the waters, they dry up;
 if he sends them out, they overwhelm the land.
[16] With him are strength and wisdom;
 the deceived and the deceiver are his.
[17] He leads counselors away stripped,
 and judges he makes fools.
[18] He looses the bonds of kings,
 and binds a waistcloth on their loins.
[19] He leads priests away stripped,
 and overthrows the mighty.
[20] He deprives of speech those who are trusted,
 and takes away the discernment of the elders.
[21] He pours contempt on princes,
 and looses the belt of the strong.
[22] He uncovers the deeps out of darkness,
 and brings deep darkness to light.
[23] He makes nations great, and he destroys them:
 he enlarges nations, and leads them away.
[24] He takes away understanding from
 the chiefs of the people of the earth,
 and makes them wander in pathless waste.
[25] They grope in the dark without light;
 and he makes them stagger like a drunken man.

13

"Lo, my eye has seen all this,
 my ear has heard and understood it.
[2] What you know, I also know;
 I am not inferior to you.
[3] But I would speak to the Almighty,
 and I desire to argue my case with God.
[4] As for you, you whitewash with lies;
 worthless physicians are you all.
[5] Oh that you would keep silent,
 and it would be your wisdom!
[6] Hear now my reasoning,
 and listen to the pleadings of my lips.
[7] Will you speak falsely for God,
 and speak deceitfully for him?
[8] Will you show partiality toward him,
 will you plead the case for God?
[9] Will it be well with you when he searches you out?
 Or can you deceive him, as one deceives a man?
[10] He will surely rebuke you
 if in secret you show partiality.
[11] Will not his majesty terrify you,
 and the dread of him fall upon you?
[12] Your maxims are proverbs of ashes,
 your defenses are defenses of clay.

[13] "Let me have silence, and I will speak,
 and let come on me what may.
[14] I will take my flesh in my teeth,
 and put my life in my hand.
[15] Behold, he will slay me; I have no hope;
 yet I will defend my ways to his face.
[16] This will be my salvation,
 that a godless man shall not come before him.
[17] Listen carefully to my words,
 and let my declaration be in your ears.

[18] Behold, I have prepared my case;
 I know that I shall be vindicated.
[19] Who is there that will contend with me?
 For then I would be silent and die.
[20] Only grant two things to me,
 then I will not hide myself from thy face:
[21] withdraw thy hand far from me,
 and let not dread of thee terrify me.
[22] Then call, and I will answer;
 or let me speak, and do thou reply to me.
[23] How many are my iniquities and my sins?
 Make me know my transgression and my sin.
[24] Why dost thou hide thy face,
 and count me as thy enemy?
[25] Wilt thou frighten a driven leaf
 and pursue dry chaff?
[26] For thou writest bitter things against me,
 and makest me inherit the iniquities of my youth.
[27] Thou puttest my feet in the stocks,
 and watchest all my paths;
 thou settest a bound to the soles of my feet.
[28] Man wastes away like a rotten thing,
 like a garment that is moth-eaten.

14

"Man that is born of a woman
 is of few days, and full of trouble.
[2] He comes forth like a flower, and withers;
 he flees like a shadow, and continues not.
[3] And dost thou open thy eyes upon such a one
 and bring him into judgment with thee?
[4] Who can bring a clean thing out of an unclean?
 There is not one.
[5] Since his days are determined,
 and the number of his months is with thee,
 and thou hast appointed his bounds that he cannot
 pass,
[6] look away from him, and desist,
 that he may enjoy, like a hireling, his day.

[7] "For there is hope for a tree,
 if it be cut down, that it will sprout again,
 and that its shoots will not cease.
[8] Though its root grow old in the earth,
 and its stump die in the ground,
[9] yet at the scent of water it will bud
 and put forth branches like a young plant.
[10] But man dies, and is laid low;
 man breathes his last, and where is he?
[11] As waters fail from a lake,
 and a river wastes away and dries up,
[12] so man lies down and rises not again;
 till the heavens are no more he will not awake,
 or be roused out of his sleep.
[13] Oh that thou wouldest hide me in Sheol,
 that thou wouldest conceal me until thy wrath be past,
 that thou wouldest appoint me a set time, and
 remember me!
[14] If a man die, shall he live again?
 All the days of my service I would wait,
 till my release should come.
[15] Thou wouldest call, and I would answer thee;

thou wouldest long for the work of thy hands.
16 For then thou wouldest number my steps,
thou wouldest not keep watch over my sin;
17 my transgression would be sealed up in a bag,
and thou wouldest cover over my iniquity.

18 "But the mountain falls and crumbles away,
and the rock is removed from its place;
19 the waters wear away the stones;
the torrents wash away the soil of the earth;
so thou destroyest the hope of man.
20 Thou prevailest for ever against him, and he passes;
thou changest his countenance, and sendest him away.
21 His sons come to honor, and he does not know it;
they are brought low, and he perceives it not.
22 He feels only the pain of his own body,
and he mourns only for himself."

15

Then Eliphaz the Temanite answered:
2 "Should a wise man answer with windy knowledge,
and fill himself with the east wind?
3 Should he argue in unprofitable talk,
or in words with which he can do no good?
4 But you are doing away with the fear of God,
and hindering meditation before God.
5 For your iniquity teaches your mouth,
and you choose the tongue of the crafty.
6 Your own mouth condemns you, and not I;
your own lips testify against you.

7 "Are you the first man that was born?
Or were you brought forth before the hills?
8 Have you listened in the council of God?
And do you limit wisdom to yourself?
9 What do you know that we do not know?
What do you understand that is not clear to us?
10 Both the gray-haired and the aged are among us,
older than your father.
11 Are the consolations of God too small for you,
or the word that deals gently with you?
12 Why does your heart carry you away,
and why do your eyes flash,
13 that you turn your spirit against God,
and let such words go out of your mouth?
14 What is man, that he can be clean?
Or he that is born of a woman, that he can be
righteous?
15 Behold, God puts no trust in his holy ones,
and the heavens are not clean in his sight;
16 how much less one who is abominable and corrupt,
a man who drinks iniquity like water!

17 "I will show you, hear me;
and what I have seen I will declare
18 (what wise men have told,
and their fathers have not hidden,
19 to whom alone the land was given,
and no stranger passed among them).
20 The wicked man writhes in pain all his days,
through all the years that are laid up for the ruthless.
21 Terrifying sounds are in his ears;
in prosperity the destroyer will come upon him.

22 He does not believe that he will return out of darkness,
and he is destined for the sword.
23 He wanders abroad for bread, saying, 'Where is it?'
He knows that a day of darkness is ready at his hand;
24 distress and anguish terrify him;
they prevail against him, like a king prepared for battle.
25 Because he has stretched forth his hand against God,
and bids defiance to the Almighty,
26 running stubbornly against him
with a thick-bossed shield;
27 because he has covered his face with his fat,
and gathered fat upon his loins,
28 and has lived in desolate cities,
in houses which no man should inhabit,
which were destined to become heaps of ruins;
29 he will not be rich, and his wealth will not endure,
nor will he strike root in the earth;
30 he will not escape from darkness;
the flame will dry up his shoots,
and his blossom will be swept away by the wind.
31 Let him not trust in emptiness, deceiving himself;
for emptiness will be his recompense.
32 It will be paid in full before his time,
and his branch will not be green.
33 He will shake off his unripe grape, like the vine,
and cast off his blossom, like the olive tree.
34 For the company of the godless is barren,
and fire consumes the tents of bribery.
35 They conceive mischief and bring forth evil
and their heart prepares deceit."

16

Then Job answered:
2 "I have heard many such things:
miserable comforts are you all.
3 Shall windy words have an end?
Or what provokes you that you answer?
4 I also could speak as you do,
if you were in my place;
I could join words together against you,
and shake my head at you.
5 I could strengthen you with my mouth,
and the solace of my lips would assuage your pain.

6 "If I speak, my pain is not assuaged,
and if I forbear, how much of it leaves me?
7 Surely now God has worn me out;
he has made desolate all my company.
8 And he has shriveled me up,
which is a witness against me;
and my leanness has risen up against me,
it testifies to my face.
9 He has torn me in his wrath, and hated me;
he has gnashed his teeth at me;
my adversary sharpens his eyes against me.
10 Men have gaped at me with their mouth,
they have struck me insolently upon the cheek,
they mass themselves together against me.
11 God gives me up to the ungodly,
and casts me into the hands of the wicked.
12 I was at ease, and he broke me asunder;
he seized me by the neck and dashed me to pieces;

he set me up as his target,
¹³his archers surround me.
He slashes open my kidneys, and does not spare;
he pours out my gall on the ground.
¹⁴He breaks me with breach upon breach;
he runs upon me like a warrior.
¹⁵I have sewed sackcloth upon my skin,
and have laid my strength in the dust.
¹⁶My face is red with weeping,
and on my eyelids is deep darkness;
¹⁷although there is no violence in my hands,
and my prayer is pure.

¹⁸"O earth, cover not my blood,
and let my cry find no resting place.
¹⁹Even now, behold, my witness is in heaven,
and he that vouches for me is on high.
²⁰My friends scorn me;
my eye pours out tears to God,
²¹that he would maintain the right of a man with God,
like that of a man with his neighbor.
²²For when a few years have come
I shall go the way whence I shall not return.

17

My spirit is broken, my days are extinct,
the grave is ready for me.
²Surely there are mockers about me,
and my eye dwells on their provocation.

³"Lay down a pledge for me with thyself;
who is there that will give surety for me?
⁴Since thou has closed their minds to understanding,
therefore thou wilt not let them triumph.
⁵He who informs against his friends to get a share of
their property,
the eyes of his children will fail.

⁶"He has made me a byword of the peoples,
and I am one before whom men spit.
⁷My eye has grown dim from grief,
and all my members are like a shadow.
⁸Upright men are appalled at this,
and the innocent stirs himself up against the
godless.
⁹Yet the righteous holds to his way,
and he that has clean hands grows stronger and
stronger.
¹⁰But you, come on again, all of you,
and I shall not find a wise man among you.
¹¹My days are past, my plans are broken off,
the desires of my heart.
¹²They make night into day;
'The light,' they say, 'is near to the darkness.'
¹³If I look for Sheol as my house,
if I spread my couch in darkness,
¹⁴if I say to the pit, 'You are my father,'
and to the worm, 'My mother,' or 'My sister,'
¹⁵where then is my hope?
Who will see my hope?
¹⁶Will it go down to the bars of Sheol?
Shall we descend together into the dust?"

18

Then Bildad the Shuhite answered:
²"How long will you hunt for words?
consider, and then we will speak.
³Why are we counted as cattle?
Why are we stupid in your sight?
⁴You who tear yourself in your anger,
shall the earth be forsaken for you,
or the rock be removed out of its place?
⁵"Yea, the light of the wicked is put out,
and the flame of his fire does not shine.
⁶The light is dark in his tent,
and his lamp above him is put out,
⁷His strong steps are shortened
and his own schemes throw him down.
⁸For he is cast into a net by his own feet,
and he walks on a pitfall.
⁹A trap seizes him by the heel,
a snare lays hold of him.
¹⁰A rope is hid for him in the ground,
a trap for him in the path.
¹¹Terrors frighten him on every side,
and chase him at his heels.
¹²His strength is hunger-bitten,
and calamity is ready for his stumbling.
¹³By disease his skin is consumed,
the first-born of death consumes his limbs.
¹⁴He is torn from the tent in which he trusted,
and is brought to the king of terrors.
¹⁵In his tent dwells that which is none of his;
brimstone is scattered upon his habitation.
¹⁶His roots dry up beneath,
and his branches wither above.
¹⁷His memory perishes from the earth,
and he has no name in the street.
¹⁸He is thrust from light into darkness,
and driven out of the world.
¹⁹He has no offspring or descendant among his people,
and no survivor where he used to live.
²⁰They of the west are appalled at his day,
and horror seizes them of the east.
²¹Surely such are the dwellings of the ungodly,
such is the place of him who knows not God."

19

Then Job answered:
²"How long will you torment me,
and break me in pieces with words?
³These ten times you have cast reproach upon me;
are you not ashamed to wrong me?
⁴And even if it be true that I have erred,
my error remains with myself.
⁵If indeed you magnify yourselves against me,
and make my humiliation an argument against me,
⁶know then that God has put me in the wrong,
and closed his net about me.
⁷Behold, I cry out, 'Violence!' but I am not answered;
I call aloud, but there is no justice.
⁸He has walled up my way, so that I cannot pass,
and he has set darkness upon my paths.
⁹He has stripped from me my glory,

and taken the crown from my head.
¹⁰ He breaks me down on every side, and I am gone,
and my hope has he pulled up like a tree.
¹¹ He has kindled his wrath against me,
and counts me as his adversary.
¹² His troops come on together;
they have cast up siegeworks against me,
and encamp round about my tent.

¹³ "He has put my brethren far from me,
and my acquaintances are wholly estranged from me.
¹⁴ My kinsfolk and my close friends have failed me;
¹⁵ the guests in my house have forgotten me;
my maidservants count me as a stranger;
I have become an alien in their eyes.
¹⁶ I call to my servant, but he gives me no answer;
I must beseech him with my mouth.
¹⁷ I am repulsive to my wife,
loathsome to the sons of my own mother.
¹⁸ Even young children despise me;
when I rise they talk against me.
¹⁹ All my intimate friends abhor me,
and those whom I loved have turned against me.
²⁰ My bones cleave to my skin and to my flesh,
and I have escaped by the skin of my teeth.
²¹ Have pity on me, have pity on me, O you my friends,
for the hand of God has touched me!
²² Why do you, like God, pursue me?
Why are you not satisfied with my flesh?

²³ "Oh that my words were written!
Oh that they were inscribed in a book!
²⁴ Oh that with an iron pen and lead
they were graven in the rock for ever!
²⁵ For I know that my Redeemer lives,
and at last he will stand upon the earth;
²⁶ and after my skin has been thus destroyed,
then from my flesh I shall see God,
²⁷ whom I shall see on my side,
and my eyes shall behold, and not another.
My heart faints within me!
²⁸ If you say, 'How we will pursue him!'
and, 'The root of the matter is found in him';
²⁹ be afraid of the sword,
for wrath brings the punishment of the sword,
that you may know there is a judgment."

20
Then Zophar the Naamathite answered:
² "Therefore my thoughts answer me,
because of my haste within me.
³ I hear censure which insults me,
and out of my understanding a spirit answers me.
⁴ Do you not know this from of old
since man was placed upon earth,
⁵ that the exulting of the wicked is short,
and the joy of the godless but for a moment?
⁶ Though his height mount up to the heavens,
and his head reach to the clouds,
⁷ he will perish for ever like his own dung;
those who have seen him will say, 'Where is he?'
⁸ He will fly away like a dream, and not be found;

he will be chased away like a vision of the night.
⁹ The eye which saw him will see him no more,
nor will his place any more behold him.
¹⁰ His children will seek the favor of the poor,
and his hands will give back his wealth.
¹¹ His bones are full of youthful vigor,
but it will lie down with him in the dust.

¹² "Though wickedness is sweet in his mouth,
though he hides it under his tongue,
¹³ though he is loath to let it go,
and holds it in his mouth,
¹⁴ yet his food is turned in his stomach;
it is the gall of asps within him.
¹⁵ He swallows down riches and vomits them up again;
God casts them out of his belly.
¹⁶ He will suck the poison of asps;
the tongue of a viper will kill him.
¹⁷ He will not look upon the rivers,
the streams flowing with honey and curds.
¹⁸ He will give back the fruit of his toil,
and will not swallow it down;
from the profit of his trading
he will get no enjoyment.
¹⁹ For he has crushed and abandoned the poor,
he has seized a house which he did not build.

²⁰ "Because his greed knew no rest,
he will not save anything in which he delights.
²¹ There was nothing left after he had eaten;
therefore his prosperity will not endure.
²² In the fulness of his sufficiency he will be in straits;
all the force of misery will come upon him.
²³ To fill his belly to the full
God will send his fierce anger into him,
and rain it upon him as his food.
²⁴ He will flee from an iron weapon;
a bronze arrow will strike him through.
²⁵ It is drawn forth and comes out of his body,
the glittering point comes out of his gall;
terrors come upon him.
²⁶ Utter darkness is laid up for his treasures;
a fire not blown upon will devour him;
what is left in his tent will be consumed.
²⁷ The heavens will reveal his iniquity,
and the earth will rise up against him.
²⁸ The possessions of his house will be carried away,
dragged off in the day of God's wrath.
²⁹ This is the wicked man's portion from God,
the heritage decreed for him by God."

21
Then Job answered:
² "Listen carefully to my words,
and let this be your consolation.
³ Bear with me, and I will speak,
and after I have spoken, mock on.
⁴ As for me, is my complaint against man?
Why should I not be impatient?
⁵ Look at me, and be appalled,
and lay your hand upon your mouth.
⁶ When I think of it I am dismayed,

and shuddering seizes my flesh.
⁷Why do the wicked live,
 reach old age, and grow mighty in power?
⁸Their children are established in their presence,
 and their offspring before their eyes.
⁹Their houses are safe from fear,
 and no rod of God is upon them.
¹⁰Their bull breeds without fail;
 their cow calves, and does not cast her calf.
¹¹They send forth their little ones like a flock,
 and their children dance.
¹²They sing to the tambourine and the lyre,
 and rejoice to the sound of the pipe.
¹³They spend their days in prosperity,
 and in peace they go down to Sheol.
¹⁴They say to God, 'Depart from us!
 We do not desire the knowledge of thy ways.
¹⁵What is the Almighty, that we should serve him?
 And what profit do we get if we pray to him?'
¹⁶Behold, is not their prosperity in their hand?
 The counsel of the wicked is far from me.

¹⁷"How often is it that the lamp of the wicked is put out?
 That their calamity comes upon them?
 That God distributes pains in his anger?
¹⁸That they are like straw before the wind,
 and like chaff that the storm carries away?
¹⁹You say, 'God stores up their iniquity for their sons.'
 Let him recompense it to themselves, that they may
 know it.
²⁰Let their own eyes see their destruction,
 and let them drink of the wrath of the Almighty.
²¹For what do they care for their houses after them,
 when the number of their months is cut off?
²²Will any teach God knowledge,
 seeing that he judges those that are on high?
²³One dies in full prosperity,
 being wholly at ease and secure,
²⁴his body full of fat
 and the marrow of his bones moist.
²⁵Another dies in bitterness of soul,
 never having tasted of good.
²⁶They lie down alike in the dust,
 and the worms cover them.

²⁷"Behold, I know your thoughts,
 and your schemes to wrong me.
²⁸For you say, 'Where is the house of the prince?
 Where is the tent in which the wicked dwelt?'
²⁹Have you not asked those who travel the roads,
 and do you not accept their testimony
³⁰that the wicked man is spared in the day of calamity,
 that he is rescued in the day of wrath?
³¹Who declares his way to his face,
 and who requites him for what he has done?
³²When he is borne to the grave,
 watch is kept over his tomb.
³³The clods of the valley are sweet to him;
 all men follow after him,
 and those who go before him are innumerable.
³⁴How then will you comfort me with empty nothings?
 There is nothing left of your answers but falsehood."

22
Then Eliphaz the Temanite answered:
²"Can a man be profitable to God?
 Surely he who is wise is profitable to himself.
³Is it any pleasure to the Almighty if you are righteous,
 or is it gain to him if you make your ways blameless?
⁴Is it for your fear of him that he reproves you,
 and enters into judgment with you?
⁵Is not your wickedness great?
 There is no end to your iniquities.
⁶For you have exacted pledges of your brothers for
 nothing,
 and stripped the naked of their clothing.
⁷You have given no water to the weary to drink,
 and you have withheld bread from the hungry.
⁸The man with power possessed the land,
 and the favored man dwelt in it.
⁹You have sent widows away empty,
 and the arms of the fatherless were crushed.
¹⁰Therefore snares are round about you,
 and sudden terror overwhelms you;
¹¹your light is darkened, so that you cannot see,
 and a flood of water covers you.

¹²"Is not God high in the heavens?
 See the highest stars, how lofty they are!
¹³Therefore you say, 'What does God know?
 Can he judge through the deep darkness?
¹⁴Thick clouds enwrap him, so that he does not see,
 and he walks on the vault of heaven.'
¹⁵Will you keep to the old way
 which wicked men have trod?
¹⁶They were snatched away before their time;
 their foundation was washed away.
¹⁷They said to God, 'Depart from us,'
 and 'What can the Almighty do to us?'
¹⁸Yet he filled their houses with good things—
 but the counsel of the wicked is far from me.
¹⁹The righteous see it and are glad;
 the innocent laugh them to scorn,
²⁰saying, 'Surely our adversaries are cut off,
 and what they left the fire has consumed.'

²¹"Agree with God, and be at peace;
 thereby good will come to you.
²²Receive instruction from his mouth,
 and lay up his words in your heart.
²³If you return to the Almighty and humble yourself,
 if you remove unrighteousness far from your tents,
²⁴if you lay gold in the dust,
 and gold of Ophir among the stones of the torrent bed,
²⁵and if the Almighty is your gold,
 and your precious silver;
²⁶then you will delight yourself in the Almighty,
 and lift up your face to God.
²⁷You will make your prayer to him, and he will hear you;
 and you will pay your vows.
²⁸You will decide on a matter, and it will be established
 for you,
 and light will shine on your ways.
²⁹For God abases the proud,
 but he saves the lowly.

30 He delivers the innocent man;
 you will be delivered through the cleanness of your
 hands."

23

Then Job answered:
2 "Today also my complaint is bitter,
 his hand is heavy in spite of my groaning.
3 Oh, that I knew where I might find him,
 that I might come even to his seat!
4 I would lay my case before him
 and fill my mouth with arguments.
5 I would learn what he would answer me,
 and understand what he would say to me.
6 Would he contend with me in the greatness of his power?
 No; he would give heed to me.
7 There an upright man could reason with him,
 and I should be acquitted for ever by my judge.

8 "Behold, I go forward, but he is not there;
 and backward, but I cannot perceive him;
9 on the left hand I seek him, but I cannot behold him;
 I turn to the right hand, but I cannot see him.
10 But he knows the way that I take;
 when he has tried me, I shall come forth as gold.
11 My foot has held fast to his steps;
 I have kept his way and have not turned aside.
12 I have not departed from the commandment of his lips;
 I have treasured in my bosom the words of his mouth.
13 But he is unchangeable and who can turn him?
 What he desires, that he does.
14 For he will complete what he appoints for me;
 and many such things are in his mind.
15 Therefore I am terrified at his presence;
 when I consider, I am in dread of him.
16 God had made my heart faint;
 the Almighty has terrified me;
17 for I am hemmed in by darkness,
 and thick darkness covers my face.

24

"Why are not times of judgment kept by the Almighty,
 and why do those who know him never see his days?
2 Men remove landmarks;
 they seize flocks and pasture them.
3 They drive away the ass of the fatherless;
 they take the widow's ox for a pledge.
4 They thrust the poor off the road;
 the poor of the earth all hide themselves.
5 Behold, like wild asses in the desert
 they go forth to their toil,
seeking prey in the wilderness
 as food for their children.
6 They gather their fodder in the field
 and they glean the vineyard of the wicked man.
7 They lie all night naked, without clothing,
 and have no covering in the cold.
8 They are wet with the rain of the mountains,
 and cling to the rock for want of shelter.
9 (There are those who snatch the fatherless child from the
 breast,
 and take in pledge the infant of the poor.)

10 They go about naked, without clothing;
 hungry, they carry the sheaves;
11 among the olive rows of the wicked they make oil;
 they tread the wine presses, but suffer thirst.
12 From out of the city the dying groan,
 and the soul of the wounded cries for help;
 yet God pays no attention to their prayer.

13 "There are those who rebel against the light,
 who are not acquainted with its ways,
 and do not stay in its paths.
14 The murderer rises in the dark,
 that he may kill the poor and needy;
 and in the night he is as a thief.
15 The eye of the adulterer also waits for the twilight,
 saying, 'No eye will see me';
 and he disguises his face.
16 In the dark they dig through houses;
 by day they shut themselves up;
 they do not know the light.
17 For deep darkness is morning to all of them;
 for they are friends with the terrors of deep darkness.

18 "You say, 'They are swiftly carried away upon the face of
 the waters;
 their portion is cursed in the land;
 no treader turns toward their vineyards.
19 Drought and heat snatch away the snow waters;
 so does Sheol those who have sinned.
20 The squares of the town forget them;
 their name is no longer remembered;
 so wickedness is broken like a tree.'

21 "They feed on the barren childless woman,
 and do no good to the widow.
22 Yet God prolongs the life of the mighty by his power;
 they rise up when they despair of life.
23 He gives them security, and they are supported;
 and his eyes are upon their ways;
24 They are exalted a little while, and then are gone;
 they wither and fade like the mallow;
 they are cut off like the heads of grain.
25 If it is not so, who will prove me a liar,
 and show that there is nothing in what I say?"

25

Then Bildad the Shuhite answered:
2 "Dominion and fear are with God;
 he makes peace in his high heaven.
3 Is there any number to his armies?
 Upon whom does his light not arise?
4 How then can man be righteous before God?
 How can he who is born of woman be clean?
5 Behold, even the moon is not bright
 and the stars are not clean in his sight;
6 how much less man, who is a maggot,
 and the son of man, who is a worm!"

26

Then Job answered:
2 "How you have helped him who has no power!
 How you have saved the arm that has no strength!
3 How you have counseled him who has no wisdom,

and plentifully declared sound knowledge!
⁴With whose help have you uttered words,
 and whose spirit has come forth from you?
⁵The shades below tremble,
 the waters and their inhabitants.
⁶Sheol is naked before God,
 and Abaddon has no covering.
⁷He stretches out the north over the void,
 and hangs the earth upon nothing.
⁸He binds up the waters in his thick clouds,
 and the cloud is not rent under them.
⁹He covers the face of the moon,
 and spreads over it his cloud.
¹⁰He has described a circle upon the face of the waters
 at the boundary between light and darkness.
¹¹The pillars of heaven tremble,
 and are astounded at his rebuke.
¹²By his power he stilled the sea;
 by his understanding he smote Rahab.
¹³By his wind the heavens were made fair;
 his hand pierced the fleeing serpent.
¹⁴Lo, these are but the outskirts of his ways;
 and how small a whisper do we hear of him!
 But the thunder of his power who can understand?"

27

And Job again took up his discourse, and said:
²"As God lives, who has taken away my right,
 and the Almighty, who has made my soul bitter;
³as long as my breath is in me,
 and the spirit of God is in my nostrils;
⁴my lips will not speak falsehood,
 and my tongue will not utter deceit.
⁵Far be it from me to say that you are right;
 till I die I will not put away my integrity from me.
⁶I hold fast my righteousness, and will not let it go;
 my heart does not reproach me for any of my days.

⁷"Let my enemy be as the wicked,
 and let him that rises up against me be as the
 unrighteous.
⁸For what is the hope of the godless when God cuts him
 off,
 when God takes away his life?
⁹Will God hear his cry,
 when trouble comes upon him?
¹⁰Will he take delight in the Almighty?
 Will he call upon God at all times?
¹¹I will teach you concerning the hand of God;
 what is with the Almighty I will not conceal.
¹²Behold, all of you have seen it yourselves;
 why then have you become altogether vain?

¹³"This is the portion of a wicked man with God,
 and the heritage which oppressors receive from the
 Almighty:
¹⁴If his children are multiplied, it is for the sword;
 and his offspring have not enough to eat.
¹⁵Those who survive him the pestilence buries,
 and their widows make no lamentation.
¹⁶Though he heap up silver like dust,
 and pile up clothing like clay;

¹⁷he may pile it up, but the just will wear it,
 and the innocent will divide the silver.
¹⁸The house which he builds is like a spider's web,
 like a booth which a watchman makes.
¹⁹He goes to bed rich, but will do so no more,
 he opens his eyes, and his wealth is gone.
²⁰Terrors overtake him like a flood;
 in the night a whirlwind carries him off.
²¹The east wind lifts him up and he is gone;
 it sweeps him out of his place.
²²It hurls at him without pity;
 he flees from its power in headlong flight.
²³It claps its hands at him,
 and hisses at him from its place.

28

"Surely there is a mine for silver,
 and a place for gold which they refine.
²Iron is taken out of the earth,
 and copper is smelted from the ore.
³Men put an end to darkness,
 and search out to the farthest bound
 the ore in gloom and deep darkness.
⁴They open shafts in a valley away from where men live;
 they are forgotten by travelers,
 they hang afar from men, they swing to and fro.
⁵As for the earth, out of it comes bread;
 but underneath it is turned up as by fire.
⁶Its stones are the place of sapphires,
 and it has dust of gold.

⁷"That path no bird of prey knows,
 and the falcon's eye has not seen it.
⁸The proud beasts have not trodden it;
 the lion has not passed over it.

⁹"Man puts his hand to the flinty rock,
 and overturns mountains by the roots.
¹⁰He cuts out channels in the rocks,
 and his eye sees every precious thing.
¹¹He binds up the streams so that they do not trickle,
 and the thing that is hid he brings forth to light.

¹²"But where shall wisdom be found?
 And where is the place of understanding?
¹³Man does not know the way to it,
 and it is not found in the land of the living.
¹⁴The deep says, 'It is not in me,'
 and the sea says, 'It is not with me.'
¹⁵It cannot be gotten for gold,
 and silver cannot be weighed as its price.
¹⁶It cannot be valued in the gold of Ophir,
 in precious onyx or sapphire.
¹⁷Gold and glass cannot equal it,
 nor can it be exchanged for jewels of fine gold.
¹⁸No mention shall be made of coral or of crystal;
 the price of wisdom is above pearls.
¹⁹The topaz of Ethiopia cannot compare with it,
 nor can it be valued in pure gold.

²⁰"Whence then comes wisdom?
 And where is the place of understanding?
²¹It is hid from the eyes of all living,

and concealed from the birds of the air.
²²Abaddon and Death say,
 'We have heard a rumor of it with our ears.'

²³"God understands the way to it,
 and he knows its place.
²⁴For he looks to the ends of the earth,
 and sees everything under the heavens.
²⁵When he gave to the wind its weight,
 and meted out the waters by measure;
²⁶when he made a decree for the rain,
 and a way for the lightning of the thunder;
²⁷then he saw it and declared it;
 he established it, and searched it out.
²⁸And he said to man,
 'Behold, the fear of the Lord, that is wisdom;
 and to depart from evil is understanding.'"

29

And Job again took up his discourse, and said:
²"Oh, that I were as in the months of old,
 as in the days when God watched over me;
³when his lamp shone upon my head,
 and by his light I walked through darkness;
⁴as I was in my autumn days,
 when the friendship of God was upon my tent;
⁵when the Almighty was yet with me,
 when my children were about me;
⁶when my steps were washed with milk,
 and the rock poured out for me streams of oil!
⁷When I went out to the gate of the city,
 when I prepared my seat in the square,
⁸the young men saw me and withdrew,
 and the aged rose and stood;
⁹the princes refrained from talking,
 and laid their hand on their mouth;
¹⁰the voice of the nobles was hushed,
 and their tongue cleaved to the roof of their mouth.
¹¹When the ear heard, it called me blessed,
 and when the eye saw, it approved;
¹²because I delivered the poor who cried,
 and the fatherless who had none to help him.
¹³The blessing of him who was about to perish came upon
 me,
 and I caused the widow's heart to sing for joy.
¹⁴I put on righteousness, and it clothed me;
 my justice was like a robe and a turban.
¹⁵I was eyes to the blind,
 and feet to the lame.
¹⁶I was a father to the poor,
 and I searched out the cause of him whom I did not
 know.
¹⁷I broke the fangs of the unrighteous,
 and made him drop his prey from his teeth.
¹⁸Then I thought, 'I shall die in my nest,
 and I shall multiply my days as the sand,
¹⁹my roots spread out to the waters,
 with the dew all night on my branches,
²⁰my glory fresh with me,
 and my bow ever new in my hand.'

²¹"Men listened to me, and waited,

and kept silence for my counsel.
²²After I spoke they did not speak again,
 and my word dropped upon them.
²³They waited for me as for the rain;
 and they opened their mouths as for the spring rain.
²⁴I smiled on them when they had no confidence;
 and the light of my countenance they did not cast
 down.
²⁵I chose their way, and sat as chief,
 and I dwelt like a king among his troops,
 like one who comforts mourners.

30

"But now they make sport of me,
 men who are younger than I,
whose fathers I would have disdained
 to set with the dogs of my flock.
²What could I gain from the strength of their hands,
 men whose vigor is gone?
³Through want and hard hunger
 they gnaw the dry and desolate ground;
⁴they pick mallow and the leaves of bushes,
 and to warm themselves the roots of the broom.
⁵They are driven out from among men;
 they shout after them as after a thief.
⁶In the gullies of the torrents they must dwell,
 in holes of the earth and of the rocks.
⁷Among the bushes they bray;
 under the nettles they huddle together.
⁸A senseless, a disreputable brood,
 they have been whipped out of the land.

⁹"And now I have become their song,
 I am a byword to them.
¹⁰They abhor me, they keep aloof from me;
 they do not hesitate to spit at the sight of me.
¹¹Because God has loosed my cord and humbled me,
 they have cast off restraint in my presence.
¹²On my right hand the rabble rise,
 they drive me forth,
 they cast up against me their ways of destruction.
¹³They break up my path, they promote my calamity;
 no one restrains them.
¹⁴As through a wide breach they come;
 amid the crash they roll on.
¹⁵Terrors are turned upon me;
 my honor is pursued as by the wind,
 and my prosperity has passed away like a cloud.

¹⁶"And now my soul is poured out within me;
 days of affliction have taken hold of me.
¹⁷The night racks my bones,
 and the pain that gnaws me takes no rest.
¹⁸With violence it seizes my garment;
 it binds me about like the collar of my tunic.
¹⁹God has cast me into the mire,
 and I have become like dust and ashes.
²⁰I cry to thee and thou dost not answer me;
 I stand, and thou dost not heed me.
²¹Thou hast turned cruel to me;
 with the might of thy hand thou dost persecute me.

²²Thou liftest me up on the wind, thou madest me ride on
 it,
 and thou tossest me about in the roar of the storm.
²³Yea, I know that thou wilt bring me to death,
 and to the house appointed for all living.

²⁴"Yet does not one in a heap of ruins stretch out his
 hand,
 and in his disaster cry for help?
²⁵Did not I weep for him whose day was hard?
 Was not my soul grieved for the poor?
²⁶But when I looked for good, evil came;
 and when I waited for light, darkness came.
²⁷My heart is in turmoil, and is never still;
 days of affliction come to meet me.
²⁸I go about blackened, but not by the sun;
 I stand up in the assembly, and cry for help.
²⁹I am a brother of jackals,
 and a companion of ostriches.
³⁰My skin turns black and falls from me,
 and my bones burn with heat.
³¹My lyre is turned to mourning,
 and my pipe to the voice of those who weep.

31
"I have made a convenant with my eyes;
 how then could I look upon a virgin?
²What would be my portion from God above,
 and my heritage from the Almighty on high?
³Does not calamity befall the unrighteous,
 and disaster the workers of iniquity?
⁴Does not he see my ways,
 and number all my steps?

⁵"If I have walked with falsehood,
 and my foot has hastened to deceit;
⁶(Let me be weighed in a just balance,
 and let God know my integrity!)
⁷if my step has turned aside from the way,
 and my heart has gone after my eyes,
 and if any spot has cleaved to my hands;
⁸then let me sow, and another eat;
 and let what grows for me be rooted out.

⁹"If my heart has been enticed to a woman,
 and I have lain in wait at my neighbor's door;
¹⁰then let my wife grind for another,
 and let others bow down upon her.
¹¹For that would be a heinous crime;
 that would be an iniquity to be punished by the
 judges;
¹²for that would be a fire which consumes unto Abaddon,
 and it would burn to the root all my increase.

¹³"If I have rejected the cause of my manservant or my
 maidservant,
 when they brought a complaint against me;
¹⁴what then shall I do when God rises up?
 When he makes inquiry, what shall I answer him?
¹⁵Did not he who made me in the womb make him?
 And did not one fashion us in the womb?

¹⁶"If I have withheld anything that the poor desired,

or have caused the eyes of the widow to fail,
¹⁷or have eaten my morsel alone,
 and the fatherless has not eaten of it
¹⁸(for from his youth I reared him as a father,
 and from his mother's womb I guided him);
¹⁹if I have seen any one perish for lack of clothing,
 or a poor man without covering;
²⁰if his loins have not blessed me,
 and if he was not warmed with the fleece of my sheep;
²¹if I have raised my hand against the fatherless,
 because I saw help in the gate;
²²then let my shoulder blade fall from my shoulder,
 and let my arm be broken from its socket.
²³For I was in terror of calamity from God,
 and I could not have faced his majesty.

²⁴"If I have made gold my trust,
 or called fine gold my confidence;
²⁵if I have rejoiced because my wealth was great,
 or because my hand had gotten much;
²⁶if I have looked at the sun when it shone,
 or the moon moving in splendor,
²⁷and my heart has been secretly enticed,
 and my mouth has kissed my hand;
²⁸this also would be an iniquity to be punished by the
 judges,
 for I should have been false to God above.

²⁹"If I have rejoiced at the ruin of him that hated me,
 or exulted when evil overtook him
³⁰(I have not let my mouth sin
 by asking for his life with a curse);
³¹if the men of my tent have not said,
 'Who is there that has not been filled with his meat?'
³²(the sojourner has not lodged in the street;
 I have opened my doors to the wayfarer);
³³if I have concealed my transgressions from men,
 by hiding my iniquity in my bosom,
³⁴because I stood in great fear of the multitude,
 and the contempt of families terrified me,
 so that I kept silence, and did not go out of doors—
³⁵Oh, that I had one to hear me!
 (Here is my signature! let the Almighty answer me!)
 Oh, that I had the indictment
 written by my adversary!
³⁶Surely I would carry it on my shoulder;
 I would bind it on me as a crown;
³⁷I would give him an account of all my steps;
 like a prince I would approach him.

³⁸"If my land has cried out against me,
 and its furrows have wept together;
³⁹if I have eaten its yield without payment,
 and caused the death of its owners;
⁴⁰let thorns grow instead of wheat,
 and foul weeds instead of barley."

The words of Job are ended.

32
So these three men ceased to answer Job, because he was
righteous in his own eyes. ²Then Elihu the son of Barachel
the Buzite, of the family of Ram, became angry. He was

angry at Job because he justified himself rather than God; ³he was angry also at Job's three friends because they had found no answer, although they had declared Job to be in the wrong. ⁴Now Elihu had waited to speak to Job because they were older than he. ⁵And when Elihu saw that there was no answer in the mouth of these three men, he became angry.

⁶And Elihu the son of Barachel the Buzite answered:
"I am young in years,
 and you are aged;
therefore I was timid and afraid
 to declare my opinion to you.
⁷I said, 'Let days speak,
 and many years teach wisdom.'
⁸But it is the spirit in a man,
 the breath of the Almighty, that makes him understand.
⁹It is not the old that are wise,
 nor the aged that understand what is right.
¹⁰Therefore I say, 'Listen to me;
 let me also declare my opinion.'
¹¹"Behold, I waited for your words,
 I listened for your wise sayings,
 while you searched out what to say.
¹²I gave you my attention,
 and, behold, there was none that confuted Job,
 or that answered his words, among you.
¹³Beware lest you say, 'We have found wisdom;
 God may vanquish him, not man.'
¹⁴He has not directed his words against me,
 and I will not answer him with your speeches.

¹⁵"They are discomfited, they answer no more;
 they have not a word to say.
¹⁶And shall I wait, because they do not speak,
 because they stand there, and answer no more?
¹⁷I also will give my answer;
 I also will declare my opinion.
¹⁸For I am full of words,
 the spirit within me constrains me.
¹⁹Behold, my heart is like wine that has no vent;
 like new wineskins, it is ready to burst.
²⁰I must speak, that I may find relief;
 I must open my lips and answer.
²¹I will not show partiality to any person
 or use flattery toward any man.
²²For I do not know how to flatter,
 else would my Maker soon put an end to me.

33
"But now, hear my speech, O Job,
 and listen to all my words.
²Behold, I open my mouth;
 the tongue in my mouth speaks.
³My words declare the uprightness of my heart,
 and what my lips know they speak sincerely.
⁴The spirit of God has made me,
 and the breath of the Almighty gives me life.
⁵Answer me, if you can;
 set your words in order before me; take your stand.
⁶Behold, I am toward God as you are;
 I too was formed from a piece of clay.

⁷Behold, no fear of me need terrify you;
 my pressure will not be heavy upon you.

⁸"Surely, you have spoken in my hearing,
 and I have heard the sound of your words.
⁹You say, 'I am clean, without transgression;
 I am pure, and there is no iniquity in me.
¹⁰Behold, he finds occasions against me,
 he counts me as his enemy;
¹¹he puts my feet in the stocks,
 and watches all my paths.'

¹²"Behold, in this you are not right. I will answer you.
 God is greater than man.
¹³Why do you contend against him,
 saying, 'He will answer none of my words'?
¹⁴For God speaks in one way,
 and in two, though man does not perceive it.
¹⁵In a dream, in a vision of the night,
 when deep sleep falls upon men,
 while they slumber on their beds,
¹⁶then he opens the ears of men,
 and terrifies them with warnings,
¹⁷that he may turn man aside from his deed,
 and cut off pride from man;
¹⁸he keeps back his soul from the Pit,
 his life from perishing by the sword.

¹⁹"Man is also chastened with pain upon his bed,
 and with continual strife in his bones;
²⁰so that his life loathes bread,
 and his appetite dainty food.
²¹His flesh is so wasted away that it cannot be seen;
 and his bones which were not seen stick out.
²²His soul draws near the Pit,
 and his life to those who bring death.
²³If there be for him an angel,
 a mediator, one of the thousand,
 to declare to man what is right for him;
²⁴and he is gracious to him, and says,
 'Deliver him from going down into the Pit,
 I have found a ransom;
²⁵let his flesh become fresh with youth;
 let him return to the days of his youthful vigor';
²⁶then man prays to God, and he accepts him,
 he comes into his presence with joy.
He recounts to men his salvation,
²⁷ and he sings before men, and says:
'I sinned, and perverted what was right,
 and it was not requited to me.
²⁸He has redeemed my soul from going down into the Pit,
 and my life shall see the light.'

²⁹"Behold, God does all these things,
 twice, three times, with a man,
³⁰to bring back his soul from the Pit,
 that he may see the light of life.
³¹Give heed, O Job, listen to me;
 be silent, and I will speak.
³²If you have anything to say, answer me;
 speak, for I desire to justify you.
³³If not, listen to me;
 be silent, and I will teach you wisdom."

34

Then Elihu said:

2 "Hear my words, you wise men,
 and give ear to me, you who know;
3 for the ear tests words
 as the palate tastes food.
4 Let us choose what is right;
 let us determine among ourselves what is good.
5 For Job has said, 'I am innocent,
 and God has taken away my right;
6 in spite of my right I am counted a liar;
 my wound is incurable, though I am without
 transgression.'
7 What man is like Job,
 who drinks up scoffing like water,
8 who goes in company with evildoers and walks with
 wicked men?
9 For he has said, 'It profits a man nothing
 that he should take delight in God.'

10 "Therefore, hear me, you men of understanding,
 far be it from God that he should do wickedness,
 and from the Almighty that he should do wrong.
11 For according to the work of a man he will requite him,
 and according to his ways he will make it befall him.
12 Of a truth, God will not do wickedly,
 and the Almighty will not pervert justice.
13 Who gave him charge over the earth
 and who laid on him the whole world?
14 If he should take back his spirit to himself,
 and gather to himself his breath,
15 all flesh would perish together,
 and man would return to dust.

16 "If you have understanding, hear this;
 listen to what I say.
17 Shall one who hates justice govern?
 Will you condemn him who is righteous and mighty,
18 who says to a king, 'Worthless one,'
 and to nobles, 'Wicked man';
19 who shows no partiality to princes,
 nor regards the rich more than the poor,
 for they are all the work of his hands?
20 In a moment they die;
 at midnight the people are shaken and pass away,
 and the mighty are taken away by no human hand.

21 "For his eyes are upon the ways of a man,
 and he sees all his steps.
22 There is no gloom or deep darkness
 where evildoers may hide themselves.
23 For he has not appointed a time for any man
 to go before God in judgment.
24 He shatters the mighty without investigation,
 and sets others in their place.
25 Thus, knowing their works,
 he overturns them in the night, and they are crushed.
26 He strikes them for their wickedness
 in the sight of men,
27 because they turned aside from following him,
 and had no regard for any of his ways,
28 so that they caused the cry of the poor to come to him,
and he heard the cry of the afflicted—
29 When he is quiet, who can condemn?
 When he hides his face, who can behold him,
 whether it be a nation or a man?
30 that a godless man should not reign,
 that he should not ensnare the people.

31 "For has any one said to God,
 'I have borne chastisement; I will not offend any more;
32 teach me what I do not see;
 if I have done iniquity, I will do it no more'?
33 Will he then make requital to suit you,
 because you reject it?
For you must choose, and not I;
 therefore declare what you know.
34 Men of understanding will say to me,
 and the wise man who hears me will say:
35 'Job speaks without knowledge,
 his words are without insight.'
36 Would that Job were tried to the end,
 because he answers like wicked men.
37 For he adds rebellion to his sin;
 he claps his hands among us,
 and multiplies his words against God."

35

And Elihu said:

2 "Do you think this to be just?
 Do you say, 'It is my right before God,'
3 that you ask, 'What advantage have I?
 How am I better off than if I had sinned?'
4 I will answer you
 and your friends with you.
5 Look at the heavens, and see;
 and behold the clouds, which are higher than you.
6 If you have sinned, what do you accomplish against him?
 And if your transgressions are multiplied, what do you
 do to him?
7 If you are righteous, what do you give to him;
 or what does he receive from your hand?
8 Your wickedness concerns a man like yourself,
 and your righteousness a son of man.

9 "Because of the multitude of oppressions people cry out;
 they call for help because of the arm of the mighty.
10 But none says, 'Where is God my Maker,
 who gives songs in the night,
11 who teaches us more than the beasts of the earth,
 and makes us wiser than the birds of the air?'
12 There they cry out, but he does not answer,
 because of the pride of evil men.
13 Surely God does not hear an empty cry,
 nor does the Almighty regard it.
14 How much less when you say that you do not see him,
 that the case is before him, and you are waiting for him!
15 And now, because his anger does not punish,
 and he does not greatly heed transgression,
16 Job opens his mouth in empty talk,
 he multiplies words without knowledge."

36

And Elihu continued, and said:

²"Bear with me a little, and I will show you,
 for I have yet something to say on God's behalf.
³I will fetch my knowledge from afar,
 and ascribe righteousness to my Maker.
⁴For truly my words are not false;
 one who is perfect in knowledge is with you.

⁵"Behold, God is mighty, and does not despise any;
 he is mighty in strength of understanding.
⁶He does not keep the wicked alive,
 but gives the afflicted their right.
⁷He does not withdraw his eyes from the righteous,
 but with kings upon the throne
 he sets them for ever, and they are exalted.
⁸And if they are bound in fetters
 and caught in the cords of affliction,
⁹then he declares to them their work
 and their transgressions, that they are behaving
 arrogantly.
¹⁰He opens their ears to instruction,
 and commands that they return from iniquity.
¹¹If they hearken and serve him,
 they complete their days in prosperity,
 and their years in pleasantness.
¹²But if they do not hearken, they perish by the sword,
 and die without knowledge.

¹³"The godless in heart cherish anger;
 they do not cry for help when he binds them.
¹⁴They die in youth,
 and their life ends in shame.
¹⁵He delivers the afflicted by their affliction,
 and opens their ear by adversity.
¹⁶He also allured you out of distress
 into a broad place where there was no cramping,
 and what was set on your table was full of fatness.

¹⁷"But you are full of the judgment on the wicked;
 judgment and justice seize you.
¹⁸Beware lest wrath entice you into scoffing;
 and let not the greatness of the ransom turn you aside.
¹⁹Will your cry avail to keep you from distress,
 or all the force of your strength?
²⁰Do not long for the night,
 when peoples are cut off in their place.
²¹Take heed, do not turn to iniquity,
 for this you have chosen rather than affliction.
²²Behold, God is exalted in his power,
 who is a teacher like him?
²³Who has prescribed for him his way,
 or who can say, 'Thou hast done wrong'?

²⁴"Remember to extol his work,
 of which men have sung.
²⁵All men have looked on it;
 man beholds it from afar.
²⁶Behold, God is great, and we know him not;
 the number of his years is unsearchable.
²⁷For he draws up the drops of water,
 he distils his mist in rain
²⁸which the skies pour down,
 and drop upon man abundantly.
²⁹Can any one understand the spreading of the clouds,

the thunderings of his pavilion?
³⁰Behold, he scatters his lightning about him,
 and covers the roots of the sea.
³¹For by these he judges peoples;
 he gives food in abundance.
³²He covers his hands with the lightning,
 and commands it to strike the mark.
³³Its crashing declares concerning him,
 who is jealous with anger against iniquity.

37
"At this also my heart trembles,
 and leaps out of its place.
²Hearken to the thunder of his voice
 and the rumbling that comes from his mouth.
³Under the whole heaven he lets it go,
 and his lightning to the corners of the earth.
⁴After it his voice roars;
 he thunders with his majestic voice
 and he does not restrain the lightnings when his voice
 is heard.
⁵God thunders wondrously with his voice;
 he does great things which we cannot comprehend.
⁶For to the snow he says, 'Fall on the earth';
 and to the shower and the rain, 'Be strong.'
⁷He seals up the hand of every man,
 that all men may know his work.
⁸Then the beasts go into their lairs,
 and remain in their dens.
⁹From its chamber comes the whirlwind,
 and cold from the scattering winds.
¹⁰By the breath of God ice is given,
 and the broad waters are frozen fast.
¹¹He loads the thick cloud with moisture;
 the clouds scatter his lightning.
¹²They turn round and round by his guidance,
 to accomplish all that he commands them
 on the face of the habitable world.
¹³Whether for correction, or for his land,
 or for love, he causes it to happen.

¹⁴"Hear this, O Job;
 stop and consider the wondrous works of God.
¹⁵Do you know how God lays his command upon them,
 and causes the lightning of his cloud to shine?
¹⁶Do you know the balancings of the clouds,
 the wondrous works of him who is perfect in knowledge,
¹⁷you whose garments are hot
 when the earth is still because of the south wind?
¹⁸Can you, like him spread out the skies,
 hard as a molten mirror?
¹⁹Teach us what we shall say to him;
 we cannot draw up our case because of darkness.
²⁰Shall it be told him that I would speak?
 Did a man ever wish that he would be swallowed up?

²¹"And now men cannot look on the light
 when it is bright in the skies,
 when the wind has passed and cleared them.
²²Out of the north comes golden splendor;
 God is clothed with terrible majesty.
²³The Almighty—we cannot find him;

he is great in power and justice,
 and abundant righteousness he will not violate.
²⁴ Therefore men fear him;
 he does not regard any who are wise in their own
 conceit."

38

Then the LORD answered Job out of the whirlwind:
² "Who is this that darkens counsel by words without
 knowledge?
³ Gird up your loins like a man,
 I will question you, and you shall declare to me.

⁴ "Where were you when I laid the foundation of the earth?
 Tell me, if you have understanding.
⁵ Who determined its measurements—surely you know!
 Or who stretched the line upon it?
⁶ On what were its bases sunk,
 or who laid its cornerstone,
⁷ when the morning stars sang together,
 and all the sons of God shouted for joy?

⁸ "Or who shut in the sea with doors,
 when it burst forth from the womb;
⁹ when I made clouds its garment,
 and thick darkness its swaddling band,
¹⁰ and prescribed bounds for it,
 and set bars and doors,
¹¹ and said, 'Thus far shall you come, and no farther,
 and here shall your proud waves be stayed'?

¹² "Have you commanded the morning since your days
 began,
 and caused the dawn to know its place,
¹³ that it might take hold of the skirts of the earth,
 and the wicked be shaken out of it?
¹⁴ It is changed like clay under the seal,
 and it is dyed like a garment.
¹⁵ From the wicked their light is withheld,
 and their uplifted arm is broken.

¹⁶ "Have you entered into the springs of the sea,
 or walked in the recesses of the deep?
¹⁷ Have the gates of death been revealed to you,
 or have you seen the gates of deep darkness?
¹⁸ Have you comprehended the expanse of the earth?
 Declare, if you know all this.

¹⁹ "Where is the way to the dwelling of light,
 and where is the place of darkness,
²⁰ that you may take it to its territory
 and that you may discern the paths to its home?
²¹ You know, for you were born then,
 and the number of your days is great!

²² "Have you entered the storehouses of the snow,
 or have you seen the storehouses of the hail,
²³ which I have reserved for the time of trouble,
 for the day of battle and war?
²⁴ What is the way to the place where the light is
 distributed,
 or where the east wind is scattered upon the earth?

²⁵ "Who has cleft a channel for the torrents of rain,
 and a way for the thunderbolt,

²⁶ to bring rain on a land where no man is,
 on the desert in which there is no man;
²⁷ to satisfy the waste and desolate land,
 and to make the ground put forth grass?

²⁸ "Has the rain a father,
 or who has begotten the drops of dew?
²⁹ From whose womb did the ice come forth,
 and who has given birth to the hoarfrost of heaven?
³⁰ The waters become hard like stone,
 and the face of the deep is frozen.

³¹ "Can you bind the chains of the Pleiades,
 or loose the cords of Orion?
³² Can you lead forth the Mazzaroth in their season,
 or can you guide the Bear with its children?
³³ Do you know the ordinances of the heavens?
 Can you establish their rule on the earth?

³⁴ "Can you lift up your voice to the clouds,
 that a flood of waters may cover you?
³⁵ Can you send forth lightnings, that they may go
 and say to you, 'Here we are'?
³⁶ Who has put wisdom in the clouds,
 or given understanding to the mists?
³⁷ Who can number the clouds by wisdom?
 Or who can tilt the waterskins of the heavens,
³⁸ when the dust runs into a mass
 and the clods cleave fast together?

³⁹ "Can you hunt the prey for the lion,
 or satisfy the appetite of the young lions,
⁴⁰ when they crouch in their dens,
 or lie in wait in their covert?
⁴¹ Who provides for the raven its prey,
 when its young ones cry to God,
 and wander about for lack of food?

39

"Do you know when the mountain goats bring forth?
 Do you observe the calving of the hinds?
² Can you number the months that they fulfil,
 and do you know the time when they bring forth,
³ when they crouch, bring forth their offspring,
 and are delivered of their young?
⁴ Their young ones become strong, they grow up in the
 open;
 they go forth, and do not return to them.

⁵ "Who has let the wild ass go free?
 Who has loosed the bonds of the swift ass,
⁶ to whom I have given the steppe for his home,
 and the salt land for his dwelling place?
⁷ He scorns the tumult of the city;
 he hears not the shouts of the driver.
⁸ He ranges the mountains as his pasture,
 and he searches after every green thing.

⁹ "Is the wild ox willing to serve you?
 Will he spend the night at your crib?
¹⁰ Can you bind him in the furrow with ropes,
 or will he harrow the valleys after you?
¹¹ Will you depend on him because his strength is great,
 and will you leave to him your labor?

¹²Do you have faith in him that he will return,
 and bring your grain to your threshing floor?

¹³"The wings of the ostrich wave proudly;
 but are they the pinions and plumage of love?
¹⁴For she leaves her eggs to the earth,
 and lets them be warmed on the ground,
¹⁵forgetting that a foot may crush them,
 and that the wild beast may trample them.
¹⁶She deals cruelly with her young, as if they were not hers;
 though her labor be in vain, yet she has no fear;
¹⁷because God has made her forget wisdom,
 and given her no share in understanding.
¹⁸When she rouses herself to flee,
 she laughs at the horse and his rider.

¹⁹"Do you give the horse his might?
 Do you clothe his neck with strength?
²⁰Do you make him leap like the locust?
 His majestic snorting is terrible.
²¹He paws in the valley, and exults in his strength;
 he goes out to meet the weapons.
²²He laughs at fear, and is not dismayed;
 he does not turn back from the sword.
²³Upon him rattle the quiver, the flashing spear and the javelin.
²⁴With fierceness and rage he swallows the ground;
 he cannot stand still at the sound of the trumpet.
²⁵When the trumpet sounds, he says 'Aha!'
 He smells the battle from afar,
 the thunder of the captains, and the shouting.

²⁶"Is it by your wisdom that the hawk soars,
 and spreads his wings toward the south?
²⁷Is it at your command that the eagle mounts up
 and makes his nest on high?
²⁸On the rock he dwells and makes his home
 in the fastness of the rocky crag.
²⁹Thence he spies out the prey;
 his eyes behold it afar off.
³⁰His young ones suck up blood;
 and where the slain are, there is he."

40

And the LORD said to Job:
²"Shall a faultfinder contend with the Almighty?
 He who argues with God, let him answer it."
³Then Job answered the LORD:
⁴"Behold, I am of small account; what shall I answer thee?
 I lay my hand on my mouth.
⁵I have spoken once, and I will not answer;
 twice, but I will proceed no further."

⁶Then the LORD answered Job out of the whirlwind:
⁷"Gird up your loins like a man;
 I will question you, and you declare to me.
⁸Will you even put me in the wrong?
 Will you condemn me that you may be justified?
⁹Have you an arm like God,
 and can you thunder with a voice like his?

¹⁰"Deck yourself with majesty and dignity;
 clothe yourself with glory and splendor.

¹¹Pour forth the overflowings of your anger,
 and look on every one that is proud, and abase him.
¹²Look on every one that is proud, and bring him low;
 and tread down the wicked where they stand.
¹³Hide them all in the dust together;
 bind their faces in the world below.
¹⁴Then will I also acknowledge to you,
 that your own right hand can give you victory.

¹⁵"Behold, Behemoth,
 which I made as I made you;
 he eats grass like an ox.
¹⁶Behold, his strength in his loins,
 and his power in the muscles of his belly.
¹⁷He makes his tail stiff like a cedar;
 the sinews of his thighs are knit together.
¹⁸His bones are tubes of bronze,
 his limbs like bars of iron.

¹⁹"He is the first of the works of God;
 let him who made him bring near his sword!
²⁰For the mountains yield food for him
 where all the wild beasts play.
²¹Under the lotus plants he lies,
 in the covert of the reeds and in the marsh.
²²For his shade the lotus trees cover him;
 the willows of the brook surround him.
²³Behold, if the river is turbulent he is not frightened;
 he is confident though Jordan rushes against his mouth.
²⁴Can one take him with hooks,
 or pierce his nose with a snare?

41

"Can you draw out Leviathan with a fishhook,
 or press down his tongue with a cord?
²Can you put a rope in his nose,
 or pierce his jaw with a hook?
³Will he make many supplications to you?
 Will he speak to you soft words?
⁴Will he make a covenant with you
 to take him for your servant for ever?
⁵Will you play with him as with a bird,
 or will you put him on leash for your maidens?
⁶Will traders bargain over him?
 Will they divide him up among the merchants?
⁷Can you fill his skin with harpoons,
 or his head with fishing spears?
⁸Lay hands on him;
 think of the battle; you will not do it again!
⁹Behold, the hope of a man is disappointed;
 he is laid low even at the sight of him.
¹⁰No one is so fierce that he dares to stir him up.
 Who then is he that can stand before me?
¹¹Who has given to me, that I should repay him?
 Whatever is under the whole heaven is mine.

¹²"I will not keep silence concerning his limbs,
 or his mighty strength, or his goodly frame.
¹³Who can strip off his outer garment?
 Who can penetrate his double coat of mail?
¹⁴Who can open the doors of his face?
 Round about his teeth is terror.
¹⁵His back is made of rows of shields,

shut up closely as with a seal.
[16] One is so near to another
 that no air can come between them.
[17] They are joined one to another;
 they clasp each other and cannot be separated.
[18] His sneezings flash forth light,
 and his eyes are like the eyelids of the dawn.
[19] Out of his mouth go flaming torches;
 sparks of fire leap forth.
[20] Out of his nostrils comes forth smoke,
 as from a boiling pot and burning rushes.
[21] His breath kindles coals,
 and a flame comes forth from his mouth.
[22] In his neck abides strength,
 and terror dances before him.
[23] The folds of his flesh cleave together,
 firmly cast upon him and immovable.
[24] His heart is hard as a stone,
 hard as the nether millstone.
[25] When he raises himself up the mighty are afraid;
 at the crashing they are beside themselves.
[26] Though the sword reaches him, it does not avail;
 nor the spear, the dart, or the javelin.
[27] He counts iron as straw,
 and bronze as rotten wood.
[28] The arrow cannot make him flee;
 for him slingstones are turned to stubble.
[29] Clubs are counted as stubble;
 he laughs at the rattle of javelins.
[30] His underparts are like sharp potsherds;
 he spreads himself like a threshing sledge on the mire.
[31] He makes the deep boil like a pot;
 he makes the sea like a pot of ointment.
[32] Behind him he leaves a shining wake;
 one would think the deep to be hoary.
[33] Upon earth there is not his like,
 a creature without fear.
[34] He beholds everything that is high;
 he is king over all the sons of pride."

42
Then Job answered the LORD:
[2] "I know that thou canst do all things,

and that no purpose of thine can be thwarted.
[3] 'Who is this that hides counsel without knowledge?'
 Therefore I have uttered what I did not understand,
 things too wonderful for me, which I did not know.
[4] 'Hear, and I will speak;
 I will question you, and you declare to me.'
[5] I had heard of thee by the hearing of the ear,
 but now my eye sees thee;
[6] therefore I despise myself,
 and repent in dust and ashes."

7 After the LORD had spoken these words to Job, the LORD said to Eliphaz the Temanite: "My wrath is kindled against you and against your two friends; for you have not spoken of me what is right, as my servant Job has. [8] Now therefore take seven bulls and seven rams, and go to my servant Job, and offer up for yourselves a burnt offering; and my servant Job shall pray for you, for I will accept his prayer not to deal with you according to your folly; for you have not spoken of me what is right, as my servant Job has." [9] So Eliphaz the Temanite and Bildad the Shuhite and Zophar the Naamathite went and did what the LORD had told them; and the LORD accepted Job's prayer.

10 And the LORD restored the fortunes of Job, when he had prayed for his friends; and the LORD gave Job twice as much as he had before. [11] Then came to him all his brothers and sisters and all who had known him before, and ate bread with him in his house; and they showed him sympathy and comforted him for all the evil that the LORD had brought upon him; and each of them gave him a piece of money and a ring of gold. [12] And the LORD blessed the latter days of Job more than his beginning; and he had fourteen thousand sheep, six thousand camels, a thousand yoke of oxen, and a thousand she-asses. [13] He had also seven sons and three daughters. [14] And he called the name of the first Jemimah; and the name of the second Keziah; and the name of the third Keren-happuch. [15] And in all the land there were no women so fair as Job's daughters; and their father gave them inheritance among their brothers. [16] And after this Job lived a hundred and forty years, and saw his sons, and his sons' sons, four generations. [17] And Job died, an old man, and full of days.

CHAPTER THREE

ANCIENT EGYPT

Protected by deserts and confined to a narrow river valley, ancient Egypt experienced a relatively isolated cultural history, virtually unbroken for thousands of years. It was a civilization unique in its dependence upon the regular annual flooding of a single river. Every year, as the Nile overflowed its banks to deposit a rich and fertile silt on the surrounding fields, it bore witness to the rhythm of a beneficent natural order which would continue beyond the grave. Death—or, rather, everlasting life in the hereafter—was the focus of the arts of the Egyptians. Created mostly in the service of the cult of a god, or to glorify the power and wealth of a pharaoh, art and architecture centered on the provision of an eternal dwelling-place for the dead. Life was celebrated and recreated in images intended to provide an eternal substitute for the mortal body.

3.1 Funerary mask of King Tutankhamun, c.1340 BC. Gold inlaid with enamel and semi-precious stones, 21¼ ins (54 cm) high. Egyptian Museum, Cairo.

CONTEXTS AND CONCEPTS

Egyptian civilization spans thousands of years, encompassing the beginning of recorded history. Egypt was a river-valley civilization, organized around and dependent for sustenance upon the floods of the Nile River. Flood waters are rich in silt, whose organic deposits renew the topsoil. After flooding, the soil was so tillable that Egyptian farmers needed nothing more elaborate than a wooden hoe to work it. Two and three crops per year could be harvested almost without effort, according to Greek authors, who spoke enviously of Egyptian agriculture. Nonetheless, effort was required to prevent the wind-blown sands of the desert from encroaching and to obtain maximum benefit from the unpredictable Nile. Dikes and canals were built, and as early as the dawn of recorded history, the Egyptians were marking the height of the Nile's successive rises.

3.2 Rhomboidal Pyramid, Dahshur, Egypt, Dynasty IV (2680–2565 BC).

OLD KINGDOM

Egypt's political organization centered around its all-powerful rulers, the pharaohs. The Egyptians themselves used no other dating system than that of their pharaonic dynasties, and the traditional chronology of Egyptian development also follows the dynasties of its rulers.

The first significant achievement we can mark is the establishment of the Old Kingdom (c.2778–2263 BC). The Old Kingdom, whose capital was Memphis, had a planned economy and strict social order, while relying on the agricultural system based on the annual Nile floods. We know little of the earliest dynasties. But during the reign of Snofru and other rulers of Dynasty IV, there emerged the structure that has come to symbolize Egyptian accomplishment—the pyramid. According to one ancient source, Snofru "arose as a beneficent king over all the earth." He was a great builder, and his mortuary temple contains a list of the strongholds and cities he founded. The ancient Egyptians attributed a standard list of accomplishments to beneficent rulers. Thus, we can infer that Snofru built many temples and more than satisfied the appetites of the gods for offerings. The propensity for building reflected the fact that no ruler wished to dwell in his father's palace. Usually he built his own, as close as possible to his mausoleum.

The horse and the cart were apparently unknown in Egypt at this time; the ship was the only means of transportation. So it comes as no surprise that a pharaoh as

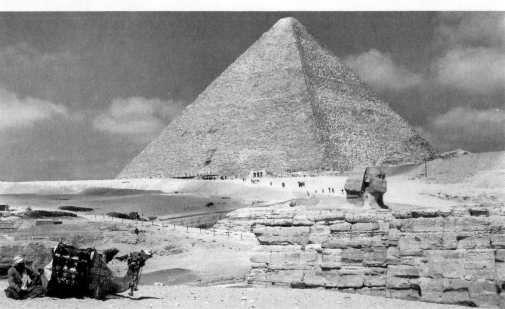

3.3 Great Pyramid of Cheops, Giza, Egypt, Dynasty IV (2680–2565 BC).

capable as Snofru also excelled in shipbuilding. This fact provides us with an additional insight into the nature of Egyptian civilization since Snofru, like his predecessors dating back at least to Dynasty II, built his ships and barges of wood. Egypt had no forests and the source of wood was Byblos, north of presentday Beirut. This indicates productive commerce and political relationships encompassing a large area around the eastern end of the Mediterranean.

But it is to pyramids that our attention and interest naturally turn. How did these ancient people bring large stones to the building site and put them into position, without access to machinery? Many answers have been suggested including the intervention of visitors from outer space. None, however, appears definitive. Whatever was the case, Snofru is credited with no fewer than three pyramids, including the Rhomboidal Pyramid at Dahshur (Fig. **3.2**), and a step pyramid.

Snofru's son Cheops (this name is a Greek derivative of Chnum-Khufwey—Chnum was the principal god of the area) proved to be a demanding and authoritative ruler. He reigned for 23, 50, or 60 years (sources vary) and his achievements remain with us even now in the form of his Great Pyramid (Fig. **3.3**). Like his father, Cheops took an interest in nations beyond his own kingdom. A low relief from Cheops' burial chamber indicates that visitors from afar, the Helu-Nebut, visited his court. The Helu-Nebut are presumed to be the ancient ancestors of the Hellenes, or Greeks.

These early dynasties produced rulers of well-defined individuality, but as time passed, the social organization, which centered on an omnipotent god-king, underwent crisis after crisis. Finally it collapsed under weak and ineffectual rulers. Changes in the social order are evident in the tendency for royal burial chambers to diminish in size, as those of wealthy courtiers and landowners grow larger.

Pepi II of Dynasty VI (Fig. **3.4**) assumed the throne at the age of six, and lived for over 100 years. We know from the king's own writings that by this time the Egyptian state was growing poor. This was partly because numerous temples were exempted from contributing to the administration's coffers. A story about the king's behavior gives us another glimpse of Egyptian society at that date. Apparently Pepi was fond of leaving the palace unescorted, at night, in order to rendezvous with one of his unmarried generals. The liaison was discovered, but the scandal was quashed before serious consequences arose.

Nonetheless, Pepi II retains a place as the last great ruler of the Old Kingdom. After his reign, the details of Egyptian history fade from view for a while. Centralized authority waned, landowners increased their power, and individual cities (*nomes*) gained in independence. It was not until the pharaohs of Dynasty XI that Egypt reemerged as a significant political entity.

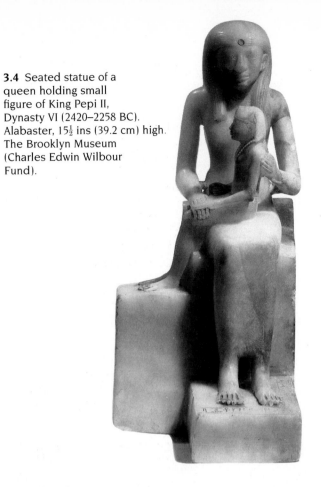

3.4 Seated statue of a queen holding small figure of King Pepi II, Dynasty VI (2420–2258 BC). Alabaster, 15½ ins (39.2 cm) high. The Brooklyn Museum (Charles Edwin Wilbour Fund).

MIDDLE KINGDOM

In about 2130 BC, the governor of Thebes successfully subdued his rivals and founded a new dynasty (XI) which unified Egypt. Dynasties XI, XII, and XIII succeeded in maintaining an effective central government for the next 400 years, a period known as the Middle Kingdom. This was an age of recovery, expansion, and material replenishment. Egypt conquered Nubia to the south, and expanded its trade to regions previously unreached. Theological changes also occurred, bringing consolidation of diverse religious cults under the sun-god Ra.

Life, however, remained precarious, even for a pharaoh. Like many of his predecessors, Amenemhet I, the founder of Dynasty XII, was assassinated in a palace conspiracy. He had assumed the throne 29 years earlier in the same way by overthrowing the last ruler of Dynasty XI.

By the mid-19th century BC, the entire Egyptian domain was administered directly from the pharaoh's palace. Its sphere of influence included the conquered Nubia, and extended to southern Syria. By the end of the 19th century, the rulers of Byblos, in the Negev, were using the Egyptian form of writing—HIEROGLYPHS—and Egyptian titles. A carefully designed system of fortresses guarded the southern approach to Egypt and the isthmus of Suez. Entry into Egypt proper was tightly controlled, even for commercial purposes, although, according to the biblical story, Abraham led his people down to sojourn in Egypt when there was famine in his own land.

BC	PERIOD	GENERAL EVENTS	VISUAL ART	LITERATURE, THEATRE & DANCE	ARCHITECTURE
3000	Archaic	Dynasties I & II		*The Book of the Dead*	Temple of Khentiamentiu (**3.25**) Saqqara tombs (**3.27–28**) Abydos tombs (**3.26**)
2778 2680 2565	Old Kingdom	Dynasty III, Zoser Dynasty IV Snofru Cheops Chephren Mycerinus Dynasty V	Prince Rahoptep and his wife Nofret (**3.16**) Grazing geese (**3.9**) King Mycerinus between two goddesses (**3.14**) Presentation of cows and poultry, tomb of Ptahotep (**3.15**)	Stride dances	Rhomboidal Pyramid (**3.2**) Pyramid of Cheops (**3.3**) The Sphinx (**3.32**)
2340 2130	First Intermediate	Dynasty VI, Pepi II Dynasties VII & VIII Dynasties IX & X Dynasty XI	Sarcophagus of Queen Kawit (**3.18**)	"Dwarf who danced like a God" Fertility dances	
2040 1790	Middle Kingdom Second Intermediate	Dynasty XII Amenemhet I Dynasties XIII—XVII (including the Hyksos)	Ka statue of King Hor (**3.17**)	Coronation Festival Play *Abydos Passion Play*	
1575 1510 1490 1405 1367 1347 1308 1290 1182 1151 1100	New Kingdom	Dynasty XVIII Thutmose II Hatshepsut Amenhotep III (Amenophis) Amenhotep IV (Akhenaton) Tutankhamun Dynasty XIX Ramesses I Ramesses II Dynasty XX Ramesses III Ramesses IV Ramesses V—XI	Theban rock tombs Tomb of Sennufer (**3.10**) Head of Nofretete (**3.38**) Gold mask of Tutankhamun (**3.1**) Tutankhamun as a sentry (**3.19**) Paintings from Nefertari's tomb (**3.12**)	Funeral dances	Temple at Luxor (**3.33**) Tell el Amarna (**3.36–37**)
270		Ptolemy II			

3.5 Timeline of ancient Egyptian culture.

3.6 Ancient Egypt and the Middle East.

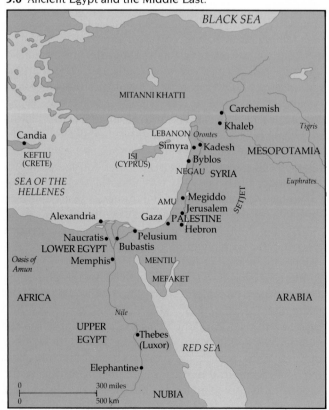

3.7 Ancient Egypt.

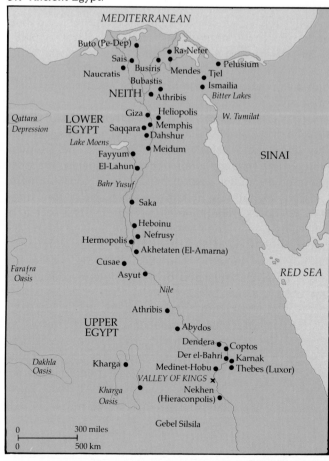

The scribes

During the Middle Kingdom, the importance of scribes to the economy increased, as did their numbers. The profession of scribe was open to anyone with talent, and the common people could send their children to the scribal school, along with the children of the highborn. Scribes were essential, and they were everywhere. All governmental functions needed to be recorded—the activities of armies, the counting of crops, the monthly inspections of utensils in the temples, and even the wicks, made of old rags, to light the work in royal tombs. In a carefully organized hierarchy, lower scribes labored diligently to become higher scribes, and even the most highly born youth started at the bottom of the bureaucratic ladder. As early as the 21st century BC we encounter the aphorism, "the pen is mightier than the sword."

SECOND INTERMEDIATE PERIOD

Late in the 18th century BC, the Hyksos succeeded in conquering Lower Egypt. The word *hyksos* means "rulers of foreign lands," and these invaders were described by the Egyptians as "wretched Asiatics." At approximately the same time, local princes gained control of the areas to the south of Elephantine. Two hundred years later, the princes of Thebes rose in revolt against the Hyksos and their collaborators, drove them out, and reconquered Nubia. This reunification of Egypt, with Thebes as its capital, heralded the New Kingdom.

The 200-year span of the Hyksos conquest is known as the Second Intermediate Period. The Hyksos' success was probably due to their iron-fitted chariots and composite bows, which gave them military superiority over the Egyptians. The importance of their brief incursion lay in what happened after the Hyksos were driven out and the New Kingdom was established. As a result of the occupation, the Egyptians' outlook had been considerably broadened, and from that time onward there existed a deliberate Egyptian foreign policy. In addition, the very weapons which had been used to defeat the Egyptians —the chariot and the composite bow—were now available to them. This enabled them first to turn on their adversaries, and, in subsequent years, to expand their kingdom through force of arms.

NEW KINGDOM

Dynasty XVIII witnessed a flood of activity encompassing both a renaissance in the arts and significant military accomplishments. Royal authority was consolidated and centralized, becoming more powerful than ever before. Around 1486 BC, a woman, Hatshepsut, came to the throne as the first queen. Commerce expanded during her reign, and it was reinforced in successive reigns by further military and imperial expansion. Thutmose III took Egyptian boundaries to the Euphrates. Monuments document marriages to Asiatic princesses. Temple decoration grew lustrous, and sculpture in the round came into favor.

Akhenaton

By the time of the reigns of Amenhotep III and Amenhotep V, c.1400–1340 BC, the Hittite kingdom well to the north had begun to destabilize the Egyptian Empire. Egypt had relied on the friendshp of Syria and the Mitanni to protect its interests, but now the Hittites were exerting pressure upon these friends as well.

Amenhotep III brought Thebes to its peak as a capital city. Booty from captured lands continued to stimulate the economy, and the skills of captured craftsmen contributed to artistic growth and development. Trouble lay in store under Amenhotep IV, however. Taking the name Akhenaton, he set out to reform the religion of Egypt. He attempted to substitute the monotheistic cult of Aton for the ancient religions. Further, he adopted the premise that he alone knew the god Aton and was his sole image on earth. Throughout Egypt the names of the gods were erased. The outrage of the populace was checked only because the army remained loyal to the pharaoh, and 15 years after Akhenaton's death, his name was damned. (His many accomplishments are examined in greater detail later in the chapter.)

Hittite pressure continued to build, around the edges of Egypt's empire. From the 14th to the 13th centuries BC, the Egyptians' outlook became more pessimistic. Funerary subjects change from optimistic scenes of perpetual delight to scenes of prostrate people praying. For unknown, but possibly related, reasons, tomb paintings of the 14th century depict women in diaphanous dresses and unclad dancing girls, while in the 13th century great pain is taken to cover the bodies of females.

Tutankhamun

Akhenaton was succeeded by the pharaoh perhaps best known to us, Tutankhamun. Amenhotep IV had changed his name to Akhenaton to erase the relationship of the pharaohs with the cult god Amun-Ra and establish his identity with Aton. Tutankhamun changed his name, from Tutankhaton, to make the opposite point. The splendor of his burial may, in fact, be attributable to the gratitude of the people for this reversal of policy.

Tutankhamun reigned only very briefly. After his death, Egypt began a 200-year slide toward the end of the New Kingdom. After 1150 BC, strikes and serious economic troubles proliferated. The power of the pharaoh gradually declined and internal disorganization

increased. Ramesses III died as a result of a harem conspiracy, while the last king of Dynasty XX, Ramesses XI, was a virtual prisoner in his own palace. By the end of the New Kingdom in 1102 BC, Egyptian civilization as a forceful, singular entity had deteriorated to a point where to all intents and purposes it was dead.

Of course, Egypt continued to exist as a political entity, and, at the command of Ptolemy II in about 270 BC, the scholar Manetho continued the dynastic chronology up to his day. The very names of the periods, however —the Later Period, the Persian Period, and the Ptolemaic Period—suggest the external dominance under which Egypt had fallen.

RELIGION

From the beginning of Egyptian civilization, the king was always identified with a god. At the time when Upper and Lower Egypt were united, in Dynasty I, the king was considered to be the earthly manifestation of the god Horus, deity of the sky. The king was also considered to be the "Son of Ra," and thus represented a direct link between the royal line and the creator sun god.

Egyptian religion was a complex combination of local and national gods, and in a cumulative process new beliefs and gods were added over the thousands of years of Egyptian dynastic history. Two gods could be amalgamated and yet retain their separate entities. The same god could appear in various manifestations. For example, Horus may be the avenger of his father, Osiris, or the infant son of Isis, or the sky-god, whose wings span the heavens and whose eyes are the sun and the moon.

The earliest local deities appeared in the shape of animals or occasionally were represented by plants, or even by inanimate objects. Later, although portrayed in human form, they often retain an animal head or some other vestige of their former identity. The list of local deities and their variations and derivations appears endless. Many of these deities appear in the funerary art that comprises the majority of surviving Egyptian art. (We shall look at this art shortly.) Here we need only to glance at this diverse panoply and to acknowledge its importance in Egyptian life.

Religion played a central role in an Egyptian's personal and social life, as well as in civil organization. Death was believed to be a doorway to an afterlife, in which the departed could cultivate his or her own portion of the elysian fields with water apportioned by the gods. Life continued for the dead as long as the corpse, or some material image of it, continued to exist. Careful burial in dry sand, which preserved the corpse, was therefore essential, as was careful mummification. The art of embalming had reached a proficient level as early as 3000 BC. Great pains were taken to ensure a long existence for the corpse, and mortuary buildings became the most important architectural features of the culture, reflecting their role as eternal home. These tombs and burial places, rich in funereal imagery and narrative, have provided most of what we know of Egyptian history. Religious practise dictated that only good things be said of the departed, however. Thus the picture of a country populated by young, handsome, well-fed men and women, and ruled by beneficent pharaohs who inspired reverence, optimism, and productivity, even among the lowest slaves, may need careful adjustment.

The pharaoh acted as a link between mortals and the eternal. Priests, or servants of the god, were delegates of the pharaoh. The common people relied on their ruler for their access to the afterlife: the offerings which would secure the pharaoh's existence in the afterlife were the people's only key to the eternal. It was therefore in every Egyptian's interest to be sure that the pharaoh's tomb could sustain and maintain him. Images and inscriptions in the tombs included the lowliest servants, ensuring that they, too, would participate forever in the pharaoh's immortality. Magic charms for the revivification of the deceased king, which were at one time spoken by priests, came to be inscribed on the walls of the tomb so that, if necessary, the deceased could read them. Eventually the nobility began to usurp these magic formulas, and by the end of the 21st century BC, they were copied regularly, and almost everyone could share the once unique privilege of the pharaoh.

The pharaoh joined the gods in the nether world after death. As befitting a ruler whose entourage also existed in the afterlife, he came to be associated with Osiris, king of the dead.

FOCUS

TERMS TO DEFINE

Pyramid	Monotheism	Ra
Scribes	Aton	Ka
Hyksos		

PEOPLE TO KNOW

Snofru	Hatshepsut	Tutankhamun
Cheops	Akhenaton	

DATES TO REMEMBER

Old Kingdom	Middle Kingdom	New Kingdom

QUESTIONS TO ANSWER

1 What was the role of the pharaoh in Egyptian society?
2 How did the role of the pharaoh change from Old to Middle to New Kingdoms?
3 How did the Egyptians view the afterlife?

THE ARTS
OF ANCIENT EGYPT

The most productive artistic periods in ancient Egypt were those when prosperity was high and the nation was at peace. There also appears to be a correlation between artistic vitality and strong rulers. To a certain degree, religious forces also affected the focus and tenor of art. For example, when Mena, the first historic king, made Memphis his capital, art flourished and reached high levels of prominence because the major god of Memphis happened to be Ptah, the god of art and all handicrafts. One of the functions of the high priest of Ptah was that of "Chief of the Stone Cutters and Artist to the King." As long as Memphis retained a central position in Egyptian life—as it did until the fall of the Middle Kingdom—art maintained its importance. During Dynasty XXVI, Memphis reemerged as a political center, and art was once again cultivated.

TWO-DIMENSIONAL ART

Egyptian painting was subordinate to sculpture. According to some sources, the Egyptians may not even have regarded it as an art form. Painting was, for the most part, a decorative medium which provided a surface finish to a work of sculpture. Sculptures in relief and in the round were painted. Flat surfaces were also painted, although such paintings often appear to be substitutes for relief sculpture.

In the Middle Kingdom, this substitution became general and painting largely replaced relief sculpture. The scenes vividly portrayed subjects of genuine human interest with original insight. The same may be said of painting in the New Kingdom. Here we often find humor in portrayals of daily life, put across with a high level of technical craftsmanship. Nonetheless, the only time when painting was regarded as a true art was during the reign of Akhenaton in the New Kingdom. Painting appears to have died out, as even a subsidiary art, after the New Kingdom.

Materials and conventions

We know a little about the materials used by Egyptian painters, thanks to analysis by the famous Egyptologist Sir Flinders Petrie, of the mastaba, or tomb, decorations of Rahotep and Nofret at Maidum. Rahotep's tomb walls date from the Old Kingdom. They show careful preparation: the sun-dried mud brick was covered with a layer an inch and a half thick of mud plaster mixed with chopped

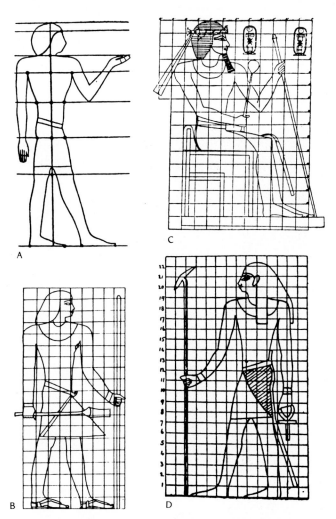

3.8 The Egyptian Canon of Proportion. A: Old Kingdom. B: Middle Kingdom. C: New Kingdom. D: Late Period.

straw. This, in turn, was covered by a very thin layer of fine GESSO. Paint was then applied with a brush. Petrie's analysis did not determine the actual pigments used, but the colors were black, blue, brown (of several values), green, grey, orange, red, white, and yellow. White gypsum was used to raise the VALUE of any HUE.

It is clear that Egyptian artists had a formulaic approach to the human figure, although proportions varied from one period to another. The basic figure was the standing male: his proportions dictated those of other figures (Fig. **3.8**). To maintain proper proportion, the painting surface was first ruled into squares. The CANON of proportion prescribed during the Middle Kingdom is as follows.

3.9 Grazing geese from the tomb of Nofret at Maidum, early Dynasty IV (c.2680–2600 BC). Painting on plaster, height of register 11$\frac{1}{5}$ ins (28.5 cm), total length 5 ft 8 ins (1.73 m). Egyptian Museum, Cairo.

3.10 The ceremonial purification of Sennufer and his wife Meretjj, from their tomb at Thebes, Egypt, Dynasty XVIII, second phase (1450–1372 BC).

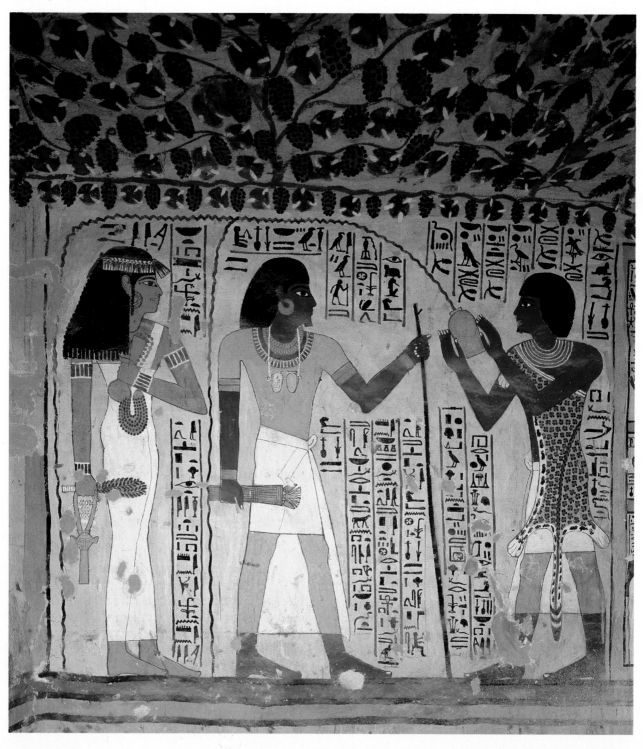

Head (hair to shoulder)	1 unit
Shoulder to hem of kilt	5 units
Hem to ground	3 units
Ground to nipple	7 units
Ground to belt (front)	5 units
Ground to base of hip	$4\frac{1}{2}$ units
Ground to base of knee	$2\frac{1}{2}$ units
Across shoulders	$2\frac{1}{2}$ units
Across waist	$1\frac{1}{8}$ units
Across feet	$3\frac{3}{4}$ units[1]

As we examine painting from the Old, Middle, and New Kingdoms, we notice some prevailing conventions and some changes. In Old-Kingdom painting, verisimilitude and intricacy are combined with flat, or two-dimensional, figure portrayal in which no attempt is made to give an impression of solidity by shading, modeling, or FORE-SHORTENING. During the Middle Kingdom, technical refinement is replaced by a decorative approach to color as realism loses its importance: fabrics are clearly stylized. Now focus shifts to lesser nobles and paintings display a new humor and liveliness. New-Kingdom painting continues the convention of two-dimensional figure depiction, with a few exceptions, and color remains vibrant.

Old Kingdom

Egyptian tomb painting often portrayed scenes of daily life. In Figure **3.9**, from the tomb of Nofret at Maidum, we find an appealing, highly realistic depiction. While the lively representation of animals was common in Egyptian art, these geese are certainly uncommon in their execution. The structure of the scene within a register, or band, might suggest a rather dry composition. The artist has countered this by using a wide PALETTE, along with subtly delicate shading. Despite the careful detailing, however, the scene is composed on the surface plane, and shows its subjects as two-dimensional, without any suggestion of perspective or modeling.

Such treatment is characteristic of Egyptian two-dimensional art as a whole. In comparison with works from the Ice Age, where there was a similar attempt to show animal activity, the results lack the dynamic force of Paleolithic art. Everything rests in the two-dimensional plane, capturing detail without essence, and form without depth.

Middle Kingdom

Painting gained greater prominence as an art form in the Middle Kingdom than it had had in the Old Kingdom. It allowed nobles to decorate their tombs more elaborately,

and more cheaply, than with sculpture. Color in Middle-Kingdom painting appears more important to the artist than drawing technique: form is restricted to flat surface details and outline figures, and the works are carried by their highly COLORISTIC details. Naturalistic portrayals were replaced by flat but colorful convention.

New Kingdom

Theban rock tombs

The painted tombs of Thebes provide most of our knowledge of Egyptian painting in the New Kingdom. Representations of gods are found for the first time in these tombs. Elaborate ceiling decorations are common. The paintings portray the vivacity and humor of daily life. Depictions of workers and peasants differ from those of the Old Kingdom, particularly in the shape of the heads and in the types of garments.

These tombs generally have a square forecourt which leads into a transverse hall. From there a long, narrow hall leads to the ritual chapel. This contained seated statues of the deceased and his or her family. Beneath the chapel lay the burial chamber, access to which was gained via a sloping corridor, steep stairs, or a vertical shaft. The walls of the transverse and long halls were often painted with hunting or farming scenes intended to ensure supplies of food for the dead in the hereafter.

Figure **3.10** depicts a ceremonial purification, from the pillared burial chamber of Sennufer, Superintendent of the Garden of the Temple of Amun under Amenophis II. As befits Sennufer's vocation, the burial chamber is decorated with vineyard scenes, and has ceilings like vine bowers. According to the custom of the period, the dead are shown as they appeared in life. Sennufer is pictured with his wife, wearing the clothes and jewels of an earthly festival. The ceremony shown is the purification of the dead, conducted by a priest attired in a leopard skin. Names and titles appear over the celebrants, and in front of Sennufer's face there is a text indicating his wish to accompany the god Amun when he goes to the Feast of the Valley.

Again, the figures are stylized, with no attempt at portraying three-dimensionality. The palette is limited, and, unlike the subtle details of the geese in Figure **3.9**, the treatment of objects is almost careless. The bunches of grapes, for example, are rendered by an oval, flat wash of color overpainted with blue discs to represent individual grapes. (This conventional depiction is also found in other Theban tombs.) One nice touch, however, is the apparent diaphanous quality of the garments over the men's legs, through which the flesh tones show as a pale red-brown. This convention later became more common.

MASTERWORK
The Tomb of Nefertari

Queen Nefertari-mi-en-Mat, of Dynasty XIX, was the favorite among the four principal wives of King Rameses II. Her tomb, which lies in the Valley of the Queens in western Thebes, rests under the precipitous cliff walls at the end of the gloomy valley of Biban el Harin. We enter through the First Room, to the east of which lies the Main Room, or offering chamber. The major part of the tomb is connected to these chambers by a flight of stairs. The Hall of Pillars, or Sarcophagus Chamber, provides the central focus of the tomb. Three side rooms open off the Hall of Pillars (Fig. **3.11**).

The paintings adorning the walls of Nefertari's tomb are elegant, charming, and alive with color. The northeast wall of the First Room carries a vibrant painting (Fig. **3.12**) showing, on the extreme left, the goddess Selkis with a scorpion on her head. On the extreme right appears the goddess Maat. On her head rests her hieroglyph, the feather. The rear wall of the recess depicts Queen Nefertari led by Isis toward the beetle-headed Khepri, a form assumed by the sun-god which implies his everlasting resurrection. Over the door to the main room, at the top right of the illustration, we see the vulture goddess Nekhbet of El-Kab. Her claws hold the shen-sign, which symbolizes eternity and sovereignty. The goddess Isis wears on her crown the horns of a cow, surrounded by the sun-disc from which hangs a cobra. In her left hand she carries the divine scepter. Queen Nefertari is dressed according to the fashion of the time, and over her vulture hood she wears the tall feathered crown of the Divine Consort. In the hieroglyphic text, Isis says, "Come great king's wife Nefertari, beloved of Mut, justified, so that I may allot thee a place in the holy land [the hereafter], the great king's wife and lady of the two lands, justified before Osiris, the great god."

The painting itself is rich, warm, and highly stylized. A black base with colored bands borders the composition, providing it with a solid anchor and raising the body of the painting above the chamber floor. A black band forms the upper terminal accent of the recessed panel and continues on to the right. The black ceiling with its conventional ochre stars provides a color link which unifies the entire composition. A small black band decorated with stars runs just below the upper MOTIF on the left panel. A similar black band without the stars reappears above the extreme right panel. The limited palette consists of only four hues, and these never change in value. Yet the overall effect of this wall decoration is one of great variety.

In the conventional style established since Dynasty I, the human forms appear only in flat profile. The pictures lie strictly on the surface. Naturalistic proportions are adhered to only minimally. Eyes, hands, head, and feet show no attempt at verisimilitude. On the contrary, the fingers become extenuated designs, elongating the arms to balance the elegant and sweeping lines of legs and feet. The matching figures of Selkis and Maat

3.11 Ground plan of Tomb of Queen Nefertari-mi-en-Mat in the Valley of the Queens, western Thebes, Egypt. 1290–1224 BC.

(extreme left and right) have arms of unequal length and proportion. Although the basic style remains consistent, we can observe a significant change in body proportions from those of the Old and Middle Kingdoms.

Figure **3.13** shows the north and part of the east walls of the Main Room of the tomb. The painting on the east wall (on the right in the illustration) depicts Queen Nefertari, with a scepter in her hand, dedicating a rich offering to Osiris-Khentamenty-Unnefer, "the King of the Living, the great God, the Lord of the Necropolis, the Lord until Eternity, the Lord of Infinity." Osiris sits on his throne holding his crook–scepter, or crosier, and flail. Before him are the four sons of Horus—Hapi, Duamutef, Qebhsenuef, and Amsety. In return for Nefertari's offering, the god promises her immortality and good fortune in his kingdom. The north wall shows the queen standing in front of Thoth, the Lord of Hermopolis, the god of writing, wisdom, and judgment. Between Nefertari and Thoth rests a writing palette and an ink pot with a frog on its edge. The hieroglyphs indicate Nefertari's title and her words to the god, asking for the ink pot and the writing palette. She is "the great Royal Wife, the Lady of the Two Lands, Nefertari, beloved of Mut, true of voice."[2]

This illustration demonstrates another Egyptian convention. Although the head, lower body, and feet appear in profile, the upper torso—including the shoulders but not the breasts—appears in full frontal view. The differing proportions of the arms noted above may, perhaps, denote some attempt at perspective. Again, both these illustrations indicate the painter's interest in fabric texture. Nefertari's diaphanous outer gown reveals the SILHOUETTE of her tightly fitting inner garment, and the flesh of her legs and upper arms is rendered in a tone of higher value, as we saw in Fig. **3.10**. The pleats or gathers of the shoulder wrap are painted in a stylized fashion as white stripes across her upper arms.

3.12 Queen Nefertari guided by Isis, from the northeast wall of the tomb of Queen Nefertari at Thebes, Egypt. 1290–1224 BC.

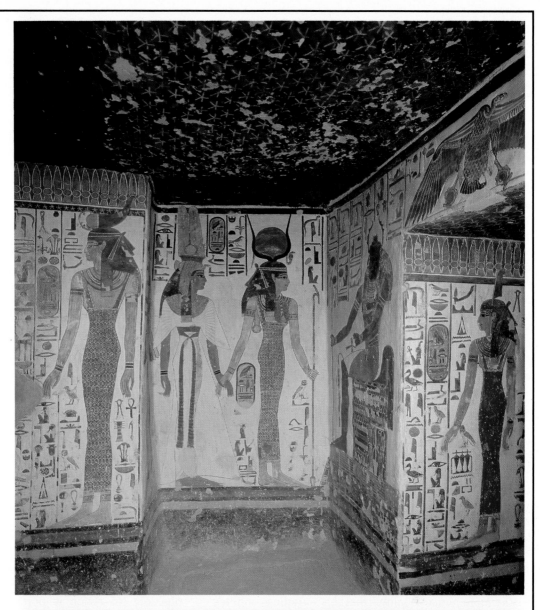

3.13 Queen Nefertari before the god Thoth (left) and the god Osiris (right), from the north and east walls of the tomb of Queen Nefertari at Thebes, Egypt. 1290–1224 BC.

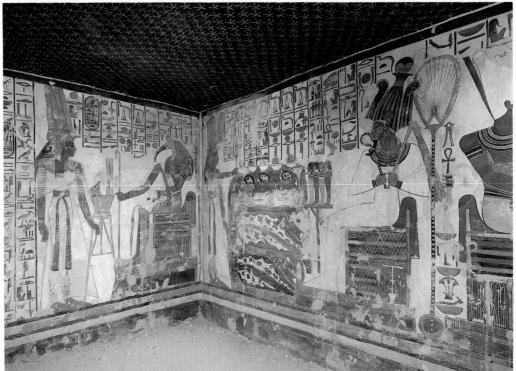

SCULPTURE

Old Kingdom

Sculpture was the major art form of the Egyptians. By the time of the Old Kingdom, sculptors of the first two dynasties had overcome many of the difficulties that plagued their predecessors of the pre-dynastic period. During those archaic times, religious tenets may have confounded sculptors: many primitive peoples throughout history have regarded the realistic portrayal of the human figure as dangerous. A close likeness of a person might have been thought capable of capturing the soul. There were also technical problems to be overcome. Pre-dynastic sculpture left detailing rough and simple. Convention rather than naturalism prevailed. Sculptors seem to have relied on memory to portray the human form, rather than working from live models.

Because pre-dynastic sculpture predates written history, we can do no more than speculate on how much conventionalization reflected lack of technical proficiency, or philosophy, or both. When we examine CLASSICAL Greek sculpture, for example, we are certain that the IDEALIZATION of FORM was philosophical because the technical command necessary to produce naturalistic or any other type of representation was obviously there. But in pre-dynastic Egypt, the reverse appears more likely.

Old-Kingdom sculpture shows full technical mastery of the craft. Life-size sculpture, capturing the human form in exquisite natural detail, became very popular. At the same time, the conventional representation of certain ideals of the pharaoh's demeanor persisted. His divine nature dictated a dignified and majestic portrayal. Although this treatment became less rigid as time went on, the more human qualities that this softening connotes never compromised the divine repose of the pharaonic statue.

The sculpture of Prince Rahotep and his wife Nofret (Fig. **3.16**) comes from the tomb of the Prince, who was one of Snofru's sons. The lifelike colors of the statues exemplify the Egyptian tendency to use paint as a decorative surface for sculpture. But the work is in no way commonplace. The eyes of both figures are made of dull- and light-colored quartz. The eyelids are painted black. Both figures wear the costume of the time. As was conventional, the skin tones of the woman are several shades lighter than those of the man: a woman's skin was traditionally painted a creamy yellow hue, whereas a man's skin ranged from light to dark brown. The kings of Dynasty IV rose from peasant stock, an ancestry which is apparent in the sturdy, broad-shouldered, well muscled physique of the Prince. At the same time his facial characteristics, particularly the eyes and expression, exhibit alertness, wisdom, strength, and capacity. The portrayal of Nofret expresses similar individuality. This may be the earliest example of Egyptian art with the full development of the naturalistic, three-dimensional female figure. Nofret wears a gown typical of the period, cut to reveal voluptuous breasts. The artist has been meticulous in his observation and depiction in the upper portions of the statues.

The Egyptian admiration for the human body is clearly revealed in both statues. Precise modeling and attention to detail are evident in even the smallest items. Nofret's gown at once covers and reveals the graceful contours of her body. Her facial features reveal an individual of less distinct character than her husband: she has a sensual and pampered face. She wears a wig shaped in the style of the day, but beneath the constricting head band we can see Nofret's much finer hair, parted in the middle and swept back beneath the wig. The treatment of the hand held open against the body reveals not only the artist's skill and perceptiveness, but also the care and attention Nofret has bestowed on it. The hand is, indeed, delicate: small dimples decorate the fingers, and the nails exhibit extraordinary detail. The unpainted nails are correctly observed as being lighter than skin tone.

The artist's attention and precision, so carefully expressed in the upper body, deteriorate almost to the point of crudity in the lower body, as is typical of sculpture of this era. The legs of both figures are lumpy, ill-defined, and coarse. The feet are nearly unrecognizable as parts of the human anatomy, except in that they have five toes. Parts of the thrones on which the figures sit show even less attention to detail—they remain rough blocks of limestone, still bearing the marks of the quarry.

Despite the crudity of certain parts of Old-Kingdom sculptures in the round, these and other works of the period are nonetheless naturalistic and vital. Old-Kingdom sculpture has a powerful and solid formal dignity, which reflects the social and political character of the pharaoh. No action is portrayed. In some cases male figures are depicted as stepping forward (Fig. **3.14**), but the axis of the body remains rigid and stable. The effect of this convention becomes clear when we compare this pose with the COUNTERPOISED stance of Greek statues such as those shown in Figures **4.15** and **5.9**. There, the axis of the torso and hip twists naturally, throwing the weight onto one leg. This suggests movement and a dynamic sense not present in the Egyptian statues. Other conventions of the Old-Kingdom style include the placement of the head exactly on the median line of the body, with the eyes staring straight forward. Finally, in two-figure groups, the woman embraces the man's shoulders or waist.

There are two distinct forms of Egyptian sculpture. We have just examined one form—sculpture in the round, or STATUARY, that is, sculpture which has a full or nearly complete three-dimensionality. The second form is relief sculpture, or that which emerges only partially from a background. Artists of the Old Kingdom produced numerous relief sculptures, and more have been preserved from this period than from any other. Many of these works are of extraordinarily high quality.

3.14 King Mycerinus between Hathor and the local deity of Diospolis Parva, Dynasty IV (2680–2565 BC). Green slate, 38½ ins (97.8 cm) high. Egyptian Museum, Cairo.

line of his skirt at the far right. Variations in the detail of this and the next register add further interest. For example, although the images of the cattle create regularity of form and rhythm throughout, individual cows differ in detail. The composition of all the registers has obviously been carefully thought out.

In spite of the formal horizontal registers, the artist has tried to unify the entire wall section, rather than piling several compositions on top of each other. Register lines break so as to allow the images in one band to flow into another. In other places, elements touch the lines at points where the eye can be swept immediately up or down into an adjoining register. The conventions of figure portrayal are somewhat modified by the artist's individual craftsmanship: forms are delicately and meticulously carved. The muscle striations in the humans' legs, the precisely rendered feet, and the accurately depicted animal legs, heads, and eyes demonstrate considerable technique.

One further detail stands out. The artist has made an apparent attempt at depicting three-dimensional space, by raising the bull's feet above the register base. This device is quite at odds with convention. It is not present, for example, in the lower registers, where the legs of the fowl which stand behind the forward groups are not depicted at all.

3.15 Presentation of cows and poultry, tomb of Ptahotep at Saqqara, Egypt. Dynasty V to early Dynasty VI (c. 2565–2350 BC).

The relief shown in Figure **3.15** is from the tomb of the priest Ptahotep at Saqqara. Typical of tombs from about Dynasty V on, this is a multi-chambered tomb belonging to a high functionary. The subject matter of the relief is quite commonplace—cows and ducks—but the artist has risen to the challenge of turning it into something beautiful. The composition is constrained by the bands, or registers, within which the images must appear.

Yet within the whole intricately composed work, subtle variations in the repeated forms and dynamic use of line turn each individual register into an active and interesting picture. Triangular arrangements of the figures, in which line swells and ebbs across the band, can be seen clearly in the upper register: the eye moves up at the left border from the arms of the herdsman, along his staff, and sharply ascends to the horns of the cow that faces in the opposite direction from the others. The eye then falls along the back of this cow, to rise again across the horns of the group of cows, and focus on the central herdsman. To the right, two juxtaposed triangles are created by a single bull and another group of cows. These create a dynamic rhythm, the continuation of which is suggested in the herdsman's downward glance and the

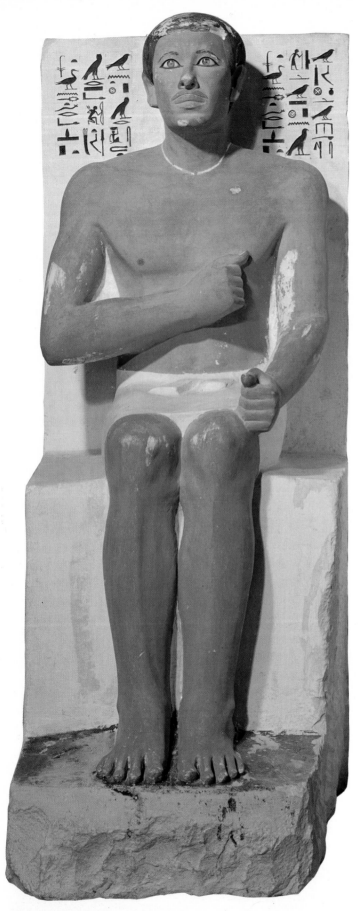
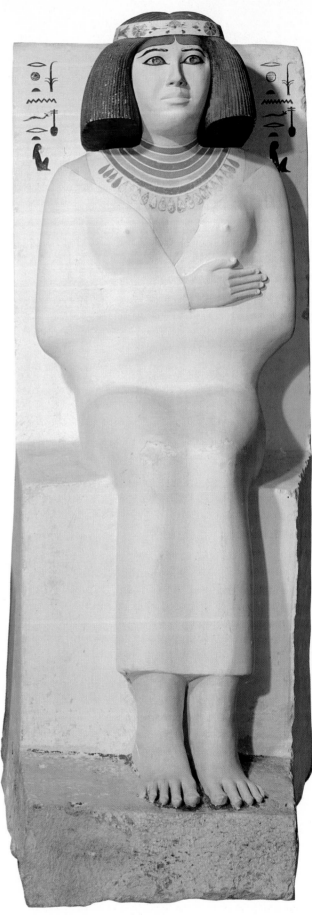

3.16 Prince Rahotep and his wife Nofret from Maidum, c.2580 BC. Painted limestone, 3 ft 11½ ins (1.2 m) high. Egyptian Museum, Cairo.

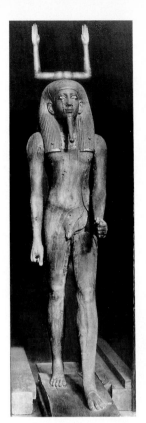

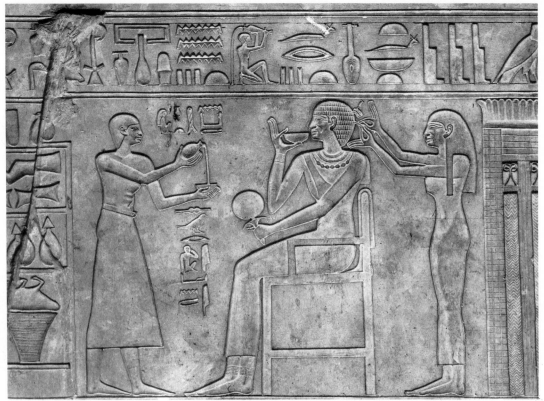

3.17 (left) Ka statue of King Hor in its shrine, Dynasty XII (1991–1786 BC). Wood, 5 ft 10 ins (1.78 m) high. Egyptian Museum, Cairo.

3.18 (right) Detail from the sarcophagus of Queen Kawit, Dynasty XI (2134–1991 BC). Limestone. Egyptian Museum, Cairo.

Middle Kingdom

In the Middle Kingdom, artistic style moved toward simplicity. General form was emphasized at the expense of details, but not of clarity and accuracy. Some scholars have interpreted this as indicating that Middle-Kingdom sculpture was generally intended to be viewed in an architectural setting, from a distance. Royal portraiture appears to have lost some of its power and dignity, and yet representations of royalty continue to express calmness and stability. A certain sadness seems to pervade royal visages, although the artists no longer attempt to capture individuals' expressions: the vitality and vigor of Old-Kingdom style have been lost.

The Ka statue of King Hor (Fig. **3.17**) provides an example of late Middle-Kingdom sculpture. This wooden statue, of an otherwise unknown king, was found in a tomb in the southern brick pyramid at Dahshur. King Hor's statue shows softer modeling of form than we have seen elsewhere. It was originally clothed in an apron and girdle of another material. (Nude statues, other than those of small children, were extremely rare in ancient Egypt.) The carving, particularly around the shoulders, is less naturalistic than that of other dynasties. The lower body, legs, and ankles nonetheless show a higher degree of anatomical accuracy than the earlier statues in Figure **3.16**.

The overall tone of the statue is less solid and powerful than that of previous works, showing a rather delicate and slender king, willowy in contrast to the powerful physiques of his predecessors. Hor stands with one foot forward, but again this is not the CONTRAPPOSTO (counterpoise) of classical Greek sculpture. The feet are square rather than realistic, and the sculptor has made the large and second toes on each foot of equal length. The eyes are inset using alabaster and a metal which might be silver or bronze. The ears, in keeping with the style of Dynasty XII, are exaggerated. On the top of his head Hor wears the upraised hands and arms which represent one of the hieroglyphic Ka signs. The treatment of the hands and arms in the Ka sign is less naturalistic than in the figure of Hor himself. According to some scholars, the hands once grasped great scepters and were covered by a layer of painted STUCCO.

Figure **3.18** shows a detail from a relief from a SARCOPHAGUS found in the Deir el Bahari temple. The limestone of this relief also shows traces of once having been painted. Queen Kawit sits on a chair with a drinking cup raised to her lips. A maidservant attends to the queen's ringlets and a manservant stands before the queen, pouring liquid into another cup. This relief is cut into the surface, a style called "sunken relief," as opposed to "raised relief." Our attention is drawn to the rather fussy details, such as the wigs and jewelry, while other parts of the sculpture remain plain and flat. The faces here are not pleasant: bulbous nostrils and coarse treatment around the mouth, with little modeling of the cheeks and jaws, give the work a stylized appearance much closer to parody than to realism. The eyes of the

queen and her maidservant are particularly heavily stylized, but this is perhaps suggestive of elaborate eye make-up. The eyes turn downward at the inward corners. The position of the hands and the general tension of the figures convey a sense of nervous energy. Other anatomical details also draw our attention. The manservant appears to be middle aged and a product of decadent living: rather than the trim musculature we are used to seeing, his mid-section displays rolls of fat. Once again, the ears are exaggerated. The male figure has two right hands, possibly the result of carelessness, but more probably of convention. On all the figures, the big toes lie on the side of the foot nearest the viewer—something fairly common in Egyptian relief sculpture.

Clearly the style sets out to deny naturalism in favor of a very mannered presentation. The overall mood is not optimistic.

New Kingdom

One of the most familiar artifacts from this period must be the exquisite sculpture from the tomb of Tutankhamun (Fig. **3.1**). The tomb of Tutankhamun was discovered in the Valley of the Kings near Thebes. The staggering quantity of artifacts recovered from this tomb makes us wonder how much must have been lost over the centuries through the looting of the burial chambers of other pharaohs. The funerary mask is of solid beaten gold inlaid with semi-precious stones and colored glass. Designed to cover the face of the king's mummy, the mask is highly naturalistic in style, and apparently a true likeness of the young king. The mask wears the royal *nemes* head-dress, which has two lappets hanging down at the sides. A ribbon holds the king's queue at the back. The front of the head-dress is adorned with two symbolic creatures, the serpent, and the vulture of the goddess Nekhbet of El-Kab, divinities who protected the ancient kingdoms of Lower and Upper Egypt.

The statues of King Tutankhamun posted like sentries at the entrance of the sepulchral chamber stand five feet nine inches tall, and must be nearly life-size (Fig. **3.19**). The two identical statues are carved from wood and covered with a shining black resin. The eyes and eyebrows are made of gold. The head-dress, staff, armlets, wristlets, apron, sandals, and scepter are gold.

Although the work is very realistic by Egyptian standards, several conventions are still observed. Once again, the left leg is placed forward. The girdle and apron are stylized: the striations intended to depict pleats in the fabric do not at all reflect the way real cloth falls. Rather, they work within the decorative scheme of the sculpture, giving the piece a sense of movement and adding an elegance of form and line. The overall treatment of detail is not particularly careful or precise, however. The hands, head-dress, armlets, and wristlets

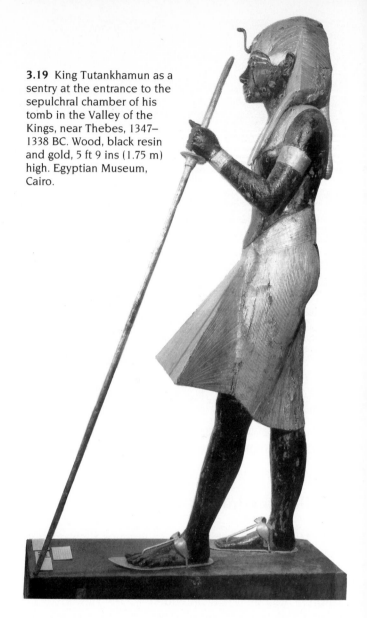

3.19 King Tutankhamun as a sentry at the entrance to the sepulchral chamber of his tomb in the Valley of the Kings, near Thebes, 1347–1338 BC. Wood, black resin and gold, 5 ft 9 ins (1.75 m) high. Egyptian Museum, Cairo.

have received only passing attention. The face, likewise, is undefined and unrefined, in contrast to the sensitive treatment in the death mask.

LITERATURE

The period from about 4250 to 2000 BC produced an amazing book (a papyrus roll 90 feet long) entitled *The Coming Forth by Day*, which we know as *The Book of the Dead*. It was intended as a guide for the departed soul on its journey to the land of the dead. Copies were placed in tombs, or portions were inscribed on the mummy case. The book explains how the soul is to exonerate itself through magic incantations, by reciting such statements as "I did not kill"; "I did not commit adultery"; "I did not steal"; "I did not cause mistreatment to slaves." *The Book of the Dead* contains many parallels to parts of the Old Testament of the Bible such as the Ten Commandments in the book of Exodus and the Proverbs, some of which date back to the eighth century BC.

THEATRE

For theatre to be described as an art form, it must be divorced from the dramatic elements of ritual. The Egyptians may have developed theatre as a separate activity as early as 3000 BC. The Greek historian Herodotus makes ample reference to the dramatic activities of the Egyptians, but it is not at all clear that the religious festivals he notes are theatre as we now understand it.

According to Freedley and Reeves, many types of Egyptian drama existed, dating back to 3200 BC. Although we have nothing resembling a play script, some scholars have found in records such as the *Pyramid Texts* what they claim are stage directions for roles played by temple priests. This may indeed be the case, as records of funds given to finance such "performances" exist. Such performances might equally well be labeled as religious incantations or rites designed to ensure the safe passage of the departed to the afterlife, however. And the same ambiguity may apply to the other sources cited as theatrical activity, notably the *Coronation Festival Play* from Dynasty XII. It was ritual, undoubtedly; drama, unquestionably. Was it theatre? Probably not.

Theatre historians often refer to the famous *Abydos Passion Play*, also known as the *Osiris Passion Play*. Its text is unknown but participants and spectators have left comments. Our understanding of this play is less certain. It appears to be mentioned in the *Pyramid Texts*, as well as in inscriptions dating to Dynasty XII. The text recounts the story of the death and dismemberment of Osiris.

According to Ikhernofret, who refurbished the play for Senworset III, he participated in the drama which he described as follows. This outline of the play is all that has been written down and preserved:

(1) "I celebrated the 'Procession of the god Upwawet' when he proceeded to champion his father [Osiris]." (This was probably a mock fight in front of the House of Osiris at Abydos in which the audience participated.)

(2) "I repulsed those who were hostile to the Neshmet barque, and I overthrew the enemies of Osiris." (This indicates a mock naval encounter on the Nile in which the audience joined.)

(3) "I celebrated the 'Great Procession,' following the god in his footsteps." (In this scene probably Osiris was slain by Seth, an episode too sacred for Ikhernofret to mention.)

(4) "I sailed the divine barque, while Thoth . . . the voyage." (Here the body of Osiris was recovered by his family led by Thoth, the god of speech, after a voyage in a boat, followed by the audience in their barques.)

(5) "I equipped the barque [called] 'Shining in Truth,' of the Lord of Abydos, with a chapel; I put on his beautiful regalia when he went forth to the district of Pekar." (This suggests the embalmment or possibly a description of Ikhernofret's production duties.)

(6) "I led the way of the god to his tomb in Pekar." (This scene was the funeral procession to the tomb of Osiris, the audience following as mourners. The actual setting was the tomb of King Djer of Dynasty I, at some distance away.)

(7) "I championed Wennofer [Osiris] on 'That Day of Great Battle;' I overthrew all the enemies upon the shores of Nedyet." (In this scene Seth dug up the body of his brother, Osiris, and dismembered it. Half the audience supported Seth while the other half joined Horus and the family of Osiris who reassembled his limbs after the battle.)

(8) "I caused him to proceed into the barque [called] 'The Great;' it bore his beauty; I gladdened the heart of the eastern highlands; I [put] jubilation in the western highlands, when they saw the beauty of the Neshmet barque. It landed at Abydos and they brought [Osiris, First of the Westerner, Lord] or Abydos to his palace." (This was the great Resurrection scene, also too sacred to mention.)[3]

These dramas were performed in mortuary temples, which a few scholars believe were constructed specifically for the purpose of staging plays.

MUSIC

The Egyptians had many contacts with other peoples of the Mediterranean world and cross-cultural influence appears to have been strong in the area of music. We know, for example, that the Egyptians were fond of Assyrian music, and vice versa, but we cannot know how their musical systems sounded. We do not have musical scores, and even if we did, we would not know how to play them. Scales, HARMONIES, textures, pitches, intervals, dynamics, and so on, remain a mystery. We can nonetheless examine some of the instruments and perhaps speculate on their musical timbre, the basic quality of sound.

The modern world is fairly well acquainted with Egyptian musical instruments: sculptures and paintings depict them, and fragments and even nearly complete instruments have been found. Harps, lyres, and numerous other stringed instruments, along with pipes, flutes, cymbals, and bells were all in the storechest of the Egyptian musician. As in Mesopotamia, the basic instrument in the Egyptian scheme was probably the harp. Harps varied tremendously in size, complexity, shape, and ornamentation (Fig. **3.20**). Harps are depicted with four, seven, ten, and 20 strings. Some are very plain, others ornate and brightly colored. How much of this variety is real and how much lies in the imagination of the painter, we do not know, but the frequent depiction of the harp does assure us of its popularity. Wall paintings also indicate that the larger harps, some of which appear to stand nearly six feet tall, were played essentially as modern harps are.

Another popular stringed instrument was the trigonon. As its name suggests, the trigonon was triangular, perhaps a hand-held variety of the harp or a more complex derivative of the lyre. This instrument has been found throughout the ancient Middle East. The lyre also took a great variety of shapes and sizes. It is frequently mentioned in the Bible, as are many other instruments found in Egypt. Some of the lyres found in the tombs of

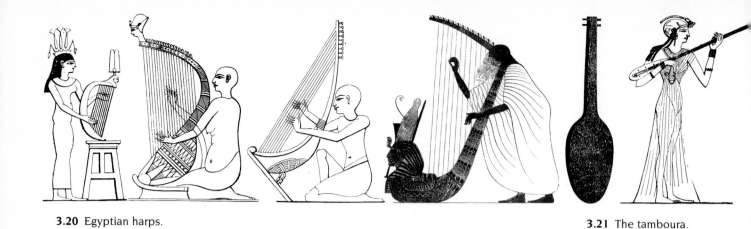

3.20 Egyptian harps.

3.21 The tamboura.

3.22 The double pipe.

3.23 The darabukkah of the modern Egyptians.

ancient Egypt still produce sound from their ancient strings.

The tamboura of ancient Egypt had two basic shapes, one oval and the other with sides slightly incurved, like a modern violin or guitar. The overall design of this long, narrow instrument is reminiscent of a simple, home-made guitar (Fig. **3.21**). Illustrations show from two to four tuning pegs, and also indicate that the tamboura could be either with or without frets. The number of frets in some illustrations, if they are accurate, suggests that the instrument could produce a large number of pitches on each string. Analysis of tambouras found with strings intact shows that the Egyptians used cat gut for stringing. Additional stringed instruments of innumerable shapes and sizes defy classification, but this variety certainly indicates that music, whatever its texture and tonal nature, held an important place among the arts of ancient Egypt.

Wind instruments were very varied in shape, size, and ornamentation. Small pipes made of reed with three, four, five, and more finger holes have been found in great quantity. Some of these appear to have been played by blowing directly across the opening at the end, and others seem to have required a reed, like the modern clarinet or oboe. The long double pipe illustrated in Figure **3.22** was made of wood or reed-stem.

3.24 Funeral dance, Dynasty XIX (1314–1197 BC). Limestone relief. Egyptian Museum, Cairo.

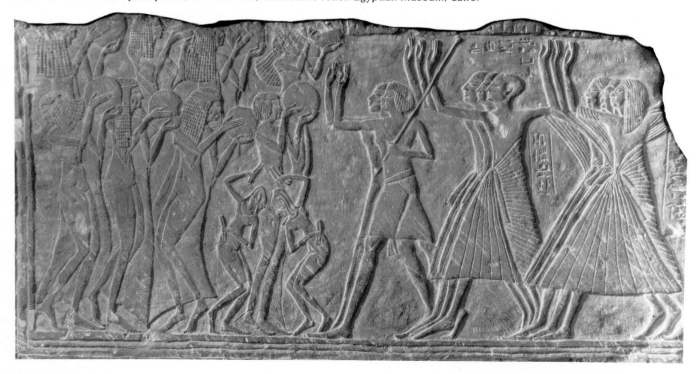

The Egyptians also had a form of trumpet. Apparently made of brass, it appears infrequently in paintings and sculpture, and its shape is straight, like Roman trumpets. If anything is to be concluded about the quality of Egyptian music from the infrequent appearance of this instrument in sculpture and painting, it is that Egyptians, like the Mesopotamians, preferred the mellow and soft timbres of strings and woodwinds to the blare and volume of brass.

They also enjoyed rhythmic emphasis, as we can deduce from a variety of percussion instruments. Three kinds of drum appear. One is a small and longish hand drum. A second appears more like an American Indian tom tom, with cords stretching between the drum heads. A third type is still found in Egypt and is called a darabukkah (Fig. **3.23**). Tambourines, bells, cymbals, and other rhythm instruments are also depicted.

Extrapolating from the shape of the stringed instruments and the number of strings, as well as from the number of finger holes in flute-type instruments, some musicologists have suggested that Egyptian music was based on pentatonic scales. But none of the extant instruments is in good enough condition to produce sufficient tones to prove them right or wrong. Scholars have also argued that Egyptian musical theory exerted a profound influence on Greek music.

DANCE

There can be no question that music and dance contributed significantly to Egyptian culture. Highly formal dances developed, and the love of dance is clearly expressed in the testimonies which have survived in the tombs. For example, when, in Dynasty VI of the Old Kingdom, Pepi II heard that a dwarf who danced like a god lived in the land of Yam between the first and second cataracts of the Nile, he commanded that the dwarf be brought to his court "alive, well, and happy."[4]

The wall paintings in the tombs of Giza from Dynasty V give us significant examples of what Sachs calls "stride dances."[5] Stride dances are typified by an exaggerated forward thrusting of the legs. Several examples of stride dancing appear in funeral dances, where the dancers seem to throw their legs forward in an effort to break the life-destroying power of death. From Dynasty VI come examples of dancers accompanying a coffin, throwing their legs high above the heads of the dancers in front of them. Other dance movements are depicted in the Theban tombs dating from 1300 BC. Figure **3.24** shows a funeral dance of the New Kingdom.

Fertility dances were another prominent form of Egyptian ritual dance. We often find images of women dancers covered in grape vines, swinging branches. One wall painting from the Middle Kingdom depicts a fertility dance in which three women mime what the hieroglyphs

call "the wind." One dancer is upright, the second bends under the outstretched arms of the first, and the third appears to be making a bridge.

ARCHITECTURE
Dynasties I and II

The architecture of monuments developed early in the prehistoric, pre-dynastic period in Egypt. Considerable skill in the quarrying of large blocks of stone—mainly white limestone found in the eastern cliffs opposite Memphis—was acquired at this time. Evidence can be found in the burial chambers from the second half of Dynasty I. Earlier in the dynasty, burial chambers were simply cut out of rock cliffs.

During the first two dynasties the temple of Khentiamentiu, the jackal god, was an important shrine at Abydos (Fig. **3.25**); the ground plan shows us how elaborate such shrines were.

We know little of the superstructures of early tombs. Time has destroyed almost everything except some foundations, many of them at Abydos, which became a sanctified area, probably because it was the burial place of the kings. Several reconstructions have been proposed, and Figure **3.26** shows one of them. It suggests a

3.25 Plan of the Temple of Khentiamentiu at Abydos, Dynasties I–II (3200–2780 BC).

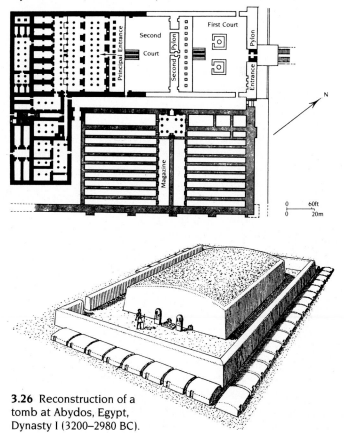

3.26 Reconstruction of a tomb at Abydos, Egypt, Dynasty I (3200–2980 BC).

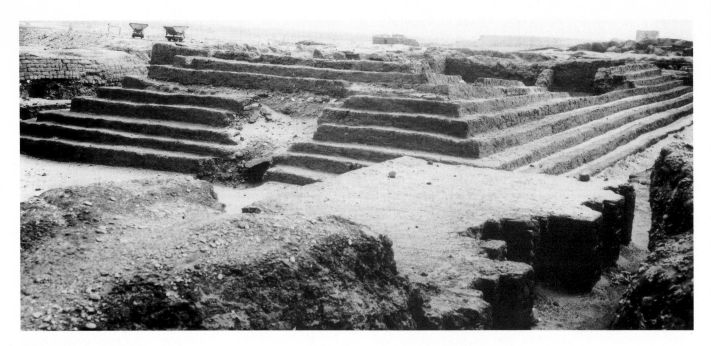

3.27 Superstructure of a tomb, Saqqara, Egypt, Dynasty I (3200–2980 BC).

3.28 Reconstruction of a king's tomb, Saqqara, Egypt, Dynasty I (3200–2980 BC).

low brick structure filled with gravel and surrounded by a wall. This enclosed an offering place housing two round-topped stelae bearing the name of Horus, the sky-god. A Dynasty I tomb at Saqqara for which part of the superstructure remains appears in Figure **3.27**. Credited to the time of Az-ib, sixth king of Dynasty I, the structure has three stepped sides while the fourth is flat. In the flat face, an opening led to stairways to the upper and lower stories of the burial pit. Figure **3.28** illustrates an elaborate reconstruction of another tomb at Saqqara from the same period. The stability and strength of the pharaoh are mirrored in this massive, well rooted design. The strong vertical lines lend elegance and grandeur, while the horizontal mass of the building gives a sense of stability.

Old and Middle Kingdoms

Pyramid-building proliferated from Dynasties III to XII, that is, throughout the Old and Middle Kingdoms. Perhaps the most notable of the pyramids before the great building period of Dynasty IV, which we noted in the introduction to this chapter, is that of King Zoser at Saqqara (Fig. **3.29**). A number of smaller buildings sur-

3.29 The tomb of King Zoser at Saqqara, Egypt, Dynasty III (2780–2680 BC).

0 200ft
0 60m

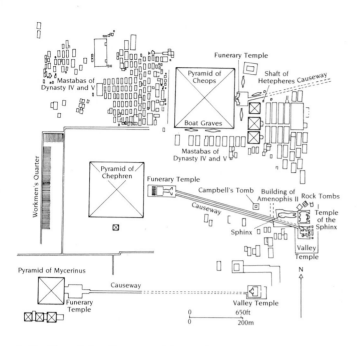

3.30 Plan of the Giza pyramid complex.

round the pyramid, and the whole complex was enclosed by a wall. The buildings include temples, chapels, and palaces, used by the king on various festival occasions. This complex appears to have been built using the predominant method of mud brick construction, in which logs and bundles of reeds were used for wall supports, and wooden beams served as ceiling supports.

Dynasty IV, however, produced the most remarkable edifices of Egyptian civilization: the images that come to mind whenever we think of Egypt are those of the pyramids at Giza (Fig. **3.30**). In addition to the three most obvious pyramids, the area comprises burial places for almost all the important people of Dynasties IV and V.

3.31 Longitudinal section, direction south–north, of the Great Pyramid of Cheops, Giza, Egypt. Dynasty IV (2680–2565 BC).

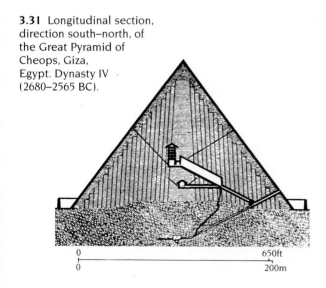

The largest pyramid, that of Cheops (Fig. **3.3**), measures approximately 750 feet square and rises at an angle of approximately 51 degrees to a height of 481 feet. The burial chamber of the king lay hidden in the middle of the pyramid (Fig. **3.31**). Construction consisted of irregularly placed, rough-hewn stone blocks covered by a carefully dressed limestone facing, approximately 17 feet thick.

The famous Sphinx (Fig. **3.32**) is a colossal figure carved from an outcrop of rock, lying at the head of the causeway leading from the funerary temple that adjoins the pyramid of Cheops' son Chephren (Fig. **3.30**). His pyramid originally measured 707 feet square, and rose, at an angle of 52 degrees, to a height of 471 feet. The Egyptian sphinx is a mythological creature, having the body of a lion and the head of a man, ram, or hawk. At Giza the giant sphinx acts as a guardian, to protect the tombs.

3.32 The Sphinx, Giza, Egypt, c.2650 BC.

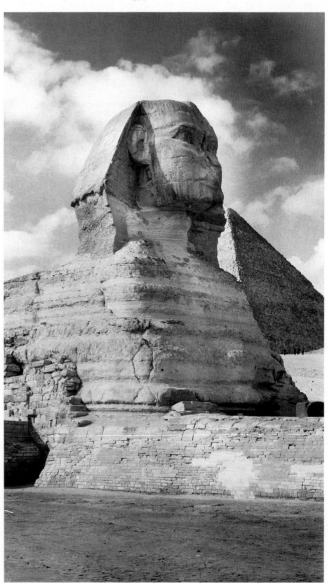

New Kingdom

Leaving the pyramids behind, we move to Dynasty XVIII and a building of great luxury and splendor, the temple at Luxor (Fig. **3.34**). This structure more nearly approaches our modern conception of architecture as a useful place for people to spend the present, rather than eternity. Built by Amenhotep III, the temple is dedicated to the Theban triad of Amun, Mut, and Chons. Amenhotep III was a great diplomat and a great builder, and his taste for splendid buildings was encouraged by a number of architects who appear to have been among the best Egypt ever produced. The most notable of these was Athribis, whose likeness is preserved in a magnificent statue. The statue shows us that Athribis had retained his intellectual and physical abilities to the age of 80. Indeed, he hoped and expected to reach the age of 110, a life span the Egyptians considered quite normal.

Amenhotep III removed all traces of the Middle-Kingdom buildings at Luxor, erecting his magnificent temple in their place. The PYLON, OBELISK, and first courtyard were added by Ramesses II in the next century. Entering the temple during Dynasty XVIII (Fig. **3.33**), we would have passed through a vestibule of giant pillars with CAPITALS carved to resemble palm fronds. From there, we would progress to a huge courtyard surrounded by bunched COLUMNS, followed by the HYPOSTYLE room (Fig. **3.34**) and the "holy of holies." The temple's most important function seems to have been as the anchoring-place for the barques of its gods during the great feast celebrating the height of the annual flooding of the Nile.

Although we cannot understand the mysteries that took place here, we cannot escape the loveliness of the buildings. The balance between the open spaces and the mass of the columns creates a beautful play of light and shade. The seven pairs of central pillars in the vestibule, or Hall of Pillars, stand nearly 52 feet tall and give us some feel for the immense proportions of the great Temple of Luxor.

Surviving the centuries, the inner sanctuary served as a place of worship for Alexander the Great, and later, in the Early Christian period, it was used as a church.

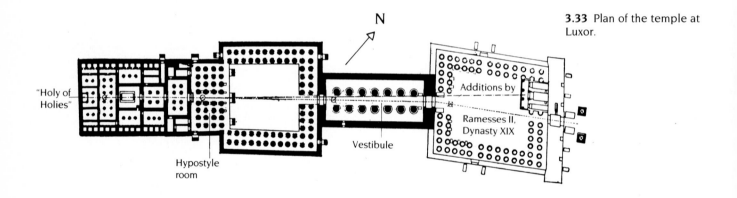

N

3.33 Plan of the temple at Luxor.

"Holy of Holies"

Additions by

Ramesses II, Dynasty XIX

Vestibule

Hypostyle room

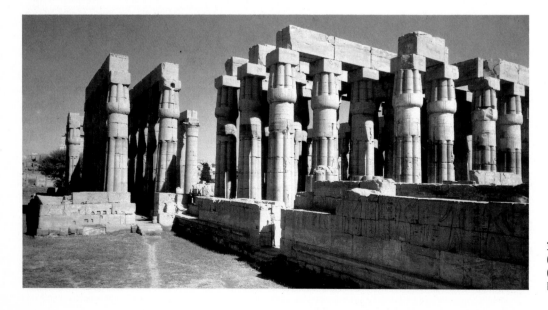

3.34 The hypostyle room (right) and part of the court (left) at the temple at Luxor, Egypt, 1417–1397 BC.

SYNTHESIS
Akhenaton and monotheism: the Tell el Amarna period

It should by now have become clear that the reign of Akhenaton marked a break in the continuity of artistic style. The stiff poses disappeared and a more natural form of representation replaced them (Fig. **3.35**). The pharaoh, moreover, was depicted in intimate scenes of domestic life, rather than in the ritual or military acts that were traditional. He is no longer seen associating with the traditional gods of Egypt. Rather, he and his queen are depicted worshipping the disc of the sun, whose rays end in hands that bless the royal pair or hold to their nostrils the *ankh*, the symbol of life.

The cause of this revolution is not certain, but some evidence suggests that the priesthood of Heliopolis, the ancient seat of the sun cult, were seeking to reestablish the primacy of their god.

Amenhotep IV, as Akhenaton was called before changing his name to reflect his god, was himself unusual. He possessed a "strange genius" for religious experience and its expression. The realistic trends of the period and Akhenaton's desire for truth seem to have resulted in the

3.35 *King Smenkhkare and Meritaten*, Tell el Amarna, Egypt, c.1360 BC. Painted limestone relief, c.5ft (1.53 m) high. Staatliche Museen, Berlin.

3.36 Plan of the excavated areas of Tell el Amarna, Egypt.

graphic depiction of his physical deformities. He is shown as having a misshapen body, an elongated head, and a drooping jaw. Yet the eyes are deep and penetrating. The effect is one of brooding genius.

In a hymn of praise to Aton, thought to have been written by the king, Akhenaton exhibits a spirit of deep joy and devotion to the deity. In his lyrical description of the way the earth and humankind react to the rising and setting of the sun, we glimpse a man of sensitive character. His vision is universal: Aton is not merely a god of Egypt, but of all people, and Akhenaton himself is the sole mediator between the two.

In the fifth or sixth year of his reign, Akhenaton moved his court to the city of Tell el Amarna, newly constructed

Throne Room

Quarters

For

Cattle

Pool

Altar

Court

N

0 100ft
0 30m

3.37 Plan of the North Palace, Tell el Amarna, Egypt, Dynasty XVIII (1570–1314 BC).

unroofed areas lead to the altar of the sun-god, Aton, left open to provide access to his rays.

Sculpture at Tell el Amarna departs from tradition. It is more secular, with less apparent emphasis on statues and reliefs for tombs and temples. The Amarna sculptors seem to have sought to represent the uniqueness of human beings through their faces. Amarna sculpture is highly naturalistic, but it transcends the merely natural, to enter the spiritual realm. The bust of Queen Nofretete illustrates these characteristics (Fig. **3.38**). Of course, we have no way of knowing how Queen Nofretete actually looked, but the figure is anatomically correct, and thus could be a realistic representation of the person. Nonetheless, the line and proportions of the neck and head are almost certainly elongated to increase the "spirituality" of her appearance. The statue of Akhenaton shown in Figure **3.39** depicts the curious physical features of the king that we noted earlier, and yet the stylization of the approach is also clear.

In the relief sculptures and wall paintings, the conventions of body proportions differ significantly from

3.38 Queen Nofretete (Nefertiti), c.1360 BC. Painted limestone, c.19 ins (48 cm) high. Egyptian Museum, Berlin.

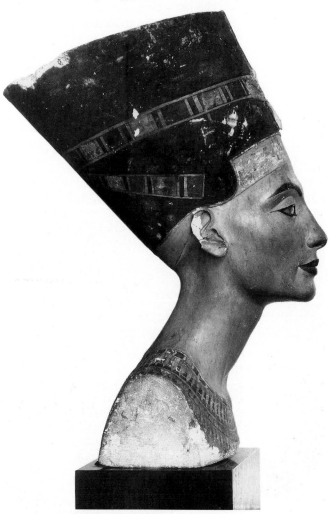

in the sandy desert on the east bank of the Nile (Fig. **3.36**). It was a new city for a new king intent on establishing a new order based on a new religion. Akhenaton failed, and Tell el Amarna, abandoned at his death, was never built over again because it lay away from cultivated land. It thus provides us with an unspoiled record of Akhenaton's social and cultural vision.

The town is dominated by the large estates of the wealthy. They chose the best sites and laid them out in the style of the Egyptian country house, with large gardens, numerous out-buildings, and a wall enclosing the entire establishment. In between these large estates lay the smaller dwellings of the less wealthy. The new city was complete, it seems, with a slum area outside the northern suburb. Near this area stood the grand North Palace (Fig. **3.37**).

In many ways the architecture of Tell el Amarna reflects the common features of New-Kingdom domestic architecture although it is less sumptuous. Its lines and style seem relatively simple. Structures are open, in contrast to the massive, dark, and secret character of the Temple of Luxor, for example. At Amarna numerous

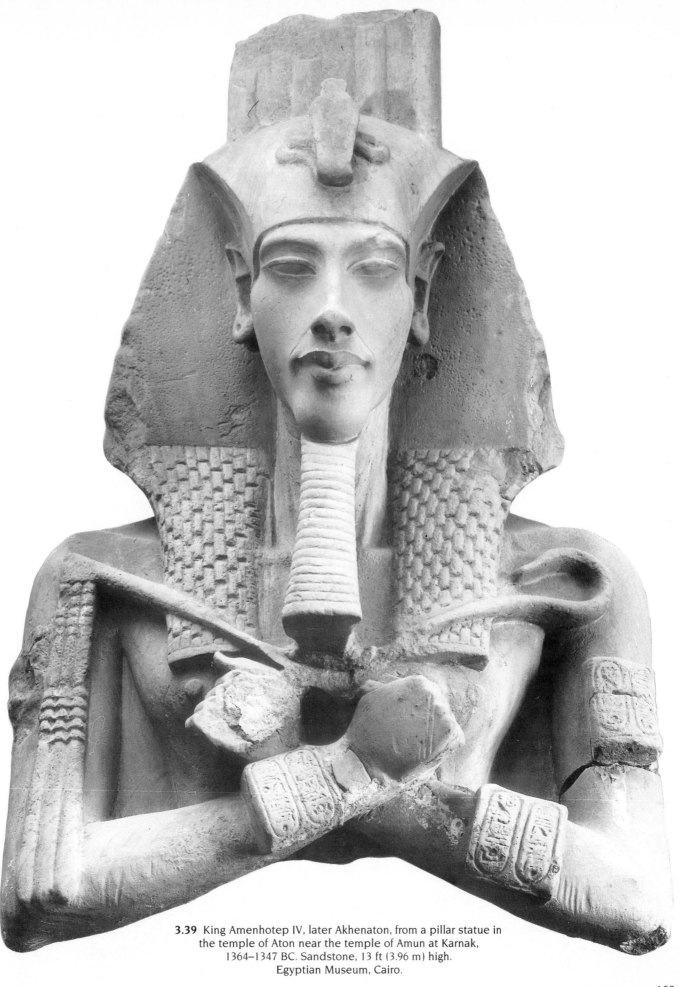

3.39 King Amenhotep IV, later Akhenaton, from a pillar statue in
the temple of Aton near the temple of Amun at Karnak,
1364–1347 BC. Sandstone, 13 ft (3.96 m) high.
Egyptian Museum, Cairo.

those of the other periods. In the Old, Middle, and early New Kingdom, head and body proportions seem to be close to a 1:8 ratio. The total figure is thus nine head lengths from top to bottom. At Tell el Amarna, the total figure is seven to eight head lengths: in other words, the head is larger. Body proportions are also different. Arms are thinner and hands are larger. Abdominal and pelvic areas are emphasized in contrast to the focus on the shoulders and upper torso of earlier periods.

Many of the structural details of Amarna architecture are strikingly original. Plant motifs seem to have been favored, and, as at Luxor, palm-shaped columns are found in abundance. The stone version has a certain stoutness or heaviness which is typical of Egyptian architecture. Also popular at Amarna were papyrus-bundle columns with capitals of clustered, open flowers, sometimes made of alabaster inlaid with blue paste. Most original are kiosk-like structures carved with convolvulus vines. The palace walls dazzled the eye with colored glazed tiles and painted stone reliefs. In fact, everything was richly colored. The entire city must have shimmered in the sunlight of Akhenaton's single god.

Painting was confined to the walls and floors of palaces. It did not appear in tombs, as earlier. Colorful plant and animal life abounded in painting, as in architecture. In Figure **3.40**, we find plants and animals portrayed in motion: papyrus plants bend in the wind, and a kingfisher swoops toward a pond. In contrast to the stark single-value treatment of colors in earlier periods, there are value changes within the same hue, giving the color areas texture and variety. The water ripples subtly, and the papyrus reeds come alive with delicate detail. Other wall paintings at Amarna display a sense of three-dimensionality, and there are highlight and shadow in figure depiction. This sense of PLASTICITY in the painted human form is rudimentary, yet what there is of it is original to the Amarna period.

Isolated from other periods by geographical and religious circumstance, the Tell el Amarna period encapsulates the artistic expressions of a single religious and philosophical concept. The religious reforms of Akhenaton were doomed to fail. Yet this Egyptian experiment in monotheism has left us with a vivid portrait of an integrated life-scheme.

3.40 Kingfisher in papyrus marsh, from Amarna, c.1350–1334 BC. Wall painting, detail 25¼ ins (64 cm) × 19¼ ins (49 cm). The Oriental Institute, University of Chicago.

SUGGESTIONS FOR THOUGHT AND DISCUSSION

Most extant Egyptian records, including art and architecture, relate to funerary matters. The content of this material indicates that Egyptian civilization was hierarchical, with the pharaoh at the top of the hierarchy. He alone had access to what appears to have been the focus of earthly life, that is, life after death. But the remains of Tell el Amarna illustrate that not all art was temple or tomb art. Yet, although its religion was unique and its artistic style was novel in some respects, its art does not tell a distinctly different story from the rest of Egyptian art.

As in Mesopotamian art, certain conventions and characteristics of Egyptian art were relatively constant over thousands of years. These constants give meaning to the label "Egyptian." Variations among the pre-dynastic, Old, Middle, and New Kingdoms, and the Tell el Amarna period do yield stylistic distinctions, however. Once we understand the conventions of Egyptian art and its variations, we can SYNTHESIZE information about religion, politics, and art to produce a fairly complete picture of this remarkable and long-lived civilization.

■ What relationships exist between the power and image of the pharaoh and art and architecture in the various periods?

■ How does the concept of divine rule in Egypt compare with that of Mesopotamia?

■ What evidence suggests an early Egyptian influence and presence in the eastern Mediterranean area?

■ How do the tomb paintings of various dynasties reflect the general social outlook of the times? How does the portrayal of domestic life and objects change over time?

■ How did conventions in painting and sculpture compare, and how did they change from the Old to the Middle and New Kingdoms? Which conventions stayed the same?

■ How did the reign of Akhenaton affect artistic style and other cultural and religious developments?

■ Discuss the assumption that theatre differs from dramatic ritual.

■ What conclusons about lifestyle can be drawn from the musical instruments of Egypt, the tomb of Sennufer, and the layout of Egyptian homes as seen at Tell el Amarna?

CHAPTER FOUR

ARCHAIC GREECE AND THE AEGEAN

As early as the first centuries of the Bronze Age, a collection of civilizations comprising farmers, shepherds, and seafaring traders had begun a succession of settlements of the Aegean world: from continental Greece and the Peloponnese, they spread out around the Aegean Sea. Identifiable to us mainly by their art, they moved outward from Mycenae to colonize Cyprus, Phoenicia, Egypt, and Italy. But by 1200 BC this Mycenaean civilization had disappeared, and a 400-year "dark age" ensued. Then the cloud of history recedes to reveal established city–states, making the Aegean a Greek sea. The artists of these city–states laid the foundations of the archaic style, and created the philosophical and cultural conditions necessary for the spark that was to ignite the crucible of western civilization.

4.1 Geometric amphora, c.760 BC. National Archeological Museum, Athens.

CONTEXTS AND CONCEPTS

AEGEAN CIVILIZATIONS

For the very beginnings of the western culture that we know today, we must look to the area of the Aegean Sea, a part of the Mediterranean stretching from the island of Crete to Asia Minor. Two civilizations—the Minoan and Mycenaean—draw our attention briefly as we move toward the cradle of western culture, ancient Greece.

Around 3000 BC on the island of Crete, small towns began expanding into large urban centers. The Minoan civilization, so-called after the legendary King Minos, emerged. The best known of these urban centers is Knossos. Others included Phaistos, Mallia, and Zakro (Fig. **4.3**). Not much is known about the Minoans, but we can tell from the ruins of their palaces and their wall paintings that they were rich and adventurous. They depended upon their naval power for defense, and their palaces were not fortified. Minoan palaces were elaborate complexes, with private homes of the aristocracy and religious leaders clustered around them. Minoan wall paintings display a spontaneous quality and a deep love of nature: the colors are brilliant, and the scenes of nature are accurately observed.

Minoan influence on the later Mycenaean civilization is evident. The Mycenaeans were early Greek tribes

people who inhabited the southeastern coastline of mainland Greece. The central city of Mycenae boasted a great palace complex. From approximately 1400 to 1200 BC, Mycenaean traders traveled throughout the Mediterranean. By the 14th century BC, they had supplanted the Minoans as rulers of Crete. Shortly after 1200 BC, the Mycenaean civilization mysteriously collapsed, in spite of its great defenses and massively fortified palaces. The fortifications of the Mycenaeans, some with walls 15 feet thick and 50 feet high, attest to their war-like nature. Yet Mycenaean wall paintings were lively and much like those of the Minoans.

BETWEEN MYTH AND HISTORY

Between the time of the Mycenaean civilization, with its art and palaces, and that of the Greek CITY–STATES of the eighth century BC, lies a historical vacuum of four centuries. Historians call this time the "Greek Middle Ages," or the "dark centuries." Although the Mycenaeans had writing, the skill seems to have vanished during this time, leaving only archeology to testify to its existence.

It seems clear that at the end of the 13th century BC a wave of destruction swept across the area. Existing cities

4.2 Timeline of archaic Greece and the Aegean.

BC	PERIOD	GENERAL EVENTS	LITERATURE & PHILOSOPHY	VISUAL ART	THEATRE & DANCE	ARCHITECTURE
3000	Mycenaean	Mycenaean traders in the Aegean				"Palace of Minos," Knossos (4.16)
1200		Destruction of Troy		Boar hunt (4.4)		Lion Gate, Mycenae (4.17)
	"Dark ages"			Protogeometric vases (4.5)		
800				Geometric vases (4.1)		
		First Olympic games	Homer, Iliad, Odyssey	Dipylon Vase (4.6)		
700		First Greek inscription	Hesiod, Works and Days			
600	Archaic		Ionian poets Sappho of Lesbos	Doric order		
500		Red-figure ware	Pythagoras	Perseus bowl (4.7) Kouroi and korai (4.11–14) Lydos, krater (4.8) Makron, skyphos (4.10)	Choric dance festivals First tragic competitions	"Basilica," Paestum (4.20)

were abandoned, and their populations moved to new sites. Some centers, such as Athens, seem to have remained intact, but the period seems typified by waves of migrants passing from one place to another, not as warriors or conquerors, but merely as transients. A great emigration occurred from the Greek mainland to the outlying shores around the Aegean, and the island of Cyprus assumed a major role as a crossroads for trade with the cultures of the Middle East. All this transmigration had the effect of making the entire Aegean area essentially a "Greek sea." During this time, iron replaced bronze in the construction of tools, and significant changes occurred in burial practices.

Homer, the I*liad* and the O*dyssey*

The best documentation of the time is in the form of two great epic poems attributed to Homer, the I*liad* and the O*dyssey*. In these stories we find a lively picture of the Trojan War and Odysseus' return to Ithaka. They show us a world that existed between the Mycenaean civilization and the establishment of the Greek city–states, in which a variety of kingdoms flourished and people enjoyed a highly organized and complex relationship with the gods. These epics also give us a glimpse of the social organization, in which "the o*ikos* (household, domain) [was] the center of economic and social power and the place in which kinship was expressed."[1] Finally, they memorialize a cast of heroes whose exploits are almost as famous today as they were then.

Homer himself was long thought to be the author of many of the narrative poems that emerged from these Greek "dark centuries." Scholars now credit him with fewer works, among which, besides the I*liad* and O*dyssey*, are shorter poems: the H*omeric Hymns* and the H*omeric Epigrams*. Learned debate over authenticity, history, text, and content of Homer's works has noted many discrepancies, with the result that, apart from his name, and the belief that he was blind, Homer remains a mysterious figure. We know little else about the author whose works laid the foundations of western literature.

THE ARCHAIC GREEK WORLD

The term "archaic" describes Greek culture during the period approximately 800 to 500 BC. The "archaic period" can be contrasted with the "classical" world of Athens, which is viewed as the "golden age" of Greek culture.

The Greek city–states developed during this period, although the precise date and circumstances of their origins are unknown. They were already well established and functioning by the time their recorded history began, but we do know, at least, that they did not all spring up simultaneously. Each city, or *polis*, consisted of a collection of people who were self-governing. The Greeks referred to cities by the collective name of their citizens, thus Athens was "the Athenians." Each city was surrounded by a group of villages and a rural territory, and each was self-governing, functioning as an independent state without any central unifying government. Each city–state developed its own ethos, or sense of itself. Some, like Athens, emerged as relatively peaceful, with high esteem for the arts and philosophy. Others, such as Sparta, were militaristic and seemingly indifferent to high culture.

All the cities formed their social orders on distinct class structures: some people were free and others were slaves. Among free males there existed a clear demarcation between those who were citizens and those who were not: only citizens could participate in political decision making, own land, or serve in wars. But access to citizenship could alter according to the city's circumstances at a given time.

THE HELLENES

According to early Greek historians, civilization flourished on the Greek islands and peninsula in the eighth century BC. They recorded the year 776 BC as the date of the first Olympic games, and they counted forward from that date as Christians now count forward from the birth of Christ. Primary among the factors that united the different peoples of this area—the Ionians, Dorians, and Aculians—was a common language. The language was old, but its written form had only recently developed. The earliest surviving Greek written characters are found on a jug dating from 725 BC. The characters appear to be adapted from Phoenician script, one example of the many outside influences, especially Asian, that helped to shape Greek culture. Central to Greek civilization were the Athenians, citizens of the city–state of Athens, and part of the group of Greeks who called themselves Ionians.

Athenian culture grew from complex inter-relationships of politics, philosophy, religion, geography, and economics, as well as from previous civilizations in the Mediterranean world, including Egypt. The ancient Greeks pointed with pride to some of the external roots of their culture. Athens shared a common heritage and religion with many independent city–states in the region. The people of these city–states called themselves Hellenes, and the development of their civilization was partly influenced by two geographic factors. One was the mountainous terrain of the Peloponnesian peninsula and surrounding areas, which kept the city–states isolated from each other. This, in turn, meant that their confederations were rather loosely organized. The other was the Aegean Sea, which provided an open highway for trade and commerce with the entire Mediterranean world. The seaport of Athens was particularly well positioned to benefit from these factors.

4.3 The Aegean.

RELIGION

The Greek mind was an earthy one, and Greek thought and religion centered on this life, rather than the one to come. Ancient Greeks may often have looked for meaning in the order of the stars, but there, as on earth, the human mind was "the measure of all things."

At the core of Greek religion was a large family of superhuman gods. Their history in myth had been traced by the poet Homer in the *Iliad*. Greek religion had no holy books or scriptures. The stories of the gods were well known, however, through oral tradition and through writings such as Hesiod's *Theogony*. These gods were called "Olympian" because they dwelt on the mythical (and also real) Mount Olympus. All were descended from a pair of older gods: Uranus, representing the heavens, and Gaia, representing the earth. But their genealogies were the subjects of so many varied myths that, although central to Greek religion, they are confusing, and, to some degree, confused. In addition to the central family of gods, the Greeks worshipped local deities who were thought to preside over certain human activities and to protect various specific geographical features such as streams and forests.

Each god had an individual human form and, sometimes, very human and not very admirable characteristics. Zeus, king of the Greek gods, is portrayed as a well intentioned but bumbling and self-indulgent fellow who pursued every opportunity to have sexual relations with the women he encountered, divine or mortal. Aphrodite, the goddess of love and fertility, could be as vain, unpredictable, and arrogant as any ordinary mortal.

Unlike the religious art of Egypt and Mesopotamia, that of the Greeks usually represented the gods in human terms, sometimes as superior to humans, but sometimes as worse than us. The difference between this approach and, for example, the monster gods of Assyria and Babylonia, indicates a radical departure from earlier religious thought. The implication is clear: if the gods can be like humans, then humans can also be god-like. Thus, an intimacy existed between the gods and their human companions, and life on earth was very similar to that of the gods.

PYTHAGORAS AND PHILOSOPHY

During the archaic period, the age of the great Greek philosophers was yet to come, but the groundwork was being laid for the rationalism and intellectual ability which would blossom in the fifth century BC. The most important philosopher of the sixth century BC was Pythagoras.

In his search for truth, Pythagoras concluded that mathematical relationships were universal. His deduction of what we call the "Pythagorean theorem" illustrates this. He postulated that "the square on the hypotenuse of a right-angled triangle equals the sum of the squares on the other two sides." Pythagoras recognized this as a universal constant, that is, a concept applicable to all cases, under all circumstances. This understanding underlies the difference between Pythagoras' view of the world and that of other philosophers. Pythagoras saw the universe as having a single reality, existing apart from substance. Others had proposed a universe based on a single physical substance constantly in a state of change. Pythagoras also saw mathematics as fundamental to all life, including the arts.

FOCUS

TERMS TO DEFINE
Minoan
Mycenae
Hellene
Zeus
Polis

PEOPLE TO KNOW
Minos
Pythagoras
Homer

DATES TO REMEMBER
Mycenaean Age
Greek Middle Ages
Archaic period

QUESTIONS TO ANSWER
1 What developments took place during the "Greek Middle Ages"?
2 What was Pythagoras' view of reality?

THE ARTS
OF ARCHAIC GREECE AND THE AEGEAN

TWO-DIMENSIONAL ART

Mycenaean wall painting

Our knowledge of the world of the ancient Mycenaeans is derived from the fragmentary remains of their art. On the walls of their palaces there are decorative paintings which also represent the activities of the time. The *Boar Hunt* (Fig. **4.4**) shows a group of dogs, hunting as a pack and attacking the prey. That the hounds are domesticated is evident from their collars, which appear to be tied around the neck. The hand and what looks like the lance of the hunter at the extreme right of the fragment indicate that the dogs have chased the boar into the vicinity of the hunters. This painting is clearly a testament not only to a successful hunt, but also to the dog breeder, whose well trained dogs carry out the commands of their owner.

Vase painting

Protogeometric style
Our earliest impressions of art during the "dark ages" between 1200 and 800 BC are given by the only artifacts that have survived: pots, or vases. Whether the ornamentation on the objects qualifies as an art form is arguable; moreover, the term vases is somewhat misleading. Unlike modern fine-art ceramics, which are objects intended to convey beauty and comment on reality, these pots were designed to serve exclusively utilitarian purposes. They were cups, jugs, and vessels for storing and carrying water, wine, and oil. Vase painting was thus, at best, a minor art form among the Greeks.

Nevertheless these vessels do provide some insights into their time. The earliest examples, which date from the period around 1000 BC, fall into a category known as

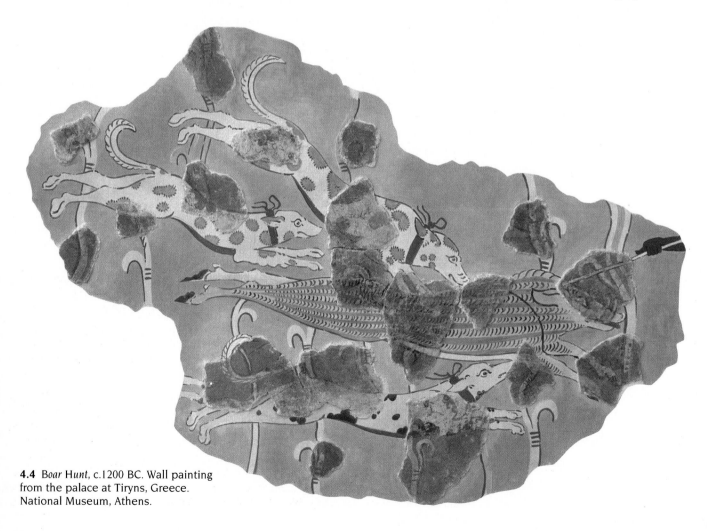

4.4 *Boar Hunt*, c.1200 BC. Wall painting from the palace at Tiryns, Greece. National Museum, Athens.

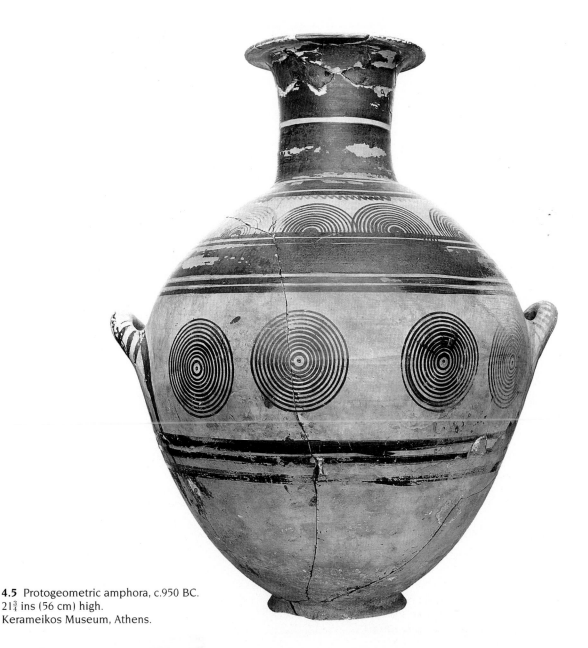

4.5 Protogeometric amphora, c.950 BC.
21¾ ins (56 cm) high.
Kerameikos Museum, Athens.

"protogeometric" (a term that simply means "before the geometric"). During this time, artists made use of bold, simple DESIGNS consisting mostly of circles and semi-circles (Fig. **4.5**). The patterns are SYMMETRICALLY balanced although the execution, while finely detailed, is somewhat haphazard. For example, the semicircles at the top of the AMPHORA in Figure **4.5** are irregularly spaced: they overlap in one place, touch in another, and are separated by a gap in a third. Nonetheless, the overall composition here and elsewhere reveals a concern for rational order and for fine detail. The quality of the potter's technique is also quite high. The vases are wheel-thrown, and exhibit an exceptionally smooth surface. Decoration was applied by brush while the vase was turned on the wheel, or, in the case of the circular motifs, with a pair of compasses.

Geometric style

Within the next two centuries, vase painting progressed to its geometric phase. Figure **4.1** shows a geometric amphora: here the circular design of the protogeometric style has been replaced by linearity, using zigzags, diamonds, and the meander or maze pattern. The vessels themselves are more intricate in shape and larger in size. Some examples are nearly six feet high—so large, in fact, that they had to be constructed in sections.

Virtually every space on the vase is filled. The decoration is composed in horizontal bands not unlike the registers found in Egyptian painting. When it appears, the human form is depicted in silhouette, with the head, legs, and feet in profile while the torso faces forward. This stylization is also very similar to the Egyptian. In general, geometric vase design expresses absolute symmetry.

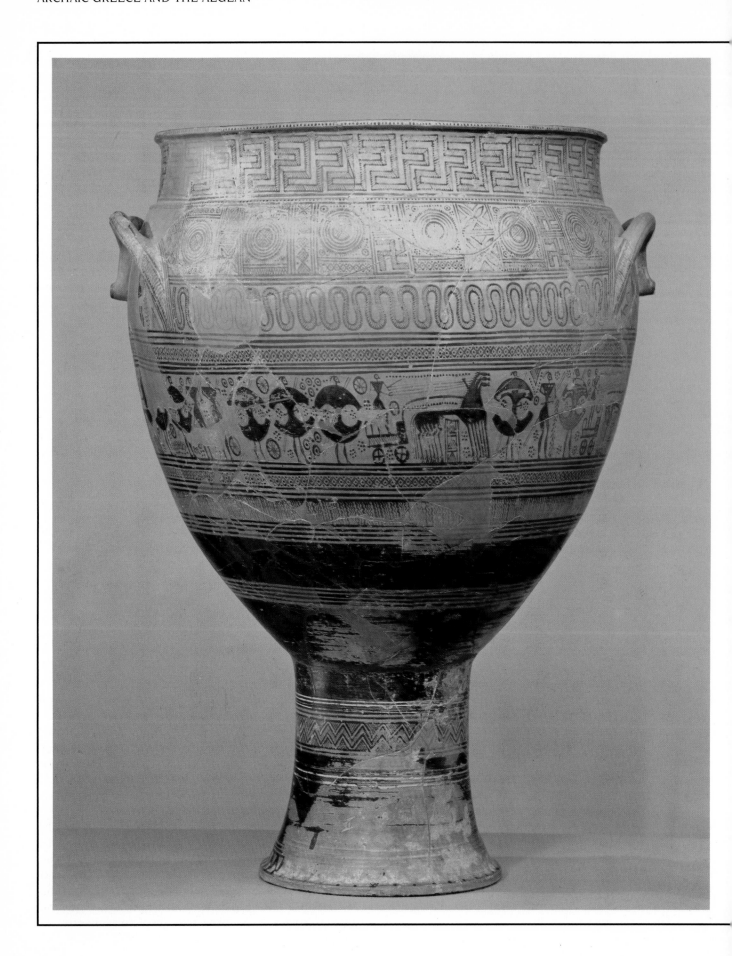

MASTERWORK
The Dipylon Vase

The Dipylon Vase (Fig. **4.6**), from slightly later in the eighth century BC, was found in the Dipylon Cemetery in Athens. This pot and others like it served as grave monuments. Holes in the bottom allowed liquid offerings to filter down into the grave.

On the opposite side of the vase from that shown in Figure **4.6**, the body of the deceased is shown lying on a funeral bier, surrounded by mourners. Also depicted on the vase is a funeral procession with warriors on foot and in chariots drawn by horses. Every human and animal figure in this complex design suggests a geometric shape and clearly represents a stylized approach, harmonizing with the other elements on the vase. Although recognizable and narrative in purpose, the figures appear as just another type of ornamentation within the larger context of the overall design. They follow the convention just noted, portraying the torso frontally while the head and legs are in profile; turning the head to the rear would denote a figure in motion.

One of the amazing facets of this vase is the amount and intricacy of detail that occupies every inch of its surface. Another important point is the careful organization of that detail into carefully balanced horizontal bands, each displaying a different geometric pattern. With only a few shapes, the artist has created a tremendously detailed painting with a subtle and sophisticated balance and focus. The dark, wide bands on the base and at the bottom of the bowl ground the design and help the viewer to focus on the story of the dead person. The patterns at the top and bottom of the vase are completely different, and yet they seem harmonious. Also notable is the balanced juxtaposition of straight lines and curves: the snake-like design and circles sit quite naturally alongside rectangles and triangles.

4.6 Dipylon Vase, Attic geometric amphora, eighth century BC. 3 ft 6⅝ ins (1.08 m) high. The Metropolitan Museum of Art, New York (Rogers Fund, 1914).

Archaic style

Figure representation remained two-dimensional until the middle of the sixth century BC. Depiction was restricted to full profile, or a full-frontal torso attached to legs in profile. The head, shown in profile, contained a full-frontal eye. Fabric was stiff and conventionalized. But by 500 BC artists were attempting to portray the body in a three-quarter position, between profile and full frontal. At the same time, a new feeling for three-dimensional space developed, and artists began to depict eyes more realistically. Fabric began to assume the drape and folds of real cloth. All these characteristics mark vase painting of the sixth century BC and they typify the various stages of the archaic style.

Individual vase-painters' styles differed greatly from each other. We know some of these artists from their signatures. Others have been assigned names based on the subject or the location of their work. The Gorgon

4.7 Attic bowl showing Perseus and the Gorgons, early sixth century BC. 36½ ins (93 cm) high. Louvre, Paris.

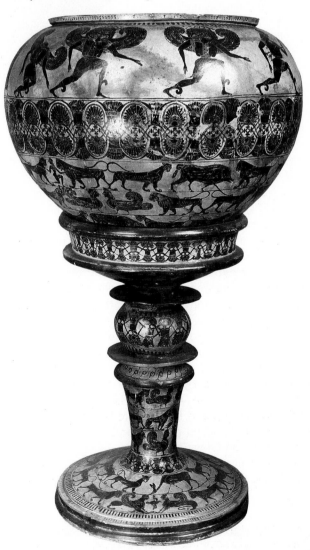

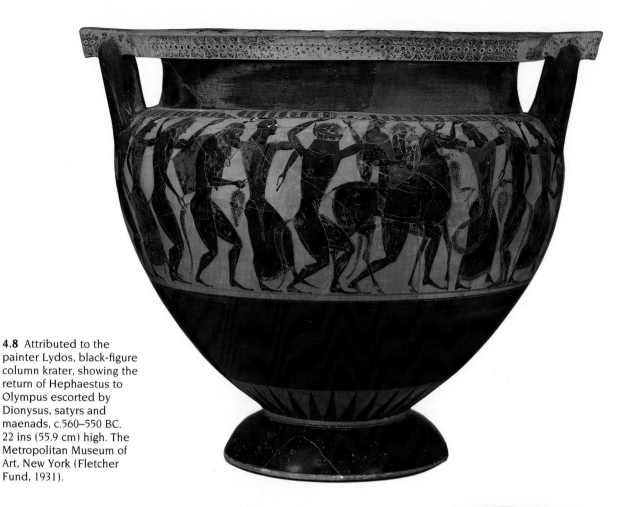

4.8 Attributed to the painter Lydos, black-figure column krater, showing the return of Hephaestus to Olympus escorted by Dionysus, satyrs and maenads, c.560–550 BC. 22 ins (55.9 cm) high. The Metropolitan Museum of Art, New York (Fletcher Fund, 1931).

Painter (Fig. **4.7**) was named after the Gorgons that decorate his work. In this example of the sixth-century style, the design is arranged in graduated registers, with an intricate and lovely geometric design as a focus on the middle band. The painter Lydos is responsible for one of the largest surviving terracotta KRATERS (bowls for mixing wine and water) (Fig. **4.8**). In this black-figure work, we see Hephaestus returning to Olympus, surrounded by a crowd of satyrs and maenads. The figures conform to the usual sixth-century conventions but their life and movement vary the rhythms of the work.

We can see the development of the archaic style toward the classical in a SKYPHOS painted by Makron in the early fifth century BC (Fig. **4.10**). Makron painted nearly all the vases signed by the potter Hieron, and in this example the delicate folds of the fabric reflect his idealization of line and form. He tells the story of Paris and Helen with graceful rhythms and repetitions of form tempered by careful variation.

The work of the painter Douris spans the years 500 to 470 BC. Over 30 vases survive with his signature, and

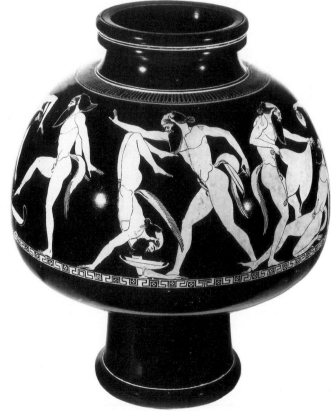

4.9 Douris, psykter showing dancing satyrs, c.500–480 BC. 11⅜ ins (28.7 cm) high. British Museum, London.

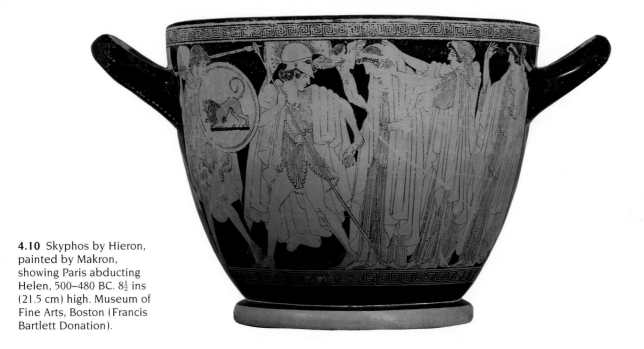

4.10 Skyphos by Hieron, painted by Makron, showing Paris abducting Helen, 500–480 BC. 8½ ins (21.5 cm) high. Museum of Fine Arts, Boston (Francis Bartlett Donation).

more than 200 others in the same style are believed to be his work. Figure **4.9** illustrates Douris' use of rhythm and his skill in animating figures.

The works of Makron and Douris clearly illustrate the new fashion for red-figure vases (see below). Painters discovered that figures were more lifelike when they appeared in the natural red color of the terracotta, with the background filled in in black. At first, the change from black-figure to red-figure was tentative. Some vases appeared with red-figure work on one side and black-figure on the other. Douris made the transition completely, and his graceful and careful rendering of the human form moves toward realism.

Red- and black-figure pottery

Attic pottery can be divided into two types—black-figure and red-figure. In black-figure vases, the design appears in black against the light red clay background. Details are incised, and white and dark red colors are added. White tends to be used for women's flesh and for old men's beards. Red is used for hair, horses' manes, and for parts of garments (Figs **4.7** and **4.8**).

Red-figure work, which first appears around 530 BC, reverses the basic scheme, with the figures appearing in the natural red clay against a glazed black background (Figs **4.9** and **4.10**). Contours and other internal lines appear in glaze and often stand out in slight relief. In early red-figure work, incision is occasionally used for the contours of the hair, with touches of white and red. Other techniques that appeared in the fifth and fourth centuries BC include the use of PALMETTES and other motifs impressed in the clay and covered with black glaze.

SCULPTURE

Stone and metal are more durable than pottery and sculpture often surpasses all other art forms in its survival of the centuries. However, Greek sculpture does not exist in great quantity, and it is unfortunately more than likely that some of the greatest examples have been lost to humanity forever.

Archaic style

Most of the free-standing statues in the archaic style are of nude youths, and are known as *kouroi*. (The term means, simply, "male youth," and the singular form is KOUROS.) More than 100 examples have survived. All exhibit a stiff, fully frontal pose. The head is raised, eyes are fixed to the front, and arms hang straight down at the sides, with the fists clenched. The emphasis of these statues is on physicality and athleticism. The shoulders are broad, the pectoral muscles well developed, and the waist narrow. The legs show the musculature of a finely tuned athlete with solid buttocks and hardened calves. Nevertheless, these figures are clearly not realistic. The sculptor seems over conscious of the block of stone from which the figures have been cut. Features are simplified, and the posture, despite the movement of one foot into the forward plane, is rigid. In spite of these limitations, however, these works represent a sculptural innovation. They are the first examples of truly free-standing sculpture. By freeing the statue of any support, the artist is able to represent the human

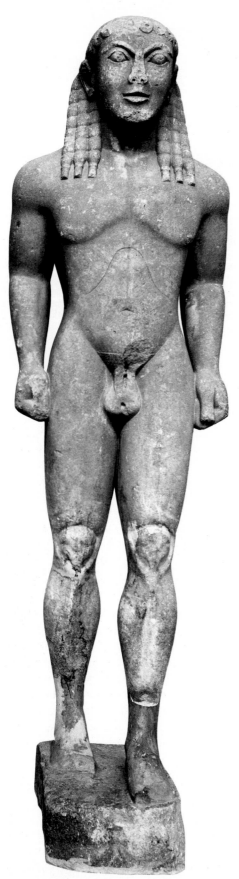

4.11 Polymedes of Argos, kouros, c.600 BC. Stone, 6 ft 5½ ins (1.97 m) high. Archeological Museum, Delphi, Greece.

form independently of any non-living matter. This accomplishment prepares the way for later, more successful representations of living beings.

Most of the kouroi were sculpted as funerary and temple art. Many of them were signed by the artist: "So-and-so made me." Whether the statues were intended to represent humans or gods (they are most definitely not portraits of individuals) is debatable. The fact that all are nudes is perhaps a celebration of the physical perfection of youth and of the marvelous nature of the human body. The kouroi may also represent, more directly, the naked athletes who took part in the games loved by the Greeks. (The Greeks explained the practice of competing in the nude by telling the story of a runner who dropped his loin cloth and, thus unimpeded, won the race.) Other more symbolic explanations of the nudity of these statues have been offered, but no one view has prevailed.

Two significant characteristics are exemplified by the kouros from around 600 BC shown in Figure **4.11**. First is the fact that although there is an obvious attempt by the sculptor to depict the human figure in a fairly realistic form, the figure does not represent a particular person. Rather, it is a stereotype, or a symbol, and an idealization, perhaps of heroism. But it does not depict ideal human form. The sculpture lacks refinement, and this is a characteristic that helps to differentiate the archaic from the classical style.

The second characteristic lies in the attempt to indicate movement. Even though the sculpture is firmly rooted, the left foot is extended forward. This creates a greater sense of motion than if both feet were side by side in the same plane, yet the weight of the body remains equally divided between the two feet, as we saw in Egyptian sculpture.

The striking similarity of form and style among the kouroi can be seen when we compare Figure **4.11** with the statue in Figure **4.12**. There are the same physical emphases, the same frontality and the same slight departure from the horizontal plane, with the left feet forward. The stylized treatment of the hair is nearly identical, except that one has the curls pushed back behind the ears, while the other wears his hair over the shoulders. In both statues the kneecaps are curiously over-articulated. Nevertheless, the kouroi differ in proportion and in facial details.

The kouros had a female counterpart in the *kore* (plural *korai*, meaning "maidens"). These figures are always fully dressed, and in other ways too the korai show far more variety than the kouroi. Some of these differences may stem from variations in regional dress, but clearly the sculptor's interest lies in the treatment of that dress, in the technical mastery required for the accurate depiction of cloth in stone. As in Egyptian sculpture, much of the rendering remains decorative rather than representational, but occasionally the sculptor achieves more than mere decoration.

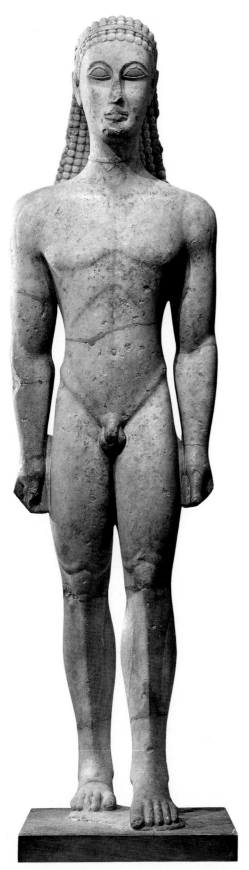

4.12 Kouros, c.615 BC. Marble. 6 ft 4 ins (1.93 m) high. Metropolitan Museum of Art, New York (Fletcher Fund, 1932).

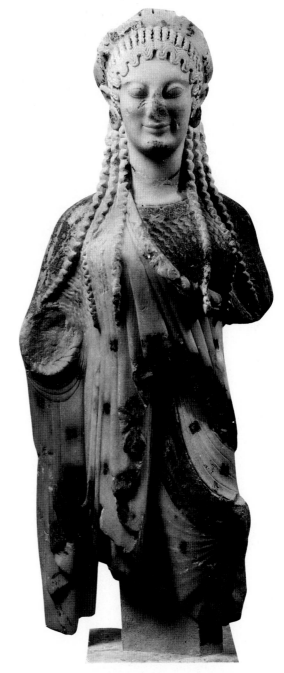

4.13 Kore, c.510 BC. Marble. 21½ ins (54.6 cm) high. Acropolis Museum, Athens, Greece.

Figure **4.13** shows a typical kore. In this delicate and refined portrayal, the sculptor seems to be reaching beyond the world of mortals, perhaps to depict an eastern goddess or queen. In contrast to the kouroi, the carving of this statue shows a lightness of touch and delicacy, not only in the anatomical features, but also in the precise folds of the robes, the finely detailed jewelry, and the stylized hair. These elements combine to give the statue a greater degree of verisimilitude than the kouroi we have examined.

119

4.14 Kore in Dorian peplos, c.530 BC. Marble, 4 ft (1.22 m) high. Acropolis Museum, Athens, Greece.

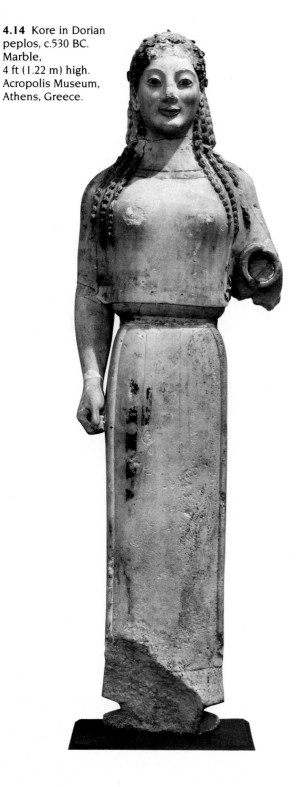

4.15 *Kritios Boy*, c.480 BC. Marble, c.34 ins (86 cm) high. Acropolis Museum, Athens, Greece.

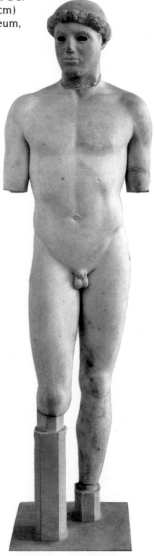

space indicates a new interest in movement outside the main block of the statue.

We should also note that although the young male figures stride forward, albeit rather tentatively, the maidens keep their feet together. Perhaps their long robes inhibit motion, or perhaps the sculptor had other purposes in mind for them.

By the early fifth century BC, the stiffness of the archaic style had begun to modify. The human form began to be portrayed with subtlety and to display movement. This transition began with the *Kritios Boy* (Fig. **4.15**), named for its presumed sculptor. Here is a statue in which the body truly stands at rest. The artist has discovered the principle of weight shift, that is, the way in which the body parts position themselves around the flexible axis of the spine. The *Kritios Boy* is the first known portrayal of this important principle. In it we can discern the beginnings of the classical style.

In comparison with Figure **4.13**, the kore shown in Figure **4.14** lacks detail, but it thereby achieves cleaner, more graceful lines. Although anatomical details are disguised by the heavy fabric, the body, with the waist naturalistically emphasized, is convincingly present beneath the robes. The kore's unusual smile exhibits more personality than the blank stare of many archaic statues, and the extension of the left arm forward into

DANCE

The religious rituals of ancient Greece centered on dance. Beginning around 600 BC, great festivals brought choruses of 50 dancers from each tribe together on special occasions for competitions. Most scholars agree that the Greek theatre developed directly from these dances. (The Greek tragic chorus had 50 members.)

Dance, music, and drama were inseparably entwined, and all played a fundamental part in early (and classical) Greek philosophy, religion, and life. The term "dance" had a broader definition for the Greeks than it does for us. In fact, it denoted almost any kind of rhythmic movement. Just as dance and music were inseparable, so were dance and poetry. A Greek could dance a poem, "interpreting with rhythmic movements of his hands, arms, body, face, and head the verses recited or sung by himself or another person."[2]

LITERATURE

Homer, whose work we examine in more detail at the end of this chapter, is probably the best known of the ancient Greek poets, but he was by no means the only one. The growth of individualism in Greece produced a new literature: personal LYRIC poetry. Ancient lyrics, anonymous, and often intended for use in rituals, had been concerned with experiences common to all. But by the end of the seventh century BC, poets appeared along the Ionian coast who tell us their names, and sing of themselves, their travels, military adventures, political contests, homesickness, drinking parties, poverty, hates, and loves.

The lyric poet Sappho, who was born around 615 BC, lived all her life on the island of Lesbos. She gathered around her a coterie of young women interested in poetry, and who may have been worshippers of the cult of Aphrodite. Many of Sappho's poems are written in honor of one or other of these young women. Sappho was married, and had a daughter, Cleïs. Other than these few facts, we know nothing certain about her, although she has inspired numerous legends.

Sappho's poems are MONODIES on the theme of love. The lyrics are very personal; typically they celebrate some important event in the lives of those around her, often a bridal ceremony or wedding night. Their tone is emotional and frank, their language simple and sensuous. Her word usage and imagery depend on sound for many of their effects. As a result, translation into a language without the sounds and rhythmic character of Greek profoundly diminishes her verses. Most of the works exist only in very brief fragments of a few words or phrases. Yet at least one of the longer fragments, "He Seems to be a God, that Man," was much admired and imitated by later poets. In it Sappho gazes at a young bride sitting and laughing next to her bridegroom and is overcome with emotion.

Born at the end of the eighth century BC, Hesiod was the son of an emigrant farmer from Asia Minor. He depicts this hard life in his poem *Works and Days*. Hesiod's lesson is that men must work, and he sketches the work that occupies a peasant throughout the year, recounting how an industrious farmer toils and how work brings prosperity, in contrast to the ruin brought about by idleness. He captures the changing seasons and countryside with vivid word pictures. He also describes life at sea, and concludes with a catechism detailing how people should deal with each other. His style is similar to Homer's, but his subject matter is quite different, for rather than telling of heroes and gods, Hesiod dwells on the mundane and mortal.

Hesiod's most famous work, however, is the *Theogony*, in which he traces the mythological history of the Greek gods. He describes the rise of the earth out of chaos, the overthrow of the Titans by Zeus, and the emergence of each god and goddess. Scholars attempting to understand Greek art and religion have found this work invaluable as a source of information.

ARCHITECTURE

The earliest civilization in the Aegean, that of the Minoans on Crete (c.2000–1000 BC), has left us many well preserved archeological sites from which it is possible to deduce a great deal of information about their builders' lifestyle and culture, in spite of the fact that their writing has yet to be fully deciphered. The Minoans were a wealthy and secure people. Their palaces on Crete were unfortified, because their navy afforded them all the protection they needed. If the so-called Palace of Minos (Fig. **4.16**) is representative, the Minoans not only enjoyed comfort, but were also capable of sophisticated elegance

4.16 Queen's chamber, Palace of Minos at Knossos, Crete, c.1500 BC.

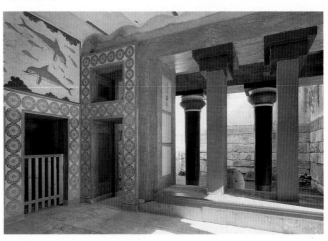

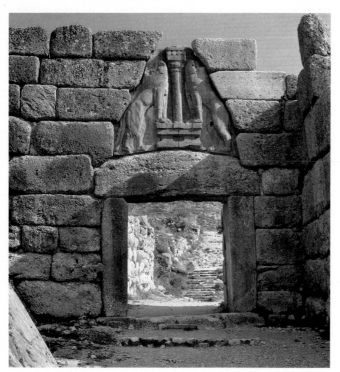

4.17 The Lion Gate, Mycenae, Greece, c.1250 BC.

The Doric order

The oldest order, the DORIC, dates from pre-classical times, but, as we shall see, it changed to meet emerging classical criteria of form and balance. The early version of the Doric column had a cumbersome appearance, with thick columns and blocky, oversized capitals. A drawing of the reconstructed west front of the Temple of Artemis on Corfu (Fig. **4.18**) shows a tapering column sitting directly on the STYLOBATE. The SHAFT is tapered, with FLUTING, or vertical grooves, and leads to a flared ECHINUS with a square ABACUS (Fig. **4.19**). The characteristics of the Doric order appear to have been drawn from elements of Egyptian, Mycenaean, and pre-archaic Greek structures. The fluted column, for example, was used in Egypt at the Temple of Zoser, Saqqara, nearly 2000 years before its

4.18 Reconstruction drawing of the west front of the Temple of Artemis, Corfu. [After Rodenwaldt.]

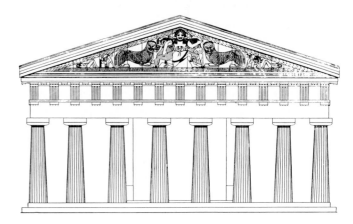

in decor and design. The palace had so many rooms that it was remembered in Greek myth as the labyrinth of the Minotaur. The walls were built of masonry and were decorated with murals and geometric motifs. Columns, both rectangular and circular, were employed as supports. They took the form of tapering wooden shafts (perhaps reflecting their origin as unworked tree-trunks) with heavy geometric capitals. The total impression is one of openness and lightness, combined with luxury and attention to detail.

The palaces of the Mycenaeans were very different from those of the Minoans. They were mere fortresses constructed of large, rough stone blocks, placed at the center of a settlement on top of the highest hill. The individual boulders were so huge that the Greeks who viewed them centuries later called them "Cyclopean," believing that only cyclopses (mythological giants) could have moved them.

The Lion Gate at the palace at Mycenae (Fig. **4.17**) demonstrates the powerful effect of juxtaposing smoothly carved elements with the massive blocks of stone. In an alcove on top of the LINTEL two lions, obviously intended as guardians, flank a tapering column similar to those found in Minoan palaces. The careful carving of the animals' musculature expresses strength and its contrast with the rough stone masonry creates a slightly uncomfortable effect, which is reinforced by the cramped nature of the composition within the alcove. Yet, despite any crudity in the design, the execution is remarkably skillful, and the jointure of the stone is tight.

4.19 The Doric order.

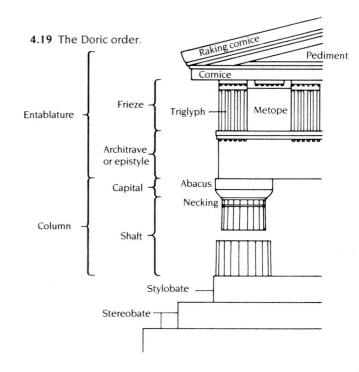

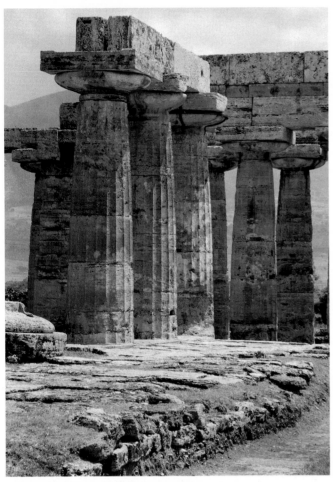

4.20 Corner of the "Basilica," Paestum, Italy, c.550 BC.

SYNTHESIS
The Iliad of Homer

The ideals that dominated the early years of the first millennium BC found their way into the books of the Old Testament and numerous other writings. Nothing better synthesizes the early Greek mind and soul, however, than the singular mythology recited by the poet Homer.

Homer's main works are the *Iliad* and the *Odyssey*, both of which date from the eighth century BC. Both poems also deal with minor episodes in the story of the battle of Troy, which ended, with the destruction of the city, in about 1230 BC. These poems became the basic texts for every schoolboy (there were no schoolgirls) in ancient Greece, and they have influenced western literature ever since.

The plot of the *Iliad* describes a quarrel between Achilles, the greatest warrior of the Greeks, and Agamemnon, the commander-in-chief of the Greek army. This story is told against the backdrop of the siege of Troy. The heroes are types, not real people, and their characters were established in legend long before Homer composed his epic poem.

When the action opens, the Greeks have for nine years been besieging Troy, trying to rescue Helen, wife of Agamemnon's brother Menelaus, from Paris, one of the sons of the Trojan King Priam. The time span covered in the poem is about 40 days, during which Homer develops events on the battlefield and behind the lines of both adversaries. From his descriptions, an elaborate evocation emerges of the splendor and tragedy of war and the inconsistencies of mortals and gods. Here is an extract from Book XX:

So these now, the Achaians, beside the curved ships were
arming around you, son of Peleus, insatiate of battle,
while on the other side at the break of the plain the Trojans
armed. But Zeus, from the many-folded peak of Olympos,
told Themis to summon all the gods into assembly. She went
everywhere, and told them to make their way to Zeus' house.
There was no river who was not there, except only Ocean,
there was not any one of the nymphs who live in the lovely
groves, and the springs of rivers and grass of the meadows,
 who came not.
These all assembling into the house of Zeus cloud gathering 10
took places among the smooth-stone cloister walks which
 Hephaistos
had built for Zeus the father by his craftsmanship and
 contrivance.
 So they were assembled within Zeus' house; and the
 shaker
of the earth did not fail to hear the goddess, but came up
 among them
from the sea, and sat in the midst of them, and asked Zeus
 of his counsel:

appearance in Greece. Whatever its inspiration, the Doric order seems to have been well established soon after 600 BC.

The best preserved temple from this period is the "Basilica" at Paestum (Fig. **4.20**). Here the flaring of the columns is exaggerated and the capitals seem unduly large, as if the architect were afraid that the lintels of the ARCHITRAVE would collapse if not supported along their length. The proportion of the width of the columns to their height gives the "Basilica" a squat appearance, without the grace of its classical successors.

"Why, lord of the shining bolt, have you called the gods to
assembly
once more? Are you deliberating Achaians and Trojans?
For the onset of battle is almost broken to flame between
them."
　　In turn Zeus who gathers the clouds spoke to him in
answer:
"You have seen, shaker of the earth, the counsel within me, 　20
and why I gathered you. I think of these men though they
are dying.
Even so, I shall stay here upon the fold of Olympos
sitting still, watching, to pleasure my heart. Meanwhile all
you others
go down, wherever you may go among the Achaians and
Trojans
and give help to either side, as your own pleasure directs
you,
for if we leave Achilleus alone to fight with the Trojans
they will not even for a little hold off swift-footed Peleion.
For even before now they would tremble whenever they
saw him,
and now, when his heart is grieved and angered for his
companion's
death, I fear against destiny he may storm their fortress." 　30
　　So spoke the son of Kronos and woke the incessant
battle,
and the gods went down to enter the fighting, with
purposes opposed.
Hera went to the assembled ships with Pallas Athene
and with Poseidon who embraces the earth, and with
generous
Hermes, who within the heart is armed with astute
thoughts.
Hephaistos went the way of these in the pride of his great
strength
limping, and yet his shrunken legs moved lightly beneath
him.
But Ares of the shining helm went over to the Trojans,
and with him Phoibos of the unshorn hair, and the lady of
arrows
Artemis, and smiling Aphrodite, Leto, and Xanthos. 　40
Now in the time when the gods were still distant from the
mortals,
so long the Achaians were winning great glory, since now
Achilleus
showed among them, who had stayed too long from the
sorrowful fighting.
But the Trojans were taken every man in the knees with
trembling
and terror, as they looked on the swift-footed son of
Peleus
shining in all his armour, a man like the murderous war
god.
But after the Olympians merged in the men's company
strong Hatred, defender of peoples, burst out, and Athene
bellowed
standing now beside the ditch dug at the wall's outside
and now again at the thundering sea's edge gave out her
great cry, 　50
while on the other side Ares in the likeness of a dark
stormcloud

bellowed, now from the peak of the citadel urging the
Trojans
sharply on, now running beside the sweet banks of
Simoeis.
So the blessed gods stirring on the opponents drove them
together, and broke out among themselves the weight of
their quarrel.
　　Thus gods went on to encounter gods; and meanwhile
Achilleus
was straining to plunge into the combat opposite Hektor,
Priam's son, since beyond all others his anger was driving
him
to glut with his blood Ares the god who fights under the
shield's guard.
But it was Aineias whom Apollo defender of people 　60
drove straight against Peleion, and inspired vast power
within him.
Zeus' son Apollo made his voice like that of Lykaon
Priam's son, and assumed his appearance, and spoke to
Aineias:
"Aineias, lord of the Trojans' counsels. Where are those
threats gone
which as you drank your wine you made before Troy's
kings, solemnly,
that you would match your battle strength with Peleian
Achilleus?"
　　In turn Aineias spoke to him in answer: "Lykaon
son of Priam, why do you urge me on against my will
to fight in the face of Peleus' son and his too great fury . . ."
　　In turn the lord the son of Zeus Apollo spoke to him: 　70
"Hero, then make your prayer, you also, to the everlasting
gods, since they say that you yourself are born of Zeus'
daughter
Aphrodite, but Achilleus was born of a lesser goddess,
Aphrodite being daughter of Zeus, Thetis of the sea's
ancient.
Carry your weariless bronze straight against him, let him by
no means
turn you back by blustering words and his threats of
terror."
So speaking, he inspired enormous strength in the
shepherd of the people,
who strode on his way among the champions helmed in
the bright bronze,
nor did Hera of the white arms fail to see the son of
Anchises
as he went through the thronging men to face the son of
Peleus, 　80
and drew the other immortals about her and spoke to
them, saying:
"Poseidon and Athene, now take counsel between you
and within your hearts as to how these matters shall be
accomplished.
Here is Aineias gone helmed in the shining bronze against
Peleus' son, and it was Phoibos Apollo who sent him.
Come then, we must even go down ourselves and turn him
back from here, or else one of us must stand by Achilleus
and put enormous strength upon him, and let him not
come short
in courage, but let him know that they love him who are
the highest

of the immortals, but those who before now fended the
 fury 90
of war, as now, from the Trojans are as wind and nothing.
For all of us have come down from Olympos to take our
 part
in this battle, so nothing may be done to him by the
 Trojans
on this day. Afterwards he shall suffer such things as
 Destiny
wove with the strand of his birth that day he was born to
 his mother.
But if Achilleus does not hear all this from gods' voices
he will be afraid, when a god puts out his strength against
 him
in the fighting. It is hard for gods to be shown in their true
 shape."
 In turn Poseidon the shaker of the earth answered her:
"Hera, do not be angry without purpose. It does not 100
become you, since I at least would not have the rest of us
 gods
encounter in battle, since indeed we are far too strong for
 them.
Let us then go away and sit down together off the path
at a viewing place, and let the men take care of their
 fighting.
Only if Ares begins to fight, or Phoibos Apollo,
or if they hold Achilleus back and will not let him fight,
then at once they will have a quarrel with us on their
 hands
in open battle. But soon, I think, when they have fought
 with us
they will get back to Olympos and the throng of the other
 gods
beaten back by the overmastering strength of our hands." 110
 So he spoke, Poseidon of the dark hair, and led the way
to the strongholds of godlike Herakles, earth-piled on both
 sides.
. . . There Poseidon and the gods who were with him sat
 down
and gathered a breakless wall of cloud to darken their
 shoulders;
while they of the other side sat down on the brows of the
 sweet bluffs
around you, lord Apollo, and Ares sacker of cities.
 So they on either side took their places, deliberating
counsels, reluctant on both sides to open the sorrowful
attack. But Zeus sitting on high above urged them on.
 But all the plain was filled and shining with bronze of
 the mortals, 120
their men and horses, and underneath their feet the earth
 staggered
as they swept together. Two men far greater than all the
 others
were coming to encounter, furious to fight with each other,
Aineias, the son of Anchises, and brilliant Achilleus.
First of the two Aineias had strode forth in menace, tossing
his head beneath the heavy helm, and he held the stark
 shield
in front of his chest, and shook the brazen spear. From the
 other
side the son of Peleus rose like a lion against him,

the baleful beast, when men have been straining to kill
 him, the county
all in the hunt, and he at the first pays them no attention 130
but goes his way, only when some one of the impetuous
 young men
has hit him with the spear he whirls, jaws open, over his
 teeth foam
breaks out, and in the depth of his chest the powerful
 heart groans;
he lashes his own ribs with his tail and the flanks on both
 sides
as he rouses himself to fury for the fight, eyes glaring,
and hurls himself straight onward on the chance of killing
 some one
of the men, or else being killed himself in the first onrush.
 So the proud heart and fighting fury stirred on Achilleus
to go forward in the face of great-hearted Aineias.
Now as these in their advance had come close to each
 other 140
first of the two to speak was swift-footed brilliant Achilleus:
"Aineias, why have you stood so far forth from the
 multitude
against me? Does the desire in your heart drive you to
 combat
in hope you will be lord of the Trojans, breakers of horses,
and of Priam's honour. And yet even if you were to kill me
Priam would not because of that rest such honour on your
 hand.
He has sons, and he himself is sound, not weakened.
Or have the men of Troy promised you a piece of land,
 surpassing
all others, fine ploughland and orchard for you to
 administer
if you kill me? But I think that killing will not be easy. 150
Another time before this, I tell you, you ran from my spear.
Or do you not remember when, apart from your cattle, I
 caught you
alone, and chased you in the speed of your feet down the
 hills of Ida
headlong, and that time as you ran you did not turn to
 look back.
Then you got away into Lyrnessos, but I went after you
and stormed that place, with the help of Athene and of
 Zeus' father,
and took the day of liberty away from their women
and led them as spoil, but Zeus and the other gods saved
 you.
I think they will not save you now, as your expectation
tells you they will. No, but I myself urge you to get back 160
into the multitude, not stand to face me, before you
take some harm. Once a thing has been done, the fool
 sees it."
 Then in turn Aineias spoke to him and made his
 answer:
"Son of Peleus, never hope by words to frighten me . . .
For you, they say you are the issue of blameless Peleus
and that your mother was Thetis of the lovely hair, the
 sea's lady;
I in turn claim I am the son of great-hearted Anchises
but that my mother was Aphrodite; and that these parents
one group or the other will have a dear son to mourn for

this day." 170

He spoke, and on the terrible grim shield drove the
 ponderous
pike, so that the great shield moaned as it took the
 spearhead.
The son of Peleus with his heavy hand held the shield
 away
from him, in fright, since he thought the far-shadowing
 spear
of great-hearted Aineias would lightly be driven through it.
Fool, and the heart and spirit in him could not understand
how the glorious gifts of the gods are not easily broken
by mortal men, how such gifts will not give way before
 them.
Nor this time could the ponderous spear of war-wise
 Aineias
smash the shield, since the gold stayed it, the god's gift.
 Indeed 180
he did drive the spear through two folds, but there were
 three left
still, since the god of the dragging feet had made five folds
 on it,
two of bronze on the outside and on the inside two of tin
and between them the single gold, and in this the ash
 spear was held fast.

After him Achilleus let go his spear far shadowing
and struck the shield of Aineias along its perfect circle
at the utter rim where the circle of bronze ran thinnest
 about it
and the oxhide was laid thinnest there. The Pelian ash
 spear
crashed clean through it there, and the shield cried out as
 it went through.
Aineias shrank down and held the shield away and above
 him 190
in fright, and the spear went over his back and crashed its
 way
to the ground, and fixed there, after tearing apart two
 circles
of the man-covering shield. But Aineias, free of the long
 spear,
stood still, and around his eyes gathered the enormous
 emotion
and fear, that the weapon had fixed so close to him. Now
 Achilleus
drew his tearing sword and swept in fury upon him
crying a terrible cry, but Aineias now in his hand caught
up a stone, a huge thing which no two men could carry
such as men are now, but by himself he lightly hefted it.
And there Aineias would have hit him with the stone as he
 swept in . . . 200
had not the shaker of the earth Poseidon sharply
 perceived all . . . [and]
went on his way through the confusion of spears and the
 fighting,
and came to where Aineias was, and renowned Achilleus.
There quickly he drifted a mist across the eyes of one
 fighter,
Achilleus, Peleus' son, and from the shield of Aineias
of the great heart pulled loose the strong bronze-headed
 ash spear
and laid it down again before the feet of Achilleus;

but Aineias he lifted high from the ground, and slung him
 through the air
so that many ranks of fighting men, many ranks of horses,
were overvaulted by Aineias, hurled by the god's hand. 210
He landed at the uttermost edge of the tossing battle
where the Kaukonians were arming them for the order of
 fighting.
And Poseidon, shaker of the earth, came and stood very
 near him
and spoke to him and addressed him in winged words:
 "Aineias,
which one of the gods is it who urges you to such madness
that you fight in the face of Peleus' son, against his high
 courage
though he is both stronger than you and dearer to the
 immortals?
Give back rather, whenever you find yourself thrown
 against him,
lest beyond your fate you go down into the house of the
 death god.
But once Achilleus has fulfilled his death and his destiny, 220
then take courage, and go on, and fight with their foremost,
since there shall be no other Achaian able to kill you."
He spoke, and left him there, when he had told him all
 this,
and at once scattered the mist away from the eyes of
 Achilleus
that the gods had sent, and now he looked with his eyes,
 and saw largely,
and in disgust spoke then to his own great-hearted spirit:
"Can this be? Here is a strange thing I see with my own
 eyes.
Here is my spear lying on the ground, but I can no longer
see the man, whom I was charging in fury to kill him.
Aineias was then one beloved of the immortal 230
gods. I thought what he said was ineffectual boasting.
Let him go. He will not again have daring to try me
in battle, since even now he was glad to escape my onset.
Come! I must urge on the Danaans whose delight is in
 battle
and go on to face the rest of the Trojans, and see what
 they can do."
. . . He spoke, urging them on, but glorious Hektor called
 out
in a great voice to the Trojans, and was minded to face
 Achilleus:
"Do not be afraid of Peleion, O high-hearted Trojans.
I myself could fight in words against the immortals,
but with the spear it were hard, since they are far stronger
 than we are. 240
Even Achilleus will not win achievement of everything
he says. Part he will accomplish, but part shall be baulked
 halfway done.
I am going to stand against him now, though his hands are
 like flame,
though his hands are like flame, and his heart like the
 shining of iron."
He spoke, urging the Trojans, and they lifted their
 spears to face them.
Their fury gathered into bulk and their battle cry rose up.
But now Phoibos Apollo stood by Hektor and spoke to
 him:

"Hektor, do not go out all alone to fight with Achilleus,
but wait for him in the multitude and out of the carnage
lest he hit you with the spear or the stroke of the sword
 from close in." 250
 He spoke, and Hektor plunged back into the swarm of
 the fighting
men, in fear, when he heard the voice of the god speaking.
But Achilleus, gathering the fury upon him, sprang on the
 Trojans
with a ghastly cry, and the first of them he killed was
 Iphition
the great son of Otrynteus and a lord over numbers of
 people,
born of a naiad nymph to Otrynteus, sacker of cities,
under the snows of Tmolos in the rich countryside of Hydé.
Great Achilleus struck him with the spear as he came in
 fury,
in the middle of the head, and all the head broke into two
 pieces.
He fell, thunderously. Great Achilleus vaunted above him: 260
"Lie there, Otrynteus' son, most terrifying of all men.
Here is your death, but your generation was by the lake
 waters
of Gyge, where is the allotted land of your fathers
by fish-swarming Hyllos and the swirling waters of
 Hermos."
 He spoke, vaunting, but darkness shrouded the eyes of
 the other,
and the running-rims of Achaian chariots cut him to pieces
in the van of the onrush. Next, after him, facing Demoleon
lord defender of battle and son of Antenor, Achilleus
stabbed him in the temple through the brazen sides of the
 helmet,
and the brazen helmet could not hold, but the bronze
 spearhead 270
driven on through smashed the bone apart, and the inward
brain was all spattered forth. So he beat him down in his
 fury.
Next he stabbed with a spear-stroke in the back
 Hippodamas
as he fled away before him and sprang from behind his
 horses.
. . . Next he went with the spear after godlike Polydoros,
Priam's son, whom his father would not let go into battle
because he was youngest born of all his sons to him, and
 also
the most beloved, and in speed of his feet outpassed all
 the others.
But now, in his young thoughtlessness and display of his
 running
he swept among the champions until thus he destroyed his
 dear life . . . 280
so before great-hearted Achilleus the single-foot horses
trampled alike dead men and shields, and the axle under
the chariot was all splashed with blood and the rails which
 encircled
the chariot, struck by flying drops from the feet of the
 horses,
from the running rims of the wheels. The son of Peleus was
 straining
to win glory, his invincible hands spattered with bloody
 filth.[3]

SUGGESTIONS FOR THOUGHT AND DISCUSSION

From about 3000 BC, the early Bronze Age, to the period between 800 and 500 BC, the civilizations of the Aegean were witness to many comings and goings. The seafaring nature of these peoples ensured contact with the other cultures of the region, from Italy to Egypt, Syria, and beyond. And they were as quick to learn from what they found as to export their own accomplishments.

The art and architecture of the Minoan, Mycenaean, and archaic Greek civilizations show a number of characteristics derived from Egyptian and Mesopotamian cultures. Think about some of the illustrations you have seen in the past three chapters. If you were to take them out of context, would you still be able to recognize them and identify to which culture they belonged? If not, try to determine why not. If you could readily identify them, think about which characteristics made that possible. Once you can describe the unique features of the art of each culture and period, you can begin making comparisons.

■ What was there about the purpose of art in the Aegean that makes it similar to or different from Egyptian and/or Mesopotamian art?

■ What techniques and styles of archaic Greek art resemble those of Egyptian art?

■ What do the materials and style of the Minoan and Mycenaean palaces reveal about their respective civilizations?

■ Choose any three pieces of sculpture, one archaic Greek, one Egyptian, and one Mesopotamian, and describe the points of similarity and difference. What effect do these features have on your own reaction to the works?

■ How does the geometric style in Greek pottery differ from the protogeometric? Does any difference in design style cause you to react differently to them?

LITERATURE EXTRACTS

The Odyssey

Homer

The *Odyssey* is the story of Odysseus' wanderings
during his return by sea from the battle of Troy,
recounted in the *Iliad*, to his home in Ithaka. In Book
Eleven, he describes his journey to the underworld,
where he meets the ghosts of many who have been
important to him.

Book XI: A Gathering of Shades

"We bore down on the ship at the sea's edge
and launched her on the salt immortal sea,
stepping our mast and spar in the black ship;
embarked the ram and ewe and went aboard
in tears, with bitter and sore dread upon us.
But now a breeze came up for us astern—
a canvas-bellying landbreeze, hale shipmate
sent by the singing nymph with sun-bright hair;
so we made fast the braces, took our thwarts,
and let the wind and steersman work the ship 10
with full sail spread all day above our coursing,
till the sun dipped, and all the ways grew dark
upon the fathomless unresting sea.

 By night
our ship ran onward toward the Ocean's bourne,
the realm and region of the Men of Winter,
hidden in mist and cloud. Never the flaming
eye of Helios lights on those men
at morning, when he climbs the sky of stars,
nor in descending earthward out of heaven; 20
ruinous night being rove over those wretches.
We made the land, put ram and ewe ashore,
and took our way along the Ocean stream
to find the place foretold for us by Kirke.
There Perimedes and Eurylokhos
pinioned the sacred beasts. With my drawn blade
I spaded up the votive pit, and poured
libations round it to the unnumbered dead:
sweet milk and honey, then sweet wine, and last
clear water; and I scattered barley down. 30
Then I addressed the blurred and breathless dead,
vowing to slaughter my best heifer for them
before she calved, at home in Ithaka,
and burn the choice bits on the altar fire;
as for Teiresias, I swore to sacrifice
a black lamb, handsomest of all our flock.
Thus to assuage the nations of the dead
I pledged these rites, then slashed the lamb and ewe,
letting their black blood stream into the wellpit.
Now the souls gathered, stirring out of Erebos, 40
brides and young men, and men grown old in pain,
and tender girls whose hearts were new to grief;
many were there, too, torn by brazen lanceheads,

battle-slain, bearing still their bloody gear.
From every side they came and sought the pit
with rustling cries: and I grew sick with fear.
But presently I gave command to my officers
to flay those sheep the bronze cut down, and make
burnt offerings of flesh to the gods below—
to sovereign Death, to pale Persephone. 50
Meanwhile I crouched with my drawn sword to keep
the surging phantoms from the bloody pit
till I should know the presence of Teiresias.

One shade came first—Elpenor, of our company,
who lay unburied still on the wide earth
as we had left him—dead in Kirke's hall,
untouched, unmourned, when other cares compelled us.
Now when I saw him there I wept for pity
and called out to him:

 'How is this, Elpenor,
how could you journey to the western gloom 60
swifter afoot than I in the black lugger?'

He sighed, and answered:

 'Son of great Laertes,
Odysseus, master mariner and soldier,
bad luck shadowed me, and no kindly power;
ignoble death I drank with so much wine.
I slept on Kirke's roof, then could not see
the long steep backward ladder, coming down,
and fell that height. My neck bone, buckled under,
snapped, and my spirit found this well of dark.
Now hear the grace I pray for, in the name 70
of those back in the world, not here—your wife
and father, he who gave you bread in childhood,
and your own child, your only son, Telemakhos,
long ago left at home.

 When you make sail
and put these lodgings of dim Death behind,
you will moor ship, I know, upon Aiaia Island;
there, O my lord, remember me, I pray,
do not abandon me unwept, unburied,
to tempt the gods' wrath, while you sail for home;
but fire my corpse, and all the gear I had, 80
and build a cairn for me above the breakers—
an unknown sailor's mark for men to come.
Heap up the mound there, and implant upon it
the oar I pulled in life with my companions.'

He ceased, and I replied:

 'Unhappy spirit,
I promise you the barrow and the burial.'

So we conversed, and grimly, at a distance,
with my long sword between, guarding the blood,
while the faint image of the lad spoke on.
Now came the soul of Antikleia, dead, 90
my mother, daughter of Autolykos,
dead now, though living still when I took ship
for holy Troy. Seeing this ghost I grieved,

but held her off, through pang on pang of tears,
till I should know the presence of Teiresias.
Soon from the dark that prince of Thebes came forward
bearing a golden staff; and he addressed me:

'Son of Laertes and the gods of old,
Odysseus, master of land ways and sea ways,
why leave the blazing sun, O man of woe, 100
to see the cold dead and the joyless region?
Stand clear, put up your sword;
let me but taste of blood, I shall speak true.'

At this I stepped aside, and in the scabbard
let my long sword ring home to the pommel silver,
as he bent down to the sombre blood. Then spoke
the prince of those with gift of speech:
 'Great captain,
a fair wind and the honey lights of home
are all you seek. But anguish lies ahead;
the god who thunders on the land prepares it, 110
not to be shaken from your track, implacable,
in rancor for the son whose eye you blinded.
One narrow strait may take you through his blows:
denial of yourself, restraint of shipmates.
When you make landfall on Thrinakia first
and quit the violet sea, dark on the land
you'll find the grazing herds of Helios
by whom all things are seen, all speech is known.
Avoid those kine, hold fast to your intent,
and hard seafaring brings you all to Ithaka. 120
But if you raid the beeves, I see destruction
for ship and crew. Though you survive alone,
bereft of all companions, lost for years,
under strange sail shall you come home, to find
your own house filled with trouble: insolent men
eating your livestock as they court your lady.
Aye, you shall make those men atone in blood!
But after you have dealt out death—in open
combat or by stealth—to all the suitors,
go overland on foot, and take an oar, 130
until one day you come where men have lived
with meat unsalted, never known the sea,
nor seen seagoing ships, with crimson bows
and oars that fledge light hulls for dipping flight.
The spot will soon be plain to you, and I
can tell you how: some passerby will say,
"What winnowing fan is that upon your shoulder?"
Halt, and implant your smooth oar in the turf
and make fair sacrifice to Lord Poseidon:
a ram, a bull, a great buck boar; turn back, 140
and carry out pure hekatombs at home
to all wide heaven's lords, the undying gods,
to each in order. Then a seaborne death
soft as this hand of mist will come upon you
when you are wearied out with rich old age,
your country folk in blessed peace around you.
And all this shall be just as I foretell.'

When he had done, I said at once,
 'Teiresias,
my life runs on then as the gods have spun it.
But come, now, tell me this; make this thing clear: 150

I see my mother's ghost among the dead
sitting in silence near the blood. Not once
has she glanced this way toward her son, nor spoken.
Tell me, my lord,
may she in some way come to know my presence?'

To this he answered:

 'I shall make it clear
in a few words and simply. Any dead man
whom you allow to enter where the blood is
will speak to you, and speak the truth; but those
deprived will grow remote again and fade.' 160

When he had prophesied, Teiresias' shade
retired lordly to the halls of Death;
but I stood fast until my mother stirred,
moving to sip the black blood; then she knew me
and called out sorrowfully to me:

 'Child,
how could you cross alive into this gloom
at the world's end?—No sight for living eyes;
great currents run between, desolate waters,
the Ocean first, where no man goes a journey
without ship's timber under him.

 Say, now, 170
is it from Troy, still wandering, after years,
that you come here with ship and company?
Have you not gone at all to Ithaka?
Have you not seen your lady in your hall?'

She put these questions, and I answered her:

'Mother, I came here, driven to the land of death
in want of prophecy from Teiresias' shade;
nor have I yet coasted Akhaia's hills
nor touched my own land, but have had hard roving
since first I joined Lord Agamemnon's host 180
by sea for Ilion, the wild horse country,
to fight the men of Troy.
But come now, tell me this, and tell me clearly,
what was the bane that pinned you down in Death?
Some ravaging long illness, or mild arrows
a-flying down one day from Artemis?
Tell me of Father, tell me of the son
I left behind me; have they still my place,
my honors, or have other men assumed them?
Do they not say that I shall come no more? 190
And tell me of my wife: how runs her thought,
still with her child, still keeping our domains,
or bride again to the best of the Akhaians?'

To this my noble mother quickly answered:

'Still with her child indeed she is, poor heart,
still in your palace hall. Forlorn her nights
and days go by, her life used up in weeping.
But no man takes your honored place. Telemakhos
has care of all your garden plots and fields,
and holds the public honor of a magistrate, 200
feasting and being feasted. But your father
is country bound and comes to town no more.
He owns no bedding, rugs, or fleecy mantles,
but lies down, winter nights, among the slaves,

rolled in old cloaks for cover, near the embers.
Or when the heat comes at the end of summer,
the fallen leaves, all round his vineyard plot,
heaped into windrows, make his lowly bed.
He lies now even so, with aching heart,
and longs for your return, while age comes on him. 210
So I, too, pined away, so doom befell me, not
that the keen-eyed huntress with her shafts
had marked me down and shot to kill me; not
that illness overtook me—no true illness
wasting the body to undo the spirit;
only my loneliness for you, Odysseus,
for your kind heart and counsel, gentle Odysseus,
took my own life away.'

 I bit my lip,
rising perplexed, with longing to embrace her,
and tried three times, putting my arms around her, 220
but she went sifting through my hands, impalpable
as shadows are, and wavering like a dream.
Now this embittered all the pain I bore,
and I cried in the darkness:

 'O my mother,
will you not stay, be still, here in my arms,
may we not, in this place of Death, as well,
hold one another, touch with love, and taste
salt tears' relief, the twinge of welling tears?
Or is this all hallucination, sent
against me by the iron queen, Persephone, 230
to make me groan again?'

 My noble mother
answered quickly:

 'O my child—alas
most sorely tried of men—great Zeus's daughter,
Persephone, knits no illusions for you.
All mortals meet this judgment when they die.
No flesh and bone are here, none bound by sinew,
since the bright-hearted pyre consumed them down—
the white bones long exanimate—to ash;
dreamlike the soul flies, insubstantial.

You must crave sunlight soon.

 Note all things strange 240
seen here, to tell your lady in after days.'

So went our talk; then other shadows came,
ladies in company, sent by Persephone—
consorts or daughters of illustrious men—
crowding about the black blood.

 I took thought
how best to separate and question them,
and saw no help for it, but drew once more
the long bright edge of broadsword from my hip,
that none should sip the blood in company
but one by one, in order; so it fell 250
that each declared her lineage and name.

Here was great loveliness of ghosts! I saw
before them all, that princess of great ladies,
Tyro, Salmoneus' daughter, as she told me,
and queen to Kretheus, a son of Aiolos.
She had gone daft for the river Enipeus,
most graceful of all running streams, and ranged

all day by Enipeus' limpid side,
whose form the foaming girdler of the islands,
the god who makes earth tremble, took and so 260
lay down with her where he went flooding seaward,
their bower a purple billow, arching round
to hide them in a sea-vale, god and lady.
Now when his pleasure was complete, the god
spoke to her softly, holding fast her hand:

'Dear mortal, go in joy! At the turn of seasons,
winter to summer, you shall bear me sons;
no lovemaking of gods can be in vain.
Nurse our sweet children tenderly, and rear them.
Home with you now, and hold your tongue, and tell 270
no one your lover's name—though I am yours,
Poseidon, lord of surf that makes earth tremble.'

He plunged away into the deep sea swell,
and she grew big with Pelias and Neleus,
powerful vassals, in their time, of Zeus.
Pelias lived on broad Iolkos seaboard
rich in flocks, and Neleus at Pylos.
As for the sons borne by that queen of women
to Kretheus, their names were Aison, Pheres,
and Amythaon, expert charioteer. 280

Next after her I saw Antiope,
daughter of Asopos. She too could boast
a god for lover, having lain with Zeus
and borne two sons to him: Amphion and
Zethos, who founded Thebes, the upper city,
and built the ancient citadel. They sheltered
no life upon that plain, for all their power,
without a fortress wall.

 And next I saw
Amphitrion's true wife, Alkmene, mother,
as all men know, of lionish Herakles, 290
conceived when she lay close in Zeus's arms;
and Megare, high-hearted Kreon's daughter,
wife of Amphitrion's unwearying son.

I saw the mother of Oedipus, Epikaste,
whose great unwitting deed it was
to marry her own son. He took that prize
from a slain father; presently the gods
brought all to light that made the famous story.
But by their fearsome wills he kept his throne
in dearest Thebes, all through his evil days, 300
while she descended to the place of Death,
god of the locked and iron door. Steep down
from a high rafter, throttled in her noose,
she swung, carried away by pain, and left him
endless agony from a mother's Furies.

And I saw Khloris, that most lovely lady,
whom for her beauty in the olden time
Neleus wooed with countless gifts, and married.
She was the youngest daughter of Amphion,
son of Iasos. In those days he held 310
power at Orkhomenos, over the Minyai.
At Pylos then as queen she bore her children—
Nestor, Khromios, Periklymenos,
and Pero, too, who turned the heads of men

with her magnificence. A host of princes
from nearby lands came courting her; but Neleus
would hear of no one, not unless the suitor
could drive the steers of giant Iphiklos
from Phylake—longhorns, broad in the brow, 320
so fierce that one man only, a diviner,
offered to round them up. But bitter fate
saw him bound hand and foot by savage herdsmen.
Then days and months grew full and waned, the year
went wheeling round, the seasons came again,
before at last the power of Iphiklos,
relenting, freed the prisoner, who foretold
all things to him. So Zeus's will was done.

And I saw Leda, wife of Tyndareus,
upon whom Tyndareus had sired twins
indomitable: Kastor, tamer of horses, 330
and Polydeukes, best in the boxing ring.
Those two live still, though life-creating earth
embraces them: even in the underworld
honored as gods by Zeus, each day in turn
one comes alive, the other dies again.
Then after Leda to my vision came
the wife of Aloeus, Iphimedeia,
proud that she once had held the flowing sea
and borne him sons, thunderers for a day,
the world-renowned Otos and Ephialtes. 340
Never were men on such a scale
bred on the plowlands and the grainlands, never
so magnificent any, after Orion.
At nine years old they towered nine fathoms tall,
nine cubits in the shoulders, and they promised
furor upon Olympos, heaven broken by battle cries,
the day they met the gods in arms.
 With Ossa's
mountain peak they meant to crown Olympos
and over Ossa Pelion's forest pile
for footholds up the sky. As giants grown 350
they might have done it, but the bright son of Zeus
by Leto of the smooth braid shot them down
while they were boys unbearded; no dark curls
clustered yet from temples to the chin.

Then I saw Phaidra, Prokris; and Ariadne,
daughter of Minos, the grim king. Theseus took her
aboard with him from Krete for the terraced land
of ancient Athens; but he had no joy of her.
Artemis killed her on the Isle of Dia
at a word from Dionysos.
 Maira, then, 360
and Klymene, and that detested queen,
Eriphyle, who betrayed her lord for gold . . .
but how name all the women I beheld there,
daughters and wives of kings? The starry night
wanes long before I close.
 Here, or aboard ship,
amid the crew, the hour for sleep has come.
Our sailing is the gods' affair and yours."

Then he fell silent. Down the shadowy hall
the enchanted banqueters were still. Only
the queen with ivory pale arms, Arete, spoke, 370
saying to all the silent men:

 "Phaiakians,
how does he stand, now, in your eyes, this captain,
the look and bulk of him, the inward poise?
He is my guest, but each one shares that honor.
Be in no haste to send him on his way
or scant your bounty in his need. Remember
how rich, by heaven's will, your possessions are."

Then Ekheneos, the old soldier, eldest
of all Phaiakians, added his word:

"Friends, here was nothing but our own thought spoken, 380
the mark hit square. Our duties to her majesty.
For what is to be said and done,
we wait upon Alkinoos' command."

At this the king's voice rang:

 "I so command—
as sure as it is I who, while I live,
rule the sea rovers of Phaiakia. Our friend
longs to put out for home, but let him be
content to rest here one more day, until
I see all gifts bestowed. And every man
will take thought for his launching and his voyage, 390
I most of all, for I am master here."

Odysseus, the great tactician, answered:

"Alkinoos, king and admiration of men,
even a year's delay, if you should urge it,
in loading gifts and furnishing for sea—
I too could wish it: better far that I
return with some largesse of wealth about me—
I shall be thought more worthy of love and courtesy
by every man who greets me home in Ithaka."

The king said:

 "As to that, one word, Odysseus: 400
from all we see, we take you for no swindler—
though the dark earth be patient of so many,
scattered everywhere, baiting their traps with lies
of old times and of places no one knows.
You speak with art, but your intent is honest.
The Argive troubles, and your own troubles,
you told as a poet would, a man who knows the world.
But now come tell me this: among the dead
did you meet any of your peers, companions
who sailed with you and met their doom at Troy? 410
Here's a long night—an endless night—before us,
and no time yet for sleep, not in this hall.
Recall the past deeds and the strange adventures.
I could stay up until the sacred Dawn
as long as you might wish to tell your story."

Odysseus the great tactician answered:

"Alkinoos, king and admiration of men,
there is a time for story telling; there is
also a time for sleep. But even so,
if, indeed, listening be still your pleasure, 420
I must not grudge my part. Other and sadder
tales there are to tell, of my companions,
of some who came through all the Trojan spears,
clangor and groan of war,

only to find a brutal death at home—
and a bad wife behind it.

 After Persephone,
icy and pale, dispersed the shades of women,
the soul of Agamemnon, son of Atreus,
came before me, sombre in the gloom,
and others gathered round, all who were with him 430
when death and doom struck in Aegisthos' hall.
Sipping the black blood, the tall shade perceived me,
and cried out sharply, breaking into tears;
then tried to stretch his hands toward me, but could not,
being bereft of all the reach and power
he once felt in the great torque of his arms.
Gazing at him, and stirred, I wept for pity,
and spoke across to him:

 'O son of Atreus,
illustrious Lord Marshal, Agamemnon,
what was the doom that brought you low in death?
Were you at sea, aboard ship, and Poseidon 440
blew up a wicked squall to send you under,
or were you cattle-raiding on the mainland
or in a fight for some strongpoint, or women,
when the foe hit you to your mortal hurt?'

But he replied at once:

 'Son of Laertes,
Odysseus, master of land ways and sea ways,
neither did I go down with some good ship
in any gale Poseidon blew, nor die
upon the mainland, hurt by foes in battle.
It was Aigisthos who designed my death, 450
he and my heartless wife, and killed me, after
feeding me, like an ox felled at the trough.
That was my miserable end—and with me
my fellows butchered, like so many swine
killed for some troop, or feast, or wedding banquet
in a great landholder's household. In your day
you have seen men, and hundreds, die in war,
in the bloody press, or downed in single combat,
but these were murders you would catch your breath at:
think of us fallen, all our throats cut, winebowl 460
brimming, tables laden on every side,
while blood ran smoking over the whole floor.
In my extremity I heard Kassandra,
Priam's daughter, piteously crying
as the traitress Klytaimnestra made to kill her
along with me. I heaved up from the ground
and got my hands around the blade, but she
eluded me, that whore. Now would she close
my two eyes as my soul swam to the underworld
or shut my lips. There is no being more fell, 470
more bestial than a wife in such an action,
and what an action that one planned!
The murder of her husband and her lord.
Great god, I thought my children and my slaves
at least would give me welcome. But that woman,
plotting a thing so low, defiled herself
and all her sex, all women yet to come,
even those few who may be virtuous.'

He paused then, and I answered:

 'Foul and dreadful.
That was the way that Zeus who views the wide world 480
vented his hatred on the sons of Atreus—
intrigues of women, even from the start.

 Myriads
died by Helen's fault, and Klytaimnestra
plotted against you half the world away.'

And he at once said:

 'Let it be a warning
even to you. Indulge a woman never,
and never tell her all you know. Some things
a man may tell, some he should cover up.
Not that I see a risk for you, Odysseus,
of death at your wife's hands. She is too wise, 490
too clear-eyed, sees alternatives too well,
Penelope, Ikarios' daughter—
that young bride whom we left behind—think of it!—
when we sailed off to war. The baby boy
still cradled at her breast—now he must be
a grown man, and a lucky one. By heaven,
you'll see him yet, and he'll embrace his father
with old fashioned respect, and rightly.

 My own
lady never let me glut my eyes
on my own son, but bled me to death first. 500
One thing I will advise, on second thought;
stow it away and ponder it.

 Land your ship
in secret on your island; give no warning.
The day of faithful wives is gone forever.
But tell me, have you any word at all
about my son's life? Gone to Orkhomenos
or sandy Pylos, can he be? Or waiting
with Menelaos in the plain of Sparta?
Death on earth has not yet taken Orestes.'

But I could only answer:

 'Son of Atreus, 510
why do you ask these questions of me? Neither
news of home have I, nor news of him,
alive or dead. And empty words are evil.'

So we exchanged our speech, in bitterness,
weighed down by grief, and tears welled in our eyes,
when there appeared the spirit of Akhilleus,
son of Peleus; then Patroklos' shade,
and then Antilokhos, and then Aias,
first among all the Danaans in strength
and bodily beauty, next to prince Akhilleus. 520
Now that great runner, grandson of Aiakhos,
recognized me and called across to me:

'Son of Laertes and the gods of old,
Odysseus, master mariner and soldier,
old knife, what next? What greater feat remains
for you to put your mind on, after this?
How did you find your way down to the dark
where these dimwitted dead are camped forever,
the after images of used-up men?'

 I answered:

'Akhilleus, Peleus' son, strongest of all 530

among the Akhaians, I had need of foresight
such as Teiresias alone could give
to help me, homeward bound for the crags of Ithaka.
I have not yet coasted Akhaia, not yet
touched my land; my life is all adversity.
But was there ever a man more blest by fortune
than you, Akhilleus? Can there ever be?
We ranked you with immortals in your lifetime,
we Argives did, and here your power is royal
among the dead men's shades. Think, then, Akhilleus: 540
you need not be so pained by death.'

To this
he answered swiftly:
'Let me hear no smooth talk
of death from you, Odysseus, light of councils.
Better, I say, to break sod as a farm hand
for some poor country man, on iron rations,
than lord it over all the exhausted dead.
Tell me, what news of the prince my son: did he
come after me to make a name in battle
or could it be he did not? Do you know
if rank and honor still belong to Peleus 550
in the towns of the Myrmidons? Or now, may be,
Hellas and Phthia spurn him, seeing old age
fetters him, hand and foot. I cannot help him
under the sun's rays, cannot be that man
I was on Troy's wide seaboard, in those days
when I made bastion for the Argives
and put an army's best men in the dust.
Were I but whole again, could I go now
to my father's house, one hour would do to make
my passion and my hands no man could hold 560
hateful to any who shoulder him aside.'

Now when he paused I answered:
'Of all that—
of Peleus' life, that is—I know nothing;
but happily I can tell you the whole story
of Neoptolemos, as you require.
In my own ship I brought him out from Skyros
to join the Akhaians under arms.
And I can tell you,
in every council before Troy thereafter
your son spoke first and always to the point;
no one but Nestor and I could out-debate him. 570
And when we formed against the Trojan line
he never hung back in the mass, but ranged
far forward of his troops—no man could touch him
for gallantry. Aye, scores went down before him
in hard fights man to man. I shall not tell
all about each, or name them all—the long
roster of enemies he put out of action,
taking the shock of charges on the Argives.
But what a champion his lance ran through
in Eurypulos the son of Telephos! Keteians 580
in throngs around that captain also died—
all because Priam's gifts had won his mother
to send the lad to battle; and I thought
Memnon alone in splendor ever outshone him.

But one fact more: while our picked Argive crew
still rode that hollow horse Epeios built,
and when the whole thing lay with me, to open
the trapdoor of the ambuscade or not,
at that point our Danaan lords and soldiers
wiped their eyes, and their knees began to quake, 590
all but Neoptolemos. I never saw
his tanned cheek change color or his hand
brush one tear away. Rather he prayed me,
hand on hilt, to sortie, and he gripped
his tough spear, bent on havoc for the Trojans.
And when we had pierced and sacked Priam's tall city
he loaded his choice plunder and embarked
with no scar on him; not a spear had grazed him
nor the sword's edge in close work—common wounds
one gets in war. Ares in his mad fits 600
knows no favorites.'

But I said no more,
for he had gone off striding the field of asphodel,
the ghost of our great runner, Akhilleus Aiakides,
glorying in what I told him of his son.

Now other souls of mournful dead stood by,
each with his troubled questioning, but one
remained alone, apart: the son of Telamon,
Aias, it was—the great shade burning still
because I had won favor on the beachhead
in rivalry over Akhilleus' arms. 610
The Lady Thetis, mother of Akhilleus,
laid out for us the dead man's battle gear,
and Trojan children, with Athena,
named the Danaan fittest to own them. Would
god I had not borne the palm that day!
For earth took Aias then to hold forever,
the handsomest and, in all feats of war,
noblest of the Danaans after Akhilleus.
Gently therefore I called across to him:
'Aias, dear son of royal Telamon, 620
you would not then forget, even in death,
your fury with me over those accurst
calamitous arms?—and so they were, a bane
sent by the gods upon the Argive host.
For when you died by your own hand we lost
a tower, formidable in war. All we Akhaians
mourn you forever, as we do Akhilleus;
and no one bears the blame but Zeus.
He fixed that doom for you because he frowned
on the whole expedition of our spearmen. 630
My lord, come nearer, listen to our story!
Conquer your indignation and your pride.'

But he gave no reply, and turned away,
following other ghosts toward Erebos.
Who knows if in that darkness he might still
have spoken, and I answered?

But my heart
longed, after this, to see the dead elsewhere.

And now there came before my eyes Minos,
the son of Zeus, enthroned, holding a golden staff,
dealing out justice among ghostly pleaders
arrayed about the broad doorways of Death. 640

And then I glimpsed Orion, the huge hunter,
gripping his club, studded with bronze, unbreakable,
with wild beasts he had overpowered in life
on lonely mountainsides, now brought to bay
on fields of asphodel.
 And I saw Tityos,
the son of Gaia, lying
abandoned over nine square rods of plain.
Vultures, hunched above him, left and right,
rifling his belly, stabbed into the liver,
and he could never push them off.
 This hulk 650
had once committed rape of Zeus's mistress,
Leto, in her glory, when she crossed
the open grass of Panopeus toward Pytho.

Then I saw Tantalos put to the torture:
in a cool pond he stood, lapped round by water
clear to the chin, and being athirst he burned
to slake his dry weasand with drink, though drink
he would not ever again. For when the old man
put his lips down to the sheet of water
it vanished round his feet, gulped underground, 660
and black mud baked there in a wind from hell.
Boughs, too, drooped low above him, big with fruit,
pear trees, pomegranates, brilliant apples,
luscious figs, and olives ripe and dark;
but if he stretched his hand for one, the wind
under the dark sky tossed the bough beyond him.

Then Sisyphos in torment I beheld
being roustabout to a tremendous boulder.
Leaning with both arms braced and legs driving,
he heaved it toward a height, and almost over, 670
but then a Power spun him round and sent
the cruel boulder bounding again to the plain.
Whereon the man bent down again to toil,
dripping sweat, and the dust rose overhead.
Next I saw manifest the power of Herakles—
a phantom, this, for he himself has gone
feasting amid the gods, reclining soft
with Hebe of the ravishing pale ankles,

daughter of Zeus and Hera, shod in gold.
But, in my vision, all the dead around him 680
cried like affrighted birds; like Night itself
he loomed with naked bow and nocked arrow
and glances terrible as continual archery.
My hackles rose at the gold swordbelt he wore
sweeping across him: gorgeous intaglio
of savage bears, boars, lions with wildfire eyes,
swordfights, battle, slaughter, and sudden death—
the smith who had that belt in him, I hope
he never made, and never will make, another.
The eyes of the vast figure rested on me, 690
and of a sudden he said in kindly tones:

'Son of Laertes and the gods of old,
Odysseus, master mariner and soldier,
under a cloud, you too? Destined to grinding
labors like my own in the sunny world?
Son of Kronion Zeus or not, how many
days I sweated out, being bound in servitude
to a man far worse than I, a rough master!
He made me hunt this place one time
to get the watchdog of the dead: no more 700
perilous task, he thought, could be; but I
brought back that beast, up from the underworld;
Hermes and grey-eyed Athena showed the way.'

And Herakles, down the vistas of the dead,
faded from sight; but I stood fast, awaiting
other great souls who perished in times past.
I should have met, then, god-begotten Theseus
and Peirithoos, whom both I longed to see,
but first came shades in thousands, rustling
in a pandemonium of whispers, blown together, 710
and the horror took me that Persephone
had brought from darker hell some saurian death's head.
I whirled then, made for the ship, shouted to crewmen
to get aboard and cast off the stern hawsers,
an order soon obeyed. They took their thwarts,
and the ship went leaping toward the stream of Ocean
first under oars, then with a following wind."

God's Wildering Daughter
Sappho

God's wildering daughter deathless Aphrodita,
A whittled perplexity your bright abstruse chair,
With heartbreak, lady, and breathlessness
Tame not my heart.

But come down to me, as you came before,
For if ever I cried, and you heard and came,
Come now, of all times, leaving
Your father's golden house

In that chariot pulled by sparrows reined and bitted,
Swift in their flying, a quick blur aquiver,
Beautiful, high. They drew you across steep air
Down to the black earth;

Fast they came, and you behind them. O
Hilarious heart, your face all laughter.
Asking, What troubles you this time, why again
Do you call me down?

Asking, In your wild heart, who now
Must you have? Who is she that persuasion
Fetch her, enlist her, and put her into bounden love?
Sappho, who does you wrong?

If she balks, I promise, soon she'll chase,
If she's turned from gifts, now she'll give them.
And if she does not love you, she will love,
Helpless, she will love.

Come, then, loose me from cruelties.
Give my tethered heart its full desire.
Fulfill, and, come, lock your shield with mine
Throughout the siege.

The Orchard
Sappho

Cold water falls between the apple-trees
And climbing roses over-arch their shade,
And rustling in the leafy boughs the breeze
 Lulls every sense.

He Seems to be a God, that Man
Sappho

He seems to be a god, that man
Facing you, who leans to be close,
Smiles, and, alert and glad, listens
To your mellow voice

And quickens in love at your laughter.
That stings my breasts, jolts my heart
If I dare the shock of a glance.
I cannot speak,

My tongue sticks to my dry mouth,
Thin fire spreads beneath my skin,
My eyes cannot see and my aching ears
Roar in their labyrinths.

Chill sweat slides down my body,
I shake, I turn greener than grass.
I am neither living nor dead and cry
From the narrow between.

But endure, even [this grief of love.]

An Absent Friend
Sappho

A glorious goddess in her eyes
Were you, her comrade, and your songs
Above all other songs she'd prize.

With Lydian women now she dwells
Surpassing them, as when day dies
The rosy-fingered moon excels

The host of stars, and light illumes
The salt sea and the cornland glows
With light upon its thousand blooms.

In loveliness the dew spills over
And with new strength revives the rose,
Slim grasses and the flowering clover.

But sadly up and down she goes,
Remembering Atthis, once her lover,
And in her heart sick longing grows.

CHAPTER FIVE

GREEK CLASSICISM AND HELLENISM

Under the ruler Pericles, classical Greek culture reached its zenith. To that civilization and its works western culture has returned for nourishment for over 2000 years. In the brief span of time between approximately 600 BC and 200 BC, Greek influence and civilization spread throughout the Mediterranean world until, under Alexander the Great, it stretched—for the space of a single lifetime—from Spain to the Indus River. All this was achieved by a people whose culture, at its height, took the human intellect as its measure. In society, as in the arts, rationality, clarity, and beauty of form were the goal. And as the style we call Hellenism developed in the fourth century BC, artists increasingly sought to imbue their works with feeling as well. Plato and Aristotle meanwhile explored adjacent paths to an understanding of reality and the possibility of its representation.

5.1 The Parthenon, Athens, 447–438 BC.

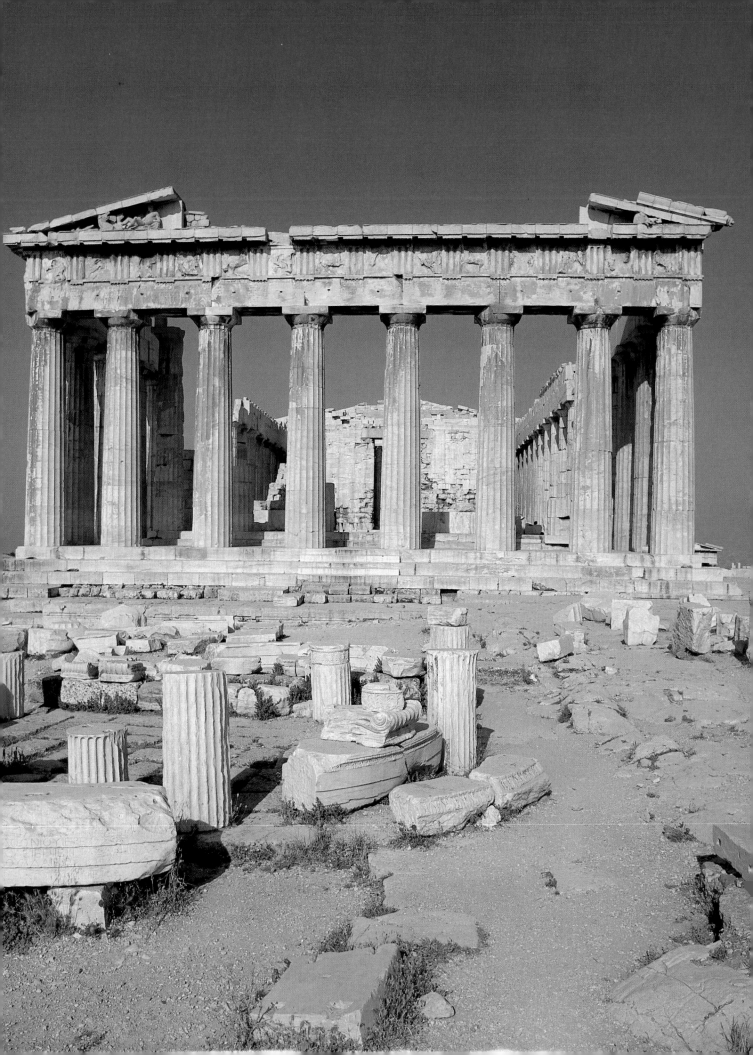

CONTEXTS AND CONCEPTS

ATHENS' GOLDEN AGE

War and victory hurled Athens into its golden age. Early in the fifth century BC, the Persians, under Xerxes I, threatened conquest of the Greek peninsula: in 480 BC, they occupied Athens after its citizens had fled, and destroyed it. The Greeks retaliated and, within a year, they had defeated the Persian fleet at Salamis and driven out the Persian armies.

Claiming to be the saviors of Greece, the Athenians set about liberating the rest of the country. Several city–states banded together with Athens to form the Delian League in 478 BC. The League took its name from the Ionian island of Delos, where the group met and stored its money. Delos was the site of the shrine of Apollo, and such sanctuaries were always chosen as treasuries so that the god would guard them. The states made a contract, and the signatories agreed to follow a common foreign policy and to contribute ships and/or money, as Athens deemed necessary. Athens contributed the most money and commanded the fleet. What followed was a systematic liberation of the Greek cities around the Aegean, and the conquest of some islands populated by non-Greeks. The Delian League became, in fact, a highly prosperous Athenian empire.

These events—the destruction of Athens, the victory over the Persians, and the formation of the Delian League—helped to transform the young democracy of Athens, with its thriving commerce, unique religion, and inquisitive philosophies, into a culture of immense artistic achievement. The ruined city had to be rebuilt, and the spirit of victory and heroics prevailed. The Delian treasury, moved to Athens by Pericles, was used to help finance the immense costs of reconstruction.

Athens had witnessed a succession of rulers, and an interesting form of democracy had gradually emerged. Historians estimate that when Pericles came to power, in 461 BC, the population of Athens was approximately 230,000 people. Approximately 40,000 of these were free male citizens; 40,000 were Athenian women; 50,000 were foreign born; and 100,000 were slaves. Athenian democracy, however, allowed only free male citizens to vote, and the tyrant, or ruler, wielded considerable power. This power emanated principally from ownership of land. Private estates provided not only for the tyrant's individual welfare, but also for the horses and arms necessary to make him a leader in warfare. The word "tyrant" did not assume negative connotations until much later. In fact, the Greek tyrants seem in general to have

been especially benevolent. They were not necessarily aristocrats, and their claims to leadership were often based on their popularity among the citizens.

The central factor in Greek politics remained the sanctity of the *polis*, or city. More than an organized conglomeration of people, the polis was also a community, which was aware of the interests of the whole group as opposed to individual interest.

By the fifth century BC, Athens was the richest of Greek city–states. Greek law had been reformed by the great Athenian lawmaker Solon, and after 508 BC, constitutional changes created a complex of institutions that became the foundations of an almost pure form of democracy. All political decisions were made, in principle at least, by a majority vote of the citizens. Conditions were now right for an age of high cultural achievement. By historical standards, the golden age of Athens was very brief. Indeed, it lasted less than three-quarters of a century. Nevertheless, that latter half of the fifth century BC was one of the most significant periods in western civilization.

War and victory ushered in the golden age of Athens, but war and defeat brought it to a close. Its decline began in the middle of the century with the onset of the Peloponnesian Wars between Athens and the rival city–state of Sparta. Although the military skill of the Athenians had led to the defeat of the Persians early in the fifth century BC, theirs was not a militaristic society. What they accomplished in the arts they could not carry over to the pursuit of military strategy. Between 461 and 429 BC, through what seem to us now like blunders, Pericles led Athens toward defeat in a war of attrition with its Spartan adversaries. As Athenian glory waned, a more realistic attitude grew: the heroics of victory turned into the reality of defeat. This change in outlook was marked by a shift from idealism toward naturalism in the arts as well.

Although Sparta achieved political dominance, it did not assume cultural leadership. Spartan society was rigorous, militaristic, and not particularly rich in culture. In fact, the term "spartan" now denotes austerity, self-discipline, political rigidity, and general fortitude—conditions basic to Sparta and its values. Therefore, the Athenian influence on Greek aesthetic life was not superseded by Sparta, and it continued to flourish despite Athens' diminished role as a political power.

During the late fifth and early fourth centuries BC, a new and more powerful Athenian middle class arose. Athenian thought was now dominated by the sting of

defeat, the popularity of rational, Sophist philosophy, and Aristotle's scientific EMPIRICISM, which had supplanted Plato's absolute ideas. Idealism and intellectualism were gradually giving way to emotionalism.

HUMANISM AND INTELLECTUALISM

The classical Greeks laid great emphasis on human rationality and the intellect. However, such an emphasis did not preclude a profound respect for the irrational and the mysterious. The Greeks recognized oracles and omens. They made pilgrimages to the shrines of Apollo's oracle at Delphi and at Didyma and there solicited advice which was respected, if not always lucid. Numerous religious cults celebrated the cycle of the seasons and encouraged the fertility of the earth by performing mysterious and secret rites. Greek dance and drama developed from these rites, and belief in the supernatural and the darker forces of human irrationality lies close to the heart of the great classical tragedies.

Philosophy was an important discipline in Greek culture. A keen mind and a desire to answer life's critical questions were considered noble qualities. Under Pericles, philosophers such as Thales, Anaximander, and Heraclitus had great influence. They wrestled with questions such as "What is the basic element of which the universe is composed?" [Water.] "How do specific things emerge from the basic elements?" [By "separating out."] "What guides the process of change?" [The universe is in a constant flow. Nothing *is*; everything is *becoming*.]

SOPHISTRY: THE DISTRUST OF REASON
Humankind: "The measure of all things"

The middle of the fifth century BC was the end of a cycle of constructive activity and the beginning of a period of criticism and skepticism. All established beliefs and standards, whether religious, moral, or scientific, came under fire. Reason, it was argued, had led only to deception. The agonies of the Peloponnesian Wars, combined with a new awareness that the value systems of other cultures seemed to work just as well as the value system of Athens, gave rise to the adoption of realism, as opposed to idealism, and relativism, as opposed to absolutism.

Skepticism emerged in an Athens torn by disputes and ruled by a form of democracy that depended on persuasion and practicality. Debating skills were thus an absolute necessity, and these conditions produced teachers of rhetoric. Those who championed this new utilitarian art of persuasion were called "Sophists," or "wise ones." They were well versed in rhetoric, grammar, diction, logical argument, as well as behind-the-scenes intrigue, and the Sophists' star began to rise. They set up schools, and charged high fees for their services—a most unethical act according to traditional Greek thinking.

Placing themselves at the disposal of the highest bidder, the Sophists became servants of the rich and enemies of the masses. Conservative Athenian elders were aghast at the way the Sophists seemed to infect the youth of the city with irony and cynicism. Most of these teachers were non-Athenians, and they were also accused of spreading foreign "broad-mindedness." They supposedly taught their students how to win an argument at all costs and by whatever means, although whether all Sophists were unscrupulous is a matter of some debate. Certainly Protagoras, the great Sophist philosopher, escaped such charges, although his approach to morality deals more with appearances than with belief. Virtue, morality, and truth, the Sophists held, were relative to circumstance.

In his treatise *On the Gods*, Protagoras indicates that one "cannot feel sure that they [the gods] are, or that they are not, nor what they are like in figure, for there are many things that hinder sure knowledge, the obscurity of the subject and the shortness of human life." He then amplifies this religious doubt into a denial of any absolute truths at all. The individual person is "the measure of all things, of things that are that they are, and of things that are not that they are not." Truth is therefore relative and subjective. What appears true to any given person at any given moment is true, and what appears as real is real so far as any one person is concerned. But one such truth cannot be measured against another.

It was not the Sophists, however, but Plato and Aristotle who laid the philosophical base of classical Greek thinking, especially as it applied to the arts.

ART AND BEAUTY

Plato

Plato was born in Athens in 427 BC, two years after the death of Pericles. His family belonged to the old Athenian aristocracy. He grew up during the years of the Peloponnesian Wars which brought an end to the Athenian Empire. Escaping the financial ruin that befell many Athenian aristocrats, Plato's family managed to give him a good education. He emerged a thoroughly well rounded individual, a good athlete, and with experience of painting, poetry, music, literature, and drama. He received military training and fought in the wars. Although well suited and well connected enough for a career in politics, Plato turned instead to philosophy and fell more and more under the influence of the teacher Socrates.

BC	PERIOD	GENERAL EVENTS	LITERATURE & PHILOSOPHY	VISUAL ART	THEATRE & DANCE	MUSIC	ARCHITECTURE
500		Persian invasion Delian League	Solon's laws	Eucharides painter (5.5) *Charioteer*, Delphi (5.8) Douris, kylix (5.7)	Aeschylus (second actor)		
450		Pericles		Myron, *Discus Thrower* (5.10)	Sophocles (third actor)		
400	Classical	"Golden Age" of Athens Death of Pericles	Sophists, Protagoras Socrates Plato Academy	Polyclitus, *Lance Bearer* (5.9) Parthenon sculptures (5.12)	Aristophanes Euripides		Parthenon (5.1, 5.29–30) Propylaea (5.31) Temple of Athena Nike (5.32) Nereid Monument (5.26)
300		Alexander the Great	Aristotle Lyceum	Praxiteles (5.15–16) Lysippus, *Scraper* (5.17)			Polyclitus the Younger Theatre at Epidaurus (5.23)
200	Hellenistic		Cynics Stoics Epicureans	*Dying Gaul* (5.18)		*Hydraulos*	Theatre at Ephesus (5.22)
100				*Nike of Samothrace* (5.19)			Temple of Olympian Zeus (5.33)
0				*Laocoön and his Two Sons* (5.20)			

5.2 Timeline of Greek classicism and Hellenism.

After Socrates was put to death for "corrupting Athenian youth," Plato concentrated entirely on philosophy, taking on himself the responsibility for vindicating his teacher's memory. Anti-Socratic feeling ran high in Athens, and for ten years Plato found it expedient to live outside the city. He wrote many of the early "dialogues" during this period. Much of his aesthetic theory can be found in these dialogues, which follow Socrates' customary question-and-answer format.

Plato invented aesthetics as a branch of philosophy, and western thought has been profoundly influenced by his metaphysical approach to the philosophy of art. We find in Plato's dialogues a clear, though not very systematic, theory of art and beauty.

For Plato, art derived primarily from the skill of knowing and making, or *techne*. *Techne* was the ability of an artist to be in command of a medium, to know what the end result would be, and to know how to execute the artwork to achieve that result. The fundamental principles of *techne* were measurement and proportion. Standards of taste—what is good and what is beautiful—could not be considered unless the work was correct in proportion and measure.

Plato's theory of beauty and the creation of beauty, or art, rests on his concept of imitation. According to Plato, the artist imitates the Ideal which exists beyond the universe. Indeed, the universe itself is only an imitation of Ideas, or unchanging Forms. This point is crucial to all Platonic thought, yet it is a very difficult one. To simplify a complex notion, Ideas, also called Forms, *are reality*. Everything on earth is an *imitation* of reality. Ideals are thus not thoughts conceived by an individual human mind (or a divine one). Forms are rather the objects of thought. They exist independently, no matter whether, or what, we think of them.

The arts are practiced to create imitations of Forms. Plato mistrusted the arts, and especially drama, however, because the individual artist may fail to understand the ultimate reality, and may instead present merely an "appearance of perceivable nature." Therefore, art must be judged by the statesman, who "envisages the human community according to the Ideas of justice, the good, courage, temperance, and the beautiful."[1] In the end, what is proper as art depends upon the "moral ends of the polis."

In addition to possessing technical ability and the ability to know and imitate Ideas, the artist must have a third quality, artistic inspiration. No one can ascend to the highest levels of artistry without divine inspiration and assistance. Plato calls artistry a form of "divine madness."

Aristotle

Born in 384 BC, Aristotle did not have Plato's advantages of birth. His family was middle-class, and his father was

court physician to Amyntas of Macedon, grandfather of Alexander the Great. Aristotle was orphaned when quite young, and gained a home and his education through the generosity of a family friend. At 18, he became a student at Plato's ACADEMY where his affectations and self-absorption caused some trouble with the school's authorities. After Plato's death, Aristotle left the Academy and married. Around 343 BC, he gained a very favorable position as tutor to Alexander the Great. Aristotle sought to teach Alexander to revere all things Greek and despise anything barbarian, that is, non-Greek.

When Alexander acceded to the throne in 336 BC, Aristotle returned to Athens to set up his own school, the Lyceum. Over the next 12 years he produced a prolific outpouring of writings as well as research in physics, astronomy, biology, physiology, anatomy, natural history, psychology, politics, ethics, logic, rhetoric, art, theology, and metaphysics. Aristotle's "is probably the only human intellect that has ever compassed at first hand and assimilated the whole body of existing knowledge on all subjects, and brought it within a single focus."[2]

Aristotle's major work on the philosophy of art is his *Poetics*. There he maintains that all the arts imitate nature, and that imitative character is rooted in human psychology. For Aristotle, the end of artistic creation determines the appropriate means for its realization. In order to assess the excellence of a work, we must determine whether the work has a perfection of form and a soundness of method that make it a satisfactory whole. The elements of composition must display symmetry, harmony, and definition.

Aristotle's theory differs considerably from Plato's. Plato insists that artistic imitation, especially tragedy, fuels the passions and misleads the seeker of truth. Aristotle, by contrast, believes that the arts repair deficiencies in nature and that tragic drama in particular makes a moral contribution. Therefore the arts are valuable and justifiable. Aristotle rejects Plato's notion of the centrality of beauty and erotic love, as well as his metaphysical idealism. He sees beauty as a property of an

5.3 Ancient Greece.

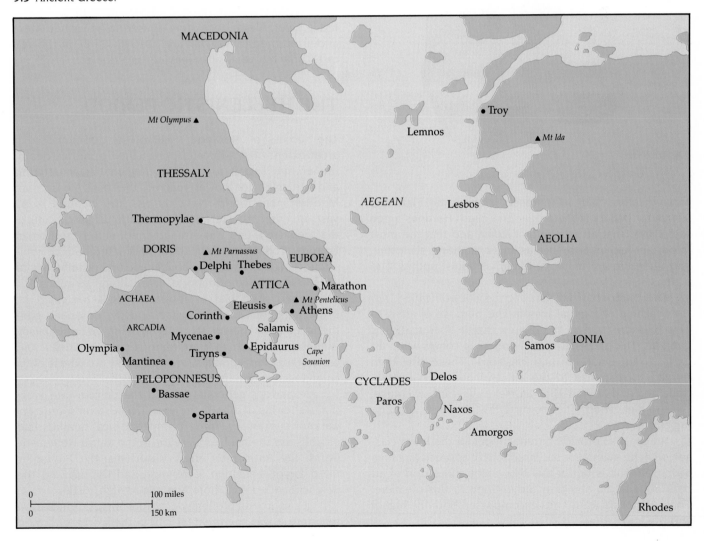

5.4 Aristotle.

artwork rather than its purpose, whereas for Plato the search for beauty is the proper end of art. He does agree with Plato "that art is a kind of *techne*, and that the most important human arts, such as music, painting, sculpture, and literature are imitative of human souls, bodies, and actions."[3]

The purpose of art, however, is not edification, nor the teaching of a moral lesson. The purpose of art is to give pleasure, and to the degree that it does that, it is good art. The pleasure Aristotle refers to comes when art excites our emotions and passions. These are then purged in response to the art, and our souls lighten, delighted and healed. High art makes us think, of course, but the highest art must produce this CATHARSIS, or purging effect.

Art can also provide entertainment for the lower classes, who, he maintains, are incapable of appreciating high art properly. It is better that they enjoy some kind of art than none at all, and they are entitled to this pleasure. Thus, Aristotle's AESTHETICS encompassed both the higher and the lower arts.

ALEXANDER

In the fourth century BC a new star was rising to the north. By the middle of the century, King Philip of Macedon had united Greece in an empire. It was to this throne that his son Alexander the Great ascended in 336 BC. Under the Alexandrian, or HELLENISTIC, Empire which stretched from Egypt in the west to the Indus River in the east, civilization and the arts flourished. The influence of Hellenistic art continued for centuries after the fall of the empire, to the Roman era and well into the Christian era.

Alexander's rule began with an expedition to Asia at the head of an army, only one fourth of which was Greek. Yet the brilliant 22-year-old carried Greek, i.e. Athenian, culture further afield than ever before. Reaching Asia, Alexander, according to legend, cut the Gordian knot and then defeated the Persian king, Darius III, at the battle of Issus. From there, Alexander led his forces against the city of Tyre in Syria, and pressed victoriously on to Egypt where he founded Alexandria, one of the most influential and important cities in the Hellenistic world. A second defeat of Darius and the subsequent sacking of his capital, Persepolis, led to Alexander's installation as successor to the Persian throne. After pushing as far as the Indus River, Alexander's army refused to go further. Alexander returned to Babylon and died in 323 BC at the age of 32, only ten years after leaving Macedonia.

THE HELLENISTIC PERIOD

The success of Alexander's conquests depended to a great extent on his forceful personality. Upon his death, the empire began to crumble. Regional fragmentation and struggles for power marked the post-Alexandrian Mediterranean world. Nevertheless, the creation of so vast an empire fostered an internationalism of culture that persisted, and was strengthened, under the Roman Empire. Commerce flourished, and international communication carried Greek thought and artistic influence to all parts of the known world. Intercultural relationships blossomed: Buddhist sculpture in India, for example, shows signs of Greek influence, and the European pantheon of gods began to reflect eastern emotionalism. Athens remained an important center for ideas and cultural accomplishments, in spite of the weakness of its commercial and military power.

Alexander's generals divided the empire into kingdoms after his death. By the year 276 BC, after a series of wars for supremacy, three prominent local families had established themselves as rulers of the entire Hellenistic world: the Antigonids ruled Macedonia; the Ptolemies ruled Egypt, Palestine, Cyrenaica, and Cyprus; and the Seleucids ruled Asia, from Anatolia to Afghanistan.

The source of Hellenistic culture was Alexandria. At this time it was the greatest city in the world, endowed

with phenomenal wealth. Legally it was a Greek city "by," not "in," Egypt. Brilliant writers and new literary forms emerged. The Ptolemies patronized science and scholarship lavishly. Royal funds paid for many splendid buildings, including an enormous library which became the focal point of the Hellenistic intellectual world.

Prosperity reigned throughout the Hellenistic world. The riches gleaned from rifling the Persian treasury provided the economic base that supported both ships and farms. Standards of living rose appreciably. As often seems to be the case, economic security spawned a cultural revival. The happiness of the individual, viewed as psychological equilibrium, became the goal of a new philosophy: one should strive to live as well as possible by one's own efforts, independent of luck and environment.

CYNICS, STOICS, AND EPICUREANS

Three schools of thought vied for philosophical supremacy in the Hellenistic period. Led by Diogenes, the Cynics taught that humans are animals and that the good life lay simply in satisfying one's animal needs. Since those needs can be troublesome, however, a wise person will have as few as possible and will then disregard any social conventions that stand in the way of his own satisfaction.

The Stoics, founded by Zeno, believed that humans were the incarnation of reason, which produces and directs the world. The good life was defined as that which follows reason, wisdom, and virtue. The only way to achieve these goals, however, lay through renunciation and asceticism. Once this was achieved, one could disregard public opinion, misfortune, and even death.

The Epicureans, followers of Epicurus, concluded that human beings consisted of a temporary arrangement of atoms which dissolved at death. Because everything was temporary anyway, the good life was simply an untroubled one. Wisdom dictated that one should avoid entanglements, maintain good health, tolerate pain, and accept death without fear.

The intellectual certitude of Hellenistic philosophy, and its indifference to the concerns of any but oneself, provoked a reaction in later times. From that reaction, rationalism began to emerge.

FOCUS

TERMS TO DEFINE

Delian League	Polis	Cynicism
Golden age	*Techne*	Stoicism
Tyrant	Ideas, Forms	Epicureanism
Sophistry	Hellenism	

PEOPLE TO KNOW

Solon
Pericles
Plato
Aristotle
Alexander the Great

DATES TO REMEMBER

The age of Pericles
Hellenistic period

QUESTIONS TO ANSWER

1 Who were the Sophists and what was their impact on Athenian society?
2 How did Plato and Aristotle differ in their view of the value of tragedy?

THE ARTS
OF CLASSICISM AND HELLENISM

TWO-DIMENSIONAL ART

Throughout history, people have sought rationality, intellectual challenge, and order from chaos. But the existence of emotion and intuitive feeling cannot be denied. The struggle between intellect and emotion is one of the most significant problems in human existence and although the two forces are not mutually exclusive, the conflict between them has been a theme of western art.

The fifth-century Athenians recognized this struggle. Indeed, Greek mythology tells a story that demonstrates the Periclean belief in the superiority of the intellect over the emotions: Marsyas, a mortal, discovered an AULOS discarded by the goddess Athena. (An aulos is a flute-like musical instrument associated with the wild revelries of the cult of Dionysus; see Fig. **5.5**.) With Athena's aulos, Marsyas challenged the god Apollo to a musical contest. Apollo, patron of the rational arts, chose the lyre as his instrument. Apollo won the contest, symbolizing the dominance of intellect over emotion.

5.5 Attributed to the Eucharides painter, amphora showing Apollo playing a lyre and Artemis holding an aulos before an altar, c.490 BC. 18½ ins (47 cm) high. The Metropolitan Museum of Art, New York (Rogers Fund, 1907).

Vase painting

Classical style

Fifth-century Athenian vase painting reflects some characteristics of earlier work, including the principally geometric nature of the designs. This indicates the continuing concern for form and order in the organization of space. What distinguishes the classical style in vase painting (our only visual evidence of Greek two-dimensional art of this period) from earlier styles is the new sense of idealized reality in figure depiction.

Such realism reflects a technical advance as well as a change in attitude. Many of the problems of foreshortening (the apparent decrease in size as an object recedes in space) had been solved. As a result, figures have a new sense of depth. The illusion could be strengthened in some cases by the use of light and shadow. Records imply that mural painters of this period were extremely skilled in realistic representation, but we have no surviving examples to study. The limited scope of vase painting does not, unfortunately, allow us to assess the true level of skill and development of the two-dimensional art of this period. Vase painting does demonstrate, however, artists' concern for formal design, that is, logic and balance in the organization of space.

In the fifth century BC, many of the most talented artists were engaged in sculpture, mural painting, and architecture. Nonetheless, vase painters like the Achilles painter continued to express the idealism and dignity of the classical style. In the LEKYTHOS shown in Figure **5.6**, a quiet grandeur infuses the elegant and stately figures. The portrayal of the feet in the frontal position is significant, reflecting the new skill of foreshortening.

By the end of the fifth century BC, vase painters had begun to break with the convention we have seen in Egyptian and Mesopotamian art of putting all the figures along the base line: spatial depth was sometimes suggested by placing some figures higher than others. But it was not until the end of the next century that this problem was fully overcome.

We generally use the word "style" to refer to form, rather than content, but often the two cannot be separated. As the forms of classicism became more individualized and naturalistic, its subject matter broadened to include the mundane, as well as the HEROIC. We find some early examples of this in vase painting. The KYLIX in Figure **5.7** shows women putting away their clothes. The graceful curves and idealized forms of the classical style are still present, but the subject matter is

5.6 The Achilles painter, white ground lekythos from Gela(?), showing a woman and her maid, 440 BC. 15 ins (38.4 cm) high. Museum of Fine Arts, Boston (Francis Bartlett Fund).

clearly taken from everyday life. The implications of this apparent change are not entirely clear. Perhaps the domestic rather than ceremonial nature of vases of this

5.7 Attributed to Douris, red-figured kylix showing two women putting away their clothes, c.470 BC. Diameter 12½ ins (31.7 cm). The Metropolitan Museum of Art, New York (Rogers Fund, 1923).

kind accounts for the humbler subject matter.

Appeal to the intellect was the cornerstone of the classical style in all the arts. In painting, as well as in other disciplines, four characteristics reflected that appeal. Foremost is an emphasis on the formal organization of the whole into structured, balanced parts. A second characteristic is idealization: the intentional portrayal of things as better than they are, in order to raise them above the level of common humanity. For example, the human figure is treated as a perfect type rather than as a flawed individual body. A third characteristic is the use of convention, and a fourth is simplicity. (This term means freedom from unnecessary ornamentation and complexity; not merely lack of sophistication.)

Hellenistic style
The four characteristics just listed were fundamental to Greek classicism. But their antitheses also existed: as the age of Pericles gave way to the Hellenistic period, the dominant characteristics of classicism gradually gave way to a less formal, more naturalistic and emotional style.

Like other art forms, vase painting around the year 400 BC tended toward a highly ornate style. Thick lines, dark patterns on garments, and generous applications of white and yellow were used, to render crowded compositions with figures seen mainly in three-quarter view.

In the Hellenistic era, everyday scenes, sometimes comic and vulgar, were common in wall painting. They are remarkable for their use of both AERIAL and LINEAR PERSPECTIVE to indicate three-dimensional space.

Unfortunately, the few extant examples of this type of Hellenistic two-dimensional art furnish us with no more than a glimpse of the characteristic style of the period.

SCULPTURE

Styles do not start on a given date and end on another, even when they are as local and limited as those of the small city–state of Athens during the rule of Pericles. Although much of what we can surmise about Greek classical sculpture is actually based on inferior copies made at a later time, we know that the Greek classical style, especially in sculpture, was continually in a state of change. One artist's works differ from another's even though, in general, they reflect the four basic characteristics of classicism. In classical sculpture, the humanism of Greek philosophy is reflected in the idealism of vigorous, youthful bodies that make a positive statement about the joy of earthly life.

Classical style

From early in the fifth century BC, we find an example of bronze sculpture representative of the new, developing classical style. The *Charioteer* from Delphi (Fig. **5.8**) records a victory in the games of 478 or 474 BC. The figure is elegantly idealized, with subtle variation of the sleeves and drapery folds. The balance departs from absolute symmetry: the weight is slightly shifted to one leg, and the head turns gently away from the center line. The excellent preservation of this statue allows full appreciation of the relaxed control of the sculptor.

However, the age of Greek classical style properly began with the sculptors Myron and Polyclitus in the middle of the fifth century BC. Both contributed to the development of cast metal sculpture. (The example in Fig. **5.9** is a marble copy of a bronze original, as is also Fig. **5.10**.) In his *Lance Bearer* (*Doryphorus*), Polyclitus is reputed to have achieved the ideal proportions for a male athlete: the *Lance Bearer* thus represents *the* male athlete, not *a* male athlete. The body's weight is thrown onto one leg in the *contrapposto* stance. The resulting sense of relaxation, controlled motion, and the subtle play of curves made possible by this simple device are hallmarks of Greek classical style.

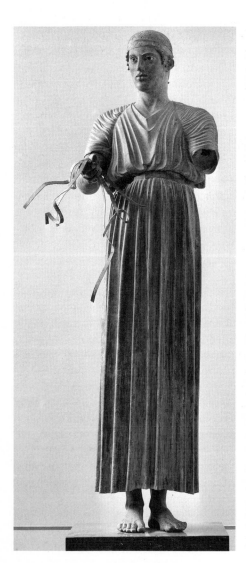

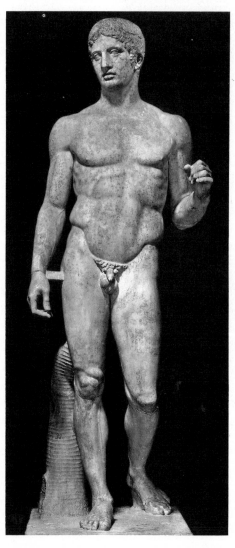

5.8 (far left) *Charioteer*, from the Sanctuary of Apollo, Delphi, c.478 or 474 BC. Bronze, life-size. Archeological Museum, Delphi.

5.9 Polyclitus, *Doryphorus* (*Lance Bearer*), Roman copy after a bronze original of c.450–440 BC. Marble, 6 ft 6 ins (1.98 m) high. Museo Archeologico Nazionale, Naples, Italy.

MASTERWORK
Myron—Discus Thrower

Myron's best known work, the *Discus Thrower* (or *Discobolus*) (Fig. **5.10**), exemplifies the classical concern for restraint in its subdued vitality and subtle suggestion of movement coupled with balance. But it also expresses the sculptor's interest in the flesh of the idealized human form. This example of the *Discus Thrower* is, unfortunately, a much later marble copy. Myron's original was in bronze, a medium that allowed more flexibility of pose than marble. A statue, as opposed to a relief sculpture, must stand on its own, and supporting the weight of the marble on a small area, such as one ankle, poses a significant structural problem. Metal has greater TENSILE STRENGTH (the ability to withstand twisting and bending), and thus this problem does not arise.

In *Discovery of the Mind: The Greek Origins of European Thought* Bruno Snell writes: "If we want to describe the statues of the fifth century in the words of their age, we should say that they represent beautiful or perfect men, or, to use a phrase employed in the early lyrics for purposes of eulogy: 'god-like' men. Even for Plato the norm of judgment still rests with the gods, and not with men."[4] Even though Greek statuary may take the form of portraiture, the features are idealized. Human beings may be the measure of all things, but in art the individual is raised above human reality to the state of perfection found only in the gods.

Myron's representation of an athlete competing in an Olympic event brought a new sense of dynamism to Greek sculpture. It captures a dramatic moment, freezing the moving figure in the split second before the explosive release of the discus, achieving confliction of opposing forces. Myron's composition draws its tension not only from the expectation of the impending force, but also in the dramatic intersection of two opposing arcs: one created by the downward sweep of the arms and shoulders, the other by the forward thrust of the thighs, torso, and head.

As is typical of Greek free-standing statues, the *Discus Thrower* is designed to be seen from one direction only. It is thus a sort of free-standing, three-dimensional "super-relief." The beginnings of classical style represented by celebration of the powerful nude male figure are an outgrowth of what is known as the "severe style." Myron was trained in this style, and the suggestions of moral idealism, dignity, and self-control in the statue are all qualities inherent in classicism. However,

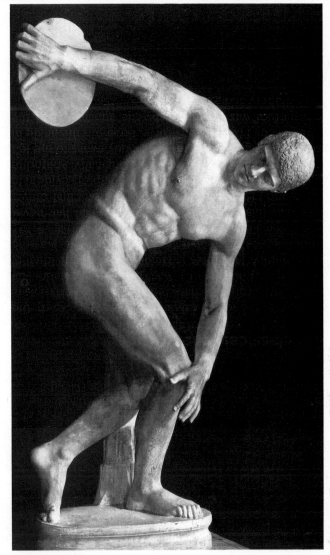

5.10 Myron, *Discobolus* (*Discus Thrower*), c.450 BC. Roman marble copy after a bronze original, life-size. Museo Nazionale Romano, Rome.

the *Discus Thrower* marks a step forward, in the increasing vitality of figure movement, a process we can trace from the frozen pose of the archaic kouros of Polymedes of Argos (Fig. **4.11**), through the counterpoised balance of the *Kritios Boy* (Fig. **4.15**), to Myron. Warm, full, and dynamic, Myron's human form achieves a new level of expressiveness and power. It is fully controlled and free of the unbridled emotion of later sculpture such as the *Laocoön* (Fig. **5.20**). For Myron, balanced composition remains the focus of the work, and form takes precedence over feeling.

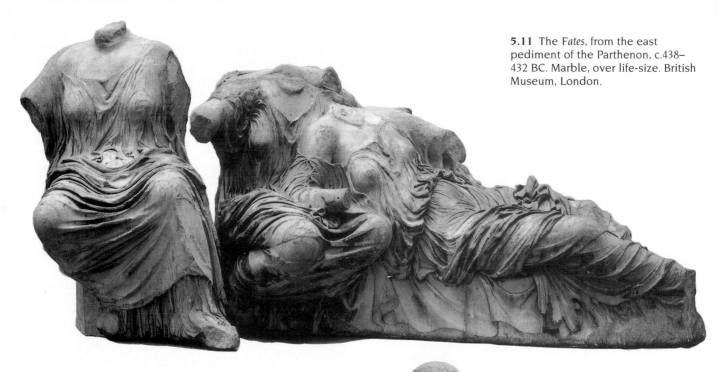

5.11 The *Fates*, from the east pediment of the Parthenon, c.438–432 BC. Marble, over life-size. British Museum, London.

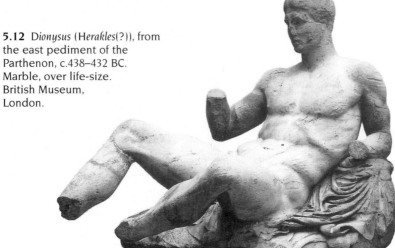

5.12 *Dionysus* (*Herakles*(?)), from the east pediment of the Parthenon, c.438–432 BC. Marble, over life-size. British Museum, London.

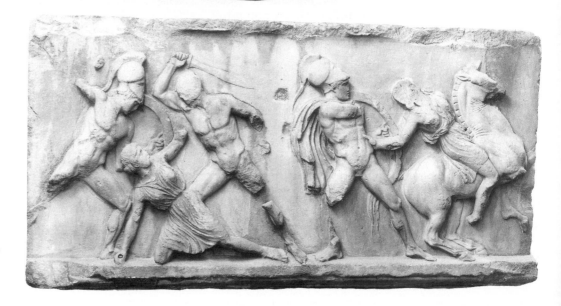

5.13 Scopas(?), Battle of Greeks and Amazons, from the east frieze of the Mausoleum, Halicarnassus, 359–351 BC. Marble, 35 ins (88.9 cm) high. British Museum, London.

The east PEDIMENT of the Parthenon once contained marvelous sculptural elements (Figs **5.11** and **5.12**). The group of *Three Goddesses*, or *Fates*, is now on display in the British Museum in London. Originally, however, it formed part of the architectural decoration high on the Parthenon. There, its diagonal curvilinearity would have offset the straight lines, and strong verticals and horizontals, of the temple. The scene depicted on this pediment was an illustration of the myth of the birth of Athena, patron goddess of Athens, from her father Zeus' head. Also from this east pediment is the figure of Dionysus (sometimes thought to be Herakles) shown in Figure **5.12**.

We can learn much from these battered but superb figures. What strikes us first is the brilliant arrangement of the figures within the geometric confines of the pediment. This triangular design encloses curving lines that flow rhythmically through the reclining figures, leading the eyes naturally from one part to the next. The treatment of the draperies of the female figures is highly sophisticated, for not only do the drape and flow of the stone fabric reinforce the simple lines of the whole, but they also reveal the perfected human female form beneath, demonstrating once again the classical goal of depicting not what is real, but what is ideal. These, and the Dionysus, are forms raised beyond the merely specific and human, to the level of symbols, as is appropriate to their intended position on a temple.

Even in their repose, these figures show grace and subtle movement: the counterthrust of tension and release is carefully controlled. This formal restraint is made more evident when we compare these figures with those of a later style in Figure **5.13**. The composition here is more open, its movement less fluid, and the geometric groups of figures jerk the eye between sections of the work, rather than leading.

Perhaps the most impressive sculptural finds of recent years are the two statues discovered in 1972 in the seabed off the coast of Riace, in southern Italy. Figure **5.14** shows one of these masterpieces, which are known as the *Riace Warriors*. The statue has been restored, but it shows the bone and glass eyes, silver teeth, and copper lips and nipples that would have adorned many ancient Greek bronzes. The simplicity with which the imposing musculature is portrayed, and the confident handling of the *contrapposto* mark the work of a great sculptor of the mid-fifth century BC. Some scholars even claim that the statues can be identified as part of a set of 13 sculpted by Phidias, dedicated to the Athenian victory at Marathon in 490 BC. They were probably shipwrecked around the first century BC, on their way to Rome, having been plundered from Greece.

5.14 Phidias(?), *Riace Warrior*, fifth century BC. Bronze with bone, glass-paste, silver and copper inlaid. 6 ft 6$\frac{4}{5}$ ins (2 m) high. Museo Nazionale, Reggio Calabria, Italy.

5.15 Praxiteles, *Cnidian Aphrodite*, probably Hellenistic copy of fourth century BC original. Marble, 5 ft ½ in (1.54 m) high. The Metropolitan Museum of Art, New York (Fletcher Fund, 1952).

Late classical style

Sculpture of the fourth century BC illustrates clearly the changes in attitude characteristic of late classicism. Among other innovations was the representation of female nudity. Praxiteles is famous for the individuality and delicacy of his treatment of his subjects, such as the earliest female nude, the *Cnidian Aphrodite* (Fig. **5.15**). (Note that this is again a copy; the original has never been found.) His work looks inward in a way that differs from the formal detachment of earlier sculptors evident in the *Dionysus* (Fig. **5.12**), for example. Originally, Aphrodite rested her weight on one foot: her body sways to the left in the famous Praxitelean S-curve. Strain on the ankle of the sculpture was minimized by the attachment of the arm to drapery and a vase.

5.16 Praxiteles, *Hermes and Dionysus*, c.340 BC. Marble, about 7 ft (2.13 m) high. Archeological Museum, Olympia, Greece.

The elegance of Praxiteles' work can also be seen in the *Hermes and Dionysus* (Fig. **5.16**). Although this marble statue may be a copy, it nonetheless exhibits fine subtlety of modeling and detailed individuality.

From the late fourth century, the sculpture of Lysippus, a favorite of Alexander the Great, displays a dignified naturalness and a new concept of space. His *Apoxyomenos* (*Scraper*) (Fig. **5.17**) illustrates an attempt to depict the figure in motion, in contrast to the poses we have seen previously. The subject of the *Scraper* is mundane—an athlete scraping dirt and oil from his body. The proportions of the figure are even more naturalistic than those of Polyclitus (see Fig. **5.9**), but the naturalism is still far from complete.

Hellenistic style

The Hellenistic style in sculpture continued to dominate the Mediterranean world until the first century BC. As time progressed, it began to reflect an increasing interest in the differences between individual humans. Hellenistic sculptors turned away from idealization, often toward pathos, trivia, even banality, or flights of technical virtuosity. These characteristics appear in Figures **5.18**, **5.19**, and **5.20**. The *Dying Gaul* (Fig. **5.18**) is a powerful expression of emotion and pathos. This Roman copy of a statue from Pergamon places the figure on a stage, as if acting out a drama. The noble warrior, a Gallic casualty in the war between Pergamon and barbarian invaders, is slowly bleeding to death from a chest wound.

5.17 Lysippus, *Apoxyomenos* (*Scraper*), Roman copy, probably after a bronze original of c.330 BC. Marble, 6 ft 9 ins (2.06 m) high. Vatican Museums, Rome.

5.18 *Dying Gaul*, Roman copy of a bronze original of c.230–220 BC. Marble, life-size. Museo Capitolino, Rome.

5.19 *Nike of Samothrace* (*Winged Victory*),
c.190 BC. Marble, 8 ft (2.44 m) high.
Louvre, Paris.

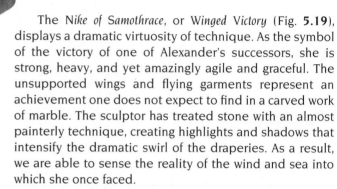

The *Nike of Samothrace*, or *Winged Victory* (Fig. **5.19**), displays a dramatic virtuosity of technique. As the symbol of the victory of one of Alexander's successors, she is strong, heavy, and yet amazingly agile and graceful. The unsupported wings and flying garments represent an achievement one does not expect to find in a carved work of marble. The sculptor has treated stone with an almost painterly technique, creating highlights and shadows that intensify the dramatic swirl of the draperies. As a result, we are able to sense the reality of the wind and sea into which she once faced.

The frequent Hellenistic theme of suffering receives violent treatment in the *Laocoön* group (Fig. **5.20**),

5.20 Hagesandrus, Polydorus, and Athenodorus, *Laocoön and his Two Sons*, first century AD. Marble, 8 ft (2.44 m) high. Vatican Museums, Rome.

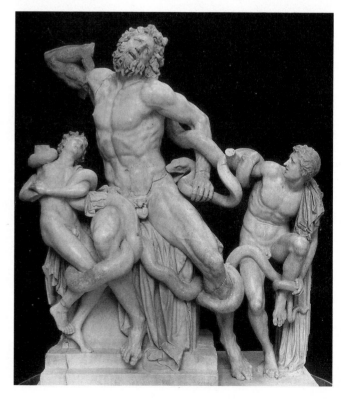

attributed to three sculptors from the first century AD, Hagesandrus, Polydorus, and Athenodorus. The Trojan priest Laocoön and his sons are being strangled by sea serpents. According to the Greek myth, this was Laocoön's punishment for defying Poseidon, god of the sea, by warning the Trojans of the Greek trick of the Trojan horse, in which soldiers were concealed. The expression of emotion is almost unrestrained. The figures seem to writhe before our eyes, their straining muscles and bulging veins indicating mortal agony.

LITERATURE

In addition to the plays of the great tragedians Aeschylus, Sophocles, and Euripides, and the comic playwright Aristophanes, important works by Plato, Aristotle, and Pericles also provide us with insight into the literary spirit of classical and Hellenistic Greece.

Plato

Perhaps the greatest of Plato's dialogues is the *Republic*, in which Socrates seeks answers to the question "What is justice?" and describes the ideal society. The *Apology*, another of Plato's dialogues, gives his version of Socrates' speech in his own defense at his trial. Socrates was accused, and found guilty, of corrupting the youth of Athens and of believing in gods of his own devising rather than the gods of Athens. The *Phaedo* concludes the story of Socrates' trial and death, and the dialogue presents his final hours as reported by Phaedo, a disciple of Socrates who was with him in prison during the last day of his life.

Phaedo

And now, O my judges, I desire to prove to you, that the real philosopher has reason to be of good cheer when he is about to die, and that after death he may hope to obtain the greatest good in the other world. And how may this be, Simmias and Cebes, I will endeavor to explain. For I deem that the true votary of philosophy is likely to be misunderstood by other men; they do not perceive that he is always pursuing death and dying; and if this be so, and he has had the desire of death all his life long, why when his time comes should he repine at that which he has been always pursuing and desiring?

Simmias said laughingly: Though not in a laughing humor, you have made me laugh, Socrates; for I cannot help thinking that the many when they hear your words will say how truly you have described philosophers, and our people at home will likewise say that the life which philosophers desire is in reality death and that they have found them out to be truly deserving of the death which they desire.

And they are right, Simmias, in thinking so, with the exception of the words "they have found them out"; for they

have not found out either the nature of that death which the true philosopher deserves, or how he deserves or desires death. But enough of them;—let us discuss another matter amongst ourselves. Do we believe that there is such a thing as death?

To be sure, replied Simmias.

Is it not the separation of soul and body? And to be dead is the completion of this; when the body exists in herself, and is released from the soul, what is this but death?

Just so, he replied.

There is another question, which will probably throw light on our present enquiry if you and I agree about it:—Ought the philosopher to care about the pleasures—if they are to be called pleasures—of eating and drinking?

Certainly not, answered Simmias.

And what about the pleasures of love—should he care for them?

By no means.

And will he think much of the other ways of indulging the body, for example, the acquisition of costly raiment, or sandals, or other adornments of the body? Instead of caring about them, does he not rather despise anything more than nature needs? What do you say?

I should say the true philosopher would despise them.

Would you not say that he is entirely concerned with the soul and not with the body? He would like, as far as he can, to get away from the body and to turn to the soul.

Quite true.

In matters of this sort philosophers, above all other men, may be observed in every sort of way to dissever the soul from the communion of the body.

Very true.

Whereas, Simmias, the rest of the world are of opinion that to him who has no sense of pleasure and no part in bodily pleasure, life is not worth having; and that he who is indifferent about them is as good as dead.

That is also true.

What shall we say of the actual acquirement of knowledge?—Is the body, if invited to share in the inquiry, a hinderer or a helper?

I mean to say, have sight and hearing any truth in them? are they not, as the poets are always telling us, inaccurate witnesses? and yet, if even they are inaccurate and indistinct, what is to be said of the other senses?—for you will allow that they are the best of them?

Certainly, he replied.

Then when does the soul attain truth?—for in attempting to consider anything in company with the body she is obviously deceived.

True.

Then must not true existence be revealed to her in thought, if at all?

Yes.

And thought is best when the mind is gathered into herself and none of these things trouble her—neither sounds nor sights nor pains nor any pleasure,—when she takes her leave of the body, and has as little as possible to do with it, when she has no bodily sense or desire, but is aspiring after true being?

Certainly.

And in this the philosopher dishonors the body; his soul runs away from his body and desires to be alone and by herself?

That is true.

Well, but there is another thing, Simmias: Is there or is there not an absolute justice?

Assuredly there is.

And an absolute beauty and absolute good?

Of course.

But did you ever behold any of them with your eyes?

Certainly not.

Or did you ever reach them with any other bodily sense?—and I speak not of these alone, but of absolute greatness, and health, and strength, and of the essence and true nature of everything. Has the reality of them ever been perceived by you through the bodily organs? or rather, is not the nearest approach to the knowledge of their several natures made by him who so orders his intellectual vision as to have the most exact conception of essence of each thing which he considers?

Certainly.

And he attains to the purest knowledge of them who goes to each with the mind alone, not introducing or intruding in the act of thought sight or any other sense together with reason, but with the very light of the mind in her own clearness, searches into the very truth of each; he who has got rid, as far as he can, of eyes and ears and, so to speak, of the whole body, these being in his opinion distracting elements which when they infect the soul hinder her from acquiring truth and knowledge—who, if not he, is likely to attain to the knowledge of true being?

What you say has a wonderful truth about it, Socrates, replied Simmias.

And when real philosophers consider all these things, will they not be led to make a reflection which they will express in words something like the following? "Have we not found," they will say, "a path of thought which seems to bring us and our argument to the conclusion, that while we are in the body, and while the soul is infected with the evils of the body, our desire will not be satisfied? For the body is a source of endless trouble to us by reason of the mere requirement of food; and is liable also to diseases which overtake and impede us in the search after true being; it fills us full of loves, and lusts, and fears, and fancies of all kinds, and endless foolery, and in fact, as men say, takes away from us the power of thinking at all. Whence come wars, and fightings, and factions? Whence but from the body and the lusts of the body? Wars are occasioned by the love of money, and money has to be acquired for the sake and in the service of the body; and by reasons of all these impediments we have no time to give to philosophy; and, last and worst of all, even if we are at leisure and betake ourselves to some speculation, the body is always breaking in upon us, causing turmoil and confusion in our enquiries, and so amazing us that we are prevented from seeing the truth.

It has been proved to us by experience that if we would have pure knowledge of anything we must be quit of the body—the soul in herself must behold all things in themselves; and then we shall attain the wisdom which we desire, and of which we say that we are lovers; not while we live, but after death; for if while in the company of the body the soul cannot have pure knowledge, one of two things follows—either knowledge is not to be obtained at all or, if at all, after death. For then, and not till then, the soul will be parted from the body and existing herself alone. In this present life, I reckon that we make the nearest approach to knowledge when we have the least possible intercourse or communion with the body, and are not surfeited with bodily

nature, but keep ourselves pure until God himself is pleased to release us. And thus having got rid of the foolishness of the body we shall be pure and hold converse with the pure, and know of ourselves the clear light everywhere, which is none other than the light of truth. For the impure are not permitted to approach the pure." These are the sort of words, Simmias, which true lovers of knowledge cannot help saying to one another and thinking. You would agree; would you not?

Undoubtedly, Socrates.

But, O my friend, if this be true, there is great reason to hope that, going whither I go, when I have come to the end of my journey, I shall attain that which has been the pursuit of my life. And I therefore go on my way rejoicing, and not I only, but every man who believes that his mind has been made ready and that he is in manner purified.

Certainly, replied Simmias.

And what is purification but the separation of the soul from the body, as I was saying before; the habit of the soul gathering herself from all sides out of the body; the dwelling in her own place alone, as in another life, so also in this, as far as she can;—the release of the soul from the chains of the body?

Very true, he said.

And this separation and release of the soul from the body is termed death?

To be sure, he said.

And the true philosophers, and they only, are ever seeking to release the soul. Is not the separation and release of the soul from the body their especial study?

That is true.

And, as I was saying at first, there would be a ridiculous contradiction in men studying to live as nearly as they can in a state of death, and yet repining when it comes upon them.

Clearly.

And the true philosophers, Simmias, are always occupied in the practice of dying, wherefore also to them the least of all men is death terrible. Look at the matter thus:—if they have been in every way enemies of the body and are wanting to be alone with the soul, when this desire of theirs is granted, how inconsistent would they be if they trembled and repined instead of rejoicing at their departure and that place where, when they arrive, they hope to gain that which in life they desired—and this was wisdom—at that same time to be rid of the company of their enemy. Many a man has been willing to go to the world below animated by the hope of seeing there an earthly love, or wife, or son, and conversing with them. And will he who is a true lover of wisdom, and is strongly persuaded in like manner that only in the world below he can worthily enjoy her, still repine at death. Will he not depart with joy? Surely he will, O my friend, if he be a true philosopher. For he will have a firm conviction that there, and there only, he can find wisdom in her purity. And if this be true, he would be very absurd, as I was saying, if he were afraid of death.

Quite so, he replied. | . . . | he arose and went into a chamber to bathe; Krito followed him, and told us to wait. So we remained behind, talking and thinking of the subject of the discourse, and also of the greatness of our sorrow; he was like a father of whom we were being bereaved, and we were about to pass the rest of our lives as orphans. When he had taken the bath and his children were brought to him—(he had two young sons and an elder one); and the women of the family also came, and he talked to them and gave them a few directions in the presence of Krito; then he dismissed them

and returned to us.

Now the hour of sunset was near, for a good deal of time had passed after his bath, but not much was said. Soon the jailer, who was the servant of the Eleven, entered and stood by him, saying:—To you, Socrates, whom I know to be the noblest and gentlest and best of all who ever came to this place, I will not impute the angry feelings of other men, who rage and swear at me, when, in obedience to the authorities, I bid them drink the poison. Indeed, I am sure that you will not be angry with me; for others, as you are aware, and not I, are to blame. And so fare you well, and try to bear lightly what must needs be—you know my errand. Then bursting into tears he turned away and went out.

Socrates looked at him, and said: I return your good wishes, and will do as you bid. How charming the man is: since I have been in prison he has always been coming to see me, and at times he would talk to me, and was good to me as could be, and now see how generously he sorrows on my account. We must do as he says, Krito and therefore let the cup be brought, if the poison is prepared: if not, let the attendant prepare some.

Yet, said Krito, the sun is still upon the hilltops, and I know that many a one has taken the draught late and after the announcement has been made to him has eaten and drunk, and enjoyed the society of his beloved; do not hurry—there is time enough.

Socrates said: Yes, Krito, and they of whom you speak are right in so acting, for they think that they will be gainers by the delay; but I am right in not following their example, for I do not think that I should gain anything by drinking the poison any later; I should only be ridiculous in my eyes for sparing and saving a life which is already forfeit. Please then do as I say and not to refuse me.

Krito made a sign to the servant, who was standing by; and he went out, and having been absent some time, returned with the jailer carrying the cup of poison. Socrates said: You, my good friend, who are expert in these matters, shall give me directions how I am to proceed. The man answered: You have only to walk about until your legs are heavy, and then to lie down, and the poison will act. At the same time he handed the cup to Socrates, who in the easiest and gentlest manner, without the least fear or change of color or feature, looking at the man with all his eyes, Enchekrates, as his manner was, took the cup and said: What do you say about making a libation out of this cup to any God? May I, or not? The man answered: We only prepare, Socrates, just so much as we deem enough. I understand, he said, but I may ask the gods to prosper my journey from this to the other world—even so—and so be it according to my prayer. Then raising the cup to his lips, quite readily and cheerfully drank off the poison. And hitherto most of us had been able to control our sorrow: but now when we saw him drinking, and saw too that he had finished the draught, we could no longer forbear, and in spite of myself my own tears were flowing fast; so that I covered my face and wept, not for him, but at the thought of my own calamity in having to part from such a friend. Nor was I the first; for Krito, when he found himself unable to restrain his tears, had got up, and I followed, and at that moment Apollodoros, who had been weeping all the time, broke out in a loud and passionate cry which made cowards of us all. Socrates alone retained his calmness: What is this strange outcry? he said. I sent away the women mainly in order that they might not misbehave in this way, for I have been told that a man should die in peace. Be quiet then, and

have patience. When we heard his words we were ashamed, and refrained our tears; and he walked about until, as he said, his legs began to fail, and then he lay on his back, according to the directions, and the man who gave him the poison now and then looked at his feet and legs; and after a while he pressed his foot hard, and asked him if he could feel; and he said, No; and then his leg, and so upward and upward, and showed us that he was cold and stiff. And he felt them himself, and said: when the poison reaches the heart that will be the end. He was beginning to grow cold about the groin, when he uncovered his face, for he had covered himself up and said—they were his last words—he said: Krito, I owe a cock to Asclepius: will you remember to pay the debt? The debt shall be paid, said Krito; is there anything else? There was no answer to this question; but in a minute a movement was heard and the attendant uncovered him; his eyes were set, and Krito closed his eyes and mouth.

Such was the end, Enchekrates, of our friend; concerning whom I may truly say that of all the men of his time whom I have known he was the wisest and justest and the best.

THEATRE

In contrast to sculpture and painting which used more-or-less realistic images to portray the ideal, Greek classical theatre pursued the same ends through quite different means. The theatre of Periclean Athens was theatre of convention. In theatre of illusion, scenic details are realistically portrayed. Stage mechanics do not hamper the playwright in the theatre of convention, however: the audience will accept a description in poetic dialogue, without demanding to see it. Imagination is the key to this kind of theatre. Greek dramatists found that, free from the need to create an illusion of reality, they were better able to pursue the lofty moral themes fundamental to the Greek perception of the universe. Although we have some extant play texts from this era that indicate what and how the playwright wrote, we do not know the specifics of how that work became theatre—that is, how it was produced. Nevertheless, we can try to envisage a production based on descriptions in the plays themselves and on other literary evidence.

Theatre productions in ancient Greece were part of three annual religious festivals: the City Dionysia, the Rustic Dionysia, and the Lenaea. The first of these was a festival of tragic, and the last, of comic plays. The City Dionysia took place at the Theatre of Dionysus in Athens. Contests held at these festivals were begun in 534 BC, before the classical era. Although we do not have most of the plays themselves, we do know the titles and the names of the authors who won the contests, from the earliest to the last. From inscriptions we know that three playwrights figured prominently and repeatedly as winners.[5] They were Aeschylus, Sophocles, and Euripides. All the complete TRAGEDIES we have were written by these playwrights—seven by Aeschylus, seven by Sophocles, and 18 by Euripides.

Playwrights entering the contests for tragedy or comedy were required to submit their plays to a panel of presiding officers, who selected three winners for production. The early classical plays had only one actor, plus a chorus. At the time of selection, the playwright was assigned the chief actor and the patron who paid all the expenses for the production. The author was also director, CHOREOGRAPHER, and musical composer, and often played the leading role as well.

Aeschylus

At the time the *Kritios Boy* (Fig. **4.15**) was created, Aeschylus, the most famous poet of ancient Greece, began to write for the theatre. He wrote magnificent tragedies of high poetry and on lofty moral themes. For example, in *Agamemnon*, the first play in the *Oresteia* trilogy, Aeschylus' chorus warns that success and wealth are insufficient without goodness.

> Justice shines in sooty dwellings
> Loving the righteous way of life,
> But passes by with averted eyes
> The house whose lord has hands unclean,
> Be it built throughout of gold,
> Caring naught for the weight of praise
> Heaped upon wealth by the vain, but turning
> All alike to its proper end.[6]

Aeschylus poses questions that we still ask, such as, how responsible are we for our own actions? how subject are we to uncontrollable forces? His characters are larger than life, to be read as types rather than individuals, in accordance with the contemporary emphasis on the ideal. Yet in their strivings, as in their flaws, they are also undeniably human. Aeschylus' casts for his early plays consist of one actor and a chorus of 50, conforming to the convention of the time. He is credited with the addition of a second actor, and, by the end of his long career, a third actor had been introduced and the chorus had been reduced to 12.

Aeschylus' plays appeal strongly to the intellect. Aristophanes, the master of Greek comedy, has Aeschylus, as a character in *The Frogs*, defend his writing as an inspiration to patriotism, to make people proud of their achievements. This is a high appeal, not a low one—to the intellect rather than the emotions. Aeschylus lived through the Persian invasion, witnessed the great Athenian victories, and fought at the battle of Marathon, and his plays reflect this experience.

Sophocles

Sophocles' career overlapped with that of Aeschylus. With *Oedipus the King*, his personal career reached its peak at the zenith of the Greek classical style. Sophocles' plots and characterizations illustrate a trend toward increasing realism similar to that in classical sculpture. The move toward realism did not involve any illusion of reality onstage, however, and even Euripides' plays, the least

MASTERWORK
Sophocles—Oedipus the King

The story of Oedipus the king is one of the great legends of western culture. It has permeated our literature and even found its way into Freudian psychology in the term "Oedipus complex," which denotes an unnatural love of a son for his mother. When Sophocles used the legend in *Oedipus the King*, the story was familiar to all Athenians. In fact, it had also formed the basis for plays by Aeschylus and Euripides. However, Sophocles' treatment can arguably claim the title of the world's greatest tragedy.

The action moves from one moment of dramatic tension to another, rising in pyramidal form to its climax. The protagonist, or central character, Oedipus, starts with no knowledge of his true identity. Slowly he discovers the truth about himself and the terrible deeds he has unknowingly committed: the murder of his father and marriage to his mother. However, his tragedy lies in the discovery of his guilt, rather than in the heinous acts themselves.

In *Oedipus*, Sophocles explores the reality of the dual nature we all share. He again poses the eternal question, can we control our destinies or are we the pawns of fate? In exploring this question, he vividly portrays the circumstances in which one's strengths become one's weaknesses. Oedipus' HAMARTIA, or tragic flaw, is the excessive pride, or HUBRIS, which drives him to pursue the truth, as a king—or a man—should, only to find the awful answer in himself.

Although the play is a tragedy, the message is one of uplift and positive resolution. (This type of structure is more fully described in the section below on Aristotle's theory of tragedy.) When Oedipus recognizes his own helplessness in the face of the full horror of his past, he performs an act of contrition: he blinds himself, and then exiles himself. As grotesque as this may seem, it nevertheless releases Oedipus onto a higher plane of understanding. The chorus chants, "I was blind," while seeing with normal eyes, and Oedipus moans, "I now have nothing beautiful left to see in this world." Yet, being blind, Oedipus is now able to "see" the nobler, truer reality of his self-knowledge.

idealistic of the Greek tragedies, are not realistic as we understand the word.

Sophocles was certainly a less formal poet than Aeschylus, however. His themes are more human, and his characters more subtle, although he explores the themes of human responsibility, dignity, and fate with the same intensity and high seriousness that we see in Aeschylus. His plots show increasing complexity, but within the formal restraints of the classical spirit.

Sophocles lived and wrote after the death of Pericles in 429 BC, and he experienced the shame of Athenian defeat. Even so, his later plays did not shift toward the emotionalism and interest in action we noted in sculpture. Classical Greek theatre consisted mostly of discussion and narration. The stories often dealt with bloodshed, but, though the play might lead up to the violence, and action was resumed when it was over, it is important to note that blood was never seen to be shed on stage.

Euripides

Euripides was younger than Sophocles, although both died in 406 BC. They did, however, compete with each other, despite the fact that their works have quite different styles. Euripides' plays carry realism further than any other Greek tragedies. His plays deal with individual emotions rather than great events. His language, though still basically poetic, has greater verisimilitude and much less formality than that of his predecessors. Euripides also experiments with, or ignores, many of the conventions of his theatre, relying less heavily on the chorus.[7] He explores the mechanical potential of scenery shifting.[8] He also questions the religion of the day in his plays. They are more TRAGICOMEDIES than pure tragedies, and some critics have described many of them as MELODRAMAS.[9] He was also less dependent on the chorus.

Plays such as The Bacchae reflect the changing Athenian spirit and dissatisfaction with contemporary events. Euripides was not particularly popular in his time, perhaps because of his less idealistic, less formal, and less conventional treatment of dramatic themes and characters. Was he perhaps too close to the reality of his age? His plays were received with enthusiasm in later years, however, and they are unquestionably the most popular of the Greek tragedies today.

Aristotle's theory of tragedy

We cannot leave the discussion of Greek theatre without noting Aristotle's analysis of tragedy. His ideas are still basic to dramatic theory and criticism, despite the fact that they have often been misunderstood and misapplied over the past 2400 years. Drawing principally on Sophocles as a model, Aristotle laid out in the Poetics the six elements of tragedy. In order of importance they are (1) plot, which includes exposition, discovery, reversal, point of attack, foreshadowing, complication, climax, crisis, and DÉNOUEMENT, where events are brought to a conclusion; (2) character; (3) thought; (4) diction; (5) music; and (6) spectacle.

Here we find further evidence of the classical focus on intellect, form, idealism, convention, and simplicity. Plot, in tragedy, is far more than the simple story line. For Aristotle, plot creates the basic structure of the play, just as form is the cornerstone of classical design. The parts of plot give shape to the play with a beginning (exposition), a middle (complication), and an end (dénouement), ensuring that the audience understands the progress of the drama. Additional points in the plot include discoveries, in which characters learn about themselves and others; foreshadowing, in which the playwright alerts the audience to future action; reversals, in which fortunes change; and crises, in which tension is created and characters grow. The point of attack and the climax are special forms of crises which respectively begin and end the complication section of the play.

Aristotle uses character to mean the force that drives the individuals in the play, that is, the psychological make-up that determines the way they respond to a situation. Thought is the intellectual content of the play. Diction is the words of the script, as opposed to music, which consists of all the aural elements of the play, including the way in which the actors speak the words. Finally, spectacle includes all the visual elements of the production.

Tragedy, for Aristotle, is a form of drama in which a protagonist goes through a significant struggle which ends in disaster. However, the protagonist is always a heroic character, who gains a moral victory even in physical defeat. Tragedy therefore asserts the dignity of humanity, as well as the existence of larger moral forces. In the end, tragedy is a positive experience, which evokes a catharsis, or purging, of pity and fear in the audience.

Aristophanes

Tragedies were not the only works produced in the theatre of the classical era in Athens. The Athenians were extremely fond of comedy, although no examples survive from the Periclean period. Aristophanes (c.450–c.380 BC), of whose plays we have 11, was the most gifted of the comic poets. His comedies of the post-classical period, such as The Acharnians, are highly satirical, topical, sophisticated, and often obscene. Productions of his comedies are still staged, in translation, but as the personal and political targets of his invective are unknown to us, these modern productions are mere shadows of what took the stage at the turn of the fourth century BC.

New comedy

In the period from the middle of the fourth to the middle of the third century BC, comedy was the staple of the Hellenistic theatre. Only five, incomplete, plays by Menander survive, but the characteristics of his style are fairly clear. In this new comedy, in contrast to the old comedy of Aristophanes, the biting political invective is gone, though the action is still bawdy. The situations are pleasant and domestic, and for the most part superficial and without satire. Religion no longer plays a central role in the theatre, and the chorus has disappeared entirely.

Costume

If the plays of the Greek classical style treated lofty themes with theatrical, poetic language, the style of the productions displayed no less formality, idealism, and convention. The larger-than-life characters were portrayed by actors, always men, in larger-than-life, conventionalized costumes. Actors and chorus wore bright robes whose colors conveyed specific information to the audience. The robes were padded to increase the actor's size; height was increased by thick-soled boots called *kothurnoi* and large masks whose fixed, conventionalized expressions were readily identified by the sophisticated and knowledgeable audience (Fig. **5.21**). Height was further increased by an *onkos*, a wiglike protrusion on top of the mask.

Theatre design

Scholars do not agree about the exact layout of the classical Greek theatre building and the precise nature of the acting area and scenery. But we can summarize some of

5.22 Reconstruction of the Hellenistic theatre at Ephesus, Turkey, c.280 BC, rebuilt c.150 BC.

the architectural and archeological speculation, bearing in mind that it is only speculation

The form of the Greek theatre owes much to its origins in the choral dances associated with the worship of Dionysus. In 534 BC, Thespis is reported to have introduced a single actor to these dances. In 472, Aeschylus added a second actor, and in 458, Sophocles added a third. Throughout its history the Greek theatre comprised a large circular ORCHESTRA—the acting and dancing area—with the vestige of an altar at its center, and a semicircular *theatron*—auditorium or viewing place—usually cut into or occupying the slope of a hill. Since the actors played more than one role, they needed somewhere to change costume, and so a SKENE—scene-building or retiring place—was added. The process by which the *skene* developed into a raised stage is somewhat obscure, but by later, Hellenistic times, it had become a rather elaborate, two-storied affair (Fig. **5.22**), with projecting wings at each end.

The earliest theatre still in existence is the theatre of Dionysus on the south slope of the Acropolis. It dates from the fifth century BC, and is where the plays of Aeschylus, Sophocles, Euripides, and Aristophanes were staged. Its current form dates from a period of reconstruction work around 338–326 BC. The theatre at Epidaurus (Figs **5.23** and **5.24**) is the best preserved. It was built by Polyclitus the Younger in about 350 BC. Its size demonstrates the monumental character the theatre had assumed by that time. The *orchestra* measures 66 feet in diameter, with an altar to Dionysus in the center. The auditorium, comprising slightly more than a semicircle, is divided by an AMBULATORY about two-thirds of the way up, and by radiating stairways. All the seats were of stone, and the first or lowest row consisted of seats for the dignitaries of Athens, which had backs and arm rests; some decorated with relief sculptures.

The design of theatres undoubtedly differed from place to place but time has removed most examples from

5.21 Greek statuette of a tragic actor, wearing a mask and a rich costume.

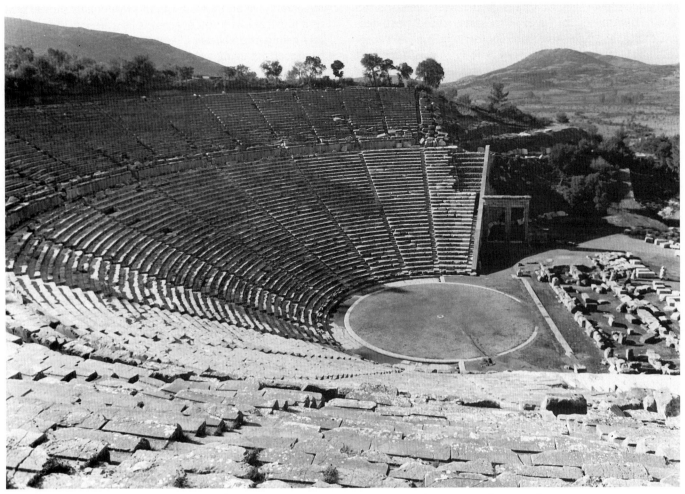

5.23 Polyclitus the Younger, theatre at Epidaurus, Greece, c.350 BC. Diameter 373 ft (114 m), *orchestra* 686 ft (20 m) across.

5.24 Plan of the theatre at Epidaurus, Greece, c.350 BC.

our study. The many theories about how Greek theatre productions worked, how scenery was used, and whether or not a raised stage was present, make fascinating reading, and the reader is encouraged to explore the area in detail elsewhere.

MUSIC

Very few examples of ancient Greek music survive from any era—merely a handful of fragments with no clue as to how they were supposed to sound. Thanks to vase paintings and literature, however, we can at least speculate on the classical Greek theory of music and about its tone quality, or timbre.

The lyre and the aulos were the instruments basic to Greek music, and each had a significant role in pre-classical ritual. In the classical era the lyre and the aulos were used as solo instruments and as accompaniment.

The spirit of contest popular among the Greeks apparently extended to instrumental and vocal music. As with all the arts, music was regarded as essential to life,

and almost everyone in Athens participated. Perhaps the word "dilettante," or lover of the arts, would best describe the average Athenian. Professionalism and professional artists, however, were held in low esteem, and Aristotle urged that skill in music stop short of the professional. Practice should develop talent only to the point where one could "delight in noble melodies and rhythms," as he says in the *Poetics*. He also discouraged excessive complexity. We should not infer too much from such an observation: complexity for the ancient Greeks would no doubt still be simplicity by our musical standards. It appears reasonably clear, for instance, that all Greek music of this era was MONOPHONIC. "Complexity" might therefore mean technical difficulty, and perhaps MELODIC ornamentation, but not textural complication. Whether that would have been contrary to the classical spirit we do not know, but a specific reaction against complexity did occur some time after 325 BC, and it is from the Hellenistic era that our only remnants of Greek music come.

It is possible to glean some information about the purpose of music from contemporary literature. Aristotle said that music should lead to noble thought. But some music in the Greek repertoire certainly led the other way. Rituals in praise of the god Dionysus were emotional and frenetic, and music played an important role in these. We can assume that the calls for restraint and pursuit of the ideal indicate that at least some music was of an intellectual nature.

If Plato's *Republic* can be taken as an accurate guide, Greek music seems to have relied on convention. Most of the performances in Periclean Athens appear to have been improvized, which may seem at odds with formal order. However, "improvization" should not be interpreted here as spontaneous or unrehearsed. The Greeks had formulas or rules concerning acceptable musical forms, and a system of scales, or MODES, for nearly every occasion. So the musician, though free to seek the momentary inspiration of the Muses—the mythological sisters who presided over the arts—was constrained by all the conventions applicable to the occasion.

The reliance on form that characterized classical style was reflected in music through its relationship to mathematics. Greek classicism exemplified an orderly, formal, and mathematical approach to reality. Pythagoras taught that an understanding of numbers was the key to an understanding of the entire spiritual and physical universe. Those views, expressed in music, as well as the other arts, led to a system of sounds and rhythms ordered by numbers. The intervals of the musical scale were determined by measuring vibrating strings. The results yielded relationships which even today are fundamental to western musical practice: 2:1=an OCTAVE; 3:2=a fifth; 4:3=a fourth. Since the characteristics of vibrating strings are constant, this aspect of Greek music, at least, is comprehensible.

Finally, in around 265 BC, the Hellenistic period gave us a musical invention of great consequence, the organ. It was called the *hydraulos*, or water organ, and sound was produced by using water to force air upward through the reeded pipes.

DANCE

Dance in the age of Pericles took the form of both classical and anti-classical styles. The dances of the Dionysiac cult revels, which may have decreased in popularity but certainly continued under Periclean rule, disregarded form, order, restraint, and idealization. They were informed by emotional frenzy, not intellect. However, the philosophies of the era, the relationship of dance to music and drama, and the treatment of dance by Plato and Aristotle, indicate that those aspects of dance which were associated with the theatre, at least, must have reflected classical values.

Dance is an evanescent art form, however. Today, even with LABANOTATION—the system of writing down dance movements—we cannot know what a dance piece looks like if we do not see the event. So the literary treatises, the musical fragments, and the archeological evidence from which so many have tried to reconstruct the dances of the Greeks can give us very little idea. In fact, the conventional nature of Greek art is our most formidable obstacle. Some vase pantings and sculptures clearly depict dancers (Fig. **5.25**), but we do not know the conventions that apply to these poses, and so we are unable to reconstruct any actual dances.

5.25 Statuette of a veiled dancer, c.225–175 BC. Bronze, 8⅛ ins (20.6 cm) high. Metropolitan Museum of Art, New York (Bequest of Walter C. Baker, 1972).

ARCHITECTURE

Classical style

Existing examples of Greek architecture offer a clear and consistent picture of the basic classical style, and nothing brings that picture so clearly to mind as the Greek temple. H. W. Janson makes an interesting point in his *History of Art* when he suggests that the crystallization of the characteristics of a Greek temple is so complete that when we think of one Greek temple, we think of all Greek temples. Even so familiar a structure as a Gothic cathedral does not quite do this, because, despite the consistent form of the Gothic ARCH, it is used in such diverse ways that no one work can typify the many.

The classical Greek temple, as seen in Figures **5.26** and **5.29**, has a structure consisting of horizontal blocks of stone laid across vertical columns. This is called "POST-AND-LINTEL" structure. It is not unique to Greece, but the Greeks refined it to its highest aesthetic level. Structures of this type have some very basic problems. Stone has no great tensile strength, although it is high in COMPRESSIVE STRENGTH (the ability to withstand crushing). Downward thrust works against the tensile qualities of horizontal slabs (lintels) but for the compressive qualities of the vertical columns (POSTS). As a result, columns can be relatively delicate, whereas lintels must be massive.

This structural system allows for only limited open interior space. This was no great problem for the Greeks because their temples were built to be seen and used from the outside. The Greek climate does not drive worshippers inside a building. Thus, exterior structure and aesthetics were the primary concern.

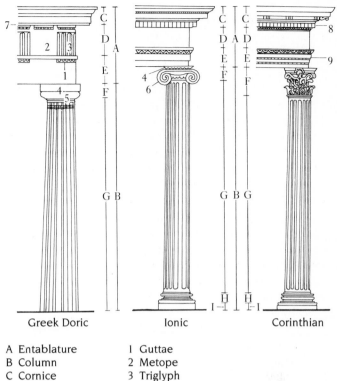

A Entablature	1 Guttae
B Column	2 Metope
C Cornice	3 Triglyph
D Frieze	4 Abacus
E Architrave	5 Echinus
F Capital	6 Volute
G Shaft	7 Fluting
H Base	8 Dentils
I Plinth	9 Fascia

Greek Doric Ionic Corinthian

5.27 The orders of Greek architecture.

5.26 The Nereid Monument, c.400 BC. British Museum, London.

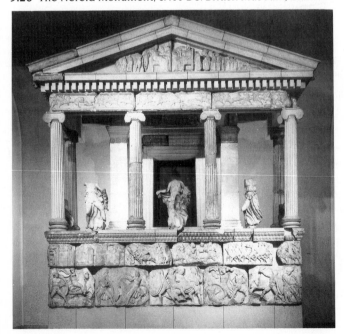

Greek temples used three orders, Doric, IONIC, and CORINTHIAN. The first two are classical; the third, though of classical derivation, is of the later, Hellenistic style. As Figure **5.27** shows, simplicity was important to the Greek classical style, and the Doric and Ionic orders maintain clean lines even in their capitals. The Corinthian order has more ornate capitals. Taken in the context of an entire building, this detail may not seem significant. But columns, and particularly their capitals, are convenient ways of identifying the order of a Greek temple. Differences are also apparent in column bases and the configuration of the lintels, but the capitals tell the story at a glance. The earlier of the two classical orders, the Doric, has a massive appearance compared with the Ionic. The Ionic column, with its round base, is raised above the baseline of the building. The flutings of the Ionic order, usually 22 per column, are deeper and more widely separated than those of the Doric, giving it a more delicate appearance. Ionic capitals consist of paired spiral shaped forms, known as VOLUTES. The Ionic architrave, or lintel, is divided into three horizontal bands, which diminish in size downward, creating a sense of lightness, unlike the massive Doric architrave.

MASTERWORK
The Parthenon

On the summit of the Acropolis at Athens (Fig. **5.28**) stands the Parthenon, the greatest temple built by the Greeks and the prototype for all classical buildings thereafter. When the Persians sacked Athens in 480 BC, they destroyed the then-existing temple and its sculpture. And when Pericles rebuilt the Acropolis later in the fifth century BC, Athens was at its zenith, and the Parthenon was its crowning glory. The Parthenon (Figs **5.29** and **5.30**) exemplifies Greek classical architecture. Balance is achieved through geometric symmetry, and the clean, simple lines represent a perfect balance of forces holding the composition together. For the Greeks, deities were only slightly superior to mortals, and in the Greek temple, deity and humanity met in an earthly rendezvous. This human-centered philosophy is reflected by the scale of the temple.

In PLAN, the Parthenon has short sides slightly less than half the length of the long sides. Its interior, or *naos*, which is divided into two parts, housed a 40-foot-high ivory and gold statue of Athena. The temple is peripteral, that is, surrounded by a single row of columns. The number of columns across the front and along the sides of the temple is determined by a specific convention. The internal harmony of the design rests in the regular repetition of virtually unvaried forms. All the columns appear alike and to be spaced equidistantly. But at the corners the spacing is adjusted to give a sense of grace and perfect balance, while preventing the monotony of unvaried repetition.

All the elements are carefully adjusted. A great deal has been written about the "refinements" of the Parthenon—those features that seem to be intentional departures from strict geometric regularity. According to some, the slight bulge of the horizontal elements compensates for the eye's tendency to see a downward sagging when all elements are straight and parallel. Each column swells toward the middle by about seven inches, to compensate for the tendency of parallel vertical lines to appear to curve inward. This swelling is known as ENTASIS. The columns also tilt inward slightly at the top, in order to appear perpendicular. The stylobate is raised toward the center so as not to appear to sag under the immense weight of the stone columns and roof. Even the white marble, which in other circumstances might appear stark, may have been chosen to reflect the intense Athenian sunlight.

Vitruvius, the Roman architect, is the earliest known commentator to describe these adjustments as "aesthetic," but some scholars now believe that practical concerns also played a role. According to Janson, the theory that they are optical corrections does not work. If that were the case, he says, we would be unable to observe them except by careful measurement. But because they *can* be seen, they were *meant* to be seen, and to add to the harmonious quality of the structure.

In a single structure the Parthenon exhibits the classical characteristics of convention, order, balance, simplicity, and grace.

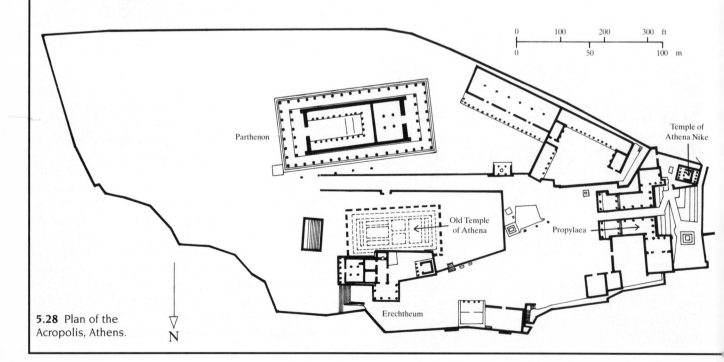

5.28 Plan of the Acropolis, Athens.

N

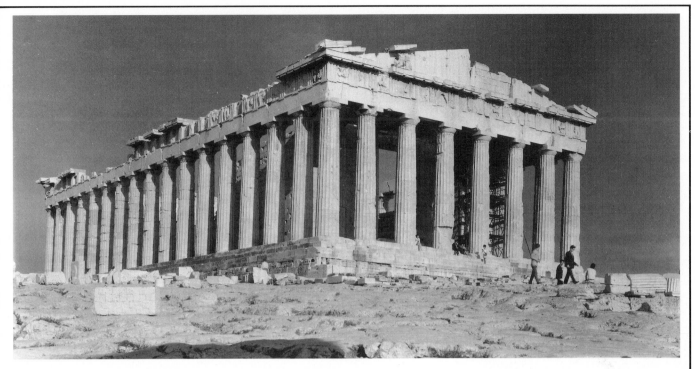

5.29 Ictinos and Callicrates, the Parthenon, Acropolis, Athens, from the northwest, 447–438 BC. Marble.

5.30 The Parthenon, frieze on the west cella, c.440BC.

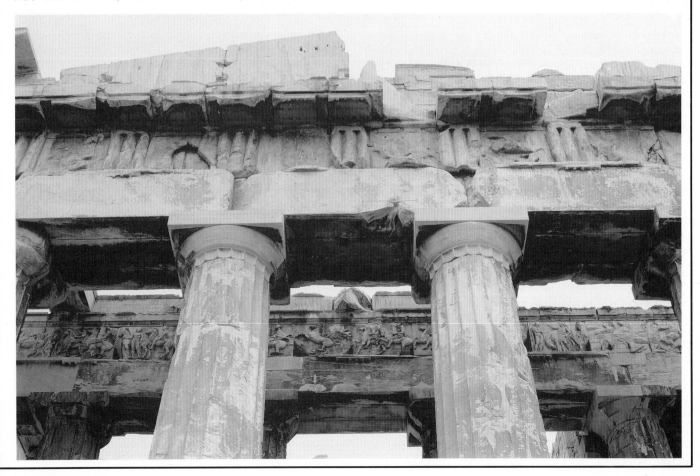

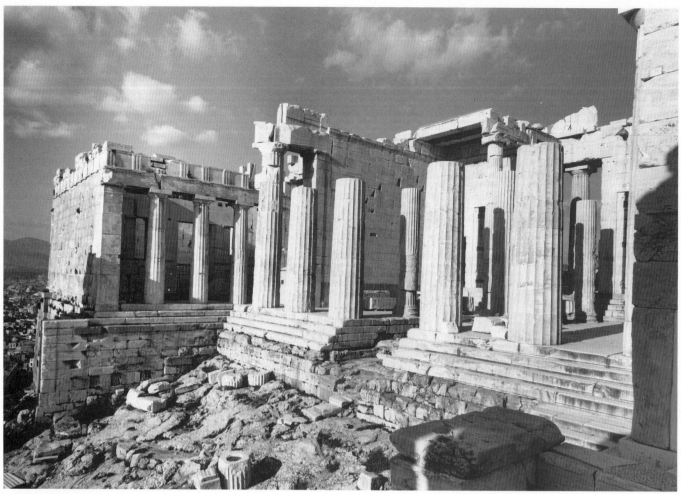

5.31 The Propylaea, Athens, from the west, c.437–432 BC.

The structure that serves as the entrance portal to the Parthenon is one of the most imposing monuments on the Acropolis. The Propylaea (Fig. **5.31**) was begun soon after the Parthenon was finished. It combines Doric and Ionic elements—two Doric temple-like FAÇADES are linked by an Ionic COLONNADE—in a design of some complexity which accommodates the awkward, sloping site. Work on the project was interrupted by the onset of the Peloponnesian Wars, and the building was never completed.

A final example of classical architecture takes us slightly beyond the classical period of the late fifth century BC. Although no inscriptional information or other evidence provides a certain date for the Temple of Athena Nike (Fig. **5.32**), this little Ionic temple probably dates from the last quarter of the century. The pediments contained sculptures, but none of these has survived. What remain are sculptures from the frieze. The Battle of Marathon of 490 BC, the Athenians' greatest victory over the Persians, is the subject matter for the frieze on the south side of the temple. It is "the only known example in temple sculpture of a conflict from near-contemporary

rather than legendary history".[10] The battle had apparently assumed a legendary status even by 420 BC.

Hellenistic style

The Temple of Olympian Zeus (Fig. **5.33**) illustrates the Hellenistic modifications of classical style in architecture. The scale and complexity of the building are considerably different from the Parthenon. Order, balance, moderation, and harmony are still present, but these huge ruins reveal a change in proportions, with the use of slender and ornate Corinthian columns: temple architecture in this style was designed to produce an overpowering emotional experience. Begun by the architect Cossutius for King Antiochus IV of Syria, this is the first major Corinthian temple. Its elaborate detail pushed its completion date into the second century AD, under the Roman emperor Hadrian. The ruins can only vaguely suggest the size and richness of the original building, which was surrounded by an immense, walled precinct.

5.32 The Temple of Athena Nike, Acropolis, Athens, (?)427–424 BC.

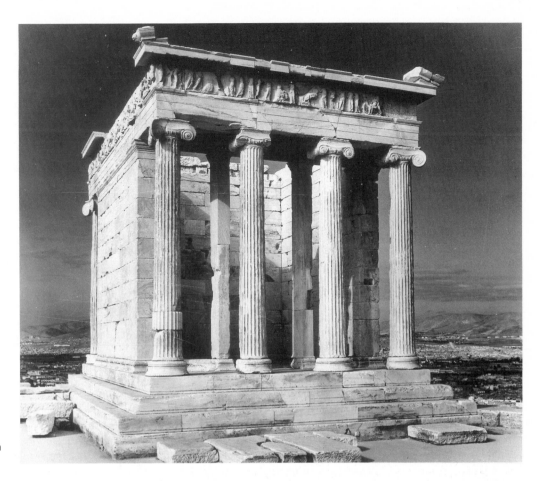

5.33 The Temple of Olympian Zeus, Athens, 174 BC–AD 130.

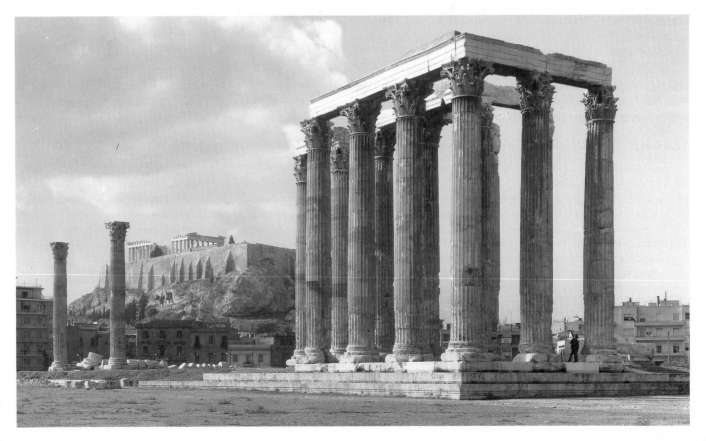

SYNTHESIS
From idealism to realism:
Prometheus and Hecuba

In examining Athenian art in this chapter, we have been able to compare the various art forms of classical and Hellenistic Greece, to isolate some shared themes, and to draw some general conclusions about them. Thus, the work of synthesis is largely done. It may be more useful here to focus on the process of change in Greek culture instead. In particular, we can see how much change occurred over a brief time in a single discipline, the theatre. To do this, we will use two plays that bracket the classical period in Athens: Aeschylus' *Prometheus Bound* and Euripides' *Hecuba*.

According to legend, Prometheus frustrated the plans of Zeus by giving fire to a race of mortals whom Zeus sought to destroy. Here is classical Greek idealism at work: through reason, application, and vision, human beings can defy the gods and win. They are capable of nobility and infinite improvement. As punishment for his presumption, however, Zeus has Prometheus chained to a rock. In Prometheus' justification of what he did, he suggests that humankind, through technology and reason, can have dominion over nature.

Prometheus is a play unusual even for Aeschylus in its heavy dependence on dialogue and character, and in its lack of action. The hero is motionless, chained to a rock. Nothing happens. There is only conversation between a parade of different people, through which the playwright reveals character and situation.

In this extract, the scene is set for an exchange between Force, Violence, and Hephaestus, the fire god. Violence does not speak, however, as there are only two actors. Force presents the situation:

> Far have we come to this far spot of earth,
> This narrow Scythian land, a desert all untrodden.
> God of the forge and fire, yours the task
> The Father laid upon you.
> To this high-piercing, head-long rock
> In adamantine chains that none can break
> Bind him—him here, who dared all things.
> Your flaming flower he stole to give to men,
> Fire, the master craftsman, through whose power
> All things are wrought, and for such error now
> He must repay the gods; be taught to yield
> To Zeus' lordship and to cease
> From his man-looking way.

Through speeches such as these, the characters are revealed—Force as a villain, and Hephaestus as a weak but kindly fool. After Force, Violence, and Hephaestus exit, Prometheus appears. He may have been revealed on a low wagon, called an *ekkyklema*, which was rolled out from the central door of the *skene*. He speaks:

> O air of heaven and swift winged winds,
> O running river waters,
> O never numbered laughter or sea waves,
> Earth, mother of all, eye of the sun, all seeing,
> On you I call.
> Behold what I, a god, endure for gods.
> See in what tortures I must struggle
> Through countless years of time.
> This shame, these bonds, are put upon me
> By the new ruler of the gods.
> Sorrow enough in what is here and what is still to come.

And so the myth unfolds itself in high poetry as Prometheus discourses with the chorus, a group of kindly sea-nymphs, with Hermes, with Ocean, a humorous old busy-body, and with Io, an ephemeral creature. When the dialogue has run its course, Prometheus declaims:

> An end to words. Deeds now,
> The world is shaken,
> The deep and secret way of thunder
> Is rent apart.
> Fiery wreaths of lightning flash.
> Whirlwinds toss the swirling dust.
> The blasts of all the winds are battling in the air,
> And sky and sea are one.
> On me the tempest falls.
> It does not make me tremble
> O holy Mother Earth, O air and sun,
> Behold me. I am wronged.[11]

Prometheus is an idealistic exploration of human capacity, achievement, and power, written as the height of the golden age of Athens approached. Euripides' play *Hecuba*, on the other hand, is a bitter tragedy of the inter-relationships between those who rule and those who obey. It was written at a time when failure of leadership had dragged Athens downward through a long war of attrition with Sparta. Here again the playwright deals with myth, in this case, the story of the sack of Troy.

Two separate events are related, giving the plot an episodic character. Hecuba is the wife of Priam, king of Troy, whose city has at last fallen to the Greeks. She endures first the slaughter of her daughter Polyxena by the Greeks, then she discovers the body of her son, Polydorus, who has been murdered by Polymestor. Each of these events takes her one step further from grief and nearer to despair. She seeks the help of the Greek king, Agamemnon, in her quest for revenge on Polymestor, but receives only pity and the question, "What woman on this earth was ever cursed like this?" Hecuba replies in language less poetic and more realistic than that of Prometheus:

There is none but goddess Suffering herself.

But let me tell you why I kneel
At your feet. And if my suffering seem just,
Then I must be content. But if otherwise,
Give me my revenge on that treacherous friend
Who flouted every god in heaven and in hell
To do this brutal murder.

At our table
He was our frequent guest; was counted first
Among our friends, respected and honoured by me,
Receiving every kindness that a man could meet—
And then, in cold deliberation killed
My son.

Murder may have its reasons, its motives,
But this—to refuse my son a grave, to throw him
To the sea, unburied! . . .

See me whole, observe
My wretchedness—

Once a queen, now
A slave; blessed with children, happy once,
Now old, childless, utterly alone,
Homeless, lost, unhappiest of women
On this earth . . .[12]

Step by step she moves inevitably toward her final acts of atrocity. The play focuses on how she is forced to yield, one at a time, her values, her self-respect, and "the faith which makes her human." Underlying the play is a stark condemnation of the logic of political necessity. When faced with power over which she has no control, she pleads the case of honor, decency, the gods, and moral law. All these appeals fail. As despair destroys her humanity, she passes beyond the reach of judgment. The chorus condemns the tragic waste of war and questions the necessity and logic of imperialism. Finally, Euripides attacks the gods themselves. Even if they exist, he implies, their justice is so far removed from humans that it has no relevance.

The transition from idealism, form, order, and restraint to greater realism and emotion represented by these two plays parallels the changes we have seen in painting, sculpture, and architecture. In all the arts, the idealization of classicism turned to the realism of succeeding styles; restraint gave way to emotion, and form gave way to feeling.

SUGGESTIONS FOR THOUGHT AND DISCUSSION

The classical period in Greece, which reached its peak during the brief but lustrous age of Pericles, put humanism at the center of philosophy, aesthetics, and the arts. Humanity was the measure of all things. The gods displayed human characteristics and characters. Earthly life was of primary concern, and the *polis* was fundamental. In temple architecture, earth-bound designs of human scale further reinforced the humanism of philosophy and religion.

A second concept, that of intellectual rationalism, was also part of Greek life and art. From dramas such as *Prometheus* to the geometric designs of vase painting, order and form predominated. Appeal to the intellect and the ability to address all issues successfully through reason are themes that underlie everything in classical Greece. A third concept, idealism, further reinforced the classical emphasis on the raising of humanity to its highest potential. From Plato to Aristotle, among sculptors, architects, and playwrights, we see this theme played out again and again.

As the golden age dissolved into the reality of Athenian defeat, however, we see a change in tone and attitude. Types become individuals, and idealism is brought down to earth. The Cynics, Stoics, and Epicureans develop more pragmatic approaches to life and happiness. As the Hellenistic period arrived, simplicity in artistic form gave way to complexity. The aesthetic that created the Doric Parthenon was replaced by the heroics that produced the Corinthian Temple of Olympian Zeus. Appeal to the emotions took precedence over appeal to the intellect.

■ In what ways can you relate the philosophies of Plato to the classical style in painting, sculpture, and drama?

■ How do Aristotle and Plato differ in their aesthetic theories?

■ What relationships can be identified between the concepts of democracy and the *polis* and Aristotle's rejection of professionalism in the arts?

■ What practical circumstances made the "golden age" possible?

■ Trace the stylistic changes in vase painting and sculpture and compare these with changes in theatre art from the early classical to the Hellenistic period.

LITERATURE EXTRACTS

Agamemnon

Aeschylus

This is the first of a series of three plays by Aeschylus, called the *Oresteia*.

CHARACTERS

Watchman
Chorus of Old Men
Klytaimnestra, Queen of Mycenae
Herald
Agamemnon, King of Mycenae
Kassandra, daughter of Priam, King of Troy
Aigisthos, cousin of Agamemnon and usurper of the throne of Mycenae
Captain of the Guard

The scene is the entrance to the palace of the Atreidae. Before the doors stand shrines of the gods.

[*A* WATCHMAN *is posted on the roof.*]

Watchman: I've prayed God to release me from sentry
 duty
All through this long year's vigil, like a dog
Couched on the roof of Atreus, where I study
Night after night the pageantry of this vast
Concourse of stars, and moving among them like
Noblemen the constellations that bring
Summer and winter as they rise and fall.
And I am still watching for the beacon signal
All set to flash over the sea the radiant
News of the fall of Troy. So confident 10
is a woman's spirit, whose purpose is a man's.
Every night, as I turn in to my stony bed,
Quilted with dew, not visited by dreams,
Not mine—no sleep, fear stands at my pillow
Keeping tired eyes from closing once too often;
And whenever I start to sing or hum a tune,
Mixing from music an antidote to sleep,
It always turns to mourning for the royal house,
Which is not in such good shape as it used to be.
But now at last may the good news in a flash 20
Scatter the darkness and deliver us.
 [*The beacon flashes.*]
O light of joy, whose gleam turns night to day,
O radiant signal for innumerable
Dances of victory! Ho there! I call the queen,
Agamemnon's wife, to raise with all the women
Alleluias of thanksgiving through the palace
Saluting the good news, if it is true
That Troy has fallen, as this blaze portends:
Yes, and I'll dance an overture myself.
My master's dice have fallen out well, and I 30
Shall score three sixes for this nightwatching.
 [*A pause.*]
Well, come what will, may it soon be mine to grasp
In this right hand my master's, home again!

[*Another pause.*]
The rest is secret. A heavy ox has trodden
Across my tongue. These walls would have tales to tell
If they had mouths. I speak only to those
Who are in the know, to others—I know nothing.
 [*The* WATCHMAN *goes into the palace.*
 Women's cries are heard. Enter CHORUS OF
 OLD MEN.]
Chorus: It is ten years since those armed prosecutors of
Justice, Menelaos and Agamemnon, twin-sceptred in God-
given sovereignty, embarked in the thousand ships crying 40
war, like eagles with long wings beating the air over a
robbed mountain nest, wheeling and screaming for their
lost children. Yet above them some god, maybe Apollo
or Zeus, overhears the sky-dweller's cry and sends after
the robber a Fury.
 [KLYTAIMNESTRA *comes out of the palace*
 and unseen by the elders places offerings before
 the shrines.]
Just so the two kings were sent by the greater king, Zeus,
for the sake of a promiscuous woman to fight Paris, Greek
and Trojan locked fast together in the dusty betrothals of
battle. And however it stands with them now, the end is
unalterable; no flesh, no wine can appease God's fixed 50
indignation.
 As for us, with all the able-bodied men enlisted and
gone, we are left here leaning our strength on a staff; for,
just as in infancy, when the marrow is still unformed, the
War-god is not at his post, so it is in extreme old age, as
the leaves fall fast, we walk on three feet, like dreams in
the daylight.
 [*They see* KLYTAIMNESTRA.]
 O Queen, what news? what message sets light to the
altars? All over the town the shrines are ablaze with
unguents drawn from the royal stores and the flames 60
shoot up into the night sky. Speak, let us hear all that
may be made public, so healing the anxieties that have
gathered thick in our hearts; let the gleam of good news
scatter them!
 [KLYTAIMNESTRA *goes out to tend the other*
 altars of the city.]
Strength have I still to recall that sign which greeted the
 two kings
Taking the road, for the prowess of song is not yet spent.
I sing of two kings united in sovereignty, leading
Armies to battle, who saw two eagles
Beside the palace
Wheel into sight, one black, and the other was
 white-tailed, 70
Tearing a hare with her unborn litter.
Cry Sorrow cry, but let good conquer!
Shrewdly the priest took note and compared each eagle
 with each king.
Then spoke out and prefigured the future in these words:
"In time the Greek arms shall demolish the fortress of
 Priam;
Only let no jealous God, as they fasten

On Troy the slave's yoke,
Strike them in anger; for Artemis[1] loathes the rapacious
Eagles of Zeus that have slaughtered the frail hare.
Cry Sorrow cry, but let good conquer! 80
O Goddess, gentle to the tender whelp of fierce lions
As to all young life of the wild,
So now fulfill what is good in the omen and mend what is
 faulty.
And I appeal unto the Lord Apollo.
Let not the north wind hold the fleet storm-bound,
Driving them on to repay that feast with another,
Inborn builder of strife, feud that fears no man, it is still
 there,
Treachery keeping the house, it remembers, revenges, a
 child's death!"
Such, as the kings left home, was the seer's revelation.
Cry Sorrow cry, but let good conquer! 90

Zeus, whoe'er he be, if so it best
Please his ear to be addressed.
So shall he be named by me.
All things have I measured, yet
None have found save him alone,
Zeus, if a man from a heart heavy-laden
Seek to cast his cares aside.
Long since lived a ruler of the world.[2]
Puffed with martial pride, of whom
None shall tell, his day is done; 100
Also, he who followed him
Met his master and is gone.
Zeus the victorious, gladly acclaim him:
Perfect wisdom shall be yours;
Zeus, who laid it down that man
Must in sorrow learn and through
Pain to wisdom find his way.
When deep slumber falls, remembered wrongs
Chafe the bruised heart with fresh pangs, and no
Welcome wisdom meets within. 110
Harsh the grace dispensed by powers immortal,
Pilots of the human soul.
Even so the elder prince,[3]
Marshal of the thousand ships,
Rather than distrust a priest,
Torn with doubt to see his men
Harbor-locked, hunger-pinched, hard-oppressed,
Strained beyond endurance, still
Watching, waiting, where the never-tiring
Tides of Aulis ebb and flow: 120
And still the storm blew from mountains far north,
With moorings windswept and hungry crews pent

In rotting hulks,
With tackling all torn and seeping timbers,
Till Time's slow-paced, enforced inaction
Had all but stripped bare the bloom of Greek manhood.
And then was found but one
Cure to allay the tempest—never a blast so bitter—
Shrieked in a loud voice, by the priest, "Artemis!"
 striking the Atreidae with dismay, each with his staff
 smiting the ground and weeping.
And then the king spoke, the elder, saying: 130
"The choice is hard—hard to disobey him,
And harder still
To kill my own child, my palace jewel,
With unclean hands before the altar
Myself, her own father, spill a maid's pure blood.
I have no choice but wrong.
How shall I fail my thousand ships and betray my
 comrades?
So shall the storm cease, and the men eager for war
 clamor for that virginal blood righteously! So pray
 for a happy outcome!"
And when he bowed down beneath the harness
Of cruel coercion, his spirit veering 140
With sudden sacrilegious change,
He gave his whole mind to evil counsel.
For man is made bold with base-contriving
Impetuous madness, first cause of much grief.
And so then he slew his own child
For a war to win a woman
And to speed the storm-bound fleet from the shore to
 battle.
She cried aloud "Father!" yet they heard not:
A girl in first flower, yet they cared not,
The lords who gave the word for war. 150
Her father prayed, then he bade his vassals
To seize her where swathed in folds of saffron
She lay, and lift her up like a yearling
With bold heart above the altar.
And her lovely lips to bridle
That they might not cry out, cursing the House of Atreus,
With gags, her voice sealed with brute force and crushed.
And then she let fall her cloak
And cast at each face a glance that dumbly craved
 compassion;
And like a picture she would but could not greet 160
Her father's guests, who at home
Had often sat when the meal was over,
The cups replenished, with all hearts enraptured
To hear her sing grace with clear unsullied voice for her
 loving father.
The end was unseen and unspeakable.
The task of priestcraft was done.
For Justice first chastens, then she presses home her
 lesson.
The morrow must come, its grief will soon be here,
So let us not weep today.
It shall be made known as clear as daybreak. 170
And so may all this at last end in good news,
For which the queen prays, the next of kin and stay of
 the land of Argos.
 [KLYTAIMNESTRA *appears at the door of the palace.*]

1. Artemis is the goddess of the hunt and all wild things. In this
context, the hare in lines 71 and 79 is the city of Troy.
2. The reference here is Ouranus and Kronos, both kings of the gods.
Zeus led a successful revolt against Kronos and became king himself.
3. This refers to the beginning of the Trojan War when the Greek fleet
was delayed in the harbor of Aulis. In order to appease Artemis and
secure favorable winds, Agamemnon, "the elder prince," followed the
prophecy of the seer, Kalkhas, and sacrificed his daughter, Iphigeneia.

Our humble salutations to the queen!
Hers is our homage, while our master's throne
Stands empty. We are still longing to hear
The meaning of your sacrifice. Is it good news?

Klytaimnestra: Good news! With good news may the
 morning rise
Out of the night—good news beyond all hope!
My news is this: The Greeks have taken Troy.

Chorus: What? No, it cannot be true! I cannot grasp it. 180

Klytaimnestra: The Greeks hold Troy—is not that plain
 enough?

Chorus: Joy steals upon me and fills my eyes with tears.

Klytaimnestra: Indeed, your looks betray your loyalty.

Chorus: What is the proof? Have you any evidence?

Klytaimnestra: Of course I have, or else the Gods have
 cheated me.

Chorus: You have given ear to some beguiling dream.

Klytaimnestra: I would not come screaming fancies out
 of my sleep.

Chorus: Rumors have wings—on these your heart has
 fed.

Klytaimnestra: You mock my intelligence as though I
 were a girl.

Chorus: When was it? How long is it since the city fell? 190

Klytaimnestra: In the night that gave birth to this
 dawning day.

Chorus: What messenger could bring the news so fast?

Klytaimnestra: The God of Fire, who from Ida sent forth
 light
And beacon by beacon passed the flame to me.
From the peak of Ida first to the cliff of Hermes
On Lemnos, and from there a third great lamp
Was flashed to Athos, the pinnacle of Zeus;
Up, up it soared, luring the dancing fish
To break surface in rapture at the light;
A golden courier, like the sun, it sped 200
Post-haste its message to Macistus, thence
Across Euripus, till the flaming sign
Was marked by the watchers on Messapium,
And thence with strength renewed from piles of heath
Like moonrise over the valley of Asopus,
Relayed in glory to Kithairon's heights,
And still flashed on, not slow the sentinels,
Leaping across the lake from peak to peak,
It passed the word to burn and burn, and flung
A comet to the promontory that stands 210
Over the Gulf of Saron, there it swooped
Down to the Spider's Crag above the city,
Then found its mark on the roof of this house of Atreus,
That beacon fathered by Ida's far off fires.
Such were the stages of our torch relay,
And the last to run is the first to reach the goal.
That is my evidence, the testimony which
My lord has signaled to me out of Troy.

Chorus: Lady, there will be time later to thank the Gods.
Now I ask only to listen: speak on and on. 220

Klytaimnestra: Today the Greeks have occupied Troy.
I seem to hear there a very strange street-music.
Pour oil and vinegar into one cup, you will see
They do not make friends. So there two tunes are heard.
Slaves now, the Trojans, brothers and aged fathers,
Prostrate, sing for their dearest the last dirge.
The others, tired out and famished after the night's
 looting,
Grab what meal chance provides, lodgers now
In Trojan houses, sheltered from the night frosts,
From the damp dews delivered, free to sleep 230
Off guard, off duty, a blissful night's repose.
Therefore, provided that they show due respect
To the altars of the plundered town and are not
Tempted to lay coarse hands on sanctities,
Remembering that the last lap—the voyage home—
Lies still ahead of them, then, if they should return
Guiltless before God, the curses of the bereaved
Might be placated—barring accidents.
That is my announcement—a message from my master.
May all end well, and may I reap the fruit of it! 240

Chorus: Lady, you have spoken with a wise man's
 judgment.
Now it is time to address the gods once more
After this happy outcome of our cares.
Thanks be to Zeus and to gracious Night, housekeeper of
heaven's embroidery, who has cast over the towers of
Troy a net so fine as to leave no escape for old or young, all
caught in the snare! All praise to Zeus, who with a shaft
from his outstretched bow has at last brought down the
transgressor!
"By Zeus struck down!" The truth is all clear 250
With each step plainly marked. He said, Be
It so, and so it was. A man denied once
That heaven pays heed to those who trample
Beneath the feet holy sanctities. He lied wickedly;
For God's wrath soon or late destroys all sinners filled
With pride, puffed up with vain presumption,
And great men's houses stocked with silver
And gold beyond measure. Far best to live
Free of want, without grief, rich in the gift of wisdom.
Glutted with gold, the sinner kicks 260
Justice out of his sight, yet
S*he* sees *him* and remembers.
As sweet temptation lures him onwards
With childlike smile into the death-trap
He cannot help himself. His curse is lit up
Against the darkness, a bright baleful light.
And just as false bronze in battle hammered turns black
 and shows
Its true worth, so the sinner time-tried stands
 condemned.
His hopes take wing, and still he gives chase, with foul
 crimes branding all his people.
He cries to deaf heaven, none hear his prayers. 270
Justice drags him down to hell as he calls for succor.
Such was the sinner Paris, who
Rendered thanks to a gracious
Host by stealing a woman.
She left behind her the ports all astir
With throngs of men under arms filing onto shipboard;
She took to Troy in lieu of dowry death.
A light foot passed through the gates and fled,
And then a cry of lamentation rose.
The seers, the king's prophets, muttered darkly: 280
"Bewail the king's house that now is desolate,

Bewail the bed marked with print of love that fled!"
Behold, in silence, without praise, without reproach,
They sit upon the ground and weep.
Beyond the wave lies their love;
Here a ghost seems to rule the palace!
Shapely the grace of statues.
Yet they can bring no comfort,
Eyeless, lifeless and loveless.
Delusive dream shapes that float through the night 290
Beguile him, bringing delight sweet but unsubstantial;
For, while the eye beholds the heart's desire,
The arms clasp empty air, and then
The fleeting vision fades and glides away
On silent wing down the paths of slumber.
The royal hearth is chilled with sorrows such as these,
And more; in each house from end to end of Greece
That sent its dearest to wage war in foreign lands
The stout heart is called to steel itself
In mute endurance against 300
Blows that strike deep into the heart's core:
Those that they sent from home they
Knew, but now they receive back
Only a heap of ashes.
The God of War holds the twin scales of strife,
Heartless gold-changer trafficking in men,
Consigning homeward from Troy a jar of dust fire-refined,
Making up the weight with grief,
Shapely vessels laden each
With the ashes of their kin. 310
They mourn and praise them saying, "He
Was practiced well in sword and spear,
And he, who fell so gallantly—
All to avenge another man's wife":
It is muttered in a whisper
And resentment spreads against each of the royal
 warlords.
They lie sleeping, perpetual
Owners each of a small
Holding far from their homeland.
The sullen rumors that pass mouth to mouth 320
Bring the same danger as a people's curse.
And brooding hearts wait to hear of what the night holds
 from sight.
Watchful are the Gods of all
Hands with slaughter stained. The black
Furies wait, and when a man
Has grown by luck, not justice, great,
With sudden turn of circumstance
He wastes away to nothing, dragged
Down to be food in hell for demons.
For the heights of fame are perilous.
With a jealous bolt the Lord Zeus in a flash shall blast 330
 them.
Best to pray for a tranquil
Span of life and to be
Neither victor nor vanquished.
—The news has set the whole town aflame.
Can it be true? Perhaps it is a trick.
—Only a child would let such fiery words
Kindle his hopes, then fade and flicker out.
—It is just like a woman

To accept good news without the evidence. 340
—An old wives' tale, winged with a woman's wishes,
Spreads like wildfire, then sinks and is forgotten.
We shall soon know what the beacon signifies,
Whether it is true or whether this joyful daybreak
Is only a dream sent to deceive us all.
Here comes a messenger breathless from the shore,
Wearing a garland and covered in a cloud
Of dust, which shows that he has news to tell,
And not in soaring rhetoric of smoke and flame,
But either he brings cause for yet greater joy, 350
Or else—no, let us abjure the alternative.
Glad shone the light, as gladly break the day!
 [Enter HERALD]
Herald: O joy! Argos, I greet you, my fatherland!
Joy brings me home after ten years of war.
Many the shattered hopes, but this has held.
Now I can say that when I die my bones
Will lie at rest here in my native soil.
I greet you joyfully, I greet the Sun,
Zeus the All-Highest, and the Pythian King,
Bending no more against us his fatal shafts, 360
As he did beside Scamander—that was enough.
And now defend us, Savior Apollo, all
The Gods I greet, among them Hermes, too,
Patron of messengers, and the spirits of our dead,
Who sent their sons forth, may they now prepare
A joyful welcome for those whom war has spared.
Joy to the palace and to these images
Whose faces catch the sun, now, as of old,
With radiant smiles greet your sovereign lord,
Agamemnon, who brings a lamp to lighten you 370
And all here present, after having leveled
Troy with the mattock of just-dealing Zeus,
Great son of Atreus, master and monarch, blest
Above all living men. The brigand Paris
Has lost his booty and brought down the house of Priam.
Chorus: Joy to you, Herald, welcome home again!
Herald: Let me die, having lived to see this day!
Chorus: Your yearning for your country has worn you out.
Herald: So much that tears spring to the eyes for joy.
Chorus: Well, those you longed for longed equally for
 you. 380
Herald: Ah yes, our loved ones longed for our safe
 return.
Chorus: We have had many anxieties here at home.
Herald: What do you mean? Has there been
 disaffection?
Chorus: Never mind now. Say nothing and cure all.
Herald: Is it possible there was trouble in our absence?
Chorus: Now, as you said yourself, it would be a joy to
 die.
Herald: Yes, all has ended well. Our expedition
Has been successfully concluded, even though in part
The issue may be found wanting. Only the Gods
Prosper in everything. If I should tell you all 390
That we endured on shipboard in the night watches,
Our lodging the bare benches, and even worse
Ashore beneath the walls of Troy, the rains
From heaven and the dews that seeped
Out of the soil into lice-infested blankets:

If I should tell of those winters, when the birds
Dropped dead and Ida heaped on us her snows;
Those summers, when unruffled by wind or wave
The sea slept breathless under the glare of noon—
But why recall that now? It is all past, 400
Yes, for the dead past never to stir again.
Ah, they are all gone. Why count our losses? Why
Should we vex the living with grievance for the dead?
Goodbye to all that for us who have come back!
Victory has turned the scale, and so before
This rising sun let the good news be proclaimed
And carried all over the world on wings of fame:
"These spoils were brought by the conquerors of Troy
And dedicated to the Gods of Greece."
And praise to our country and to Zeus the giver 410
And thanks be given. That is all my news.
 [KLYTAIMNESTRA *appears at the palace*
 door.]
Chorus: Thank God that I have lived to see this day!
This news concerns all, and most of all the queen.
Klytaimnestra: I raised my alleluia hours ago,
When the first messenger lit up the night,
And people mocked me saying, "Has a beacon
Persuaded you that the Greeks have captured Troy?
Truly a woman's hopes are lighter than air."
But I still sacrificed, and at a hundred
Shrines throughout the town the women chanted 420
Their endless alleluias on and on,
Singing to sleep the sacramental flames.
And now what confirmation do I need from you?
I wait to hear all from my lord, for whom
A welcome is long ready. What day is so sweet
In a woman's life as when she opens the door
To her beloved, safe home from war? Go and tell him
That he will find, guarding his property,
A wife as loyal as he left her, one
Who in all these years has kept his treasuries sealed, 430
Unkind only to enemies, and knows no more
Of other men's company than of tempering steel.
 [*Exit*]
Herald: Such a protestation, even though entirely true,
Is it not unseemly on a lady's lips?
Chorus: Such is her message, as you understand,
Full of fine phrases plain to those who know.
But tell us now, what news have you of the king's
Co-regent, Menelaos? Is he too home again?
Herald: Lies cannot last, even though sweet to hear.
Chorus: Can you not make your news both sweet and
 true? 440
Herald: He and his ships have vanished. They are
 missing.
Chorus: What, was it a storm that struck the fleet at sea?
Herald: You have told a long disaster in a word.
Chorus: Has no one news whether he is alive or dead?
Herald: Only the Sun, from whom the whole earth draws
 life.
Chorus: Tell us about the storm. How did it fall?
Herald: A day of national rejoicing must not be marred
By any jarring tongue. A messenger who comes
With black looks bringing the long prayed-against
Report of total rout, which both afflicts 450

The state in general and in every household leaves
The inmates prostrate under the scourge of war—
With such a load upon his lips he may fitly
Sing anthems to the Furies down in hell;
But when he greets a prospering people with
News of the war's victorious end—how then
Shall I mix foul with fair and find words to tell you
Of the blow that struck us out of that angry heaven?
 Water and Fire, those age-old enemies,
Made common cause against the homebound fleet. 460
Darkness had fallen, and a northerly gale
Blew up and in a blinding thunderstorm
Our ships were tossed and buffeted hull against hull
In a wild stampede and herded out of sight;
Then, at daybreak, we saw the Aegean in blossom
With a waving crop of corpses and scattered timbers.
Our ship came through, saved by some spirit, it seems,
Who took the helm and piloted her, until
She slipped under the cliffs into a cove.
There, safe at last, incredulous of our luck, 470
We brooded all day, stunned by the night's disaster.
And so, if any of the others have survived,
They must be speaking of us as dead and gone.
May all yet end well! Though it is most to be expected
That Menelaos is in some great distress.
Yet, should some shaft of sunlight spy him out
Somewhere among the living, rescued by Zeus,
Lest the whole house should perish, there is hope
That he may yet come home. There you have the truth.
Chorus: Tell us who invented that 480
Name so deadly accurate?
Was it one who presaging
Things to come divined a word
Deftly tuned to destiny?
Helen—hell indeed she carried
To men, to ships, to a proud city, stealing
From the silk veils of her chamber, sailing seaward
With the Zephyr's breath behind her;
And they set forth in a thousand ships to hunt her
On the path that leaves no imprint, 490
Bringers of endless bloodshed.
So, as Fate decreed, in Troy,
Turning into keeners kin,
Furies, instruments of God's
Wrath, at last demanded full
Payment for the stolen wife:
And the wedding song that rang out
To greet the bride from beyond the broad Aegean
Was in time turned into howls of imprecation
From the countless women wailing 500
For the loved ones they had lost in war for her sake,
And they curse the day they gave that
Welcome to war and bloodshed.
An old story is told of an oxherd who reared at his hearth
 a lion-cub, a pet for his children,
Pampered fondly by young and old with dainty morsels
 begged at each meal from his master's table.
But Time showed him up in his true nature after his kind
 —a beast savaging sheep and oxen,
Mad for the taste of blood, and only then they knew 510
 what they had long nursed was a curse from heaven.

And so it seemed then there came to rest in Troy
A sweet-smiling calm, a clear sky, seductive,
A rare pearl set in gold and silver,
Shaft of love from a glancing eye.
She is seen now as an agent
Of death sent from Zeus, a Fury
Demanding a bloody bride-price.
　　　[Enter KLYTAIMNESTRA]
From ancient times people have believed that when
A man's wealth has come to full growth it breeds　520
And brings forth tares and tears in plenty.
No, I say, it is only wicked deeds
That increase, fruitful in evil.
The house built on justice always
Is blest with a happy offspring.
And yet the pride bred of wealth often burgeons anew
In evil times, a cloud of deep night,
Spectre of ancient crimes that still
Walks within the palace walls,
True to the dam that bore it.　　530
But where is Justice? She lights up the smoke-darkened
　　　hut.
From mansions built by hands polluted
Turning to greet the pure in heart,
Proof against false praise, she guides
All to its consummation.
　　　[Enter AGAMEMNON in a chariot followed by
　　　another chariot carrying KASSANDRA and
　　　spoils of war.]
Agamemnon, conqueror, joy to our king! How shall my
greeting neither fall short nor shoot too high? Some men
feign rejoicing or sorrow with hearts untouched; but
those who can read man's nature in the book of the eyes
will not be deceived by dissembled fidelity. I declare　540
that, when you left these shores ten years ago to recover
with thousands of lives one woman, who eloped of her
own free will, I deemed your judgment misguided; but
now in all sincerity I salute you with joy. Toil happily
ended brings pleasure at last, and in time you shall learn
to distinguish the just from the unjust steward.
Agamemnon: First, it is just that I should pay my
　　　respects
To the land of Argos and her presiding Gods,
My partners in this homecoming as also
In the just penalty which I have inflicted on　　550
The city of Troy. When the supreme court of heaven
Adjudicated on our cause, they cast
Their votes unanimously against her, though not
Immediately, and so on the other side
Hope hovered hesitantly before it vanished.
The fires of pillage are still burning there
Like sacrificial offerings. Her ashes
Redolent with riches breathe their last and die.
For all this it is our duty to render thanks
To the celestial powers, with whose assistance　560
We have exacted payment and struck down
A city for one woman, forcing our entry
Within the Wooden Horse, which at the setting
Of the Pleiads like a hungry lion leapt
Out and slaked its thirst in royal blood.
As to your sentiments, I take due note

And find that they accord with mine. Too few
Rejoice at a friend's good fortune. I have known
Many dissemblers swearing false allegiance.
One only, though he joined me against his will,　570
Once in the harness, proved himself a staunch
Support, Odysseus, be he now alive or dead.
All public questions and such as concern the Gods
I shall discuss in council and take steps
To make this triumph lasting; and if here or there
Some malady comes to light, appropriate
Remedies will be applied to set it right.
Meanwhile, returning to my royal palace,
My first duty is to salute the Gods
Who led me overseas and home again.　　580
Victory attends me; may she remain with me!
Klytaimnestra: Citizens of Argos, councillors and elders,
I shall declare without shame in your presence
My feelings for my husband. Diffidence
Dies in us all with time. I shall speak of what
I suffered here, while he was away at the war,
Sitting at home, with no man's company,
Waiting for news, listening to one
Messenger after another, each bringing worse
Disasters. If all his rumored wounds were real,　590
His body was in shreds, shot through and through.
If he had died—the predominant report—
He was a second Geryon, an outstretched giant
With three corpses and one death for each,
While I, distraught, with a knot pressing my throat,
Was rescued forcibly, to endure still more.
　　And that is why our child is not present here,
As he should be, pledge of our marriage vows,
Orestes. Let me reassure you. He lives
Safe with an old friend, Strophius, who warned me　600
Of various dangers—your life at stake in Troy
And here a restive populace, which might perhaps
Be urged to kick a man when he is down.
　　As for myself, the fountains of my tears
Have long ago run dry. My eyes are sore
After so many nights watching the lamp
That burnt at my bedside always for you.
If I should sleep, a gnat's faint whine would shatter
The dreams that were my only company.
　　But now, all pain endured, all sorrow past,　610
I salute this man as the watchdog of the fold,
The stay that saves the ship, the sturdy oak
That holds the roof up, the longed-for only child,
The shore despaired-of sighted far out at sea.
God keep us from all harm! And now, dearest,
Dismount, but not on the bare ground! Servants,
Spread out beneath those feet that have trampled Troy
A road of royal purple, which shall lead him
By the hand of Justice into a home unhoped-for,
And there, when he has entered, our vigilant care　620
Shall dispose of everything as the Gods have ordained.
Agamemnon: Lady, royal consort and guardian of our
　　　home,
I thank you for your words of welcome, extended
To fit my lengthy absence; but due praise
Should rather come from others; and besides,
I would not have effeminate graces unman me

With barbarous salaams and beneath my feet
Purple embroideries designed for sacred use.[4]
Honor me as a mortal, not as a god.
Heaven's greatest gift is wisdom. Count him blest 630
Who has brought a long life to a happy end.
I shall do as I have said, with a clear conscience.
Klytaimnestra: Yet tell me frankly, according to your
 judgment.
Agamemnon: My judgment stands. Make no mistake
 about that.
Klytaimnestra: Would you not in time of danger have
 vowed such an act?
Agamemnon: Yes, if the priests had recommended it.
Klytaimnestra: And what would Priam have done, if he
 had won?
Agamemnon: Oh, he would have trod the purple without
 a doubt.
Klytaimnestra: Then you have nothing to fear from
 wagging tongues.
Agamemnon: Popular censure is a potent force. 640
Klytaimnestra: Men must risk envy in order to be
 admired.
Agamemnon: A contentious spirit is unseemly in a
 woman.
Klytaimnestra: Well may the victor yield a victory.
Agamemnon: Do you set so much store by your victory?
Klytaimnestra: Be tempted, freely vanquished, victor
 still!
Agamemnon: Well, if you will have it, let someone
 unlace
These shoes, and, as I tread the purple, may
No far-off god cast at me an envious glance
At the prodigal desecration of all this wealth!
Meanwhile, extend your welcome to this stranger. 650
Power tempered with gentleness wins God's favor.
No one is glad to be enslaved, and she
Is a princess presented to me by the army,
The choicest flower culled from a host of captives.
And now, constrained to obey you, setting foot
On the sacred purple, I pass into my home.
Klytaimnestra: The sea is still there, nothing can dry it
 up.
Renewing out of its infinite abundance
Unfailing streams of purple and blood-red dyes.
So too this house, the Gods be praised, my lord, 660
Has riches inexhaustible. There is no counting
The robes I would have vowed to trample on,
Had some oracle so instructed, if by such means
I could have made good the loss of one dear soul.[5]
So now your entry to your hearth and home
Is like a warm spell in the long winter's cold,
Or when Zeus from the virgin grape at last
Draws wine, coolness descends upon the house
(For then from the living root the new leaves raise
A welcome shelter against the burning Dog-Star) 670
As man made perfect moves about his home.

4. The purple dye was extracted from seaweed. It was very rare,
therefore very expensive; a color reserved for the gods.
5. Iphigeneia.

[Exit AGAMEMNON]
Zeus, perfecter of all things, fulfil my prayers
And fulfil also your own purposes!
 [Exit]
Chorus: What is this delirious dread,
Ominous, oracular,
Droning through my brain with unrelenting
Beat, irrepressible prophet of evil?
Why can I not cast it out
Planting good courage firm
On my spirit's empty throne? 680
In time the day came
When the Greeks with anchors plunged
Moored the sloops of war, and troops
Thronged the sandy beach of Troy.
So today my eyes have seen
Safe at last the men come home.
Still I hear the strain of stringless music,
Dirge of the Furies, a choir uninvited
Chanting in my heart of hearts.
Mortal souls stirred by God 690
In tune with fate divine the shape
Of things to come; yet
Grant that these forebodings prove
False and bring my fears to naught.
If a man's health be advanced over the due mean,
It will trespass soon upon sickness, who stands
Next neighbour, between them a thin wall.
So does the vessel of life
Launched with a favoring breeze
Suddenly founder on reefs of destruction. 700
Caution seated at the helm
Casts a portion of the freight
Overboard with measured throw;
So the ship may ride the storm.
Furrows enriched each season with showers from heaven
Banish hunger from the door.
But if the red blood of a man spatters the ground,
 dripping and deadly, then who
Has the magical power to recall it?
Even the healer who knew
Spells to awaken the dead, 710
Zeus put an end to his necromancy.
Portions are there preordained.
Each supreme within its own
Province fixed eternally.
That is why my spirit groans
Brooding in fear, and no longer it hopes to unravel
Mazes of a fevered mind.
 [Enter KLYTAIMNESTRA]
Klytaimnestra: You, too, Kassandra, come inside! The
 merciful
Zeus gives you the privilege to take part
In our domestic sacrifice and stand 720
Before his altar among the other slaves there.
Put by your pride and step down. Even Heracles
Submitted once to slavery, and be consoled
In serving a house whose wealth has been inherited
Over so many generations. The harshest masters
Are those who have snatched their harvest out of hand.
You shall receive here what custom prescribes.

Chorus: She is speaking to you. Caught in the net,
 surrender.
Klytaimnestra: If she knows Greek and not some
 barbarous language,
My mystic words shall fill the soul within her. 730
Chorus: You have no choice. Step down and do her will.
Klytaimnestra: There is no time to waste. The victims are
All ready for the knife to render thanks
For this unhoped-for joy. If you wish to take part,
Make haste, but, if you lack the sense to understand,—
 [*To the* CHORUS]
Speak to her with your hands and drag her down.
Chorus: She is like a wild animal just trapped.
Klytaimnestra: She is mad, the foolish girl. Her city
 captured,
I'll waste no words on her to demean myself.
 [*Exit*]
Kassandra: Oh! oh! Apollo! 740
Chorus: What blasphemy, to wail in Apollo's name!
Kassandra: Oh! oh! Apollo!
Chorus: Again she cries in grief to the god of joy!
Kassandra: Apollo, my destroyer! a second time!
Chorus: Ah, she foresees what is in store for her. She is
 now a slave, and yet God's gift remains.
Kassandra: Apollo, my destroyer! What house is this?
Chorus: Do you not know where you have come, poor
 girl?
Then let us tell you. This is the House of Atreus.
Kassandra: Yes, for its very walls smell of iniquity,
A charnel house that drips with children's blood.[6] 750
Chorus: How keen her scent to seize upon the trail!
Kassandra: Listen to them as they bewail the foul
Repast of roast meat for a father's mouth!
Chorus: Enough! Reveal no more! We know it all.
Kassandra: What is it plotted next? Horror unspeakable.
A hard cross for kinsfolk.
The hoped-for savior is far away.
Chorus: What does she say? This must be something
 new.
Kassandra: Can it be so—to bathe one who is
 travel-tired,
And then smiling stretch out 760
A hand followed by a stealthy hand!
Chorus: She speaks in riddles, and I cannot read them.
Kassandra: What do I see? A net!
Yes, it is she, his mate and murderess!
Cry alleluia, cry, angels of hell, rejoice,
Fat with blood, dance and sing!
Chorus: What is the Fury you have called upon?
Helpless the heart faints with the sinking sun.
Closer still draws the stroke.
Kassandra: Ah, let the bull[7] beware! 770
It is a robe she wraps him in, and strikes!
Into the bath he slumps heavily, drowned in blood.
Such her skilled handicraft.
Chorus: It is not hard to read her meaning now.

Why does the prophet's voice never have good to tell,
Only cry woes to come?
Kassandra: Oh, pitiful destiny! Having lamented his,
Now I lament my own passion to fill the bowl.
Where have you brought me? Must I with him die?
Chorus: You sing your own dirge, like the red-brown bird 780
That pours out her grief-stricken soul,
Itys, Itys! she cries, the sad nightingale.
Kassandra: It is not so; for she, having become a bird,
Forgot her tears and sings her happy lot,
While I must face the stroke of two-edged steel.
Chorus: From whence does this cascade of harsh
 discords
Issue, and where will it at last be calmed?
Calamity you cry—O where must it end?
Kassandra: O wedding day, Paris accurst of all!
Scamander,[8] whose clear waters I grew beside! 790
Now I must walk weeping by Akheron.
Chorus: Even a child could understand.
The heart breaks, as these pitiful cries
Shatter the listening soul.
Kassandra: O fall of Troy, city of Troy destroyed!
The king's rich gifts little availed her so
That she might not have been what she is now.
Chorus: What evil spirit has possessed
Your soul, strumming such music upon your lips
As on a harp in hell? 800
Kassandra: Listen! My prophecy shall glance no longer
As through a veil like a bride newly-wed,
But bursting towards the sunrise shall engulf
The whole world in calamities far greater
Than these. No more riddles, I shall instruct,
While you shall verify each step, as I
Nose out from the beginning this bloody trail.
Upon this roof—do you see them?—stands a choir—
It has been there for generations—a gallery
Of unmelodious minstrels, a merry troop 810
Of wassailers drunk with human blood, reeling
And retching in horror at a brother's outraged bed.
Well, have I missed? Am I not well-read in
Your royal family's catalogue of crime?
Chorus: You come from a far country and recite
Our ancient annals as though you had been present.
Kassandra: The Lord Apollo bestowed this gift on me.
Chorus: Was it because he had fallen in love with you?
Kassandra: I was ashamed to speak of this till now.
Chorus: Ah yes, adversity is less fastidious. 820
Kassandra: Oh, but he wrestled strenuously for my love.
Chorus: Did you come, then, to the act of getting child?
Kassandra: At first I consented, and then I cheated him.
Chorus: Already filled with his gift of prophecy?
Kassandra: Yes, I forewarned my people of their destiny.
Chorus: Did your divine lover show no displeasure?
Kassandra: Yes, the price I paid was that no one
 listened to me.
Chorus: Your prophecies seem credible enough to us.

6. She refers to Thyestes' banquet, at which he was served his own children to eat.
7. Agamemnon.

8. Scamander is a river near Troy; Akheron is the river of the underworld.

Kassandra: Oh!
Again the travail of the prophetic trance 830
Runs riot in my soul. Do you not see them
There, on the roof, those apparitions—children
Murdered by their own kin, in their hands
The innards of which their father ate—oh
What'a pitiable load they carry! For that crime
Revenge is plotted by the fainthearted lion,[9]
The stay-at-home, stretched in my master's bed
(Being his slave, I must needs call him so),
Lying in wait for Troy's great conqueror.
Little he knows what that foul bitch with ears 840
Laid back and rolling tongue intends for him
With a vicious snap, her husband's murderess.
What abominable monster shall I call her—
A two-faced amphisbaene or Scylla that skulks
Among the rocks to waylay mariners,
Infernal sea-squib locked in internecine
Strife—did you not hear her alleluias
Of false rejoicing at his safe return?
Believe me or not, what must be will be, and then
You will pity me and say, She spoke the truth. 850
Chorus: The feast of Thyestes I recognized, and
 shuddered,
But for the rest my wits are still astray.
Kassandra: Your eyes shall see the death of
 Agamemnon.
Chorus: No, hush those ill-omened lips, unhappy girl!
Kassandra: There is no Apollo present, and so no cure.
Chorus: None, if you speak the truth; yet God forbid!
Kassandra: Pray God forbid, while they close in for the
 kill!
Chorus: What man is there who would plot so foul a
 crime?
Kassandra: Ah, you have altogether misunderstood.
Chorus: But how will he do it? That escapes me still. 860
Kassandra: And yet I can speak Greek only too well.
Chorus: So does Apollo, but his oracles are obscure.
Kassandra: Ah, how it burns me up! Apollo! Now
That lioness[10] on two feet pours in the cup
My wages too, and while she whets the blade
For him promises to repay my passage money
In my own blood. Why wear these mockeries,
This staff and wreath, if I must die, then you
Shall perish first and be damned. Now we are quits!
Apollo himself has stripped me, looking upon me 870
A public laughingstock, who has endured
The name of witch, waif, beggar, castaway.
So now the god who gave me second sight
Takes back his gift and dismisses his servant,
Ready for the slaughter at a dead man's grave.
Yet we shall be avenged. Now far away,
The exile[11] shall return, called by his father's
Unburied corpse to come and kill his mother.
Why weep at all this? Have I not seen Troy fall,

And those who conquered her are thus discharged. 880
I name this door the gate of Hades: now
I will go and knock, I will take heart to die.
I only pray that the blow may be mortal,
Closing these eyes in sleep without a struggle,
While my life blood ebbs quietly away.
Chorus: O woman, in whose wisdom is so much grief,
How, if you know the end, can you approach it
So gently, like an ox that goes to the slaughter?
Kassandra: What help would it be if I should put it off?
Chorus: Yet, while there is life there's hope—so people
 say. 890
Kassandra: For me no hope, no help. My hour has come.
Chorus: You face your end with a courageous heart.
Kassandra: Yes, so they console those whom life has
 crossed.
Chorus: Is there no comfort in an honorable death?
Kassandra: O Priam, father, and all your noble sons!
 [*She approaches the door, then draws back.*]
Chorus: What is it? Why do you turn back, sick at heart?
Kassandra: Inside there is a stench of dripping blood.
Chorus: It is only the blood of their fireside sacrifice.
Kassandra: It is the sort of vapor that issues from a
 tomb.
I will go now and finish my lament 900
Inside the house. Enough of life! O friends!
I am not scared. I beg of you only this:
When the day comes for them to die, a man
For a man, woman for woman, remember me!
Chorus: Pour soul condemned to death, I pity you.
Kassandra: Yet one word more, my own dirge for myself,
I pray the Sun, on whom I now look my last,
That he may grant to my master's avengers
A fair price for the slave-girl slain at his side.
O sad mortality! when fortune smiles, 910
A painted image; and when trouble comes,
One touch of a wet sponge wipes it away. [*Exit*]
Chorus: And her case is even more pitiable than his.
Human prosperity never rests but always craves more, till
blown up with pride it totters and falls. From the opulent
mansions pointed at by all passersby none warns it away,
none cries, "Let no more riches enter!" To him was
granted the capture of Troy, and he has entered his home
as a god, but now, if the blood of the past is on him, if he
must pay with his own death for the crimes of bygone 920
generations, then who is assured of a life without sorrow?
Agamemnon: Oh me!
Chorus: Did you hear?
Agamemnon: Oh me, again!
Chorus:[12] It is the King. Let us take counsel!
 1 I say, raise a hue and cry!
 2 Break in at once!
 3 Yes, we must act.
 4 *They* spurn delay.
 5 They plot a tyranny. 930

9. Aigisthos.
10. Klytaimnestra.
11. Orestes.

12. To the best of our knowledge, this is the first time in any Greek
play when the chorus-members have spoken as individuals. Some
translations show the passage as a crescendo through the seventh
speech; then a lapse into a do-nothing attitude.

6 Must we live their slaves?
7 Better to die.
8 Old men, what can we do?
9 We cannot raise the dead.
10 His death is not yet proved.
11 We are only guessing.
12 Let us break in and learn the truth!
 [*The doors are thrown open and*
 KLYTAIMNESTRA *is seen standing over the*
 bodies of AGAMEMNON *and* KASSANDRA,
 which are laid out on a purple robe.]

Klytaimnestra: All that I said before to bide my time
Without any shame I shall now unsay. How else
Could I have plotted against an enemy 940
So near and seeming dear and strung the snare
So high that he could not jump it? Now the feud
On which I have pondered all these years has been
Fought out to its conclusion. Here I stand
Over my work, and it was so contrived
As to leave no loophole. With this vast dragnet
I enveloped him in purple folds, then struck
Twice, and with two groans he stretched his legs,
Then on his outspread body I struck a third blow,
A drink for Zeus the Deliverer of the dead. 950
There he lay gasping out his soul and drenched me
In these deathly dew-drops, at which I cried
In sheer delight like newly-budding corn
That tastes the first spring showers. And so,
Venerable elders, you see how the matter stands.
Rejoice, if you are so minded. I glory in it.
With bitter tears he filled the household bowl;
Now he has drained it to the dregs and gone.

Chorus: How can you speak so of your murdered king?

Klytaimnestra: You treat me like an empty-headed
 woman. 960
Again, undaunted, to such as understand
I say—commend or censure, as you please—
It makes no difference—here is Agamemnon,
My husband, dead, the work of this right hand,
Which acted justly. There you have the truth.

Chorus: Woman, what evil brew have you devoured to
 take
On you a crime that cries out for a public curse?
Yours was the fatal blow, banishment shall be yours,
Hissed and hated of all men.

Klytaimnestra: Your sentence now for me is banishment, 970
But what did you do then to contravene
As though picking a ewe-lamb from his flocks,
Whose wealth of snowy fleeces never fails
To increase and multiply, he killed his own
Child, born to me in pain, my best-beloved?
Why did you not drive *him* from hearth and home?
I bid you cast at me such menaces
As make for mastery in equal combat
With one prepared to meet them, and if, please God,
The issue goes against you, suffering 980
Shall school those grey hairs in humility.

Chorus: You are possessed by some spirit of sin that
 stares
Out of your bloodshot eyes matching your bloody hands.
Dishonored and deserted of your kind, for this

Stroke you too shall be struck down.

Klytaimnestra: Listen! By Justice, who avenged my child,
By the Fury to whom I vowed this sacrament,
So long as the hearth within is kindled by
Aigisthos, faithful to me now as always.
Low lies the man who insulted his wedded wife, 990
The darling of the Khryseids at Troy,
And stretched beside him this visionary seer,
Whom he fondled on shipboard, both now rewarded,
He as you see, and she swanlike has sung
Her dying ditty, his tasty side dish, for me
A rare spice to add relish to my joy.

Chorus: Oh, for the gift of death
To bring the long sleep that knows no waking,
Now that my lord and loyal protector
Breathes his last. For woman's sake 1000
Long he fought overseas,
Now at home falls beneath a woman's hand
 Helen, the folly-beguiled, having ravaged the city of
 Troy,
 She has set on the curse of Atreus
 A crown of blood beyond ablution.

Klytaimnestra: Do not pray for death nor turn your anger
 against one woman as the slayer of thousands!

Chorus: Demon of blood and tears
Inbred in two women single-hearted!
Perched on the roof he stands and preens his
Sable wings, a carrion-crow 1010
Loud he croaks, looking down
Upon the feast spread before him here below.

Klytaimnestra: Ah now you speak truth, naming the
 thrice-fed demon, who, glutted with blood, craves
 more, still young in his hunger.

Chorus: When will the feast be done?
Alas, it is the will of Zeus,
Who caused and brought it all to pass.
Nothing is here but was decreed in heaven.

Klytaimnestra: It was not my doing, nor am I
 Agamemnon's wife, but a ghost in woman's guise,
 the shade of the banqueter whom Atreus fed.

Chorus: How is the guilt not yours?
And yet the crimes of old may well 1020
Have had a hand, and so it drives
On, the trail of internecine murder.

Klytaimnestra: What of *him*? Was the guilt not his,
 when he killed the child that I bore him? And so by
 the sword he has fallen.

Chorus: Alas, the mind strays. The house is falling.
A storm of blood lays the walls in ruins.
Another mortal stroke for Justice's hand
Will soon be sharpened.
 Oh me, who shall bury him, who sing the dirge?
 Who shall intone at the tomb of a blessed spirit
 A tribute pure in heart and truthful? 1030

Klytaimnestra: No, I'll bury him, but without mourners.
 By the waters of Akheron Iphigeneia is waiting for
 him with a kiss.

Chorus: The charge is answered with countercharges.
The sinner must suffer: such is God's will.
The ancient curse is bringing down the house
In self-destruction.

Klytaimnestra: That is the truth, and I would be
content that the spirit of vengeance should rest,
having absolved the house from its madness.
[*Enter* AIGISTHOS *with a bodyguard*]

Aigisthos: Now I have proof that there are Gods in
heaven,
As I gaze on this purple mesh in which
My enemy lies, son of a treacherous father,
His father, Atreus, monarch of this realm, 1040
Was challenged in his sovereign rights by mine,
Thyestes, his own brother, and banished him
From hearth and home. Later he returned
A suppliant and found sanctuary, indeed
A welcome; for his brother entertained him
To a feast of his own children's flesh, of which
My father unsuspecting took and ate.
Then, when he knew what he had done, he fell
Back spewing out the slaughtered flesh and, kicking
The table to the floor, with a loud cry 1050
He cursed the House of Pelops. That is the crime
For which the son lies here. And fitly too
The plot was spun by me; for as a child
I was banished with my father, until Justice
Summoned me home. Now let me die, for never
Shall I live to another sight so sweet.

Chorus: Aigisthos, if it was you who planned this murder,
Then be assured, the people will stone you for it.

Aigisthos: Such talk from the lower benches! Even in
dotage
Prison can teach a salutary lesson. 1060
Better submit, or else you shall smart for it.

Chorus: You, woman, who stayed at home and wallowed
in
His bed, you plotted our great commander's death!

Aigisthos: Orpheus led all in rapture after him.[13] Your
senseless bark will be snuffed out in prison.

Chorus: You say the plot was yours, yet lacked the
courage
To raise a hand but left it to a woman!

Aigisthos: As his old enemy, I was suspect.
Temptation was the woman's part. But now
I'll try my hand at monarchy, and all 1070
Who disobey me shall be put in irons
And starved of food and light till they submit.

Chorus: Oh, if Orestes yet beholds the sun,
May he come home and execute them both!

Aigisthos: Ho, my guards, come forward, you have work
to do.

Captain of the Guard: Stand by, draw your swords!

Chorus: We are not afraid to die.

Aigisthos: Die! We'll take you at your word.

Klytaimnestra: Peace, my lord, and let no further wrong
be done.
Captain, sheathe your swords. And you, old men, 1080
Go home quietly. What has been, it had to be.
Scars enough we bear, now let us rest.

Aigisthos: Must I stand and listen to their threats?

13. That is: You are not Orpheus, whose music caused people to
follow him.

Chorus: Men of Argos never cringed before a rogue.

Aigisthos: I shall overtake you yet—the day is near.

Chorus: Not if Orestes should come home again.

Aigisthos: Vain hope, the only food of castaways.

Chorus: Gloat and grow fat, blacken justice while you
dare!

Aigisthos: All this foolish talk will cost you dear.

Chorus: Flaunt your gaudy plumes and strut beside your
hen! 1090

Klytaimnestra: Pay no heed to idle clamor. You and I,
Masters of the house, shall now direct it well.

Eumenides

Aeschylus

The third play of the *Oresteia*, *Eumenides* tells of Orestes'
persecution by the Furies, who are demanding revenge
for his murder of Klytaimnestra. Athena takes his side,
and convenes a court in Athens to judge Orestes.

CHARACTERS

Athena, virgin goddess of wisdom, crafts, and warfare
Chorus of judges and citizens of Athens
Apollo, god of light, music, and healing
Orestes, son of Klytaimnestra and Agamemnon
Chorus of the Escort

The scene is a court in Athens.

[*Enter* ATHENA *with the* JUDGES, *followed
by citizens of Athens.*]

Athena: Herald, give orders to hold the people back,
Then sound the trumpet and proclaim silence.
For while this new tribunal is being enrolled,
It is right that all should ponder on its laws,
Both the litigants here whose case is to be judged,
And my whole people for all generations.
[*Enter* APOLLO]

Chorus: Apollo, what is there here that concerns you?
We say you have no authority in this matter.

Apollo: I come both as a witness, the accused
Having been a suppliant at my sanctuary 10
And purified of homicide at my hands,
And also to be tried with him, for I too
Must answer for the murder of his mother.
Open the case, and judge as you know how.

Athena: The case is open. You shall be first to speak.
[*To the* CHORUS]
The prosecutors shall take precedence
And first inform us truthfully of the facts.

Chorus: Many in number, we shall be brief in speech.
We beg you to answer our questions one by one.
First, is it true that you killed your mother? 20

Orestes: I killed her. That is true, and not denied.

Chorus: So then the first of the three rounds is ours.

Orestes: You should not boast that you have thrown me
yet.

Chorus: Next, since you killed her, you must tell us how.

Orestes: Yes, with a drawn sword leveled at the throat.

Chorus: Who was it who impelled or moved you to it?

Orestes: The oracle of this God who is my witness.

Chorus: The God of prophecy ordered matricide?

Orestes: Yes, and I have not repented it to this day.

Chorus: You *will* repent it, when you have been
 condemned. 30

Orestes: My father shall defend me from the grave.

Chorus: Having killed your mother, you may well trust
 the dead!

Orestes: She was polluted by a double crime.

Chorus: How so? Explain your meaning to the judges.

Orestes: She killed her husband and she killed my
 father.

Chorus: She died without bloodguilt, and you still live.

Orestes: Why did you not hunt her when she was alive?

Chorus: She was not bound by blood to the man she
 killed.

Orestes: And am I then bound by blood to my mother?

Chorus: Abandoned wretch, how did she nourish you 40
Within the womb? Do you repudiate
The nearest and dearest tie of motherhood?

Orestes: Apollo, give your evidence. I confess
That I did this deed as I have said.
Pronounce your judgment: was it justly done?

Apollo: Athena's appointed judges, I say to you,
Justly, and I, as prophet, cannot lie.
Never from my prophetic shrine have I
Said anything of city, man or woman
But what my father Zeus has commanded me. 50
This plea of mine must override all others,
Since it accords with our great father's will.

Chorus: Your argument is, then, that Zeus commanded
 you
To charge Orestes with this criminal act
Regardless of the bond between son and mother?

Apollo: It is not the same, to murder a great king,
A woman too to do it, and not in open
Fight like some brave Amazon, but in such
Manner as I shall now inform this court.
On his return from battle, bringing home 60
A balance for the greater part of good,
She welcomed him with fine words and then, while
He bathed, pavilioned him in a purple robe
And struck him down and killed him—a man and king
Whom the whole world had honored. Such was the crime
For which she paid. Let the judges take note.

Chorus: According to your argument Zeus gives
Precedence to the father; yet Zeus it was
Who cast into prison his own father Kronos.
Judges, take note, and ask him to explain. 70

Apollo: Abominable monsters, loathed by gods
And men, do you not understand that chains
Can be unfastened and prison doors unlocked?
But once the dust has drunk a dead man's blood,
He can never rise again—for that no remedy
Has been appointed by our almighty Father,
Although all else he can overturn at will
Without so much effort as a single breath.

Chorus: See what your plea for the defendant means.

Is this not what he did—to spill his mother's 80
Blood on the ground? And shall he then be allowed
To live on in his father's house? What public
Altar can he approach and where find fellowship?

Apollo: The mother is not a parent, only the nurse
Of the seed which the true parent, the father,
Commits to her as to a stranger to
Keep it with God's help safe from harm. And I
Have proof of this. There can be a father
Without a mother. We have a witness here,
This daughter of Olympian Zeus, who sprang 90
Armed from her father's head, a goddess whom
No goddess could have brought to birth. Therefore,
Out of goodwill to your country and your people
I sent this suppliant to seek refuge with you,
That you, Athena, may find in him and his
A faithful ally for all time to come.

Athena: Enough has now been spoken. Are you agreed
That I call on the judges to record
Their votes justly according to their conscience?

Apollo: Our quiver is empty, every arrow spent. 100
We wait to hear the issue of the trial.

Athena: And has my ruling your approval too?

Chorus: Sirs, you have heard the case, and now declare
Judgment according to your solemn oath.

Athena: Citizens of Athens, hear my declaration
At this first trial in the history of man.
This great tribunal shall remain in power
Meeting in solemn session on this hill,
Where long ago the Amazons encamped
When they made war on Theseus, and sacrificed 110
To Ares—hence its name.[1] Here reverence
For law and inbred fear among my people
Shall hold their hands from evil night and day,
Only let them not tamper with the laws,
But keep the fountain pure and sweet to drink.
I warn you not to banish from your lives
All terror but to seek the mean between
Autocracy and anarchy; and in this way
You shall possess in ages yet unborn
An impregnable fortress of liberty 120
Such as no people has throughout the world.
With these words I establish this tribunal
Grave, quick to anger, incorruptible,
And always vigilant over those that sleep.
Let the judges now rise and cast their votes.[2]

Chorus: We charge you to remember that we have
Great power to harm, and vote accordingly.

Apollo: I charge you to respect the oracles
Sanctioned by Zeus and see that they are fulfilled.

Chorus: By interfering in what is not your office 130
You have desecrated your prophetic shrine.

Apollo: Then was my Father also at fault when he
Absolved Ixion, the first murderer?

Chorus: Keep up your chatter, but if your cause should
 fail,
We shall lay on this people a heavy hand.

1. The hill and the court which met on it were called the Areopagus.
2. It is understood that the members of the jury are dropping their votes into an urn during the next eight speeches.

Apollo: Yes, you will lose your case, and then you may
Spit out your poison, but it will do no harm.
Chorus: Insolent youth mocks venerable age.
We await the verdict, ready to let loose
Against this city our destructive rage. 140
Athena: The final judgment rests with me, and I
Announce that my vote shall be given to Orestes.
No mother gave me birth, and in all things
Save marriage I commend with all my heart
The masculine, my father's child indeed.
Therefore I cannot hold in higher esteem
A woman killed because she killed her husband.
If the votes are equal, Orestes wins.
Let the appointed officers proceed
To empty the urns and count the votes. 150
Orestes: O bright Apollo, how shall the judgment go?
Chorus: O black mother Night, are you watching this?
Orestes: My hour has come—the halter or the light.
Chorus: And ours—to exercise our powers or perish.
Apollo: Sirs, I adjure you to count carefully.
If judgment errs, great harm will come of it,
Whereas one vote may raise a fallen house.
Athena: He stands acquitted on the charge of
bloodshed,
The human votes being equally divided.
Orestes: Lady Athena, my deliverer, 160
I was an outcast from my country, now
I can go home again and live once more
In my paternal heritage, thanks to you
And to Apollo and to the third, Zeus,
Who governs the whole world. Before I go
I give my word to you and to your people
For all posterity that no commander
Shall lead an Argive army in war against
This city. If any should violate this pledge,
Out of the graves which shall then cover us 170
We would arise with adverse omens to
Obstruct and turn them back. If, however,
They keep this covenant and stand by your side,
They shall always have our blessing. And so farewell!
May you and your people always prevail
Against the assaults of all your enemies!
[*Exit*]
Chorus: Oho, you junior gods, since you have trod under
foot
The laws of old and robbed us of our powers,
We shall afflict this country
With damp contagion, bleak and barren, withering up the
soil, 180
Mildew on bud and birth abortive. Venomous pestilence
Shall sweep your cornlands with infectious death.
To weep—No! To work? Yes! To work ill and lay low the
people!
So will the maids of Night mourn for their stolen honors.
Athena: Let me persuade you to forget your grief!
You are not defeated. The issue of the trial
Has been determined by an equal vote.
It was Zeus himself who plainly testified
That Orestes must not suffer for what he did.
I beg you, therefore, do not harm my country, 190
Blasting her crops with drops of rank decay

And biting cankers in the early buds.
Rather accept my offer to stay and live
In a cavern on this hill and there receive
The adoration of my citizens.
Chorus: Oho, you junior gods, etc.
Athena: No, *not* dishonored, and therefore spare my
people!
I too confide in Zeus—why speak of that?—
And I alone of all the Olympian gods
Know of the keys which guard the treasury 200
Of heaven's thunder. But there is no need of that.
Let my persuasion serve to calm your rage.
Reside with me and share my majesty;
And when from these wide acres you enjoy
Year after year the harvest offerings
From couples newly-wed praying for children,
Then you will thank me for my intercession.
Chorus: How can you treat us so?
Here to dwell, ever debased, defiled!
Hear our passion, hear, black Night! 210
For the powers once ours, sealed long, long ago
Have by the junior gods been all snatched away.
Athena: You are my elders, and therefore I indulge
Your passion. And yet, though not so wise as you,
To me too Zeus has granted understanding.
If you refuse me and depart, believe me,
This country will yet prove your heart's desire,
For as the centuries pass so there will flow
Such glory to my people as will assure
To all divinities worshipped here by men 220
And women gathered on festive holidays
More honors than could be yours in any other
City throughout the world. And so, I beg you,
Keep from my citizens the vicious spur
Of internecine strife, which pricks the breast
Of manhood flown with passion as with wine!
Abroad let battle rage for every heart
That is fired with love of glory—that shall be theirs
In plenty. So this is my offer to you—
To give honor and receive it and to share 230
My glory in this country loved by heaven.
Chorus: How can you, etc.
Athena: I will not weary in my benedictions,
Lest it should ever be said that you, so ancient
In your divinity, were driven away
By me and by my mortal citizens.
No, if Persuasion's holy majesty,
The sweet enchantment of these lips divine,
Has power to move you, please, reside with me.
But, if you still refuse, then, since we have made 240
This offer to you, it would be wrong to lay
Your hands upon us in such bitter rage.
Again, I tell you, it is in your power to own
This land attended with the highest honors.
Chorus: Lady Athena, what do you offer us?
Athena: A dwelling free of sorrow. Pray accept.
Chorus: Say we accept, what privileges shall we have?
Athena: No family shall prosper without your grace.
Chorus: Will you ensure us this prerogative?
Athena: I will, and bless all those that worship you. 250
Chorus: And pledge that assurance for all time to come?

Athena: I need not promise what I will not perform.

Chorus: Your charms are working, and our rage subsides.

Athena: Here make your dwelling, where you shall win friends.

Chorus: What song then shall we chant in salutation?

Athena: A song of faultless victory—from land and sea,
From skies above let gentle breezes blow
And breathing sunshine float from shore to shore;
Let crops and cattle increase and multiply
And children grow in health and happiness, 260
And let the righteous prosper; for I, as one
Who tends flowers in a garden, cherish fondly
The seed that bears no sorrow. That is your part,
While I in many a battle shall strive until
This city stands victorious against all
Its enemies and renowned throughout the world.

Chorus: We accept; we agree to dwell with you
Here in Athens, which by grace of Zeus
Stands a fortress for the gods,
Jeweled crown of Hellas. So 270
With you now we join in prayer
That smiling suns and fruitful soils unite to yield
Lifelong joy, fortune fair,
Light and darkness reconciled.

Athena: For the good of my people I have given homes
in the city to these deities,[3] whose power is so great and
so slowly appeased; and, whenever a man falls foul of
them, apprehended to answer for the sins of his fathers,
he shall be brought to judgment before them, and the
dust shall stifle his proud boast. 280

Chorus: Free from blight may the early blossom deck
Budding trees, and may no parching drought
Spread across the waving fields.
Rather Pan in season grant
From the flocks and herds a full
Return from year to year, and from the rich
Store which these gods vouchsafe
May the Earth repay them well!

Athena: Guardians of my city, listen to the blessings they
bring, and remember that their power is great in heaven 290
and hell, and on earth too they bring to some glad
music and to some lives darkened with weeping.

Chorus: Free from sudden death that cuts
Short the prime of manhood, blest
In your daughters too, to whom
Be granted husband and home, and may the dread Fates
Keep them safe, present in every household,
Praised and magnified in every place!

Athena: Fair blessings indeed from powers that so
lately were averted in anger, and I thank Zeus and the 300
spirit of persuasion that at last there is no strife left
between us, except that they vie with me in blessing my
people.

Chorus: Peace to all, free from that
Root of evil, civil strife!
May they live in unity,
And never more may the blood of kin be let flow!

3. This is the transition of the awful goddesses from the *Erinyes* (the
Furies) to the *Eumenides* (the Gracious Ones).

Rather may all of them bonded together
Feel and act as one in love and hate!

Athena: From these dread shapes, so quick to learn a 310
new music, I foresee great good for my people, who, if
only they repay their favors with the reverence due, shall
surely establish the reign of justice in a city that will
shine as a light for all mankind.
 [*Enter* ESCORT OF WOMEN, *carrying
 crimson robes and torches.*]

Chorus: Joy to you all in your justly appointed riches,
Joy to all the people blest
With the Virgin's love, who stands
Next beside her Father's throne!
Wisdom man has learnt at last.
Under her protection this 320
Land enjoys the grace of Zeus.

Athena: Joy to you also, and now let me lead you in
torchlight to your new dwelling place! Let solemn
oblations speed you in joy to your home beneath the
earth, and there imprison all harm while still letting flow
your blessings!

Chorus: Joy to you, joy, yet again we pronounce our
 blessing,
Joy to all the citizens,
Gods and mortals both alike.
While you hold this land and pay 330
Homage to our residence,
You shall have no cause to blame
Chance and change in human life.

Athena: I thank you for your gracious salutations,
And now you shall be escorted in the light
Of torches to your subterranean dwelling,
Attended by the sacristans of my temple
Together with this company of girls
And married women and others bowed with years.
Women, let them put on these robes of crimson, 340
And let these blazing torches light the way,
That the goodwill of our new co-residents
Be shown in the manly prowess of your sons!
 [*The* CHORUS *put on the crimson robes and a
 procession is formed led by young men in
 armor, with the* CHORUS *and the escort
 following, and behind them the citizens of
 Athens. The rest is sung as the procession
 moves away.*]

Chorus of the Escort: Pass on your way, O powers
 majestic,
Daughters of darkness in happy procession!
People of Athens, hush, speak fair!
Pass to the caverns of earth immemorial
There to be worshipped in honor and glory!
People of Athens, hush, speak fair!
Gracious and kindly of heart to our people, 350
Come with us, holy ones, hither in gladness,
Follow the lamps that illumine the way!
O sing at the end alleluia!
Peace to you, peace of a happy community,
People of Athens! Zeus who beholds all
Watches, himself with the Fates reconciled.
O sing at the end alleluia!

Oedipus the King
Sophocles

CHARACTERS

Oedipus, King of Thebes
Priest of Zeus
Kreon, Oedipus' brother-in-law
Chorus of Theban elders
Leader of the chorus
Teiresias, prophet, servant to Apollo
Iokaste, wife of Oedipus
Messenger from Corinth
Shepherd, member of Laios' household
Servant, household slave of Oedipus
 Delegation of Thebans, servants to lead Teiresias and
 Oedipus; attendants to Oedipus, Kreon, Iokaste;
 and Antigone and Ismene, the daughters of Oedipus.

The scene. Dawn. Silence. The royal palace of Thebes. The altar of
Apollo to the left of the central palace. A delegation of Thebans—old
men, boys, young children—enters the orchestra by the steps below
the altar, assembles, and waits. They carry suppliant boughs—olive
branches tied with strips of wool. Some climb the steps between the
orchestra and the altar, place their branches on the altar, and
return to the orchestra. A PRIEST stands apart from the suppliants
at the foot of one of the two stairs. Silence. Waiting. The central
doors open. From inside the palace, limping, OEDIPUS comes
through the palace doors and stands at the top of the steps leading
down into the orchestra. He is dressed in gold and wears a
golden crown.

Oedipus: Why, children,
why are you here, why
are you holding those branches tied with wool,
begging me for help? Children,
the whole city smolders with incense.
Wherever I go I hear sobbing, praying. Groans fill the air.
Rumors, news from messengers, they are not enough for
 me.
Others cannot tell me what you need.
I am king, I had to come. As king,
I had to know. Know for myself, know for me. 10
Everybody everywhere knows who I am: Oedipus. King.
Priest of Zeus, we respect your age, your high office.
Speak.
Why are you kneeling? Are you afraid, old man?
What can I give you?
How can I help? Ask.
Ask me anything. Anything at all.
My heart would be a stone
if I felt no pity for these poor shattered people of mine
kneeling here, at my feet. 20
Priest: Oedipus, lord of Thebes, you see us, the people
 of Thebes, your people,
crowding in prayer around your altar,
these small children here, old men bent with age, priests,
 and I, the priest of Zeus,
and our noblest young men, the pride and strength of
 Thebes.

And there are more of us, lord Oedipus, more—gathered
 in the city, stunned,
kneeling, offering their branches, praying before the two
 great temples of Athena
or staring into the ashes of burnt offerings, staring,
waiting, waiting for the god to speak.
Look,
look at it, 30
lord Oedipus—right there,
in front of your eyes—this city—
it reels under a wild storm of blood, wave after wave
 battering Thebes.
We cannot breathe or stand.
We hunger, our world shivers with hunger. A disease
 hungers,
nothing grows, wheat, fruit, nothing grows bigger than a
 seed.
Our women bear
dead things,
all they can do is grieve,
our cattle wither, stumble, drop to the ground, 40
flies simmer on their bloated tongues,
the plague spreads everywhere, a stain seeping through
 our streets, our fields, our houses,
look—god's fire eating everyone, everything,
stroke after stroke of lightning, the god stabbing it alive—
it can't be put out, it can't be stopped,
its heat thickens the air, it glows like smoking metal,
this god of plague guts our city and fills the black world
 under us where the dead go
with the shrieks of women,
living women, wailing.
You are a man, not a god—I know. 50
We all know this, the young kneeling here before you
 know it, too,
but we know how great you are, Oedipus, greater than
 any man.
When crisis struck, you saved us here in Thebes,
you faced the mysterious, strange disasters hammered
 against us by the gods.
This is our history—
we paid our own flesh to the Sphinx until you set us free.
You knew no more than anyone, but you knew.
There was a god in it, a god in you.
 [*The* PRIEST *kneels*]
Help us, Oedipus, we beg you, we all turn to you,
 kneeling to your greatness.
Advice from the gods or advice from human beings—you
 will know which is needed. 60
But help us. Power and experience are yours, all yours.
Between thought and action, between our plans and their
 results a distance opens.
Only a man like you, Oedipus, tested by experience,
can make them one. That much I know.
Oedipus, more like a god than any man alive,
deliver us, raise us to our feet. Remember who you are.
Remember your love for Thebes. Your skill was our
 salvation once before.
For this Thebes calls you savior.
Don't let us remember you as the king—godlike in
 power— 70

who gave us back our life, then let us die.
Steady us forever. You broke the riddle for us then.
It was a sign. A god was in it. Be the man you were—
rule now as you ruled before.
Oh Oedipus,
how much better to rule a city of men than be king of
 empty earth.
A city is nothing, a ship is nothing
where no men live together, where no men work
 together.
Oedipus: Children, poor helpless children,
I know what brings you here, I know. 80
You suffer, this plague is agony for each of you,
but none of you, not one suffers as I do.
Each of you suffers for himself, only himself.
My whole being wails and breaks
for this city, for myself, for all of you,
old man, all of you.
Everything ends here, with me. I am the man.
You have not wakened me from some kind of sleep.
I have wept, struggled, wandered in this maze of thought,
tried every road, searched hard— 90
finally I found one cure, only one:
I sent my wife's brother, Kreon, to great Apollo's shrine at
 Delphi;
I sent him to learn what I must say or do to save Thebes.
But his long absence troubles me. Why isn't he here?
 Where is he?
When he returns, what kind of man would I be
if I failed to do everything the god reveals?
 [*Some of the suppliants by the steps to the orchestra
 stand to announce KREON's arrival to the PRIEST.
 KREON comes in by the entrance to the audience's
 left with a garland on his head.*]
Priest: You speak of Kreon, and Kreon is here.
 [*OEDIPUS turns to the altar of Apollo, then to
 KREON*]
Oedipus: Lord Apollo, look at him—his head is crowned
 with laurel, his eyes glitter.
Let his words blaze, blaze like his eyes, and save us.
Priest: He looks calm, radiant, like a god. If he brought
 bad news, 100
would he be wearing that crown of sparkling leaves?
Oedipus: At last we will know.
Lord Kreon, what did the god Apollo say?
Kreon: His words are hopeful.
Once everything is clear, exposed to the light,
we will see our suffering is blessing. All we need is luck.
Oedipus: What do you mean? What did Apollo say?
 What should we do?
Speak.
Kreon: Here? Now? In front of all these people?
Or inside, privately? 110
 [*KREON moves toward the palace*]
Oedipus: Stop. Say it. Say it to the whole city.
I grieve for them, for their sorrow and loss, far more than
 I grieve for myself.
Kreon: This is what I heard—there was no mistaking the
 god's meaning—
Apollo commands us:
Cleanse the city of Thebes, cleanse the plague from that city,

destroy the black stain spreading everywhere, spreading,
poisoning the earth, touching each house, each citizen,
sickening the hearts of the people of Thebes!
Cure this disease that wastes all of you, spreading,
 spreading,
before it grows so vast nothing can cure it 120
Oedipus: What is this plague?
How can we purify the city?
Kreon: A man must be banished. Banished or killed.
Blood for blood. The plague is blood,
blood, breaking over Thebes.
Oedipus: *Who* is the man? *Who* is Apollo's victim?
Kreon: My lord, before you came to Thebes, before you
 came to power,
Laios was our king.
Oedipus: I know. But I never saw Laios.
Kreon: Laios was murdered. Apollo's command was very
 clear: 130
Avenge the murderers of Laios. Whoever they are.
Oedipus: But where *are* his murderers?
The crime is old. How will we find their tracks?
The killers could be anywhere.
Kreon: Apollo said the killers are still here, here in
 Thebes.
Pursue a thing, and you may catch it;
ignored, it slips away.
Oedipus: And Laios—where was he murdered?
At home? Or was he away from Thebes?
Kreon: He told us before he left—he was on a mission
 to Delphi, 140
his last trip away from Thebes. He never returned.
Oedipus: Wasn't there a witness, someone with Laios
 who saw what happened?
Kreon: They were all killed, except for one man. He
 escaped.
But he was so terrified he remembered only one thing.
Oedipus: What was it? One small clue might lead to
 others.
Kreon: This is what he said: bandits ambushed Laios,
 not one man.
They attacked him like hail crushing a stalk of wheat.
Oedipus: How could a single bandit dare attack a king
unless he had supporters, people with money, here,
here in Thebes? 150
Kreon: There were suspicions. But after Laios died we
 had no leader, no king.
Our life was turmoil, uncertainty.
Oedipus: But once the throne was empty,
what threw you off the track, what kept you from
 searching
until you uncovered everything, knew every detail?
Kreon: The intricate, hard song of the Sphinx
persuaded us the crime was not important, not then.
It seemed to say we should focus on what lay at our feet,
 in front of us,
ignore what we could not see.
Oedipus: Now *I* am here. 160
I will begin the search again, I
will reveal the truth, expose everything, let it all be seen.
Apollo and you were right to make us wonder about the
 dead man.

Like Apollo, I am your ally.
Justice and vengeance are what I want,
for Thebes, for the god.
Family, friends—I won't rid myself of this stain, this
 disease, for them—
they're far from here. I'll do it for myself, for me.
The man who killed Laios might take revenge on me
just as violently. 170
So by avenging Laios' death, I protect myself.
 [Turning to the suppliants]
Rise, children,
pick up your branches,
let someone announce my decision to the whole city of
 Thebes.
 [To the PRIEST]
I will do everything. Everything.
And, with the god's help, we will be saved.
Bright Apollo, let your light help us see.
Our happiness is yours to give, our failure and ruin yours.
Priest: Rise. We have the help we came for, children.
The king himself has promised. 180
May Apollo, who gave these oracles, come as our savior
 now.
Apollo, heal us, save us from this plague!
 [OEDIPUS enters the palace. Its doors close. KREON
 leaves by a door to the right on the wing of the stage.
 The PRIEST and suppliants go down into the orchestra
 and leave by the entrance to the left as a chorus of 15
 Theban elders files into the orchestra by the entrance
 on the right, preceded by a flute player.]
Chorus: voice voice voice[1]
voice who knows everything o god
glorious voice of Zeus
how have you come from Delphi bathed in gold
what are you telling our bright city Thebes
what are you bringing me
health death fear
I know nothing 190
so frightened rooted here
awed by you
healer what have you sent
is it the sudden doom of grief
or the old curse the darkness
looming in the turning season

o holy immortal voice
hope golden seed of the future
listen be with me speak
these cries of mine rise 200
tell me
I call to you reach out to you first
holy Athena god's daughter who lives forever
and your sister Artemis
who cradles the earth our earth
who sits on her great throne at the hub of the market
 place
and I call to Apollo who hurls light

1. In this translation, the choruses are not punctuated, so as to give
an impression of the way they fluctuate between talk and song,
somewhat like a chant.

from deep in the sky
o gods be with us now
shine on us your three shields 210
blazing against the darkness
come in our suffering as you came once before
to Thebes o bright divinities
and threw your saving light against the god of grief
o gods
be with us now

pain pain my sorrows have no sound
no name no word no pain like this
plague sears my people everywhere
everyone army citizens no one escapes 220
no spear of strong anxious thought protects us
great Thebes grows nothing
seeds rot in the ground
our women when they labor
cry Apollo Apollo but their children die
and lives one after another split the air
birds taking off
wingrush hungrier than fire
souls leaping away they fly
to the shore 230
of the cold god of evening
west

the death stain spreads
so many corpses lie in the streets everywhere
nobody grieves for them
the city dies and young wives
and mothers gray-haired mothers wail
sob on the altar steps
they come from the city everywhere mourning their bitter
 days
prayers blaze to the Healer 240
grief cries a flute mingling
daughter of Zeus o shining daughter show us
the warm bright face of peace of help
of our salvation
 [The doors of the palace open. OEDIPUS enters.]
and turn back the huge raging jaws of the death god Ares
drive him back drive him away

his flames lash at me
this is his war these are his shields
shouts pierce us on all sides
turn him back lift him on a strong wind 250
rush him away
to the two seas at the world's edge
the sea where the waters boil
the sea where no traveler can land
because if night leaves anything alive
day destroys it
o Zeus
god beyond all other gods
handler of the fire
father 260
make the god of our sickness
ashes

Apollo
great bowman of light draw back your bow

fire arrow after arrow
make them a wall circling us
shoot into our enemy's eyes
draw the string twined with gold
come goddess
who dances on the mountains 270
sowing light where your feet brush the ground
blind our enemy come
god of golden hair
piled under your golden cap Bacchus
your face blazing like the sea when the sun falls on it
like sunlight on wine
god whose name is our name Bacchus
god of joy god of terror
be with us now your bright face
like a pine torch roaring 280
thrust into the face of the slaughtering war god
blind him
drive him down from Olympos
drive him away from Thebes
forever
Oedipus: Every word of your prayers has touched me.
Listen. Follow me. Join me in fighting this sickness, this
 plague,
and all your sufferings may end, like a dark sky,
clear suddenly, blue, after a week of storms,
soothing the torn face of the sea, 290
soothing our fears.
Your fate looms in my words—
I heard nothing about Laios' death,
I know nothing about the murder,
I was alone, how could I have tracked the killer, without a
 clue,
I came to Thebes after the crime was done,
I was made a Theban after Laios' death. Listen carefully—
these words come from an innocent man.
 [Addressing the CHORUS]
One of you knows who killed Laios.
Where is that man? 300
Speak.
I command it. Fear is no excuse.
He must clear himself of the dangerous charge.
Who did this thing?
Was it a stranger?
Speak.
I will not harm him. The worst he will suffer is exile.
I will pay him well. He will have a king's thanks.
But if he will not speak because he fears me,
if he fears what I will do to him or to those he loves, 310
if he will not obey me,
I say to him:
My power is absolute in Thebes, my rule reaches
 everywhere,
my words will drive the guilty man, the man who *knows*,
out of this city, away from Thebes, forever.
Nothing.
My word for him is nothing.
Let him *be* nothing.
Give him nothing.
Let him touch nothing of yours, he is nothing to you. 320
Lock your doors when he approaches.

Say nothing to him, do not speak.
No prayers with him, no offerings with him.
No purifying water.
Nothing.
Drive him from your homes. Let him have no home,
 nothing.
No words, no food, shelter, warmth of hand, shared
 worship.
Let him have nothing. Drive him out, let him die.
He is our disease.
 I know. 330
 Apollo has made it clear.
Nothing can stop me, nothing can change my words.
I fight for Apollo, I fight for the dead man.
You see me, you hear me, moving against the killer.
My words are his doom.
Whether he did it alone, and escaped unseen,
whether others helped him kill, it makes no difference—
let my hatred burn out his life, hatred, always.
Make him an ember of suffering.
Make all his happiness 340
ashes.
If he eats at my side, sits at my sacred hearth, and I
 know these things,
let every curse I spit out against him find *me*,
come home to *me*.
Carry out my orders. You must,
for me, for Apollo, and for Thebes, Thebes,
this poor wasted city,
deserted by its gods.
I know—the gods have given us this disease. 350
That makes no difference. You should have acted,
you should have done something long ago to purge our
 guilt.
The victim was noble, a king—
you should have done everything to track his murderer
 down.
And so,
because I rule now where he ruled;
because I share his bed, his wife;
because the same woman who mothered my children
 might have mothered his;
because fate swooped out of nowhere and cut him down;
because of all these things 360
I will fight for him as I would fight for my own murdered
 father.
Nothing will stop me.
No man, no place, nothing will escape my gaze. I will not
 stop
until I know it all, all, until everything is clear.
For every king, every king's son and his sons,
for every royal generation of Thebes, *my* Thebes,
I will expose the killer, I will reveal him
to the light.
Oh gods, gods,
destroy all those who will not listen, will not obey. 370
Freeze the ground until they starve.
Make their wives barren as stone.
Let this disease that shakes Thebes to its roots—
or any worse disease, if there is any worse than
 this—waste them,

crush everything they have, everything they are.
But you men of Thebes—
you, who know my words are right, who obey me—
may justice and the gods defend you, bless you,
graciously, forever.
Leader: Your curse forces me to speak, Master. 380
I cannot escape it.
I did not murder the king, I cannot show you the man
 who did.
Apollo told us to search for the killer.
Apollo must name him.
Oedipus: No man can force the gods to speak.
Leader: Then I will say the next best thing.
Oedipus: If there's a third best thing, say that too.
Leader: Teiresias sees what the god Apollo sees.
Truth, truth.
If you heard the god speaking, heard his voice, 390
you might see more, more, and more.
Oedipus: Teiresias? I have seen to that already.
Kreon spoke of Teiresias, and I sent for him. Twice.
I find it strange he still hasn't come.
Leader: And there's an old story, almost forgotten,
a dark, faded rumor.
Oedipus: What rumor? I must sift each story,
see it, understand it.
Leader: Laios was killed by bandits.
Oedipus: I have heard that story: but who can show me
 the man who saw the murderer? 400
Has anyone seen him?
Leader: If he knows the meaning of fear,
if he heard those curses you spoke against him,
those words still scorching the air,
you won't find him now, not in Thebes.
Oedipus: The man *murdered.* Why would words frighten him?
 |TEIRESIAS *has appeared from the stage entrance*
 to the right of the audience. He walks with a staff
 and is helped by a slave boy and attendants.
 He stops at some distance from center stage.|
Leader: Here is the man who can catch the criminal.
They're bringing him now—
the godlike prophet who speaks with the voice of god.
He, only he, knows truth. 410
The truth is rooted in his soul.
Oedipus: Teiresias, you understand all things,
what can be taught, what is locked in silence,
the distant things of heaven, and things that crawl the
 earth.
You cannot see, yet you know the nature of this plague
 infesting our city.
Only you, my lord, can save us, only you can defend us.
Apollo told our messenger—did you hear?—
that we could be saved only by tracking down Laios'
 killers,
only by killing them, or sending them into exile.
Help us, Teiresias. 420
Study the cries of birds, study their wild paths,
ponder the signs of fire, use all your skills of prophecy.
Rescue us, preserve us.
Rescue yourself, rescue Thebes, rescue me.
Cleanse every trace of the growing stain left by the dead
 man's blood.

We are in your hands, Teiresias.
No work is more nobly human than helping others,
helping with all the strength and skill we possess.
Teiresias: Wisdom is a curse
when wisdom does nothing for the man who has it. 430
Once I knew this well, but I forgot.
I never should have come.
Oedipus: Never should have come? Why this reluctance,
 prophet?
Teiresias: Let me go home.
That way is best, for you, for me.
Let me live my life, and you live yours.
Oedipus: Strange words, Teiresias, cruel to the city that
 gave you life.
Your holy knowledge could save Thebes. How can you
 keep silent?
Teiresias: What have *you* said that helps Thebes? Your
 words are wasted.
I would rather be silent than waste my words. 440
Oedipus: Look at us,
 |OEDIPUS *stands, the* CHORUS *kneel*|
kneeling to you, Teiresias, imploring you.
In the name of the gods, if you know—
help us, tell us what you know.
Teiresias: You kneel because you do not understand.
But I will never let you see my grief. Never.
My grief is yours.
Oedipus: What? You know and won't speak?
You'd betray us all, you'd destroy the city of Thebes?
Teiresias: I will do nothing to hurt myself, or you. Why
 insist? 450
I will not speak.
Oedipus: Stubborn old fool, you'd make a rock angry!
Tell me what you know! Say it!
Where are your feelings? Won't you ever speak?
Teiresias: You call me cold, stubborn, unfeeling, you
 insult me. But *you,*
Oedipus, what do you know about yourself,
about your real feelings?
You don't see how much alike we are.
Oedipus: How can *I* restrain my anger when I see how
 little you care for Thebes.
Teiresias: The truth will come, by itself, 460
the truth will come
no matter how I shroud it in silence.
Oedipus: All the more reason why you should speak.
Teiresias: Not another word.
Rage away. You will never make me speak.
Oedipus: I'll rage, prophet, I'll give you all my anger.
I'll say it all—
Listen: I think you were involved in the murder of Laios,
you helped plan it, I think you
did everything in your power to kill Laios, 470
everything but strike him with your own hands,
and if you weren't blind, if you still had eyes to see with,
I'd say you, and *you* alone, did it all.
Teiresias: Do you think so? Then obey your own words,
 obey
the curse everyone heard break from your own lips:
Never speak again to these men of Thebes,
never speak again to me.

You, it's
you.
What plagues the city is *you*. 480
The plague is *you*.
Oedipus: Do you know what you're saying?
Do you think I'll let you get away with these vile
 accusations?
Teiresias: I am safe.
Truth lives in me, and the truth is strong.
Oedipus: Who taught you this truth of yours? Not your
 prophet's craft.
Teiresias: You taught me. You forced me to speak.
Oedipus: Speak what? Explain. Teach me.
Teiresias: Didn't you understand?
Are you trying to make me say the word? 490
Oedipus: What word? Say it. Spit it out.
Teiresias: Murderer.
I say *you*,
you are the killer you're searching for.
Oedipus: You won't say *that* again to me and get away
 with it.
Teiresias: Do you want more? Shall I make you really
 angry?
Oedipus: Say anything you like. Your words are wasted.
Teiresias: I say you live in shame, and you do not know it,
do not know that you
and those you love most 500
wallow in shame,
you do not know
in what shame you live.
Oedipus: You'll pay for these insults, I swear it.
Teiresias: Not if the truth is strong.
Oedipus: The truth *is* strong, but not your truth.
You have no truth. You're blind.
Blind in your eyes. Blind in your ears. Blind in your mind.
Teiresias: And I pity you for mocking my blindness.
Soon everyone in Thebes will mock you, Oedipus. They'll
 mock you 510
as you have mocked me.
Oedipus: One endless night swaddles you in its
 unbroken black sky.
You can't hurt me, you can't hurt anyone who sees the
 light of day.
Teiresias: True. Nothing I do will harm you. You, you
and your fate belong to Apollo.
Apollo will see to *you*.
Oedipus: Are these your own lies, prophet—or Kreon's?
Teiresias: Kreon? Your plague is *you*, not Kreon.
Oedipus: Money, power, one great skill surpassing
 another,
if a man has these things, other men's envy grows and
 grows, 520
their greed and hunger are insatiable.
Most men would lust for a life like mine—but I did not
 demand my life,
Thebes gave me my life, and from the beginning, my
 good friend Kreon,
loyal, trusted Kreon,
was reaching for my power, wanted to ambush me, get
 rid of me by hiring this cheap wizard,
this crass, conniving priest, who sees nothing but profit,

whose prophecy is simple profit. *You*,
what did you ever do that proves you a real seer? What
 did you ever *see*, prophet?
And when the Sphinx who sang mysteriously 530
imprisoned us
why didn't you speak and set us free?
No ordinary man could have solved her riddle,
it took prophecy, prophecy and skill you clearly never had.
Even the paths of birds, even the gods' voices were
 useless.
But I showed up, I, Oedipus,
stupid, untutored Oedipus,
I silenced her, I destroyed her, I used my wits, not omens,
to sift the meaning of her song.
And this is the man you want to kill so you can get close
 to King Kreon, 540
weigh his affairs for him, advise him, influence him.
No, I think you and your master, Kreon, who contrived
 this plot,
will be whipped out of Thebes.
Look at you.
If you weren't so old, and weak, oh
I'd make you pay
for this conspiracy of yours.
Leader: Oedipus, both of you spoke in anger.
Anger is not what we need.
We need all our wits, all our energy to interpret Apollo's
 words. 550
Then we will know what to do.
Teiresias: Oedipus, you are king, but you must hear my
 reply.
My right to speak is just as valid as yours.
I am not your slave. Kreon is not my patron.
My master is Apollo. I can say what I please.
You insulted me. You mocked me. You called me blind.
Now hear *me* speak, Oedipus.
You have eyes to see with,
but you do not see yourself, you do not see
the horror shadowing every step of your life, 560
the blind shame in which you live,
you do not see where you live and who lives with you,
lives always at your side.
Tell me, Oedipus, who are your parents?
Do you know?
You do not even know
the shame and grief you have brought your family,
those still alive, those buried beneath the earth.
But the curse of your mother, the curse of your father
will whip you, whip you again and again, wherever you
 turn, 570
it will whip you out of Thebes forever,
your clear eyes flooded with darkness.
That day will come.
And then what scoured, homeless plain, what leafless tree,
what place on Kithairon,
where no other humans are or ever will be,
where the wind is the only thing that moves,
what raw track of thorns and stones, what rock, gulley,
or blind hill won't echo your screams, your howls of anguish
when you find out that the marriage song, 580
sung when you came to Thebes, heard in your house,

guided you to *this* shore, this wilderness
you thought was home, *your* home?
And you do not see
all the other awful things
that will show you who you really are, show you
to your children, face to face.
Go ahead! Call me quack, abuse Kreon, insult Apollo, the
 god
who speaks through me, whose words move on my lips.
No man will ever know worse suffering than you, 590
your life, your flesh, your happiness an ember of pain.
 Ashes.
 [*To the* CHORUS]
Oedipus: Must I stand here and listen to these attacks?
 [TEIRESIAS *begins to move away*]
Teiresias: I am here, Oedipus, because you sent for me.
Oedipus: You old fool,
I'd have thought twice before asking you to come
if I had known you'd spew out such idiocy.
Teiresias: Call me fool, if you like, but your parents,
who gave you life, they respected my judgment.
Oedipus: Parents?
 What do you mean? 600
 Who are my mother and father?
Teiresias: This day is your mother and father—this day
 will give you your birth,
it will destroy you too.
Oedipus: How you love mysterious, twisted words.
Teiresias: Aren't you the great solver of riddles?
Aren't you Oedipus?
Oedipus: Taunt me for the gift of my brilliant mind.
That gift is what makes me great.
Teiresias: That gift is your destiny. It made you
 everything you are,
and it has ruined you. 610
Oedipus: But if this gift of mine saved Thebes, who cares
 what happens to me?
Teiresias: I'm leaving. Boy, take me home.
Oedipus: Good. Take him home. Here
I keep stumbling over you, here you're in my way.
Scuttle home, and leave us in peace!
Teiresias: I'm going. I said what I came to say,
and that scowl, darkening your face, doesn't frighten me.
 How can you hurt me?
I tell you again:
the man you've been trying to expose—
with all your threats, with your inquest into Laios'
 murder— 620
that man is here, in Thebes.
Now people think he comes from Corinth, but later
they will see he was born in Thebes.
When they know, he'll have no pleasure in that news.
Now he has eyes to see with, but they will be slashed out;
rich and powerful now, he will be a beggar,
poking his way with a stick, feeling his way to a strange
 country.
And his children—the children he lives with—
will see him at last, see what he is, see who he really is:
their brother and their father; his wife's son, his mother's
 husband; 630
the lover who slept with his father's wife; the man who

murdered his father—
the man whose hands still drip with his father's blood.
These truths will be revealed.

Go inside and ponder *that* riddle, and if you find I've lied,
then call me a prophet who cannot see.
 [OEDIPUS *turns and enters the palace.* TEIRESIAS
 is led out through the stage entrance on the right.]
Chorus: who did crimes unnameable things
things words cringe at
which man did the rock of prophecy at Delphi say
did these things
his hands dripping with blood 640
he should run now flee
his strong feet swallowing the air
stronger than the horses of storm winds
their hooves slicing the air
now in his armor
Apollo lunges at him
his infinite branching fire reaches out
and the steady dread death-hungry Fates follow and
 never stop
their quick scissors seeking the cloth of his life

just now 650
from high snowy Parnassus
the god's voice exploded its blazing message
follow his track find the man
no one knows
a bull loose under wild bushes and trees
among caves and gray rocks
cut from the herd he runs and runs but runs nowhere
zigzagging desperate to get away
birds of prophecy birds of death circling his head
forever 660
voices forged at the white stone core of the earth
they go where he goes always

terror's in me flooding me
how can I judge
what the god Apollo says
trapped hoping confused
I do not see what is here now
when I look to the past I see nothing
I know nothing about a feud
wounding the families of Laios or Oedipus 670
no clue to the truth then or now
nothing to blacken his golden fame in Thebes
and help Laios' family
solve the mystery of his death

Zeus and Apollo know
they understand
only they see
the dark threads crossing beneath our life
but no man can say a prophet sees more than I
one man surpasses another 680
wisdom against wisdom skill against skill
but I will not blame Oedipus
whatever anyone says
until words are as real as things

one thing is clear
years back the Sphinx tested him

his answer was true
he was wise and sweet to the city
so he can never be evil
not to me 690
 [KREON *enters through the stage entrance at*
 right, and addresses the CHORUS]
Kreon: Men of Thebes, I hear Oedipus, our king and
 master,
has brought terrible charges against me.
I have come to face those charges. I resent them bitterly.
If he imagines I have hurt him, spoken or acted against him
while our city dies, believe me—I have nothing left to
 live for.
His accusations pierce me, wound me mortally—
nothing they touch is trivial, private—
if you, my family and friends,
think I'm a traitor, if all Thebes believes it, says it.
Leader: Perhaps he spoke in anger, without thinking, 700
perhaps his anger made him accuse you.
Kreon: Did he really say I persuaded Teiresias to lie?
Leader: I heard him say these things,
but I don't know what they mean.
Kreon: Did he look you in the eyes when he accused me?
Was he in his right mind?
Leader: I do not know or see what great men do.
 [*Turning to* OEDIPUS, *who has emerged from*
 the palace]
But here he is—Oedipus.
Oedipus: What? *You* here? Murderer!
You dare come here, to my palace, when it's clear 710
you've been plotting to murder me and seize the throne
 of Thebes?
You're the bandit, *you're* the killer.
 Answer me—
Did you think I was cowardly or stupid?
Is that why you betrayed me?
Did you really think I wouldn't see what you were plotting,
how you crept up on me like a cloud inching across the
 sun?
Did you think I wouldn't defend myself against you?
You thought I was a fool, but the fool was *you*, Kreon.
Thrones are won with money and men, you fool! 720
Kreon: You have said enough, Oedipus. Now let me reply.
Weigh my words against your charges, then judge for
 yourself.
Oedipus: Eloquent, Kreon. But you won't convince me
 now.
Now that I know your hatred, your malice.
Kreon: Let me explain.
Oedipus: Explain?
What could explain your treachery?
Kreon: If you think this stubborn anger of yours, this
 perversity,
is something to be proud of, you're mad.
Oedipus: And if you think you can injure your sister's
 husband, 730
and not pay for it, *you're* mad.
Kreon: I would be mad to hurt you. How have I hurt you?
Oedipus: Was it you who advised me to send for that
 great holy prophet?
Kreon: Yes, and I'd do it again.

Oedipus: How long has it been since Laios disappeared?
Kreon: Disappeared?
Oedipus: Died. Was murdered
Kreon: Many, many years.
Oedipus: And this prophet of yours—was he practicing
 his trade at the time?
Kreon: With as much skill, wisdom and honor as ever. 740
Oedipus: Did he ever mention my name?
Kreon: Not in my presence.
Oedipus: Was there an inquest? A formal inquiry?
Kreon: Of course. Nothing was ever discovered.
Oedipus: Then why didn't our wonderful prophet, our
 Theban wizard,
denounce me as the murderer then?
Kreon: I don't know. And when I don't know, I don't speak.
Oedipus: But you know this. You know it with perfect
 certainty.
Kreon: What do you mean?
Oedipus: This: if you and Teiresias were not conspiring
 against me, 750
Teiresias would never have charged *me* with Laios' murder.
Kreon: If he said that, you should know.
But now, Oedipus, it's my right, my turn to question you.
Oedipus: Ask anything. You'll never prove I killed Laios.
Kreon: Did you marry my sister, Iokaste?
Oedipus: I married Iokaste.
Kreon: And you gave her an equal share of the power in
 Thebes?
Oedipus: Whatever she wants is hers.
Kreon: And I share that power equally with you and her?
Oedipus: Equally. 760
And that's precisely why it's clear you're false, treacherous.
Kreon: No, Oedipus.
Consider it rationally, as I have. Reflect:
What man, what sane man, would prefer a king's power
with all its dangers and anxieties,
when he could enjoy that same power, without its cares,
and sleep in peace each night? Power?
I have no instinct for power, no hunger for it either.
It isn't royal power I want, but its advantages.
And any sensible man would want the same. 770
Look at the life I lead. Whatever I want, I get from you,
with your goodwill and blessing. I have nothing to fear.
If I were king, my life would be constant duty and
 constraint.
Why would I want your power or the throne of Thebes
more than what I enjoy now—the privilege of power
without its dangers? I would be a fool to want more
than what I have—the substance, not the show, of power.
As matters stand, no man envies me, I am courted
and admired by all. Men wear no smiling masks for Kreon.
And those who want something from you come to me 780
because the way to royal favor lies through me.
Tell me, Oedipus, why should I give these blessings up
to seize your throne and all the dangers it confers?
A man like me, who knows his mortal limits and accepts
 them,
cannot be vicious or treacherous by nature.
The love of power is not my nature, nor is treason
or the thoughts of treason that go with love of power.
I would never dare conspire against your life.

Do you want to test the truth of what I say?
Go to Delphi, put the question to the oracle, 790
ask if I have told you exactly what Apollo said.
Then if you find that Teiresias and I have plotted against
 you,
seize me and put me to death. Convict me
not by one vote alone, but two—yours *and* mine, Oedipus.
But don't convict me on the strength of your suspicions,
don't confuse friends with traitors, traitors with friends.
There's no justice in that.
To throw away a good and loyal friend
is to destroy what you love most—
your own life, and what makes life worth living. 800
Someday you will know the truth:
time, only time reveals the good man;
one day's light reveals the evil man.
Leader: Good words
for someone careful, afraid he'll fall.
But a mind like lightning
stumbles.
Oedipus: When a clever man plots against me and
 moves swiftly
I must move just as swiftly, I must plan.
But if I wait, if I do nothing, he will win, win everything, 810
and I will lose.
Kreon: What do you want? My exile?
Oedipus: No. Your death.
Kreon: You won't change your mind? You won't believe
 me?
Oedipus: I'll believe you when you teach me the
 meaning of envy.
Kreon: Envy? You talk about envy. You don't even know
 what sense is.
Can't you listen to me?
Oedipus: I *am* listening. To my own good sense.
Kreon: Listen to *me*. I have sense on my side too.
Oedipus: You? You were born devious. 820
Kreon: And if you're wrong?
Oedipus: I still must govern.
Kreon: Not if you govern badly.
Oedipus: Oh Thebes, Thebes . . .
Kreon: Thebes is mine too.
 [*Turning to* IOKASTE, *who has entered from
 the palace, accompanied by a woman attendant*]
Leader: Stop. I see
Iokaste coming from the palace
just in time, my lords, to help you
settle this deep, bitter feud raging between you.
Listen to what she says. 830
Iokaste: Oedipus! Kreon! Why this insane quarreling?
You should be ashamed, both of you. Forget yourselves.
This is no time for petty personal bickering.
Thebes is sick, dying.
 —Come inside, Oedipus
—And you, Kreon, leave us.
Must you create all this misery over nothing, nothing?
Kreon: Iokaste,
Oedipus has given me two impossible choices:
Either I must be banished from Thebes, my city, my
 home, 840
or be arrested and put to death.

Oedipus: That's right.
I caught him plotting against me, Iokaste.
Viciously, cunningly plotting against the king of Thebes.
Kreon: Take every pleasure I have in life, curse me, let
 me die,
if I've done what you accuse me of, let the gods
destroy everything I have, let them do anything to me.
I stand here, exposed to their infinite power.
Iokaste: Oedipus, in the name of the gods, believe him.
His prayer has made him holy, naked to the mysterious 850
whims of the gods, has taken him beyond what is human.
Respect his words, respect me, respect these men
 standing at your side.
 [*Beginning a dirge-like appeal to* OEDIPUS]
Chorus: listen to her
think yield
we implore you
Oedipus: What do you want?
Chorus: be generous to Kreon give him respect
he was never foolish before
now his prayer to the gods has made him great
great and frightening 860
Oedipus: Do you know what you're asking?
Chorus: I know
Oedipus: Then say it.
Chorus: don't ever cut him off
without rights or honor
blood binds you both
his prayer has made him sacred
don't accuse him
because some blind suspicion hounds you
Oedipus: Understand me: 870
when you ask for these things
you ask for my death or exile.
Chorus: no
by the sun
the god who bathes us in his light
who sees all
I will die godless no family no friends
if what I ask means that
it is Thebes
Thebes dying wasting away life by life 880
this is the misery
that breaks my heart
and now this quarrel raging between you and Kreon
is more more than I can bear
Oedipus: Then let him go, even if it means I must die
or be forced out of Thebes forever, stripped of all my
 rights, all my honors.
Your grief, *your* words touch me. Not his.
I pity you. But him,
my hatred will reach him wherever he goes.
Kreon: It's clear you hate to yield, clear 890
you yield only under pressure, only
when you've worn out the fierceness of your anger.
Then all you can do is sit, and brood.
Natures like yours are a torment to themselves.
Oedipus: Leave. Go!
Kreon: I'm going. Now I know
you do not know me.
But these men know I am the man I seem to be, a just man,

not devious, not a traitor.
[KREON *leaves*]
Chorus: woman why are you waiting 900
lead him inside comfort him
Iokaste: Not before I know what has happened here.
Chorus: blind ignorant words suspicion without proof
the injustice of it
gnaws at us
Iokaste: From both men?
Chorus: yes
Iokaste: What caused it?
Chorus: enough enough
no more words 910
Thebes is so tormented now
let it rest where it ended
Oedipus: Look where cooling my rage,
where all your decent, practical thoughts have led you.
Chorus: Oedipus I have said this many times
I would be mad helpless to give advice
if I turned against you now
once
you took our city in her storm of pain
straightened her course found fair weather 920
o lead her to safety now
if you can
Iokaste: If you love the gods, tell me, too, Oedipus—I
 implore you—
why are you still so angry, why can't you let it go?
Oedipus: I will tell you, Iokaste.
You mean more, far more to me than these men here.
Iokaste, it is Kreon—Kreon and his plots against me.
Iokaste: What started your quarrel?
Oedipus: He said I murdered Laios.
Iokaste: Does he know something? Or is it pure
 hearsay? 930
Oedipus: He sent me a vicious, trouble-making prophet
to avoid implicating himself. He did not say it to my face.
Iokaste: Oedipus, forget all this. Listen to me:
no mortal can practise the art of prophecy, no man can
 see the future.
One experience of mine will show you why.
Long ago an oracle came to Laios.
It came not from Apollo himself but from his priests.
It said Laios was doomed to be murdered by a son, his
 son and mine.
But Laios, from what we heard, was murdered by bandits
 from a foreign country,
cut down at a crossroads. My poor baby 940
was only three days old when Laios had his feet pierced
 together behind the ankles
and gave orders to abandon our child on a mountain,
 leave him alone to die
in a wilderness of rocks and bare gray trees
where there were no roads, no people.
So you see—Apollo didn't make that child his father's
 killer,
Laios wasn't murdered by his son. That dreadful act
 which so terrified Laios—
it never happened.

All those oracular voices meant was nothing, nothing.
Ignore them.

Apollo creates. Apollo reveals. He needs no help from
 men. 950
[OEDIPUS *has been very still*]
Oedipus: While you were speaking, Iokaste, it flashed
 through my mind
like wind suddenly ruffling a stretch of calm sea.
It stuns me. I can almost see it—some memory, some
 image.
My heart races and swells—
Iokaste: Why are you so strangely excited, Oedipus?
Oedipus: You said Laios was cut down *near* a crossroads?
Iokaste: That was the story. It hasn't changed.
Oedipus: Where did it happen? Tell me. Where?
Iokaste: In Phokis. Where the roads from Delphi and
 Daulia meet.
Oedipus: When? 960
Iokaste: Just before you came to Thebes and assumed
 power.
Just before you were proclaimed King.
Oedipus: O Zeus, Zeus,
what are you doing with my life?
Iokaste: Why are you so disturbed, Oedipus?
Oedipus: Don't ask me. Not yet.
 Tell me about Laios.
How old was he? What did he look like?
Iokaste: Streaks of gray were beginning to show in his
 black hair.
He was tall, strong—built something like you. 970
Oedipus: No! O gods, o
it seems each hard, arrogant curse
I spit out
was meant for me, and I
didn't
know it!
Iokaste: Oedipus, what do you mean? Your face is so
 strange.
You frighten me.
Oedipus: It *is* frightening—can the blind prophet see,
 can he really see?
I would know if you told me . . . 980
Iokaste: I'm afraid to ask, Oedipus.
Told you what?
Oedipus: Was Laios traveling with a small escort
or with many armed men, like a king?
Iokaste: There were five, including a herald.
Laios was riding in his chariot.
Oedipus: Light, o light, light
now everything, everything is clear. All of it.
Who told you this? Who was it?
Iokaste: A household slave. The only survivor. 990
Oedipus: Is he here, in Thebes?
Iokaste: No. When he returned and saw that you were
 king
and learned Laios was dead, he came to me and
 clutched my hand,
begged me to send him to the mountains
where shepherds graze their flocks, far from the city,
so he could never see Thebes again.
I sent him, of course. He deserved that much, for a slave,
 and more.
Oedipus: Can he be called back? Now?

Iokaste: Easily. But why?

Oedipus: I am afraid I may have said too much— 1000
I *must* see him.
Now.

Iokaste: Then he will come.
But surely I have a right to know what disturbs you,
 · Oedipus.

Oedipus: Now that I've come this far, Iokaste,
hope torturing me, each step of mine heavy with fear,
I won't keep anything from you.
Wandering through the mazes of a fate like this,
how could I confide in anyone but you?

My father was Polybos, of Corinth. 1010
My mother, Merope, was Dorian.
Everyone in Corinth saw me as its first citizen,
but one day something happened,
something strange, puzzling. Puzzling, but nothing more.
Still, it worried me.
One night, I was at a banquet,
and a man—he was very drunk—said I wasn't my father's
 son,
called me "bastard." That stung me, I was shocked.
I could barely control my anger, I lay awake all night.
The next day I went to my father and mother, 1020
I questioned them about the man and what he said.
They were furious with him, outraged by his insult,
and I was reassured. But I kept hearing the word
 "bastard" "bastard"—
I couldn't get it out of my head.
Without my parents' knowledge, I went to Delphi: I
 wanted the truth,
but Apollo refused to answer me.
And yet he did reveal other things, he did show me
a future dark with torment, evil, horror,
he made me *see*—
see myself, doomed to sleep with my own mother,
 doomed 1030
to bring children into this world where the sun pours
 down,
children no one could bear to see, doomed
to murder the man who gave me life, whose blood is *my*
 blood. My father.
And after I heard all this, I fled Corinth,
measuring my progress by the stars, searching for a place
where I would never see those words, those dreadful
 predictions
come true. And on my way
I came to the place where you say King Laios was
 murdered.

Iokaste, the story I'm about to tell you is the truth:
I was on the road, near the crossroads you mentioned, 1040
when I met a herald, with an old man, just as you
 described him.
The man was riding in a chariot
and his driver tried to push me off the road
and when he shoved me I hit him. I hit him.
The old man stood quiet in the chariot until I passed
 under him,
then he leaned out and caught me on the head with an
 ugly goad—

its two teeth wounded me—and with this hand of mine,
this hand clenched around my staff,
I struck him back even harder—so hard, so quick he
 couldn't dodge it,
and he toppled out of the chariot and hit the ground,
 face up. 1050
I killed them. Every one of them. I still see them.
 [*To the* CHORUS]
If this stranger and Laios
are somehow linked by blood,
tell me what man's torment equals mine?

Citizens, hear my curse again—
Give this man nothing. Let him touch nothing of yours.
Lock your doors when he approaches.
Say nothing to him when he approaches.
 And these,
 these curses,
with my own mouth I 1060
spoke these monstrous curses against myself.
 [OEDIPUS *turns back to* IOKASTE]
These hands, these bloodstained hands made love to
 you in your dead husband's bed,
these hands murdered him.

If I must be exiled, never to see my family,
never to walk the soil of my country
so I will not sleep with my mother
and kill Polybos, my father, who raised me—his son!—
wasn't I born evil—answer me!—isn't every part of me
unclean? Oh
some unknown god, some savage venomous demon must
 have done this, 1070
raging, swollen with hatred. Hatred
for me.
Holiness, pure, radiant powers, o gods
don't let me see that day,
don't let it come, take me away
from men, men with their eyes, hide me
before I see
the filthy black stain reaching down over me, into me.
 [*The* CHORUS *have moved away from the stage*]

Leader: Your words make us shudder, Oedipus,
but hope, hope 1080
until you hear more from the man who witnessed the
 murder.

Oedipus: That is the only hope I have. Waiting.
Waiting for that man to come from the pastures.

Iokaste: And when he finally comes, what do you hope
 to learn?

Oedipus: If his story matches yours, I am saved.

Iokaste: What makes you say that?

Oedipus: Bandits—you said he told you bandits killed
 Laios.
So if he still talks about bandits,
more than one, I couldn't have killed Laios.
One man is not the same as many men. 1090
But if he speaks of one man, traveling alone,
then all the evidence points to me.

Iokaste: Believe me, Oedipus, those were his words.
And he can't take them back: the whole city heard him,
 not only me.

And if he changes only the smallest detail of his story,
that still won't prove Laios was murdered as the oracle
 foretold.
Apollo was clear—it was Laios' fate to be killed by my
 son,
but my poor child died before his father died.
The future has no shape. The shapes of prophecy lie.
I see nothing in them, they are all illusions. 1100
Oedipus: Even so, I want that shepherd summoned here.
Now. Do it now.
Iokaste: I'll send for him immediately. But come inside.
My only wish is to please you.
 |IOKASTE *dispatches a servant*|
Chorus: fate
be here let what I say be pure
let all my acts be pure
laws forged in the huge clear fields of heaven
rove the sky
shaping my words limiting what I do 1110
Olympos made those laws not men who live and die
nothing lulls those laws to sleep
they cannot die
and the infinite god in them never ages

arrogance insatiable pride
breed the tyrant
feed him on thing after thing blindly
at the wrong time uselessly
and he grows reaches so high 1120
nothing can stop his fall
his feet thrashing the air standing on nothing
and nowhere to stand he plunges down
o god shatter the tyrant
but let men compete let self-perfection grow
let men sharpen their skills
soldiers citizens building the good city
Apollo
protect me always
always the god I will honor 1130
if a man walks through his life arrogant
strutting proud
says anything does anything
does not fear justice
fear the gods bow to their shining presences
let fate make him stumble in his tracks
for all his lecheries and headlong greed
if he takes whatever he wants right or wrong
if he touches forbidden things
what man who acts like this would boast 1140
he can escape the anger of the gods
why should I join these sacred public dances
if such acts are honored

no
I will never go to the holy untouchable stone
navel of the earth at Delphi
never again
go to the temples at Olympia at Abai
if all these things are not joined
if past present future are not made one 1150
made clear to mortal eyes
o Zeus if that is your name

power above all immortal king
see these things look
those great prophecies are fading
men say they're nothing
nobody prays to the god of light no one believes
nothing of the gods stays
 |IOKASTE *enters from the palace, carrying a*
 branch tied with strands of wool, and a jar of
 incense. She is accompanied by a servant
 woman. She addresses the CHORUS.|
Iokaste: Lords of Thebes, I come to the temples of the
 god
with offerings—this incense and this branch. 1160
So many thoughts torture Oedipus. He never rests.
He acts without reason. He is like a man
who has lost everything he knows—the past
is useless to him; strange, new things baffle him.
And if someone talks disaster, it stuns him: he listens, he
 is afraid.
I have tried to reassure him, but nothing helps.
So I have come to you—
Apollo, close to my life, close to this house,
listen to my prayers:
 |*She kneels*|
 help us purify ourselves of this disease, 1170
help us survive the long night of our suffering,
protect us. We are afraid when we see Oedipus confused
and frightened—Oedipus, the only man who can pilot
 Thebes
to safety.
 |A MESSENGER *from Corinth has arrived by*
 the entrance to the orchestra on the audience's
 left. He sees IOKASTE praying, then turns to
 address the CHORUS.|
Messenger: Friends,
can you tell me where King Oedipus lives
or better still, where I can find him?
Leader: Here, in this house.
This lady is his wife and mother
of his children. 1180
Messenger: May you and your family prosper.
May you be happy always under this great roof.
Iokaste: Happiness and prosperity to you, too, for your
 kind words.
But why are you here? Do you bring news?
Messenger: Good news for your house, good news for
 King Oedipus.
Iokaste: What is your news? Who sent you?
Messenger: I come from Corinth, and what I have to say
 I know will bring you joy.
And pain perhaps I do not know.
Iokaste: Both joy and pain? What news could do that?
Messenger: The people of Corinth want Oedipus as their
 king. 1190
That's what they're saying.
Iokaste: But isn't old Polybos still king of Corinth?
Messenger: His kingdom is his grave.
Iokaste: Polybos is *dead*?
Messenger: If I'm lying, my lady, let me die for it.
Iokaste: You.
 |*To a servant*|

Go in and tell Oedipus.
O oracles of the gods, where are you now!
This man, the man Oedipus was afraid he would murder,
the man he feared, the man he fled from has died a
 natural death.
Oedipus didn't kill him, it was luck, luck. 1200
 |*She turns to greet* OEDIPUS *as he comes out
 of the palace*|

Oedipus: Iokaste, why did you send for me?
 |*Taking her gently by the arm*|

Iokaste: Oedipus,
listen to this man, see what those ominous, holy
 predictions of Apollo mean now.

Oedipus: Who is this man? What does he say?

Iokaste: He comes from Corinth.
Your father is dead. Polybos is dead!

Oedipus: What?
Let me hear those words from your own mouth, stranger.
Tell me yourself, in your own words. 1210

Messenger: If that's what you want to hear first, then I'll
 say it:
Polybos is dead.

Oedipus: How did he die? Assassination? Illness? How?

Messenger: An old man's life hangs by a fragile thread.
 Anything can snap it.

Oedipus: That poor old man. It was illness then?

Messenger: Illness and old age.

Oedipus: Why, Iokaste,
why should men look to the great hearth at Delphi
or listen to birds shrieking and wheeling overhead—
cries meaning I was doomed to kill my father? 1220
He is dead, gone, covered by the earth.
And here I am—my hands never even touched a spear—
I did not kill him,
unless he died from wanting me to come home.
No. Polybos has bundled up all these oracles
and taken them with him to the world below.
They are only words now, lost in the air.

Iokaste: Isn't that what I predicted?

Oedipus: You were right. My fears confused me.

Iokaste: You have nothing to fear. Not now. Not ever. 1230

Oedipus: But the oracle said I am doomed to sleep with
 my mother.
How can I live with that and not be afraid?

Iokaste: Why should men be afraid of anything? Fortune
 rules our lives.
Luck is everything. Things happen. The future is
 darkness.
No human mind can know it.
It's best to live in the moment, live for today, Oedipus.
Why should the thought of marrying your mother make
 you so afraid?
Many men have slept with their mothers in their dreams.
Why worry? See your dreams for what they are—nothing,
 nothing at all.
Be happy, Oedipus. 1240

Oedipus: All that you say is right, Iokaste. I know it.
I should be happy,
but my mother is still living. As long as she's alive,
I live in fear. This fear is necessary.
I have no choice.

Iokaste: But Oedipus, your father's death is a sign, a
 great sign—
the sky has cleared, the sun's gaze holds us in its warm,
 hopeful light.

Oedipus: A great sign, I agree. But so long as my mother
 is alive,
my fear lives too.

Messenger: Who is this woman you fear so much? 1250

Oedipus: Merope, King Polybos' wife.

Messenger: Why does Merope frighten you so much?

Oedipus: A harrowing oracle hurled down upon us by
 some great god.

Messenger: Can you tell me? Or did the god seal your
 lips?

Oedipus: I can.
Long ago, Apollo told me I was doomed to sleep with my
 mother
and spill my father's blood, murder him
with these two hands of mine.
That's why I never returned to Corinth. Luckily, it would
 seem.
Still, nothing on earth is sweeter to a man's eyes 1260
than the sight of his father and mother.

Messenger: And you left Corinth because of this
 prophecy?

Oedipus: Yes. And because of my father. To avoid killing
 my father.

Messenger: But didn't my news prove you have nothing
 to fear?
I brought good news.

Oedipus: And I will reward you for your kindness.

Messenger: That's why I came, my lord. I knew you'd
 remember me
when you returned to Corinth.

Oedipus: I will never return, never live with my parents
 again.

Messenger: Son, it's clear you don't know what you're
 doing. 1270

Oedipus: What do you mean? In the name of the gods,
 speak.

Messenger: If you're afraid to go home because of your
 parents.

Oedipus: I *am* afraid, afraid
Apollo's prediction will come true, all of it,
as god's sunlight grows brighter on a man's face at dawn
when he's in bed, still sleeping,
and reaches into his eyes and wakes him.

Messenger: Afraid of murdering your father, of having his
 blood on your hands?

Oedipus: Yes. His blood. The stain of his blood. That
 terror never leaves me. 1280

Messenger: But Oedipus, then you have no reason to be
 afraid.

Oedipus: I'm their son, they're my parents, aren't they?

Messenger: Polybos is nothing to you.

Oedipus: Polybos is not my father?

Messenger: No more than I am.

Oedipus: But you are nothing to me. Nothing.

Messenger: And Polybos is nothing to you either.

Oedipus: Then why did he call me his son?

Messenger: Because I gave you to him. With these hands

I gave you to him. 1290
Oedipus: How could he have loved me like a father if I
 am not his son?
Messenger: He had no children. That opened his heart.
Oedipus: And what about you?
Did you buy me from someone? Or did you find me?
Messenger: I found you squawling, left alone to die in
 the thickets of Kithairon.
Oedipus: Kithairon? What were you doing on Kithairon?
Messenger: Herding sheep in the high summer pastures.
Oedipus: You were a shepherd, a drifter looking for work?
Messenger: A drifter, yes, but it was I who saved you.
Oedipus: Saved me? Was I hurt when you picked me
 up? 1300
Messenger: Ask your feet.
Oedipus: Why,
why did you bring up that childhood pain?
Messenger: I cut you free. Your feet were pierced, tied
 together at the ankles
with leather thongs strung between the tendons and the
 bone.
Oedipus: That mark of my shame—I've worn it from the
 cradle.
Messenger: That mark is the meaning of your name:
Oedipus, Swollenfoot, Oedipus.
Oedipus: Oh gods
who did this to me? 1310
My mother?
My father?
Messenger: I don't know. The man I took you from—he
 would know.
Oedipus: So you didn't find me? Somebody else gave
 me to you?
Messenger: I got you from another shepherd.
Oedipus: What shepherd? Who was he? Do you know?
Messenger: As I recall, he worked for Laios.
Oedipus: The same Laios who was king of Thebes?
Messenger: The same Laios. The man was one of Laios'
 shepherds.
Oedipus: Is he still alive? I want to see this man. 1320
 [The MESSENGER points to the CHORUS]
These people would know that better than I do.
Oedipus: Do any of you know this shepherd he's talking
 about?
Have you ever noticed him in the fields or in the city?
Answer, if you have.
It is time everything came out, time everything was made
 clear.
Everything.
Leader: I think he's the shepherd you sent for.
But Iokaste, she would know.
 [To IOKASTE]
Oedipus: Iokaste, do you know this man?
Is he the man this shepherd here says worked for Laios? 1330
Iokaste: What man? Forget about him. Forget what was
 said.
It's not worth talking about.
Oedipus: How can I forget
with clues like these in my hands?
With the secret of my birth staring me in the face?
Iokaste: No, Oedipus!

No more questions.
For god's sake, for the sake of your own life!
Isn't my anguish enough—more than enough?
Oedipus: You have nothing to fear, Iokaste. 1340
Even if my mother
and her mother before her were both slaves,
that doesn't make *you* the daughter of slaves.
Iokaste: Oedipus, you *must* stop.
 I beg you—stop!
Oedipus: Nothing can stop me now. I must know
 everything.
Everything!
Iokaste: I implore you, Oedipus. For your own good.
Oedipus: Damn my own good!
Iokaste: Oh, Oedipus, Oedipus, 1350
I pray to god you never see who you are!
 [OEDIPUS turns to one of the attendants, who
 hurries off through the exit stage left]
Oedipus: You there, go find that shepherd, bring him here.
Let that woman bask in the glory of her noble birth.
Iokaste: God help you, Oedipus—
you were born to suffer, born
to misery and grief.
These are the last last words I will ever speak, ever
Oedipus.
 [IOKASTE rushes offstage into the palace. Long silence.]
Leader: Why did Iokaste rush away,
Oedipus, fleeing in such pain? 1360
I fear disaster, or worse,
will break from this silence of hers.
Oedipus: Let it break! Let everything break!
I must discover who I am, know the secret of my birth,
no matter how humble, how vile.
Perhaps Iokaste is ashamed of my low birth, ashamed to
 be my wife.
Like all women she's proud.
But Luck, goddess who gives men all that is good, made *me*,
and I won't be cheated of what is mine, nothing can
 dishonor me, ever.
I am like the months, my brothers the months—they
 shaped me 1370
when I was a baby in the cold hills of Kithairon,
they guided me, carved out my times of greatness,
and they still move their hands over my life.
I am the man I am. I will not stop
until I discover who my parents are.
Chorus: if I know if I see
if the dark force of prophecy is mine
Kithairon
when the full moon
rides over us tomorrow 1380
listen listen to us sing to you
dance worship praise you
mountain where Oedipus was found
know Oedipus will praise you
praise his nurse country and mother
who blessed our king
I call on you Apollo
let these visions please you
god Apollo
healer 1390

Oedipus son
who was your mother
which of the deathless mountain nymphs who lay
with the great god Pan
on the high peaks he runs across
or with Apollo
who loves the high green pastures above
which one bore you
did the god of the bare windy peaks Hermes
or the wild, dervish Dionysos 1400
living in the cool air of the hills
take you
a foundling
from one of the nymphs he plays with
joyously lift you hold you in his arms
Oedipus: Old men, I think the man coming toward us
 now
must be the shepherd we are looking for.
I have never seen him, but the years, chalking his face
 and hair, tell me
he's the man. And my men are with him. But you
 probably know him.
Leader: I do know him. If Laios ever had a man he
 trusted, 1410
this was the man.
 [To the MESSENGER]
Oedipus: You—is this the man you told me about?
Messenger: That's him. You're looking at the man.
 [To the SHEPHERD who has been waiting,
 hanging back]
Oedipus: You there, come closer.
 Answer me, old man.
Did you work for Laios?
Shepherd: I was born his slave, and grew up in his
 household.
Oedipus: What was your work?
Shepherd: Herding sheep, all my life.
Oedipus: Where? 1420
Shepherd: Kithairon, mostly. And the country around
 Kithairon.
Oedipus: Do you remember ever seeing this man?
Messenger: Which man?
 [OEDIPUS points to the MESSENGER]
Oedipus: This man standing here. Have you ever seen
 him before?
Shepherd: Not that I remember.
Messenger: No wonder, master. But I'll make him
 remember.
He knows who I am. We used to graze our flocks together
in the pastures around Kithairon.
Every year, for six whole months, three years running.
From March until September, when the Dipper rose,
 signaling the harvest. 1430
I had one flock, he had two.
And when the frost came, I drove my sheep back to their
 winter pens
and he drove his back to Laios' fold.
Remember, old man? Isn't that how it was?
Shepherd: Yes. But it was all so long ago.
Messenger: And do you remember giving me a baby
 boy at the time—

to raise as my own son?
Shepherd: What if I do? Why all these questions?
Messenger: That boy became King Oedipus, friend.
Shepherd: Damn you, can't you keep quiet. 1440
Oedipus: Don't scold him, old man.
It's you who deserve to be punished, not him.
Shepherd: What did I say, good master?
Oedipus: You haven't answered his question about the
 boy.
Shepherd: He's making trouble, master. He doesn't know
 a thing.
 [OEDIPUS takes the SHEPHERD by the cloak]
Oedipus: Tell me or you'll be sorry.
Shepherd: For god's sake, don't hurt me, I'm an old man.
 [OEDIPUS turns to one of his men]
Oedipus: You there, hold him. We'll make him talk.
 [The attendant pins the SHEPHERD's arms
 behind his back]
Shepherd: Oedipus, Oedipus,
god knows I pity you.
What more do you want to know? 1450
Oedipus: Did you give the child to this man?
 Speak. Yes or no?
Shepherd: Yes.
And I wish to god I'd died that day.
Oedipus: You *will* be dead unless you tell me the whole
 truth.
Shepherd: And worse than dead, if I do.
Oedipus: It seems our man won't answer.
Shepherd: No. I told you already. I gave him the boy.
Oedipus: Where did you get him? From Laios'
 household? Or where?
Shepherd: He wasn't my child. He was given to me. 1460
 [OEDIPUS turns to the CHORUS and the
 audience]
Oedipus: By whom? Someone here in Thebes?
Shepherd: Master, please, in god's name, no more
 questions.
Oedipus: You're a dead man if I have to ask you once
 more.
Shepherd: He was one
of the children
from Laios'
household.
Oedipus: A slave child? Or Laios' own?
Shepherd: I can't say it . . . it's
awful, the words 1470
are awful . . . awful
Oedipus: And I,
I am afraid to hear them . . .
but I must.
Shepherd: He was Laios' own child.
Your wife, inside the palace, she can explain it all.
Oedipus: *She* gave you the child?
Shepherd: My lord . . . yes.
Oedipus: Why?
Shepherd: She wanted me to abandon the child on a
 mountain. 1480
Oedipus: His own mother?
Shepherd: Yes. There were prophecies, horrible oracles.
 She was afraid.

Oedipus: What oracles?

Shepherd: Oracles predicting he would murder his own
father.

Oedipus: But why did you give the boy to this old man?

Shepherd: Because I pitied him, master, because I
thought the man would take the child away, take him to
another country.
Instead he saved him. Saved him for—oh gods,
a fate so horrible, so awful, words can't describe it.
If you were the baby that man took from me, Oedipus, 1490
what misery, what grief is yours!
 [OEDIPUS *looks up at the sun*]

Oedipus: LIGHT LIGHT LIGHT
never again flood these eyes with your white radiance, oh
gods, my eyes. All, all
the oracles have proven true. I, Oedipus, I
am the child
of parents who should never have been mine—doomed,
doomed!
Now everything is clear—I
lived with a woman, she was my mother, I slept in my
mother's bed, and I
murdered, murdered my father,
the man whose blood flows in these veins of mine, 1500
whose blood stains these two hands red.
 [OEDIPUS *raises his hands to the sun, then
 turns and walks into the palace*]

Chorus: man after man after man
o mortal generations
here once
almost not here
what are we
dust ghosts images a rustling of air
nothing nothing
we breathe on the abyss
we are the abyss 1510
our happiness no more than traces of a dream
the high noon sun sinking into the sea
the red spume of its wake raining behind it
we are you
we are you Oedipus
dragging your maimed foot
in agony
and now that I see your life finally revealed
your life fused with the god
blazing out of the black nothingness of all we know 1520
I say
no happiness lasts nothing human lasts

wherever you aimed you hit
no archer had your skill
you grew rich powerful great
everything came falling to your feet
o Zeus
after he killed the Sphinx
whose claws curled under
whose weird song of the future baffled and destroyed 1530
he stood like a tower high above our country
warding off death
and from then on Oedipus we called you
king our king
draped you in gold

our highest honors were yours
and you ruled this shining city
Thebes Thebes
now
your story is pain pity no story is worse 1540
than yours Oedipus
ruined savage blind
as you struggle with your life
as your life changes
and breaks and shows you who you are
Oedipus Oedipus
son father you harbored in the selfsame place
the same place sheltered you both
bridegroom
how could the furrow your father plowed 1550
not have cried out all this time
while you lay there unknowing
and saw the truth too late

time like the sun sees all things
and it sees you
you cannot hide from that light
your own life opening itself to you
to all
married unmarried father son
for so long 1560
justice comes like the dawn
always
and it shows the world your marriage now

I wish
o child of Laios
I wish I had never seen you
I grieve for you
wail after wail fills me and pours out
because of you my breath came flowing back
but now 1570
the darkness of your life
floods my eyes
 [*The palace doors open. A* SERVANT *enters
 and approaches the* CHORUS *and audience.*]

Servant: Noble citizens, honored above all others in
Thebes,
if you still care for the house of Laios,
if you still can feel the spirit of those who ruled before,
now
the horrors you will hear, the horrors you will see,
will shake your hearts and shatter you with grief beyond
enduring.
Not even the waters of those great rivers Ister and Phasis
could wash away the blood
that now darkens every stone of this shining house, 1580
this house that will reveal, soon, soon
the misery and evil two mortals,
both masters of this house, have brought upon
themselves.

The griefs we cause ourselves cut deepest of all.

Leader: What we already know
has hurt us enough,
has made us cry out in pain.
What more can you say?

Servant: This:

Iokaste is dead. The queen is dead. 1590
Leader: Ah, poor
unhappy Iokaste,
how did she die?
Servant: She killed herself. She did it.
But you did not see what happened there,
you were not there, in the palace. You did not see it.
I did.
I will tell you how Queen Iokaste died,
the whole story, all of it. All I can remember.
After her last words to Oedipus 1600
she rushed past us through the entrance hall, screaming,
raking her hair with both hands, and flew into the
 bedroom, *their* bedroom,
and slammed the doors shut as she lunged at her bridal
 bed,
crying "Laios" "Laios"—dead all these years—
remembering Laios—how his own son years ago
grew up and then killed him, leaving her to
sleep with her own son, to have his children, *their*
 children,
children—not sons, not daughters, something else,
 monsters
Then she collapsed, sobbing, cursing the bed where she
 held both men in her arms,
got husband from husband, children from her child. 1610
We heard it all, but suddenly, I couldn't tell what was
 happening.
Oedipus came crashing in, he was howling,
stalking up and down—we couldn't take our eyes off
 him—
and we stopped listening to her pitiful cries.
We stood there, watching him move like a bull, lurching,
 charging,
shouting at each of us to give him a sword, demanding
 we tell him
where his wife was, that woman whose womb carried him,
him and his children, that wife who gave him birth.
Some god, some demon, led him to her, and he knew—
none of us showed him— 1620
suddenly a mad, inhuman cry burst from his mouth
as if the wind rushed through his tortured body,
and he heaved against those bedroom doors so the
 hinges whined
and bent from their sockets and the bolts snapped,
and he stood in the room.
There she was—
we could see her—his wife
dangling by her neck from a noose of braided, silken
 cords
tied to a rafter, still swaying.
And when he saw her he bellowed and stretched up and
 loosened the rope, 1630
cradling her in one arm,
and slowly laid her body on the ground.

That's when it happened—he
ripped off the gold
brooches she was wearing—one on each shoulder of her
 gown—
and raised them over his head—you could see them
 flashing—

and tilted his face up and
brought them right down into his eyes
and the long pins sank deep, all the way back into the
 sockets,
and he shouted at his eyes: 1640
"Now you won't see me, you won't see
my agonies or my crimes,
but in endless darkness, always, there you'll see
those I never should have seen.
And those I should have known were my parents, father
 and mother—
these eyes will never see their faces in the light.
These eyes will never see the light again, never."
Cursing his two blind eyes over and over, he
lifted the brooches again and drove their pins through
 his eyeballs up
to the hilts until they were pulp, until the blood
 streamed out 1650
soaking his beard and cheeks,
a black storm splashing its hail across his face.

Two mortals acted. Now grief tears their lives apart
as if that pain sprang from a single, sorrowing root
to curse each one, man and wife. For all those years
their happiness was truly happiness, but now, now
wailing, madness, shame and death,
every evil men have given a name,
everything criminal and vile
that mankind suffers they suffer. Not one evil is missing. 1660
Leader: But now
does this torn, anguished man
have any rest from his pain?
Servant: No, no—
then he shouted at us to open the doors and show
 everyone in Thebes
his father's killer, his mother's—I cannot say it.
Once we have seen him as he is
he will leave Thebes, lift the curse from his city—
banish himself, cursed by his own curses.
But his strength is gone, his whole life is pain, 1670
more pain than any man can bear.
He needs help, someone to guide him.
He is alone, and blind. Look,
look—the palace doors are opening—now
a thing
so horrible will stand before you
you will shudder with disgust and try to turn away
while your hearts will swell with pity for what you see.
 [*The central doors open.* OEDIPUS *enters, led
 by his household servants. His mask is covered
 with blood. The* CHORUS *begin a dirge to
 which* OEDIPUS *responds antiphonally.*]
Chorus: horror horror o what suffering
men see 1680
but none is worse than this
Oedipus o
how could you have slashed out your eyes
what god leaped on you
from beyond the last border of space
what madness entered you
clawing even more misery into you
I cannot look at you

but there are questions
so much I would know 1690
so much that I would see
no no
the shape of your life makes me shudder
Oedipus: I I
this voice of agony
I am what place am I
where? Not here, nowhere I know!
What force, what tide breaks over my life?
Pain, demon stabbing into me
leaving nothing, nothing, no man I know, not human, 1700
fate howling out of nowhere what am I
fire a voice where where
is it being taken?
Leader: Beyond everything to a place
so terrible nothing is seen there, nothing is heard.
 [OEDIPUS *reaches out, groping*]
Oedipus: Thing thing darkness
spilling into me, my
black cloud smothering me forever,
nothing can stop you, nothing can escape,
I cannot push you away. 1710

I am
nothing but my own cries breaking
again and again
the agony of those gold pins
the memory of what I did
stab me
again
again.
Leader: What can you feel but pain.
It all comes back, pain in remorse, 1720
remorse in pain, to tear you apart with grief.
Oedipus: Dear, loyal friend
you, only you, are still here with me, still care
for this blind, tortured man.
Oh,
I know you are there, I know you, friend,
even in this darkness, friend, touched by your voice.
Leader: What you did was horrible,
but how could you quench the fire of your eyes,
what demon lifted your hands? 1730
Oedipus: Apollo Apollo
it was Apollo, always Apollo,
who brought each of my agonies to birth,
but I,
nobody else, I,
I raised these two hands of mine, held them above my
 head,
and plunged them down,
I stabbed out these eyes.
Why should I have eyes? Why,
when nothing I saw was worth seeing? 1740
Nothing.
Leader: Nothing. Nothing.
Oedipus: Oh friends. Nothing.
No one to see, no one to love,
no one to speak to, no one to hear!
 Friends, friends, lead me away now.

Lead me away from Thebes—Oedipus,
destroyer and destroyed,
the man whose life is hell
for others and for himself, the man 1750
more hated by the gods than any other man, ever.
Leader: Oh I pity you,
I weep for your fate
and for your mind,
for what it is to be you, Oedipus.
I wish you had never seen the man you are.
Oedipus: I hate
the man who found me, cut the thongs from my feet,
snatched me from death, cared for me—
I wish he were dead! 1760
I should have died up there on those wild, desolate
 slopes of Kithairon.
Then my pain and the pain
those I love suffer now
never would have been.
Leader: These are my wishes too.
Oedipus: Then I never would have murdered my father,
never heard men call me my mother's husband.

Now
I am
Oedipus! 1770
Oedipus, who lay in that loathsome bed, made love
 there in that bed,
his father's and mother's bed, the bed
where he was born.

No gods anywhere now, not for me, now,
unholy, broken man.
What man ever suffered grief like this?
Leader: How can I say that what you did was right?
Better to be dead than live blind.
Oedipus: I did what I had to. No more advice.
How could *my* eyes, 1780
when I went down into that black, sightless place
 beneath the earth,
the place where the dead go down, how,
how could I have looked at anything,
with what human eyes could I have gazed
on my father, on my mother—
oh gods, my mother!
What I did against those two
not even strangling could punish.
And my children, how would the sight of them, born as
 they were born,
be sweet? Not to these eyes of mine, never to these
 eyes. 1790
Nothing, nothing is left me now—no city with its high
 walls,
no shining statues of the gods. I stripped all these things
 from myself—
I, Oedipus, fallen lower than any man now, born nobler
 than the best,
born the king of Thebes! Cursed with my own curses, I
commanded Thebes to drive out the killer.
I banished the royal son of Laios, the man the gods
 revealed
is stained with the awful stain. The secret stain

that I myself revealed is *my* stain. And now, revealed at last,
how could I ever look men in the eyes?
Never. Never. 1800

If I could, I would have walled my ears so they heard nothing,
I would have made this body of mine a wall.
I would have heard nothing, tasted nothing, smelled nothing, seen
nothing.
 No thought. No feeling. Nothing. Nothing.
So pain would never reach me any more.

O Kithairon,
why did you shelter me and take me in?
Why did you let me live? Better to have died on that bare slope of yours
where no man would ever have seen me or known the secret of my birth! 1810

Polybos, Corinth, that house I thought was my father's home,
how beautiful I was when you sheltered me as a child
and oh what disease festered beneath that beauty.
Now everyone knows the secret of my birth, knows
how vile I am.

O roads, secret valley, cluster of oaks,
O narrow place where two roads join a third,
roads that drank my blood as it streamed from my hands,
flowing from my dead father's body,
do you remember me now? 1820
Do you remember what I did with my own two hands,
 there in your presence,
and what I did after that, when I came here to Thebes?
O marriage, marriage, you gave me my life, and then
from the same seed, *my* seed, spewed out
fathers, brothers, sisters, children, brides, wives—
nothing, no words can express the shame.
No more words. Men should not name what men should never do.
 [To the CHORUS]
Gods, oh gods, gods,
hide me, hide me
now 1830
far away from Thebes,
kill me,
cast me into the sea,
drive me where you will never see me—never again.
 [*Reaching out to the CHORUS, who back away*]
Touch this poor man, touch me,
don't be afraid to touch me. Believe me, nobody,
nobody but me can bear
this fire of anguish.
It is mine. Mine.
Leader: Kreon has come. 1840
Now he, not you, is the sole guardian of Thebes,
and only he can grant you what you ask.
 [OEDIPUS *turns toward the palace*]
Oedipus: What can I say to him, how can anything I say
make him listen now?
I wronged him. I accused him, and now everything I said

proves I am vile.
 [KREON *enters from the entrance to the right.*
 He is accompanied by men who gather around
 OEDIPUS.]
Kreon: I have not come to mock you, Oedipus; I have
not come to blame you for the past.
 [*To attendants*]
You men, standing there, if you have no respect for human dignity,
at least revere the master of life,
the all-seeing sun whose light nourishes 1850
every living thing on earth.
Come, cover this cursed, naked, holy thing, hide him
from the earth and the sacred rain and the light,
you powers who cringe from his touch.
Take him. Do it now. Be reverent.
Only his family should see and hear his grief.
Their grief.
Oedipus: I beg you, Kreon, if you love the gods,
grant me what I ask.
I have been vile to you, worse than vile. 1860
I have hurt you, terribly, and yet
you have treated me with kindness, with nobility.
You have calmed my fear, you did not turn away from me.
Do what I ask. Do it for yourself, not for me.
Kreon: What do you want from me, Oedipus?
Oedipus: Drive me out of Thebes, do it now, now—
drive me someplace where no man can speak to me,
where no man can see me any more.
Kreon: Believe me, Oedipus, I would have done it long ago.
But I refuse to act until I know precisely what the god desires. 1870
Oedipus: Apollo has revealed what he desires.
 Everything is clear.
I killed my father, I am polluted and unclean.
I must die.
Kreon: That is what the god commanded, Oedipus.
But there are no precedents for what has happened.
We need to *know* before we act.
Oedipus: Do you care so much for me, enough to ask Apollo?
For *me*, Oedipus?
Kreon: Now even you will trust the god, I think.
Oedipus: I will. And I turn to you, I implore you, Kreon— 1880
the woman lying dead inside, your sister,
give her whatever burial you think best.
 As for me,
never let this city of my fathers see me here in Thebes.
Let me go and live on the mountain, on Kithairon—the mountain
my parents intended for my grave.
Let me die the way they wanted me to die: slowly, alone—
die *their* way.
And yet this much I know—
 no sickness, 1890
no ordinary, natural death is mine.
I have been saved, preserved, kept alive
for some strnge fate, for something far more awful still.

When that thing comes, let it take me
where it will.
 |OEDIPUS *turns, looking for something,*
 waiting|
As for my sons, Kreon,
they are grown men, they can look out for themselves.
But my daughters, those two poor girls of mine,
who have never left their home before, never left their
 father's side,
who ate at my side every day, who shared whatever was
 mine, 1900
I beg you, Kreon,
care for them, love them.
But more than anything, Kreon,
I want to touch them,
 |He *begins to lift his hands*|
let me touch them with these hands of mine,
let them come to me so we can grieve together.
My noble lord, if only I could touch them with my hands,
they would still be mine just as they were
when I had eyes that could still see.
 |*Oedipus' two small daughters are brought out*
 of the palace|
O gods, gods, is it possible? Do I hear 1910
my two daughters crying? Has Kreon pitied me and
 brought me
what I love more than my life—
my daughters?
Kreon: I brought them to you, knowing how much you
 love them, Oedipus
knowing the joy you would feel if they were here.
Oedipus: May the gods who watch over the path of your
 life, Kreon,
prove kinder to you than they were to me.
Where are you, children?
Come, come to your brother's hands—
 |*Taking his daughters into his arms*|
his mother was your mother, too, 1920
come to these hands which made these eyes, bright clear
 eyes once,
sockets seeing nothing, the eyes
of the man who fathered you. Look . . . your father's eyes,
your father—
who knew nothing until now, saw nothing until now, and
 became
the husband of the woman who gave him birth.
 I weep for you
when I think how men will treat you, how bitter your lives
 will be.
What festivals will you attend, whose homes will you visit
and not be assailed by whispers, and people's stares? 1930
Where will you go and not leave in tears?
And when the time comes for you to marry,
what men will take you as their brides, and risk the
 shame of marrying
the daughters of Oedipus?
What sorrow will not be yours?
Your father killed his father, made love
to the woman who gave birth to him. And he fathered
 you
in the same place where he was fathered.

That is what you will hear; that is what they will say.
Who will marry you then? You will never marry, 1940
but grow hard and dry like wheat so far beyond harvest
that the wind blows its white flakes into the winter sky.
Oh Kreon,
now you are the only father my daughters have.
Iokaste and I, their parents, are lost to them forever.
These poor girls are yours. Your blood.
Don't let them wander all their lives,
begging, alone, unmarried, helpless.
Don't let them suffer as their father has. Pity them,
 Kreon,
pity these girls so young and helpless except for you. 1950
Promise me this. Noble Kreon,
touch me with your hand, give me a sign.
 |KREON *takes his hands*|
 Daughters,
daughters, if you were older, if you could understand,
there is so much more I would say to you.
But for now, I give you this prayer—
 Live,
live your lives, live each day as best you can,
may your lives be happier than your father's was.
Kreon: No more grief. Come in. 1960
Oedipus: I must. But obedience comes hard.
Kreon: Everything has its time.
Oedipus: First, promise me this.
Kreon: Name it.
Oedipus: Banish me from Thebes.
Kreon: I cannot. Ask the gods for that.
Oedipus: The gods hate me.
Kreon: Then you will have your wish.
Oedipus: You promise?
Kreon: I say only what I mean. 1970
Oedipus: Then lead me in.
 |OEDIPUS *reaches out and touches his*
 daughters, trying to take them with him|
Kreon: Oedipus, come with me. Let your daughters go.
 Come.
Oedipus: No. You will not take my daughters. I forbid it.
Kreon: You *forbid* me?
You have no power anymore.
All the great power you once had is gone,
gone forever.
 |T*he* CHORUS *turn to face the audience.*
 KREON *leads* OEDIPUS *toward the palace.*
 His daughters follow. He moves slowly, and
 disappears into the palace as the CHORUS
 ends.|
Chorus: O citizens of Thebes, this is Oedipus,
who solved the famous riddle, who held more power
 than any mortal.
See what he is: all men gazed on his fortunate life, 1980
all men envied him, but look at him, look.
All he had, all this man was,
pulled down and swallowed by the storm of his own life,
and by the god.
Keep your eyes on that last day, on your dying.
Happiness and peace, they were not yours
unless at death you can look back on your life and say
I lived, I did not suffer.

Medea

Euripides

Euripides was the least popular of the Athenian dramatists, because he questioned the morality of many of the legends surrounding the accepted religion. His sympathetic treatment of women is exemplified in the *Medea*, where the heroine takes bitter revenge on her husband for his unfaithfulness.

CHARACTERS

Jason, hero of the Argo, now in exile
Medea, a princess of Kolchis, wife of Jason
Attendant
Two sons
Choragos, leader of the Chorus
Chorus
Messenger

The scene is outside the house of Medea, Jason, and their children.

[JASON *enters.*]

Jason: I have come at your bidding, Medea. For although you are full of hatred for me, this small favor I will grant you: I will listen to you, my lady, and hear what new favor you are asking.

Medea: Jason, I beg your forgiveness for what I have said! Surely you can afford to forgive my bad temper: after all, there has been much love between us! I have reasoned with myself and reproached myself. 'Poor fool,' I said, 'Why am I so distraught? Why am I so bitter against all good advice, why am I so angry at the rulers of this country, and my husband as well, who does the best he can for me in marrying a royal princess, and in having royal children, who will be brothers to my own? Why not stop complaining? What is wrong with me, when the gods are being so generous? Don't I have my children to consider? Don't I realize that we are exiles after all, and in need of friends?' . . . And when I had thought all this over, Jason, I saw how foolish I'd been, and how silly my anger. So now I agree with you. I think you are well advised in taking this new wife; and I was mad. I should have helped you in your plans, I should have helped arrange the wedding. I should have stood by the wedding bed and been happy to wait on your bride. But we women are—well, I shan't say entirely worthless, but we are what we are. And you men shouldn't stoop to our level: you shouldn't reply to our folly with folly. I give in. I admit I was wrong. I have thought better of it all. . . .

[*She turns toward the house.*]

Come, come, my children, come out from the house, come and greet your father, and then say good-bye to him. Give up your anger, as your mother does; be friends with him again, be reconciled!

[*The* ATTENDANT *enters wtih the* CHILDREN.]

We have made peace now; our bitterness is gone. Take his right hand . . . O God: I can't help thinking of the things that lie dark and hidden in the future! . . . My children, hold out your arms—the way one holds them in farewell after a long, long life . . . I am close to tears, my children! I am full of fear! I have ended my quarrel with your father at last, and look! My eyes are full of tears.

Choragos: And our eyes too are filling with tears. O, do not let disasters worse than the present descend on you!

Jason: I approve of your conduct, Medea; not that I blame you for anything in the past. It is natural for a woman to be furious with her husband when he begins to have other affairs. But now your heart has grown more sensible, and your mind is changed for the better; you are behaving like a woman of sense. And of you, my sons, your father will take good care, and make full provision, with the help of God. And I trust that in due time you with your brothers will be among the leading men in Corinth. All you need to do is grow up, my sons; and as for your future, you may leave it safely in the hands of your father, and of those among the gods who love him. I want to see you when you've grown to be men, tall and strong, towering over my enemies! . . . Medea, why are your eyes wet with tears? Why are your cheeks so pale? Why are you turning away? Don't these happy words of mine make you happy?

Medea: It is nothing. I was only thinking about these children.

Jason: Take heart, then. I shall look after them well.

Medea: I will, Jason. It is not that I don't trust you. Women are weak; and tears come easily to them.

Jason: But why should you feel disturbed about the children?

Medea: I gave birth to them, Jason. And when you prayed that they might live long, my heart filled with sorrow to think that all these things must happen . . . Well now: I have told you some of the things I called you here to tell you; now let me tell you the rest. Since the ruler of this land has resolved to banish me, and since I am considered an enemy, I know it will be best for me not to stand in your way, or in the way of the King, by living here. I am going forth from this land into exile. But these children—O let them feel that you are protecting them, and beg of Kreon not to banish them!

Jason: I doubt whether I can persuade him; still, I will try.

Medea: Or at least ask your wife to beg her father to do this, and give the children reprieve from exile.

Jason: I will try; and with her I think I shall succeed.

Medea: She's a woman, after all: and like all other women. And I will help you in this matter; I will send the children to her with gifts far more exquisite, I am sure, than any now to be found among men—a finely woven dress and a diadem of chased gold. There: let one of the servants go and bring me these lovely ornaments.

[*One of the* ATTENDANTS *goes into the house.*]

And she'll be happy not in one way, but a thousand! With so splendid a man as you to share her bed, and with this marvelous gown as well, which once the Sun God Helios himself, my father's father, gave his descendants.

[*The* ATTENDANT *returns with the poisoned dress and diadem.*]

There, my children, take these wedding presents in your hands and take them as an offering to the royal princess, the lucky bride; give them to her: they are not gifts to be scorned.

Jason: But why do you give them away so rashly, Medea?

Do you think the royal palace is lacking in dresses, or in gold? Keep them. Don't give them away. If my wife really loves me, I am sure she values me more highly than gold.

Medea: No; don't say that, Jason. For I have heard it said that gifts can persuade even the gods; and men are governed more by gold than by words! Luck has fallen on your bride, and the gods have blessed her fortune. She is young: she's a princess. Yet I'd give not only gold but my life to save my children from exile. Enter that rich palace together, children, and pray to your father's new bride; pray to my mistress, and beg her to save you from banishment. Present this garment to her: and above all let her take the gift from you with her own hands. Go: don't linger. And may you succeed, and bring back to your mother the good news for which she longs!

[*Exit* JASON, *the* ATTENDANT, *and the* CHILDREN *bearing the poisoned gifts.*]

Chorus: No hope now remains for the children's lives!

[Strophe 1

No, none. Even now they are moving toward death;
The luckless bride will accept the gown that will kill her,
And take the golden crown, and hold it
In her hand, and over her golden head will
Lift the garment of Hell!

The grace and glitter of gold will enchant her:

[Antistrophe 1

She will put on the golden robe and wear
The golden crown: and deck herself as the bride
Of Death. And thus, pitiful girl,
Will fall in the trap: will fall and perish.
She will never escape!

You likewise, O miserable groom, [Strophe 2
Who planned a royal wedding ceremony,
Do not see the doom you are bringing
Upon your sons: and the terrible death
Now lying in wait for your bride. Pity
Upon you! O, how you are fallen!

And I weep for you too, Medea, [Antistrophe 2
O mother who are killing your sons,
Killing in revenge for the loss
Of your love: you whom your lover Jason
Now has deserted and betrayed
To love and marry another mistress!

[*Enter* ATTENDANT *with the* CHILDREN.]

Attendant: My lady, your children are reprieved from exile. The royal bride was delighted to receive your gifts with her own hands. And there is peace between her and your children . . . Medea! Why are you so distraught at this lucky moment? Why are you turning your head away? Are you not happy to hear this news, my lady?

Medea: Oh, I am lost!

Attendant: That cry does not suit the news I have brought you, surely!

Medea: I am lost! I am lost!

Attendant: Have I told you of some disaster, without knowing it? Was I wrong in thinking that my news was good?

Medea: You have said what you have said: I do not wish to blame you.

Attendant: Then why are you so disturbed? Why are you weeping?

Medea: Oh, my old friend, I can't help weeping. It was I, it was I and the gods, who planned these things so badly.

Attendant: Take heart, Medea. Your sons will bring you back to your home some day.

Medea: And I'll bring others back to their homes, long before that happens!

Attendant: And often before this, mothers have been parted from their sons. Bear your troubles, Medea, as all mortals must bear them.

Medea: I will, I will. Go back into the house; and plan your daily work for the children.

[*The* ATTENDANT *goes into the house, and* MEDEA *turns to her* CHILDREN.]

O my children, my children, you will still have a city, you will still have a home where you can dwell forever, far away from me, far forever from your mother! But I am doomed to go in exile to another land, before I can see you grow up and be happy, before I can take pride in you, before I can wait on your brides and make your marriage beds, or hold the torch at your wedding ceremony! What a victim I am of my own self-will! It was all in vain, my children, that I reared you! It was all in vain that I grew weary and worn, and suffered the anguish and pangs of childbirth! Oh pity me! Once I had great hopes for you; I had hopes that you'd look after me in my old age, and that you'd lovingly deck my body with your own hands when I died, as all men hope and desire. But now my lovely dreams are over. I shall love you both. I shall spend my life in grief and solitude. And never again will you see your mother with your own dear eyes; now you will pass into another kind of life. Ah, my dear children, why do you look at me like this? Why are you smiling your sweet little smiles at me? O children, what can I do? My heart gives way when I see the joy shining in my children's eyes. O women, I cannot do it! . . . Farewell to all my plans! I will take my babies away with me from this land. Why should I hurt their father by hurting them? Why should I hurt myself doubly? No: I cannot do it. I shall say good-bye to my plans . . . And yet—O, what is wrong with me? Am I willing to see my enemies go unpunished? Am I willing to be insulted and laughed at? I shall follow this thing to the end. How weak I am! How weak to let my heart be touched by these soft sentiments! Go back into the house, my children . . . And if anyone prefers not to witness my sacrifice, let him do as he wishes! My poor heart—do not do this thing! My poor heart, have pity on them, let them go, the little children! They'll bring cheer to you, if you let them live with you in exile! . . . No, by all the avenging Furies, this shall not be! Never shall I surrender my children to the insolence and mockery of my enemies! It is settled. I have made my decision. And since they must die, it is their mother who must kill them. Now there is no escape for the young bride! Already the crown is on her head; already the dress is hanging from her body; the royal bride, the princess is dying! This I know. And now—since I am about to follow a dreadful path, and am sending them on a path still more terrible—I will simply say this: I want to speak to my children.

[*She calls and the* CHILDREN *come back;*

she takes them in her arms.]

Come, come, give me your hands, my babies, let your mother kiss you both. O dear little hands, dear little lips: how I have loved them! How fresh and young your eyes look! How straight you stand! I wish you joy with all my heart; but not here; not in this land. All that you had here your father has stolen from you. . . . How good it is to hold you, to feel your soft young cheeks, the warm young sweetness of your breath. . . . Go now: leave me. I cannot look at you any longer . . . I am overcome. . . .

[The CHILDREN *go into the house again.*]

Now at last I understand the full evil of what I have planned. At last I see how my passion is stronger than my reason: passion, which brings the worst of woes to mortal man.

[*She goes out at the right, toward the palace.*]

Choragos: Many a time before
I have gone through subtler reasoning,
Many times I have faced graver questioning
Than any woman should ever have to face:
But we women have a goddess to help us, too,
And lead us into wisdom.
Not all of us: perhaps not many;
But some women there are who are capable of wisdom.
And I say this: that those who have never
Known the fullness of life and never had children,
Are happier far than those who are parents.
For the childless, who never discover whether
Their children grow up to be a cause for joy or for pain,
Are spared many troubles:
While those who know in their houses
The sweet presence of children—
We have seen how their lives are wasted by worry.
First they fret about how they shall raise them
Properly; and then how to leave them enough
Money to live on; and then they continue
To worry about whether all this labor
Has gone into children that will turn out well
Or turn out ill: and the question remains unanswered.
And let me tell of one more trouble,
The last of all, and common to all mortals:
For suppose you have found enough
For them to live on, and suppose
You have seen them grow up and turn out well;
Still, if fate so decrees it, Death
Will come and tear away your children!
What use is it, then, that the gods
For the sake of children
Should pile on us mortals,
After all other griefs,
This grief for lost children? This grief
Greater by far than any?

[MEDEA *comes out of the house.*]

Medea: I have been waiting in suspense, ladies; I have waited long to learn how things will happen . . . Look! I see one of Jason's servants coming toward us; he is panting; and the bearer of news, I think; of bad news . . .

[A MESSENGER *rushes in.*]

Messenger: Fly, Medea, fly! You have done a terrible thing, a thing breaking all human laws: fly, and take with you a ship for the seas, or a chariot for the plains!

Medea: Why? What reason have you for asking me to fly?

Messenger: She lies dead! The royal princess, and her father Kreon too! They have died: they have been slain by your poisons!

Medea: You bring me blessed news! Now and from now on I count you among my friends, my benefactors!

Messenger: What! Are you insane? Are you mad, Medea? You have done an outrage to the royal house: does it make you happy to hear it? Can you hear of this dreadful thing without horror?

Medea: I too have words to say in reply to yours. Do not be impatient, my friend. Tell me: how did they die? You will make me doubly happy if you say they died in anguish!

Messenger: When those two children, your own babies, Medea, came with their father and entered the palace of the bride, it gave joy to all of us, the servants who have suffered with you; for instantly all through the house we whispered that you had made up your quarrel with your husband. One of us kissed your children's hands, and another their golden hair, and I myself was so overjoyed that I followed them in person to the women's chambers. And there stood our mistress, whom we now serve instead of you; and she kept her eyes fixed longingly on Jason. When she caught sight of your children, she covered up her eyes, and her face grew pale, and she turned away, filled with petulance at their coming. But your husband tried to soothe the bride's ill humor, and said: 'Do not look so unkindly at your friends! Do not feel angry: turn your head to me once more, and think of your husband's friends as your own friends! Accept these gifts, and do this for my sake: beg of your father not to let these children be exiled!' And then, when she saw the dress, she grew mild and yielded, and gave in to her husband. And before the father and the children had gone far from her rooms, she took the gorgeous robe and put it on; and she put the golden crown on her curly head, and arranged her hair in the shining mirror, smiling as she saw herself reflected. And then she rose from her chair and walked across the room, stepping softly and delicately on her small white feet, filled with delight at the gift, and glancing again and again at the delicate turn of her ankles. And after that it was a thing of horror we saw. For suddenly her face changed its color, and she staggered back, and began to tremble as she ran, and reached a chair just as she was about to fall to the ground. An old woman servant, thinking no doubt that this was some kind of seizure, a fit sent by Pan, or some other god, cried out a prayer: and then, as she prayed, she saw the flakes of foam flow from her mouth, and her eyeballs rolling, and the blood fade from her face. And then it was a different prayer she uttered, a terrible scream, and one of the women ran to the house of the King, and another to the newly wedded groom to tell him what had happened to the bride; and the whole house echoed as they ran to and fro.

Let me tell you, time enough for a man to walk two hundred yards passed before the poor lady awoke from her trance, with a dreadful scream, and opened her eyes again. A twofold torment was creeping over her. The golden diadem on her head was sending forth a violent stream of flame, and the finely woven dress which your

children gave her was beginning to eat into the poor girl's snowy soft flesh. And she leapt from her chair, all on fire, and started to run, shaking her head to and fro, trying to shake off the diadem; but the gold still clung firmly, and as she shook her hair the fire blazed forth with double fury. And then she sank to the ground, helpless, overcome; and past all recognition except to the eye of a father—for her eyes had lost their normal expression, and the familiar look had fled from her face, and from the top of her head a mingled stream of blood and fire was pouring. And it was like the drops falling from the bark of a pine tree when the flesh dropped away from her bones, torn loose by the secret fangs of the poison. And terror kept all of us from touching the corpse; for we were warned by what had happened.

But then her poor father, who knew nothing of her death, came suddenly into the house and stumbled over her body, and cried out as he folded his arms about her, and kissed her, and said: "O my child, my poor child, which of the gods has so cruelly killed you? Who has robbed me of you, who am old and close to the grave? O my child, let me die with you!" And he grew silent and tried to rise to his feet again, but found himself fastened to the finely spun dress, like vine clinging to a laurel bough, and there was a fearful struggle. And still he tried to lift his knees, and she writhed and clung to him; and as he tugged, he tore the withered flesh from his bones. And at last he could no longer master the pain, and surrendered, and gave up the ghost. So there they are lying together: and it is a sight to send us weeping. . . .

As for you, Medea, I will say nothing of your own problems: you yourself must discover an escape from punishment. I think, and I have always thought, the life of men is a shadow; and I say without fear that those who are wisest among all men, and probe most deeply into the causes of things—they are the ones who suffer most deeply! For, believe me, no man among mortals is happy; if wealth comes to a man, he may be luckier than the rest; but happy—never.

[Exit MESSENGER.]

Choragos: It seems that heaven has sent, today, a heavy load of evils upon Jason; and he deserves them. Alas, poor girl, poor daughter of Kreon! I pity you and your anguish; and now you are gone, all because of your wedding with Jason: gone away to the halls of Hades!

Medea: Women, the deed shall be done! Swiftly I will go and kill my children, and then leave the land: and not delay nor let them be killed by a crueler hand. For die they must in any case: and if they must be slain, it is I, their mother who gave them life, who must slay them! O my heart, my heart, arm yourself in steel! Do not shrink back from this hideous thing which has to be done! Come, my hand, and seize the sword, take it and step forward to the place where my life's true sorrow begins! Do not be a coward . . . do not think of the children, and how dear they are to you who are their mother! For one brief day, Medea, forget your children; and then forever after you may mourn; for though you will kill them, they were dear to you, very dear . . . I am a miserable woman!

[With a cry MEDEA rushes into the house.]

Chorus: O Earth, and the all-brightening [Strophe

Beam of the Sun, look, look
Upon this lost one, shine upon
This pitiful woman before she raises
Her hand in murder against her sons!
For lo! these are the offspring
Of thine own golden seed, and I fear
That divine blood may now be shed by men!
O Light flung forth by Zeus,
O heavenly Light,
Hold back her hand,
Restrain her, and drive out
This dark demoniac fury from the house!

Was it all in vain, Medea, [Antistrophe
What you suffered in bearing your sons?
Was it utterly in vain
You bore the babes you loved, after you left
Behind you that dark passage through the straits
And past the perilous rocks, the blue Symplegades?
Wretched woman, how has it happened
That your soul is torn by anger
And darkened by the shadow of death?
Heavy will be the price
To pay for kindred blood staining the earth!
Heavy the woe sent down by heaven
On the house of the killer for such a crime!

[A cry is heard from the CHILDREN within.]

Choragos: Listen! Do you hear? Do you hear the children crying?
Hate-hardened heart! O woman born for evil!

[Crying within.]

First Son: What can I do? How can I run from mother's hands?

[Crying within.]

Second Son: I don't know! We are lost, we are lost, brother!

Choragos: Shall I enter the house? Oh surely I must help! I must save these children from murder!

[Within.]

First Son: Help, in the name of heaven! We need your help!

[Within.]

Second Son: Now, now it's coming closer! The sword is falling!

Choragos: Oh, you must be made of stone or steel,
To kill the fruit of your womb
With your own hands, unhappy woman!
I have heard of only one,
Of all the women who ever lived, who laid
Her hand upon her children: it was Ino,
Who was driven insane by the Gods
When the wife of Zeus sent her wandering from her home.
And wild with grief at killing her children,
She flung herself from the sea-battered cliff
And plunged into the sea, and in the sea
Rejoined her two dead children.
Can anything so dreadful ever happen again?
Woe flows forth from the bed of a woman
Whom fate has touched with trouble!
Great is the grief that they have brought on men!

[Enter JASON with his ATTENDANTS.]

Jason: Ladies, you have been sitting near this house! Tell

me! Is Medea, is the woman who did this frightful thing, still in the house? Or has she fled already? O believe me, she'll have to hide deep under the earth, or fly on wings through the sky, if she hopes to escape the vengeance of the royal house! Does she dream, after killing the rulers of the land, that she herself can escape from these halls unpunished? But I am thinking of her far less than of her children; for she herself will duly suffer at the hands of those she wronged. Ladies, I have come to save the lives of my boys, lest the royal house should harm them in revenge for this vile thing done by their mother.

Choragos: O Jason, you do not yet know the full depth of your misery, or you would not have spoken those words!

Jason: What do you mean? Is she planning to kill me also?

Choragos: Your boys are dead; dead at their mother's hand.

Jason: What have you said, woman? You are destroying me!

Choragos: You may be sure of this: your children are dead.

Jason: Oh where did she kill them? Was it here, or in the house?

Choragos: Open the doors, and you will see their murdered bodies!

Jason: Open the doors! Unlock the bolts! Undo the fastenings! And let me see this twofold horror! Let me see my murdered boys! Let me look on her whom I shall kill in vengeance!

> [His ATTENDANTS rush to the door. MEDEA appears above the house in a chariot drawn by dragons. The dead CHILDREN are at her side.]

Medea: Why do you batter at the doors? Why do you shake these bolts, in quest of the dead and their murderess? You may cease your trouble, Jason; and if there is anything you want to say, then say it! Never again shall you lay your hand on me; so swift is the chariot which my father's father gave me, the Sun God Helios, to save me from my foes!

Jason: Horrible woman! Now you are utterly loathed by the gods, and by me, and by all mankind. You had the heart to stab your children; you, their own mother, and to leave me childless; you have done these fearful things, and still you dare to gaze as ever at the sun and the earth! O I wish you were dead! Now at last I see clearly what I did not see on the day I brought you, loaded with doom, from your barbarous home to live in Hellas—a traitress to your father and your native land. On me too the gods have hurled the curse which has haunted you. For you killed your own brother at his fireside, and then came aboard our beautiful ship the Argo. And that was how it started. And then you married me, and slept with me, and out of your passion bore me children; and now, out of your passion, you have killed them. There is no woman in all of Greece who would dare to do this. And yet I passed them over, and chose you instead; and chose to marry my own doom! I married not a woman, but a monster, wilder of heart than Scylla[1] in the Tyrrhenian Sea!

But even if I hurled a thousand insults at you, Medea, I know I could not wound you: your heart is so hard, so utterly hard. Go, you wicked sorceress; I see the stains of your children's blood upon you! Go; all that is left to me now is to mourn. I shall never lie beside my newly wedded love; I shall never have my sons, whom I bred and brought up, alive beside me to say a last farewell! I have lost them forever, and my life is ended.

Medea: O Jason, to these words of yours I could make a long reply; but Zeus, the father, himself well knows all that I did for you, and what you did to me. Destiny has refused to let you scorn my love, and lead a life of pleasure, and mock at me; nor were the royal princess and the matchmaker Kreon destined to drive me into exile, and then go untormented! Call me a monster if you wish; call me the Scylla in the Tyrrhenian Sea. For now I have torn your heart: and this indeed was destined, Jason!

Jason: You too must feel the pain; you will share my grief, Medea.

Medea: Yes; but the pain is milder, since you cannot mock me!

Jason: O my sons, it was an unspeakable mother who bore you!

Medea: O my sons, it was really your father who destroyed you!

Jason: But I tell you: it was not my hand that slew them!

Medea: No; but your insolence, and your new wedding slew them!

Jason: And you thought this wedding cause enough to kill them?

Medea: And you think the anguish of love is trifling for a woman?

Jason: Yes, if her heart is sound: but yours makes all things evil.

Medea: Your sons are dead, Jason! Does it hurt you when I say this?

Jason: They will live on, Medea, by bringing suffering on you.

Medea: The gods are well aware who caused all this suffering.

Jason: Yes, the gods are well aware. They know your brutal heart.

Medea: You too are brutal. And I am sick of your bitter words!

Jason: And I am sick of yours. Oh Medea, it will be easy to leave you.

Medea: Easy! Yes! And for me too! What, then, do you want?

Jason: Give me those bodies to bury, and to mourn.

Medea: Never! I will bury them myself. I will bring them myself to Hera's[2] temple, which hangs over the Cape, where none of their enemies can insult them, and where none can defile their graves! And in this land of Corinth I shall ordain a holy feast and sacrifice, forever after, to atone for this guilt of killing. And I shall go myself to Athens, to live in the house of Aegeus, the son of Pandion. And I predict that you, as you deserve, will die without honor; and your head crushed by a beam of the shattered Argo; and then you will know the bitter end of all my love for you!

1. A female monster who lived on a rock opposite the whirlpool Charybdis. Sailors trying to avoid one were in danger of falling prey to the other.

2. Wife of Zeus.

Jason: May the avenging fury of our sons destroy you! May Justice destroy you, and repay blood with blood!
Medea: What god, what heavenly power would listen to you? To a breaker of oaths? To a betrayer of love?
Jason: Oh, you are vile! You sorceress! Murderess!
Medea: Go to your house. Go, and bury your bride.
Jason: Yes, I shall go; and mourn for my murdered sons.
Medea: Wait; do not weep yet, Jason! Wait till age has sharpened your grief!
Jason: Oh my sons, whom I loved! My sons!
Medea: It was I, not you, who truly loved them.
Jason: You say you loved them; yet you killed them.
Medea: Yes, I killed them to make you suffer.
Jason: Medea, I only long to kiss them one last time.
Medea: Now, now, you long to kiss them! Now you long to say farewell: but before, you cast them from you!
Jason: Medea, I beg you, let me touch the little bodies of my boys!
Medea: No. Never. You speak in vain.
Jason: O Zeus, high in your heaven, have you heard these words? Have you heard this unutterable cruelty? Have you heard this woman, this monster, this murderess? And now I shall do the only thing I still can do! Yes! I shall cry, I shall cry aloud to heaven, and call on the gods to witness how you killed my sons, and refused to let me kiss them farewell, or touch them, or give them burial! Oh, I'd rather never have seen them live, than have seen them slaughtered so!

[*The chariot carries* MEDEA *away.*]

Choragos: Many, many are the things
That Zeus determines, high on the Olympian throne;
Many the things beyond men's understanding
That the gods achieve, and bring to pass.
Many the things we think will happen,
Yet never happen.
And many the things we thought could never be,
Yet the gods contrive.
Such things have happened on this day,
And in this place!

Apology

Plato

Socrates was tried in Athens in 399 BC on vague charges of corruption of the young and impropriety toward the gods. This was as a result of the general distrust in which he was held because of his relentless questioning. Socrates admitted that he intended to cause unrest, as the gods had commanded him to seek the truth. The *Apology* is his defense, in court, of his philosophy.

CHARACTERS

Socrates
Meletus

The scene is the Court of Justice.

Socrates: I cannot tell what impression my accusers have made upon you, Athenians. For my own part, I know that

they nearly made me forget who I was, so persuasive were they; and yet they have scarcely uttered one single word of truth. But of all their many falsehoods, the one which astonished me most was when they said that I was a clever speaker, and that you must be careful not to let me deceive you. I thought that it was most shameless of them not to be ashamed to talk in that way; for as soon as I open my mouth they will be refuted, and I shall prove that I am not a clever speaker in any way at all—unless, indeed, by a clever speaker they mean a man who speaks the truth. If that is their meaning, I agree with them that I am an orator not to be compared with them. My accusers, then I repeat, have said little or nothing that is true; but from me you shall hear the whole truth. Certainly you will not hear an elaborate speech, Athenians, dressed up, like theirs, with words and phrases. I will say to you what I have to say, without preparation, and in the words which come first, for I believe that my cause is just; so let none of you expect anything else. Indeed, my friends, it would hardly be seemly for me, at my age, to come before you like a young man with his specious phrases. But there is one thing, Athenians, which I do most earnestly beg and entreat of you. Do not be surprised and do not interrupt with shouts if in my defense I speak in the same way that I am accustomed to speak in the market-place, at the tables of the money-changers, where many of you have heard me, and elsewhere. The truth is this, I am more than seventy years old, and this is the first time that I have ever come before a law-court; so your manner of speech here is quite strange to me. If I had been really a stranger, you would have forgiven me for speaking in the language and the manner of my native country; and so now I ask you to grant me what I think I have a right to claim. Never mind the manner of my speech—it may be better or it may be worse—give your whole attention to the question, Is what I say just, or is it not? That is what makes a good judge, as speaking the truth makes a good orator.

I have to defend myself, Athenians, first against the old false accusations of my old accusers, and then against the later ones of my present accusers. For many men have been accusing me to you, and for very many years, who have not uttered a word of truth; and I fear them more than I fear Anytus and his associates, formidable as they are. But, my friends, those others are still more formidable; for they got hold of most of you when you were children, and they have been more persistent in accusing me untruthfully and have persuaded you that there is a certain Socrates, a wise man, who speculates about the heavens, and who investigates things that are beneath the earth, and who can make the worse argument appear the stronger. These men, Athenians, who spread abroad this report are the accusers whom I fear; for their hearers think that persons who pursue such inquiries never believe in the gods. Then they are many, and their attacks have been going on for a long time, and they spoke to you when you were at the age most readily to believe them, for you were all young, and many of you were children, and there was no one to answer them when they attacked me. And the most unreasonable thing of all is that I do not even know their names: I cannot tell you who they are except when one happens to be a comic poet. But all the rest who have persuaded you, from

motives of resentment and prejudice, and sometimes, it may be, from conviction, are hardest to cope with. For I cannot call any one of them forward in court to cross-examine him. I have, as it were, simply to spar with shadows in my defense, and to put questions which there is no one to answer. I ask you, therefore, to believe that, as I say, I have been attacked by two kinds of accusers—first, by Meletus and his associates, and, then, by those older ones of whom I have spoken. And, with your leave, I will defend myself first against my old accusers; for you heard their accusations first, and they were much more forceful than my present accusers are.

Well, I must make my defense, Athenians, and try in the short time allowed me to remove the prejudice which you have been so long a time acquiring. I hope that I may manage to do this, if it be good for you and for me, and that my defense may be successful; but I am quite aware of the nature of my task, and I know that it is a difficult one. Be the outcome, however, as is pleasing to God, I must obey the law and make my defense.

Let us begin from the beginning, then, and ask what is the accusation which has given rise to the prejudice against me, which was what Meletus relied on when he brought his indictment. What is the prejudice which my enemies have been spreading about me? I must assume that they are formally accusing me, and read their indictment. It would run somewhat in this fashion: "Socrates is a wrongdoer, who meddles with inquiries into things beneath the earth and in the heavens, and who makes the worse argument appear the stronger, and who teaches others these same things." That is what they say; and in the comedy of Aristophanes[1] you yourselves saw a man called Socrates swinging round in a basket and saying that he walked the air, and sputtering a great deal of nonsense about matters of which I understand nothing, either more or less. I do not mean to disparage that kind of knowledge if there is any one who is wise about these matters. I trust Meletus may never be able to prosecute me for that. But the truth is, Athenians, I have nothing to do with these matters, and almost all of you are yourselves my witnesses of this. I beg all of you who have ever heard me discussing, and they are many, to inform your neighbors and tell them if any of you have ever heard me discussing such matters, either more or less. That will show you that the other common statements about me are as false as this one.

But the fact is that not one of these is true. And if you have heard that I undertake to educate men, and make money by so doing, that is not true either, though I think that it would be a fine thing to be able to educate men, as Gorgias of Leontini, and Prodicus of Keos, and Hippias of Elis do. For each of them, my friends, can go into any city, and persuade the young men to leave the society of their fellow citizens, with any of whom they might associate for nothing, and to be only too glad to be allowed to pay money for the privilege of associating with themselves. And I believe that there is another wise man from Paros residing in Athens at this moment. I happened to meet Kallias, the son of Hipponicus, a man who has spent more money on sophists than every one else put together. So I said to him (he has two sons), Kallias, if your two sons had been foals or calves, we could have hired a trainer for them who would have made them perfect in the virtue which belongs to their nature. He would have been either a groom or a farmer. But whom do you intend to take to train them, seeing that they are men? Who understands the virtue which belongs to men and to citizens? I suppose that you must have thought of this, because of your sons. Is there such a person, said I, or not? Certainly there is, he replied. Who is he, said I, and where does he come from, and what is his fee? Evenus, Socrates, he replied, from Paros, five minae. Then I thought that Evenus was a fortunate person if he really understood this art and could teach so cleverly. If I had possessed knowledge of that kind, I should have been conceited and disdainful. But, Athenians, the truth is that I do not possess it.

Perhaps some of you may reply: But, Socrates, what is the trouble with you? What has given rise to these prejudices against you? You must have been doing something out of the ordinary. All these rumors and reports of you would never have arisen if you had not been doing something different from other men. So tell us what it is, that we may not give our verdict in the dark. I think that that is a fair question, and I will try to explain to you what it is that has raised these prejudices against me and given me this reputation. Listen, then. Some of you, perhaps, will think that I am joking, but I assure you that I will tell you the whole truth. I have gained this reputation, Athenians, simply by reason of a certain wisdom. But by what kind of wisdom? It is by just that wisdom which is perhaps human wisdom. In that, it may be, I am really wise. But the men of whom I was speaking just now must be wise in a wisdom which is greater than human wisdom, or else I cannot describe it, for certainly I know nothing of it myself, and if any man says that I do, he lies and speaks to arouse prejudice against me. Do not interrupt me with shouts, Athenians, even if you think that I am boasting. What I am going to say is not my own. I will tell you who says it, and he is worthy of your respect. I will bring the god of Delphi to be the witness of my wisdom, if it is wisdom at all, and of its nature. You remember Khaerephon. From youth upwards he was my comrade; and also a partisan of your democracy, sharing your recent exile[2] and returning with you. You remember, too, Khaerephon's character—how impulsive he was in carrying through whatever he took in hand. Once he went to Delphi and ventured to put this question to the oracle—I entreat you again, my friends, not to interrupt me with your shouts—he asked if there was any one who was wiser than I. The priestess answered that there was no one. Khaerephon himself is dead, but his brother here will witness to what I say.

Now see why I tell you this. I am going to explain to you how the prejudice against me has arisen. When I heard of the oracle I began to reflect: What can the god mean by this riddle? I know very well that I am not wise, even in the smallest degree. Then what can he mean by saying that I am the wisest of men? It cannot be that he is

1. *The Clouds.* The basket was satirically assumed to facilitate Socrates' inquiries into things in the heavens.

2. During the totalitarian regime of *The Thirty* which remained in power for eight months (404 BC), five years before the trial.

speaking falsely, for he is a god and cannot lie. For a long time I was at a loss to understand his meaning. Then, very reluctantly, I turned to investigate it in this manner: I went to a man who was reputed to be wise, thinking that there, if anywhere, I should prove the answer wrong, and meaning to point out to the oracle its mistake, and to say, "You said that I was the wisest of men, but this man is wiser than I am." So I examined the man—I need not tell you his name, he was a politician—but this was the result, Athenians. When I conversed with him I came to see that, though a great many persons, and most of all he himself, thought that he was wise, yet he was not wise. Then I tried to prove to him that he was not wise, though he fancied that he was; and by so doing I made him indignant, and many of the bystanders. So when I went away, I thought to myself, "I am wiser than this man: neither of us knows anything that is really worthwhile, but he thinks that he has knowledge when he has not, while I, having no knowledge, do not think that I have. I seem, at any rate, to be a little wiser than he is on this point: I do not think that I know what I do not know." Next I went to another man who was reputed to be still wiser than the last, with exactly the same result. And there again I made him, and many other men, indignant.

Then I went on to one man after another, seeing that I was arousing indignation every day, which caused me much grief and anxiety. Still I thought that I must set the god's command above everything. So I had to go to every man who seemed to possess any knowledge, and investigate the meaning of the oracle. Athenians, I must tell you the truth; by the dog, this was the result of the investigation which I made at the god's bidding: I found that the men whose reputation for wisdom stood highest were nearly the most lacking in it, while others who were looked down on as common people were much more intelligent. Now I must describe to you the wanderings which I undertook, like Heraklean labors, to prove the oracle irrefutable. After the politicians, I went to the poets, tragic, dithyrambic, and others, thinking that there I should find myself manifestly more ignorant than they. So I took up the poems on which I thought that they had spent most pains, and asked them what they meant, hoping at the same time to learn something from them. I am ashamed to tell you the truth, my friends, but I must say it. Almost any one of the bystanders could have talked about the works of these poets better than the poets themselves. So I soon found that it is not by wisdom that the poets create their works, but by a certain natural power and by inspiration, like soothsayers and prophets, who say many fine things, but who understand nothing of what they say. The poets seemed to me to be in a similar situation. And at the same time I perceived that, because of their poetry, they thought that they were the wisest of men in other matters, too, which they were not. So I went away again, thinking that I had the same advantage over the poets that I had over the politicians.

Finally, I went to the artisans, for I knew very well that I possessed no knowledge at all worth speaking of, and I was sure that I should find that they knew many fine things. And in that I was not mistaken. They knew what I did not know, and so far they were wiser than I. But,

Athenians, it seemed to me that the skilled artisans had the same failing as the poets. Each of them believed himself to be extremely wise in matters of the greatest importance because he was skillful in his own art: and this presumption of theirs obscured their real wisdom. So I asked myself, on behalf of the oracle, whether I would choose to remain as I was, without either their wisdom or their ignorance, or to possess both, as they did. And I answered to myself and to the oracle that it was better for me to remain as I was.

From this examination, Athenians, has arisen much fierce and bitter indignation, and from this a great many prejudices about me, and people say that I am "a wise man." For the bystanders always think that I am wise myself in any matter wherein I refute another. But, gentlemen, I believe that the god is really wise, and that by this oracle he meant that human wisdom is worth little or nothing. I do not think that he meant that Socrates was wise. He only made use of my name, and took me as an example, as though he would say to men, "He among you is the wisest who, like Socrates, knows that in truth his wisdom is worth nothing at all." Therefore I still go about testing and examining every man whom I think wise, whether he be a citizen or a stranger, as the god has commanded me: and whenever I find that he is not wise, I point out to him, on the god's behalf, that he is not wise. I am so busy in this pursuit that I have never had leisure to take any part worth mentioning in public matters or to look after my private affairs. I am in great poverty as the result of my service to the god.

Besides this, the young men who follow me about, who are the sons of wealthy persons and have the most leisure, take pleasure in hearing men cross-examined. They often imitate me among themselves; then they try their hands at cross-examining other people. And, I imagine, they find plenty of men who think that they know a great deal when in fact they know little or nothing. Then the persons who are cross-examined get angry with me instead of with themselves, and say that Socrates is an abomination and corrupts the young. When they are asked, "Why, what does he do? what does he teach?" they do not know what to say; but, not to seem at a loss, they repeat the stock charges against all philosophers, and allege that he investigates things in the air and under the earth, and that he teaches people to disbelieve in the gods, and to make the worse argument appear the stronger. For, I suppose, they would not like to confess the truth, which is that they are shown up as ignorant pretenders to knowledge that they do not possess. So they have been filling your ears with their bitter prejudices for a long time, for they are ambitious, energetic, and numerous; and they speak vigorously and persuasively against me. Relying on this, Meletus, Anytus, and Lykon have attacked me. Meletus is indignant with me on the part of the poets, Anytus on the part of the artisans and politicians, and Lykon on the part of the orators. And so, as I said at the beginning, I shall be surprised if I am able, in the short time allowed me for my defense, to remove from your minds this prejudice which has grown so strong. What I have told you, Athenians, is the truth: I neither conceal nor do I suppress anything, small or great. Yet I know that it is just this plainness of

speech which rouses indignation. But that is only a proof that my words are true, and that the prejudice against me, and the causes of it, are what I have said. And whether you investigate them now or hereafter, you will find that they are so.

What I have said must suffice as my defense against the charges of my first accusers. I will try next to defend myself against Meletus, that "good patriot," as he calls himself, and my later accusers. Let us assume that they are a new set of accusers, and read their indictment, as we did in the case of the others. It runs thus. He says that Socrates is a wrongdoer who corrupts the youth, and who does not believe in the gods whom the state believes in, but in other new divinities. Such is the accusation. Let us examine each point in it separately. Meletus says that I do wrong by corrupting the youth. But I say, Athenians, that he is doing wrong, for he is playing a solemn joke by casually bringing men to trial, and pretending to have a solemn interest in matters to which he has never given a moment's thought. Now I will try to prove to you that it is so.

Come here, Meletus. Is it not a fact that you think it very important that the young should be as good as possible?

Meletus: It is.

Socrates: Come then, tell the judges who is it who improves them? You care so much,[3] you must know. You are accusing me, and bringing me to trial, because, as you say, you have discovered that I am the corrupter of the youth. Come now, reveal to the gentlemen who improves them. You see, Meletus, you have nothing to say; you are silent. But don't you think that this is shameful? Is not your silence a conclusive proof of what I say—that you have never cared. Come, tell us, my good man, who makes the young better?

Meletus: The laws.

Socrates: That, my friend, is not my question. What man improves the young, who starts with the knowledge of the laws?

Meletus: The judges here, Socrates.

Socrates: What do you mean, Meletus? Can they educate the young and improve them?

Meletus: Certainly.

Socrates: All of them? or only some of them?

Meletus: All of them.

Socrates: By Hera, that is good news! Such a large supply of benefactors! And do the listeners here improve them, or not?

Meletus: They do.

Socrates: And do the senators?

Meletus: Yes.

Socrates: Well then, Meletus, do the members of the assembly corrupt the young or do they again all improve them?

Meletus: They, too, improve them.

Socrates: Then all the Athenians, apparently, make the young into good men except me, and I alone corrupt them. Is that your meaning?

3. Throughout the following passage Socrates plays on the etymology of the name "Meletus" as meaning "the man who cares."

Meletus: Most certainly; that is my meaning.

Socrates: You have discovered me to be most unfortunate. Now tell me: do you think that the same holds good in the case of horses? Does one man do them harm and every one else improve them? On the contrary, is it not one man only, or a very few—namely, those who are skilled with horses—who can improve them, while the majority of men harm them if they use them and have anything to do with them? Is it not so, Meletus, both with horses and with every other animal? Of course it is, whether you and Anytus say yes or no. The young would certainly be very fortunate if only one man corrupted them, and every one else did them good. The truth is, Meletus, you prove conclusively that you have never thought about the youth in your life. You exhibit your carelessness in not caring for the very matters about which you are prosecuting me.

Now be so good as to tell us, Meletus, is it better to live among good citizens or bad ones? Answer, my friend. I am not asking you a difficult question. Do not the bad harm their associates and the good, good?

Meletus: Yes.

Socrates: Is there any one who would rather be injured than benefited by his companions? Answer, my good sir; you are obliged by the law to answer. Does any one like to be injured?

Meletus: Certainly not.

Socrates: Well then, are you prosecuting me for corrupting the young and making them worse, voluntarily or involuntarily?

Meletus: For doing it voluntarily.

Socrates: What, Meletus? Do you mean to say that you, who are so much younger than I, are yet so much wiser than I that you know that bad citizens always do evil, and that good citizens do good, to those with whom they come in contact, while I am so extraordinarily ignorant as not to know that, if I make any of my companions evil, he will probably injure me in some way, and as to commit this great evil, as you allege, voluntarily? You will not make me believe that, nor anyone else either, I should think. Either I do not corrupt the young at all or if I do I do so involuntarily: so that you are lying in either case. And if I corrupt them involuntarily, the law does not call upon you to prosecute me for an error which is involuntary, but to take me aside privately and reprove and educate me. For, of course, I shall cease from doing wrong involuntarily, as soon as I know that I have been doing wrong. But you avoided associating with me and educating me; instead you bring me up before the court, where the law sends persons, not for education, but for punishment.

The truth is, Athenians, as I said, it is quite clear that Meletus has never cared at all about these matters. However, now tell us, Meletus, how do you say that I corrupt the young? Clearly, according to your indictment, by teaching them not to believe in the gods the state believes in, but other new divinities instead. You mean that I corrupt the young by that teaching, do you not?

Meletus: Yes, most certainy I mean that.

Socrates: Then in the name of these gods of whom we are speaking, explain yourself a little more clearly to me and to these gentlemen here. I cannot understand what you

mean. Do you mean that I teach the young to believe in some gods, but not in the gods of the state? Do you accuse me of teaching them to believe in strange gods? If that is your meaning, I myself believe in some gods, and my crime is not that of complete atheism. Or do you mean that I do not believe in the gods at all myself, and that I teach other people not to believe in them either?

Meletus: I mean that you do not believe in the gods in any way whatever.

Socrates: You amaze me, Meletus! Why do you say that? Do you mean that I believe neither the sun nor the moon to be gods, like other men?

Meletus: I swear he does not, judges; he says that the sun is a stone, and the moon earth.

Socrates: My dear Meletus, do you think that you are prosecuting Anaxagoras? You must have a very poor opinion of these men, and think them illiterate, if you imagine that they do not know that the works of Anaxagoras of Klazomenae are full of these doctrines. And so young men learn these things from me, when they can often buy them in the theatre for a drachma at most, and laugh at Socrates were he to pretend that these doctrines, which are very peculiar doctrines, too, were his own. But please tell me, do you really think that I do not believe in the gods at all?

Meletus: Most certainly I do. You are a complete atheist.

Socrates: No one believes that, Meletus, not even you yourself. It seems to me, Athenians, that Meletus is very insolent and reckless, and that he is prosecuting me simply out of insolence, recklessness and youthful bravado. For he seems to be testing me, by asking me a riddle that has no answer. "Will this wise Socrates," he says to himself, "see that I am joking and contradicting myself? or shall I deceive him and every one else who hears me?" Meletus seems to me to contradict himself in his indictment: it is as if he were to say, "Socrates is a wrongdoer who does not believe in the gods, but who believes in the gods." But this is joking.

Now, my friends, let us see why I think that this is his meaning. Do you answer me, Meletus; and do you, Athenians, remember the request which I made to you at the start, and do not interrupt me with shouts if I talk in my customary manner.

Is there any man, Meletus, who believes in the existence of things pertaining to men and not in the existence of men? Make him answer the question, gentlemen, without these interruptions. Is there any man who believes in the existence of horsemanship and not in the existence of horses? or in flute-playing and not in flute-players? There is not, my friend. If you will not answer, I will tell both you and the judges. But you must answer my next question. Is there any man who believes in the existence of divine things and not in the existence of divinities?

Meletus: There is not.

Socrates: I am very glad that these gentlemen have managed to extract an answer from you. Well then, you say that I believe in divine things, whether they be old or new ones, and that I teach others to believe in them; at any rate, according to your statement, I believe in divine things. That you have sworn in your indictment. But if I believe in divine things, I suppose it follows necessarily that I believe in divinities. Is it not so? It is. I assume that you grant that, as you do not answer. But do we not believe that divinities are either gods themselves or the children of the gods? Do you admit that?

Meletus: I do.

Socrates: Then you admit that I believe in divinities. Now, if these divinities are gods, then, as I say, you are joking and asking a riddle, and asserting that I do not believe in the gods, and at the same time that I do, since I believe in divinities. But if these divinities are the illegitimate children of the gods, either by the nymphs or by other mothers, as they are said to be, then, I ask, what man could believe in the existence of the children of the gods, and not in the existence of the gods? That would be as absurd as believing in the existence of the offspring of horses and asses, and not in the existence of horses and asses. You must have indicted me in this manner, Meletus, either to test me or because you could not find any crime that you could accuse me of with truth. But you will never contrive to persuade any man with any sense at all that a belief in divine things and things of the gods does not necessarily involve a belief in divinities, and in the gods, and in heroes.

But in truth, Athenians, I do not think that I need say very much to prove that I have not committed the crime for which Meletus is prosecuting me. What I have said is enough to prove that. But I repeat it is certainly true, as I have already told you, that I have aroused much indignation. That is what will cause my condemnation if I am condemned; not Meletus nor Anytus either, but that prejudice and resentment of the multitude which have been the destruction of many good men before me, and I think will be so again. There is no fear that I shall be the last victim.

Perhaps some one will say, "Are you not ashamed, Socrates, of leading a life which is very likely now to cause your death?" I should answer him with justice, and say: "My friend, if you think that a man of any worth at all ought to reckon the chances of life and death when he acts, or that he ought to think of anything but whether he is acting rightly or wrongly, and as a good or bad man would act, you are mistaken. According to you, the demigods who died at Troy would be foolish, and among them the son of Thetis, who thought nothing of danger when the alternative was disgrace. For when his mother—and she was a goddess—addressed him, when he was resolved to slay Hektor, in this fashion, "My son, if you avenge the death of your comrade Patroklos and slay Hektor, you will die yourself, for 'fate awaits you straightway after Hektor's death'"; when he heard this, he scorned danger and death; he feared much more to live a coward and not to avenge his friend. "Let me punish the evildoer and straightway die," he said, "that I may not remain here by the beaked ships jeered at, encumbering the earth."[4] Do you suppose that he thought of danger or of death? For this, Athenians, I believe to be the truth. Wherever a man's station is, whether he has chosen it of his own will, or whether he has been placed at it by his

4. Homer, *Iliad*, xviii, 96, 98.

211

commander, there it is his duty to remain and face the danger without thinking of death or of any other thing except disgrace.

When the generals whom you chose to command me, Athenians, assigned me my station at Potidaea and at Amphipolis and at Delium, I remained where they stationed me and ran the risk of death, like other men. It would be very strange conduct on my part if I were to desert my station now from fear of death or of any other thing when God has commanded me—as I am persuaded that he has done—to spend my life in searching for wisdom, and in examining myself and others. That would indeed be a very strange thing. Then certainly I might with justice be brought to trial for not believing in the gods, for I should be disobeying the oracle, and fearing death and thinking myself wise when I was not wise. For to fear death, my friends, is only to think ourselves wise without really being wise, for it is to think that we know what we do not know. For no one knows whether death may not be the greatest good that can happen to man. But men fear it as if they knew quite well that it was the greatest of evils. And what is this but that shameful ignorance of thinking that we know what we do not know? In this matter, too, my friends, perhaps I am different from the multitude; and if I were to claim to be at all wiser than others, it would be because, not knowing very much about the other world, I do not think I know. But I do know very well that it is evil and disgraceful to do wrong, and not to be persuaded by my superior, whether man or god. I will never do what I know to be evil, and shrink in fear from what I do not know to be good or evil. Even if you acquit me now, and do not listen to Anytus' argument that, if I am to be acquitted, I ought never to have been brought to trial at all, and that, as it is, you are bound to put me to death because, as he said, if I escape, all your sons will be utterly corrupted by practicing what Socrates teaches. If you were therefore to say to me, "Socrates, this time we will not listen to Anytus; we will let you go, but on this condition that you give up this investigation of yours, and philosophy; if you are found following those pursuits again, you shall die." I say, if you offered to let me go on these terms, I should reply: "Athenians, I hold you in the highest regard and affection, but I will be persuaded by the god rather than you; and as long as I have breath and strength I will not give up philosophy and exhorting you and declaring the truth to every one of you whom I meet, saying, as I am accustomed, "My good friend, you are a citizen of Athens, a city which is very great and very famous for its wisdom and power—are you not ashamed of caring so much for the making of money and for fame and prestige, when you neither think nor care about wisdom and truth and the improvement of your soul?" And if he disputes my words and says that he does care about these things, I shall not at once release him and go away: I shall question him and cross-examine him and test him. If I think that he does not possess virtue, though he says that he does, I shall reproach him for under-valuing the most valuable things, and over-valuing those that are less valuable. This I shall do to every one whom I meet, young or old, citizen or stranger, but especially to citizens, for they are more closely related to me. For know that the god has commanded me to do so. And I think that no greater good has ever befallen you in the state than my service to the god. For I spend my whole life in going about and persuading you all to give your first and greatest care to the improvement of your souls, and not till you have done that to think of your bodies or your wealth; and telling you that virtue does not come from wealth, but that wealth, and every other good thing which men have, whether in public or in private, comes from virtue. If then I corrupt the youth by this teaching, these things must be harmful; but if any man says that I teach anything else, there is nothing in what he says. And therefore, Athenians, I say, whether you are persuaded by Anytus or not, whether you acquit me or not, I shall not change my way of life: no, not if I have to die for it many times.

Do not interrupt me, Athenians, with your shouts. Remember the request which I made to you, and do not interrupt my words. I think that it will profit you to hear them. I am going to say something more to you, at which you may be inclined to protest, but do not do that. Be sure that if you put me to death, who am what I have told you that I am, you will do yourselves more harm than me. Meletus and Anytus can do me no harm: that is impossible, for I am sure it is not allowed that a good man be injured by a worse. He may indeed kill me, or drive me into exile, or deprive me of my civil rights; and perhaps Meletus and others think those things great evils. But I do not think so: I think it is a much greater evil to do what he is doing now, and to try to put a man to death unjustly. And now, Athenians, I am not arguing in my own defense at all, as you might expect me to do, but rather in yours in order you may not make a mistake about the gift of the god to you by condemning me. For if you put me to death, you will not easily find another who, if I may use a ludicrous comparison, clings to the state as a sort of gadfly to a horse that is large and well-bred but rather sluggish from its size, and needing to be aroused. It seems to me that the god has attached me like that to the state, for I am constantly alighting upon you at every point to rouse, persuade, and reproach each of you all day long. You will not easily find anyone else, my friends, to fill my place; and if you are persuaded by me, you will spare my life. You are indignant, as drowsy persons are, when they are awakened, and, of course, if you are persuaded by Anytus, you could easily kill me with a single blow, and then sleep on undisturbed for the rest of your lives unless the god in his care for you sends another to arouse you. And you may easily see that it is the god who has given me to your city; for it is not human the way in which I have neglected all my own interests and endured seeing my private affairs neglected now for so many years, while occupying myself unceasingly in your interests, going to each of you privately, like a father or an elder brother, trying to persuade him to care for virtue. There would have been a reason for it, if I had gained any advantage by this, or if I had been paid for my exhortations; but you see yourselves that my accusers, though they accuse me of everything else without shame, have not had the shamelessness to say that I ever either exacted or demanded payment. To that they have no witness. And I

think that I have sufficient witness to the truth of what I say—my poverty.

Perhaps it may seem strange to you that, though I go about giving this advice privately and meddling in others' affairs, yet I do not venture to come forward in the assembly and advise the state. You have often heard me speak of my reason for this, and in many places: it is that I have a certain divine sign, which is what Meletus has caricatured in his indictment. I have had it from childhood. It is a kind of voice which, whenever I hear it, always turns me back from something which I was going to do, but never urges me to act. It is this which forbids me to take part in politics. And I think it does well to forbid me. For, Athenians, it is quite certain that, if I had attempted to take part in politics, I should have perished at once and long ago without doing any good either to you or to myself. And do not be indignant with me for telling the truth. There is no man who will preserve his life for long, either in Athens or elsewhere, if he firmly opposes the multitude, and tries to prevent the commission of much injustice and illegality in the state. He who would really fight for justice must do so as a private citizen, not as an office-holder, if he is to preserve his life, even for a short time.

I will prove to you that this is so by very strong evidence, not by mere words, but by what you value more—actions. Listen then to what has happened to me, that you may know that there is no man who could make me consent to do wrong from the fear of death, but that I would perish at once rather than give way. What I am going to tell you may be a commonplace in the lawcourt: nevertheless it is true. The only office that I ever held in the state, Athenians, was that of Senator. When you wished to try the ten generals who did not rescue their men after the battle of Arginusae, as a group, which was illegal, as you all came to think afterwards, the tribe Antiokhis, to which I belong, held the presidency. On that occasion I alone of all the presidents opposed your illegal action and gave my vote against you. The orators were ready to impeach me and arrest me; and you were clamoring against me, and crying out to me to submit. But I thought that I ought to face the danger, with law and justice on my side, rather than join with you in your unjust proposal, from fear of imprisonment or death. That was when the state was democratic. When the oligarchy came in, the Thirty sent for me, with four others, to the council-chamber, and ordered us to bring Leon the Salaminian from Salamis, that they might put him to death. They were in the habit of frequently giving similar orders to many others, wishing to implicate as many as possible in their crimes. But, then, I again proved, not by mere words, but by my actions, that, if I may speak bluntly, I do not care a straw for death; but that I do care very much indeed about not doing anything unjust or impious. That government with all its power did not terrify me into doing anything unjust; but when we left the council-chamber, the other four went over to Salamis and brought Leon across to Athens; and I went home. And if the rule of the Thirty had not been overthrown soon afterwards, I should very likely have been put to death for what I did then. Many of you will be my witnesses in this matter.

Now do you think that I could have remained alive all these years if I had taken part in public affairs, and had always maintained the cause of justice like a good man, and had held it a paramount duty, as it is, to do so? Certainly not, Athenians, nor could any other man. But throughout my whole life, both in private and in public, whenever I have had to take part in public affairs, you will find I have always been the same and have never yielded unjustly to anyone: no, not to those whom my enemies falsely assert to have been my pupils.[5] But I was never anyone's teacher. I have never withheld myself from anyone, young or old, who was anxious to hear me discuss while I was making my investigation; neither do I discuss for payment, and refuse to discuss without payment. I am ready to ask questions of rich and poor alike, and if any man wishes to answer me, and then listen to what I have to say, he may. And I cannot justly be charged with causing these men to turn out good or bad, for I never either taught or professed to teach any of them any knowledge whatever. And if any man asserts that he ever learned or heard anything from me in private which everyone else did not hear as well as he, be sure that he does not speak the truth.

Why is it, then, that people delight in spending so much time in my company? You have heard why, Athenians. I told you the whole truth when I said that they delight in hearing me examine persons who think that they are wise when they are not wise. It is certainly very amusing to listen to that. And, I say, the god has commanded me to examine men, in oracles and in dreams and in every way in which the divine will was ever declared to man. This is the truth, Athenians, and if it were not the truth, it would be easily refuted. For if it were really the case that I have already corrupted some of the young men, and am now corrupting others, surely some of them, finding as they grew older that I had given them bad advice in their youth, would have come forward today to accuse me and take their revenge. Or if they were unwilling to do so themselves, surely their relatives, their fathers or brothers, or others, would, if I had done them any harm, have remembered it and taken their revenge. Certainly I see many of them in Court. Here is Crito, of my own deme and of my own age, the father of Critobulus; here is Lysanias of Sphettus, the father of Aeschines; here is also Antiphon of Cephisus, the father of Epigenes. Then here are others whose brothers have spent their time in my company—Nicostratus, the son of Theozotides and brother of Theodotus—and Theodotus is dead, so he at least cannot entreat his brother to be silent; here is Paralus, the son of Demodocus and the brother of Theages; here is Adeimantus, the son of Ariston, whose brother is Plato here; and Aeantodorus, whose brother is Aristodorus. And I can name many others to you, some of whom Meletus ought to have called as witnesses in the course of his own speech; but if he forgot to call them then, let him call them now—I will yield the floor to him—and tell us if he has any such evidence. No, on the contrary, my friends, you will find all these men ready to support me, the corrupter, the injurer, of their relatives, as

5. E.g. Kritias, a leader of *The Thirty*, and Alkibiades.

Meletus and Anytus call me. Those of them who have been already corrupted might perhaps have some reason for supporting me, but what reason can their relatives have who are grown up, and who are uncorrupted, except the reason of truth and justice—that they know very well that Meletus is lying, and that I am speaking the truth?

Well, my friends, this, and perhaps more like this, is pretty much all I have to offer in my defense. There may be some one among you who will be indignant when he remembers how, even in a less important trial than this, he begged and entreated the judges, with many tears, to acquit him, and brought forward his children and many of his friends and relatives in Court in order to appeal to your feelings: and then finds that I shall do none of these things, though I am in what he would think the supreme danger. Perhaps he will harden himself against me when he notices this: it may make him angry, and he may cast his vote in anger. If it is so with any of you—I do not suppose that it is, but in case it should be so—I think that I should answer him reasonably if I said: "My friend, I have relatives, too, for, in the words of Homer,[6] 'I am not born of an oak or a rock but of flesh and blood'"; and so, Athenians, I have relatives, and I have three sons, one of them a lad, and the other two still children. Yet I will not bring any of them forward before you and implore you to acquit me. And why will I do none of these things? It is not from arrogance, Athenians, nor because I lack respect for you—whether or not I can face death bravely is another question—but for my own good name, and for your good name, and for the good name of the whole state. I do not think it right, at my age and with my reputation, to do anything of that kind. Rightly or wrongly, men have made up their minds that in some way Socrates is different from the multitude of men. And it will be shameful if those of you who are thought to excel in wisdom, or in bravery, or in any other virtue, are going to act in this fashion. I have often seen men of reputation behaving in an extraordinary way at their trial, as if they thought it a terrible fate to be killed, and as though they expected to live for ever if you did not put them to death. Such men seem to me to bring shame upon the state, for any stranger would suppose that the best and most eminent Athenians, who are selected by their fellow citizens to hold office, and for other honors, are no better than women. Those of you, Athenians, who have any reputation at all ought not to do these things, and you ought not to allow us to do them; you should show that you will be much more ready to condemn men who make the state ridiculous by these pitiful pieces of acting, than to men who remain quiet.

But apart from the question of reputation, my friends, I do not think that it is right to entreat the judge to acquit us, or to escape condemnation in that way. It is our duty to teach and persuade him. He does not sit to give away justice as a favor, but to pronounce judgment; and he has sworn, not to favor any man whom he would like to favor, but to judge according to law. And, therefore, we ought not to encourage you in the habits of breaking your oaths; and you ought not to allow yourselves to fall into this habit, for then neither you nor we would be acting piously.

Therefore, Athenians, do not require me to do these things, for I believe them to be neither good nor just nor pious; and, more especially, do not ask me to do them today when Meletus is prosecuting me for impiety. For were I to be successful and persuade you by my entreaties to break your oaths, I should be clearly teaching you to believe that there are no gods, and I should be simply accusing myself by my defense of not believing in them. But, Athenians, that is very far from the truth. I do believe in the gods as no one of my accusers believes in them: and to you and to god I commit my cause to be decided as is best for you and for me.

[He is found guilty by 281 votes to 220.]

I am not indignant at the verdict which you have given, Athenians, for many reasons. I expected that you would find me guilty; and I am not so much surprised at that as at the numbers of the votes. I certainly never thought that the majority against me would have been so narrow. But now it seems that if only thirty votes had changed sides, I should have escaped. So I think that I have escaped Meletus, as it is; and not only have I escaped him, for it is perfectly clear that if Anytus and Lycon had not come forward to accuse me, too, he would not have obtained the fifth part of the votes, and would have had to pay a fine of a thousand drachmae.

So he proposes death as the penalty. Be it so. And what alternative penalty shall I propose to you, Athenians?[7] What I deserve, of course, must I not? What then do I deserve to pay or to suffer for having determined not to spend my life in ease? I neglected the things which most men value, such as wealth, and family interests, and military commands, and popular oratory, and all the political appointments, and clubs, and factions, that there are in Athens; for I thought that I was really too honest a man to preserve my life if I engaged in these matters. So I did not go where I should have done no good either to you or to myself. I went, instead, to each one of you privately to do him, as I say, the greatest of benefits, and tried to persuade him not to think of his affairs until he had thought of himself and tried to make himself as good and wise as possible, nor to think of the affairs of Athens until he had thought of Athens herself; and to care for other things in the same manner. Then what do I deserve for such a life? Something good, Athenians, if I am really to propose what I deserve; and something good which it would be suitable to me to receive. Then what is a suitable reward to be given to a poor benefactor who requires leisure to exhort you? There is no reward, Athenians, so suitable for him as a public maintenance in the prytaneum. It is a much more suitable reward for him than for any of you who has won a victory at the Olympic games with his horse or his chariots. Such a man only makes you seem happy, but I make you really happy; and he is not in want, and I am. So if I am to propose the penalty which I really deserve, I propose this—a public maintenance in the prytaneum [town hall].

6. Homer, *Odyssey*, xix. 163.

7. For certain crimes no penalty was fixed by Athenian law, and, having reached a verdict of guilty, the court had still to decide between the alternative penalties proposed by the prosecution and the defense.

Perhaps you think me stubborn and arrogant in what I am saying now, as in what I said about the entreaties and tears. It is not so, Athenians; it is rather that I am convinced that I never wronged any man voluntarily, though I cannot persuade you of that, for we have discussed together only a little time. If there were a law at Athens, as there is elsewhere, not to finish a trial of life and death in a single day, I think that I could have persuaded you; but now it is not easy in so short a time to clear myself of great prejudices. But when I am persuaded that I have never wronged any man, I shall certainly not wrong myself, or admit that I deserve to suffer any evil, or propose any evil for myself as a penalty. Why should I? Lest I should suffer the penalty which Meletus proposes when I say that I do not know whether it is a good or an evil? Shall I choose instead of it something which I know to be an evil, and propose that as a penalty? Shall I propose imprisonment? And why should I pass the rest of my days in prison, the slave of successive officials? Or shall I propose a fine, with imprisonment until it is paid? I have told you why I will not do that. I should have to remain in prison, for I have no money to pay a fine with. Shall I then propose exile? Perhaps you would agree to that. Life would indeed be very dear to me if I were unreasonable enough to expect that strangers would cheerfully tolerate my discussions and arguments when you who are my fellow citizens cannot endure them, and have found them so irksome and odious to you that you are seeking now to be relieved of them. No, indeed, Athenians, that is not likely. A fine life I should lead for an old man if I were to withdraw from Athens and pass the rest of my days in wandering from city to city, and continually being expelled. For I know very well that the young men will listen to me wherever I go, as they do here; and if I drive them away, they will persuade their elders to expel me; and if I do not drive them away, their fathers and kinsmen will expel me for their sakes.

Perhaps some one will say, "Why cannot you withdraw from Athens, Socrates, and hold your peace?" It is the most difficult thing in the world to make you understand why I cannot do that. If I say that I cannot hold my peace because that would be to disobey the god, you will think that I am not in earnest and will not believe me. And if I tell you that no greater good can happen to a man than to discuss virtue every day and the other matters about which you have heard me arguing and examining myself and others, and that an unexamined life is not worth living, then you will believe me still less. But that is so, my friends, though it is not easy to persuade you. And, what is more, I am not accustomed to think that I deserve anything evil. If I had been rich, I would have proposed as large a fine as I could pay: that would have done me no harm. But I am not rich enough to pay a fine unless you are willing to fix it at a sum within my means. Perhaps I could pay you a mina, so I propose that. Plato here, Athenians and Crito, and Critobulus, and Apollodorus bid me propose thirty minae, and they will be sureties for me. So I propose thirty minae.[8] They will be sufficient sureties to you for the money.

[*He is condemned to death.*]

You have not gained very much time, Athenians, and, as the price of it, you will have an evil name for all who wish to revile the state, and they will say that you put Socrates, a wise man, to death. For they will certainly call me wise, whether I am wise or not, when they want to reproach you. If you would have waited for a little while, your wishes would have been fulfilled in the course of nature; for you see that I am an old man, far advanced in years, and near to death. I am saying this not to all of you, only to those who have voted for my death. And to them I have something else to say. Perhaps, my friends, you think that I have been convicted because I was wanting in the arguments by which I could have persuaded you to acquit me, if, that is, I had thought it right to do or to say anything to escape punishment. It is not so. I have been convicted because I was wanting, not in arguments, but in impudence and shamelessness—because I would not plead before you as you would have liked to hear me plead, or appeal to you with weeping and wailing, or say and do many other things which I maintain are unworthy of me, but which you have been accustomed to from other men. But when I was defending myself, I thought that I ought not to do anything unworthy of a free man because of the danger which I ran, and I have not changed my mind now. I would very much rather defend myself as I did, and die, than as you would have had me do, and live. Both in a lawsuit and in war, there are some things which neither I nor any other man may do in order to escape from death. In battle, a man often sees that he may at least escape from death by throwing down his arms and falling on his knees before the pursuer to beg for his life. And there are many other ways of avoiding death in every danger if a man is willing to say and to do anything. But, my friends, I think that it is a much harder thing to escape from wickedness than from death, for wickedness is swifter than death. And now I, who am old and slow, have been overtaken by the slower pursuer: and my accusers, who are clever and swift, have been overtaken by the swifter pursuer—wickedness. And now I shall go away, sentenced by you to death; and they will go away, sentenced by truth to wickedness and injustice. And I abide by this award as well as they. Perhaps it was right for these things to be so; and I think that they are fairly balanced.

And now I wish to prophesy to you, Athenians, who have condemned me. For I am going to die, and that is the time when men have most prophetic power. And I prophesy to you who have sentenced me to death that a far more severe punishment than you have inflicted on me will surely overtake you as soon as I am dead. You have done this thing, thinking that you will be relieved from having to give an account of your lives. But I say that the result will be very different. There will be more men who will call you to account, whom I have held back, though you did not recognize it. And they will be harsher toward you than I have been, for they will be younger, and you will be more indignant with them. For if you think that you will restrain men from reproaching you for not living as you

8. One mina was a trifling sum, Socrates's honest opinion of his just deserts but insulting to the court. A thirty minae fine was comparable to the dowry of a moderately rich man's daughter, as Plato later mentioned, but, by this time, totally unacceptable to the court.

should, by putting them to death, you are very much mistaken. That way of escape is neither possible nor honorable. It is much more honorable and much easier not to suppress others, but to make yourselves as good as you can. This is my parting prophecy to you who have condemned me.

With you who have acquitted me I should like to discuss this thing that has happened, while the authorities are busy, and before I go to the place where I have to die. So, remain with me until I go: there is no reason why we should not talk with each other while it is possible. I wish to explain to you, as my friends, the meaning of what has happened to me. An amazing thing has happened to me, judges—for you I am right in calling judges.[9] The prophetic sign has been constantly with me all through my life till now, opposing me in quite small matters if I were not going to act rightly. And now you yourselves see what has happened to me—a thing which might be thought, and which is sometimes actually reckoned, the supreme evil. But the divine sign did not oppose me when I was leaving my house in the morning, nor when I was coming up here to the court, nor at any point in my speech when I was going to say anything; though at other times it has often stopped me in the very act of speaking. But now, in this matter, it has never once opposed me, either in my words or my actions. I will tell you what I believe to be the reason. This thing that has come upon me must be a good; and those of us who think that death is an evil must needs be mistaken. I have a clear proof that that is so; for my accustomed sign would certainly have opposed me if I had not been going to meet with something good.

And if we reflect in another way, we shall see that we may well hope that death is a good. For the state of death is one of two things: either the dead man wholly ceases to be and loses all consciousness or, as we are told, it is a change and a migration of the soul to another place. And if death is the absence of all consciousness, and like the sleep of one whose slumbers are unbroken by any dreams, it will be a wonderful gain. For if a man had to select that night in which he slept so soundly that he did not even dream, and had to compare with it all the other nights and days of his life, and then had to say how many days and nights in his life he had spent better and more pleasantly than this night, I think that a private person, nay, even the great King[10] himself, would find them easy to count, compared with the others. If that is the nature of death, I for one count it a gain. For then it appears that all time is nothing more than a single night. But if death is a journey to another place, and what we are told is true—that there are all who have died—what good could be greater than this, my judges? Would a journey not be worth taking, at the end of which, in the other world, we should be delivered from the pretended judges here and should find the true judges who are said to sit in judgment below, such as Minos and Rhadamanthus and Aeacus and Triptolemus, and the other demigods who were just in their own lives? Or what would you not give to

discuss with Orpheus and Musaeus and Hesiod and Homer? I am willing to die many times if this be true. And for my own part I should find it wonderful to meet there Palamedes, and Aias, the son of Telamon, and the other men of old who have died through an unjust judgment, and in comparing my experiences with theirs. That I think would be no small pleasure. And, above all, I could spend my time in examining those who are there, as I examine men here, and in finding out which of them is wise, and which of them thinks himself wise when he is not wise. What would we not give, my judges, to be able to examine the leader of the great expedition against Troy, or Odysseus, or Sisyphus, or countless other men and women whom we could name? It would be an infinite happiness to discuss with them and to live with them and to examine them. Assuredly there they do not put men to death for doing that. For besides the other ways in which they are happier than we are, they are immortal, at least if what we are told is true.

And you, too, judges, must face death hopefully, and believe this as a truth that no evil can happen to a good man, either in life or after death. His fortunes are not neglected by the gods; and what has happened to me today has not happened by chance. I am persuaded that it was better for me to die now, and to be released from trouble; and that was the reason why the sign never turned me back. And so I am not at all angry with my accusers or with those who have condemned me to die. Yet it was not with this in mind that they accused me and condemned me, but meaning to do me an injury. So far I may blame them.

Republic

Plato

The Republic, in which Plato outlines his ideal society, also contains the clearest exposition of his theory of forms, which has been influential on philosophers even up to the present day. The dialog in this extract is between the narrator, Socrates, and Plato's brother, Glaucon.

Book IV

For the moment, we had better finish the inquiry which we began with the idea that it would be easier to make out the nature of justice in the individual if we first tried to study it in something on a larger scale. That larger thing we took to be a state, and so we set about constructing the best one we could, being sure of finding justice in a state that was good. The discovery we made there must now be applied to the individual. If it is confirmed, all will be well; but if we find that justice in the individual is something different, we must go back to the state and test our new result. Perhaps if we brought the two cases into contact like flint and steel, we might strike out between them the spark of justice, and in its light confirm the

9. The form of address hitherto has always been "Athenians," or "my friends."
10. Of Persia.

conception in our own minds.

A good method. Let us follow it.

Now, I continued, if two things, one large, the other small, are called by the same name, they will be alike in that respect to which the common name applies. Accordingly, in so far as the quality of justice is concerned, there will be no difference between a just man and a just society.

No.

Well, but we decided that a society was just when each of the three types of human character it contained performed its own function; and again, it was temperate and brave and wise by virtue of certain other affections and states of mind of those same types.

True.

Accordingly, my friend, if we are to be justified in attributing those same virtues to the individual, we shall expect to find that the individual soul contains the same three elements and that they are affected in the same way as are the corresponding types in society.

That follows.

Here, then, we have stumbled upon another little problem: Does the soul contain these three elements or not?

Not such a very little one, I think. It may be a true saying, Socrates, that what is worth while is seldom easy.

Apparently; and let me tell you, Glaucon, it is my belief that we shall never reach the exact truth in this matter by following our present methods of discussion; the road leading to that goal is longer and more laborious. However, perhaps we can find an answer that will be up to the standard we have so far maintained in our speculations.

Is not that enough? I should be satisfied for the moment.

Well, it will more than satisfy me.

Don't be disheartened, then, but go on.

Surely, we must admit that the same elements and characters that appear in the state must exist in every one of us; where else could they have come from? It would be absurd to imagine that among peoples with a reputation for a high-spirited character, like the Thracians and Scythians and northerners generally, the states have not derived that character from their individual members; or that it is otherwise with the love of knowledge, which would be ascribed chiefly to our own part of the world, or with the love of money, which one would specially connect with Phoenicia and Egypt.

Certainly.

So far, then, we have a fact which is easily recognized. But here the difficulty begins. Are we using the same part of ourselves in all these three experiences, or a different part in each? Do we gain knowledge with one part, feel anger with another, and with yet a third desire the pleasures of food, sex, and so on? Or is the whole soul at work in every impulse and in all these forms of behavior? The difficulty is to answer that question satisfactorily.

I quite agree.

Let us approach the problem whether these elements are distinct or identical in this way. It is clear that the same thing cannot act in two opposite ways or be in two opposite states at the same time, with respect to the same part of itself, and in relation to the same object. So if we find such contradictory actions or states among the elements concerned, we shall know that more than one must have been involved.

Very well.

Consider this proposition for mine, then. Can the same thing, at the same time and with respect to the same part of itself, be at rest and in motion?

Certainly not.

We had better state this principle in still more precise terms, to guard against misunderstanding later on. Suppose a man is standing still, but moving his head and arms. We should not allow anyone to say that the same man was both at rest and in motion at the same time, but only that part of him was at rest, part in motion. Isn't that so?

Yes.

An ingenious objector might refine still further and argue that a peg-top, spinning with its peg fixed at the same spot, or indeed any body that revolves in the same place, is both at rest and in motion as a whole. But we should not agree, because the parts in respect of which such a body is moving and at rest are not the same. It contains an axis and a circumference; and in respect of the axis it is at rest inasmuch as the axis is not inclined in any direction, while in respect of the circumference it revolves; and if, while it is spinning, the axis does lean out of the perpendicular in all directions, then it is in no way at rest.

That is true.

No objection of that sort, then, will disconcert us or make us believe that the same thing can ever act or be acted upon in two opposite ways, or be two opposite things, at the same time, in respect of the same part of itself, and in relation to the same object.

I can answer for myself at any rate.

Well, anyhow, as we do not want to spend time in reviewing all such objections to make sure that they are unsound, let us proceed on this assumption, with the understanding that, if we ever come to think otherwise, all the consequences based upon it will fall to the ground.

Yes, that is a good plan.

Now, would you class such things as assent and dissent, striving after something and refusing it, attraction and repulsion, as pairs of opposite actions or states of mind—no matter which?

Yes, they are opposites.

And would you not class all appetites such as hunger and thirst, and again willing and wishing, with the affirmative members of those pairs I have just mentioned? For instance, you would say that the soul of a man who desires something is striving after it, or trying to draw to itself the thing it wishes to possess, or again, in so far as it is willing to have its want satisfied, it is giving its assent to its own longing, as if to an inward question.

Yes.

And, on the other hand, disinclination, unwillingness, and dislike, we should class on the negative side with acts of rejection or repulsion.

Of course.

That being so, shall we say that appetites form one

class, the most conspicuous being those we call thirst and hunger?

Yes.

Thirst being desire for drink, hunger for food?

Yes.

Now, is thirst, just in so far as it is thirst, a desire in the soul for anything more than simply drink? Is it, for instance, thirst for hot drink or for cold, for much drink or for little, or in a word for drink of any particular kind? Is it not rather true that you will have a desire for cold drink only if you are feeling hot as well as thirsty, and for hot drink only if you are feeling cold; and if you want much drink or little, that will be because your thirst is a great thirst or a little one? But, just in itself, thirst or hunger is a desire for nothing more than its natural object, drink or food, pure and simple.

Yes, he agreed, each desire, just in itself, is simply for its own natural object. When the object is of such and such a particular kind, the desire will be correspondingly qualified.[1]

We must be careful here, or we might be troubled by the objection that no one desires mere food and drink, but always wholesome food and drink. We shall be told that what we desire is always something that is good; so if thirst is a desire, its object must be, like that of any other desire, something—drink or whatever it may be—that will be good for one.[2]

Yes, there might seem to be something in that objection.

But surely, wherever you have two correlative terms, if one is qualified, the other must always be qualified too: whereas if one is unqualified, so is the other.

I don't understand.

Well, "greater" is a relative term; and the greater is greater than the less: if it is much greater, then the less is much less; if it is greater at some moment, past or future, then the less is less at that same moment. The same principle applies to all such correlatives, like "more" and "fewer," "double," and "half"; and again to terms like "heavier" and "lighter," "quicker" and "slower," and to things like hot and cold.

Yes.

Or take the various branches of knowledge: is it not the same there? The object of knowledge pure and simple is the knowable—if that is the right word—without any qualification; whereas a particular kind of knowledge has an object of a particular kind. For example, as soon as men learnt how to build houses, their craft was distinguished from others under the name of architecture, because it had a unique character, which was itself due to the character of its object; and all other branches of craft and knowledge were distinguished in the same way.

True.

This, then, if you understand me now, is what I meant by saying that, where there are two correlatives, the one is qualified if, and only if, the other is so. I am not saying that the one must have the same quality as the other—that the science of health and disease is itself healthy and diseased, or the knowledge of good and evil is itself good and evil—but only that, as soon as you have a knowledge that is restricted to a particular kind of object, namely health and disease, the knowledge itself becomes a particular kind of knowledge. Hence we no longer call it merely knowledge, which would have for its object whatever can be known, but we add the qualification and call it medical science.

I understand now and I agree.

Now, to go back to thirst: is not that one of these relative terms? It is essentially thirst for something.

Yes, for drink.

And if the drink desired is of a certain kind, the thirst will be correspondingly qualified. But thirst which is just simply thirst is not for drink of any particular sort—much or little, good or bad—but for drink pure and simple.

Quite so.

We conclude, then, that the soul of a thirsty man, just in so far as he is thirsty, has no other wish than to drink. That is the object of its craving, and towards that it is impelled.

That is clear.

Now if there is ever something which at the same time pulls it the opposite way, that something must be an element in the soul other than the one which is thirsting and driving it like a beast to drink: in accordance with our principle that the same thing cannot behave in two opposite ways at the same time and towards the same object with the same part of itself. It is like an archer drawing the bow: it is not accurate to say that his hands are at the same time both pushing and pulling it. One hand does the pushing, the other the pulling.

Exactly.

Now, is it sometimes true that people are thirsty and yet unwilling to drink?

Yes, often.

What, then, can one say of them, if not that their soul contains something which urges them to drink and something which holds them back, and that this latter is a distinct thing and overpowers the other?

I agree.

And is it not true that the intervention of this inhibiting principle in such cases always has its origin in reflection; whereas the impulses driving and dragging the soul are engendered by external influences and abnormal conditions.[3]

Evidently.

We shall have good reason, then, to assert that they are two distinct principles. We may call that part of the soul whereby it reflects, rational: and the other, with which it feels hunger and thirst and is distracted by sexual passion and all the other desires, we will call irrational appetite,

1. The object of the following subtle argument about relative terms is to distinguish thirst as a mere blind craving for drink from a more complex desire whose object includes the pleasure of health expected to result from drinking.

2. If this objection were admitted, it would follow that the desire would always be correspondingly qualified. It is necessary to insist that we do experience blind cravings which can be isolated from any judgment about the goodness of their object.

3. Some of the most intense bodily desires are due to morbid conditions, e.g. thirst in fever, and even milder desires are caused by a departure from the normal state, which demands "replenishment."

associated with pleasure in the replenishment of certain wants.

Yes, there is good ground for that view.

Let us take it, then, that we have now distinguished two elements in the soul. What of that passionate element which makes us feel angry and indignant? Is that a third, or identical in nature with one of those two?

It might perhaps be identified with appetite.

I am more inclined to put my faith in a story I once heard about Leontius, son of Aglaion. On his way up from the Piraeus outside the north wall, he noticed the bodies of some criminals lying on the ground, with the executioner standing by them. He wanted to go and look at them, but at the same time he was disgusted and tried to turn away. He struggled for some time and covered his eyes, but at last the desire was too much for him. Opening his eyes wide, he ran up to the bodies and cried, "There you are, curse you; feast yourselves on this lovely sight!"

Yes, I have heard that story too.

The point of it surely is that anger is sometimes in conflict with appetite, as if they were two distinct principles. Do we not often find a man whose desires would force him to go against his reason, reviling himself and indignant with this part of his nature which is trying to put constraint on him? It is like a struggle between two factions, in which indignation takes the side of reason. But I believe you have never observed, in yourself or anyone else, indignation make common cause with appetite in behavior which reason decides to be wrong.

No, I am sure I have not.

Again, take a man who feels he is in the wrong. The more generous his nature, the less can he be indignant at any suffering, such as hunger and cold, inflicted by the man he has injured. He recognizes such treatment as just, and, as I say, his spirit refuses to be roused against it.

This is true.

But now contrast one who thinks it is he that is being wronged. His spirit boils with resentment and sides with the right as he conceives it. Persevering all the more for the hunger and cold and other pains he suffers, it triumphs and will not give in until its gallant struggle has ended in success or death; or until the restraining voice of reason, like a shepherd calling off his dog, makes it relent.

An apt comparison, he said; and in fact it fits the relation of our Auxiliaries to the Rulers: they were to be like watch-dogs obeying the shepherds of the commonwealth.

Yes, you understand very well what I have in mind. But do you see how we have changed our view? A moment ago we were supposing this spirited element to be something of the nature of appetite; but now it appears that, when the soul is divided into factions, it is far more ready to be up in arms on the side of reason.

Quite true.

Is it, then, distinct from the rational element or only a particular form of it, so that the soul will contain no more than two elements, reason and appetite? Or is the soul like the state, which had three orders to hold it together, traders, Auxiliaries, and counsellors? Does the spirited element make a third, the natural auxiliary of reason, when not corrupted by bad upbringing?

It must be a third.

Yes, I said, provided it can be shown to be distinct for reason, as we saw it was from appetite.

That is easily proved. You can see that much in children: they are full of passionate feelings from their very birth; but some, I should say, never become rational, and most of them only late in life.

A very sound observation, said I, the truth of which may also be seen in animals. And besides, there is the witness of Homer in that line I quoted before: "He smote his breast and spoke, chiding his heart." The poet is plainly thinking of the two elements as distinct, when he makes the one which has chosen the better course after reflection rebuke the other for its unreasoning passion.

I entirely agree.

The Equality of Women

What I see is that, whereas there is only one form of excellence, imperfection exists in innumerable shapes, of which there are four that specially deserve notice.

What do you mean?.

It looks as if there were as many types of character as there are distinct varieties of political constitution.

How many?

Five of each.

Will you define them?

Yes, I said. One form of constitution will be the form we have been describing, though it may be called by two names: monarchy, when there is one man who stands out above the rest of the Rulers; aristocracy, when there are more than one.[4]

True.

That, then, I regard as a single form; for, so long as they observe our principles of upbringing and education, whether the Rulers be one or more, they will not subvert the important institutions in our commonwealth.

Naturally not.

Such, then, is the type of state or constitution that I call good and right, and the corresponding type of man. By this standard, the other forms in which a state or an individual character may be organized are depraved and wrong. There are four of these vicious forms.

What are they?

Here I was going on to describe these forms in the order in which, as I thought, they develop one from another, when Polemarchus, who was sitting a little way from Adeimantus, reached out his hand and took hold of his garment by the shoulder. Leaning forward and drawing Adeimantus towards him, he whispered something in his ear, of which I only caught the words: What shall we do? Shall we leave it alone?

Certainly not, said Adeimantus, raising his voice.

What is this, I asked, that you are not going to leave alone?

You, he replied.

Why, in particular? I inquired.

4. The question whether wisdom rules in the person of one man or of several is unimportant. In the sequel the ideal constitution is called kingship or aristocracy (the rule of the best) indifferently.

Because we think you are shirking the discussion of a very important part of the subject and trying to cheat us out of an explanation. Everyone, you said, must of course see that the maxim "friends have all things in common" applies to women and children. You thought we should pass over such a casual remark!

But wasn't that right, Adeimantus? said I.

Yes, he said, but "right" in this case, as in others, needs to be defined. There may be many ways of having things in common, and you must tell us which you mean. We have been waiting a long time for you to say something about the conditions in which children are to be born and brought up and your whole plan of having wives and children held in common. This seems to us a matter in which right or wrong management will make all the difference to society; and now, instead of going into it thoroughly, you are passing on to some other form of constitution. So we came to the resolution which you overheard, not to let you off discussing it as fully as all the other institutions.

I will vote for your resolution too, said Glaucon.

In fact, Socrates, Thrasymachus added, you may take it as carried unanimously.

You don't know what you are doing, I said, in holding me up like this. You want to start, all over again, on an enormous subject, just as I was rejoicing at the idea that we had done with this form of constitution. I was only too glad that my casual remark should be allowed to pass. And now, when you demand an explanation, you little know what a swarm of questions you are stirring up. I let it alone, because I foresaw no end of trouble.

Well, said Thrasymachus, what do you think we came here for—to play pitch-and-toss or to listen to a discussion?

A discussion, no doubt, I replied; but within limits.

No man of sense, said Glaucon, would think the whole of life too long to spend on questions of this importance. But never mind about us; don't be fainthearted yourself. Tell us what you think about this question: how our Guardians are to have wives and children in common, and how they will bring up the young in the interval between their birth and education, which is thought to be the most difficult time of all. Do try to explain how all this is to be arranged.

I wish it were as easy as you seem to think, I replied. These arrangements are even more open to doubt than any we have so far discussed. It may be questioned whether the plan is feasible, and even if entirely feasible, whether it would be for the best. So I have some hesitation in touching on what may seem to be an idle dream.

You need not hesitate, he replied. This is not an unsympathetic audience; we are neither incredulous nor hostile.

Thank you, I said; I suppose that remark is meant to be encouraging.

Certainly it is.

Well, I said, it has just the opposite effect. You would do well to encourage me, if I had any faith in my own understanding of these matters. If one knows the truth, there is no risk to be feared in speaking about the things one has most at heart among intelligent friends; but if one is still in the position of a doubting inquirer, as I am now, talking becomes a slippery venture. Not that I am afraid of being laughed at—that would be childish—but I am afraid I may miss my footing just where a false step is most to be dreaded and drag my friends down with me in my fall. I devoutly hope, Glaucon, that no nemesis will overtake me for what I am going to say; for I really believe that to kill a man unintentionally is a lighter offense than to mislead him concerning the goodness and justice of social institutions. Better to run that risk among enemies than among friends; so your encouragement is out of place.

Glaucon laughed at this. No, Socrates, he said, if your theory has any untoward effect on us, our blood shall not be on your head; we absolve you of any intention to mislead us. So have no fear.

Well, said I, when a homicide is absolved of all intention, the law holds him clear of guilt; and the same principle may apply to my case.

Yes, so far as that goes, you may speak freely.

We must go back, then, to a subject which ought, perhaps, to have been treated earlier in its proper place; though, after all, it may be suitable that the women should have their turn on the stage when the men have quite finished their performance, especially since you are so insistent. In my judgment, then, the question under what conditions people born and educated as we have described should possess wives and children, and how they should treat them, can be rightly settled only by keeping to the course on which we started them at the outset. We undertook to put these men in the position of watch-dogs guarding a flock. Suppose we follow up the analogy and imagine them bred and reared in the same sort of way. We can then see if that plan will suit our purpose.

How will that be?

In this way. Which do we think right for watch-dogs: should the females guard the flock and hunt with the males and take a share in all they do, or should they be kept within doors as fit for no more than bearing and feeding their puppies, while all the hard work of looking after the flock is left to the males?

They are expected to take their full share, except that we treat them as not quite so strong.

Can you employ any creature for the same work as another, if you do not give them both the same upbringing and education?

No.

Then, if we are to set women to the same tasks as men, we must teach them the same things. They must have the same two branches of training for mind and body and also be taught the art of war, and they must receive the same treatment.

That seems to follow.

Possibly, if these proposals were carried out, they might be ridiculed as involving a good many breaches of custom.

They might indeed.

The most ridiculous—don't you think?—being the notion of women exercising naked along with the men in the wrestling-schools; some of them elderly women too, like the old men who still have a passion for exercise

when they are wrinkled and not very agreeable to look at.

Yes, that would be thought laughable, according to our present notions.

Now we have started on this subject, we must not be frightened of the many witticisms that might be aimed at such a revolution, not only in the matter of bodily exercise but in the training of women's minds, and not least when it comes to their bearing arms and riding on horseback. Having begun upon these rules, we must not draw back from the harsher provisions. The wits may be asked to stop being witty and try to be serious; and we may remind them that it is not so long since the Greeks, like most foreign nations of the present day, thought it ridiculous and shameful for men to be seen naked. When gymnastic exercises were first introduced in Crete and later at Sparta, the humorists had their chance to make fun of them; but when experience had shown that nakedness is better uncovered than muffled up, the laughter died down and a practice which the reason approved ceased to look ridiculous to the eye. This shows how idle it is to think anything ludicrous but what is base. One who tries to raise a laugh at any spectacle save that of baseness and folly will also, in his serious moments, set before himself some other standard than goodness of what deserves to be held in honour.

Most assuredly.

The first thing to be settled, then, is whether these proposals are feasible; and it must be open to anyone, whether a humorist or serious-minded, to raise the question whether, in the case of mankind, the feminine nature is capable of taking part with the other sex in all occupations, or in none at all, or in some only; and in particular under which of these heads this business of military service falls. Well begun is half done, and would not this be the best way to begin?

Yes.

Shall we take the other side in this debate and argue against ourselves? We do not want the adversary's position to be taken by storm for lack of defenders.

I have no objection.

Let us state his case for him. "Socrates and Glaucon," he will say, "there is no need for others to dispute your position; you yourselves, at the very outset of founding your commonwealth, agreed that everyone should do the one work for which nature fits him." Yes, of course; I suppose we did. "And isn't there a very great difference in nature between man and woman?" Yes, surely. "Does not that natural difference imply a corresponding difference in the work to be given to each?" Yes. "But if so, surely you must be mistaken now and contradicting yourselves when you say that men and women, having such widely divergent natures, should do the same things?" What is your answer to that, my ingenious friend?

It is not easy to find one at the moment. I can only appeal to you to state the case on our own side, whatever it may be.

This, Glaucon, is one of many alarming objections which I foresaw some time ago. That is why I shrank from touching upon these laws concerning the possession of wives and the rearing of children.

It looks like anything but an easy problem.

True, I said; but whether a man tumbles into a swimming-pool or into mid-ocean, he has to swim all the same. So must we, and try if we can reach the shore, hoping for some Arion's dolphin or other miraculous deliverance to bring us safe to land.[5]

I suppose so.

Come then, let us see if we can find the way out. We did agree that different natures should have different occupations, and that the natures of man and woman are different; and yet we are now saying that these different natures are to have the same occupations. Is that the charge against us

Exactly.

It is extraordinary, Glaucon, what an effect the practice of debating has upon people.

Why do you say that?

Because they often seem to fall unconsciously into mere disputes which they mistake for reasonable argument, through being unable to draw the distinctions proper to their subject; and so, instead of a philosophical exchange of ideas, they go off in chase of contradictions which are purely verbal.

I know that happens to many people; but does it apply to us at this moment?

Absolutely. At least I am afraid we are slipping unconsciously into a dispute about words. We have been strenuously insisting on the letter of our principle that different natures should not have the same occupations, as if we were scoring a point in a debate; but we have altogether neglected to consider what sort of sameness or difference we meant and in what respect these natures and occupations were to be defined as different or the same. Consequently, we might very well be asking one another whether there is not an opposition in nature between bald and long-haired men, and, when that was admitted, forbid one set to be shoemakers, if the other were following that trade.

That would be absurd.

Yes, but only because we never meant any and every sort of sameness or difference in nature, but the sort that was relevant to the occupations in question. We meant, for instance, that a man and a woman have the same nature if both have a talent for medicine; whereas two men have different natures if one is a born physician, the other a born carpenter.

Yes, of course.

If, then, we find that either the male sex or the female is specially qualified for any particular form of occupation, then that occupation, we shall say, ought to be assigned to one sex or the other. But if the only difference appears to be that the male begets and the female brings forth, we shall conclude that no difference between man and woman has yet been produced that is relevant to our purpose. We shall continue to think it proper for our Guardians and their wives to share in the same pursuits.

And quite rightly.

The next thing will be to ask our opponent to name any profession or occupation in civic life for the purposes of

5. The musician Arion, to escape the treachery of Corinthian sailors, leapt into the sea and was carried ashore at Taenarum by a dolphin.

which woman's nature is different from man's.

That is a fair question.

He might reply, as you did just now, that it is not easy to find a satisfactory answer on the spur of the moment, but that there would be no difficulty after a little reflection.

Perhaps.

Suppose, then, we invite him to follow us and see if we can convince him that there is no occupation concerned with the management of social affairs that is peculiar to women. We will confront him with a question: When you speak of a man having a natural talent for something, do you mean that he finds it easy to learn, and after a little instruction can find out much more for himself; whereas a man who is not so gifted learns with difficulty and no amount of instruction and practice will make him even remember what he has been taught? Is the talented man one whose bodily powers are readily at the service of his mind, instead of being a hindrance? Are not these the marks by which you distinguish the presence of a natural gift for any pursuit?

Yes, precisely.

Now do you know of any human occupation in which the male sex is not superior to the female in all these respects? Need I waste time over exceptions like weaving and watching over saucepans and batches of cakes, though women are supposed to be good at such things and get laughed at when a man does them better?

It is true, he replied, in almost everything one sex is easily beaten by the other. No doubt many women are better at many things than many men; but taking the sexes as a whole, it is as you say.

To conclude, then, there is no occupation concerned with the management of social affairs which belongs either to woman or to man, as such. Natural gifts are to be found here and there in both creatures alike; and every occupation is open to both, so far as their natures are concerned, though woman is for all purposes the weaker.

Certainly.

Is that a reason for making over all occupations to men only?

Of course not.

No, because one woman may have a natural gift for medicine or for music, another may not.

Surely.

Is it not also true that a woman may, or may not, be warlike or athletic?

I think so.

And again, one may love knowledge, another hate it; one may be high-spirited, another spiritless?

True again.

It follows that one woman will be fitted by nature to be a Guardian, another will not; because these were the qualities for which we selected our men Guardians. So for the purpose of keeping watch over the commonwealth, woman has the same nature as man, save in so far as she is weaker.

So it appears.

It follows that women of this type must be selected to share the life and duties of Guardians with men of the same type, since they are competent and of a like nature,

and the same natures must be allowed the same pursuits.

Yes.

We come round, then, to our former position, that there is nothing contrary to nature in giving our Guardians' wives the same training for mind and body. The practice we proposed to establish was not impossible or visionary, since it was in accordance with nature. Rather, the contrary practice which now prevails turns out to be unnatural.

So it appears.

Well, we set out to inquire whether the plan we proposed was feasible and also the best. That it is feasible is now agreed; we must next settle whether it is the best.

Obviously.

Now, for the purpose of producing a woman fit to be a Guardian, we shall not have one education for men and another for women, precisely because the nature to be taken in hand is the same.

True.

What is your opinion on the question of one man being better than another? Do you think there is no such difference?

Certainly I do not.

And in this commonwealth of ours which will prove the better men—the Guardians who have received the education we described, or the shoemakers who have been trained to make shoes?[6]

It is absurd to ask such a question.

Very well. So these Guardians will be the best of all the citizens?

By far.

And these women the best of all the women?

Yes.

Can anything be better for a commonwealth than to produce in it men and women of the best possible type?

No.

And that result will be brought about by such a system of mental and bodily training as we have described?

Surely.

We may conclude that the institution we proposed was not only practicable, but also the best for the commonwealth.

Yes.

The wives of our Guardians, then, must strip for exercise, since they will be clothed with virtue, and they must take their share in war and in the other social duties of guardianship. They are to have no other occupation; and in these duties the lighter part must fall to the women, because of the weakness of their sex. The man who laughs at naked women, exercising their bodies for the best of reasons, is like one that "gathers fruit unripe," for he does not know what it is that he is laughing at or what he is doing. There will never be a finer saying than the one which declares that whatever does good should be held in honour, and the only shame is in doing harm.

That is perfectly true.

6. Elementary education will be open to all citizens, but presumably carried further (to the age of 17 or 18) in the case of those who show special promise.

Book V

Philosophers must be Kings

But really, Socrates, Glaucon continued, if you are allowed to go on like this, I am afraid you will forget all about the question you thrust aside some time ago: whether a society so constituted can ever come into existence, and if so, how.

Well, said I, let me begin by reminding you that what brought us to this point was our inquiry into the nature of justice and injustice.

True; but what of that?

Merely this: suppose we do find out what justice is, are we going to demand that a man who is just shall have a character which exactly corresponds in every respect to the ideal of justice? Or shall we be satisfied if he comes as near to the ideal as possible and has in him a larger measure of that quality than the rest of the world?

That will satisfy me.

If so, when we set out to discover the essential nature of justice and injustice and what a perfectly just and perfectly unjust man would be like, supposing them to exist, our purpose was to use them as ideal patterns: we were to observe the degree of happiness or unhappiness that each exhibited, and to draw the necessary inference that our own destiny would be like that of the one we most resembled. We did not set out to show that these ideals could exist in fact.

That is true.

Then suppose a painter had drawn an ideally beautiful figure complete to the last touch, would you think any the worse of him, if he could not show that a person as beautiful as that could exist?

No, I should not.

Well, we have been constructing in discourse the pattern of an ideal state. Is our theory any the worse, if we cannot prove it possible that a state so organized should be actually founded?

Surely not.

That, then, is the truth of the matter. But if, for your satisfaction, I am to do my best to show under what conditions our ideal would have the best chance of being realized, I must ask you once more to admit that the same principle applies here. Can theory ever be fully realized in practice? Is it not in the nature of things that action should come less close to truth than thought? People may not think so; but do you agree or not?

I do.

Then you must not insist upon my showing that this construction we have traced in thought could be reproduced in fact down to the last detail. You must admit that we shall have found a way to meet your demand for realization, if we can discover how a state might be constituted in the closest accordance with our description. Will not that content you? It would be enough for me.

And for me, too.

Then our next attempt, it seems, must be to point out what defect in the working of existing states prevents them from being so organized, and what is the least change that would effect a transformation into this type of government—a single change if possible, or perhaps two;

at any rate let us make the changes as few and insignificant as may be.

By all means.

Well, there is one change which, as I believe we can show, would bring about this revolution—not a small change, certainly, nor an easy one, but possible.

What is it?

I have now to confront what we called the third and greatest wave. But I must state my paradox, even though the wave should break in laughter over my head and drown me in ignominy. Now mark what I am going to say.

Go on.

Unless either philosophers become kings in their countries or those who are now called kings and rulers come to be sufficiently inspired with a genuine desire for wisdom; unless, that is to say, political power and philosophy meet together, while the many natures who now go their several ways in the one or the other direction are forcibly debarred from doing so, there can be no rest from troubles, my dear Glaucon, for states, nor yet, as I believe, for all mankind; nor can this commonwealth which we have imagined ever till then see the light of day and grow to its full stature. This it was that I have so long hung back from saying; I knew what a paradox it would be, because it is hard to see that there is no other way of happiness either for the state or for the individual.

Book VII

The Allegory of the Cave

Next, said I, here is a parable to illustrate the degrees in which our nature may be enlightened or unenlightened. Imagine the condition of men living in a sort of cavernous chamber underground, with an entrance open to the light and a long passage all down the cave.[7] Here they have been from childhood, chained by the leg and also by the neck, so that they cannot move and can see only what is in front of them, because the chains will not let them turn their heads. At some distance higher up is the light of a fire burning behind them; and between the prisoners and the fire is a track[8] with a parapet built along it, like the screen at a puppet show, which hides the performers while they show their puppets over the top.

I see, said he.

Now behind this parapet imagine persons carrying along various artificial objects, including figures of men and animals in wood or stone or other materials, which project above the parapet. Naturally, some of these persons will be talking, others silent.[9]

It is a strange picture, he said, and a strange sort of prisoners.

Like ourselves, I replied; for in the first place prisoners

7. The length of the "way in" (eisodos) to the chamber where the prisoners sit is an essential feature, explaining why no daylight reaches them.

8. The track crosses the passage into the cave at right angles, and is above the parapet built along it.

9. A modern Plato would compare his Cave to an underground cinema. The film itself is only an image of "real" things and events in the world outside the cinema.

so confined would have seen nothing of themselves or of one another, except the shadows thrown by the fire-light on the wall of the Cave facing them, would they?

Not if all their lives they had been prevented from moving their heads.

And they would have seen as little of the objects carried past.

Of course.

Now, if they could talk to one another, would they not suppose that their words referred only to those passing shadows which they saw?[10]

Necessarily.

And suppose their prison had an echo from the wall facing them? When one of the people crossing behind them spoke, they could only suppose that the sound came from the shadow passing before their eyes.

No doubt.

In every way, then, such prisoners would recognize as reality nothing but the shadows of those artificial objects.

Inevitably.

Now consider what would happen if their release from the chains and the healing of their unwisdom should come about in this way. Suppose one of them set free and forced suddenly to stand up, turn his head, and walk with eyes lifted to the light; all these movements would be painful, and he would be too dazzled to make out the objects whose shadows he had been used to see. What do you think he would say, if someone told him that what he had formerly seen was meaningless illusion, but now, being somewhat nearer to reality and turned towards more real objects, he was getting a truer view? Suppose further that he were shown the various objects being carried by and were made to say, in reply to questions, what each of them was. Would he not be perplexed and believe the objects now shown him to be not so real as what he formerly saw?

Yes, not nearly so real.

And if he were forced to look at the fire-light itself, would not his eyes ache, so that he would try to escape and turn back to the things which he could see distinctly, convinced that they really were clearer than these other objects now being shown to him?

Yes.

And suppose someone were to drag him away forcibly up the steep and rugged ascent and not let him go until he had hauled him out into the sunlight, would he not suffer pain and vexation at such treatment, and, when he had come out into the light, find his eyes so full of its radiance that he could not see a single one of the things that he was now told were real?

Certainly he would not see them all at once.

He would need, then, to grow accustomed before he could see things in that upper world. At first it would be easiest to make out shadows, and then the images of men and things reflected in water, and later on the things themselves. After that, it would be easier to watch the heavenly bodies and the sky itself by night, looking at the light of the moon and stars rather than the Sun and the Sun's light in the day-time.

Yes, surely.

Last of all, he would be able to look at the Sun and contemplate its nature, not as it appears when reflected in water or any alien medium, but as it is in itself in its own domain.

No doubt.

And now he would begin to draw the conclusion that it is the Sun that produces the seasons and the course of the year and controls everything in the visible world, and moreover is in a way the cause of all that he and his companions used to see.

Clearly he would come at last to that conclusion.

Then if he called to mind his fellow prisoners and what passed for wisdom in his former dwelling-place, he would surely think himself happy in the change and be sorry for them. They may have had a practice of honouring and commending one another, with prizes for the man who had the keenest eye for the passing shadows and the best memory for the order in which they followed or accompanied one another, so that he could make a good guess as to which was going to come next. Would our released prisoner be likely to covet those prizes or to envy the men exalted to honour and power in the Cave? Would he not feel like Homer's Akhilleus, that he would far sooner "be on earth as a hired servant in the house of a landless man" or endure anything rather than go back to his old beliefs and live in the old way?

Yes, he would prefer any fate to such a life.

Now imagine what would happen if he went down again to take his former seat in the Cave. Coming suddenly out of the sunlight, his eyes would be filled with darkness. He might be required once more to deliver his opinion on those shadows, in competition with the prisoners who had never been released, while his eyesight was still dim and unsteady; and it might take some time to become used to the darkness. They would laugh at him and say that he had gone up only to come back with his sight ruined; it was worth no one's while even to attempt the ascent. If they could lay hands on the man who was trying to set them free and lead them up, they would kill him.[11]

Yes, they would.

Application of the Cave Allegory

Every feature in this parable, my dear Glaucon, is meant to fit our earlier analysis. The prison dwelling corresponds to the region revealed to us through the sense of sight, and the fire-light within it to the power of the Sun. The ascent to see the things in the upper world you may take as standing for the upward journey of the soul into the region of the intelligible; then you will be in possession of what I surmise, since that is what you wish to be told. Heaven knows whether it is true; but this, at any rate, is how it appears to me. In the world of knowledge, the last thing to be perceived and only with great difficulty is the essential Form of Goodness. Once it is perceived, the conclusion must follow that, for all things, this is the cause

10. The prisoners, having seen nothing but shadows, cannot think their words refer to the objects carried past behind their backs. For them shadows (images) are the only realities.

11. An allusion to the fate of Socrates.

of whatever is right and good; in the visible world it gives birth to light and to the lord of light, while it is itself sovereign in the intelligible world and the parent of intelligence and truth. Without having had a vision of this Form no one can act with wisdom, either in his own life or in matters of state.

So far as I can understand, I share your belief.

Then you may also agree that it is no wonder if those who have reached this height are reluctant to manage the affairs of men. Their souls long to spend all their time in that upper world—naturally enough, if here once more our parable holds true. Nor, again, is it at all strange that one who comes from the contemplation of divine things to the miseries of human life should appear awkward and ridiculous when, with eyes still dazed and not yet accustomed to the darkness, he is compelled, in a law-court or elsewhere, to dispute about the shadows of justice or the images that cast those shadows, and to wrangle over the notions of what is right in the minds of men who have never beheld Justice itself.

It is not at all strange.

No; a sensible man will remember that the eyes may be confused in two ways—by a change from light to darkness or from darkness to light; and he will recognize that the same thing happens to the soul. When he sees it troubled and unable to discern anything clearly, instead of laughing thoughtlessly, he will ask whether, coming from a brighter existence, its unaccustomed vision is obscured by the darkness, in which case he will think its condition enviable and its life a happy one; or whether, emerging from the depths of ignorance, it is dazzled by excess of light. If so, he will rather feel sorry for it; or, if he were inclined to laugh, that would be less ridiculous than to laugh at the soul which has come down from the light.

That is a fair statement.

If this is true, then, we must conclude that education is not what it is said to be by some, who profess to put knowledge into a soul which does not possess it, as if they could put sight into blind eyes. On the contrary, our own account signifies that the soul of every man does possess the power of learning the truth and the organ to see it with; and that, just as one might have to turn the whole body round in order that the eye should see light instead of darkness, so the entire soul must be turned away from this changing world, until its eye can bear to contemplate reality and that supreme splendour which we have called the Good. Hence there may well be an art whose aim would be to effect this very thing, the conversion of the soul, in the readiest way; not to put the power of sight into the soul's eye, which already has it, but to ensure that, instead of looking in the wrong direction, it is turned the way it ought to be.

Yes, it may well be so.

It looks, then, as though wisdom were different from those ordinary virtues, as they are called, which are not far removed from bodily qualities, in that they can be produced by habituation and exercise in a soul which has not possessed them from the first. Wisdom, it seems, is certainly the virtue of some diviner faculty, which never loses its power, though its use for good or harm depends on the direction towards which it is turned. You must have

noticed in dishonest men with a reputation for sagacity the shrewd glance of a narrow intelligence piercing the objects to which it is directed. There is nothing wrong with their power of vision, but it has been forced into the service of evil, so that the keener its sight, the more harm it works.

Quite true.

And yet if the growth of a nature like this had been pruned from earliest childhood, cleared of those clinging overgrowths which come of gluttony and all luxurious pleasure and, like leaden weights charged with affinity to this mortal world, hang upon the soul, bending its vision downwards; if, freed from these, the soul were turned round towards true reality, then this same power in these very men would see the truth as keenly as the objects it is turned to now.

Yes, very likely.

Is it not also likely, or indeed certain after what has been said, that a state can never be properly governed either by the uneducated who know nothing of truth or by men who are allowed to spend all their days in the pursuit of culture? The ignorant have no single mark before their eyes at which they must aim in all the conduct of their own lives and of affairs of state; and the others will not engage in action if they can help it, dreaming that, while still alive, they have been translated to the Islands of the Blest.

Quite true.

It is for us, then, as founders of a commonwealth, to bring compulsion to bear on the noblest natures. They must be made to climb the ascent to the vision of Goodness, which we called the highest object of knowledge; and, when they have looked upon it long enough, they must not be allowed, as they now are, to remain on the heights, refusing to come down again to the prisoners or to take any part in their labours and rewards, however much or little these may be worth.

Shall we not be doing them an injustice, if we force on them a worse life than they might have?

You have forgotten again, my friend, that the law is not concerned to make any one class specially happy, but to ensure the welfare of the commonwealth as a whole. By persuasion or constraint it will unite the citizens in harmony, making them share whatever benefits each class can contribute to the common good; and its purpose in forming men of that spirit was not that each should be left to go his own way, but that they should be instrumental in binding the community into one.

True, I had forgotten.

You will see, then, Glaucon, that there will be no real injustice in compelling our philosophers to watch over and care for the other citizens. We can fairly tell them that their compeers in others states may quite reasonably refuse to collaborate: there thay have sprung up, like a self-sown plant, in despite of their country's institutions; no one has fostered their growth, and they cannot be expected to show gratitude for a care they have never received. "But," we shall say, "it is not so with you. We have brought you into existence for your country's sake as well as for your own, to be like leaders and king-bees in a hive; you have been better and more thoroughly educated than those others and hence you are more capable of playing your part both as men of thought and as men of

action. You must go down, then, each in his turn, to live with the rest and let your eyes grow accustomed to the darkness. You will then see a thousand times better than those who live there always; you will recognize every image for what it is and know what it represents, because you have seen justice, beauty, and goodness in their reality; and so you and we shall find life in our commonwealth no mere dream, as it is in most existing states, where men live fighting one another about shadows and quarrelling for power, as if that were a great prize; whereas in truth government can be at its best and free from dissension only where the destined rulers are least desirous of holding office."

Quite true.

Then will our pupils refuse to listen and to take their turns at sharing in the work of the community, though they may live together for most of their time in a purer air?

No; it is a fair demand, and they are fair-minded men. No doubt, unlike any ruler of the present day, they will think of holding power as an unavoidable necessity.

Yes, my friend; for the truth is that you can have a well-governed society only if you can discover for your future rulers a better way of life than being in office; then only will power be in the hands of men who are rich, not in gold, but in the wealth that brings happiness, a good and wise life. All goes wrong when, starved for lack of anything good in their own lives, men turn to public affairs hoping to snatch from thence the happiness they hunger for. They set about fighting for power, and this internecine conflict ruins them and their country. The life of true philosophy is the only one that looks down upon offices of state; and access to power must be confined to men who are not in love with it; otherwise rivals will start fighting. So whom else can you compel to undertake the guardianship of the commonwealth, if not those who, besides understanding best the principles of government, enjoy a nobler life than the politician's and look for rewards of a different kind?

There is indeed no other choice.

Poetics

Aristotle

The objects the imitator represents are actions, with agents who are necessarily either good men or bad—the diversities of human character being nearly always derivative from this primary distinction, since the line between virtue and vice is one dividing the whole of mankind. It follows, therefore, that the agents represented must be either above our own level of goodness, or beneath it, or just such as we are. It is clear that each of the arts will admit of these differences, and that it will become a separate art by representing objects with this point of difference. Even in dancing, flute-playing, and lyre-playing such diversities are possible; and they are also possible in the nameless art that uses language, prose or verse without harmony, as its means. This difference it is that distinguishes Tragedy and Comedy also; the one would make its personages worse, and the

other better, than the men of the present day.

A third difference in these arts is in the manner in which each kind of object is represented. Given both the same means and the same kind of object for imitation, one may either (1) speak at one moment in narrative and at another as an assumed character, as Homer does; or (2) one may remain the same throughout, without any such change; or (3) the imitators may represent the whole story dramatically, as though they were actually doing the things described. Therefore, the differences in the imitation of these arts comes under three heads, their means, their objects, and their manner.

It is clear that the general origin of poetry was due to two causes, each of them part of human nature. Imitation is natural to man since childhood, one of his advantages over the lower animals being this, that he is the most imitative creature in the world, and learns at first by imitation. And it is also natural for all to delight in works of imitation. The truth of this second point is shown by experience: though the objects themselves may be painful to see, we delight to view the most realistic representations of them in art, the forms for example of the lowest animals and of dead bodies. The explanation is to be found in a further fact: to be learning something is the greatest of pleasures not only to the philosopher but also to the rest of mankind, however small their capacity for it; the reason of the delight in seeing the picture is that one is at the same time learning—gathering the meaning of things, e.g. that the man there is so-and-so; for if one has not seen the things before, one's pleasure will not be in the picture as an imitation of it, but will be due to the execution or coloring or some similar cause. Imitation, then, being natural to us—as also the sense of harmony and rhythm, the meters being obviously species of rhythms—it was through their original aptitude, and by a series of improvements for the most part gradual on their first efforts, that they created poetry out of their improvisations.

Poetry, however, soon broke up into two kinds according to the differences of character in the individual poets; for the graver among them would represent noble actions, and those of noble personages; and the meaner sort the actions of the ignoble. The latter class produced invectives at first, just as others did hymns and panegyrics. We know of no such poem by any of the pre-Homeric poets, though there were probably many such writers among them; instances, however, may be found from Homer downwards, e.g. his *Margites*, and similar poems of others. In this poetry of invectives its natural fitness brought an iambic meter into use; hence our present term "iambic," because it was the meter of their "iambs" or invectives against one another. The result was that some of the old poets became writers of heroic and others of iambic verse. Homer's position, however, is peculiar: just as he was in the serious style the poet of poets, standing alone not only through the literary excellence, but also through the dramatic character of his imitations, so too he was the first to outline for us the general forms of Comedy by producing not a dramatic invective, but a dramatic picture of the Ridiculous; his *Margites* in fact stands in the same relation to our comedies as the *Iliad* and the *Odyssey*

to our tragedies. As soon, however, as Tragedy and Comedy appeared in the field, those naturally drawn to the one line of poetry became writers of comedies instead of iambs, and those naturally drawn to the other, writers of tragedies instead of epics, because these new modes of art were grander and of more esteem than the old. If it be asked whether Tragedy is now all that it need be in its formative elements, to consider that, and decide it theoretically and in relation to the theatres, is a matter for further inquiry.

It certainly began in improvisations—as did also Comedy; the one originating with the authors of the Dithyramb, the other with those of the phallic songs, which still survive as institutions in many of our cities. And its advance after that was little by little, through their improving on whatever they had before them at each stage. It was in fact only after a long series of changes that the movement of Tragedy stopped on attaining its natural form. (1) The number of actors was first increased to two by Aeschylus, who curtailed the business of the Chorus, and made the dialogue, or spoken portion, take the leading part in the play. (2) A third actor and scenery were due to Sophocles. (3) Tragedy acquired also its magnitude. Discarding short stories and a ludicrous diction, through its passing out of its satyric stage, it assumed, though only at a late point in its progress, a tone of dignity; and its meter changed from trochaic to iambic. The reason for their original use of the trochaic tetrameter was that their poetry was satyric and more connected with dancing than it now is. As soon, however, as a spoken part came in, nature herself found the appropriate meter. The iambic, we know, is the most speakable of meters, as is shown by the fact that we very often fall into it in conversation, whereas we rarely talk hexameters, and only when we do depart from the speaking tone of voice. (4) Another change was a plurality of episodes or acts.

As for Comedy, it is (as has been observed) an imitation of men worse than the average; worse, however, not as regards any and every sort of fault, but only as regards one particular kind, the Ridiculous, which is a species of the Ugly. The Ridiculous may be defined as a mistake or deformity not productive of pain or harm to others; the mask, for instance, that excites laughter, is something ugly and distorted without causing pain.

Though the successive changes in Tragedy and their authors are not unknown, we cannot say the same of Comedy; its early stages passed unnoticed, because it was not yet taken up in a serious way. It was only at a late point in its progress that a chorus of comedians was officially granted by the archon; they used to be mere volunteers. It had also already certain definite forms at the time when the record of those termed comic poets begins. Who it was who supplied it with masks, or prologues, or a plurality of actors and the like, has remained unknown.

Epic poetry has been seen to agree with Tragedy to this extent, that of being an imitation of serious subjects in a grand kind of verse. It differs from it, however, (1) in that it is in one kind of verse and in narrative form; and (2) in its length—which is due to its action having no fixed limit of time, whereas Tragedy endeavors to keep as far as possible within a single circuit of the sun, or something near that. This, I say, is another point of difference between them, though at first the practice in this respect was just the same in tragedies as in epic poems. They differ also (3) in their constituents, some being common to both and others peculiar to Tragedy—hence a judge of good and bad in Tragedy is a judge of that in epic poetry also. All of the parts of an epic are included in Tragedy; but those of Tragedy are not all of them to be found in the Epic.

Let us proceed now to the discussion of Tragedy; before doing so, however, we must gather up the definition resulting from what has been said. A tragedy, then, is the imitation of an action that is serious and also, as having magnitude, complete in itself; in language with pleasurable accessories, each kind brought in separately in the parts of the work; in a dramatic, not a narrative form; with incidents arousing pity and fear, wherewith to accomplish its katharsis of such emotions. Here by "language with pleasurable accessories" I mean that with rhythm and harmony or song superadded; and by "the kinds separately" I mean that some portions are worked out with verse only, and others in turn with song.

As they act the stories, it follows that in the first place the Spectacle (or stage-appearance of the actors) must be some part of the whole; and in the second Melody and Diction; these two being the means of their imitation. Here by "Diction" I mean merely this, the composition of the verses; and by "melody," what is too completely understood to require explanation. But further: the subject represented also is an action; and the action involves agents, who must necessarily have their distinctive qualities both of character and thought, since it is from these that we ascribe certain qualities to their actions. There are in the natural order of things, therefore, two causes, Thought and Character, of their actions, and consequently of their success or failure in their lives. Now the action (that which was done) is represented in the play by the Fable or Plot. The Fable, in our present sense of the term is simply this, the combination of the incidents, or things done in the story; whereas Character is what makes us ascribe certain moral qualities to the agents; and Thought is shown in all they say when proving a particular point or, it may be, enunciating a general truth. There are six parts consequently of every tragedy, as a whole (that is) of such or such quality, viz. a Fable or Plot, Characters, Diction, Thought, Spectacle, and Melody; two of them arising from the means, one from the manner, and three from the objects of the dramatic imitation; and there is nothing else besides these six. Of these, its formative elements, then, not a few of the dramatists have made due use, as every play, one may say, admits of Spectacle, Character, Fable, Diction, Melody, and Thought.

The most important of the six is the combination of the incidents of the story. Tragedy is essentially an imitation not of persons but of action and life, of happiness and misery. All human happiness or misery takes the form of action; the end for which we live is a certain kind of activity, not a quality. Character gives us qualities, but it is in our actions—what we do—that we are happy or the reverse. In a play accordingly they do not act in order to portray the Characters; they include the Characters for the sake of the action. So that it is the action in it, i.e. its Fable or Plot, that is the end and purpose of the tragedy;

and the end is everywhere the chief thing. Besides this, a tragedy is impossible without action, but there may be one without Character.

The first essential, the life and soul, so to speak, of Tragedy is the Plot; the Characters come second—compare the parallel in painting, where the most beautiful colors laid on without order will not give one the same pleasure as a simple black-and-white sketch of a portrait. We maintain that Tragedy is primarily an imitation of action, and that it is mainly for the sake of the action that it imitates the personal agents. Third comes the element of Thought, i.e. the power of saying whatever can be said, or what is appropriate to the occasion. One must not confuse it with Character. Character in a play is that which reveals the moral purpose of the agents, i.e. the sort of thing they seek or avoid, where that is not obvious—hence there is no room for Character in a speech on a purely indifferent subject. Thought, on the other hand, is shown in all they say when proving or disproving some particular point, or enunciating some universal proposition. Fourth among the literary elements is the Diction of the personages, the expression of their thoughts in words, which is practically the same thing with verse as with prose. As for the two remaining parts, the Melody is the greatest of the pleasurable accessories of Tragedy. The Spectacle, though an attraction, is the least artistic of all the parts, and has least to do with the art of poetry. The tragic effect is quite possible without a public performance and actors; and besides, the getting-up of the Spectacle is more a matter for the costumier than the poet.

Let us now consider the proper construction of the Fable or Plot, as that is at once the first and the most important thing in Tragedy. We have laid it down that a tragedy is an imitation of an action that is complete in itself, as a whole of some magnitude; for a whole may be of no magnitude to speak of. Now a whole is that which has beginning, middle, and end. A beginning is that which is naturally after something itself, either as its necessary or usual consequent, and with nothing else after it; and a middle, that which is by nature after one thing and has also another after it. A well-constructed Plot, therefore, cannot either begin or end at any point one likes; beginning and end in it must be of the forms just described. Again: to be beautiful, a living creature, and every whole made up of parts, must not only present a certain order in its arrangement of parts, but also be of a certain definite magnitude. Beauty is a matter of size and order, and therefore impossible either (1) in a very minute creature, since our perception becomes indistinct as it approaches instantaneity; or (2) in a creature of vast size, so large that its unity and wholeness is lost to the beholder. Just in the same way, then, as a beautiful whole made up of parts, or a beautiful living creature, must be of some size, but a size to be taken in by the eye, so a story or Plot must be of some length, but of a length to be taken in by the memory. The limit set by the actual nature of the thing is this: the longer the story, consistently with its being comprehensible as a whole, the finer it is by reason of its magnitude. As a rough general formula, a length which allows of the hero passing by a series of probable or necessary stages from misfortune to happiness, or from happiness to misfortune, may suffice as a limit for the magnitude of the story.

The Unity of a Plot does not consist, as some suppose, in its having one man as its subject. An infinity of things befall that one man, some of which it is impossible to reduce to unity; and in like manner there are many actions of one man which cannot be made to form one action. The truth is that, just as in the other imitative arts one imitation is always of one thing, so in poetry the story, as an imitation of action, must represent one action, a complete whole, with its several incidents so closely connected with the transposal or withdrawal of any one of them will disjoin and dislocate the whole. For that which makes no perceptible difference by its presence or absence is no real part of the whole.

From what we have said it will be seen that the poet's function is to describe, not the thing that has happened, but a kind of thing that might happen, i.e. what is possible as being probable or necessary. The distinction between historian and poet is not in the one writing prose and the other verse—you might put the work of Herodotos into verse, and it would still be a species of history; it consists really in this, that the one describes the thing that has been, and the other a kind of thing that might be. Hence poetry is something more philosophic and of graver import than history, since its statements are of the nature rather of universals, whereas those of history are singulars. By a universal statement I mean one as to what such or such a kind of man will probably or necessarily say or do—which is the aim of poetry, though it affixes proper names to the characters.

It is evident that the poet must be more the poet of his stories or Plots than of his verses, inasmuch as he is a poet by virtue of the imitative element in his work, and it is actions that he imitates. And if he should come to a subject from actual history, he is none the less a poet for that; since some historic occurrences may very well be in the probable and possible order of things; and it is in that aspect of them that he is their poet.

Tragedy is an imitation not only of a complete action but also of incidents arousing pity and fear. Such incidents have the very greatest effect on the mind when they occur unexpectedly and at the same time in consequence of one another; there is more of the marvelous in them then than if they happened of themselves or by mere chance. Even matters of chance seem most marvelous if there is an appearance of design as it were in them. A Plot, therefore, of this sort is necessarily finer than others.

The next points after what we have said above will be these: (1) What is the poet to aim at, and what is he to avoid, in constructing his Plots? and (2) What are the conditions on which the tragic effect depends?

We assume that, for the finest form of Tragedy, the Plot must be not simple but complex: and further, that it must imitate actions arousing fear and pity, since that is the distinctive function of this kind of imitation. It follows, therefore, that there are three forms of Plot to be avoided. (1) A good man must not be seen passing from happiness to misery, or (2) a bad man from misery to happiness. The first situation is not fear-inspiring or piteous, but simply odious to us. The second is the most untragic that can be;

it has not one of the requisites of Tragedy; it does not appeal either to the human feeling in us, or to our pity, or to our fears. Nor, on the other hand, should (3) an extremely bad man be seen falling from happiness into misery. Such a story may arouse the human feeling in us, but it will not move us to either pity or fear; pity is occasioned by undeserved misfortune, and fear by that of one like ourselves; so that there will be nothing either piteous or fear-inspiring in the situation. There remains, then, the intermediate kind of personage, a man not pre-eminently virtuous and just, whose misfortune, however, is brought upon him not by vice or depravity but by some error of judgement, of the number of those in the enjoyment of great reputation and prosperity, e.g.: Oedipus, Thyestes, and the men of note of similar families. The perfect Plot, accordingly, must have a single, and not (as some tell us) a double issue; the change in the hero's fortunes must be not from misery to happiness, but on the contrary from happiness to misery; and the cause of it must lie not in any depravity, but in some great error on his part; the man himself being either such as we have described, or better, not worse than that. The theoretically best tragedy, then, has a Plot of this description. The critics, therefore, are wrong who blame Euripides for taking this line in his tragedies, and giving many of them an unhappy ending. It is, as we have said, the right line to take.

The tragic fear and pity may be aroused by the Spectacle; but they may also be aroused by the very structure and incidents of the play—which is the better way and shows the better poet. The Plot in fact should be so framed that, even without seeing the things take place, he who simply hears the account of them shall be filled with horror and pity at the incidents; which is just the effect that the mere recital of the story of *Oedipus* would have on one. To produce the same effect by means of the Spectacle is less artistic, and requires extraneous aid. Those, however, who make use of the Spectacle to put before us that which is merely monstrous and not productive of fear, are wholly out of touch with Tragedy; not every kind of pleasure should be required of a tragedy, but only its own proper pleasure.

The tragic pleasure is that of pity and fear, and the poet has to produce it by a work of imitation; it is clear, therefore, that the causes should be included in the incidents of his story. Let us see, then, what kinds of incident strike one as horrible, or rather as piteous. In a deed of this description the parties must necessarily be either friends, or enemies, or indifferent to one another. Now when enemy does it on enemy, there is nothing to move us to pity either in his doing or in his meditating the deed, except so far as the actual pain of the sufferer is concerned; and the same is true when the parties are indifferent to one another. Whenever the tragic deed, however, is done within the family—when murder or the like is done or meditated by brother on brother, by son on father, by mother on son, or son on mother—these are the situations the poet should seek after. The traditional stories, accordingly, must be kept as they are, e.g. the murder of Klytaimnestra by Orestes.

In the Characters there are four points to aim at. First and foremost, that they shall be good. There will be an element of character in the play, if (as has been observed) what a personage says or does reveals a certain moral purpose; and a good element of character, if the purpose so revealed is good. Such goodness is possible in every type of personage, even in a woman or a slave, though the one is perhaps an inferior, and the other a wholly worthless being. The second point is to make them appropriate. The Character before us may be, say, manly; but it is not appropriate in a female Character to be manly, or clever. The third is to make them like the reality, which is not the same as their being good and appropriate, in our sense of the term. The fourth is to make them consistent and the same throughout; even if inconsistency be part of the man before one for imitation as presenting that form of character, he should still be consistently inconsistent.

There should be nothing improbable among the actual incidents. If it be unavoidable, however, it should be outside the tragedy, like the improbability in the *Oedipus* of Sophocles. But to return to the Characters. As Tragedy is an imitation of personages better than the ordinary man, we in our way should follow the example of the good portrait-painters, who reproduce the distinctive features of a man, and at the same time, without losing the likeness, make him handsomer than he is. The poet in like manner, in portraying men quick or slow to anger, or with similar infirmities of character, must know how to represent them as such, and at the same time as good men, as Agathon and Homer have represented Akhilleus.

The Plot and Characters having been discussed, it remains to consider the Diction and the Thought. As for the Thought, we may assume what is said of it in our Art of Rhetoric, as it belongs more properly to that department of inquiry. The Thought of the personages is shown in everything to be effected by their language—in every effort to prove or disprove, to arouse emotion (pity, fear, anger, and the like) or to maximize or minimize things. It is clear, also, that their mental procedure must be on the same lines in their actions likewise, whenever they wish them to arouse pity or horror, or to have a look of importance or probability. The only difference is that with the act the impression has to be made without explanation; whereas with the spoken word it has to be produced by the speaker, and result from his language. What, indeed, would be the good of the speaker, if things appeared in the required light even apart from anything he says?

As regards the Diction, one subject for inquiry under this head is the turns given to the language when spoken; e.g. the difference between command and prayer, simple statement and threat, question and answer, and so forth. The theory of such matters, however, belongs to Elocution and the professors of that art. Whether the poet knows these things or not, his art as a poet is never seriously criticized on that account. What fault can one see in Homer's "sing of the wrath, Goddess"?—which Protagoras has criticized as being a command where a prayer was meant, since to bid one do or not do, he tells us, is a command. Let us pass over this, then, as appertaining to another art, and not to that of poetry.

Let this, then, suffice as an account of Tragedy, the art imitating by means of action on the stage.

CHAPTER SIX

THE ROMANS

The Romans conquered their world. By AD 70, they had destroyed the Temple at Jerusalem and colonized Britain, spreading their pragmatic version of the Hellenistic Mediterranean civilization to the Iron-Age peoples in north and west Europe. Under Augustus, Roman culture drew its inspiration from Greek classicism, and in that spirit glorified its capital city, its emperor, and the empire. The Augustan period, at the opening of the Christian era, forms a plateau linking the Roman Republic and Empire. A slide into chaos and ultimate extinction were to follow over the next 300 years. In contrast to the temples, art, and ideas of the Greeks, the Romans left us things with practical functions—roads, fortifications, viaducts, planned administration, and a sophisticated yet robust legal system. These provide us with the foundations for our society. Roman culture represents the final and, for us, the most historically important flowering of classical civilization.

6.1 *Gemma Augustea* (detail of the crowning of Augustus), early first century AD. Onyx cameo, whole cameo $7\frac{1}{2} \times 9$ ins (19 \times 23 cm). Kunsthistorisches Museum, Vienna.

CONTEXTS AND CONCEPTS

The civilization that would become the Roman one arose at the same time as that of ancient Greece. By the sixth century BC, the Etruscan invaders who had come out of Asia by way of Greece dominated the Italian peninsula. The Etruscans brought to their new land a militaristic and practical society, an ANTHROPOMORPHIC conception of the deities, and arts roughly equivalent to those of archaic Greece, whose style had influenced them. Roman legend held that Rome was founded in 753 BC by Romulus, an orphan, who, with his twin brother Remus, had been suckled by a wolf as the boys' foster-mother. One Etruscan religious cult revered wolves, and this legend is taken as further evidence that Roman civilization had Etruscan roots.

6.2 Etruscan warrior supporting a wounded comrade, early fifth century BC. Bronze, height (without base) 5¼ ins (13.4 cm). The Metropolitan Museum of Art, New York (Rogers Fund, 1947).

Despite the rich archeological record left by the Etruscans, very little is known about them as a people. There are several hypotheses about where they came from. They probably migrated from Asia at the end of the Hittite Empire. They joined with groups occupying the Italian peninsula perhaps as early as 1000 BC. It is clear that they had an advanced culture. Metallurgy had been developed as early as the tenth century BC. They were also literate, and had an alphabet much like the Greek one. Politically and economically, they were organized as a group of wealthy city–states governed by kings. One of these cities, at the southern edge of Etruria (the region for which the Etruscans are named), was Rome. Although small, Rome occupied an important location as a convenient bridging point across the Tiber River.

Toward the end of the sixth century BC, Rome joined with other Latin cities in instigating a revolt against Etruscan domination. In 509 BC, according to Roman tradition, the last Etruscan king was expelled from Rome. This set the Romans on a 900-year course that would lead them to all corners of the then known world. Etruscan influence continued, however, and it was largely due to that influence and its inherited links with Greece that the Romans carried forward the classical ideas that continue to permeate the western approach to life today.

THE ROMAN REPUBLIC

Once free of Etruscan domination, the Romans developed a republican form of government which lasted until the first century BC. This political stability provided important continuity for other Roman institutions. The motto "S.P.Q.R."—*Senatus Populusque Romanus*, "the Roman Senate and People"—reflected the early Roman political and social order, and remained the watchword of Roman society until Imperial times. It meant that sovereignty rested in the people themselves, and not in any particular form of government. In many ways the Roman Republic functioned as a democracy. Decisions affecting society were made at a series of assemblies which all citizens attended to express their will. The Senate, on the other hand, conducted the actual business of government, including the passage of legislation and the supervision of elected magistrates. Over the centuries, the greatest issues affecting Roman society were played out as dramas between the people and the Senate.

The Senate itself was an hereditary institution comprising an assembly of the heads, or *patres*, of old families

and, later, of wealthy members of the citizenry, or *plebs*. The Senate's 300 members therefore represented old and new money, power, and social interest. It was a self-renewing oligarchy. The two most important officers who ruled the state were the *consuls*. They were elected by the representative assemblies for one-year terms, at the end of which they became members of the Senate.

In Rome, the rich ruled via the Senate and the general citizenry were little more than peasants. By the third century BC, the division between aristocrat and peasant had widened appreciably—the former growing in riches and the latter sinking further and further into poverty. Yet as long as Rome remained reasonably small, the constitutional framework of the Republic held the social order together, it warded off revolution while permitting change, and provided the body politic with reasonably well trained leaders who knew how, above all else, to keep the Republic functioning and alive. It was, in fact, the internal stability of the Republic that made expansion possible, bringing about the next phase of Roman history.

Military expansion

Roman expansion was based on military conquest. Through conquest, Rome assumed a position of political dominance in the Hellenistic world during the third and second centuries. The internationalization of culture, evident in Hellenic times, increased further under the Romans. Later, Rome would extend its control throughout Europe and eventually as far as the British Isles.

Because Roman expansion and conquest depended upon strong military power, the Roman army became a powerful institution. Every male citizen (citizenship was bestowed on conquered peoples as well) who held property had an obligation to serve for up to 16 years in the army, if conscripted. The basic unit of the army was the legion, comprising 5000 men. Apparently the only occasion during the early period on which the army did not successfully discharge its responsibilities occurred in 390 BC, when the Gauls succeeded in sacking Rome itself.

By 272 BC, the Romans had conquered western Greece. Then they took on Carthage, the other major power of the period, in the first of the Punic wars. Over the next 100 years, in three great stages, Rome and Carthage battled each other for total control of the Mediterranean world. It was during the second Punic war, which began in 218 BC, that the Carthaginian general Hannibal marched his legions, including his elephant corps, over the Alps into Italy. The end of the second Punic war, in 202 BC, left Rome in a position of advantage and at a watershed.

Rome had the choice either to consolidate order and security in the west by ridding itself of the Carthaginian threat, or to expand toward the east. The Romans chose to move eastward, hoping to gain new riches from the conquered territories. The outcome, though unforeseen,

was to leave Rome overlord of the entire Hellenistic world. But with the third Punic war, which began in 149 BC, Rome also accomplished its other objective: within three years Carthage was destroyed.

Julius Caesar

The continuous state of war on the borders of the Roman provinces, as well as the practical requirements for effective government, led to an increase of power and authority in the hands of the Roman Senate and a decrease in the participation of ordinary citizens. Unlike Athens, Rome had very little commerce or industry, and the quality of life in Rome came to depend directly upon the wealth of conquered regions brought back to Rome as spoils.

Meanwhile, a new force was emerging in Roman political affairs. The immense wealth to be gained in conquered lands increased the power of the territorial governors and generals, most of whom came from patrician families. Even the most scrupulous politicians found it difficult to balance the needs imposed by running such a vast area with the requirements of the constitution, and corruption began to appear in the Senate. The populace was seething with turmoil and ripe for revolution. The conflict was between rich and poor, and both had a vote.

During the last century of the Republic, that is, from approximately 112 to 27 BC, a succession of men attempted leadership. Marius was the first of these. Then came a power struggle in the late first century BC from which the dictator Sulla emerged, to be followed by Pompey.

In 59 BC, Marius' nephew Julius Caesar (Caesar was the family name) was elected consul. During a five-year campaign against the Gauls, he kept a close watch on Roman politics. Corruption, intrigue, and murder were disfiguring public life and discrediting the Senate. Having returned to Italy in 49 BC he declared war on Pompey by crossing the River Rubicon, which marked the limit of his province. By 44 BC, he had returned to Rome in triumph, to be voted dictator for life. His life was cut short only days later, however, on 15 March 44 BC, at the hands of assassins in the Senate. After his death, Caesar was proclaimed a god.

One of Caesar's most lasting achievements was the invention of the Julian calendar, in which the year has 365 days, with an additional day every four years. The new calendar was used from 1 January 45 BC.

THE EMPIRE

If anyone had hoped that the assassination of Julius Caesar would bring about the return of Republican rule, they must surely have been disappointed. The political

BC/AD	PERIOD	GENERAL EVENTS	LITERATURE & PHILOSOPHY	VISUAL ART	THEATRE & DANCE	ARCHITECTURE
753BC		Legendary founding of Rome by Romulus and Remus Development of Etruscan civilization				
500		Roman revolution		Etruscan Warrior (6.2)	Phlyakes farces	
400		Gauls invade Rome			Mime	
300	Roman Republic	Roman conquest of western Greece First Punic war Second Punic war Hannibal	Stoicism of Chryssipus		Development of Roman comedy Plautus	
200		Marius Third Punic war	Middle Stoa Diogenes		Terence First stone theatres in Rome	The Pantheon (6.30–32) Temple of Fortuna Virilis (6.26)
100		Julius Caesar elected consul Julian calendar Battle of Actium Augustus, end of Republic	Roman Late Stoa Horace Seneca Virgil	Villa at Boscoreale (6.12) Portrait of an Unknown Roman (6.15) Augustus (6.16)	Pantomime invented	Vitruvius Ara Pacis (6.38)
0	Roman Empire	Roman destruction of the Temple of Jerusalem Mt. Vesuvius erupts	Livy Epictetus Juvenal, satire Apuleius New Testament	Hercules and Telephos (6.10) Lady playing a Cithara (6.11) Collegium of Augustales (6.13)		Forum of Augustus (6.36) The Colosseum (6.27) Arch of Titus (6.29)
100AD			Marcus Aurelius			
200			Plotinus	Sarcophagus (6.20)		
300		Split between Rome and Byzantium		Head of Constantine (6.19)		

6.3 Timeline of Roman culture.

6.4 The Roman Republic, showing important battles, and date (BC) that areas came under dominion.

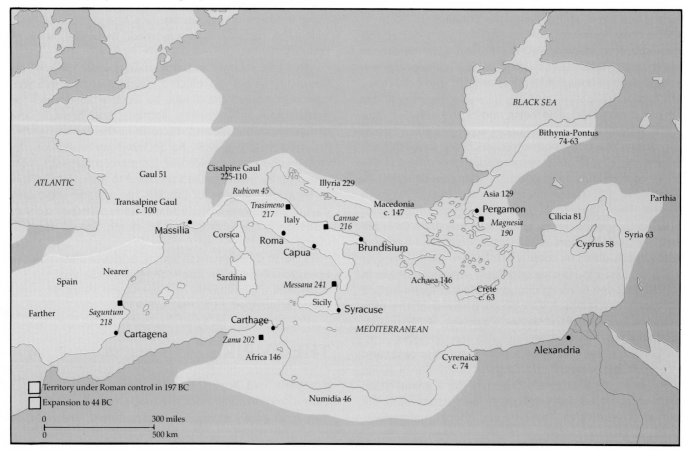

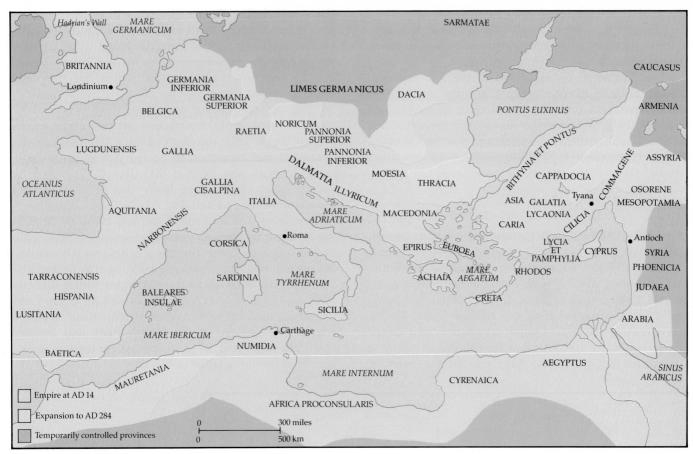

6.5 The Roman Empire AD 14–284.

6.6 Italy during the Roman Empire AD 14–284 showing date (BC) conquered.

turbulence simply continued, until Julius Caesar's great-nephew and adopted son Octavian defeated Mark Antony at the battle of Actium in 31 BC. Mark Antony's death brought some relief to the chaos. As Horace wrote in the 37th poem in his first book of *Odes*, "N*unc est bibendum nunc pede libero pulsanda tellus!*" ("Now is the time for drinking, now, with unshackled foot, for dancing!") Octavian took power, and Horace hailed him as Caesar, which became an honorific title.

Octavian knew how to adorn reality with palatable outward forms: he replaced democracy with autocracy, and made the public like it. In so doing, he called on the services of culture, religion, literature, architecture, and the visual arts to help create a new picture of the world. The result was a politically inspired aesthetic revolution, leading toward the legalization of absolute power. In 27 BC, Octavian formally divested himself of authority: he was promptly reinvested with it as "Augustus," by the Senate and the will of the people. Four years later he assumed complete power as the first emperor. This included the right of veto over any law, and thus formally ended the Republic.

This was the age of the poets Virgil and Horace, and Virgil's epic poem, the *Aeneid*, is said by some critics to have brought "instant mythology" to the Romans. Virgil

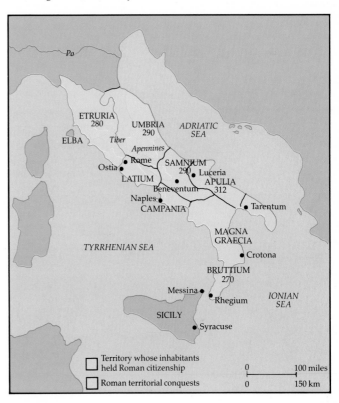

235

recognized the greatness of the golden age of Athens and the influence that Homer's *Iliad* and *Odyssey* had had upon that era. The *Aeneid* created a mythical history of Rome complete with a founding hero, Aeneas.

The Flavian–Antonine period of the late first and second centuries AD produced the architectural style we identify today as typically Roman, with its VAULTS and arches. During this time the Roman Empire expanded eastward, culminating in the siege and destruction of the Temple at Jerusalem in AD 70.

Jesus and Jerusalem

At the height of the Roman Empire, in the remote provincial capital of Jerusalem, a singular series of events marked the end of one era and the beginning of another. This watershed was the birth, life, and death (and, many believe, resurrection) of Jesus, or Jesus Christ. The name "Jesus" is an adaptation of the Hebrew name Joshua, which means "savior." "Christ" comes from the Greek translation of the Hebrew word for "Messiah," which in turn, means "anointed." The major sources of information about the life of Jesus are the gospels, written in Greek after Jesus' death by Matthew, Mark, Luke, and John (only Matthew and John were actually disciples). Other information is given by contemporary Jewish and Roman writers and by the letters, or epistles, written by the early Christian missionaries.

The western practice of distinguishing events as BC (before Christ) or AD (*Anno Domini*, or "year of our Lord") did not begin until the sixth century AD. Although the year AD 1 was supposed to be the year of Jesus' birth, many scholars now believe that date to be wrong by several years: it is more likely that Jesus was born sometime between 8 and 4 BC.

Jerusalem was (and still is) the holy city of the Jews. In AD 70, approximately 40 years after Jesus' crucifixion, the Romans destroyed the Temple at Jerusalem. This ended the era that had begun with the building of the temple by Solomon, son of David, nearly 1000 years earlier. The city of Jerusalem is holy to Moslems as well as to Jews and Christians. Reclaiming Jerusalem for Christianity was the goal of the crusades in the Middle Ages, and the city continues to be a focus of desperate contention among people of the three faiths to this day.

6.7 Imperial Rome.

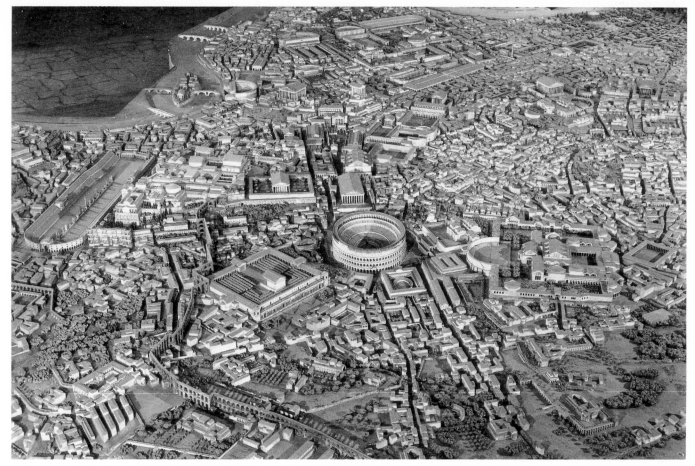

6.8 Scale model of ancient Rome. Museo della Civiltà Romana, Rome.

Decline and fall

In AD 180, the army seized power and, to all intents and purposes, central authority in Rome collapsed. For the next century and a half, emperors came and went, largely at the whim of the army, until early in the fourth century, when Constantine I assumed the throne. During his reign two vitally important events occurred. First, Christianity was recognized as the state religion in AD 337. Second, a new "Rome" was founded in the east at Byzantium, which was renamed Constantinople, and the empire thenceforth had two capital cities.

By the fifth century AD Rome had fallen to the Goths, and a new era in the history of western art and civilization was beginning.

Control of so vast an area for so long a time is the greatest monument to Roman genius. The Romans were superb managers and administrators. They brought to their world a code of law and innumerable engineering projects such as aqueducts and roads, many of which are still in use. Rome's Etruscan heritage bequeathed it a concern for the useful and the practical that became a focus for its architecture. Greek architecture had served the gods. It nearly always reflected mythical or religious conventions. But Roman architecture solved practical problems. The temple symbolizes Greek architecture,

while the triumphal arch, the bath, and the amphitheatre (Fig. **6.9**) symbolize that of the Romans.

ROMAN LAW

Probably the most influential concept developed by the Romans in any field was the technique for deciding how general laws could be applied to specific cases (jurisprudence). This question was dealt with by legal experts—jurisconsults—who were not part of the state machinery, but who had special knowledge of the meanings of laws. Judges were able to choose only from opinions they submitted; thus the jurisconsults, in effect, became the lawmakers.

Thus a knowledge of the law and a body of expert opinion on its interpretation was established and handed down. Legal knowledge replaced family and position as a requisite for the practice of law.

Roman law was transformed from a set of isolated instances into a legal system by applying philosophical methods to legal cases: drawing out similarities and differences between them. General principles could thus be laid down. These showed how laws should be applied consistently, thereby making the law predictable and the same for all.[1]

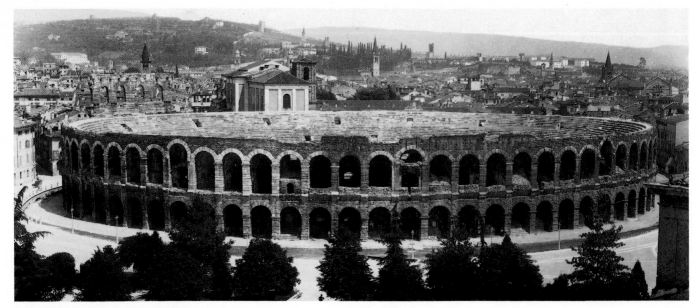

6.9 Amphitheatre, Verona, AD 290.

RELIGION

The religious system of the Romans contained elements from many other cultures, among them Etruscan, Greek, Syrian, Persian, and Egyptian. As in other areas of their culture, the Romans were a practical people, and they formed a religion corresponding to their needs. It was important that the gods would protect them, but it was not felt necessary to love and worship the deities in return.

The gods adopted by Rome fall into several distinct categories: gods of the state, such as Mars and Jupiter; agricultural divinities, such as Silvanus and Flora; gods of the Underworld, such as Orcus and the Manes; gods of the city, such as Fortuna and Tiberinus; deified heroes, such as Hercules and Aeneas; and gods of the family, such as the *lares* and *penates*.

STOICISM

Rome assimilated much of its thought from the Greeks and the Hellenistic world. For example, it was particularly receptive to Stoicism. For the Stoic, reason, or *logos*, governed the world, and the Great Intelligence was god. Specific guidelines for goodness and nobility gave order to life. The main tenets of Stoicism were acceptance of fate and duty, and the kinship of all people. The latter idea gave to Roman law the goal of providing justice for everyone, and this was one of Rome's great contributions to subsequent western culture. Essentially, however, Stoicism was deterministic. The Great Intelligence controlled all things, and a person could do nothing but submit to this greater will.

The philosophy of Stoicism followed a wandering course over the years. It traced its roots back to the Greek philosopher of the third century BC, Zeno. Then, it dealt primarily with a scheme of salvation and a way of life—that is, a definition of human happiness and a means of attaining it. By 280 BC, the Stoic philosohy had fallen under the charge of Chrysippus, who redefined it, giving it a form that would be unchanged for as long as Stoicism remained vital. Called the Old Stoa, this period witnessed a modification of some of the more extreme tenets, and a thrust which resulted in the Romans turning Stoicism into a religion.

On its way to Rome, Stoicism passed into the hands of Diogenes of Babylon in the second century BC, a period known as the Middle Stoa. Diogenes brought Stoicism to Rome in 156–155 BC, where he lectured on his philosophy, favorably impressing the Romans. The fate of Stoicism finally, however, depended upon the skills of Panaetius and Posidonius in the early first century BC. Under them it lost much of its cynicism, became more cultured and universal, and more attuned to the Roman spirit. Panaetius adopted Aristotle's definition of virtue as a "golden mean," and espoused the belief that material goods might not only be a means to right living, but could also be pursued as an end in themselves. An emphasis on temperance, propriety in daily life, and the performance of daily duty made Stoicism even more attractive to the Roman way of thinking.

As a result of the work of Panaetius and Posidonius, Rome became the home of Stoic philosophy and Stoicism entered its Late Stoa. The worldliness and common sense of the Romans made it into a mellow, urbane, and tolerant set of beliefs, and freed it from intellectual and moral dogmatism.

Seneca

The changes wrought on Stoicism by the Romans and the general nature of the times are illustrated by the writings of the Roman philosopher, dramatist, and statesman, Seneca (8 BC–AD 65). "Austere and somewhat sanctimonious by nature, he was given to deploring human weakness and to bewailing the vanity and wickedness of the world, from which he professed himself to await impatiently release in a happier home beyond the grave."[2] He was not, however, averse to success in his own life. His business sense was shrewd and he was tireless in his attempts to increase the considerable fortune he had inherited. While the Epicureans deprecated wealth, Seneca staunchly defended the "righteousness of great wealth" in his philosophical sermons. He believed that reason was bankrupt, and late Stoicism saw sentimental and moral needs as sufficient grounds for religious convictions.

Marcus Aurelius and Epictetus

By the time of Augustus Caesar (63 BC–AD 14), Stoicism had gained popularity among the masses as well as the upper classes, by accepting popular religion as an allegory of the truth. But by the time of Nero (AD 37–68), who sought to suppress all freedom of thought, Stoicism, which propounded free inquiry and discussion, had fallen on hard times. It was seen as a threat to the state, and many of its leaders were executed or exiled.

Stoicism reemerged as a central doctrine under the Stoic Emperor Marcus Aurelius (AD 121–80) who, along with the slave Epictetus, gave final definition to the revived philosophy. The *Discourses* and the *Manual* of Epictetus and the *Meditations* of Marcus Aurelius show us a somewhat old-fashioned Stoicism, leaning toward austerity and concerned mainly with moral and religious rules of behavior. Stoicism now appealed to the moral sense rather than the intellect, and turned people to the "way that led to happiness and peace." Salvation lay in cultivating independence from external circumstances, enriching oneself by religious sentiment, and having faith in "an assurance that all is for the best." Central to the thinking of both Marcus Aurelius and Epictetus was the idea that all people are the "children of one Father." Thus, everyone, regardless of age or status, should be loved uncritically, as one loves one's family.

Above all, the world was seen as rationally ordered. Everything was an expression of a divine Reason. Death was the end of the individual, merging each of us with that from which we sprang, and reuniting our reason with the *Logos* of which it was a part. Death was therefore to be neither feared nor desired: it was merely to be accepted. After Marcus Aurelius' death, however, Stoicism lost ground to the emerging Christianity.

PLOTINUS: BEAUTY AND SYMBOL

Plotinus (c.205–70) was an Egyptian-born philosopher and the greatest exponent of the neo-Platonist school: that is, a partial return to Platonic doctrines with additions from Stoic and Epicurean teachings.

According to Plotinus, beauty in art and nature reflect a unified universe—individual beauty is a reflection of harmony in the universe and a higher "reality" on which all experiences of beauty depend. As a result, artists' products are valuable because they are symbols of a higher order of existence. Plotinus was the first philosopher to treat art in a comprehensive manner. In the *Ennead*, Plotinus uses dance as a symbol of how nature has harmony and exists as a "living whole." He also reasons that a universal "Good" is the source of all "Beauty"; artworks—that is, man-made objects of beauty—thus imitate the universal "Beauty" and, in so doing, imitate the "Good." In addition, the arts are able to perfect the incomplete beauty of natural objects. As a result, for Plotinus, artworks occupy a special place in human experience because they form a bridge between incomplete natural objects and the universal concept of beauty, and, therefore, good: art raises the mind to a higher moral plane. An artwork can thus be seen as symbolic in two senses: it symbolizes the natural world, but perfected; and it symbolizes ultimate reality in the only way comprehensible to human minds.[3]

FOCUS

TERMS TO DEFINE

Roman Republic	Etruscans	Stoicism
Roman Empire	Senate	Neo-Platonism

PEOPLE TO KNOW

Romulus and Remus	Seneca	Marcus Aurelius
Julius Caesar	Augustus Caesar	Epictetus
	Jesus	Plotinus

DATES TO REMEMBER

Roman Republic	Founding of Rome (legend)
Roman Empire	Fall of Rome (approximate)

QUESTIONS TO ANSWER

1 What were the Punic wars and why were they important to Roman history?
2 In what ways did Stoicism reinforce Roman values?
3 According to Plotinus, where do works of art stand relative to nature and the ideal concept of Beauty?

THE ARTS
OF THE ROMANS

TWO-DIMENSIONAL ART

Very little Roman painting has survived. Most of what there is comes from Pompeii, preserved by the cataclysmic eruption of Mount Vesuvius. Most two-dimensional art appears to have been in bright colors, in FRESCO, that is, painting on wet plaster that becomes a permanent part of the wall surface, and much of that art was an outright copy of classical and Hellenistic work. Greek artists and craftspeople were brought to Rome, and it was they who produced most early Roman art. It is therefore not surprising that Roman painting reflected classical and Hellenistic themes and styles, although certain uniquely Roman qualities were added. We cannot promise that the illustrations that appear here are typical of Roman painting. They are, however, typical of what survives.

The wall painting of *Hercules and Telephos* (Fig. **6.10**) clearly displays the naturalistic figure depiction typical of the Hellenistic style. We also note the mythical and heroic nature of the subject matter. In contrast, the painting of the *Lady Playing the Cithara* (Fig. **6.11**) combines naturalistic detail with everyday subject matter. Each of these frescos is a formally composed picture, fitting its imposed boundary.

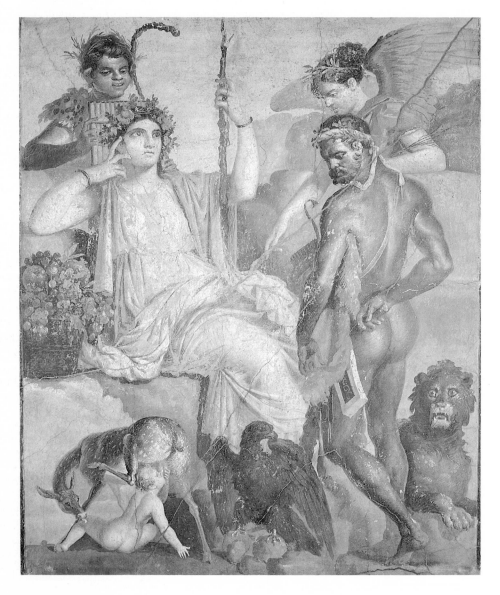

6.10 *Hercules and Telephos*, Roman copy of a Greek work of the second century BC. Wall painting from Herculaneum, 5 ft 7½ ins (1.71 m) high. Museo Archeologico Nazionale, Naples, Italy.

6.11 (opposite) *Lady Playing the Cithara*, c.50 BC. Wall painting, 6 ft 1½ ins (1.87 m) square. The Metropolitan Museum of Art, New York (Rogers Fund, 1903).

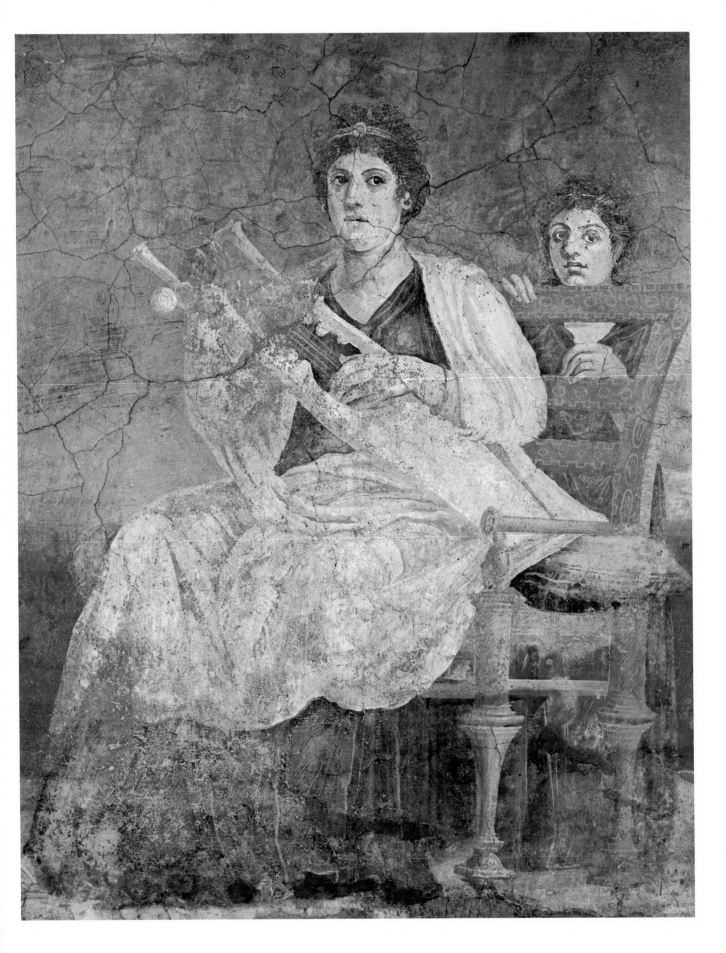

6.12 Bedroom of a villa at Boscoreale, Italy, showing painted decorations, c.50 BC. Wall painting, average height 8 ft (2.44 m). The Metropolitan Museum of Art, New York (Rogers Fund, 1903).

Much Roman wall painting combines landscape representation with painted architectural detail (Fig. **6.12**). Often, the outdoor view appears as a panoramic vista seen through a TROMPE L'OEIL window. Rooms painted in this style reflect the tastes of late Republican aristocratic society. They took as their models the opulence and stylishness of the late Hellenistic princely courts still influential around the Mediterranean.

Scenes from Greek mythology were very popular in Roman wall decoration. It is possible that the treatment of subject matter in wall painting had some relationship to the painting of scenery in the theatres. The Roman

6.13 Wall decoration, c.AD 70–79. Wall painting, room dimensions 14 ft 2 ins × 13 ft 4 ins (4.32 × 4.06 m). Collegium of the Augustales, Herculaneum.

architectural historian Vitruvius (first century AD) indicates in his book De Architectura that wall painters imitated theatrical scenery for tragedies, comedies, and satyr plays. Different styles prevailed in the different GENRES, and examples of each can be seen in surviving Roman wall paintings. Tragic scenery depicted columns, pediments, statues, and palace decor. Comic scenery portrayed private dwellings with balconies and windows. Satyric scenery illustrated trees, mountains, and rustic scenes. If the villa at Boscoreale does indeed reflect theatrical scenery, it seems clear that all three types are represented here. The left panel seems satyric, the center panel tragic, and the right panel comic.[4]

Mystery cults, especially that of Dionysus, were fashionable, and are represented in various manifestations in wall paintings, particularly in the so-called Villa of the Mysteries, located just outside the boundaries of the city of Pompeii.

The wall painting of the Flavian period of the first century shown in Figure **6.13** exemplifies the Roman taste for forceful colors and the painted "architectural structuring" of large areas. This was a shrine devoted to the cult of the emperor, and the central panel, depicting the introduction of Hercules into Olympus in the presence of Minerva and Juno, is a metaphor for the divinity of the emperor.

All these illustrations of Roman wall decoration demonstrate the colorfulness of Roman interior design. The style of the painting is certainly theatrical in other respects as well, but has a sense of permanence, not only in that it forms an integral part of the wall itself, but also in that each panel contains an architecturally complete composition, enclosed in a frame. This approach to pictorial art is very different from that of later periods in which pictures have frames that can be moved from place to place.

SCULPTURE

Not all Roman art was an imitative reconstruction of Greek prototypes, although some Roman statues do fit this category. Figure **6.14** illustrates a Roman copy of a Greek statue of Hermes dating back to c.400 BC. It would have represented to the Romans not only a mythological subject, but also the qualities of the earlier Hellenic era.

Some Roman sculpture, however, expresses a vigor that is uniquely Roman. Scholars do not always agree on what particular works of Roman sculpture mean, or on why they were made. The *Portrait of an Unknown Roman* (Fig. **6.15**) dates from a time when Hellenistic influence was becoming well established in Rome. It is tempting to

6.14 *Hermes*, Roman copy of a Greek work of c.400 BC. Marble, 5 ft 11 ins (1.8 m) high. The Metropolitan Museum of Art, New York (Gift of the Hearst Foundaton, 1956).

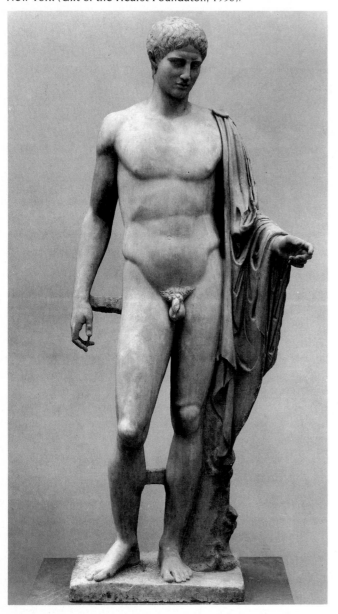

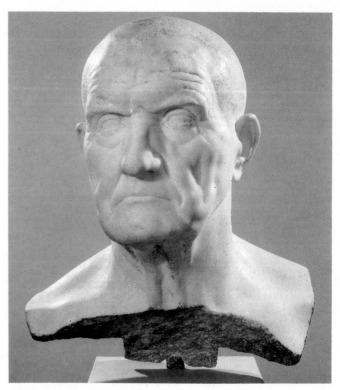

6.15 *Portrait of an Unknown Roman*, first century BC. Marble, 14⅜ ins (36.5 cm) high. The Metropolitan Museum of Art, New York (Rogers Fund).

attribute the highly realistic representation of this work to the same artistic viewpoint that governed Hellenistic style, and conclude that it is a copy of a Hellenistic work. An important Etruscan–Roman religious practice undoubtedly had a stronger influence, however. Portraits were an integral part of household and ancestor worship, and wax death masks were often made and kept by the family to remember a loved one. Wax is not a substance ideally suited for immortality, and it is possible that the bust in Figure **6.15** was made from a death mask. There may be more to this portrait, however, than mere accuracy. Some scholars point to an apparent emphasis on certain features which reinforces the ideas of ruggedness and character.

The straightforward naturalism of the Republic was modified during the Augustan period. Although Hellenistic influence had become strong by the late first century BC, in certain quarters, Greek classical influence always predominated—but with a Roman, that is, a more practical and individual, flavor. By the time of the empire, classical influence had gained precedence, returning sculpture to the idealized character of that of Periclean Athens.

Augustus (Fig. **6.16**) boasted that when he came to power Rome was a city of sun-dried bricks, and that when

6.16 (opposite) Augustus in armor, Villa of Livia, Prima Porta, c.20 BC. Marble, 6 ft 8 ins (2.03 m) high. Vatican Museums, Rome.

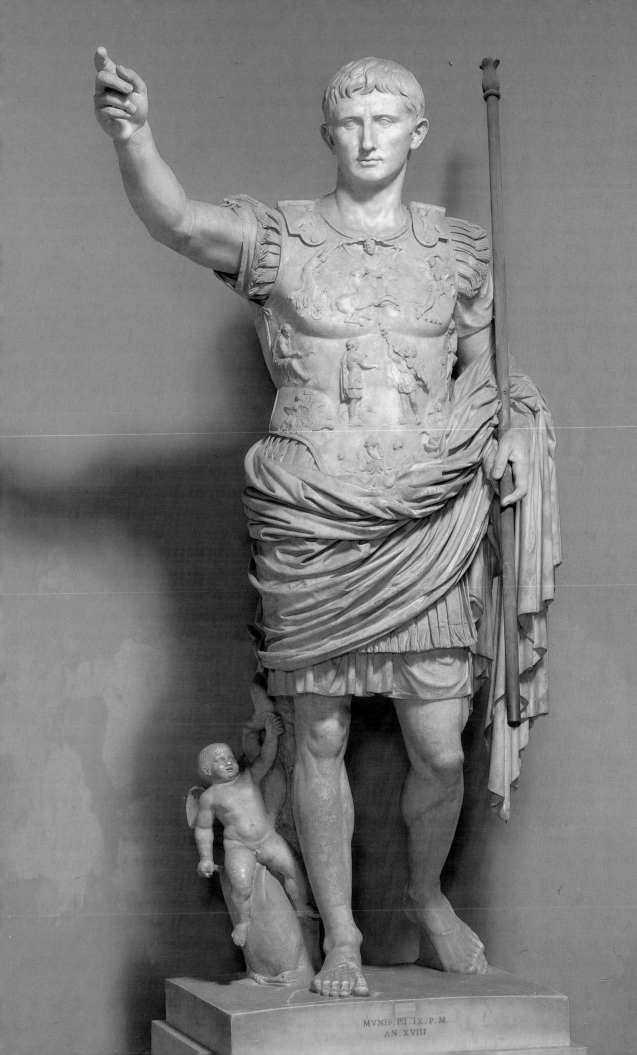

MVNIF·PII·IX·P·M·
AN·XVIII

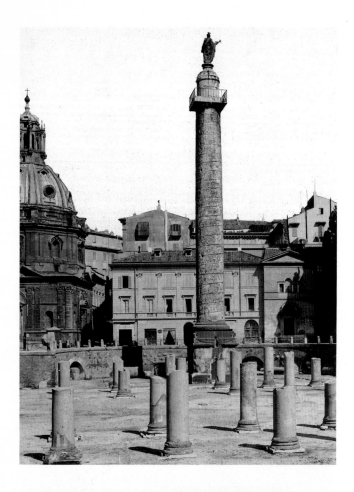

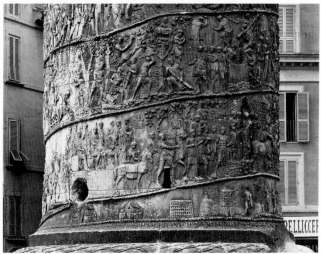

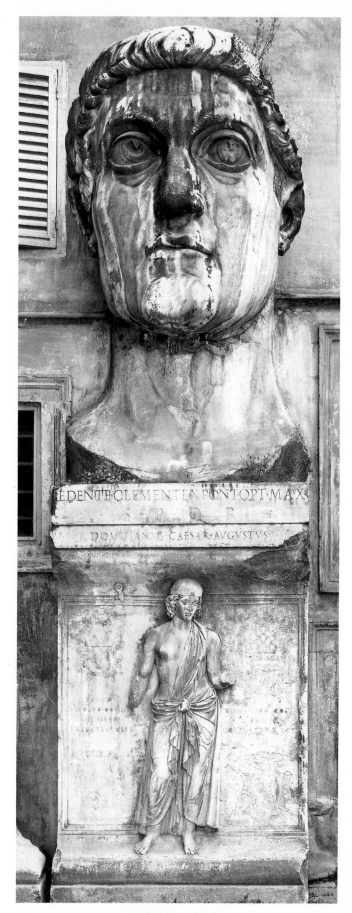

6.17 (above, top) Apollodorus of Damascus, Trajan's Column and ruins of Basilica Ulpia, Rome. Trajan's Column AD 106–13. Marble; height of base 18 ft (5.49 m), height of column 97 ft (29.57 m).

6.18 (above) Trajan's Campaign against the Dacians, detail of Trajan's Column, AD 106–13. Marble, height of frieze band 4 ft 2 ins (1.27 m).

6.19 (right) Head of Constantine the Great (originally part of a colossal seated statue), AD 313. Marble, 8 ft 6¾ ins (2.61 m) high. Palazzo dei Conservatori, Rome.

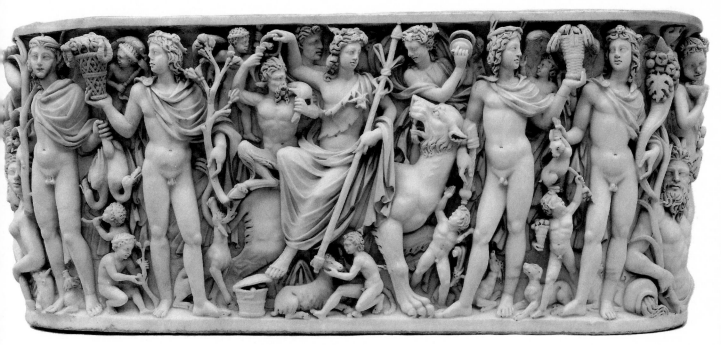

6.20 Roman sarcophagus, showing Dionysus, the Seasons and other figures, c.AD 220–30. Marble, 7 ft 3¾ ins (2.23 m) long. The Metropolitan Museum of Art, New York (Purchase, 1955, Joseph Pulitzer Bequest).

he left it, it had become a metropolis of marble. Greek classical form in sculpture was revived and translated into vital forms of the present. The Greek concept of the "perfect body" held sway. It was common for a sculptor to copy the idealized body of a well known Greek statue and add to it a highly realistic portrait head of a contemporary Roman. Other figures after the Greek style were similarly Romanized. A male nude might be draped in a toga; another might be made to represent Augustus in armor. The aesthetics of sculptural depiction thus remained Greek, with Roman clothing added. The pose, rhythm, and movement of the body originated in the past.

At this time much sculpture portrayed the emperor. Emperors had been raised to the status of gods, perhaps because in so far-flung an empire it was useful for people to revere their leaders as superhuman.

Other sculptures told the story of a leader's accomplishments. Trajan's Column, erected in the Emperor's Forum, rose 128 feet above the pavement on an 18-foot base. Atop the 97-foot column stood a more than twice life-size statue of Trajan (Fig. **6.17**). (Trajan's statue was later replaced by a figure of St Peter.) Inside the column, a staircase winds upward to the top. On the outside, from bottom to top, a spiral band of relief sculpture (Fig. **6.18**) depicts the campaign in which Trajan defended Rome. Trajan himself appears 90 times in the narration, each appearance marking the start of a new episode.

The sculpture relies on symbolism and convention. Water is represented by a waving line; mountains, by jagged lines. Proportions are not realistic, and perspective is irrational. However, the intent and effect are clear.

Trajan's story unfolds in a form to be "read" by the man and woman in the street.

The fact that people are people, and not gods, was not long in returning to Roman consciousness, however, and third-century sculpture exhibited a stark and expressive realism. In the fourth century AD, Constantine I, a new and powerful emperor, took the throne. His likeness (Fig. **6.19**), part of a gigantic sculpture (the head is over eight feet tall), has an exaggerated, ill-proportioned intensity. This work is not a portrait of Constantine. Instead, it is the artist's view of Constantine's presentation of himself as emperor and of the office of emperor itself.

We have touched already on the death mask as Roman funerary art. The intricate relief sculpture which decorated Roman sarcophagi shows the way that Roman art reflected private life. This type of sculpture emerged early in the second century AD when the practice of cremation fell out of favor. Marble sarcophagi were adorned with rich and varied relief decoration. There were three major centers of sarcophagus production—Athens, Asia Minor, and Rome. Sarcophagi were often exported before completion and finished at the site. Attic sarcophagi had decoration on all four sides, with scenes drawn from Greek mythology. They were typically carved in high relief, with a somber tone. Sarcophagi from Asia Minor had figures carved almost in the round, against a background of architectural detail. Roman sarcophagi were carved on three sides, with the fourth side designed to sit against a wall. The front typically showed a mythological scene, while the ends were carved with decorative motifs in low relief (Fig. **6.20**).

LITERATURE

The practical early Romans did not produce any remarkable literature. When literature as an art form did become reasonably popular, it was Greek slaves who nurtured it. The first literary works were imitations of Greek works, and they were written in Greek. Latin was initially considered a peasant language, with few words capable of expressing abstract notions. A Latin prose style and vocabulary for the expression of philosophical ideas had to wait for Cicero.

During the reign of Augustus, the poets Horace and Virgil were commanded to write verses glorifying the emperor, the origins of Rome, the simple honesty of rural Roman life, patriotism, and the glory of dying for one's country. Livy set about retelling Roman history in sweeping style. An epic account of the journey of Aeneas from the ruins of Troy to the shores of Italy, Virgil's *Aeneid* far surpasses mere propaganda. Here we include the main section of Book I.

Arms and the man I sing, who first made way
Predestined exile, from the Trojan shore
To Italy, the blest Lavinian strand.
Smitten of storms he was on land and sea
By violence of Heaven, to satisfy
Stern Juno's sleepless wrath; and much in war.
He suffered, seeking at the last to found
The city, and bring o'er his fathers' gods
To safe abode in Latium; whence arose
The Latin race, old Alba's reverend lords, 10
And from her hills wide-walled, imperial Rome.

O Muse, the causes tell! What sacrilege,
Or vengeful sorrow, moved the heavenly Queen
To thrust on dangers dark and endless toil
A man whose largest honor in men's eyes
Was serving Heaven? Can gods such anger feel?

In ages gone an ancient city stood—
Carthage, a Tyrian seat, which from afar
Made front on Italy and on the mouths
Of Tiber's stream; its wealth and revenues 20
Were vast, and ruthless was its quest of war.

'Tis said that Juno, of all lands she loved,
Most cherished this,—not Samos' self so dear.
Here were her arms, her chariot; even then
A throne of power o'er nations near and far,
If Fate opposed not, 'twas her darling hope
To 'stablish here; but anxiously she heard
That of the Trojan blood there was a breed
Then rising, which upon the destined day
Should utterly o'erwhelm her Tyrian towers; 30
A people of wide sway and conquest proud
Should compass Libya's doom—such was the web
The Fatal Sisters spun.
 Such was the fear
Of Saturn's daughter, who remembered well
What long and unavailing strife she waged

For her loved Greeks at Troy. Nor did she fail
To meditate th' occasions of her rage,
And cherish deep within her bosom proud
Its griefs and wrongs: the choice by Paris made;
Her scorned and slighted beauty; a whole race 40
Rebellious to her godhead; and Jove's smile
That beamed on eagle-ravished Ganymede.
With all these thoughts infuriate, her power
Pursued with tempests o'er the boundless main
The Trojans, though by Grecian victor spared
And fierce Achilles; so she thrust them far
From Latium; and they drifted, Heaven-impelled
Year after year, o'er many an unknown sea—
O labor vast, to found the Roman line!
Below th' horizon the Sicilian isle 50
Just sank from view, as for the open sea
With heart of hope they sailed, and every ship
Clove with its brazen beak the salt, white waves.
But Juno of her everlasting wound
Knew no surcease, but from her heart of pain
Thus darkly mused: "Must I, defeated, fail
Of what I will, nor turn the Teucrian King
From Italy away? Can Fate oppose?
Had Pallas power to lay waste in flame
The Argive fleet and sink its mariners, 60
Revenging but the sacrilege obscene
By Ajax wrought, Oileus' desperate son?
She, from the clouds, herself Jove's lightning threw,
Scattered the ships, and ploughed the sea with storms.
Her foe, from his pierced breast out-breathing fire,
In whirlwind on a deadly rock she flung.
But I, who move among the gods a queen,
Jove's sister and his spouse, with one weak tribe
Make war so long! Who now on Juno calls?
What suppliant gifts henceforth her altars crown?" 70

So, in her fevered heart complaining still,
Unto the storm-cloud land the goddess came,
A region with wild whirlwinds in its womb,
Aeolia named, where royal Aeolus
In a high-vaulted cavern keeps control
O'er warring winds and loud concourse of storms.
There closely pent in chains and bastions strong,
They, scornful, make the vacant mountain roar,
Chafing against their bonds. But from a throne
Of lofty crag, their king with sceptred hand 80
Allays their fury and their rage confines.
Did he not so, our ocean, earth, and sky
Were whirled before them through the vast inane
But over-ruling Jove, of this in fear,
Hid them in dungeon dark: then o'er them piled
Huge mountains, and ordained a lawful king
To hold them in firm sway, or know what time,
With Jove's consent, to loose them o'er the world.

To him proud Juno thus made lowly plea:
"Thou in whose hands the Father of all gods 90
And Sovereign of mankind confides the power
To calm the waters or with winds upturn,
Great Aeolus! a race with me at war
Now sails the Tuscan main towards Italy,
Bringing their Ilium and its vanquished powers.

Uprouse thy gales! Strike that proud navy down!
Hurl far and wide, and strew the waves with dead!
Twice seven nymphs are mine, of rarest mould,
Of whom Deiopea, the most fair,
I give thee in true wedlock for thine own, 100
To mate thy noble worth; she at thy side
Shall pass long, happy years, and fruitful bring
Her beauteous offspring unto thee their sire."
Then Aeolus: "'Tis thy sole task, O Queen,
To weigh thy wish and will. My fealty
Thy high behest obeys. This humble throne
Is of thy gift. Thy smiles for me obtain
Authority from Jove. Thy grace concedes
My station at your bright Olympian board,
And gives me lordship of the darkening storm." 110
Replying thus, he smote with spear reversed
The hollow mountain's wall; then rush the winds
Through that wide breach in long embattled line,
And sweep tumultuous from land to land:
With brooding pinions o'er the waters spread,
East wind and south, and boisterous Afric gale
Upturn the sea; vast billows shoreward roll;
The shout of mariners, the creak of cordage,
Follow the shock; low-hanging clouds conceal
From Trojan eyes all sight of heaven and day; 120
Night o'er the ocean broods; from sky to sky
The thunders roll, the ceaseless lightnings glare;
And all things mean swift death for mortal man.
Straightway Aeneas, shuddering with amaze,
Groaned loud, upraised both holy hands to Heaven,
And thus did plead: "O thrice and four times blest,
Ye whom your sires and whom the walls of Troy
Looked on in your last hour! O bravest son
Greece ever bore, Tydides! O that I
Had fallen on Ilian fields, and given this life 130
Struck down by thy strong hand! where by the spear
Of great Achilles, fiery Hector fell,
And huge Sarpedon; where the Simois
In furious flood engulfed and whirled away
So many helms and shields and heroes slain!"
While thus he cried to Heaven, a shrieking blast
Smote full upon the sail. Up surged the waves
To strike the very stars; in fragments flew
The shattered oars; the helpless vessel veered
And gave her broadside to the roaring flood, 140
Where watery mountains rose and burst and fell.
Now high in air she hangs, then yawning gulfs
Lay bare the shoals and sands o'er which she drives.
Three ships a whirling south winds snatched and flung
On hidden rocks,—altars of sacrifice
Italians call them, which lie far from shore
A vast ridge in the sea; three ships beside
An east wind, blowing landward from the deep,
Drove on the shallows,—pitiable sight,—
And girdled them in walls of drifting sand. 150

That ship, which, with his friend Orontes, bore
The Lycian mariners, a great, plunging wave
Struck straight astern, before Aeneas' eyes.
Forward the steersman rolled and o'er the side
Fell headlong, while three times the circling flood

6.21 *Dido sacrificing*, illustration to Virgil's *Aeneid*, early fifth century AD. Parchment, page width 13 ins (33.2 cm). Biblioteca Apostolica, Vatican Museum.

Spun the light bark through swift engulfing seas.
Look, how the lonely swimmers breast the wave!
And on the waste of waters wide are seen
Weapons of war, spars, planks, and treasures rare,
Once Ilium's boast, all mingled with the storm. 160
Now o'er Achates and Ilioneus.
Now o'er the ship of Abas or Aletes,
Burst the tempestuous shock; their loosened seams
Yawn wide and yield the angry wave its will.

Meanwhile, how all his smitten ocean moaned,
And how the tempest's turbulent assault
Had vexed the stillness of his deepest cave,
Great Neptune knew; and with indignant mien
Uplifted o'er the sea his sovereign brow.
He saw the Teucrian navy scattered far 170
Along the waters; and Aeneas' men
O'erwhelmed in mingling shock of wave and sky.
Saturnian Juno's vengeful stratagem
Her brother's royal glance failed not to see;
And loud to eastward and to westward calling,
He voiced this word: "What pride of birth or power
Is yours, ye winds, that, reckless of my will,
Audacious thus, ye ride through earth and heaven,
And stir these mountains waves? Such rebels!—
Nay, first I calm this tumult! But yourselves 180
By heavier chastisement shall expiate
Hereafter your bold trespass. Haste away
And bear your king this word! Not unto him
Dominion o'er the seas and trident dread,
But unto me, Fate gives. Let him possess
Wild mountain crags, thy favored haunt and home,
O Eurus! In his barbarous mansion there,
Let Aeolus look proud, and play the king
In yon close-bounded prison-house of storms!"
He spoke, and swiftlier than his word subdued 190
The swelling of the floods; dispersed afar
Th' assembled clouds, and brought back light to heaven.
Cymothoë then and Triton, with huge toil,
Thrust down the vessels from the sharp-edged reef

While, with the trident, the great god's own hand
Assists the task; then, from the sand-strewn shore
Out-ebbing far, he calms the whole wide sea,
And glides light-wheeled along the crested foam.
As when, with not unwonted tumult, roars
In some vast city a rebellious mob, 200
And base-born passions in its bosom burn,
Till rocks and blazing torches fill the air
(Rage never lacks for arms)—if haply then
Some wise man comes, whose reverend looks attest
A life to duty given, swift silence falls;
All ears are turned attentive; and he sways
With clear and soothing speech the people's will.
So ceased the sea's uproar, when its grave Sire
Lookd o'er th' expanse, and, riding on in light,
Flung free rein to his winged obedient car. 210

Aeneas' wave-worn crew now landward made,
And took the nearest passage, whither lay
The coast of Libya. A haven there
Walled in by bold sides of a rocky isle,
Offers a spacious and secure retreat,
Where every billow from the distant main
Breaks, and in many a rippling curve retires.
Huge crags and two confronted promontories
Frown heaven-high, beneath whose brows outspread
The silent, sheltered waters; on the heights 220
The bright and glimmering foliage seems to show
A woodland amphitheatre; and yet higher
Rises a straight-stemmed grove of dense, dark shade.
Fronting on these a grotto may be seen,
O'erhung by steep cliffs; from its inmost wall
Clear springs gush out; and shelving seats it has
Of unhewn stone, a place the wood-nymphs love.
In such a port, a weary ship rides free
Of weight of firm-fluked anchor or strong chain.
Hither Aeneas, of his scattered fleet 230
Saving but seven, into harbor sailed;
With passionate longing for the touch of land,
Forth leap the Trojans to the welcome shore,
And fling their dripping limbs along the ground.[5]

The influence of the lyric poet Horace, Virgil, and Livy on western culture is difficult to overestimate. In the words of one commentator, "They are so much a part of us that we take their values for granted and their epigrams for truisms."[6] To the emperor Augustus, they fully expressed the Roman tradition and Roman language. The three writers created a literature that distracted the upper classes from Greek "free thought" and made it easier for the emperor to rally them to the "ancient Roman order" as represented in his person.

A moralizing Stoicism runs throughout the literature of the Augustan period. In poetry, this Stoicism was expressed through satire, which allowed writers to combine morality with popular appeal. Martial and Juvenal used satire to attack vice by describing it in graphic detail. Petronius produced satirical PICARESQUES of verse and prose that were as readable as Martial's and Juvenal's

work, but free of their moralizing.

Finally, Apuleius and Lucan followed in the same tradition. Apuleius' *Golden Ass* is one of the earliest precursors of the novel. The author creates a fictional biography that describes how the central character is tried and condemned to death for the murder of three wineskins. He is brought back to life by a sorceress, but as he tries to follow her in the form of a bird, he is changed instead into an ass. The only cure for this affliction appears to be the procurement of some rose leaves, and in his search for these, he has bizarre and fantastic adventures.

One of the most significant works produced during this time was the New Testament of the Bible. A collection of prose writings by early Christian disciples and apostles, it begins with the Gospels attributed to Matthew, Mark, Luke, and John, which tell of the life and teachings of Jesus. It also includes the Acts of the Apostles—the missionary efforts of Peter and Paul—plus a series of epistles (letters) and the apocalyptic vision of John called Revelation.

THEATRE

The Romans loved entertainment, and particularly drama. Roman drama, for the most part, occupied the opposite end of the intellectual spectrum from classical Greek theatre. Roman theatre was wild, unrestrained, lewd, and highly realistic. Accounts of stage events suggest that very little was left to the audience's imagination. The Roman theatre buildings might seem strange to us and we would need to learn the conventions behind the use of the various masks, but for the most part we would probably find the grotesquely padded costumes and farcical action as hilarious as the Romans did.

Dramatic forms

Three important dramatic forms prevailed at various times in Roman history: *phlyakes* FARCE, Roman comedy, and MIME. Probably the earliest was the *phlyakes* farce which may be traceable to Greek origins in Sicily as early as the fifth century BC. The *phlyakes* (the name derives from the word for "gossips") had an earthy style. Its themes parodied mythology and, later, burlesqued tragedy. Very little literary evidence exists about the *phlyakes*, but a considerable number of vase paintings testify to its existence and character. If such evidence can be taken at face value, the *phlyakes* was bawdy, with actors suggestively padded and extravagantly masked. These farces seem to have used a raised stage consisting of a rough wooden platform with a simple background, and doors for entrances and exits. Curtains masked the area below the stage.

As Roman comedy developed in the third and

second centuries BC, it borrowed much from Hellenistic comedy, with its large theatres, high stages, and elaborate scene buildings (see Chapter 5). The Romans were receptive to the New Comedy of Menander and assimilated it quickly. The importation of this Greek comedy led to the rise of two of Rome's most important playwrights, Plautus (c.254–184 BC) and Terence (c.185–159 BC).

The 20 plays by Plautus that survive provide a picture of a playwright who was principally a translator and adaptor. He copied Greek originals, changing the locations to Rome and inserting details of Roman domestic life. His characters were types, not individuals: the braggart soldier, the miser, the parasite, and the wily but mistreated slave. With their slapstick humor and "sight gags," Plautus' plays are full of farcical energy and appeal directly to the emotions, not to the intellect. They are not particularly well written, but they work well enough on stage.

Terence was better educated than Plautus, and a more literary writer. He enjoyed the support of a wealthy patron. In his six extant plays he appears to be a dramatist capable of drawing universal situations and characters. Like Plautus, he had a great influence on the theatre of later ages. He was not particularly popular with Roman audiences, however, perhaps because he did not use banality and buffoonery.

The third form of Roman theatre, the mime, may in fact have been older than the other two forms, but it did not achieve prominence in Rome until the time of the empire. Mimes dealt with low life, and appealed to all classes of Romans. Some mimes were adventures, and some ridiculed Christianity, particularly the rite of baptism. Consequently they found little favor with the Christian community and early Christian writers condemned the obscenities of the mimes, noting that adultery actually took place on stage. While that may be an exaggeration, the style of Roman theatre in general clearly was anti-classical. Idealization, formality, simplicity, and intellectual appeal were not among its characteristics.

Theatre fulfilled an important social function in keeping the minds of the masses off their problems. Yet it also served as a forum in which the general public could address grievances to the bureaucracy. When an official of the state had betrayed his trust, when a wrong had been suffered, or when an impropriety of state had become flagrant, the bite of Roman satire could be fierce, direct, and penetrating.

Theatre design

The design of theatre buildings in Rome changed over the centuries. For years the rough, raised stage of the *phlyakes* sufficed. Indeed, all theatres were constructed of wood until the second century BC. The plan to build a permanent stone theatre brought to a head some of the moral, political, and philosophical conflicts within Rome. In 54 BC, one year after construction of the first stone theatre had begun, the Roman Senate passed a decree that no seats should be provided in any theatre, and, furthermore, no one should sit down at any theatre production in the city or within a mile of its gates. Their grounds were that theatre was injurious to public morals. Three years later, the consul Pompey nevertheless built a permanent stone theatre (seating 40,000), copied, according to Plutarch, from the Hellenistic theatre at Mytilene on the island of Lesbos. To circumvent the Senate's decree, he placed a shrine to Venus at the highest point in the rear of the auditorium so that all the seats served as steps to the shrine.

By the turn of the Christian era, the *orchestra* of the Greek theatre had been infringed upon by the scene building, so that the theatre had become a single architectural unit. The Romans added two new features to their theatres: one was a curtain, which could be raised and lowered from a slot across the front of the stage; the second was a roof over the stage which served both to protect the stage and to improve the ACOUSTICS.

The ground plan of the Theatre of Marcellus (Fig. **6.22**) demonstrates how the vestiges of the Greek theatre building were developed into a unified, single construction. Rather than being carved out of a hillside, the Roman theatre was a free-standing building. The circular *orchestra* of classical Greece became a semicircle. The action of the play took place on a raised stage, and the background became an elaborate wall, usually ornamented with columns and niches. An elaborate background

6.22 Plan of the Theatre of Marcellus, Rome, 23–13 BC.

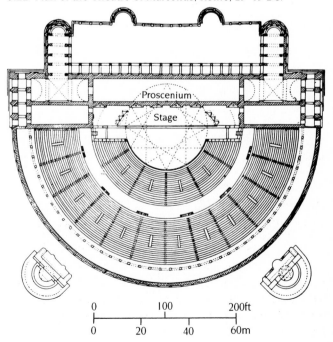

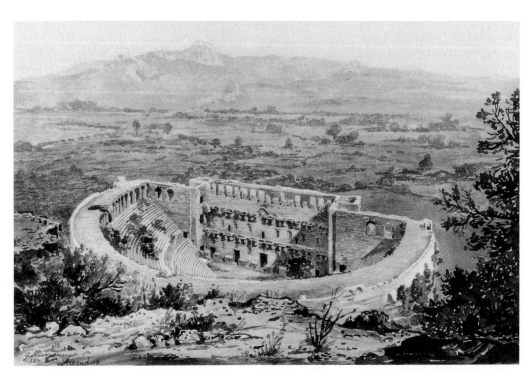

6.23 The theatre of Aspendos, second century AD.

6.24 Reconstruction of the stage area at Aspendos.

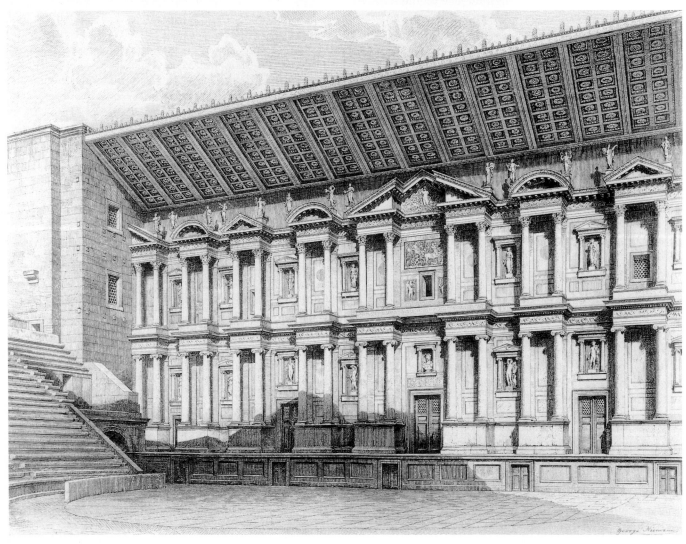

6.25 Reconstruction of the stage of the theatre at Orange, France.

rose behind the actors. The auditorium, or *cavea*, was also reduced from its Greek proportions to a semicircle. The architectural unity of the Roman theatre is evident from a recreation of the theatre at Aspendos (Fig. **6.23**). The elaborate stage and background of the Roman theatre seen in Figures **6.24** and **6.25** display the classical convention of three entrance doorways in the back wall as well as the Hellenistic addition of two entrances at each end of the stage. The enormous scale of the background relative to the actors is striking. As well as the roof that could be added over the stage, the auditorium could apparently be covered with an awning. As a result, the Roman theatre came very close to indoor performances. The front curtain made the Roman theatre very similar to a modern one.

The low social status of the Roman actor was probably a consequence of the deteriorating condition of Roman theatre. Professionally managed dramatic troupes, made up of actors who were slaves, became typical. Unlike the Greek actor, whose costume elevated his height and idealized him, the Roman actor wore contemporary dress. The large mask and wig of the classical theatre was replaced with smaller wigs and less idealized masks. Costume at the time of Plautus and Terence in the second century BC was similar to that of the Hellenistic theatre. Throughout the history of the Roman theatre, colors were consistently used symbolically. Old men usually wore white; young men, purple; "parasites," gray; and courtesans, yellow.

By the end of the Roman Empire, however, theatre had virtually disappeared as an art form. Plays were understood to be for reading, not for performing. The only remaining theatrical entertainments were mimes and PANTOMIMES.

MUSIC

Music was very popular among the Romans. Contemporary reports describe festivals, competitions, and virtuoso performances. Many Roman emperors were patrons of music, and Greek music teachers were popular and very well paid. Large choruses and orchestras performed regularly, and the *hydraulos*, or water organ, was a popular attraction at the Colosseum. The *hydraulos* was apparently so loud that it could be heard a mile away, and the fact that it provided "background music" for the spectacles in which Christians were fed to lions meant that it was banned from Christian churches for centuries.

Aristotle had deplored professionalism in the pursuit of music. Music, he believed, existed for its own aesthetic qualities and as a moral force in character development. It was a measure of intelligence. The pragmatic Romans did not see it this way. Professional dexterity and VIRTUOSITY were social assets, and meaningless accomplishments, such as blowing the loudest tone or holding the longest note, were rewarded with great acclaim. Musical entertainment did fulfill an important social and political function for the Romans, however. As more and more people flocked to Rome from conquered territories, the numbers of unemployed grew. The state began to provide entertainments to keep them occupied and under control. "Bread and circuses" became the answer to the dissatisfactions of the poor and the oppressed, and music also played an important role. As a result, music became less an individual pastime and more an exclusively professional activity.

The Romans seem to have contributed little to musical practice or theory. They took their music direct from Greece after it became a Roman province in 146 BC, adopting Greek instruments and theory. They did invent some new instruments, principally brass trumpets and horns for military use. As with most ancient music, we know that Roman music existed, and we understand a little of its theory, practice, and instrumentation, but we have no real conception of how it sounded, melodically or rhythmically.

By the end of the fifth century AD, all mention of secular music had virtually disappeared. It must have existed, but we have no record of it.

DANCE

One of Rome's significant legacies was the unique dance form of pantomime. Pylades of Cilicia and Buthyllus of Alexandria are credited with the invention of pantomime, around 22 BC. They brought together a number of dance elements, some of which dated to prehistoric Greece. Although the words "mime" and "pantomime" are sometimes used interchangeably in our vocabulary, they were very different art forms. Pantomime was serious and

interpretative. Some pictorial evidence suggests that a single dancer portrayed many roles by changing costumes and masks. Wind, brass, and string instruments played as the dancer leapt, twisted, and performed acrobatic feats. The interpretation of delicate emotions also played a part. Pantomimes often had tragic themes, apparently taken from Greek and Roman tragedies and mythology. But many pantomimes also had a distinctly sexual orientation that some sources call pornographic.

This dance form fell into disfavor as its lewdness increased. Treated comically, as in the mimes, lewdness may have been tolerable, even endearing. The same subject matter treated seriously, however, may have become tedious or obnoxious, even to the pragmatic (and decadent) Romans. The more notorious emperors, such as Nero and Caligula, apparently loved pantomime, as did certain of the populace. Eventually, however, pantomimists were forced out of the major cities to the provinces. These itinerant entertainers may have helped to keep theatrical dance alive through the Middle Ages and into the Renaissance.

ARCHITECTURE

Given the practicality of the Roman mind, it is not surprising to find that a distinctive Roman style is most evident in architecture. The clarity of form we found in the post-and-lintel structure of the classical Greek temple is also present in the Roman arch. Whereas in Greek architectural composition the part is subordinate to the whole, however, in Roman architecture, each part often carries its own significance. The result is that we can usually surmise the appearance of a whole structure from one element,

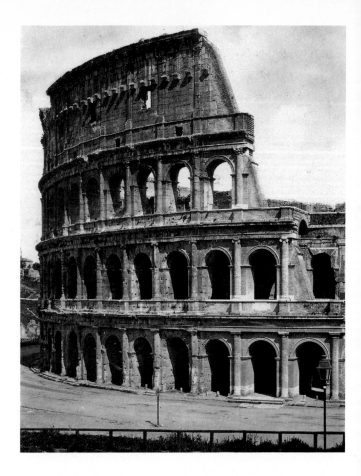

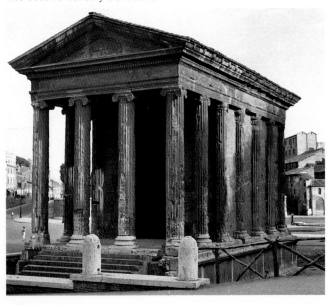

6.26 Temple of Fortuna Virilis, Rome, late second century BC. Stone.

since there was a convention governing which forms were suitable for particular purposes.

Very little survives of the architecture of the Republican period, but the use of Corinthian features and the graceful lines of what remains suggest a strong Hellenistic influence. There are notable differences, however. Hellenistic temples were built on an impressive scale (see Fig. **5.33**). Classical Greek temples were smaller, and Roman temples smaller still, principally because Roman worship was mostly a private rather than a public matter.

Roman temple architecture employed ENGAGED COLUMNS, that is, columns partly embedded in the wall. As a result, Roman temples lacked the open colonnades of Greek peripteral temples, giving them a closed, slightly mysterious atmosphere. The Temple of Fortuna Virilis (Fig. **6.26**) is the earliest well preserved example of its kind, dating from the second century BC. Greek influence appears in the delicate Ionic columns and ENTABLATURE, but Etruscan elements are also present in the deep porch and in the engaged columns that are necessitated by the wide CELLA, or main enclosed space. (The one-room cella departs from the Etruscan convention of three rooms.) The Romans needed more spacious temple interiors than the Greeks, because they used them for displaying trophies from military campaigns, as well as to house the image of the deity.

In the Augustan age at the beginning of the Imperial period Roman architecture, like contemporary sculpture, was refashioned in Greek style. This accounts to a large extent for the dearth of surviving buildings from previous

6.27 (opposite) Colosseum, Rome, c.AD 70–82. Stone and concrete, 159 ft (48.5 m) high.

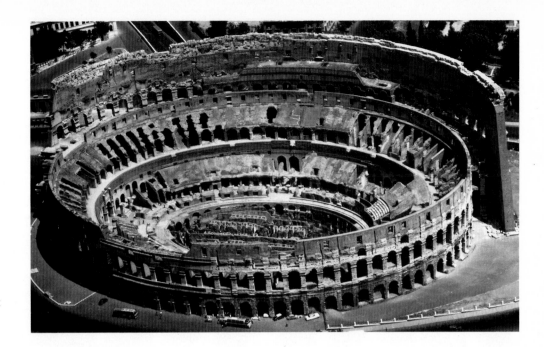

6.28 Colosseum, interior. 616 ft 9 ins (188 m) long; 511 ft 10 ins (156 m) wide.

eras since old buildings were replaced with new ones, in the new style. Temples were built on Greek plans, but the proportions were significantly different from those of the classical Greek.

The first through the fourth centuries AD brought what is now typically identified as the "Roman style." The most significant characteristic of this style is the use of the arch as a structural element, in ARCADES and TUNNEL and GROIN VAULTS. The Colosseum (Figs **6.27** and **6.28**), the best known of Roman buildings and one of the most stylistically typical, could seat 50,000 spectators. Combining an arcaded exterior with vaulted corridors, it was a marvel of engineering. The circular sweep of its plan and the curves of the arches are countered by the vertical lines of the engaged columns flanking each arch. The columns at each level are of different orders, and progress upward from heavy Doric columns, to Ionic ones, to lighter Corinthian ones at the top level.

Placed in the center of the city of Rome, the Colosseum was the site of gladiatorial games and other gruesome spectator sports. Emperors competed with their predecessors to produce the most lavish spectacles there. The Colosseum was a new type of building, called an AMPHITHEATRE, in which two semicircular theatres are combined, facing each other, to form an arena surrounding an oval interior space. Originally, a system of poles and ropes supported awnings to shade spectators. The space below the arena contained animal enclosures, barracks for gladiators, and machines for raising and lowering scenery.

Roman triumphal arches are also impressive architectural monuments. The Roman classical style survives in a memorial to Titus raised by his younger brother, Domitian. The Arch of Titus (Fig. **6.29**) was a political gesture of homage to the accomplishments of Titus and his father Vespasian during the conquest of Jerusalem. The reliefs on the arch illustrate allegories rather than

actual historical events. Titus appears as *triumphator*, along with figures such as the *genius Senatus*, or spirit of the Senate, and the *genius populi romani*, or spirit of the people of Rome. The richly and delicately ornamented façade of this arch, that is, its external appearance, stands in marked contrast to its massive internal structure. This is an important characteristic of Roman architecture, which distinguishes it from Greek principles, in which the structure can always be seen.

6.29 Arch of Titus, Roman Forum, Rome, c.AD 81. Marble. About 50 ft (15 m) high.

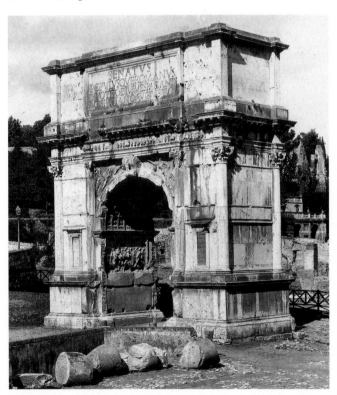

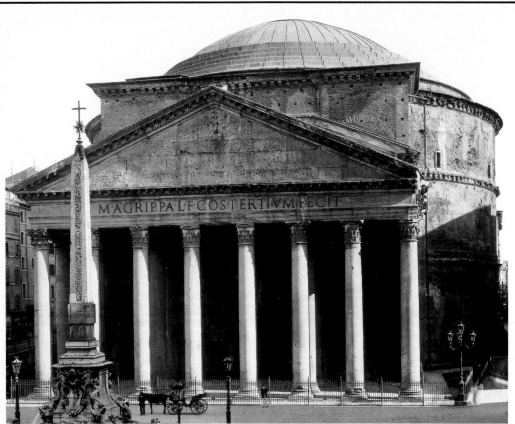

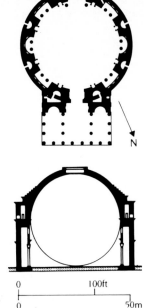

6.31 (above) Plan and cross-section of the Pantheon, Rome.

6.30 (left) Pantheon, Rome, c.AD 118–28. Marble, brick, and concrete.

MASTERWORK
The Pantheon

As its name suggests, the Pantheon (Figs **6.30**, **6.31**, and **6.32**) was built to honor all the gods. The structure brought together Roman engineering, practicality, and style in a domed temple of unprecedented scale.

Until the mid-19th century, only two buildings had equalled the span of its dome, and during the Middle Ages, it was suspected that demons might be holding up the roof of this pagan temple. Around the circular interior statues of the gods stood in NICHES in the massive walls. Corinthian columns add grace and lightness to the lower level. Heavy horizontal moldings accentuate the feeling of open space under the huge dome. The dome itself is 143 feet in both diameter and height (from the floor to the OCULUS, or eye, the round opening at the top of the dome). The circular walls supporting the dome are 20 feet thick and 70 feet high. Square COFFERS on the underside of the dome give an added sense of lightness and reflect the framework into which concrete was poured. Originally the dome's interior was gilded to suggest "the golden dome of heaven."

In both plan and CROSS-SECTION the Pantheon is designed on a perfect circle: the dome is a hemisphere (Fig. **6.31**). From the exterior, we see a simple, sparsely adorned cylinder capped by a gently curving dome. The entrance is via a porch in the Hellenistic style with graceful Corinthian columns. Originally the porch was approached by a series of steps and a rectangular forecourt, so what remains is only part of a larger, more complex original design.

Inside, both the scale and the detail are overwhelming, but the way in which practical problems have been solved is equally impressive. Support PIERS for the dome stand in niches that are alternately rectangular and rounded. The vault over each niche is designed to transfer the weight of the dome onto solid footings. Drains cut into the slightly concave floor of the building carry away any rain that falls through the oculus above.

What captures our immediate attention is the sense of space. In most Egyptian and Greek architecture, the focus is on mass—the solids of the buildings. Here, despite the scale and beauty of the solids, it is the vast openness of the interior that strikes us. This is Roman inventiveness and practicality at its best, yet the atmosphere of the building is not one of practical achievement but of sublimity.

How could the Romans build such a colossal structure? Some historians argue that the key lies in a new building technology made possible by concrete containing a specific kind of cement newly developed near Naples. The secret, however, may lie in the mysterious rings around the dome. As a recent study at Princeton University suggests, they probably "perform a function similar to the buttresses of a Gothic cathedral. . . . The extra weight of the rings . . . helps stabilize the lower portion of the dome. Rather than functioning like a conventional dome, the Pantheon behaves like a circular array of arches, with the weight of the rings holding the end of each arch in place."[7]

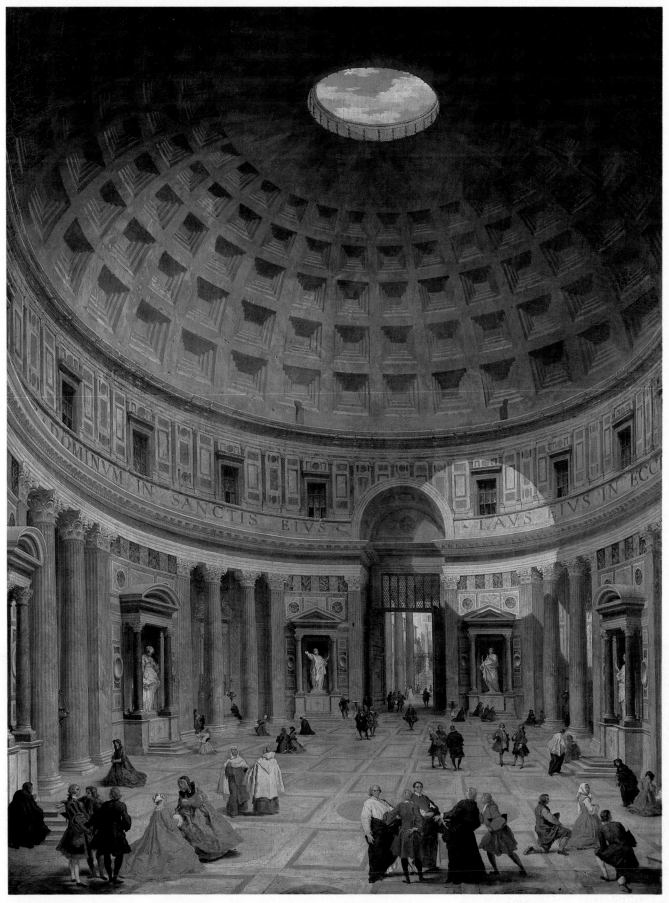

6.32 Giovanni Paolo Panini, *Interior of the Pantheon*, c.1740. Oil on canvas, 4 ft 2 ins × 3 ft 3 ins (1.27 m × 99 cm). National Gallery of Art, Washington DC (Samuel H. Kress Collection).

SYNTHESIS
Augustus: classical visions

The aesthetic revolution at the start of the Roman Empire saw a shift in the purpose of art toward propaganda. One of the artistic ramifications of Augustus' new political order was the emergence of the NEO-ATTIC style.

Sculptural works, with their new emphasis on portraying the emperor, can be divided into three main types. These are differentiated by scholars primarily by hairstyle, while facial features remain recognizably the same. In the first type (Fig. **6.33**), before Octavian was made emperor, his hair is shown in realistic disorder. The second type (Fig. **6.34**) depicts the same man (now called Augustus) as emperor, with a more refined, nobler face and the hair divided into two strands above the right eyebrow. In the third type (Fig. **6.35**), the forelock is gone, and the hair is combed to the side.

The essence of Roman neo-Attic sculpture, however, is to be found in the statue of Augustus shown in Figure **6.16**. The portrait head of the Emperor sits on an idealized, youthful body like that Polyclitus made for his *Lance Bearer* (Fig. **5.9**). Unlike the lance bearer, however, Augustus reaches outside his cube of compositional space, and the final effect is much less introspective and more dignified than that of its prototype.

The Forum of Augustus in Rome (Figs **6.36** and **6.37**) exemplifies monumental Imperial art at its classical grandest. In both its conception and its dimensions it speaks of greatness. Constructed from war booty, the Forum honors Mars the Avenger, to whom Octavian had made a vow during his wars against the assassins of Julius Caesar. The Forum's style reflects Augustus' view that in all the arts the Greeks had achieved perfection in the classical style. All this served to establish Augustus as the greatest among *summi viri*, or the greatest "among all the great men of Roman history."[8]

Finally, we turn to a "jewel" of Augustan classicism, the *Ara Pacis*, or Altar of Peace (Fig. **6.38**). It is representative of a movement toward a saturating symbolism, in which every detail was intended to convey meaning. Here, even apparently decorative elements are symbolic: the garlands, or swags, strung from ox-skulls represent peace, while the fact that they are composed of varieties of fruit which do not ripen together symbolizes the unending nature of this peace. The figures themselves, though their poses are perfectly natural, exude royal dignity and nobility, characteristics which Augustus sought to emphasize in the popular conception of himself. The whole altar, dedicated to peace, thus serves as an image of the golden age of Augustus—that is, an era of peace and prosperity whose source was the emperor himself.

Monumentality, symbolism, practicality, and a resurrection of Greek classicism adapted to Roman tastes—these are the hallmarks of the Augustan age. Taken together, they describe what we have come to know as Roman classicism, and they reflect the quintessence of Roman life, as the Romans themselves saw it.

6.33 Octavian, copy of a type created in 31 BC. Marble, 14⅝ ins (37.2 cm) high. Museo Capitolino, Rome.

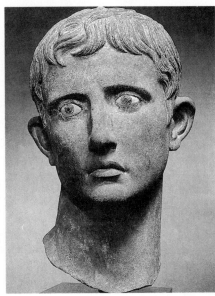

6.34 Augustus, copy of a type created in 27 BC. Bronze, 16⅞ ins (42.9 cm) high. British Museum, London.

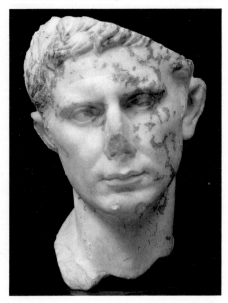

6.35 Augustus, final type before 12 BC. Marble, 12 ins (30.5 cm) high. Museum of Fine Arts, Boston (Gift of Edward W. Forbes).

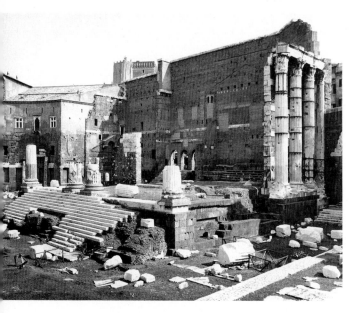

6.36 Temple of Mars the Avenger, Forum of Augustus, Rome, from the south, dedicated 2 BC. Marble facing over stone and concrete.

6.37 Temple of Mars the Avenger, Forum of Augustus, reconstructed view.

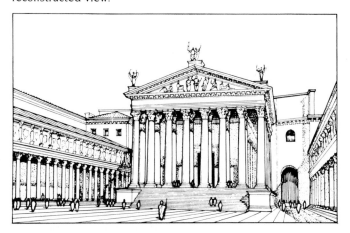

6.38 *Ara Pacis* (Altar of Peace). Rome, 13–9 BC. Marble. Outer wall about 34 ft 5 ins × 38 × 23 ft (10.5 × 11.6 × 7 m).

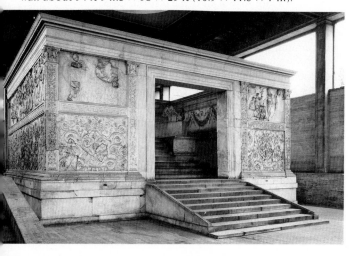

SUGGESTIONS FOR THOUGHT AND DISCUSSION

In Plotinus' first formulation of the symbolic nature of art, we find the seeds of a Roman aesthetic purpose which goes beyond the purely practical. Our overall impression of Roman culture as derivative and highly practical, however, remains unaltered. Clearly the arts held a broad interest for the Roman populace from the earliest days of the Republic to the late years of the empire under Constantine, whether as an outlet for popular discontent, as a sop thrown to them by the authorities, or as a neo-Attic vehicle for glorifying the Emperor Augustus. Roman artists in general served their constituency. Engineering and technology contributed to spectacular architectural structures such as the Pantheon and the Colosseum, while music and drama served to keep the vast army of the unemployed in check. At the same time, the utilitarian yielded somewhat to the aesthetic. Sarcophagi were sculpted with delicate detail and triumphal arches displayed masterly decoration. Indeed, the triumphal arch, with its rough interior covered by a thin veneer of exquisite adornment, is an apt symbol for the culture of Rome.

■ In what ways did Roman arts adopt or change classical Greek and Hellenistic styles?

■ In what ways is the classical vision of Augustus similar to or different from the efforts of Akhenaton at Tell el Amarna?

■ In what ways does Stoicism still influence western society?

■ What are the similarities and differences between Plotinus' concepts of beauty and symbol and those of Aristotle and Plato? What is neo-Platonism?

■ What characteristics of Roman theatre make it closer to contemporary theatre than it was to its immediate predecessor, Greek theatre?

LITERATURE EXTRACTS

Aeneid

Virgil

Book VI

Virgil's most famous work, the Aeneid is in essence a Roman version of Homer's Odyssey. It tells of the seaborne wanderings of the Trojan hero Aeneas after the fall of Troy. He eventually lands in Italy and founds the city of Rome. When he reaches Carthage, its queen, Dido, falls in love with him. Book VI tells of Aeneas' visit to the underworld, mirroring Book XI of the Odyssey. He encounters the ghosts of his father, Anchises, and of Dido, who killed herself for love of him at the end of Book IV.

Ye realms yet unrevealed to human sight,
Ye gods who rule the regions of the night,
Ye gliding ghosts, permit me to relate
The mystic wonders of your silent state.
 Obscure they went through dreary shades that led
Along the waste dominions of the dead.
Thus wander travellers in woods by night,
By the moon's doubtful and malignant light,
When Jove in dusky clouds involves the skies,
And the faint crescent shoots by fits before their eyes. 10
 Just in the gate and in the jaws of hell,
Revengeful cares and sullen sorrows dwell,
And pale diseases and repining age—
Want, fear, and famine's unresisted rage.
Here toils and death, and death's half-brother, sleep,
Forms terrible to view, their sentry keep.
With anxious pleasures of a guilty mind,
Deep frauds before and open force behind;
The Furies' iron beds, and strife that shakes
Her hissing tresses and unfolds her snakes. 20
Full in the midst of this infernal road,
An elm displays her dusky arms abroad.
The God of Sleep there hides his heavy head,
And empty dreams on every leaf are spread.
Of various forms unnumbered spectres more,
Centaurs and double shapes besiege the door.
Before the passage horrid Hydra stands,
And Briareus with all his hundred hands;
Gorgons, Geryon with his triple frame,
And vain Chimaera vomits empty flame. 30
The chief unsheathed his shining steel, prepared,
Though seized with sudden fear, to force the guard,
Offering his brandished weapon at their face,
Had not the Sibyl stopped his eager pace,
And told him what those empty phantoms were—
Forms without bodies and impassive air.
Hence to deep Acheron they take their way,
Whose troubled eddies, thick with ooze and clay,
Are whirled aloft and in Cocytus lost.

There Charon stands, who rules the dreary coast— 40
A sordid god—down from his hoary chin
A length of beard descends, uncombed, unclean;
His eyes, like hollow furnaces on fire;
A girdle, foul with grease, binds his obscene attire.
He spreads his canvas, with his pole he steers,
The freights of flitting ghosts in his thin bottom bears
He looked in years, yet in his years were seen
A youthful vigor and autumnal green.
An airy crowd came rushing where he stood,
Which filled the margin of the fatal flood. 50
Husbands and wives, boys and unmarried maids,
And mighty heroes' more majestic shades,
And youths, intombed before their father's eyes,
With hollow groans, and shrieks, and feeble cries;
Thick as the leaves in autumn strew the woods:
Or fowls, by winter forced, forsake the floods,
And wing their hasty flight to happier lands;
Such, and so thick, the shivering army stands,
And press for passage with extended hands.
 Now these, now those, the surly boatman bore: 60
The rest he drove to distance from the shore.
The hero, who beheld with wondering eyes,
The tumult mixed with shrieks, laments, and cries,
Asked of his guide what the rude concourse meant?
Why to the shore the thronging people bent?
What forms of law among the ghosts were used?
Why some were ferried o'er, and some refused?
 "Son of Anchises, offspring of the gods."
The Sibyl said, "you see the Stygian floods,
The sacred streams, which heaven's imperial state 70
Attests in oaths and fears to violate
The ghosts rejected are the unhappy crew
Deprived of sepulchres and funeral due.
The boatman Charon; those the buried host
He ferries over to the farther coast;
Nor dares his transport vessel cross the waves,
With such whose bones are not composed in graves.
A hundred years they wander on the shore,
At length, their penance done, are wafted o'er."
The Trojan chief his forward pace repressed, 80
Revolving anxious thoughts within his breast.
He saw his friends, who whelmed beneath the waves,
Their funeral honors claimed and asked their quiet
 graves.
The lost Leucaspis in the crowd he knew,
And the brave leader of the Lycian crew,
Whom, on the Tyrrhene seas, the tempests met,
The sailors mastered and the ship o'erset.
Amidst the spirits Palinurus pressed,
Yet fresh from life, a new admitted guest,
Who, while he steering viewed the stars, and bore 90
His course from Afric to the Latian shore,
Fell headlong down. The Trojan fixed his view,
And scarcely through the gloom the sullen shadow knew.
Then thus the Prince: "What envious power, O friend,
Brought your loved life to this disastrous end?

For Phoebus, ever true in all he said,
Has, in your fate alone, my faith betrayed.
The god foretold you should not die before
You reached, secure from seas, the Italian shore.
Is this the unerring power?" The ghost replied: 100
"Nor Phoebus flattered, nor his answers lied,
Nor envious gods have sent me to the deep.
But while the stars and course of heaven I keep,
My wearied eyes were seized with fatal sleep.
I fell; and with my weight, the helm constrained
Was drawn along, which yet my grip retained.
Now by the winds and raging waves I swear
Your safety, more than mine, was then my care;
Lest, of the guide bereft, the rudder lost,
Your ship should run against the rocky coast.
Three blustering nights, borne by the southern blast, 110
I floated, and discovered land at last.
High on a mounting wave my head I bore,
Forcing my strength, and gathering to the shore.
Panting, but past the danger, now I seized
The craggy cliffs, and my tired members eased.
While cumbered with my dripping clothes I lay,
The cruel nation, covetous of prey,
Stained with my blood the inhospitable coast.
And now by winds and waves my lifeless limbs are
 tossed. 120
Which, O avert, by yon ethereal light
Which I have lost, for this eternal night.
Or if by dearer ties you may be won,
By your dead sire, and by your living son,
Redeem from this reproach my wandering ghost.
Or with your navy seek the Velin coast;
And in a peaceful grave my corpse compose;
Or, if a nearer way your mother shows—
Without whose aid you durst not undertake
This frightful passage o'er the Stygian lake— 130
Lend to this wretch your hand, and waft him o'er
To the sweet banks of yon forbidden shore."
Scarce had he said, the prophetess began:
"What hopes delude thee, miserable man?
Think'st thou thus unentombed to cross the floods,
To view the furies and infernal gods,
And visit without leave the dark abodes?
Attend the term of long-revolving years,
Fate and the dooming gods are deaf to tears.
This comfort of thy dire misfortune take— 140
The wrath of heaven, inflicted for thy sake,
With vengeance shall pursue the inhuman coast,
Till they propitiate thy offended ghost,
And raise a tomb, with vows and solemn prayer,
And Palinurus' name the place shall bear."
This calmed his cares, soothed with his future fame,
And pleased to hear his propagated name.
 Now nearer to the Stygian lake they draw,
Whom from the shore the surly boatman saw,
Observed their passage through the shady wood, 150
And marked their near approaches to the flood.
Then thus he called aloud, inflamed with wrath:
"Mortal, whate'er who this forbidden path
In arms presumest to tread, I charge thee stand,
And tell thy name and business in the land.

Know this, the realm of night, the Stygian shore,
My boat conveys no living bodies o'er;
Nor was I pleased great Theseus once to bear,
Who forced a passage with his pointed spear;
Nor strong Alcides, men of mighty fame, 160
And from the immortal gods their lineage came.
In fetters one the barking porter tied,
And took him trembling from his sovereign's side;
Two sought by force to seize his beauteous bride."
To whom the Sibyl thus: "Compose thy mind:
Nor frauds are here contrived, nor force designed.
Still may the dog the wandering troops constrain
Of airy ghosts, and vex the guilty train;
And with her grisly lord his lovely queen remain.
The Trojan chief, whose lineage is from Jove, 170
Much famed for arms and more for filial love,
Is sent to seek his sire in your Elysian grove.
If neither piety nor heaven's command
Can gain his passage to the Stygian strand,
This fatal present shall prevail at least;"
Then showed the shining bough concealed within her
 vest.
No more was needful, for the gloomy god
Stood mute with awe to see the golden rod;
Admired the destined offering to his queen
(A venerable gift so rarely seen). 180
His fury thus appeased, he puts to land;
The ghosts forsake their seats at his command;
He clears the deck, receives the mighty freight,
The leaky vessel groans beneath the weight.
Slowly he sails, and scarcely stems the tides,
The pressing water pours within her sides.
His passengers at length are wafted o'er,
Exposed in muddy weeds upon the miry shore
No sooner landed, in his den they found
The triple porter of the Stygian sound, 190
Grim Cerberus, who soon began to rear
His crested snakes and armed his bristling hair.
The prudent Sibyl had before prepared
A sop, in honey steeped, to charm the guard,
Which, mixed with powerful drugs, she cast before
His greedy grinning jaws, just oped to roar.
With three enormous mouths he gapes, and straight,
With hunger pressed, devours the pleasing bait.
Long draughts of sleep his monstrous limbs enslave,
He reels, and falling, fills the spacious cave. 200
The keeper charmed, the chief without delay
Passed on, and took the irremeable way.
Before the gates the cries of babes new-born,
Whom Fate had from their tender mothers torn
Assault his ears; then those whom form of laws
Condemned to die when traitors judged their cause;
Nor want they lots, nor judges to review
The wrongful sentence and award a new.
Minos, the strict inquisitor, appears,
And lives and crimes, with his assessors, hears; 210
Round in his urn the blended balls he rolls,
Absolves the just and dooms the guilty souls.
The next in place and punishment are they
Who prodigally throw their souls away;
Fools who, repining at their wretched state,

And loathing anxious life, suborned their fate;
With late repentance now they would retrieve
The bodies they forsook, and wish to live;
Their pains and poverty desire to bear,
To view the light of heaven and breath the vital air. 220
But fate forbids, the Stygian floods oppose,
And with nine circling streams the captive souls enclose.

 Not far from thence the mournful fields appear,
So called from lovers that inhabit there—
The souls whom that unhappy flame invades,
In secret solitudes and myrtle shades,
Make endless moans, and, pining with desire,
Lament too late their unextinguished fire.
Here Procris, Eriphyle here, he found
Baring her breast, yet bleeding with the wound 230
Made by her son. He saw Pasiphae there,
With Phaedra's ghost, a foul incestuous pair;
There Laodamia with Evadne moves,
Unhappy both, but loyal in their loves;
Caeneus, a woman once, and once a man,
But ending in the sex she first began;
Not far from these Phoenician Dido stood,
Fresh from her wound, her bosom bathed in blood.
Whom, when the Trojan hero hardly knew,
Obscure in shades, and with a doubtful view
(Doubtful as he who runs through dusky night, 240
Or thinks he sees the moon's uncertain light);
With tears he first approached the sullen shade,
And, as his love inspired him, thus he said:
"Unhappy Queen, then is the common breath
Of rumour true in your reported death?
And I, alas, the cause? By heaven, I vow,
And all the powers that rule the realms below,
Unwilling I forsook your friendly state,
Commanded by the gods and forced by fate—
Those gods, that fate, whose unresisted might 250
Have sent me to these regions, void of light,
Through the vast empire of eternal night;
Nor dared I to presume that, pressed with grief,
My flight should urge you to this dire relief.
Stay, stay your steps, and listen to my vows—
'Tis the last interview that fate allows!"
In vain he thus attempts her mind to move
With tears and prayers and late repenting love;
Disdainfully she looked, then turning round,
But fixed her eyes unmoved upon the ground, 260
And what he says and swears regards no more
Than the deaf rocks when the loud billows roar;
But whirled away, to shun his hateful sight,
Hid in the forest and the shades of night;
Then sought Sichaeus through the shady grove,
Who answered all her cares and equalled all her love.
Some pious tears the pitying hero paid,
And followed with his eyes the flitting shade.

The Art of Poetry

Horace

Suppose a painter chose to couple a horse's neck with a human head, and to lay feathers of every hue on limbs gathered here and there, so that a woman, lovely above, foully ended in an ugly fish below; would you restrain your laughter, my friends, if admitted to a private view? Believe me, dear Pisos, a book will appear uncommonly like that picture, if impossible figures are wrought into it—like a sick man's dreams—with the result that neither head nor foot is ascribed to a single shape, and unity is lost.

"But poets and painters have always had an equal right to indulge their whims." Quite so: and this excuse we claim for ourselves and grant to others: but not so that harsh may mate with gentle, serpents be paired with birds, lambs with tigers.

Frequently grave openings, that promise much, have one or two purple patches tagged on, to catch the eye and enhance the color. Thus, for example, we get descriptions of "Diana's grove and altar," "the moving waters hurrying through fair fields," or get a picture of the Rhine, or of a rainbow; but all the time there is no place for these scenes. Perhaps you know how to limn a cypress; but what avails this if you have to represent a sailor, who has paid to have his portrait painted, as struggling hopelessly to shore from a wreck? A wine-jar was designed: why, when the wheel goes round, does it come out a pitcher? In short, be your subject what you will, only let it be simple and consistent.

Most of us poets—O father, and sons worthy of your father,—are misled by our idea of what is correct. I try to be terse, and end by being obscure; another strives after smoothness, to the sacrifice of vigor and spirit; a third aims at grandeur, and drops into bombast; a fourth, through excess of caution and a fear of squalls, goes creeping along the ground. He who is bent on lending variety to a theme that is by nature uniform, so as to produce an unnatural effect, is like a man who paints a dolphin in a forest or a wild boar in the waves. If artistic feeling is not there, mere avoidance of a fault leads to some worse defeat.

The humblest bronze-smith who lives near the Aemilian training school will depict you nails, and imitate waving hair in metal, yet fail in his work because he cannot represent the figure as a whole. Now if I wanted to compose a work, I should no more wish to be like that smith than to live admired for my dark eyes and dark hair while I had a crooked nose.

You writers, choose a subject that is within your powers, and ponder long what your shoulders can and cannot bear. He who makes every effort to select his theme aright will be at no loss for choice words or lucid arrangement.

[42] Unless I am mistaken, the force and charm of arrangement will be found in this: to say at once what ought at once to be said, deferring many points, and waiving them for the moment.

Careful and nice, too, in his choice of words, the author of the promised poem must reject one word and welcome another; you will have expressed yourself admirably if a

clever setting gives a spice of novelty to a familiar word.

[47] If by chance some abstruse subject needs new terms to make the meaning clear, it will be right to frame words never heard of by old-fashioned folk like the Cethegi, and the licence will be allowed if not abused; new and lately-minted words will be accepted if drawn from a Greek source, provided this be done sparingly. Why should a Roman grant to Caecilius and Plautus a privilege denied to Virgil and Varius? Why am I myself, if I can capture a phrase or two, grudged this freedom, seeing that the works of Cato and Ennius have enriched the mother-tongue and broadcasted new names for things? It has always been and always will be permissible to circulate a word stamped with the hall-mark of the day.

As forests suffer change of leaves with each declining year, so the earliest-invented words are the first to fall: an elder generation passes away and new-born words, like youth, flourish and grow. Death claims both us and our works. What matter if the sea, let into the heart of the land, shelters our ships from the north winds—a right royal work; or the marsh, long barren and fit for boats alone, feeds neighboring cities and groans under the plowshare; or the river, taught a better channel, has changed its course once ruinous to crops? The works of men's hands must perish, much less can the glory and charm of words endure undecaying. Many a word long disused will revive, and many now high in esteem will fade, if Custom wills it, in whose power lie the arbitrament, the rule, and the standard of language.

[73] Homer has shown in what meter the deeds of kings and captains and the sorrows of war may be written. First came the voice of lament, in couplets unequally paired; then the joy of the successful lover; but who the author was that first published the dainty measures, critics dispute, and the matter is still unjudged.

It was fury that armed Archilochus with his own device, the iamb; this meter comedy and stately tragedy adopted, as fitted for dialogue, drowning the din of the audience, and born for action.

The Muse has assigned to the lyre the work of celebrating gods and heroes, the champion boxer, the victorious steed, the fond desire of lovers, and the cup that banishes care.

[86] In works of genius are clearly marked differences of subject and shades of style. If, through ignorance, I fail to maintain these, why hail me Poet? Why, from a false shame, do I prefer ignorance to knowledge? A subject for comedy refuses to be handled in tragic verse; the banquet of Thyestes disdains to be rehearsed in lines suited to daily life and right enough for comedy. At times, however, even Comedy exalts her voice, and an angry Chremes rants and raves; often, too, in a tragedy Telephus or Peleus utters his sorrow in the language of prose, when, poor and in exile, he flings aside his paint-pots and his words a yard long, in eagerness to touch the spectator's heart with his lamentable tale.

[99] It is not enough for poems to be fine; they must charm, and draw the mind of the listener at will. As the human face answers a smile with a smile, so does it wait upon tears; if you would have me weep, you must first of all feel grief yourself; then and not till then will your misfortunes, Telephus or Peleus, touch me. If the part assigned you is not in character, I shall fall asleep or laugh.

Sad words suit a gloomy countenance, menacing words an angry; sportive words a merry look, stern words a grim one. For Nature shapes first our inner thoughts to take the bent of circumstance; she moves to gladness or drives to anger, bows the heart to earth and tortures it with bitter grief. After, with the tongue her aid, does she express emotion.

[112] If a speaker's words are out of gear with his fortunes, all Rome, horse and foot, will guffaw. It will make a world of difference whether god or demigod be talking; an old man well on in years or a stripling in the first flush of youth, a wealthy dame or some bustling nurse; a roving trader or a son of the soil; a Colchian or an Assyrian; one reared in Argos or in Thebes.

[119] Either stick to tradition or see that your inventions be consistent. If when writing a play you introduce yet again the "far-famed Achilles," make him impatient, hot-tempered, ruthless, fierce; he must disown all laws: they were not made for him; his appeal will be to the sword. In like manner let Medea be high-hearted and unconquerable, Ino tearful, Ixion a traitor, Io a wanderer, Orestes forlorn.

[125] If you bring on to the stage a subject unattempted yet, and are bold enough to create a fresh character, let him remain to the end such as he was when he first appeared—consistent throughout. It is hard to treat a hackneyed theme with originality, and you act more rightly by dramatizing the Iliad than by introducing a subject unknown and hitherto unsung. [240-3] I shall aim at a poem so deftly fashioned out of familiar matter that anybody might hope to emulate the feat, yet for all his efforts sweat and labor in vain. Such is the power of order and arrangement; such the charm that waits upon common things. [131] The common quarry will become your own by right, if you do not dally in the cheap and easy round; if you do not, an all too faithful translator, essay to render your author word for word; if you do not—a mere copyist—take a plunge into some narrow pit from which diffidence or the conditions of the work itself forbid you to escape.

Nor should your exordium be like that of the cyclic poet of old: "I'll sing the fate of Priam, and the famous war of Troy." What will this writer produce worthy of such mouthing? it will be a case of "mountains in labour and—a mouse comes out!" Much better he who makes no ill-judged effort: "Sing me, O Muse, the tale of that hero who, after the capture of Troy, surveyed the manners and cities of mankind."

[143] His aim is to fetch not smoke from a flash but light from smoke, that afterwards he may bring you marvels of the picturesque—Antiphates and the Cyclops, Scylla and Charybdis. He does not date "the Return of Diomed" from Meleager's death, not the Trojan war from the twin eggs: he ever hurries to the crisis and carries the listener into the midst of the story as though it were already known; what he despairs of illuminating with his touch he omits; and so employs fiction, so blends false with true, that beginning, middle, and end all strike the same note.

[153] Now hear what I, and the world at large, expect. If you want an appreciative audience that will sit quiet till the curtain drops and the call for "cheers" begins, you must observe the characteristics of each age and assign a fitting grace to natures that shift with the years. The child who can just talk and feel his feet with confidence longs to play with his peers; is quick to anger, as quick to cool; his moods change hourly. The beardless boy, his tutor out of the way, finds delight in horses and dogs and the turf of the sunny plain. Pliant as wax to vice, he is gruff with his counsellors, slow to provide for his own best interests, lavish with his money; high-spirited, passionate, ready to discard his fancies. With manhood comes a change of tastes: his aim now is money and friendship; he will be the slave of ambition, and will shun doing what, later on, he might wish to undo.

Many are the discomforts of age, partly because the old man, ever amassing, shrinks from his gains and dares not enjoy them; partly because he handles everything in chill and listless fashion,—irresolute, a laggard in hope, lazy, greedy of long life, crossgrained, querulous, one who extols the past as it was "when I was a boy"; a censor and critic of the rising generation. The years as they come bring many blessings: many do they take as they go. Lest an old man's part be given to a youth, or a man's part to a boy, we shall do wisely to dwell on the attributes proper to each period of life.

[178] An action either takes place on this stage, or is announced as having taken place off it. What finds entrance through the ear strikes the mind less vividly than what is brought before the trusty eyes of the spectator himself. And yet you will not present incidents which ought to be enacted behind the scenes, and will remove from sight a good deal for the actor to relate on the stage by and by—so that, for example, Medea may not butcher her boys or savage Atreus cook human flesh in front of the audience, Procne turn into a bird or Kadmos into a snake. Anything you thrust under my nose in this fashion moves my disgust—and incredulity.

[189] A play which is to be in demand and, after production, to be revived, should consist of five acts—no more, no less. A god must not be introduced unless a difficulty occurs worthy of such a deliverer; nor should a fourth actor be forward to speak. The Chorus should discharge the part and duty of an actor with vigor, and chant nothing between the acts that does not forward the action and fit into the plot naturally. The Chorus must back the good and give sage counsel; must control the passionate and cherish those that fear to do evil; it must praise the thrifty meal, the blessings of justice, the laws, and Peace with her unbarred gates. It will respect confidences and implore heaven that prosperity may revisit the miserable and quit the proud.

[201] In days gone by the pipe, not as now bound with brass and rival of the trumpet, but soft and simple with its few stops, was useful to accompany a Chorus and give it its note. It could fill with sound the not yet overcrowded benches, to which of course the people would gather, readily counted (for they were few)—a thrifty folk, chaste and honest. When victorious nations began to extend their boundaries, and an ever-widening wall to compass their

cities, and people were free to enjoy themselves uncensored on feast-days with early revels, a greater license was granted to rhythms and tunes. What taste could you expect in some unlettered rustic, out for a holiday, when in company with a townsman—clown and gentleman together? So the piper added movement and wanton gestures to his art of old, and would trail his robes as he strutted about the stage; so were new notes added to the sober lyre; bold eloquence brought with it a language unknown before; and wise saws, prophetic of the future, would match the oracles of Delphi.

[220] The poet who competed in tragic verse for a paltry goat soon made the rustic satyrs doff their garments and ventured on coarse jests without loss of dignity, sure that a spectator, fresh from the sacrifice, drunk and subject to no law, must needs be held by the charms and enticements of novelty.

[225] It will be well so to commend to your audience the quips and laughter of Satyrs, so to pass from grave to gay, that no god or hero who is to be staged—so conspicuous of late in royal gold and purple—should in his discourse sink to the level of tavern-talk; or again, while shunning the ground, catch at clouds and emptiness. It is beneath the dignity of Tragedy to blurt out trivial verse: like a matron bidden to dance on holy days, the Muse, if she has to move among saucy Satyrs, will show a due reserve.

[234] If I write satyric plays, I shall not choose only bald and everyday terms; nor so try to vary from tragic diction that none can guess whether Davus is the speaker, or bold Pythias who won a talent by wiping her master's eye, or Silenus—guide, philosopher, and friend of a god.

[244] In my judgment, when woodland Fauns are brought on to the stage they should be careful not to languish in love-verses, like city exquisites, nor rap out filthy and shameful jests. For those who possess horse, father, or estate take offense; nor do they receive with favor or award a crown to everything the purchaser of fried peas and chestnuts may approve.

[251] A long syllable following a short is termed an "iambus"—a lively foot; hence the word "trimeter" was given to iambic lines, although, uniform from first to last, they yielded six beats. Not so long ago, to permit of a slower and more sedate movement, the iambus granted the staid spondee a share in its native rights, with the proviso that it kept its place in the second and the fourth feet, in friendly fashion. The iambic foot is rarely found in the much-vaunted trimeters of Accius, and brands those ponderous lines which Ennius launched on to the stage with the dishonoring charge of over-hurry and carelessness in workmanship or, worse, of ignorance of the poetic art.

[263] It is not every critic that notices false rhythms; and it is true that needless indulgence is given to Roman poets. Am I, therefore, to run riot and break the rules? or shall I assume that the public will mark my slips? If so, then, wary and safe within the hope of forgiveness, I have indeed escaped censure, praise I have deserved not.

Do you, my friends, study the Greek masterpieces: thumb them day and night.

"But," someone answers, "your forebears praised the measures and pleasantries of Plautus." True: they admired

both far too tolerantly, not to say foolishly, if only you and I know how to distinguish vulgarity from wit, and are quick with fingers and ears alike to catch the right cadences.

[275] Thespis is said to have discovered Tragedy—a form of poetry hitherto unknown—and to have carried his plays about in tumbrils, to be chanted and performed by actors with faces smeared with lees. After him Aeschylus, inventor of the mask and comely robe, laid his stage on short planks, teaching his company how to talk grandiloquently and strut on buskined feet. Next came the Old Comedy, praised by all; but freedom degenerated into license and violence, to be checked by law; to law it yielded, and the Chorus, robbed of its power to hurt, fell silent—to its shame.

Our own poets have left no style untried; not the least of their merits was when they boldly forsook the footsteps of Greece and celebrated, in comedy and tragedy alike, our national deeds. Latium would not be mightier in valor or feats of arms than in letters, if only her poets, one and all, did not scorn the long labor of the file. Do you, O Pisos, sprung from Numa, censure the poem that has not been pruned by time and many a cancellation—corrected ten times over and finished to the finger-nail.

[295] Because Democritus believes that genius is happier than miserable art, and shuts the gates of Helicon on all sane poets, a good few will not cut their nails or beard, but court solitude and shun the baths. The fact is, a poet may win a poet's name and reward if only he has never entrusted to Licinus, the barber, a pate that not three Anticyras could cure!

What a fool I am to rid the bile when spring comes on! but for that, no poet would write better. But nothing is worth that! I'll serve as a whetstone which, though it cannot cut of itself, can sharpen iron. Though I write nothing, I'll teach the business and duty of a writer; show where his materials may be found; what it is that trains and molds a poet; what becomes him, what does not; whither knowledge tends, and whither error.

[309] The secret of all good writing is sound judgment. The works of the Socratics will supply you with the facts: get these in clear perspective and the words will follow naturally. Once a man has learned his duty to friend and fatherland, the just claims of parent, brother, or guest on his love, the obligations of senator or judge, or the duty of a general sent on active service, he will infallibly know how to assign to each character its fitting part. I shall bid the clever imitator look to life and morals for his real model, and draw thence language true to life. Sometimes a play, tricked out with commonplaces and with characters well drawn, even though it be void of charm, force, or artistic skill, delights the populace and holds their interest far better than "lines without sense, and tuneful trifles."

It was the Greeks, aye, the Greeks covetous of praise alone, that the Muse endowed with quick wit and rounded utterance. Our Roman youths by long calculations learn how to divide the shilling into a hundred parts. "Come, young Albinus, tell me this: take a penny from sixpence, and what is over? You ought to know." "Fivepence." "Good! you'll hold your own some day. Now add a penny: what's the result?" "Sevenpence." Ah, once this canker of

avarice, this money-grubbing, has trained the soul, can we hope that poems will be written worthy of cedar oil and to be treasured in polished cases?

[333] The poet's aim is either to profit or to please, or to blend in one the delightful and the useful. Whatever the lesson you would convey, be brief, that your hearers may catch quickly what is said and faithfully retain it. Every superfluous word is spilled from the too-full memory. Fictions made to please should keep close to the truth of things; your play should not demand an unlimited credence; it will not do to describe how a living boy is ripped from Lamia's belly after she has just eaten him. Elder folk rail at what contains no serviceable lesson; our young aristocrats cannot away with grave verses: the man who mingles the useful with the sweet carries the day by charming his reader and at the same time instructing him. That's the book to enrich the publisher, to be posted overseas, and to prolong its author's fame.

[347] Yet some faults there are that we can gladly overlook. The string does not invariably give the note intended by mind and hand; we listen for a flat, and often get a sharp; nor does the arrow always hit the target. But whenever beauties in a poem form a majority, I shall not stumble at a few blemishes that are due to carelessness or that the weakness of human nature has failed to guard against.

[353] How, then, do we stand? A copyist who continually makes the same blunder, spite of constant warning, gets no quarter; a harpist who is for ever fumbling with the same string is laughed at; so, too, I rank the slovenly poet with Choerilus, whose occasional fine lines, though surprising, move one to mirth. Am I, then, to be indignant whenever good Homer nods?

[360] "Yes, but it is natural for slumber to steal over a long work. Poetry is like painting: one piece takes your fancy if you stand close to it, another if you keep at some distance. One courts a dim light, another, challenging keen criticism, will fain be seen in the glare; this charms but once, that will please if ten times repeated."

[366] Hope of the Pisos! although you have your father to guide your judgment aright and are yourself wise to boot, cherish this lesson and take it home: that only in limited fields is mediocrity tolerable or pardonable. A counsel or second-rate pleader at the bar may not rival Messalla in eloquence, nor possess the knowledge of Cascellius; yet he has his value; but mediocrity in poets has never been tolerated by gods, men, or—booksellers. Just as, at some pleasant banquet, ugly music, coarse perfume, and poppy seed mixed with Sardinian honey offend the taste, because the meal could have passed without such things: so a poem, created to give delight, if it fails but a little of the highest sinks to the lowest. One who is ignorant of games will abstain from the weapons of the Campus; and if he knows nothing of ball, or quoit, or hoop, will hold aloof, lest the thronging onlookers laugh with none to check them; yet he who is no poet, presumes to write verses! "And why not? Is he not free, of gentle birth, rated at a knight's income, with nothing against him?" You, I know, will say and do nothing "against the grain"—such is your resolve, such your good sense. If, however, you should one day produce something, pray

submit it first to Maecius the critic, to your father, to me; and then put back the manuscript in your desk and let it stand over for a decade. The unpublished may be cancelled; but a word once uttered can never be recalled.

[390] Orpheus, seer and bard in one, weaned savage forest-tribes from murder and foul living; whence the legend that he tamed tigers and fierce lions. It was said, too, that Amphion, founder of Thebes, moved stones by the sound of his lyre and drew them where he would by the magic of his entreaty. This was the poets' wisdom of old—to draw a line between the Man and the State, the sacred and the common; to build cities, to check promiscuous lust, to assign rights to the married, to engrave laws on wood. Thus did praise and honor come to divine poets and their lays. Following upon them, noble Homer with impressive art depicted the character of heroes and their wrath, while Tyrtaeus with his songs kindled men's hearts to warrior deeds, in verse were oracles delivered, and the path of life shown forth, while the favor of monarchs was courted by Pierian strains, and festivals were devised to sweeten human toil. This I say lest perchance you should be ashamed of the lyric Muse, and of Apollo lord of song.

[408] Whether a good poem be the work of nature or of art is a moot point. For my part I fail to see the use of study without wit, or of wit without training: so true is it that each requires the other's aide in helpful union.

The athlete who is eager to reach the longed-for goal has endured and done much in boyhood, has borne heat and cold, has abstained from women and wine; the flute-player who plays at the Pythian games has first learned his lesson and trembled before a teacher. Nowadays people think it enough to say: "I make wonderful poems; devil take the hindmost! it's a shame for me to be outdone and to own I really do not know what I have never learned."

[419] As a crier collects a crowd to buy his wares, so a poet, rich in land and rich in investments, bids flatterers flock him for their profit. If there is one who can provide a costly feast, who will go bail for a poor man and rescue him from the law's grim toils, I shall be surprised if, for all his wealth, he is clever enough to distinguish the false friend from the true. Whether you have given another a present, or mean to do so, never call him, when filled with joy, to listen to your verses; for he will be sure to cry, "Splendid! bravo!" He will change color over them, drop tears of pleasure, leap, beat upon the floor.

Hired mourners outstrip in word and action those whose sorrow is real: so is the sham admirer moved far more than the honest one. Wealthy folk, when keen to mark whether a man be worthy of friendship, are said to ply him with many a bumper and put him to the ordeal of wine; so, if you write poems, you will never fail to detect the spirit that lurks beneath the fox's skin.

In days gone by, when you read a piece to Quintilius he would exclaim, "Correct this, I pray, or that." If you replied that you could do no better, that you had tried twice or thrice in vain, he would bid you cut out the ill-turned lines and bring them to the anvil again. If you chose rather to defend than to mend the faulty line, not a word more would he say, or waste his efforts. Henceforth you might hug yourself and your works, alone, without a rival.

[445] A kind and sensible critic will censure verses when they are weak, condemn them when they are rough, ugly lines he will score in black, will lop off pretentious ornaments, force you to clear up your obscurities, criticize a doubtful phrase, and mark what needs a change—in fact prove another Aristarchus. He will not say, "Why should I take my friend to task for mere trifles?"—it is such trifles that will bring into said scrapes the poet who has been fooled and flattered unfairly.

[453] As men shun the patient troubled with itch, jaundice, insanity, or moonstruck frenzy, so wise men dread to touch a mad poet, and avoid him: boys jostle him and fools pursue. If, spouting lines and roaming, head in air (like a fowler watching thrushes), your bard falls into a pit or ditch, he may bawl, "Help, neighbors, help!" but there's no one to pull him out. Should somebody minded to assist throw a rope, I shall say, "Who knows whether he has not thrown himself there on purpose, and does not want to be saved?" And then I shall relate the Sicilian poet's end: "Empedocles, wishing to be thought a god, in cold blood leapt into blazing Etna." Suffer poets to destroy themselves if they choose; he who saves a man against his will as good as murders him. No first attempt, this; if pulled back straightway, he'll never become like other folk nor lay down his desire for a theatrical ending. Nobody quite knows why he fashions verses: possibly he has fouled his father's grave or violated some sacred boundary, and so lost caste. Well, he's mad: that's clear; and like a bear that has managed to break its prison bars this pitiless reciter stampedes scholar and dunce alike. Once he has captured his victim, he sticks till he slays him with reading—like a leech that will never let go till gorged with blood.

The Bible

Matthew

5

Seeing the crowds, he went up on the mountain, and when he sat down his disciples came to him. ²And he opened his mouth and taught them, saying:

3 "Blessed are the poor in spirit, for theirs is the kingdom of heaven.

4 "Blessed are those who mourn, for they shall be comforted.

5 "Blessed are the meek, for they shall inherit the earth.

6 "Blessed are those who hunger and thirst for righteousness, for they shall be satisfied.

7 "Blessed are the merciful, for they shall obtain mercy.

8 "Blessed are the pure in heart, for they shall see God.

9 "Blessed are the peacemakers, for they shall be called sons of God.

10 "Blessed are those who are persecuted for righteousness' sake, for theirs is the kingdom of heaven.

11 "Blessed are you when men revile you and persecute you and utter all kinds of evil against you falsely on my account. ¹²Rejoice and be glad, for your reward is great in heaven, for so men persecuted the prophets who were before you.

13 "You are the salt of the earth; but if salt has lost its taste, how can its saltness be restored? It is no longer good for anything except to be thrown out and trodden under foot by men.

14 "You are the light of the world. A city set on a hill cannot be hid. ¹⁵Nor do men light a lamp and put it under a bushel, but on a stand, and it gives light to all in the house. ¹⁶Let your light so shine before men, that they may see your good works and give glory to your Father who is in heaven.

17 "Think not that I have come to abolish the law and the prophets; I have come not to abolish them but to fulfill them. ¹⁸For truly, I say to you, till heaven and earth pass away, not an iota, not a dot, will pass from the law until all is accomplished. ¹⁹Whoever then relaxes one of the least of these commandments and teaches men so, shall be called least in the kingdom of heaven; but he who does them and teaches them shall be called great in the kingdom of heaven. ²⁰For I tell you, unless your righteousness exceeds that of the scribes and Pharisees, you will never enter the kingdom of heaven.

21 "You have heard that it was said to the men of old, 'You shall not kill; and whoever kills shall be liable to judgment.' ²²But I say to you that every one who is angry with his brother shall be liable to judgment; whoever insults his brother shall be liable to the council, and whoever says, 'You fool!' shall be liable to the hell of fire. ²³So if you are offering your gift at the altar, and there remember that your brother has something against you, ²⁴leave your gift there before the altar and go; first be reconciled to your brother, and then come and offer your gift. ²⁵Make friends quickly with your accuser, while you are going with him to court, lest your accuser hand you over to the judge, and the judge to the guard, and you be put in prison; ²⁶truly, I say to you, you will never get out till you have paid the last penny.

27 "You have heard that it was said, 'You shall not commit adultery.' ²⁸But I say to you that every one who looks at a woman lustfully has already committed adultery with her in his heart. ²⁹If your right eye causes you to sin, pluck it out and throw it away; it is better that you lose one of your members than that your whole body be thrown into hell. ³⁰And if your right hand causes you to sin, cut it off and throw it away; it is better that you lose one of your members than that your whole body go into hell.

31 "It was also said, 'Whoever divorces his wife, let him give her a certificate of divorce.' ³²But I say to you that every one who divorces his wife, except on the ground of unchastity, makes her an adulteress; and whoever marries a divorced woman commits adultery.

33 "Again you have heard that it was said to the men of old, 'You shall not swear falsely, but shall perform to the Lord what you have sworn.' ³⁴But I say to you, do not swear at all, either by heaven, for it is the throne of God, ³⁵or by the earth, for it is his footstool, or by Jerusalem, for it is the city of the great King. ³⁶And do not swear by your head, for you cannot make one hair white or black. ³⁷Let what you say be simply 'Yes' or 'No'; anything more than this comes from evil.

38 "You have heard that it was said, 'An eye for an eye and a tooth for a tooth.' ³⁹But I say to you, Do not resist one who is evil. But if any one strikes you on the right cheek, turn to him the other also; ⁴⁰and if any one would sue you and take your coat, let him have your cloak as well; ⁴¹and if any one forces you to go one mile, go with him two miles. ⁴²Give to him who begs from you, and do not refuse him who would borrow from you.

43 "You have heard that it was said, 'You shall love your neighbor and hate your enemy.' ⁴⁴But I say to you, Love your enemies and pray for those who persecute you, ⁴⁵so that you may be sons of your Father who is in heaven; for he makes his sun rise on the evil and on the good, and sends rain on the just and on the unjust. ⁴⁶For if you love those who love you, what reward have you? Do not even the tax collectors do the same? ⁴⁷And if you salute only your brethren, what more are you doing than others? Do not even the Gentiles do the same? ⁴⁸You, therefore, must be perfect, as your heavenly Father is perfect.

CHAPTER SEVEN

BYZANTIUM

Astride the main land route from Europe to Asia and its riches, the city of Byzantium had great potential as a major metropolis. A defensible deep-water port controlling the passage between the Mediterranean and the Black Sea, and blessed with agriculturally fertile surroundings, the city formed an ideal "New Rome." And this was precisely the objective of the Emperor Constantine when he dedicated his new capital in AD 330 and changed its name to Constantinople (it is now known as Istanbul). The city prospered, becoming the center of Christian Orthodoxy and source of a unique and intense style in the visual arts and architecture. When Rome fell to the Goths in 476, it had long since handed the torch of its civilization to Constantinople. Here the arts and learning of the classical world were preserved and nurtured, while western Europe suffered the turmoil and destruction of wave upon wave of barbarian invasion.

7.1 Empress Theodora and attendants, c.547. Detail of wall mosaic. S. Vitale, Ravenna, Italy.

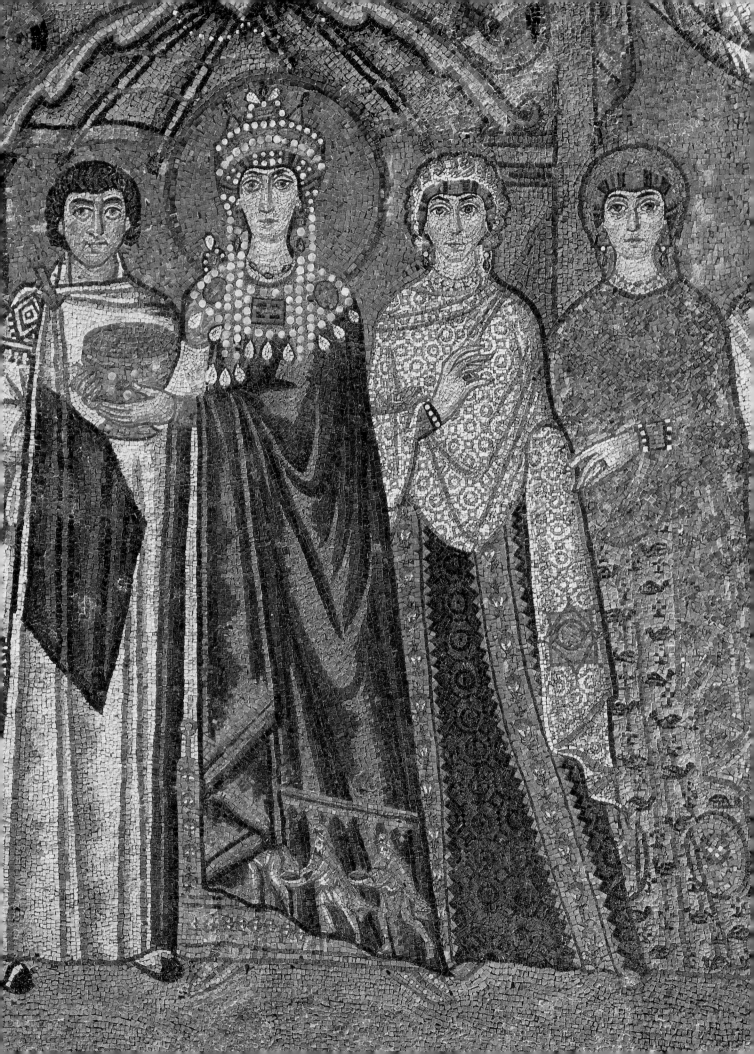

CONTEXTS AND CONCEPTS

Although the Eastern Empire of Byzantium is geographically considered part of the eastern world, its relationship with and influence on western thought and art was highly significant. Here we examine the history and culture of the capital city of the Eastern Roman Empire from the year 330 until its conquest by the Turks in 1453. Parallel developments in the west are covered in Chapters 8 and 9.

The Byzantine Empire was founded on 11 May 330. On that day, Constantine made Byzantium the second capital of the Roman Empire, and renamed it Constantinople. The geographical location of the city, at the bridging point between Europe and Asia, made it an ideal center for trade, governance, and the development of the arts. The culture of the region at that time was based upon a mixture of Hellenistic tradition and Christian thought.

The separation of the Eastern Roman Empire from Rome and the Western Roman Empire became fact in the year 395. The Emperor Theodosius the Great died that year, and he divided his empire between his two sons, Arcadius and Honorus. While eastern in many respects, Constantinople maintained its Roman traditions after the fall of the Roman Empire in 476 until the end of the sixth century. From then on, it followed its own independent course.

Two crises contributed to the distinctive character of the Eastern Empire. First, barbarians invaded Europe in the fifth century—the Visigoths, led by Alaric; the Huns, led by Attila; and the Ostrogoths, led by Theodoric. The barbarians were successful in carving up the Western Empire, yet they were unable to make more than superficial inroads into the east. This gave the New Rome political supremacy. The second crisis was religious. During the fourth and fifth centuries, the Eastern Empire was the seedbed of several "heresies" in the Christian Church. True to its Greek spirit, the Eastern Orthodox Church revelled in subtle theological metaphysics. This characteristic led to the development of ideas that conflicted with the official theology of the Church in Italy and eventually caused a schism between the Eastern and Roman Church establishments that persists to this day.

Out of this schism emerged the important concept of a purely eastern empire. Its system of government was an absolute monarchy in the eastern tradition. Its Church used the Greek language in its writings and rituals, and it was closely linked with the government that ruled it.

JUSTINIAN

The movement toward total separation from the Western Empire lost some momentum under the rule of the Emperor Justinian (527–65). He aspired to be Roman Emperor as well as Emperor in the east, and tried to promote both imperialism and Christianity. He claimed to be heir to the Caesars, and his great ambition was to re-establish Roman unity. This ambition was partly achieved as he reconquered Africa, Italy, Corsica, Sardinia, the Balearic Islands, and part of Spain. The Frankish kings of Gaul recognized his suzerainty. As head of the Eastern Empire, he was also revered as Vicar of God on earth and champion of Orthodoxy.

In an attempt to hold his reconstructed empire together, Justinian sought a close alliance with the Roman papacy. As he concentrated on the west, however, he left the Eastern Empire vulnerable to hostile forces from the east, who tried to exploit this weakness over the following two centuries.

Justinian's greatest legacy lies not in his brief reconstruction of the Roman Empire, however, but in the enormous work of recodifying the outmoded and cumbersome apparatus of Roman law. The result was the *Corpus Juris Civilis*, which reduced the reference books needed by a Roman lawyer from 106 volumes to six. This recodification of the law greatly influenced Justinian's own and succeeding centuries.

REORGANIZATION OF THE EASTERN EMPIRE

Because Justinian's power was so concentrated, his abilities so great, and his spending so extravagant, his death left the Eastern Empire severely weakened, both economically and militarily. This attracted the interest of the Persians and, shortly after, of the Arabs. Heraclius (610–41) was able to rebuff the Persians. He led his legions in triumph as far as Nineveh and Ctesiphon, earning for himself the title of the "first crusader." Before his death, however, the empire was already facing its next challenge from the Arabs, who conquered Syria, Egypt, North Africa, and Armenia. The following decades were the darkest in Byzantine history. Threats on all sides, from Lombards, Slavs, Arabs, and Bulgars, effectively reduced the empire to an enclave centered on Constantinople.

It was not until the advent of the Isaurian emperors in

717 that Byzantium recovered, but critical changes resulted. All political power was invested in the military leaders. Latin was replaced by Greek, and literary forms began to take on eastern characteristics. Orthodox Christianity, with its emphasis on monastic retreat from worldly life, strengthened its hold on public affairs. In all areas of life, the breach with the Roman legacy widened. Out of all this arose a truly eastern and enduring empire, militarily strong and efficiently organized.

THE ISAURIAN EMPERORS AND ICONOCLASM

The task of stabilizing the Eastern Empire fell to the first oriental rulers to take control. These were the Isaurian emperors, who ruled from 717 to 867. They had originally come from the distant mountains of Anatolia. The first ruler of the Isaurian dynasty, Leo III, finally drove the Arabs from Constantinople in 717. His successor, Constantine V, reestablished control over important territories in Asia Minor, and fortified and consolidated the Balkan frontier. As they tried to minimize internal strife, the Isaurians concerned themselves with administrative order and the general welfare of their subjects. The bureaucracy of the empire thus became more closely associated with the Imperial Palace.

An even briefer legal code, called the E*cloga*, replaced Justinian's *Corpus*. The E*cloga* limited the traditional authority of the Roman *paterfamilias*, the male head of the household, by increasing rights for women and children. This was a concept new to Christian society: marriage was no longer a dissoluble human contract, but, rather, an irrevocable sacrament. The oriental punishment of mutilation replaced the death penalty in criminal justice, reflecting at least some concern for rehabilitation.

The period of Isaurian rule saw violent conflict within the Christian Church, however. The causes of this conflict, known as the "iconoclastic controversy," have been variously interpreted. In the preface to the E*cloga*, the emperor's duties were cast in terms of a divine mandate:

Since God has put in our hands the imperial authority . . . we believe that there is nothing higher or greater that we can do in return than to govern in judgment and justice those who are commited by him to our care.[1]

In his self-appointed role of king–priest, Leo III entered the controversy, which concerned the use of ICONS in the eastern Church. Icons, or images, depicting the saints, the blessed Virgin, and God himself, by now occupied a special place in Orthodox churches. From the sixth century onward, these paintings and mosaics had been extremely important in Orthodox worship and teaching. But in the eighth century, their use came into question, and those who were opposed to them maintained that icons were idols, that is, they had become objects of worship in themselves, perverting the worship of God. They demanded the removal of icons, and on many occasions they used force to impose their will, hence the name "iconoclast," or "icon-destroyer."

Leo III favored the iconoclasts, and, in 730, issued a proclamation which forbade the use of images in public worship. One reason for the edict appears to have been Leo's belief that the Arab invasions and volcanic eruptions at the time indicated God's displeasure with Orthodox practices. The iconoclast movement reached its peak under Constantine V and was formally approved by the council of bishops in 754. Over the next century icons remained at the center of controversy, and their use ebbed and flowed, depending on the current emperor. Gradually, however, the "iconophiles," or "icon-lovers," gained ground. Persecution was relaxed, and on the first Sunday of Lent in 843, a day still celebrated as an Orthodox feast day, icons were permanently restored to their place in eastern worship.

The resolution of the iconoclastic struggle and the establishment of a united empire under Charlemagne in the west in 800 finally set Byzantium on its own course. By the time of the Emperor Theophilus (829–92), the Byzantine court rivalled any in the world. The University of Constantinople was reorganized, in about 850, by Caesar Bordas, and became a great intellectual center. The triumph of the iconophiles in 843 united the Orthodox Church, and strengthened its influence and character. The 150 years that followed the reign of Theophilus were a period of great prosperity and brilliance.

FROM RISE TO FALL (867–1453)

Nothing in the west during this period remotely resembled the splendor and sophistication of Byzantium. In the east, unlike the west, religious and secular life were closely intertwined. The visual arts flourished, and the subject matter was almost without exception religious. The Church calendar was inseparable from the court calendar. Moreover, the spectacle of court and Church ritual had a THEATRICAL splendor which reinforced the majesty of the empire and the place of the emperor as the vice-regent of God. Even the emperor's public appearances were staged. Seated behind a series of heavy curtains which were raised one by one, he was revealed only when the final curtain was lifted.[2] Yet despite its strong economic and commercial base, and its military strength, Constantinople was unable to withstand the trials of the 11th century.

Internal troubles developed. A succession of feeble, short-lived emperors weakened the central authority, and disputes between provincial aristocracy and the bureaucrats in the capital got out of hand. The excessive ritualism and exaggerated manners of the court masked

AD	GENERAL EVENTS	LITERATURE & PHILOSOPHY	VISUAL ART	THEATRE & DANCE	MUSIC	ARCHITECTURE
330	Constantinople founded	Early hagiography	Theodosian obelisk (7.12)		Christian hymnody well established	
400	Eastern & Western Empires split Fall of Rome		Narrative Christian art			
500	Reign of Justinian	History developed as high art Procopius	Barberini Ivory (7.14) Mosaic floors Justinian and his Court and other mosaics, S. Vitale (7.1, 7.23–24)			S. Vitale Ravenna (7.20–22) Hagia Sophia (7.25)
600	Isaurian rulers Leo III repulses Muslims		Silk textile art (7.11)	Disappearance of formal theatre performance		
800	Charlemagne unifies Western Empire End of iconoclast struggle		Raising of Lazarus (7.10) Vision of Ezekiel (7.9) Harbaville Triptych (7.15) Virgin and Child (7.13)		Kanones	
1000	Comneni rulers	Recurrence of Platonism Michael Psellus Prodromic poems	Emergence of hierarchical formula			St Theodosia (7.17) St Luke and the Virgin (7.18)
1200	Constantinople sacked by Frankish Crusaders			Turkish Orta Oinu		St Mary Pammakaristos (7.19)
1453	Fall of Constantinople to the Ottoman Turks			Exodus of actors		

7.2 Timeline of the Byzantine Empire.

7.3 The empire of Justinian I.

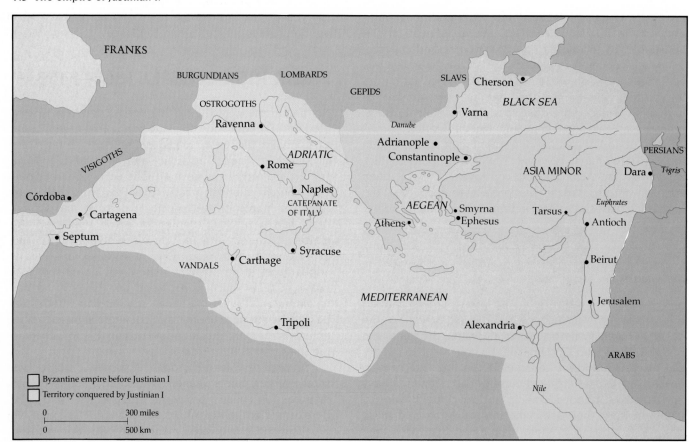

yet encouraged the habitual conspiracy and intrigue that still give negative meaning to the adjective "Byzantine."

At the same time, a serious rift developed between the intellectual élite and the military. As a result, the army and navy were deprived of the funds needed to defend the empire against new threats from the outside. These came from the Normans in the west and the Turks in the east. A new religious controversy also arose which was fueled by hatred of the higher Greek clergy and led the Bulgars to initiate a series of revolts.

The slide into chaos was checked for a time under the rule of the Comneni emperors. The Comneni dynasty, which lasted until 1185, succeeded in ridding Greece of the Normans and defending the empire against the Petchenegs, a group of southern Russian nomads. Venice had supplied naval assistance, however, and in return demanded important commercial concessions. Venetian influence and power increased immensely, while Byzantium could not recover its former strength, and internal struggles and conflicts proliferated.

In 1203, a crusade set out from the west for the Holy Land. But the Venetian contingent diverted it instead to Constantinople, whose wealth Venice was keen to plunder. In 1204, a riot provided the Crusaders with an excuse for sacking the city. This delivered the fatal blow to the empire. The treasures of the city—books and works of art centuries old—were almost all destroyed or carried off. Central organization collapsed. Trying to preserve themselves, parts of the empire broke away. The Crusaders had stripped the empire of its strength, and it lay defenseless against the Ottoman Turks when they overran it in 1453.

BYZANTINE INTELLECTUALISM

Nowhere in the Medieval world was the classical tradition better preserved than in Constantinople. Although heir to the Roman Empire, the Eastern Empire was directly descended from classical Greece. The famed Greek cities of Athens, Antioch, and Alexandria all lay within its borders. Constantinople itself was to all intents and purposes a Greek city. Its native language was Greek—at a time when no other nation of the Western Empire even spoke Greek—and so its citizens were better versed in Greek classicism than anyone else. Eastern libraries overflowed with treasured classical texts. Greek literature formed the basis of Byzantine education. Homer, Hesiod, Aristophanes, Aeschylus, Plato, and Aristotle were widely read among the cultured classes. At the University of Constantinople, the "consuls of the philosophers" and the "masters of the rhetoricians" found inspiration in classical traditions. The same love of antiquity seems also to have been felt by private individuals. Even at its very lowest ebb, Constantinople never fell into a cultural dark age.

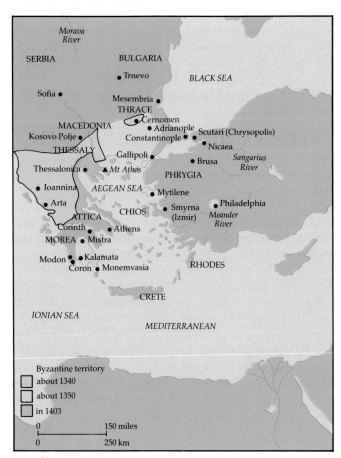

7.4 The Byzantine Empire 1340–1403.

The study of history took pride of place in Byzantine thought. In the sixth century great historians arose, who were without equal in the western world. They understood both politics and human psychology and their writings display superb composition and style. Although some, such as Anna Comnena, imitated the ancients so faithfully that their style became cramped and involved, she and others, such as Nicephorus Bryennius, were inspired to make the historian's task a true art, rather than a sterile recitation of events.

Theology held the second highest place among eastern intellectual pursuits. The proliferation of theological literature was undoubtedly fueled by the seemingly endless heresies that troubled Byzantium and required defenses of Orthodoxy. The list of significant eastern theologians is substantial, including Leontius of Byzantium, John of Damascus, Maximum the Confessor and Photius, among others. Numerous works were devoted to scriptural commentary, and the development of monasticism produced a new genre: mystical literature. Classical rhetoric influenced religious speaking, which became very popular. As the ninth century passed, theological creativity seems to have failed, however, and only tradition remained. A period of stagnation set in.

In the realm of philosophy, Platonic thought re-emerged in the University of Constantinople during the 11th century. Platonism was spread through the proselytizing zeal of Michael Psellus. Often in conflict with the strict Orthodoxy of the patriarchs, Psellus worked his way back from neo-Platonism to "the pure light of Plato."

INTELLECTUAL INFLUENCE

The intellectual accomplishments of the Eastern Empire influenced the west considerably. The Byzantine conception of Imperial power which derived from the Justinian Code had a profound effect on emerging western ideas of absolute monarchy. The law of Justinian was brought to Italy, and by the 11th century, law schools in Rome, Ravenna, and Bologna were teaching its doctrines. Here Frederick Barbarossa found strong arguments for establishing his Imperial claims in the middle of the 12th century. In the 13th century, scholars in Bologna provided the bases on which the Emperor Frederick II Hohenstaufen proclaimed himself "law incarnate upon earth," and justified "his right to order ecclesiastical affairs as freely as the secular interests of his empire."[3] In the same tradition, the king of France was later declared "above the law."

Theological accomplishment in the Eastern Orthodox Church was superior to that in the west, at least until the 12th century. Its influence can be seen in the works of many western theologians, among them Scotus Erigena, Peter Lombard, and St Thomas Aquinas. French literature and legend also display strong links with Byzantine sources, and particularly its hagiography, or descriptions of lives of the saints.

Other Byzantine legacies included the promulgation of Aristotelian philosophy and a strong current of humanism, both of which figured prominently in the Renaissance of the mid-15th century in western Europe centered on Italy. Platonic doctrine had taken a place of honor in the University of Constantinople in the 11th century, and it was from there that Platonic thought spread, first to Florence, in Italy, and then to the rest of Europe. The Greek scholars who left Constantinople after its sack and came to Italy brought Byzantine humanism with them. Humanism enjoyed great currency during the 13th and early 14th centuries in Europe. These scholars also brought many important Greek manuscripts, and an appreciation of Greek intellecutal accomplishment was thus rekindled in the west.

FOCUS

TERMS TO DEFINE

Byzantine	Iconoclasm	Orthodoxy
Monasticism	*Ecloga*	

PEOPLE TO KNOW
Justinian
Comneni emperors
Leo III

DATES TO REMEMBER
Founding of Constantinople
Reign of Justinian
Fall of Constantinople to the Turks

THE ARTS
OF BYZANTIUM

TWO-DIMENSIONAL ART

Fundamental to the visual art of the Eastern Empire is the idea that art can be used to interpret as well as to represent its subject matter. Byzantine art was conservative, and, for the most part, anonymous and impersonal. The artist was clearly subordinate to the work. Much of Byzantine art remains undated, and questions about how styles developed and where they came from are unresolved. The expansion of artistic forms from those appropriate to the constrained spaces of late Roman Christian churches to those better suited to the vast wall surfaces of new Byzantine churches posed problems that took time to resolve. The development of this new narrative Christian art dates back to the mid-fifth century, but early attempts at the depiction of religious ideas can be traced to the third and fourth centuries.

The content and purpose of Byzantine art was always religious, although representational style underwent many changes. Classical standards slipped with the decline in enlightened patronage and skilled craftsmanship. The ostentation of the Imperial court influenced artistic style, and Christ and the saints were depicted as

7.5 *Dormition of the Virgin* (detail), 1258–64. Fresco. Church of the Trinity, Sopoćani, Yugoslavia.

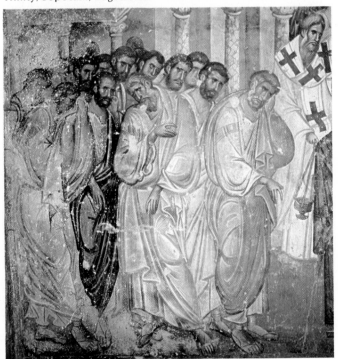

frozen in immobile poses and garbed in regal purples. Lacy ornamentation corrupted what was left of classical purity in the sixth century.

The period of Justinian marks an apparently deliberate break with the past. What we describe as the distinctly "Byzantine style," with its characteristic abstraction and its focus on feeling rather than form, began to take shape in the fifth and sixth centuries. (If the classical Hellenistic tradition survived at all, it was only as an undercurrent.) The style of some works where the realism of the depiction appears to predate the work itself has caused some confusion over dating. Throughout the seventh century, classical realism and decorative abstraction intermingled in Byzantine art.

By the 11th century, Byzantine style had developed a hierarchical formula for wall painting and mosaics. There was reduced emphasis on narrative. The Church represented the kingdom of God, and as one moves up the hierarchy, one encounters figures ranging in form from human to the divine. The placing of figures in the composition depended upon religious, not spatial, relationships. The representation of figures is in no way illusionistic: it is strictly two-dimensional, but the style is elegant and decorative. In 12th- and especially in 13th-century art, this style intensifies, detailed with architectural backdrops, flowing garments, and elongated but dynamic figures (Fig. **7.5**). The 14th century produced small-scale, crowded works that are highly narrative. Space is confused by irrational perspective, and figures are distorted, with small heads and feet. The effect is of intense spirituality.

Mosaic

Covering a period of 1000 turbulent years, Byzantine art contains a complex repertoire of styles. When Constantine established his capital at Constantinople, a group of artists and craftsmen, trained in other centers, was already there. When these people set to work on Constantine's artistic projects, they naturally rendered their subjects in a manner quite different from the Roman style.

One of the earliest examples of two-dimensional art is a MOSAIC floor in the Imperial Palace of Constantinople. Mosaic was a characteristic Byzantine medium, and Figures **7.6** through **7.8** show examples whose finely detailed execution allows for an essentially naturalistic style. The mosaics depict figures, buildings, and scenes,

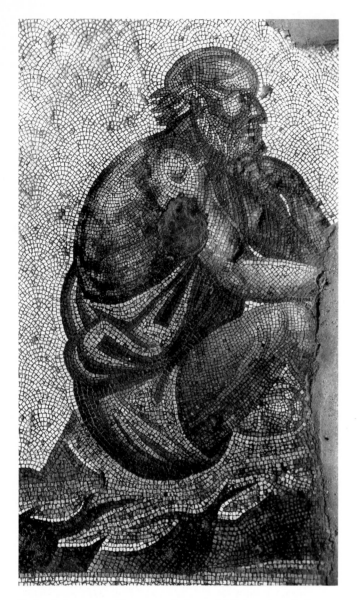

Early sixth century. Floor mosaic. Imperial Palace, Istanbul.
7.6 A seated "philosopher."

7.7 Eagle and serpent.
7.8 Border, detail of head.

unconnected with each other, presented against a white background. The grandeur and elegance of these works reveal Greek classical influence. Although the figures are fairly naturalistic, the absence of background and shadow indicates that pictorial realism was neither intended nor important. Rather, each figure has a mystical, abstract feel which is clearly unclassical.

The palette is rich and varied. The fragment shown in Figure **7.8** is representative of one important development in the use of color. The hair of the head which forms part of the decorative border as it intermingles with the foliage is green in places, while the mustache is blue. Yet the overall effect remains quite realistic—a curious mix of the vividness and stylization that would later typify Byzantine art.

Hieratic style

In the middle centuries of the empire, a style known as "HIERATIC," meaning here "holy" or "sacred," emerged, consisting of formal, almost rigid, images. It was less intended to represent real life than to inspire reverence and meditation. The canon of proportion of the hieratic style ordained that a man should measure nine heads in height (seven heads gives the modern proportion). The hairline was one nose length above the forehead. In addition, "if the man is naked, four noses' lengths are needed for half his width."

By the 13th century, mosaics had returned to more naturalistic depictions, but they did not lose the clear sense of the spiritual that was apparent in the much

7.9 *The Vision of Ezekiel*, from the Homilies of Gregory Nazianzus, Bibliothèque Nationale, Paris.

earlier Ravenna mosaic of Emperor Justinian and his court (Fig. **7.24**). The hieratic style also occurs in other media, for example, in the *Harbaville Triptych* (Fig. **7.15**) and *Virgin and Child* ivories (Fig. **7.13**). In both, we see the formality, frontal poses, and slight elongation of forms that are typical of the style.

Manuscript illumination

In addition to the mosaics that decorated palaces and the wealthier churches, manuscript ILLUMINATION and wall painting were also important in Byzantine art. From the period immediately after the iconoclastic controversy

come exquisite manuscript illuminations. The rich colors are handled with masterful control and delicacy, to give assured shading and elegant detail.

The scenes shown in Figures **7.9** and **7.10** tell stories. The *Vision of Ezekiel* (Fig. **7.9**) treats the story from the Old Testament in four separate panels. Continuity is established by some part of each scene (except the last) breaking through its border into the neutral space between the panels. In the upper right corner, one picture actually breaks into the adjoining scene. Figure **7.10** unfolds its narrative in two registers, depicting the New Testament stories of Jesus raising Lazarus from the dead, and of his entry into Jerusalem shortly afterward. The technique is called "continuous narration," with the episodes laid out across the top, and then continuing in the bottom register. There is much in these works that is classically derived, and yet the treatment of space, with its crowded figures, its concentration on the surface plane, and lack of realistic linear perspective, is entirely Byzantine.

Figure **7.11** shows the use of figure reversal and repetition, similar in character to the Mesopotamian designs discussed in Chapter 2, now adapted to a particularly suitable medium, woven textiles. The central, repeated figure of the design is probably Samson, whose struggle with a lion is recounted in the Old Testament book of Judges. The borders are composed of representational and geometric elements, and the whole design gains force from the bold colors.

7.10 *The Raising of Lazarus and the Entry into Jerusalem*, from the Homilies of Gregory Nazianzus, 867–86. 16.1 × 12 ins (41 × 30.5 cm). Bibliothèque Nationale, Paris.

7.11 A lion strangler (Samson?), eighth century. Silk textile, 15.6 × 12.2 ins (39.5 × 31 cm). Victoria and Albert Museum, London.

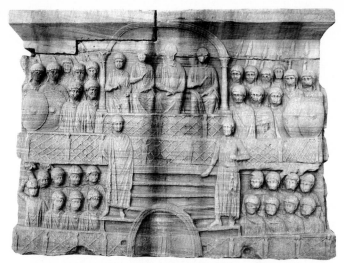

7.12 Base of the Theodosian obelisk, c.395. Marble, about 13 ft 11 ins (4.2 m) high. The Hippodrome, Istanbul.

SCULPTURE

Sculpture developed in the same historical context as the two-dimensional arts. Early works include sculptural vignettes illustrating Old and New Testament themes of salvation and life after death. For two centuries or so, the old art of Roman portrait sculpture held sway. But by the end of the fourth century, styles had begun to change. In Figure **7.12**, the base of an obelisk set up by Theodosius I, the frontal poses of figures, the ranks in which they are grouped, and the large, accentuated heads reflect oriental influence. Oriental and classically inspired works existed alongside each other in this period. Large-scale sculpture virtually disappeared from Byzantine art after the fifth century. Small-scale reliefs in ivory and metal continued in abundance, however. The clear-cut, precise style of Greek carving later became an outstanding characteristic of Byzantine sculpture. As in painting, sculpture took a classical turn after the iconoclastic struggle, but with an added awareness of the spiritual side of human beauty.

Ivory, traditionally a precious material, was always very popular in Byzantium. The number of carved works in different styles provides evidence of the various influences and degrees of technical ability in the Eastern Empire. Many of the ivories are diptychs, that is, in two panels. The *Barberini Ivory* (Fig. **7.14**) is a work of five separate pieces, one of which is missing. At the center, an emperor is depicted on horseback. To the side is a consul in military costume, and above is a bust of Christ with winged victories on either side. The long panel at the bottom depicts Gothic emissaries on the left side and emissaries from India on the right; interestingly, the latter are portrayed carrying elephant tusks—the source of the artist's material. The rounded features and brilliant high-relief technique are typical of the period. The portrait of the emperor is individualized and recognizable. Later ivories show a more delicate elegance and a highly finished style.

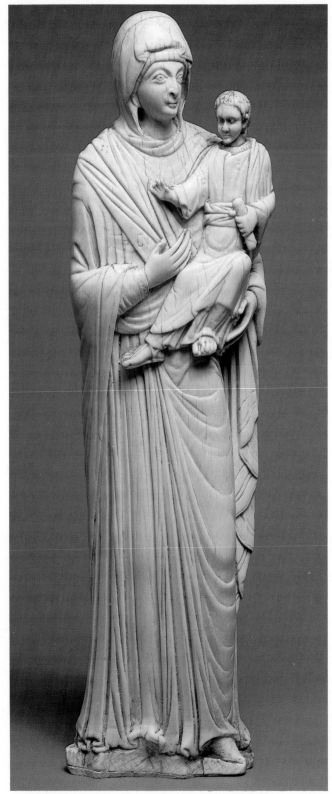

7.13 *The Virgin and Child*, tenth century. Ivory, 12⅞ ins (32.5 cm) high. Victoria and Albert Museum, London.

The only known Byzantine free-standing sculpture in ivory is the tenth-century *Virgin and Child* (Fig. **7.13**). The drapery falls exquisitely and the surface is highly finished. The facial features, hands, and torsos display characteristic hieratic elongation.

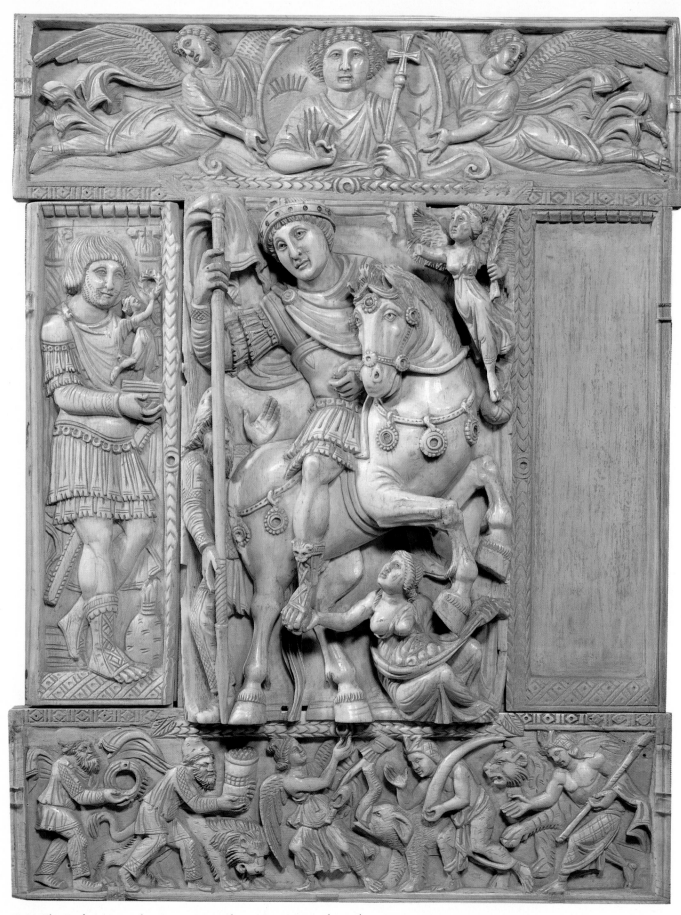

7.14 The *Barberini Ivory*, showing a mounted emperor, c.500. $13\frac{1}{2} \times 10\frac{1}{2}$ ins (34.1 \times 26.6 cm). Louvre, Paris.

MASTERWORK
The Harbaville Triptych

The tenth and 11th centuries have left us the greatest number of ivory objects, many decorated with small, elegant reliefs. In secular art, ivory caskets covered with minute carvings were the most popular form. Byzantine ivory carvers of the time showed remarkable ease and skill in imitating classical models. The same technique was used for small-scale reliefs of religious subjects, which cover an extensive variety of content and style. The *Harbaville Triptych* (Fig. **7.15**) is an exquisite example.

The TRIPTYCH (work in three sections) was probably intended as a portable altar or shrine. The two wings folded shut for traveling, across the center panel. In the top center Christ is enthroned and flanked by John the Baptist and the Virgin Mary, an arrangement known as *deesis*, where these two plead for mercy on behalf of all humanity. Five of the apostles appear below. The two registers of the central panel are divided by an ornament repeated, with the addition of rosettes at the bottom border, and three heads in the top border. On either side of Christ's head appear medallions depicting angels holding symbols of the sun and the moon. The figures have hieratic formality and solemnity, yet the depiction exhibits a certain softness that may result from a strong classical influence.

The figures stand on a plain, flat ground, ornamented only by the lettering of their names beside the heads. The side wings contain portraits of four soldier saints and four bishop saints. Between the levels are bust-length portraits of other saints. All the saints wear the dress of various civilian dignitaries. The triptych thus aligns the powers of Church and State, within the hierarchical formula of Byzantine art: each personage has his or her own place in the divine hierarchy, with Christ at the top.

This work and others from the same period belong to a class of works known as "Romanus," after a PLAQUE in the Bibliothèque Nationale in Paris that shows Christ crowning the Emperor Romanus IV and his Empress Eudocia. The works of this Romanus school of ivory carvers are identifiable by style, of course, but they have a particular ICONOGRAPHIC peculiarity as well. The cross in Christ's NIMBUS, or halo, shows the usual rectangular outline, but a pearled border has been added to both cross and nimbus. Similarly fine workmanship is found in the mosaics and painting of the time, and, in fact, stylistic developments in the ivories were closely associated with those in painting.

7.15 The *Harbaville Triptych*, interior, late tenth century. Ivory, 9½ ins (24.2 cm) high, central panel 5⅝ ins (14.2 cm) wide. Louvre, Paris.

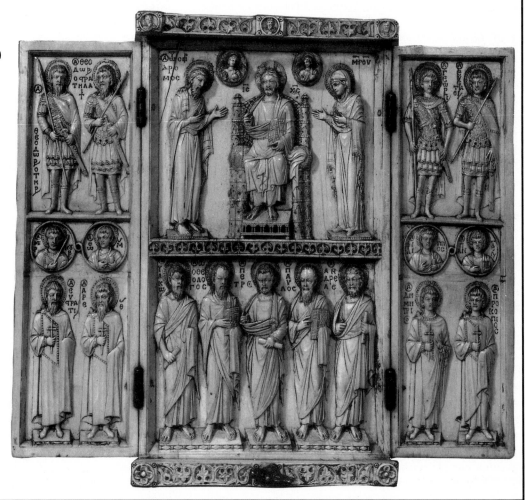

LITERATURE

The literature of Byzantium is often thought of as Greek literature. That is true of the majority of Byzantine literary works, and certainly of the literature coming out of Constantinople. But the Eastern Empire of Byzantium was not confined to Constantinople. The literature of the empire in fact includes works in Latin, Syriac, Coptic, Church Slavonic, Armenian, and Georgian.

Byzantine literature in Greek, however, does comprise a vast quantity of works. Much from the early period has unfortunately been lost, and much remains unpublished, in manuscript form. Most of Greek Byzantine literature is on religious subjects, and much of it is hagiographic, that is, covering the life stories of saints and other religious figures. In addition, there are sermons, liturgical books, poetry, theology, devotional works, scriptural commentaries, and so on. Of the thousands of volumes that have survived, only a few hundred are secular, and those include the histories mentioned in an earlier section.

To understand Byzantine literature, we need to know something about Byzantine aesthetic taste, which was quite different from our own. Modern readers do not obtain much pleasure from Byzantine literature, because we expect to find quite different qualities in what we read: we like originality of thought and expression. Educated Byzantines did not wish to be surprised. They liked clichés. Where we value clarity and directness, they admired elaboration and verbiage.[4]

The Greek language itself had gone through several stages: an epic stage (the language of Homer and Hesiod); a literary stage (the Attic of the fifth and fourth centuries BC), and a New Testament Greek stage, which Byzantine scholars considered decadent. Sensitive to the rhetorical excesses of the past, churchmen admired only humble Byzantine speech and rejected "the fine style of the Hellenes," which they compared "to the proverbial honey that drips from the mouth of a whore." They would have considered that using the epic meters of the past was "an insult to Christ and the apostles."[5] As a result, each generation of Byzantine authors resisted the influence of its predecessors, going directly to ancient models. Many Byzantine works, therefore, exist in a sort of stylistic vacuum, without an acknowledged author, without contemporary references, and without place.

Byzantine literature falls into three principal genres. The first is historiography. This is not the history we speak of when we refer to a chronicled record of events, which was a separate activity in Byzantium. Historiography is, rather, a specific literary genre, related to rhetoric. It is written in ancient Greek, in imitation of ancient models, and interprets events and their influence on each other. As Theophanes Continuatus wrote, "The body of history is indeed mute and empty if it is deprived of the cause of actions." Probably the best known of the Byzantine historiographers was Procopius of Caesarea. His broad, sweeping narratives, which were known for their objectivity and accuracy, were modeled on the work of the Athenian historian Thucydides.

The bulk of Byzantine literature belongs to the second genre, hagiography. Many of these texts on the lives of the saints survive, most of them written in ecclesiastical Greek. They consist of anecdotes about the saints, as well as full life-histories, which had been preserved by Egyptian monks. The anecdotal accounts were first circulated by word of mouth, then collected in books. The stories told of supernatural deeds attributed to monks, and stressed the moral precepts they followed in their lives. The first "life" was written by Athanasius of Alexandria (c.360) about St Anthony. Principally designed to praise the behavior of its subject, a "life" usually follows a specific rhetorical format. The writer first proclaims embarrassment at undertaking a task so great; then the birthplace (if it is worthy of note) or the nation in which the subject was born is described and praised; next comes a description of the family, but only if it is glorious; then the subject's birth and any miraculous signs accompanying it, real or invented, are noted; finally, in carefully organized subdivisions, physical appearance, education, upbringing, characteristics, deeds, and so on, are described. This outline, or SCHEMA, made it easy to develop biographies of saints about whom little was known or who may never have existed. The "lives" are interesting and readable, if somewhat predictable, and they provided heroes and heroines for the Medieval world. Written in simple language, they were intended for as wide an audience as possible.

The third genre was literature written in the vernacular, or language of the common people. The earliest works of this sort, the Prodromic poems, date to the first half of the 12th century. They are attributed to the court poet Theodore Prodromos, although they may have been written by several authors.

These poems employ a popular verse-form based on 15 syllables and are written as complaints directed to the Emperors John II and Manuel I and other members of the Comneni family. One of the poems tells the story of a hen-pecked husband; another, the story of the father of a large family who cannot make ends meet on his small salary.[6] These works are largely humorous, although their tendency to monotony and repetition often mars the effect of the slapstick and the coinage of bizarre words. Romances of chivalric knights, maidens, witches, and dragons in the fashion of the Western Empire were also popular. Epic poems that told heroic tales of the eastern border between Byzantium and the Arabs in the ninth and tenth centuries also found favor.

Much of Byzantine literature, however, is solemn, even somber in mood. Its writers seem most at home with themes of calamity, death, and the precariousness of human existence.

THEATRE

The Byzantines were undoubtedly familiar with theatre. Ruins of Hellenistic theatres have been found throughout the Eastern Empire. Justinian's wife, Theodora, was an actress, and theatrical spectacles surrounded the life of the Imperial court. There are references to an exodus of actors and playwrights from Byzantium at the time of the Turkish conquest.

But what of theatre itself? The period between the fall of Rome and the late Middle Ages witnessed the virtual extinction of theatre in both east and west, except in its most rudimentary form. The Byzantine preference for artistic anonymity might account for the absence of dramas, and the literature of Byzantium certainly excluded drama from its priorities. In a society dominated by the Christian Church, the kind of debased spectacles popular in the late years of the Roman Empire were undoubtedly frowned upon. Such was the moral tone of the time that senators were barred by law from marrying actresses: Justinian had to change this law in order to marry Theodora. *Scaenici*, as theatre productions were called, continued into the sixth century in the west, and we hear of professional actors in Byzantium as late as the seventh century, but after that formal theatre performances seem to have disappeared. As one commentator puts it, "In the East problems more serious soon set people thinking of things sterner than merry supper-parties with groups of dancing girls."[7]

Throughout the Middle Ages, critical remarks to the effect that it was "better to please God than the actors" suggest that some form of performance art continued, however, and it is not unlikely that this was also the case in Byzantium. The mime, and some form of pantomime, were probably the only forms of theatrical activity during this period.

Twelfth-century Turkish theatre would almost certainly have been influenced by Byzantine practice. Evidence of its character is provided by the Turkish *Orta Oinu*, which consisted of simple plays that were acted in the open, with minimal scenery.[8] Popular theatre in Byzantium may well have followed this course. During the latter period of the Eastern Empire, the aristocracy seems to have satisfied its dramatic inclinations with spectacles involving the actual members of the Imperial court.

MUSIC

Before reaching Europe, the Christian Church spread throughout Asia Minor, accumulating musical elements on its way. Byzantium appears to have acquired much of its musical heritage from the monasteries and churches of Syria, where the development of antiphonal psalmody and the use of hymns originated. Clear evidence of hymn singing can be found in the New Testament, both in the Gospels and in the letters of Paul and James, and in the writings of Pliny the Younger in Bithynia and Asia Minor in the second century. Some early Christian hymns were probably sung to folk melodies. Thus there seem to have been both eastern and Greek influences on early Christian music.

Although no music manuscripts survive from this period, the strong traditions of the Greek Orthodox, Russian, and other eastern Churches still preserve what must be a flavor of the Byzantine chants that served as their models. Based on Syrian melodies and incorporating short responses between verses of the psalms, an independent HYMNODY gradually developed. Byzantine hymns had an elaborate structure, which stood in contrast to the simple hymns of the western Church.

One type, developed in the eighth to tenth centuries, was based on sixth-century hymns and was called *kanones*. Its texts were commentaries based on passages from the Bible. Its melodies, also not entirely original, were constructed on a principle common to eastern music but quite unfamiliar in the west. Rather than building a new melody from the tones in a scale, eastern singers constructed melody out of a series of short given motifs, which they chose and combined. Some motifs were designed for beginnings, some for middles, some for endings, and some for links. There were also standard ornamental formulas, and originality in performance depended on the combination, variation, and ornamentation of the motifs. Byzantine music had eight forms, or *echoi*. These *echoi* played a fundamental part in the development of western music. Our knowledge of them is limited, however, by the fact that in the Byzantine Church music was passed on by oral tradition for centuries before being written down.

Undoubtedly eastern music had a contemplative, even mystical, character and a degree of complexity that was quite in keeping with the character of eastern thought.

DANCE

References to dance occur from time to time throughout this period. Whether we should consider Byzantine dance as an artistic form is problematical, however. Two situations, at least, in which dance occurred are known. Some form of dancing apparently took place as part of religious services, but we do not know any details of its content or purpose. A second form of dancing provided entertainment. This was probably a vestige of the Roman pantomime, in which case it would have exhibited subtlety of movement and expression. Pantomime was mounted throughout the Byzantine Empire either as solo performances at fairs and village festivals or using small traveling bands.

ARCHITECTURE

The architecture of the early years of the Eastern Empire was dominated by the personality and objectives of the Emperor Justinian. It was an age in which royal patronage encouraged artistry, but the arts clearly reflected the source of that encouragement. Justinian's purpose was to glorify Justinian, and, in a remarkably creative way, the arts and architecture of the age succeeded in doing just that. The results of his efforts can be seen both in the west (see Fig. **7.21**) and in the east (see Figs **7.25–7.29**).

The period from the sixth century until the beginning of the ninth was, as we have seen, characterized by external and internal struggles. But out of this turbulence emerged the Byzantine state and, eventually, a high Byzantine culture.

After Justinian's death, the construction of public churches all but ceased. The palace was the only important building project. Yet the churches that were built at this time became models for later Byzantine architecture. The general form of these early churches, such as that of St Clement in Ankara, consists of a central dome and a group of three APSES at the east end (Fig. **7.16**). The entire

space describes a cross-in-square layout, which, again, can be seen in later churches. The cross-in-square is outlined on the ground plan: look outward from the center to the end of each of the transverse arms, the lower arm of the nave, and the upper arm just to the edge of the circular apse at top center.

The churches constructed in the two or three centuries after St Clement's employed the classical principles of harmony among their parts, and composition to express human aspirations (Fig. **7.17**). The three apses just described point toward the viewer, and the dome above the central pavilion is visible at the top. The church's vertical striving and precise symmetry give it an elegant solidity. Delicate, arched niches and grilled windows tend to counter the heaviness of the walls.

As Byzantine power waned, the vigor and scale of new church construction reduced. The ground plans became smaller, and in partial compensation, height was increased. Increased emphasis was also placed on the appearance of the exterior, with decorative surface treatment of the brickwork or masonry of the walls (Figs **7.18** and **7.19**). Another characteristic of later church building was the addition of churches or chapels to existing ones,

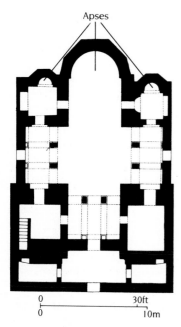

7.16 Ground plan of the church of St Clement, Ankara, Turkey.

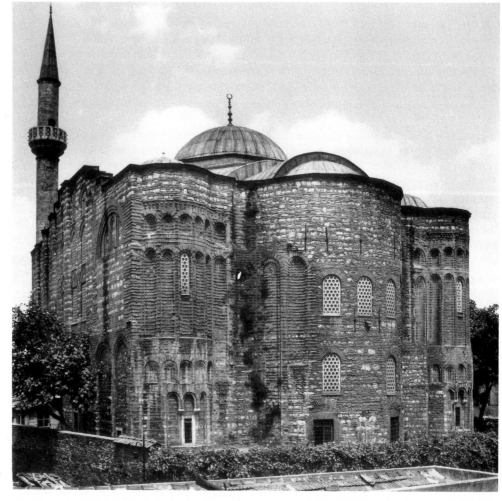

7.17 (right) St Theodosia, Istanbul, c.1000.

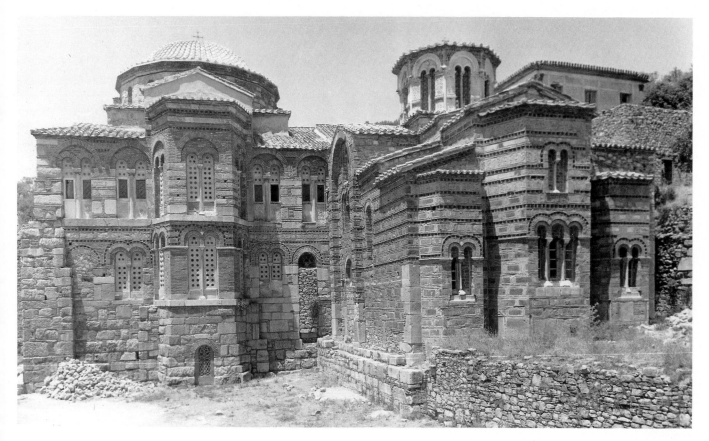

7.18 Churches of St Luke and the Virgin, Stiris, Turkey, 11th century.

7.19 St Mary Pammakaristos, Istanbul, 13th century.

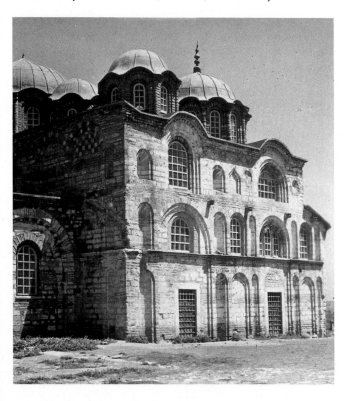

creating very different forms from the organized massing of the single-domed church. The elaborate detail and frequent changes of plane that these additions created give us a fascinating surface with which to interreact, as the Churches of St Luke and the Virgin illustrate. Here, verticality or upward striving line is much less apparent —the strength of horizontal elements and the shorter apses give the impression that the building is much more squat.

The interiors of these churches are elegant, jewel-like, sumptuous, glowing with color, and heavily decorated. They are reached through NARTHEXES, and sometimes side porches, that create a spatial and visual transition from the outside world to the interior. The spaces of the church flow smoothly from one to another and are carefully designed to meet liturgical needs. A deep, vaulted SANCTUARY and apse house the altar. Chambers adjoin the apse on either side. Just beyond the eastern columns a screen painted with icons stands across the sanctuary. The entire effect of the mosaic-covered vaults, elaborate ecclesiastical vestments, chants, ancient rites, and incense sought to create for the worshipper the spiritual and physical sense of another world—one central to Byzantine life.[9]

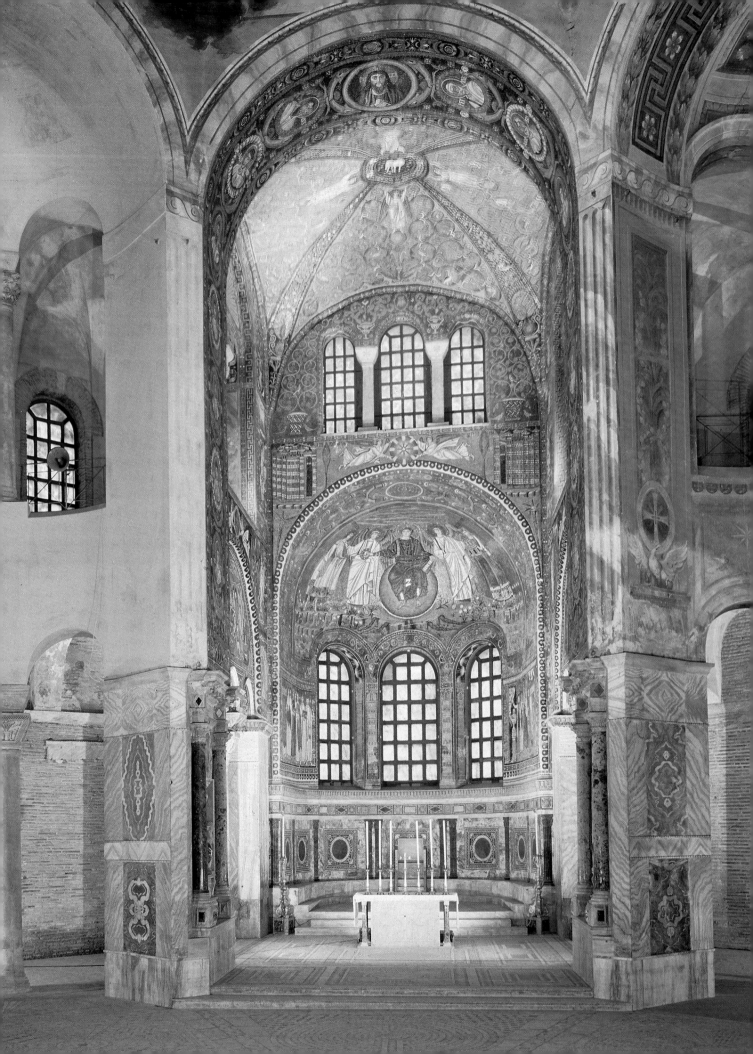

SYNTHESIS
In praise of the emperor:
the mark of Justinian

The portraits of Justinian that appear in mosaics (such as that in Fig. **7.24**) reveal a man who does not look like an emperor. He was of average height and build, and had dark hair and a ruddy complexion. He was clean shaven, and every portrait shows a slight smile. However, despite his unexceptional appearance, he was a brilliant thinker who possessed enormous talents. He apparently liked the role of emperor and played it to the hilt, but he seems to have been likeable, in spite of his vigor and arrogance.[10]

San Vitale in Ravenna (Figs **7.20–7.22**) is the major Justinian monument in the west. It was probably built as a testament to the power of Orthodoxy in the declining kingdom of the Ostrogoths.

The church consists of two concentric octagons (Fig. **7.22**). The hemispherical dome, 100 ft above the floor, rises from a drum above the inner octagon which is pierced with windows that flood the interior with light. Below, eight large PIERS alternate with columned niches to define precisely the central space and to create an intricate, many-layered design. The narthex is placed at an odd angle. There are two possible explanations for this: the practical one is that the narthex paralleled a then-existing street; a more spiritual one is that the narthex was so designed in order to force worshippers to reorient themselves on entering, thereby facilitating the transition from the outside world to the spiritual one.

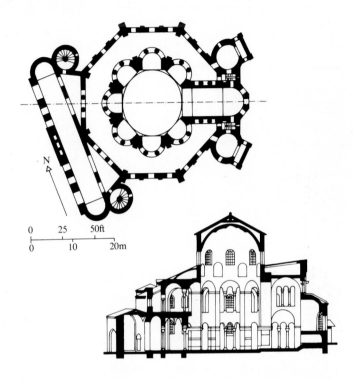

7.22 Plan and transverse section of S. Vitale, Ravenna.

7.20 (opposite) S. Vitale, Ravenna, Italy, 526–47. Interior, looking east.

7.21 Façade of S. Vitale, Ravenna.

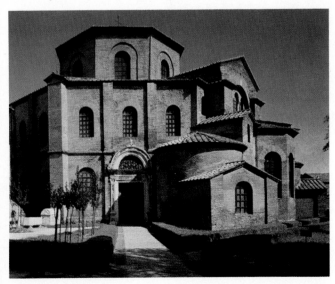

On the second level of the ambulatory was a special gallery reserved for women—a standard feature of Byzantine churches.

The internal spatial design is intricate. The visitor experiences an ever-changing vista of arches within arches, linking flat walls and curved spaces. All the aisles and galleries contrast strikingly with the calm area under the dome. The CLERESTORY light reflects off the mosaic tiles with great richness. In fact, new construction techniques in the vaulting allowed for windows on every level and opened the sanctuary to much more light than had previously been possible.

The sanctuary itself is alive with mosaics of the Imperial court and of sacred events. The difference in style between two mosaics in the same church is particularly fascinating: *Abraham's Hospitality and the Sacrifice of Isaac* (Fig. **7.23**) demonstrates what is, by Byzantine standards, a relaxed naturalism. The mosaic showing Justinian and his court (Fig. **7.24**), on the other hand, demonstrates the orientalized style, more typically Byzantine, with the figures posed rigidly and facing forward. The mosaics clearly link the church to the Byzantine court, reflecting again, the connection of the emperor to the Faith, of Christianity to the State, and, indeed, the concept of the

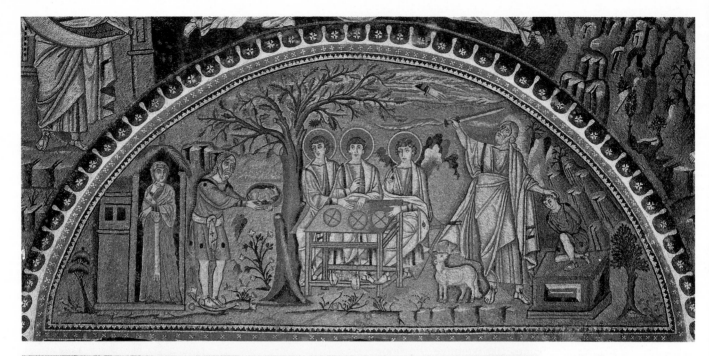

7.23 *Abraham's Hospitality and the Sacrifice of Isaac.* Wall mosaic, S. Vitale, Ravenna.

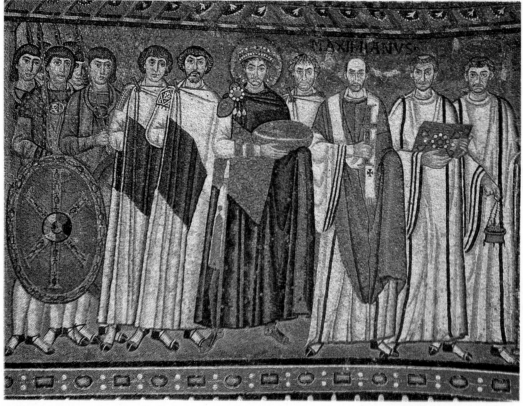

7.24 *Emperor Justinian and His Court,* c.547. Wall mosaic, S. Vitale, Ravenna.

"Divine Emperor." Justinian (Fig. **7.24**) and Theodora (Fig. **7.1**) are portrayed very much like Christ and the Virgin. The two mosaics face each other behind the high altar of San Vitale. In Figure **7.24** the emperor has a golden halo with a red border, he wears a regal purple robe, and he is shown presenting a golden bowl to Christ, who is pictured in the SEMIDOME above the mosaic (Fig. **7.20**).

If San Vitale praises the emperor and Orthodoxy in the west, Hagia Sophia, or St Sophia, is a crowning monument to his achievement in the east (Figs **7.25–7.29**). Its architect, Anthemius, was a natural scientist and geometer from Tralles in Asia Minor. Hagia Sophia is characteristic of the Justinian Byzantine style in its use of well rehearsed Roman vaulting techniques combined with Hellenistic principles of design and geometry. The

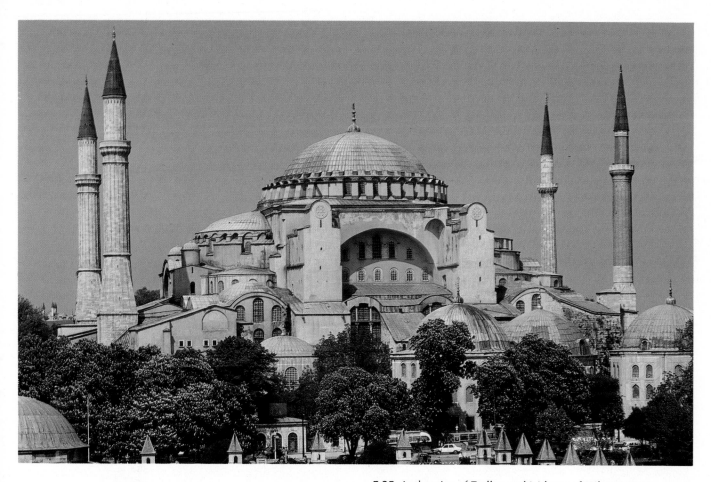

7.25 Anthemius of Tralles and Isidorus of Miletus, Hagia Sophia, Istanbul, 532–37.

7.26 (left) Plan of Hagia Sophia.

7.27 Axonometric section (perspective view) of Hagia Sophia.

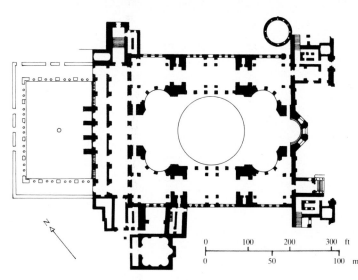

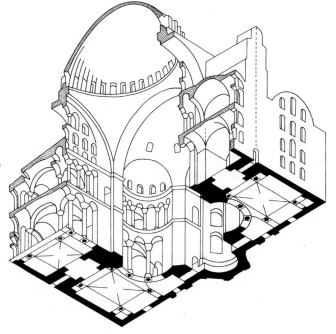

result is a building in an orientalized, antique style.

Built to replace an earlier basilica, Hagia Sophia was for a long time the largest church in the world. It was completed in only five years and ten months, between 532 and 537. The speed of the work, together with Byzantine masonry techniques, in which courses of brick alternate with courses of mortar as thick as, or thicker than, the bricks, caused great weight to be placed on insufficiently

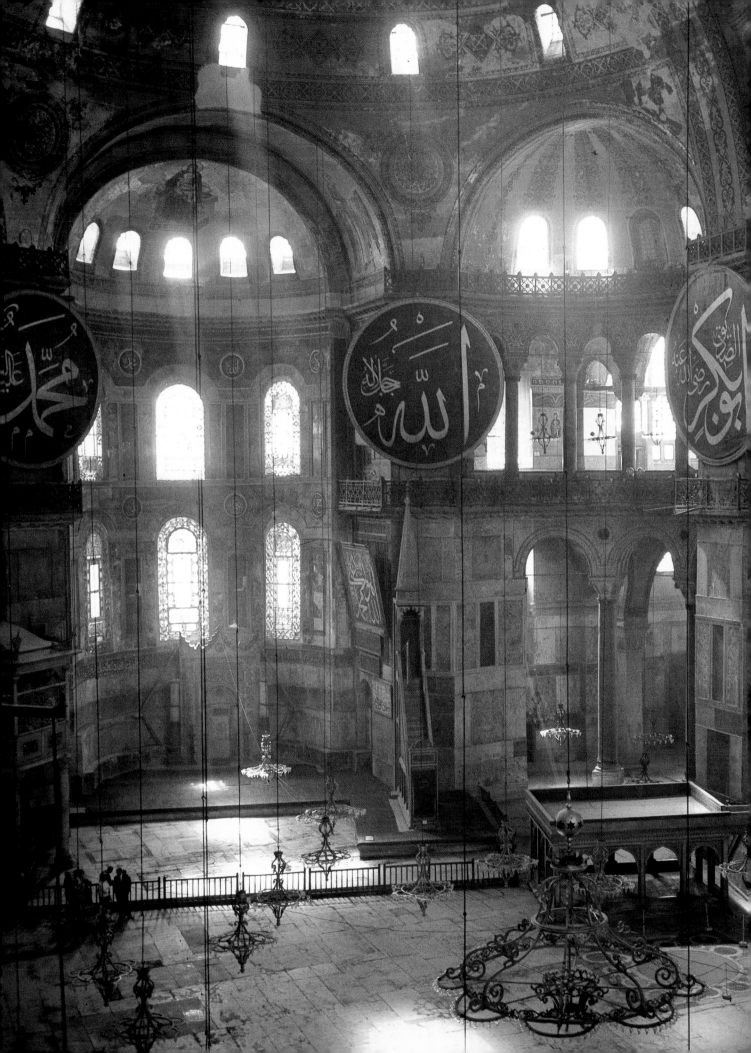

dry mortar. As a result, arches buckled, and buttresses had to be erected almost at once. The additional effects of two earthquakes caused the eastern arch and part of the dome itself to fall in 557.

The flatness of a dome so large (110 ft in diameter) remains unique, and the delicate proportioning of the vaults that support such great weight is also remarkable. Basic to the conception is the elevated central area, with its picture of heaven in the dome and its large, open, and functional spaces. The building could hold large numbers of worshippers in a transcendental environment, where thoughts at once rise to a spiritual sphere. "It seemed as if the vault of heaven were suspended above one," wrote Procopius.

The capitals of the columns in Hagia Sophia (Fig. **7.29**) illustrate a style that is totally Byzantine. The deeply undercut ornament shows originality and technical mastery. Classical elements, such as volutes and leaves like those on Corinthian capitals, are subsumed into the vigorous decoration. This is in no way a dilution of classicism, but the birth of a new style. Justinian's other buildings show work of the same type, but that in Hagia Sophia represents the highest quality.

Justinian's reign inaugurated the style called "Byzantine," blending traces of previous styles, eastern and western, to form a new style. The hieratic art from the reign of Justinian expresses the relationship between God and the State. With the emperor governing by, and for, the will of God, all reality—political, philosophical, and artistic—became spiritualized.

7.28 (opposite) Hagia Sophia, interior.

7.29 Capitals in Hagia Sophia.

SUGGESTIONS FOR THOUGHT AND DISCUSSION

Although eastern by nature, the Byzantine Empire played a significant role in the development of western culture throughout the last 700 years of the first millennium. It was the guardian of classical thought and style, even though it quickly developed its own characteristics. Justinian's rule marked a high point in Byzantine development, even though he sought above all to reunify the Eastern and Western Empires. After Justinian, a new flowering of artistic development helped to consolidate the stylistic qualities that we recognize as Byzantine.

Fundamental to Byzantine art were the characteristics of the hieratic style, where naturalism is replaced by mysticism expressed, among other ways, in elongation of the human form. Painting, mosaic, and sculpture were infused with an eastern spirituality.

■ Icons are central to Byzantine art and religion. What was the iconoclastic controversy and what role did it play in the development of Byzantine art?
■ Relate the characteristics of Byzantine literature to the characteristics of the other arts in Byzantium.
■ How does the Byzantine literary genre of historiography differ from our conceptions of history?
■ Discuss hagiography as a literary discipline.
■ Is it possible to separate Church, State, and art in this period?
■ What examples can you cite of Byzantine influence in the political, intellectual, religious, and artistic life of the west?

CHAPTER EIGHT

THE EARLY MIDDLE AGES

The "Middle Ages" is the name we have come to use for the period that began with the fall of Rome and closed with the "reawakening" of the Renaissance in Italy. In the "Dark Ages," the early part of this period, it seemed that humankind had crept into an enclosed world of mental and physical isolation and self-protection. It was, for many, a time of fear and superstition, a "vale of tears" for the Christian, who had little to hope, save that beyond this life lay the promise of heaven for those who obediently followed the teachings of the Catholic Church. But, in monasteries and convents throughout Europe, literacy, learning, and artistic creativity were nurtured, and the works of the period are in many cases filled with a deeply moving intuitive vision. It was widely believed that the end of the first millennium would bring the Second Coming of Christ.

8.1 Scenes from the life of St Paul, from the Bible of Charles the Bald, c.875–77. S. Paolo fuori le Mura, Rome.

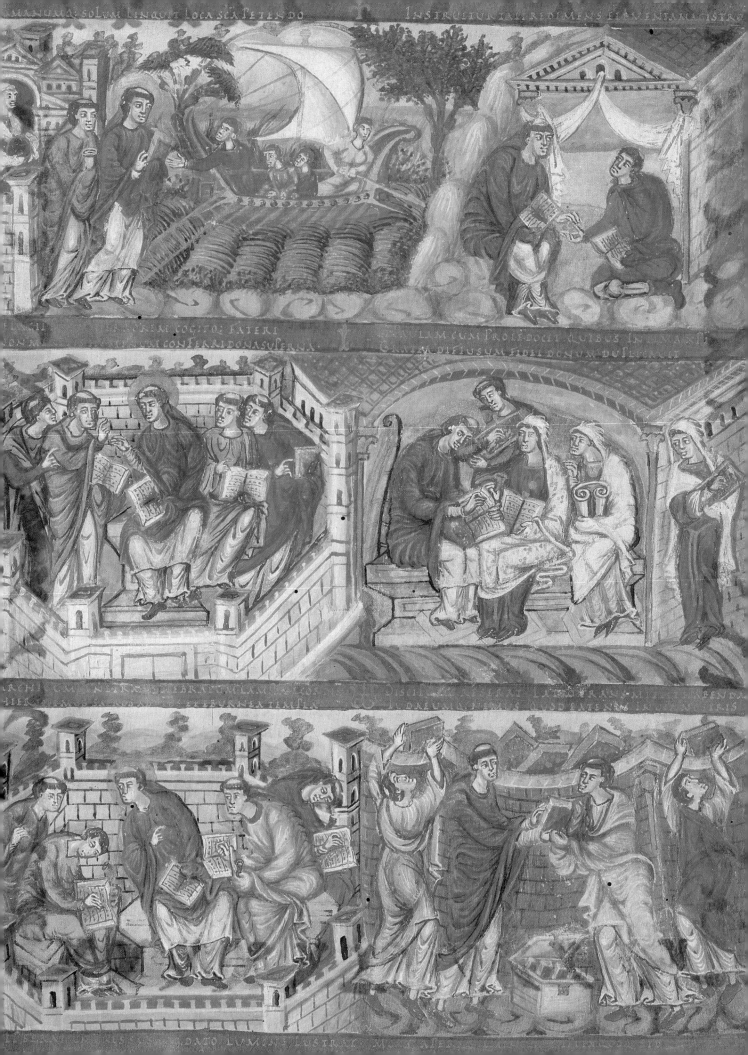

CONTEXTS AND CONCEPTS

Periclean Athens saw a consolidation of diverse forces that created a cohesive civilization, but the early Middle Ages was a period of dissolution. Indeed, the western world disintegrated into a chaotic confusion and, to a large degree, spiritual and intellectual darkness.

The 1000 years between the fifth and the 15th centuries have been called the "Dark Ages" and the "Middle Ages," or Medieval period, on the theory that nothing happened—or worse than nothing—between the classical perfection of Greece and Rome and the revival of classical humanism in the 15th century. We shall use the terms as convenient labels, but not as value judgments. Furthermore, in an overview such as this, we must remember that specific exceptions to any general summary always exist, and this is especially true of a world as fragmented as that of the Middle Ages.

Pessimism and disillusionment had increased in ancient Rome, and this mood continued into the Middle Ages. A well known epitaph seems to have summed it up: "I was not; I was; I am not; I care not." Civic, secular government had all but ceased to exist. When Constantine I founded the second capital of the Roman Empire at Constantinople, he set in motion a division that became permanent in 395. In the west, the cloak of internationalism, which had loosely united the Mediterranean world since Alexander, fell apart. It became a case of "every locality and every people for themselves."

Since the turn of the Christian era, the Roman Empire had been attacked from without while decaying from within. The Goths, the Huns, the Visigoths, the Vandals and, in the seventh century, the armies of Islam pressured and pierced the perimeters of the empire. The western world was in a state of continual change. As one people pressed against another, the victim turned upon its neighbor on the other side. Nations as we know them did not exist. Borders changed from day to day as one or another people wandered into the nebulously defined territory of its neighbors, bringing confusion and war.

THE BARBARIANS

The Roman Empire did not fall on one specific date. Throughout the third and fourth centuries, a gradual Germanization of the western provinces accompanied a reciprocal Romanization of the Germanic peoples. The Germanic tribes constantly pressed against the borders of the empire. Occasionally they gained a victory, only to be pushed back by a fresh contingent of Roman troops. In

the far northwest, the Angles and Saxons raided the coasts of Britain. On the lower part of the Rhine River, the Franks fought each other, some allied with Rome and others not. Frankish troops formed the backbone of Roman defenses along the upper Rhine against Germanic peoples there, while Germans defended Roman territory along the Danube. By the end of the fourth century, the Roman army had, to a large extent, become an army of barbarians, often led by barbarian officers.

Around the beginning of the fifth century, entire populations of Germanic peoples migrated into Roman territories rather than raiding them, and they established permanent settlements. At the same time, the Huns, a Mongolian people, "a race savage beyond all parallel" as one Roman historian put it, turned their attention from the borders of China to the Germanic peoples, and set off a further chain of migrations. The Visigoths, led by their greatest king, Alaric I, rose up in 396 and ravaged Greece. Alaric and the Goths turned on Italy in 402, only to be repulsed by a defending army under a Vandal general. By 406, Roman defenses had deteriorated considerably, and a mixed horde of Germanic peoples, mostly Vandals, surged into the empire and made their way through Gaul into Spain. Capitalizing on the situation, Alaric again attacked Italy and succeeded in sacking Rome itself in 410. He apparently had designs on Africa as well, but died before he could carry out his plans.

His successor, Ataulph, returned to the policy of placing his armies in the service of the Imperial Roman government. Ataulph married Galla Placidia, sister of the Emperor Honorius, and took the Visigoths to southern Gaul, eventually attacking the Vandals in Spain. Between 425 and 455, Galla Placidia exercised Imperial authority in the name of her son, Emperor Valentinian III, born of her second marriage to the Roman general Constantius. In response to further internal strife in Rome, the Imperial government moved its seat to Ravenna. In 455 the Vandals, under Gaiseric, looted Rome even more viciously than had the Visigoths. Meanwhile, in 452 the Huns led by Attila invaded along the Rhine. They penetrated into Italy, and threatened Rome in 453. Weakened by pestilence and, finally, the death of Attila in 453, the Hun threat dissipated, leaving the western borders in relative peace.

Valentinian III was assassinated in 454, and his successor, Maximian, was lynched by the Roman mob a few months later, for failing to protect Rome from Gaiseric. From 456 onward, the Germans ruled Italy, and in 476 the puppet Roman Emperor Romulus Augustus was deposed

AD	GENERAL EVENTS	LITERATURE & PHILOSOPHY	VISUAL ART	THEATRE & DANCE	MUSIC	ARCHITECTURE
100						Basilica Ulpia (8.12)
200		Tertullian				
300	Barbarian invasions Council of Nicea Christianity becomes the state religion	St Augustine St Jerome			Christian hymnody	Old St Peter's, Rome (8.15) S. Paulo fuori le Mura, Rome (8.16)
400	Fall of Rome Pope Leo I	St Benedict			Antiphonal psalmody	
500	Gregory the Great		St Luke, Gospels of St Augustine (8.5)		Gregorian chant	
600	Islam founded	Troubadours	Lindisfarne Gospels (8.6) Shoulder clasp— Sutton Hoo burial (8.7)			
700	Charles Martel repels Muslim invaders	Beowulf Minnesänger Trouvères				
800	Charlemagne crowned Holy Roman Emperor	Song of Roland	Gospel Book of Godescale (8.23) Gospel Book of St Médard (8.25) So-called Statuette of Charlemagne (8.27) Ivory cover, Dagulf Psalter (8.28) Ivory cover, Lorsch Gospels (8.29)		Polyphony—organa	Palatine Chapel, Aachen (8.32) Crypts at Auxerre (8.24, 8.26)
900	Ottonian Empire begins		Gero crucifix (8.8)	Tropes	Responsorial psalmody	
1000			Bronze doors, Hildesheim Cathedral (8.9)	Professional dance		St Sernin (8.17–18) Abbey Church, Cluny III (8.19–21)
1100	Ottonian Empire ends		Tympanum, Vézelay (8.11)			
1200		Nibelungenlied				St Albans (8.22)

(vertical label: Feudalism, spanning AD 700–1100)

8.2 Timeline of the Early Middle Ages.

and not replaced. The Western Roman Empire had seen its last emperor. Two more invasions by the Franks and the Ostrogoths completed the picture, and in 489 Theodoric led the entire Ostrogothic people over the Alps and established himself as ruler of Italy. By the year 500, every part of what had been the Western Roman Empire was ruled by barbarian kings.

THE EARLY CHRISTIAN CHURCH

Meanwhile Christianity was struggling to survive. Like most emerging religions, it felt an intense need to create institutions. Christianity was loosely organized and totally different in its theology from the religions around it. It needed a united front in order to grow and to make its way in a suspicious, pagan world. In the first centuries of its existence, Christians had shed each other's blood as

various sects battled over questions of dogma. This had to stop if the Church were to survive. In the thrust and counterthrust of all this, however, the emerging Church was a force coming together in a world that was mainly falling apart.

Why and how did Christianity survive? Its monotheism was an extension of the Jewish heritage. The historical immediacy of its founder and the doctrines he taught appealed to men and women of the late Roman and post-Roman periods. In its extreme simplicity on the one hand and its subtlety on the other, Christianity had a multi-faceted appeal that made it acceptable to the most lowly and illiterate people as well as those of sophistication and schooling.

Little is known about the spread of Christianity through the Roman Empire. Conversions among the aristocracy and upper classes enhanced its chances of survival substantially, and by the end of the third century,

Christians were numerous enough to count as a political force. Every city of consequence had a Christian community presided over by a bishop who was assisted by priests and deacons. Regarded as successors of the original apostles, bishops were chosen by their communities, and theological disputes were decided in councils of bishops.

Christianity encountered varying degrees of tolerance from the Roman state. In general, the Imperial government treated all the various religious practices in its diverse empire with an even hand. Occasionally, however, Christians suffered fierce persecution, mainly because they refused to worship the emperor as a divine being. In addition, their secret meetings and rites troubled the authoritarian government. Christians also abhorred violence and refused to serve in the Roman army, which was very difficult for the beseiged state to tolerate.

The last great persecution occurred under Diocletian in 303. Shortly afterward, Constantine transformed Christianity into a favored religion in the Roman state. According to the bishop Eusebius, Constantine reported that he had had a dream prior to the Battle of Milvian Bridge against his co-ruler, the tetrarch Maxentius, in which he was told to send his soldiers into battle carrying standards marked with Christian symbols. Constantine did so, won the battle, and was converted to Christianity. He later claimed that he was "brought to the faith by God to be the means of the faith's triumph." Christianity soon became the official religion of the empire.

Numerous privileges came with this new status. The Church could receive legacies, its clergy were exempt from taxation, and bishops were permitted to settle disputes of law in all civil cases in which a Christian was a party. In addition, the Church obtained the rights of sanctuary, that is, it became a place where a criminal was immune from arrest or punishment.

After Constantine's conversion, the Church began to build up its own administration, adopting a structure similar to that of the civil bureaucracy. By the fourth century, each province was divided into bishoprics, with an archbishop at its head. There was, however, no centralized administration for the whole Church comparable to the Imperial government. The bishops of the four great cities of Rome, Jerusalem, Antioch, and Alexandria claimed special privilege because the Church in each of those cities was founded by the apostles. Rome claimed supremacy both because it was founded by St Peter, to whom Jesus had entrusted the building of the Church, and because it was capital of the empire.

Yet the opportunities presented by the conversion of emperors to Christianity were to some extent offset by problems that stemmed from the same source. In return for championing the faith, the emperor expected the bishops to act as loyal servants of the Imperial crown. When theological disputes arose, the emperor often insisted on deciding the matter himself. For example, in the fourth century, the Arianist controversy broke out over the nature of the Son in the Christian Trinity of Father, Son, and Holy Spirit. In an attempt to quell the controversy, a new institution of Church government was

8.3 Europe and North Africa in the Late Roman period.

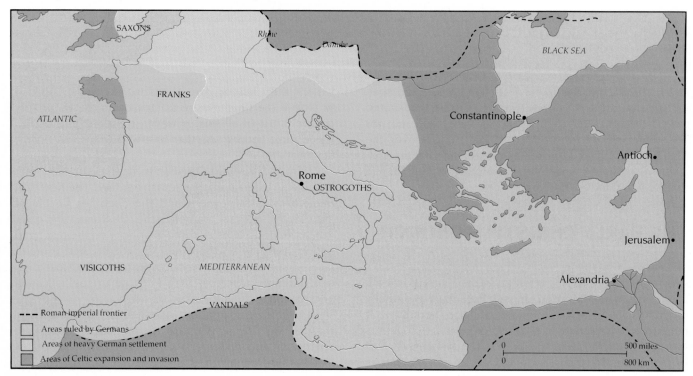

established—the General Council. When the Council met in Nicea in 325, at its first convocation, it agreed on the doctrine that the Son was "of one substance with the Father." The issue of Jesus' divinity or humanity continued to flare up over the reigns of successive emperors—Constantine I, Constantius II, and, finally, Theodosius I, whose Council of Constantinople in 381 reaffirmed the doctrine of Nicea and put the issue to rest.

The Popes

References to the primacy of Rome can be found as early as the letters of St Ignatius in 110 and St Irenaesis around 185. The claim of the Medieval Popes to exercise complete authority over all of Christendom was developed slowly, however. The bishops of Rome claimed supremacy because they were the heirs of St Peter and because their city was the capital. Other arguments included the sanctification of Rome by the blood of martyrs and its freedom from the contamination of the heresies that had touched other churches. Specific acknowledgement of Rome's supremacy by a Church Council first came in 344 from the Council of Sardica. The Council of Constantinople placed the bishop of Constantinople second after the bishop of Rome "because Constantinople is the New Rome." A series of strong and able bishops of Rome consolidated the move toward Rome's supremacy during the next century.

The argument put forward by the bishops of Rome in support of their case came to be known as the "Petrine theory." Perhaps its clearest formulation came from Pope Leo I (440–61), a man with considerable administrative ability who played a significant role in civil affairs. Leo was twice called on by the emperor to negotiate with the leaders of the barbarian armies that invaded Italy in 453 and 455. Pope Leo insisted that he was "heir" of St Peter and that "Christ had appointed Peter to be head of the whole universal Church." He affirmed that because all other apostles were subordinate to Peter, all other bishops were subordinate to the bishop of Rome, who had succeeded to Peter's See at Rome. In fact, nearly all western Christians came to acknowledge the Pope of Rome as head of the whole Church. What remained unclear was the actual extent of his authority in temporal affairs and in affairs of Church governance.

Early Christian thought

Tertullian and legalism

The study of Medieval thought of the first millennium is really the study of Christian thought. In order to understand the men and women of the early Middle Ages—how they might have seen the universe, and how that viewpoint was translated into art—it is important to examine

some of early Christian thought. Two of its most important thinkers were Tertullian and Augustine, and our examination focuses on them.

In the early years of the Middle Ages, the west depended for its culture on the east. Its art, literature, and philosophy tended to be derivative rather than original. On the other hand, the prevailing interests of the west differed significantly from those of the east. Reflecting the west's Roman heritage, they concentrated on the functional, practical, and ethical. Law and government, the sovereignty of the state, institutions and tradition, were social preoccupations, and they also affected western Christianity. The functions and authority of the Church as an institution were of prime importance. Duty, responsibility, sin, and grace were all topics of great interest.

The theistic and cosmological problems that took precedence in the east seem to have caused far less concern in the west. The major theological conflicts occurred in the east, and the west almost automatically accepted the doctrinal decisions of the eastern Church. In North Africa, however, in the Roman provinces of Africa, Numidia, and Mauritania, eastern influence was less apparent than in Gaul and Italy. Particularly in the province of Africa, large numbers of Italian colonists had close ties to the provincial capital, Carthage, and thereby to Rome. By 200, Carthage boasted a strong and vital Christian Church, and from this community came Tertullian, the first of the Latin "Fathers."

Born of heathen parents around the middle of the second century, Tertullian studied and perhaps practiced law for a time in Rome, but spent most of his life in Carthage. He became a Christian convert in mid-life, but seems to have been free of the morbid concerns about previous immoral pursuits that beset Augustine. Soon after the start of the third century, however, Tertullian joined the sect of early charismatics called the "Montanists," and he remained a member at his death, sometime after 220. He was a prolific writer and covered a large number of themes. He was the first important theologian to switch to writing in Latin from Greek. He also created a large new Christian vocabulary and gave technical meanings to many words in current use.

Tertullian's main contributions to Christian thought lie in two areas. He founded the language of the western Church, and he enunciated those aspects of its theology that marked a break with the east. His writings were highly influential, and continued to be so even after his defection to Montanism destroyed his standing as a Catholic Father.

Probably the most important of Tertullian's writings is an elaborate analysis of the soul. His arguments lean heavily on Stoicism. He believed that the soul has length, breadth, and thickness. It is not identical with the body, but permeates all its parts, with its center lying in the heart. The soul controls the body, using the body as it wills. Yet, for all of that, the soul remains spiritual, not

material. For Tertullian, spirit and matter were two substances, different in nature but both equally real. Spirit, being indivisible, was therefore indestructible.

His notion of God and the Trinity was based on legal concepts. When Tertullian says that God has three parts, he means that God is "three persons in the legal sense, that is, three persons who share or own in common one substance or property."[1] God is a personal sovereign, to whom all people are subject. Independent and omnipotent, God created the world out of nothing. On the question of one's proper relationship to God, Tertullian was precise in defining God as an authority figure whom one approaches with humility and fear. "The fear of man is the honor of God. . . . Where there is no fear there is no amendment. . . . How are you going to love unless you are afraid not to love?" Virtue is thus obedience to divine law springing from fear of punishment if the law is broken. In this and many other areas, Tertullian's legal training is clear. He also formulated an elaborate list of sins, including the seven deadly sins of idolatry, blasphemy, murder, adultery, fornication, false witness, and fraud.

By the time of Tertullian, the Church had begun to see this life as a mere probation for the life to come. Earthly life was without value in itself and possessed meaning only in that it provided the opportunity to lay up rewards in the life beyond the grave. Tertullian believed the supreme virtues were humility and the spirit of otherworldliness, by which Christians could escape the perils of this life and be assured of enjoying the reward prepared for the saints in heaven.

St Augustine and neo-Platonism

St Augustine (354–430) did not receive the sacrament of baptism until he was an adult. His mother, who was a Christian, believed that if he were baptized as a child, the healing virtue of accepting the faith would be destroyed by the lusts of youth. Nonetheless, after a period of skepticism, and adherence to Manichaeism (a philosophy that combined Christianity with elements from other religions of the time), he was baptized into the Christian faith. He later became Bishop of Hippo, in Asia Minor. A prolific writer, his works greatly influenced developing Christian thought. The *Confessions* and *City of God* are the best known of his works.

Apparently Augustine found great inspiration in the writings of Plotinus, but he was also highly influenced by Platonic and neo-Platonic thought. Thus, he recoiled from Tertullian's emphasis on the senses and the body. He shared Tertullian's belief in intuition as the source of knowledge concerning God, but Augustine's concept of intuition had an intellectual cast. The senses, he believed, give us unreliable images of the truth. Instead, our intuition, our AFFECTIVE thinking, has a certainty which springs from "the fact that it is of the very nature of reason to know the truth."[2] Knowledge is an inner illumination of the soul by God. Whatever we find intelligible is,

therefore, certain. Knowledge comes from intuition and "confirms and amplifies the certainty of faith."[3]

Augustine followed Tertullian in maintaining that God created the universe out of nothing. Creation occurred at a given moment which was the *first* moment, that is, the universe and time were created together. This assertion countered two arguments: that if the universe were not eternal then God's creative power must have lain idle for some time before he used it; and that God's will to create must therefore have been an afterthought or sudden whim.

Regarding the soul, Augustine argued that to doubt the existence of the soul is in fact to confirm its existence: in order to doubt we must think, and if we think, we therefore must be thinking beings, and therefore souls. Unlike Tertullian, Augustine thought the soul immaterial, that is, a purely spiritual entity. This spiritual character, as well as its immortality, is demonstrated by our power to grasp eternal and immaterial essences. The question of where the soul comes from caused Augustine some difficulty. It did not, as Plato suggested, exist prior to the person's birth. It did not emanate from God, but was created by him. Augustine was uncertain whether the soul derived in each individual from the souls of the parents or was created by God and directly implanted in each new body. However, each soul was unique and contained three faculties—intellect, will, and memory.

His concept of original sin, as developed in *City of God*, led Augustine into a central role in the so-called Pelagian heresy. Pelagius and his followers opposed the concept of original sin. The doctrine of original sin, to which Augustine subscribed, held that all people are born to sin because of Adam's fall from grace when he disobeyed God in the Garden of Eden. Thus, we are "punished by being born to a state of sin and death, physical and spiritual, from which only Christ's passion and saving grace can redeem us."

Pelagius rejected the doctrine of original sin. He insisted that sin was purely voluntary and individual, and that it could not be transmitted, for, as he said, "Adam's fall affected neither the souls nor the bodies of his descendants." Every soul enters the world sinless, according to Pelagius, and becomes sinful by individual act. Death is a natural event having nothing to do with the fall. Thus, whereas Pelagius argued that people were bad *if* they did bad things, Augustine held that people were bad *and therefore* did bad things. The Pelagian heresy may have gained popularity from its consequences of possible salvation for the unbaptized (including those who had lived before Jesus).

Augustine also attacked the question of predestination and divine foreknowledge (i.e. whether God's omniscience robs humans of free will). His conclusion, that free will is not a certainty, influenced many later contributors to the debate, which still continues among Christian theologians today.

The Roman Church

In the sixth century, Italy faced a very uncertain future. Although Rome no longer ruled a secular empire, the primacy claimed by its bishops gave Rome a potential position of great importance in the Christian world. Such a possibility, however, was clouded by two significant factors. One was the barbarism that still held sway in the western provinces. The other was the complex theocracy of the east, with its emperors who were both secular and sacred rulers.

In response to yet another quarrel over doctrine, Pope Gelasius (492–96) drew up a new formulation of the roles of priests and kings in the government of the Christian world. The world, he said, was ruled by two powers, the sacred authority of the priesthood and royal power: the responsibilities of the priesthood were the greater, however, because priests had kings within their pastoral charge. The problem was further complicated by Justinian's grand designs for a unified empire (see Chapter 7). Justinian had not the slightest intention of yielding to the Roman bishops in matters of religion if it were politically inconvenient for him. By the middle of the sixth century, it appeared likely that the Roman Church and its Pope would simply become a tool of Byzantine Imperial policy. Rome appeared to have been demoted to a peripheral status as a mere center of Catholic Christianity, with little actual power or influence.

Rome was rescued from potential demise by one of the greatest pontiffs in the history of the Roman Church, Gregory I (the Great). As Pope between 590 and 604, Gregory showed great abilities as a ruler and teacher that significantly affected numerous aspects of the Church and its history, as well as many political and social matters in Rome. His land reforms and his administration of estates that had been given to the Church revitalized Church income, relieved famine, and provided money for churches, hospitals, and schools. His influence spread from Rome to the rest of Italy and beyond. One of the most important tasks he undertook was the sponsorship of St Augustine in his mission to convert England in 597. The most significant of Gregory's written works was his *Book of Pastoral Care*, in which he spoke idealistically of the way a bishop should live and how he should care for his flock.

As a result of Gregory's efforts, Rome regained its position of primacy among the western Christian Churches. Despite the long-term results of Gregory's actions, he did not himself consider that he was building for the future. He believed that the Second Coming of Christ was near, and he merely did what he thought had to be done in what little time remained. Thus it was unintentionally that he built a base for an enduring Church and a dominant papacy of wealth and great prestige.

FEUDALISM

From the sixth to ninth centuries, Europe was a dismal place of illiteracy and primitive living conditions. Death was a constant companion, and superstition and fear flourished amidst general ignorance. Neither the slowly emerging system of government called "feudalism" nor the ministrations of the Church did much to elevate the lot of the common people.

Feudalism involved political division of territory into units, each one small enough to be governed by one man. Because no powerful authority ultimately controlled the individual parts, the system encouraged bloodshed and warfare. Feudal lords continually raided each other as they tried to increase their wealth and property. Although feudalism was based on a system of vassalage, where barons were responsible to, or vassals of, kings, sufficient power to effect real control very rarely existed at any level above the individual landholder. Thus, despotic rulers flourished. Trapped at the bottom of this rigid social structure (and often in the middle of the bloodletting) were the common people, or serfs. Serfs were little more than slaves, attached to the land, working for the local lord, and subject to the lord's bidding. It was a life of ignorance and destitution. As Christianity spread, the terrors of "today" were endurable only in anticipation of reward in a life to come.

The devil, as a symbol of the powers of darkness and evil, was a strong force in Medieval thinking, and the Church manipulated those fears as it sought, often fanatically, to convert the pagan world of the early Middle Ages. The promise of heaven and the prospect of the fires of hell were constant themes of the times. Ever-present devils and demons fostered a certain fascination as well as fear. As we shall see, in Medieval theatre, for example, the devil often has the best part.

The Church, nevertheless, played an important stabilizing role in this often desperate and frenzied world. It provided a source of continuity, and, as its influence spread, Medieval philosophy turned from human beings as the measure of all things to God as the measure of all things. Led by the Church, the western world slowly came to believe that death promised a glorious life in the hereafter, at least for a select few.

The Church was itself divided, however, and it did little to reduce the isolation and ignorance of its followers. Very early the clergy separated into two groups. One consisted of the regular clergy, monks, and others who preferred to withdraw into a cloistered life. (This lifestyle held strong appeal for many intellectuals as well.) The second was the secular clergy, that is, the Pope, bishops, and parish priests who served in society at large. The overall effect of this division was to confine learning and philosophy to monasteries, and thereby to withhold intellectual activity from the broader world. In both cases, inquiry was rigidly restricted. Detailed and unquestioned

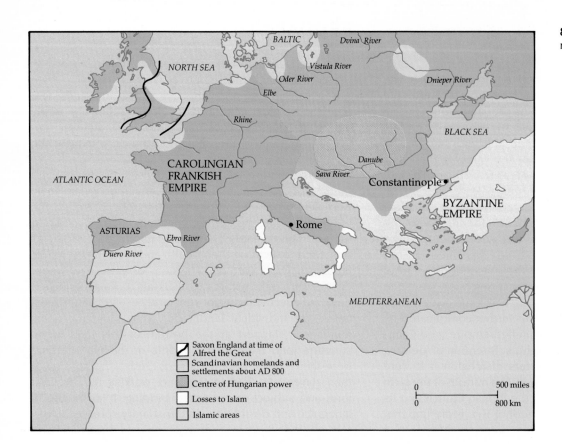

8.4 Europe in the ninth century.

dogma was deemed essential to the Church's mission of conversion—and, indeed to its very survival. As a result, the Medieval world was one of barricades—physical, spiritual, and intellectual. Each man, woman, and institution retreated behind whatever barricade he, she, or it found safest.

The western world was affected by other events emanating from the Middle East. The founding and spread of Islam in the seventh and eighth centuries threatened the Christian areas of Europe. In many ways, Islam also influenced artistic culture, especially in Spain, and it acted as a major repository of classical tradition.

The Arabic word I*slam* means "submission to God." It designates the religion of which Mohammed was the major prophet. Islam drew heavily upon the two other great Middle Eastern monotheistic religions, Judaism and Christianity, and it includes both Abraham and Jesus in the list of prophets that preceded Mohammed. Muslims generally believe that Jesus will return as the Mahdi, or Islamic Messiah, at the end of the world. Islam's concepts of the hereafter are similar to those of Judaism and Christianity. The sacred book of Islam is known as the *Koran*.

Mohammed conquered Mecca in 630, and the Islamic philosophy of "conquest by the sword" spread the religion from Spain throughout northern Africa to India. Islamic scholars delved into science, mathematics, and literature, and their endeavors kept Greek classicism

alive in their many libraries. The Arabic numerals we use today are a lasting inheritance of Muslim culture in the early Middle Ages.

CHARLEMAGNE

As feudalism developed, people tried to free themselves from the unbearable restraints of the system and return to a broader sense of political order. Occasionally a ray of hope shone through. One such hope appeared in the person of Charlemagne. In 732, the expanding threat of Islam and the Moorish Conquest had been repelled by Charles Martel at the Battle of Poitiers in France. The succeeding Carolingian period, under his grandson, Charlemagne—the name means "Charles the Great" —saw the first significant centralized political organization since the fall of Rome. Charlemagne united parts of Spain, France, western Germany, and northern Italy. He was crowned Holy Roman Emperor by the Pope in 800, an office he held until his death in 814. He revived interest in art, antiquity, and learning. The Carolingian renaissance had a different focus from that of the Renaissance of 600 or so years later, but it did rekindle some of the spirit of classical art and inquiry, if only in cloistered circles.

The Carolingian era lasted until late in the ninth century. When it was over, however, Europe quickly reverted to its divided and troubled condition.

THE OTTONIANS

The focus of Europe shifted to Germany in the tenth century when the Pope crowned the German Emperors Otto I, II, and III. These Ottonians subsequently attempted to control the still struggling Church. The resulting conflict between emperor and Pope, along with the effects of the developing feudal and monastic system, ensured Europe's continued political fragmentation.

The Ottonian emperors failed in their attempts to subjugate the growing Christian Church, however. By the 11th century, the Church, and especially its monastic orders, had come to great power and wealth. Throughout Europe, Christianity had triumphed, and the threat of invasion from the perimeters had ceased. Religious fervor and fanaticism now resurfaced. More and more pilgrimages were made to sacred sites, and the crusades to liberate the Holy Land began. Trade started up again as the Italian port cities of Venice, Genoa, and Pisa began to reclaim the trade routes of the Mediterranean. Towns and cities were growing, and a new middle class was emerging between the aristocracy and the peasants.

ST AUGUSTINE'S PHILOSOPHY OF ART

St Augustine's philosophy of art represents a radical shift from that of Plato and Aristotle, especially in the principles of art evaluation. Plato and Aristotle approach art from political and metaphysical points of view. Augustine approaches the subject from a Christian point of view. Scripture, not philosophy, is his guide. Augustine considers the production and consumption of art to hold the interest for the Church that Plato felt they held for the *polis*. The Christian and the pagan face the same questions about the function and purpose of art. Augustine, however, finds the answers in a strictly Christian context, in the teachings of scripture and tradition. For him, the answers are found in an understanding of God's relationship with the world, and in the mission of the Church. In dealing with art, Augustine untiringly attempted to satisfy the requisites of faith while doing justice to the natural pleasures that art can provide.

Even when the basic conflict is resolved, Augustine still has a problem in the immediate sensuous gratification of art. Although "divine order and harmony" are reflected in nature and to a degree in art, "perceptual objects tie the senses down to earthly things and prevent the mind from contemplating what is eternal and unchanging."[4] Art and beauty are thus guides for the soul. Those arts that depend least upon the senses are the best mirrors of the divine order.

The best teacher of all, however, is scripture. Properly interpreted, scripture provides the most direct knowledge of God's purpose and order, although the arts can contribute to our understanding as well. As long as art agrees with the tenets of faith and reflects the harmony of divine creation, it is justified.

FOCUS

TERMS TO DEFINE

Dark Ages	Council of Nicea
Middle Ages	Feudalism

PEOPLE TO KNOW

Tertullian	Constantine	Ottonian rulers
St Augustine	Charlemagne	Pope Gregory I

DATES TO REMEMBER

Vandal invasion of Rome
Council of Nicea
Reign of Charlemagne as Holy Roman Emperor

QUESTIONS TO ANSWER

1 According to St Augustine, what is the best way to interpret divine order?
2 Briefly indicate the factors fundamental first to the spread and then to the entrenchment of the early Christian Church.

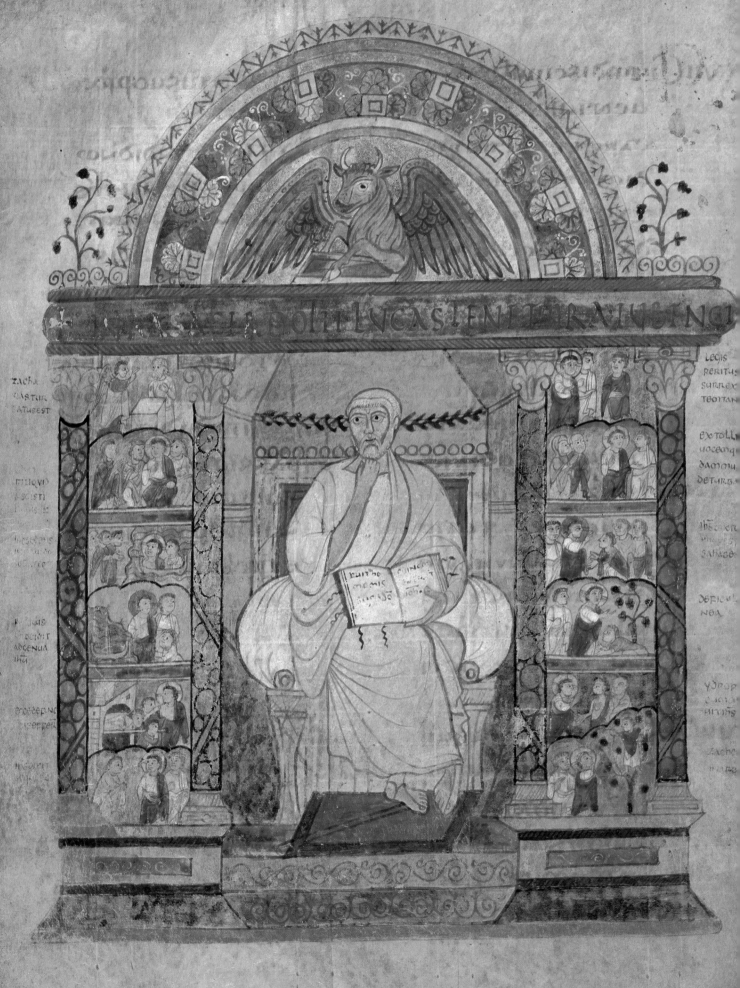

THE ARTS
OF THE EARLY MIDDLE AGES

TWO-DIMENSIONAL ART

Early Christian painting adopted local styles. For example, the tomb paintings in the catacombs of Rome—the only safe haven for Christians—were Roman in style but incorporated Christian symbolism. Roman Christians were converted Roman pagans, and their paintings had a frankly practical intent. In its earliest phases, before Constantine, Christian painting was a secret art in a secret place; its function was simply to affirm the faith of the follower on his or her tomb.

One often finds in early Christian painting a primitive quality; it is probably more a reflection of lack of technical ability than anything else. The need to pictorialize the faith was foremost. Artistic skill was not important.

Christian painting developed in several stages. From the beginning, it reflected the absolute belief in another, superior existence in which individual believers retained their identity. Painting was a tangible expression of faith. Later, it was used to make the rites of the Church more vivid. Its final role was that of depicting and recording Christian history and tradition. Inherent from the start was a code of symbolism whose meaning could only be grasped by a fellow Christian.

As the Roman world first split and then fell apart, plunging the west into chaos, painting became once again a private art, more an intellectual pursuit than an inspiration to the faithful. A new and exquisite form of two-dimensional art emerged, not on canvases or church walls, but on the beautifully illustrated pages of scholarly Church manuscripts. By the time Christianity had sufficient status to come into the open, a dramatic change had occurred in the format of written texts. Rolls of papyrus had been replaced by more convenient and durable parchment pages bound together between hard, protective covers, known as a *codex*. Although scrolls continued to be used for special occasions throughout the Middle Ages, they were now made of stitched parchment.

The only illustrated manuscript of the New Testament in Latin to survive from this early period is a copy of the Gospels that probably came to England in 597 with St Augustine, the first Archbishop of Canterbury and a missionary from Pope Gregory the Great. (This Augustine is not to be confused with the earlier St Augustine of Hippo.) Only two full-page miniatures survive, one of which (Fig. **8.5**) shows St Luke and 12 scenes from his Gospel. It is a full-page frontispiece. We see the saint seated in the foreground within an arched border. In the sides of the frame are little compartments portraying events, including the story of the washing of feet, with an unbearded Peter. The rich colors and detailing of this miniature rival those of the wall mosaics and decorations of Byzantium. The artistic quality of the St Augustine Gospels is not very high, however, in that the figure proportions are inaccurate, the medium is handled loosely, and details are carelessly executed. Perhaps it was not considered worthwhile to send a more valuable book to the still largely heathen England.

Nonetheless, this work is an interesting example of an early picture cycle, and it typifies certain stylistic qualities that became more marked in Medieval painting and sculpture. Compositions are close and nervous: figures bump against each other amid an atmosphere of frenetic energy. We feel a certain discomfort emanating from these "walled-in" and crowded scenes, which perhaps mirror the closed-in world of the Medieval illustrator.

8.6 St Matthew, from the Lindisfarne Gospels, before 698. $13\frac{1}{2} \times 9\frac{3}{4}$ ins (34.3 × 24.8 cm). British Library, London.

8.5 (opposite) St Luke, from the presumed St Augustine Bible, sixth century. Corpus Christi College, Cambridge, England.

An Irish contribution to Medieval manuscript illumination appears in Figure **8.6**. Here the figures are flat and almost ornamental though they are precisely and delicately rendered. Highlight and shadow give a sense of depth in the curtain, and space is suggested by the oblique treatment of the bench. Accurate linear perspective is unknown to these artists. Colors are few and subtle. Of note here is the frontal treatment of the angel's eye, in contrast to the head, which is in profile. Outlining adds to the stylization. The picture is carefully composed, with both color and form controlled to achieve a pleasing balance.

From the fifth to the 11th centuries, a tremendous wealth of artistic work emerged in several nontraditional areas. Life was generally in a state of flux throughout Europe in the early Middle Ages, and it was to ordinary and portable media that nonmonastic nomadic people turned much of their artistic energy. Clothing, jewelry, and ships, for example, all exhibited the artistry of the Germanic, Irish, and Scandinavian peoples (Fig. **8.7**).

Emotionalism in art increased as the approach of the millennium sounded its trumpet of expected doom. The fact that the world did not end on 1 January 1001 reduced this feeling only slightly. Emotionalism was strengthened further by an influx of eastern art into the Ottonian Empire, when Otto II married a Byzantine princess. A combination of Roman, Carolingian, and Byzantine characteristics typify Ottonian manuscript illustration. Despite the Medieval crowding and an inherent appeal to feeling, such work testifies to the increasingly outward-looking approach of the early years of the second millennium.

Soon after the year 1000, a new style in painting began to emerge. It initially differed from earlier styles very little, and it was regionally fragmented. Because it was associated with a revolution in architecture, however, it took the name given to that style, Romanesque, and it effectively replaced all earlier styles of two-dimensional art.

8.7 Hinged shoulder clasp from the ship burial at Sutton Hoo, England, seventh century. Gold decorated with garnets, mosaic, glass, and filigree. British Museum, London.

SCULPTURE

Sculpture played only a very minor role in the centuries between the collapse of the Roman Empire and the rise of the Romanesque style in the 11th century. The fact that the Old Testament prohibited graven images may have been partly responsible for this. The association of statuary with pagan societies, notably Rome, was fresh in the memory of the Church. Thus, when Christian sculpture emerged, it was largely funerary and not monumental. The earliest examples are all sarcophagi.

Some of the most beautiful sculptural work of the Christian era after Constantine resembles manuscript illumination in its small-scale, MINIATURE-like detail. Its restless, linear style is eloquent with emotion, and it is very precise in its detail.

Especially poignant is the *Gero crucifix* (Fig. **8.8**). The realism of the crucified Christ, whose downward and forward sagging body pulls against the nails, and the emotion with which it is rendered, are very compelling. The muscle striations on the right arm and chest, the bulging belly, and the rendering of cloth are particularly expressive. This work has a hardness of surface. The form is human, but the flesh, hair, and cloth do not have the soft texture we might expect. The face is a mask of agony, but no less full of pathos for that. An intense spirituality reflects the mysticism prevalent in the early Middle Ages. The *Gero crucifix* depicts a suffering Christ whose agony parallels the spirit of the times. This portrayal contrasts markedly with the *Christus Rex* crucifixes which became popular later and are frequently seen today, in which Christ on the cross is a victorious, resurrected King.

8.8 *Gero crucifix*, 969–76. Oak, 6 ft 1⅝ ins (1.87 m) high. Cologne Cathedral, Germany.

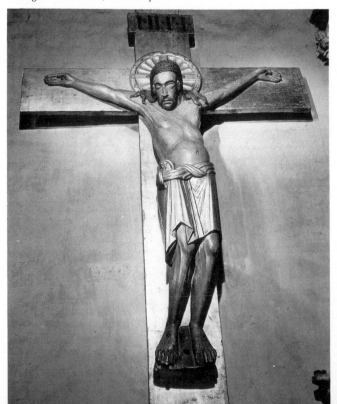

MASTERWORK
The bronze doors of Hildesheim Cathedral

Of the Ottonian rulers, Henry II was the greatest patron of the arts. In the Church, that honor belongs to Bernward of Hildesheim, tutor of Otto III. During his years as bishop (993–1022), the city of Hildesheim became a center for manuscript painting and other arts. Bernward's patronage, however, was largely confined to the area of metalwork, in particular, the bronze doors of the Hildesheim Cathedral (Fig. **8.9**). These doors were cast by the *cire-perdue*, or LOST-WAX process that had been used for casting the bronze doors at Aachen 200 years earlier.

The building of the Abbey church of St Michael at Hildesheim was part of Bishop Bernward's plan to make the town a center of learning. The doors for the south portal of St Michael's were completed in 1015 and they were probably installed before 1035. Apparently cast in one piece, Hildesheim's doors are the first in a succession of figured bronze doors throughout the Middle Ages and the Renaissance, a tradition that culminated in Ghiberti's *Gates of Paradise*. The massive doors of Hildesheim also represent a return to larger-scale sculpture that was to become typical of the Romanesque period.

The scenes portrayed on Bernward's doors tell biblical stories in a carefully arranged order. The number of scenes depicted—16—is an example of Medieval number symbolism. (Sixteen is the number of the Gospels multiplied by itself.) Reading from top to bottom, the scenes are paired, so that the left door unfolds the Old Testament story of the fall, and the right, the New Testament story of the redemption. For example, *The Temptation of Adam and Eve* (third from the top, left), which depicts the fall from grace, is purposely aligned with the *Crucifixion* (third from the top, right), which illustrates the redemption of humankind. The scenes are highly reminiscent of manuscript illustration, and tell their stories with a simple directness. In the fourth panel from the top on the left, an angry God reproaches Adam and Eve. His angry glare is heightened by his accusatory, pointing finger, and Adam and Eve cower under his condemnation. As the sinners try to shield their nakedness, Adam points to Eve, passing to her the blame for his transgression; she, in turn, looks downward, and with her left hand points an accusing finger at the serpent.

What is striking about all the scenes is the strong sense of composition and physical movement. Every set of images, against a plain background of open space, speaks forcefully in dumbshow. The doors tell their story in Medieval fashion, as a vivid but silent drama, effectively communicating the message of the Christian faith to a largely illiterate public. Replace these simple scenes with a clergy-actor, and you have the beginnings of liturgical drama (see the theatre section below). Just as the mystics of the Middle Ages understood communication through the intuition and nonrational emotions, so the artists of the period understood the raw power and effectiveness of the simple nonverbal image.

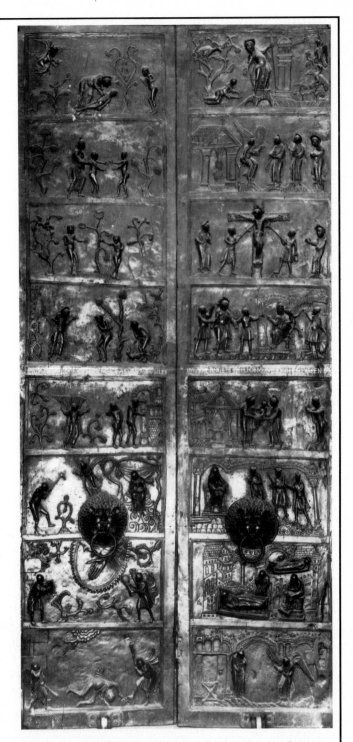

8.9 Doors of Hildesheim Cathedral, 1015. Bronze, 16 ft 6 ins (5.03 m) high. Hildesheim, Germany.

Romanesque style

Like the painting of the period, sculpture of the 11th and early 12th centuries is called Romanesque. In the case of sculpture, the label refers more to an era than to a style. Examples of sculpture are so diverse that we probably could not group them under a single label, were it not for the fact that most of them take the form of decorative elements attached to Romanesque architecture. We can, however, draw some general conclusions about Romanesque sculpture, unlike painting. First, it is associated with Romanesque architecture; second, it is heavy and solid; third, it is stone; fourth, it is monumental. The last two characteristics represent a distinct departure from previous sculptural style. Monumental stone sculpture had all but disappeared in the fifth century. Its re-emergence across Europe at the end of the 11th century over such a short period was remarkable. The emergence of sculptural decoration indicated at least the beginning of dissemination of knowledge from the cloistered world of the monastery to the general populace. Romanesque sculpture was applied to exteriors of buildings where the lay worshipper could see it and respond to it. The relationship of this artistic development to the increase in religious zeal among the laity was probably strong. In works such as the Last Judgment TYMPANUM of Autun (Fig. **8.10**), the illiterate masses could now read the message of the Church, an opportunity previously reserved for the

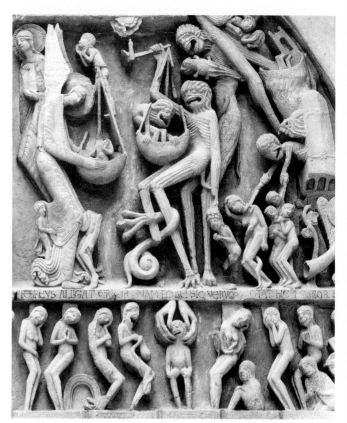

8.10 Gislebertus, Last Judgment tympanum c.1130–35. Autun Cathedral, France.

8.11 *The Mission of the Apostles* tympanum of central portal of narthex, 1120–32. Ste-Madeleine, Vézelay, France.

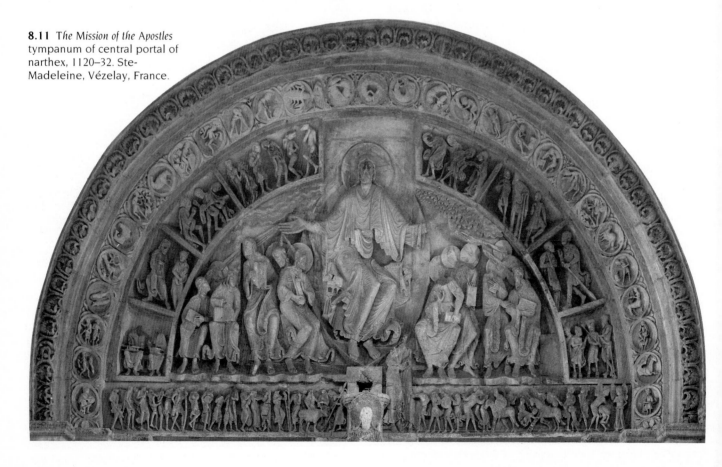

clergy. The message of this carved scene is quite clear. In the center of the composition, framed by a Roman style arch, is an awe-inspiring figure of Christ. Next to him, malproportioned figures writhe in various degrees of torment. The inscription of the artist, Gislebertus, tells us that their purpose was "to let this horror appal those bound by earthly sin." Evil was still central to Medieval thought, and devils share the stage with Christ, attempting to tip the scales of judgment in their favor and gleefully pushing the damned into the flaming pit.

Another Romanesque tympanum comes from the central portal of the narthex of the abbey and pilgrim church of Ste-Madeleine, Vézelay, in Burgundy (Fig. **8.11**). The story depicts the mission of the apostles and was especially meaningful to Medieval Christians at the time of the crusades (see Chapter 9). Here the artist proclaimed the duty of every Christian to spread the Gospel to the ends of the earth. At the center of the tympanum, a rather elongated figure of Christ spreads his arms, from which emanate the rays of the Holy Spirit, empowering the apostles, who carry the scriptures as tokens of their mission. Around the border is a plethora of representatives of the heathen world. The arch is framed by the signs of the zodiac and labors appropriate to the months of the year, stressing that the preaching of the faith is an on-going year-round responsibility without end.

Although revolutionary in its material, scale, and scope, Romanesque sculpture retains the emotional, crowded, nervous qualities of previous Medieval works. The Romanesque style was a close cousin of its predecessors—the closing stages of a point of view that was about to be supplemented by another.

LITERATURE

It seems clear that in the Early Middle Ages—with the notable exception of the Carolingian court—the politically powerful cared little for culture, and for the most part could neither read nor write. Thanks to the efforts of the monastic community, and particularly the Benedictine monks, however, important books and manuscripts were preserved and copied. St Benedict (c.480–c.550) was one of the few great scholars of the Dark Ages.

The Muslims had come into contact with Greek culture when they invaded Egypt, and brought it with them to Spain, where literature flourished. The schools they set up in Cordoba studied Aristotle and Plato alongside the Koran. Toledo and Seville were also centers of learning. It was biblical literature, however, that became the central focus during the Early Middle Ages.

St Jerome was a contemporary of St Augustine, and his writings assumed a position of primary importance in the last years of the Roman Empire. St Jerome was familiar with the classical writers, and the style of the scriptures seemed somewhat crude to him. He had a

dream, however, in which Christ reproached him and accused him of being more a Ciceronian than a Christian. As a result, Jerome resolved to spend the rest of his life in the study of the sacred books. He made a famous translation of the Bible into Latin. Assisted by Jewish scholars, he also translated the Old Testament from the Hebrew.

The other major literary accomplishment of the early Middle Ages, one with a completely different subject matter, was the German *Nibelungenlied* ("Song of the People of the Mists," meaning the dead). These early hero-stories of northern peoples, which took their final shape in southeast Germany in about 1200, are a rich mixture of history, magic, and myth. There are ten complete and 20 incomplete manuscripts of the *Nibelungenlied*, folk tales of 39 adventures, commencing with that of the hero Siegfried, son of Siegmund, King of the Netherworld. Wagner used this and other stories from the cycle as sources for his operas.

The favorite Old English epic, *Beowulf* (c.725), is the earliest extant poem in a modern European language. Composed by an unknown author, it falls into separate episodes that incorporate old legends. The poem is written in unrhymed alliterative verse. Its three folk stories center on the hero, Beowulf, and his exploits against the monster Grendel, Grendel's mother—a hideous water-hag—and a fire-breathing dragon.

The *Song of Roland*

The literature of this period also included the poems of the court singer–poets, who were popular throughout Europe. These professional storytellers produced fantastic legends and romances, such as the *Song of Roland*. In it, with fine but simple dramatic skills, an unknown poet tells the story of a great battle between Charlemagne and the Saracens of Saragossa in the Pyrenees. Charlemagne is deceived by the Saracens, draws his main army back into France, and leaves Roland with a rearguard to hold the pass. The Saracens are aided by disloyal Christian knights, and after a furious struggle, Roland and his entire army are killed. This extract describes the battle between Roland's army and the Saracens.

King Marsilion comes along a valley
with all his men, the great host he assembled:
twenty divisions, formed and numbered by the King,
helmets ablaze with gems beset in gold,
and those bright shields, those hauberks sewn with brass.
Seven thousand clarions sound the pursuit,
and the great noise resounds across that country.
Said Roland then: "Oliver, Companion, Brother,
that traitor Ganelon has sworn our deaths:
it is treason, it cannot stay hidden,
the Emperor will take his terrible revenge.
We have this battle now, it will be bitter,
no man has ever seen the like of it.
I will fight here with Durendal, this sword,

10

and you, my companion, with Halteclere—
we've fought with them before, in many lands!
how many battles have we won with these two!
Let no one sing a bad song of our swords." AOI.[5]

When the French see the pagans so numerous,
the fields swarming with them on every side, 20
they call the names of Oliver, and Roland,
and the Twelve Peers: protect them, be their warranter.
The Archbishop told them how he saw things:
"Barons, my lords, do not think shameful thoughts,
do not, I beg you all in God's name, run.
Let no brave man sing shameful songs of us:
let us all die here fighting: that is far better.
We are promised: we shall soon find our deaths,
after today we won't be living here.
But here's one thing, and I am your witness: 30
Holy Paradise lies open to you,
you will take seats among the Innocents."
And with these words the Franks are filled with joy,
there is no man who does not shout Munjoie! AOI.

A Saracen was there of Saragossa,
half that city was in this pagan's keeping,
this Climborin, who fled before no man,
who took the word of Ganelon the Count,
kissed in friendship the mouth that spoke that word,
gave him a gift: his helmet and its carbuncle. 40
Now he will shame, says he, the Land of Fathers,
he will tear off the crown of the Emperor;
sits on the horse that he calls Barbamusche,
swifter than the sparrowhawk, than the swallow;
digs in his spurs, gives that war horse its head,
comes on to strike Engeler of Gascony,
whose shield and fine hauberk cannot save him;
gets the head of his spear into his body,
drives it in deep, gets all the iron through,
throws him back, dead, lance straight out, on the field. 50
And then he cries: "It's good to kill these swine!
At them, Pagans! At them and break their ranks!"
"God!" say the French, "the loss of that good man!" AOI.

Roland the Count calls out to Oliver:
"Lord, Companion, there is Engeler dead,
we never had a braver man on horse."
The Count replies: "God let me avenge him";
and digs with golden spurs into his horse,
grips—the steel running with blood—Halteclere,
comes on to strike with all his mighty power: 60
the blow comes flashing down; the pagan falls.
Devils take away the soul of Climborin.
And then he killed Alphaën the duke,
cut off the head of Escababi,
struck from their horses seven great Arrabites:
they'll be no use for fighting any more!
And Roland said: "My companion is enraged!
Why, he compares with me! he earns his praise!
Fighting like that makes us dearer to Charles";
lifts up his voice and shouts: "Strike! you are warriors!" AOI. 70

And now again: a pagan, Valdabrun,
the man who raised Marsilion from the font,
lord of four hundred dromonds that sail the sea:
there is no sailor who does not call him lord;

the man who took Jerusalem by treason:
he violated the temple of Solomon,
he killed the Patriarch before the fonts;
took the sworn word of Ganelon the Count,
gave him his sword and a thousand gold coins.
He rides the horse that he calls Gramimund, 80
swifter by far than the falcon that flies;
digs hard into its flanks with his sharp spurs,
comes on to strike Sansun, our mighty duke:
smashes his shield, bursts the rings of his hauberk,
drives in the streamers of his bright gonfanon,
knocks him down, dead, lance straight out, from the saddle:
"Saracens, strike! Strike and we will beat them."
"God!" say the French, "the loss of that great man!" AOI.

Roland the Count, when he sees Sansun dead—
now, lords, you know the rage, the pain he felt; 90
digs in his spurs, runs at that man in fury,
grips Durendal, more precious than fine gold,
comes on, brave man, to strike with all his power,
on his helmet, beset with gems in gold,
cuts through the head, the hauberk, the strong body,
the good saddle beset with gems in gold,
into the back, profoundly, of the horse,
and kills them both, praise him or damn him who will.
Say the pagans: "A terrible blow for us!"
Roland replies: "I cannot love your men, 100
all the wrong and presumption are on your side." AOI.

An African, come there from Africa,
is Malquidant, the son of King Malcud,
his battle gear studded with beaten gold:
he shines to heaven, aflame among the others
rides the war horse that he calls Salt Perdut—
no beast on earth could ever run with him;
comes on to strike Anseïs, strikes on his shield
straight down, and cut away the red and blue,
burst into shreds the panels of his hauberk, 110
thrust into him the iron and the shaft.
The Count is dead, his days are at an end.
And the French say: "Lord, you fought well and died!"

Across the field rides Archbishop Turpin.
Tonsured singer of masses! Where is the priest
who drove his body to do such mighty deeds?
Said to the pagan: "God send you every plague,
you killed a man it pains my heart to remember";
and sent his good war horse charging ahead,
struck on that pagan shield of Toledo; 120
and he casts him down, dead, on the green grass.

And now again: a pagan, Grandonie,
son of Capuel, the king of Cappadocia;
he is mounted on the horse he calls Marmorie,
swifter by far than the bird on the wing;
loosens the reins, digs in sharp with his spurs,
comes on to strike with his great strength Gerin,
shatters the dark red shield, drags it from his neck,
and driving bursts the meshes of his hauberk,
thrusts into him the blue length of his banner 130
and casts him down, dead, upon a high rock;
and goes on, kills Gerer, his dear companion,
and Berenger, and guion of Saint Antonie;
goes on still, strikes Austorie, a mighty duke

who held Valence and Envers on the Rhone;
knocks him down, dead, puts joy into the pagans.
The French cry out: "Our men are losing strength!"

Count Roland holds his sword running with blood;
he has heard them: men of France losing heart;
filled with such pain, he feels he will break apart; 140
said to the pagan: "God send you every plague,
the man you killed, I swear, will cost you dear";
his war horse, spurred, runs straining every nerve.
One must pay, they have come face to face.

Grandonie was a great and valiant man,
and very strong, a fighter; and in his path
he came on Roland, had never seen him before;
but knew him now, knew him now, knew him now,
that fury on his face, that lordly body,
that look, and that look, the tremendous sight of him; 150
does not know how to keep down his panic,
and wants to run, but that will not save him;
the blow comes down, Roland's strength is in it,
splits his helmet through the nosepiece in two,
cuts through the nose, through the mouth, through the teeth,
down through the trunk, the Algerian mail,
the silver bows of that golden saddle,
into the back, profoundly, of the horse;
and killed them both, they never rode again.
The men of Spain cry out their rage and grief. 160
And the French say: "Our defender has struck!"

The battle is fearful, there is no rest,
and the French strike with all their rage and strength,
cut through their fists and their sides and their spines,
cut through their garments into the living flesh,
the bright blood flows in streams on the green grass.
The pagans cry: "We can't stand up to this!
Land of Fathers, Mahummet's curse on you!
Your men are hard, we never saw such men!"
There is not one who does not cry: "Marsilion! 170
Come to us, King! Ride! We are in need! Help!"

The battle is fearful, and vast,
the men of France strike hard with burnished lances.
There you would have seen the great pain of warriors,
so many men dead and wounded and bleeding,
one lies face up, face down, on another.
The Saracens cannot endure it longer.
Willing and unwilling they quit the field.
The French pursue, with all their heart and strength. AOI.

Marsilion sees his people's martyrdom. 180
He commands them: sound his horns and trumpets;
and he rides now with the great host he has gathered.
At their head rides the Saracen Abisme:
no worse criminal rides in that company,
stained with the marks of his crimes and great treasons,
lacking the faith in God, Saint Mary's son.
And he is black, as black as melted pitch,
a man who loves murder and treason more
than all the gold of rich Galicia,
no living man ever saw him play or laugh; 190
a great fighter, a wild man, mad with pride,
and therefore dear to that criminal king;
holds high his dragon, where all his people gather.

The Archbishop will never love that man,
no sooner saw than wanted to strike him;
considered quietly, said to himself:
"That Saracen—a heretic, I'll wager.
Now let me die if I do not kill him—
I never loved cowards or cowards' ways." AOI

Turpin the Archbishop begins the battle. 200
He rides the horse that he took from Grossaille,
who was a king this priest once killed in Denmark.
Now this war horse is quick and spirited,
his hooves high-arched, the quick legs long and flat,
short in the thigh, wide in the rump, long in the flanks,
and the backbone so high, a battle horse!
and that white tail, the yellow mane on him,
the little ears on him, the tawny head!
No beast on earth could ever run with him.
The Archbishop—that valiant man—spurs hard, 210
he will attack Abisme, he will not falter,
strikes on his shield, a miraculous blow:
a shield of stones, of amethysts, topazes,
esterminals, carbuncles all on fire—
a gift from a devil, in Val Metas,
sent on to him by the Amiral Galafre.
There Turpin strikes, he does not treat it gently—
after that blow, I'd not give one cent for it;
cut through his body, from one side to the other,
and casts him down dead in a barren place. 220
And the French say: "A fighter, that Archbishop!
Look at him there, saving souls with that crozier!"

Roland the Count calls out to Oliver:
"Lord, Companion, now you have to agree
the Archbishop is a good man on horse,
there's none better on earth or under heaven,
he knows his way with a lance and a spear."
The Count replies: "Right! Let us help him then."
And with these words the Franks began anew,
the blows strike hard, and the fighting is bitter; 230
there is a painful loss of Christian men.
To have seen them, Roland and Oliver,
these fighting men, striking down with their swords,
the Archbishop with them, striking with his lance!
One can recount the number these three killed:
it is written—in charters, in documents;
the Geste tells it: it was more than four thousand.
Through four assaults all went well with our men;
then comes the fifth, and that one crushes them.
They are all killed, all these warriors of France, 240
all but sixty, whom the Lord God has spared:
they will die too, but first sell themselves dear. AOI.

Count Roland sees the great loss of his men,
calls on his companion, on Oliver:
"Lord, Companion, in God's name, what would you do?
All these good men you see stretched on the ground
we can mourn for sweet France, fair land of France!
a desert now, stripped of such great vassals.
Oh King, and friend, if only you were here!
Oliver, Brother, how shall we manage it? 250
What shall we do to get word to the King?"
Said Oliver: "I don't see any way.
I would rather die now than hear us shamed." AOI.[6]

THEATRE

Scholars used to argue that theatre ceased to exist in the western world for a period of several hundred years. That viewpoint is no longer widely held, and two pieces of evidence certainly suggest that theatrical productions continued. One is the presence of the wandering entertainers we have already noted. In this tribe of entertainers were mimists, jugglers, bear baiters, acrobats, wrestlers, and storytellers. The propensity of human beings for acting out or mimicking actions and events is too compelling to deny its existence amid the entertainments we know existed in this era. We do not know, however, how such entertainments were presented during the early Middle Ages. They may have consisted simply of the acting out of a story silently or the reading of a play script, rather than the formal presentations we call "theatre."

Our second piece of evidence, however, proves more conclusively that theatre existed. Writings from North Africa argue that there was a continuation of the mime there and it is probable that if it still existed in North Africa, it also existed in Europe. Sisebert, King of Spain in the seventh century, refers to the popularity of *ludi theatrici*, or old Roman festival plays, at marriages and feasts, adding that members of the clergy should leave when these were performed. In France in the ninth century, the Council of Tours and the Council of Aix-la-Chapelle ruled that the clergy should witness neither plays nor the obscenities of actors. These railings of the Church against the theatre certainly suggest that it existed. Charlemagne added his powerful backing in defense of the clergy by ruling that no actor could wear a priest's robe under penalty of corporal punishment or banishment. This edict has been taken by some as evidence of theatrical presentation and also, perhaps inaccurately, as evidence of the beginnings of liturgical drama. If this were the case, the prohibition would imply the use of actors other than the clergy in church drama. In the tenth century, the German nun Hrosvitha is known to have written six plays based on comedies by Terence. We do not know if Hrosvitha's plays were performed, but if they were, the audience would have been restricted to the other nuns in the convent.

We are sure, however, that liturgical drama began as an elaboration of the Roman Catholic Mass, probably in France. These elaborations were called TROPES, and they took place on ceremonial occasions, especially at Easter, the dramatic highlight of the Church year. Records at Winchester in southern England dating from the late tenth century tell of a trope in which priests acted out the discovery of Jesus' empty tomb by his followers on Easter morning.

So theatre, along with all the other arts, except dance, was adopted by the Church and became an instrument of God in an age of faith and demons.

MUSIC

Most of the music from the Greek, Hellenistic, and Roman traditions was rejected by the early Christian Church. Music cultivated simply for enjoyment and any music or musical instrument associated with activities objectionable to the Church were considered unsuitable. The *hydraulos*, for example, was banned. Disapproval of Roman or Greek music apparently did not reflect a negative attitude toward music itself. Rather, it represented a need to break ties with pagan traditions.

We know that music played a role in Christian worship from earliest times, and since Christian services were modeled on Jewish synagogue services, it is likely that any music in them was closely linked to liturgical function. In responsorial PSALMODY the leader sang a line of the psalm and the congregation sang a second in response. The melody began with a single note for the first few words, changing for the final words to a "HALF CADENCE." The congregation then sang the beginning of the response on the same note, concluding with a CADENCE. The early Church also used an ANTIPHONAL psalmody, in which singing alternated between two choruses. Local churches in the west were relatively independent at first, and between the fifth and the eighth centuries several different liturgies and chants developed. After the eighth century, virtually all these local variants were unified into a single practice under the central authority of Rome.

Early in the fourth century, hymns were introduced into the western Church. Some sources credit St Ambrose for this innovation, while others credit Hilary, bishop of Poitiers. Early hymns had poetic texts consisting of several verses, all of which were sung to the same melody, which may have been taken from popular secular songs. Mostly the hymns were syllabic, that is, each syllable was sung on a single note, and they were intended to be sung by the congregations, not by a choir or a soloist. In style and content, early Church hymns tended to express personal, individual ideas. Other sections of the liturgy were more formal, objective, and impersonal.

Another type of Church music at this time was the *alleluia*, which presented an interesting contrast in style to the hymn. The *alleluia* was MELISMATIC in style—that is, with many notes for each syllable of text—and it was sung after the verse of a psalm. The last syllable of the word was drawn out "in ecstatic melody, soaring phrase 'in gladness of heart and flowing joy too full to be expressed in words'."[7] Eastern in influence and emotional in appeal, the *alleluia* came to the Christian service directly from Jewish liturgy.

Probably the most significant contribution to Medieval music was made by Pope Gregory I, after whom the "GREGORIAN CHANT" is named. Gregory provided the driving force for the codification of the diverse musical traditions of the early Church. An editor rather than a

composer, he supervised the selection of melodies and texts he thought most appropriate for the musical setting of Church celebrations. Having organized Church music, he then became active in disseminating it throughout the west. The result of his efforts was not only to create an additional unifying force in the Church, but also to lay the foundations of a basic universal musical language.

In this era, or perhaps slightly before it, a significant change in tradition and practice took place, one which stemmed from practical considerations. As increasing numbers of converts strained the capacities of churches, their monetary contributions to the Church created wealth which was, in turn, used to build larger sanctuaries. When these great buildings were filled, informal worship, and particularly the responses, could no longer be conducted in an orderly fashion. So music became more the province of the choir or a chief solo singer, like the cantor in the Jewish synagogue. Increased formality in the liturgy further divided clerics and congregations. Formal solo and choir music led to the establishment of a central training center, a *Schola Cantorum*, or singing school, for Church musicians in Rome. In addition to formalizing the training of Church musicians, the *Schola Cantorum* also provided a means by which Gregorian reform could be universally introduced, since the *Schola*-trained musicians served congregations throughout Europe.

Chant melodies were passed on mostly by oral tradition from one generation of priests and monks to another. It seems likely that early chants had a simple, undulating character, the effect of which was haunting. They were monophonic, that is, they had a single melodic line. Chants were sung in a flexible tempo, with unmeasured rhythms, following the natural accents of normal Latin speech. Medieval chants have provided a unique and rich source of material for later composers, and they are still used in Christian worship.

The Middle Ages also witnessed a growth in secular music. As might be expected, secular music used vernacular texts, that is, texts in the language of the common people, as opposed to the Latin of Church music. The subject matter mostly concerned love, but other topics were also popular. Secular music probably owed much to the dance pantomime of Roman times. Those performers were, as we noted in Chapter 6, expelled from cities and forced to become wandering bands of entertainers. A strong link probably exists between the traditions of the pantomime and the poet–musicians of later Medieval Europe—*trouvères* in northern France, *troubadours* in southern France, and *Minnesänger* in Germany. These wandering minstrels created and performed vocal music as they traveled throughout the countryside. Apparently most of their music was monophonic, like Church music, but they also sang with some form of musical accompaniment. Medieval secular song was probably mostly strophic, that is, composed of several stanzas that were sung to the same melody.

Musical instruments of this era included the lyre, the harp, and a bowed instrument called the vielle or fiedel, that is, the viol, or fiddle. The psaltery, which is an instrument similar to a zither, the lute, the flute, the shawm, which is a reed instrument like an oboe, trumpets, horns, drums, and bagpipes, as well as the organ, were all popular. There were small versions of the organ which were portable. Despite its unpleasant associations with Rome, the organ eventually found its way into the Medieval Church.

While liturgical and secular traditions developed, a different philosophy of music emerged from the monastic community. The scholar Boëthius emphasized, as did the Greeks, the relationship of music to character and morals. He saw the value of music as an educational device, and noted that its mathematical properties served as a springboard to higher philosophical inquiry. Boëthius conceived of music as a form of study rather than an expression of feeling. For him, the true musician was not the performer, but the composer/critic/philosopher who carefully examined "the diversity of high and low sounds by means of reason and the senses."

In the ninth or tenth century, a new compositional and radically different texture appeared in music. POLYPHONY brought more than one melodic line into musical composition. Early polyphonic compositions were called *organa* (the singular is ORGANUM). In the earliest polyphonic forms, the rhythmic component of music remained free and unstructured. However, as melodic lines gained freedom from each other, necessity dictated that some type of rhythmic structure be employed to coordinate them. So, at the very end of this era, a new rhythmic notation emerged, called "mensural notation." This made it possible to indicate the precise duration of each tone.

DANCE

Dancing is a natural form of expression, predating even the theatre, and it can be found at the center of ritual in almost every culture. It did not surrender to the dictates of Christianity in the early Middle Ages. Church writings continue to condemn dancing from Constantine's time to the 11th century and beyond. St Augustine complained that it was better to dig ditches on the Sabbath than to dance a "choric Reigen" (a type of "round dance").

Bitter conflict understandably characterized a previously pagan world in an age of expanding Church influence. A religious philosophy in which all pleasures of the flesh were evil clashed with a pagan belief to which fertility rites, including wild dances and orgies, were central. History records many examples of masked pagan dancers attempting to invade churches. Even when Christianity gained a firm hold, it was impossible to eradicate deeply-rooted ritualistic dancing completely. It

appears that a certain unspoken compromise was reached. Dancing continued because people will continue to do what gives them pleasure, Church or not, the threat of damnation notwithstanding. But the pagan contexts of dance were put aside.

The Christian Church made many such compromises with life as it found it. We still celebrate ancient pagan festivals ·today without a thought of risking our souls. Which child who has danced around a maypole or gone trick-or-treating has considered such a practice a fertility dance or demonic mummery?

It is fairly clear, however, that little of the dancing to which various sources refer in the early Middle Ages was significant either as individual artistic expression or as collective activity in a theatre. Any outpouring of emotion through dance in this period was largely spontaneous and took no account of a performer/audience relationship. Such dancing was a response to a chaotic and frightening world in which people were reduced to their baser selves. Later, demonic dances, dances of death, and animal mummeries would take on a more formal, presentational character—Death as a dancer was a frequent Medieval image—but in these early years, dance was surely not a recognized art form.

We are fairly certain that, like theatre, theatrical dance remained alive through successors to the pantomimes. Performers, called *joculatores*, or jugglers, appeared at fairs and festivals, nearly always for the peasants, rarely for the nobility. Manuscript illustrations survive that prove that there were professional dancers in the 11th century. Some evidence suggests that a kind of undefined "hand dance" existed, as well as dances using the themes of Roman mythology.

ARCHITECTURE
Basilica form

When Christianity became a state religion in Rome, an explosion of building took place to accommodate the need for places to worship. Previously, small groups of the faithful had gathered as inconspicuously as possible wherever it was practical and prudent for them to do so. Even had it been safe to worship publicly, there was no need for a building of any size to house so few people. Respectability changed all that.

Like painting, early Christian architecture was an adaptation of existing Roman style. For the most part, churches took the form of the Roman BASILICA. We tend to think of the term "basilica" as referring specifically to Christian structures, as in St Peter's Basilica in Rome. However, the term referred originally to Roman law courts, whose form the first large Christian churches took.

The original basilica had a specific architectural design, to which Christian architects made some very simple alterations. Roman basilicas had many doors along

the sides of the building to facilitate entrances and exits. Church ritual required the altar to be the focal point. Therefore, the entrance to the Christian basilica was moved to the end of the building, usually at the western end, so that attention focused down the long, relatively narrow NAVE to the altar at the far end. Often the altar was set off by a large archway reminiscent of a Roman triumphal arch, and elevated to enhance sightlines from the congregation, who occupied a flat floorspace.

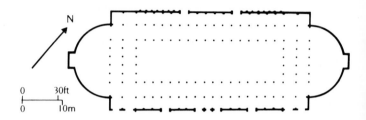

8.12 Plan of the Basilica Ulpia, Rome, c.110.

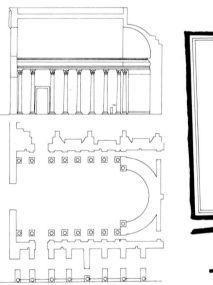

8.13 Plan and section of a basilica in the Imperial Palace, Rome, c.85.

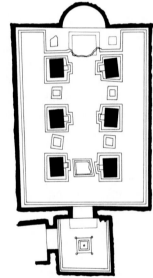

8.14 Plan of an underground basilica near the Porta Maggiore, Rome, first century AD.

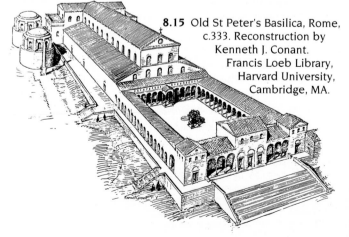

8.15 Old St Peter's Basilica, Rome, c.333. Reconstruction by Kenneth J. Conant. Francis Loeb Library, Harvard University, Cambridge, MA.

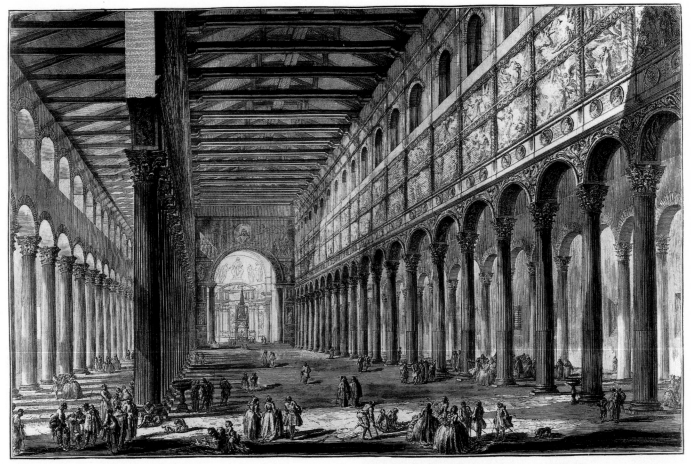

8.16 Interior of S. Paolo fuori le Mura, Rome, late fourth century. Engraving by Giovanni Battista Piranesi (1720–78).

Figures **8.12** through **8.16** clearly show the underlying structure of the basilican form in different scales and proportions. The basic structure has two or four long, parallel rows of columns, or piers, surrounded by an outer wall that is separated from the columns by an aisle. The central space, or nave, was heightened by a clerestory and a beam or simple truss roof describing an isosceles triangle of fairly low pitch. Low-pitched roofs covered the side aisles. The basilica was reasonably easy to build, yielding a nave width of 70 or 80 feet. In contrast to later church styles, the basilica was not monumental by virtue of its height, although its early association with the law courts gave it an air of social authority. Interior parts and spaces were clearly defined, and this form was stated in simple structural terms.

Another change occurred in the treatment of interior space as different from the exterior shell. In architectural design, there are two approaches to the interior/exterior problem. Either the exterior structure expresses and reveals the nature and quality of interior space and *vice versa*, or the exterior shell is just that—a shell, in many instances obscuring what lies inside. The basilica exemplified the latter style. Whether intentionally or not, it thus symbolizes the difference between the exterior world of the flesh and the interior world of the spirit.

Carolingian design

No serious attempt at architectural design was made until the rule of Charlemagne. Charlemagne's renaissance included architecture, and he returned to his capital, Aachen (Aix-la-Chapelle), from visits to Italy not only with visions of Roman monuments, but also with a belief that majesty and permanence must be symbolized in impressive architecture.

The realization of these dreams, however, was tempered by some of the difficult facts of life that stand between builders and their completed works. Charlemagne took as his model the church of San Vitale in Ravenna (Figs **7.20–7.22**), which had been built by Justinian in the Byzantine style. All Charlemagne's materials, including columns and bronze gratings, had to be transported over the Alps from Italy to Aachen in Germany. Skilled stonemasons were few and far between. The task, nevertheless, was accomplished, and the design of Charlemagne's Palatine Chapel is still dominant and compelling today (Figs **8.32–8.34**), despite later alterations to the building. Charlemagne also encouraged the building of monasteries and apparently developed a standard plan for their design that was used, with local modifications, throughout his empire.

Romanesque style

As Charlemagne's empire in the ninth century and then the tenth century passed, a new and radical style in architecture emerged. Unlike its counterparts in painting and sculpture, Romanesque architecture had a fairly identifiable style, despite its diversity. The Romanesque took hold throughout Europe in a relatively short period of time. When people of the Renaissance saw its curved arches over doorways and windows throughout Europe, they saw a style that was pre-Gothic and post-Roman —but like the Roman. Therefore, they called it "Romanesque." With its arched doorways and windows, this style

8.17 and **8.18** St Sernin, Toulouse, France, c.1080–1120.

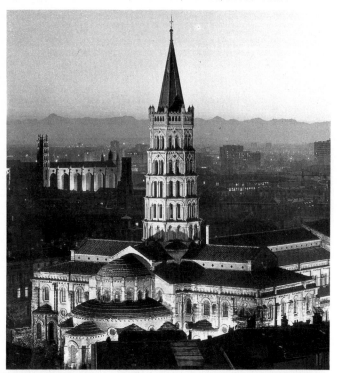

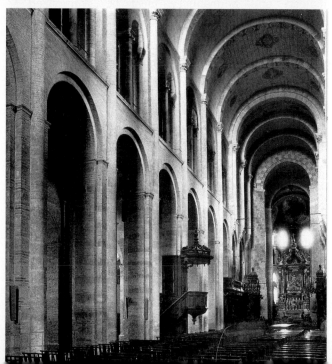

was massive, static, and comparatively lightless. This seems further to reflect the barricaded mentality and lifestyle generally associated with the Middle Ages.

The Romanesque style nonetheless exemplified the power and wealth of the Church militant and triumphant. If the style mirrored the social and intellectual system that produced it, it also reflected a new religious fervor and a turning of the Church toward its growing flock. Romanesque churches were larger than earlier ones; we can see their scale in Figures **8.17** and **8.18**. St Sernin is an example of southern French Romanesque, and it reflects a heavy elegance and complexity we have not previously seen. The plan of the church describes a Roman cross, that is, a cross with the lower staff longer than the arms. The side aisles extend beyond the crossing to create an ambulatory, or walking space. This was so that pilgrims, most of whom were on their way to Spain, could walk around the altar without disturbing the service.

One additional change is worth noting. The roof of this church is made of stone, whereas earlier buildings had wooden roofs. As we view the magnificent vaulted interior, we wonder how successfully the architect reconciled the conflicts between engineering, material properties, and aesthetics. Given the properties of stone and the increased force of added height, did he try to push his skills to the edge, in order to create a breathtaking interior? Did he aim to reflect the glory of God or the ability of humanity?

Returning to the exterior view, we can see how some of the stress of the high tunnel vaulting was diffused. In a complex series of vaults, transverse arches, and bays, the tremendous weight and outward thrust of the central vault were transferred to the ground, leaving a high and unencumbered central space. If we compare this structural system with post-and-lintel structure and consider the compressive and tensile properties of stone, we can see why the arch is superior as a structural device for creating open space. Because of the weight and the distribution of stress in this style, only very small windows were possible. So, although the fortress-like, lightless qualities of Romanesque architecture reflect the spirit of their time, they also had a practical explanation.

The tenth-century church of Cluny, known as Cluny II, inspired numerous buildings throughout the west in the 11th century. When it became too small, a new church, Cluny III, was begun in 1088. It remained the largest church in Christendom until St Peter's in Rome was rebuilt in the 16th century. Although Cluny III (Figs **8.19–8.21**) was very badly damaged during the French Revolution, we know that the nave, which had double aisles, the double transepts, and the choir with an ambulatory were all enormous in scale. The arcades of the nave had pointed arches, and the interior housed magnificent wall paintings. Protruding apses and numerous towers adorned the exterior.

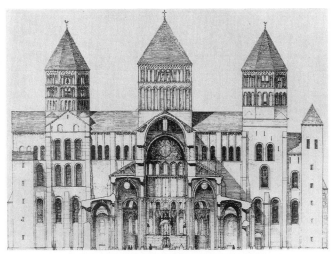

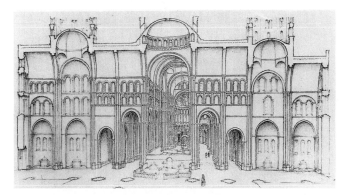

8.19 Transverse section of the nave, and west elevation of the great transept of the Abbey Church, Cluny III, France, 1088–1130.
8.20 (below) Transverse section of the transept.
Drawing by Kenneth J. Conant. Frances Loeb Library, Harvard University, Cambridge, MA.

8.21 Exterior of southwest transept of Cluny III.

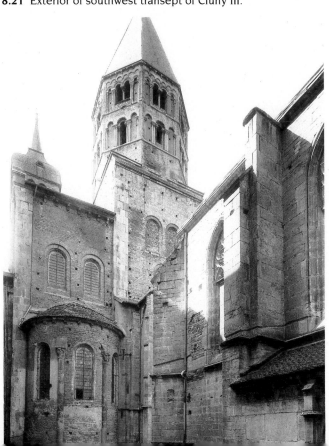

English Norman style

The Norman style of building, with its accent on rounded arches, was loosely based on the classical architecture of Roman times. It is, therefore, covered by the broad umbrella term, "Romanesque style." Norman style came to England from western Europe even before the Norman invasion of 1066 and flourished alongside the earlier Saxon architecture. Norman style, however, became firmly established in the flurry of building—especially church building and rebuilding—that followed the Conquest and continued until around 1190. Its impact was especially noticeable on the larger churches. Small parish churches adopted the changes more slowly.

Most Norman churches were built of stone cut into square blocks, although when stone was not readily available, bricks and cut flints were also used. In the Abbey Church of St Alban (Fig. **8.22**) bricks and cut flints from the ruined Roman city of Verulamium served for the building. The Roman bricks were thinner than our bricks—about the size and shape of paving stones. The massive walls and piers of St Albans (nearly six feet thick at the tower ceiling level) are constructed of rubble faced with Roman bricks. The walls of the nave were plastered over and painted white.

Norman arches were often decorated with carvings of various designs. At St Albans, the Roman brickwork proved too hard to carve and so the arches of the nave were brightly painted in typical Norman linear designs. RIBBED VAULTING, introduced late in the Norman period, proved stronger and more attractive than groin vaulting. The earliest known Norman ribbed vaults appear in Durham Cathedral, and date from approximately 1095.

8.22 St Albans Cathedral, the nave facing east.

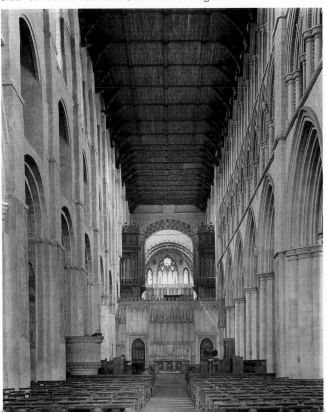

SYNTHESIS
The Carolingian Renaissance

When Pepin III died in 768, he was succeeded by his two sons, Charles and Carloman. Carloman died three years later, and Charles, denying the succession of Carloman's infant sons, acquired for himself the entire Frankish Empire. Carrying on the work of his father and grandfather, Charlemagne set about subduing the Frankish peoples and other tribes throughout Europe. He ruled over a vast empire of many nations. He became protector of Pope Leo III in Rome. On Christmas day in the year 800, as Charlemagne knelt in prayer before the altar in the old church of St Peter, Pope Leo suddenly placed a crown on his head, and the people acclaimed him as emperor.

Perhaps his greatest contributions to European civilization lay in his support of education, reform of the Church, and cultivation of the liberal arts. Under the leadership of

8.23 St Mark and St Luke, from the Gospel Book of Godescalc, 781–83. Vellum, 12¼ × 8¼ ins (31.1 × 21 cm). Bibliothèque Nationale, Paris.

8.24 The crypts at St-Germain, Auxerre, France, ninth century.

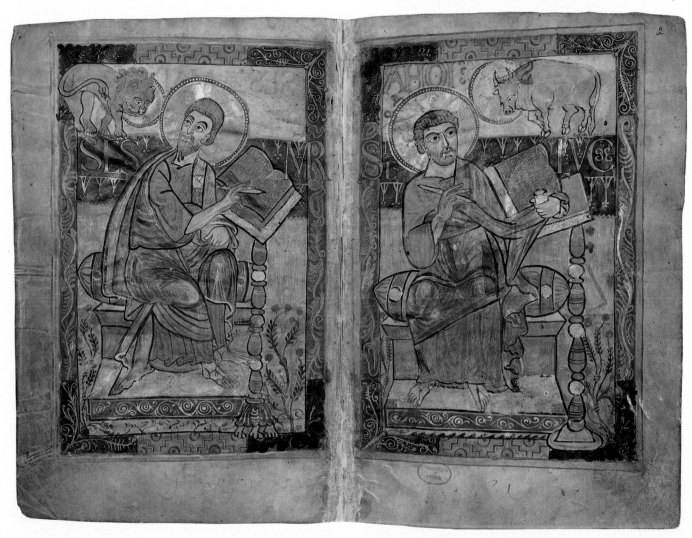

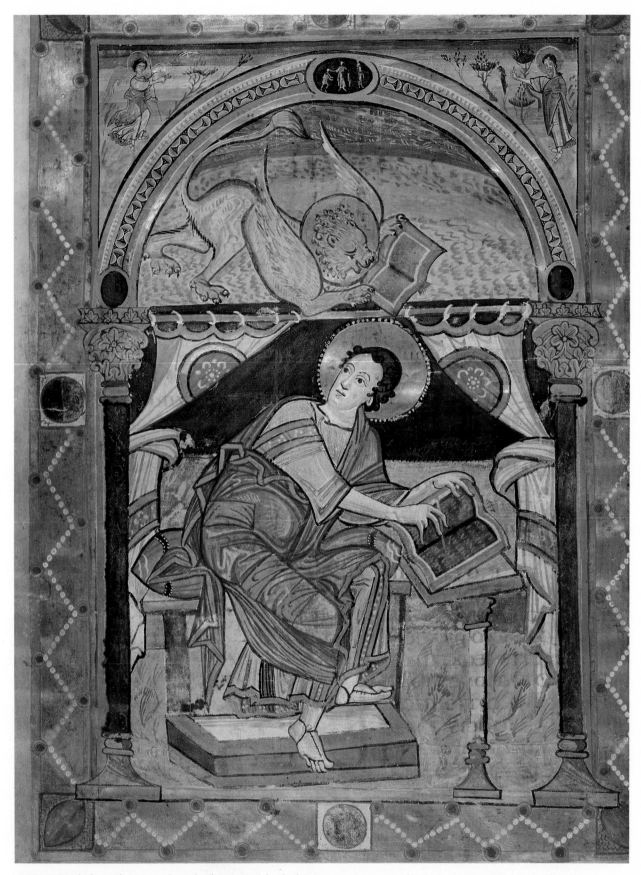

8.25 St Mark, from the Gospel Book of Saint Médard of Soissons, France, early ninth century. Paint on vellum, 14⅜ × 10¼ ins (36.5 × 26 cm). Bibliothèque Nationale, Paris.

Alcuin of York, scholars were assembled from all parts of the west to reunite the scattered fragments of the classical heritage. The Carolingian renaissance—or *renovatio*, as it was called—represents the hinge, as it were, on which the ancient world turned into the Middle Ages. The classical revival initiated by Charlemagne was part of his attempt to revive the Roman Empire.

Carolingian manuscript illuminations are striking examples of early Medieval painting. As an official court art, book illumination was promoted by the king, his relatives, associates, and officers of state. One exemplary product of the time was the Gospel Book of Godescale (Fig. **8.23**). The models for this work were probably Byzantine. The evangelists have lean, bearded faces. The cloth of their garments reveals a rudimentary attempt at modeling, with little attention to realism, merely light and dark stripes representing the highlight and shadow of the folds. Unlike the Gospel Book of Godescale, the Gospel Book of Saint-Médard of Soissons (Fig. **8.25**) displays a definite classicism in its arches complete with columns, intricate architecture, and frames adorned with CAMEOS and pictures containing tiny figures. Nonetheless, there is a confusion in the plethora of detail and a crowded nervousness that is characteristic of Medieval work.

Wall paintings were a highly original feature of Carolingian art and architecture. Although few examples remain, it seems clear that Carolingian palaces and churches were brightly painted in a style not unlike that of the Romans. For example, three-dimensional architectural detail is presented in a highly realistic fashion on a two-dimensional surface. Large frescos depicting the history of the Franks were also typical. In many cases, the inscriptions accompanying these frescos reflect the scholarship of Alcuin and others. The life-size figures of several bishops of Auxerre found in the crypts there (Fig. **8.24**) show a great deal of originality. Clearly the mural painters of the period possessed great skill and imagination. In the segment depicting the stoning of St Stephen (Fig. **8.26**), all of the important vertical lines of the painting conform to a mathematical formula based on a grid created from the half-square in which the arch bordering the painting is framed.

The works of the palace school at Charlemagne's court also reflect an effort to revive classical style by copying sculpture from the late antique period. Classical influence continued to be nurtured, perhaps because Charlemagne's political opposition to the Byzantine Empire led him to reject its artistic style as well. The so-

8.26 *The Stoning of St Stephen at the Gate of Jerusalem*, ninth century. Wall painting. Crypts of St-Germain, Auxerre.

8.27 So-called *Statuette of Charlemagne*, c.860–70. Bronze cast and gilt, 9¼ ins (23.5 cm) high. Louvre, Paris.

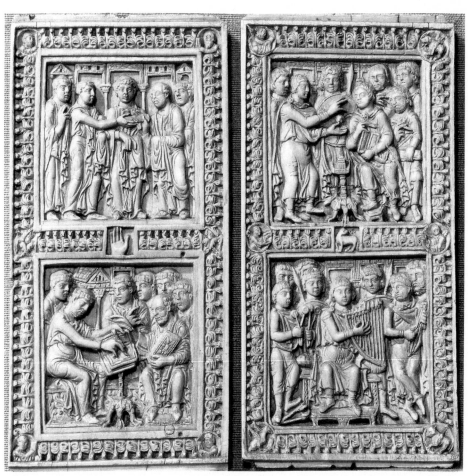

8.28 Cover of the Dagulf Psalter, showing David in various scenes, 783–95. Ivory, each leaf 6⅝ × 3¼ ins (16.8 × 8.3 cm). Louvre, Paris.

called "*Statuette of Charlemagne*" (Fig. **8.27**), for example, clearly imitates a classical model.

It is, however, the ivories of this period that most clearly show both the classicizing trend and the artistry of the time. Although derived from antique models, these works are highly individual. The ivory covers of the Dagulf Psalter (Fig. **8.28**) bear a close resemblance to Roman work. Commissioned as a gift for Pope Adrian I, the figures and ornamentation on this cover are stilted and lifeless. There is little attempt at creating three-dimensional space, although the figures themselves appear in high relief. Composition in each panel appears to be organized around a central area, to which interior line directs the viewer's eye. This focus is reinforced by the direction in which the figures themselves are looking. The scenes are crowded, but not frenetic. The figures have strange proportions, almost dwarf-like, with heavy rounded heads, long torsos, and short legs. Hairstyles reflect the late Roman Imperial period.

The ivory cover of the ninth-century Lorsch Gospels (Fig. **8.29**), on the other hand, is an exact replica of a sixth-century design. The images in the upper register, the

layout, and the rounded faces in the figure depiction clearly show its kinship with the *Barberini Ivory*, Figure **7.14**. The Roman arches in each of the three middle panels testify to the classical derivation of the Lorsch Gospels. In the center panel sits the Virgin Mary, enthroned, with the infant Christ and surrounded by saints. The face of the Christ child is that of a wise adult, a common Medieval practice. Encircled in the top register and flanked by heraldic angels, the risen Christ appears. In the lower register are scenes from the nativity. So the Gospel cover reads chronologically from birth to Resurrection in hierarchical fashion.

Architecture, like painting and sculpture, was ruled by the political goals of the Carolingian court. It is also clear that the artists of the period were capable of reproducing capitals and friezes from classical antiquity accurately, as Figure **8.31** illustrates. Charlemagne carefully chose bishops for his kingdom who would assist in the building program he envisaged, and almost immediately new construction began across the empire. Large-scale building in the period was short-lived, however, despite its bold conception.

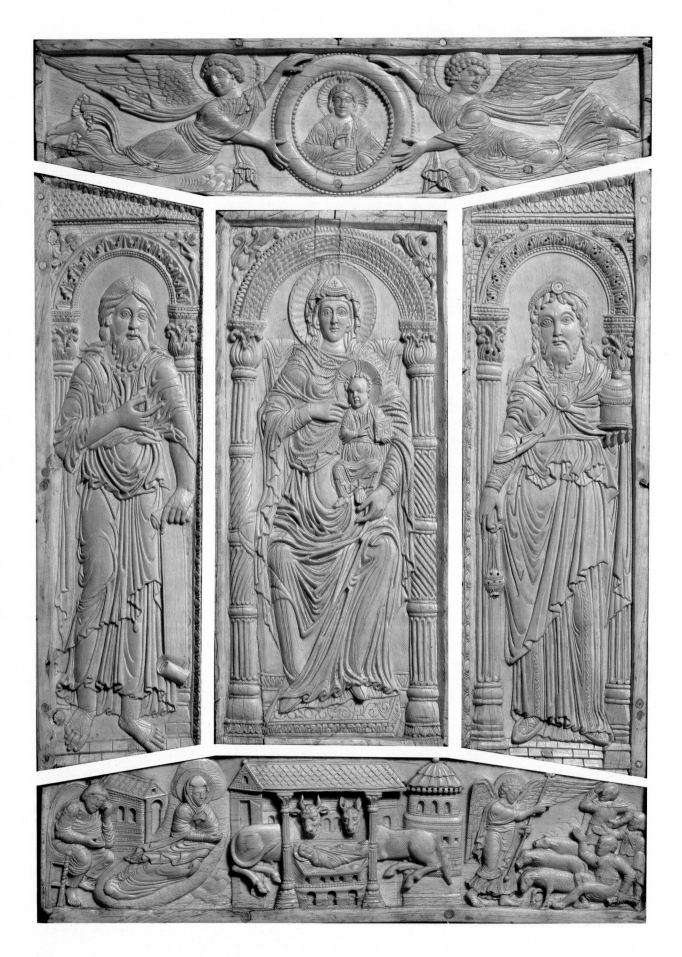

8.29 (opposite) Back of the Lorsch Gospels, showing the Virgin and Child between Zacharias and John the Baptist, c.810. Ivory, $15\frac{1}{8} \times 10\frac{5}{8}$ ins (38.4 × 27 cm). Victoria and Albert Museum, London.

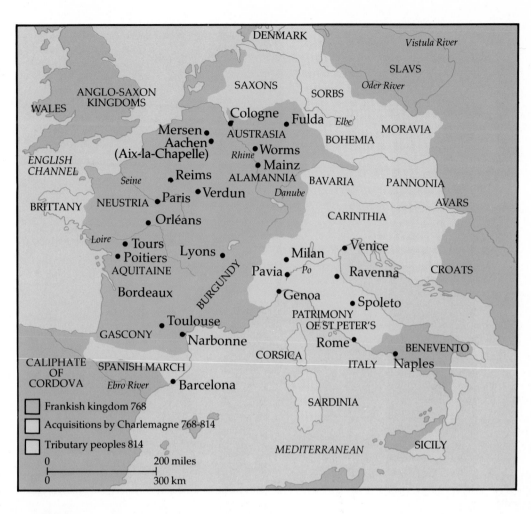

8.30 The Carolingian Empire.

8.31 Detail of the parapet railings in the Tribune of the Palatine Chapel, Aachen, Germany, 792–805.

8.32 Palatine Chapel of Charlemagne, Aachen, 792–805.

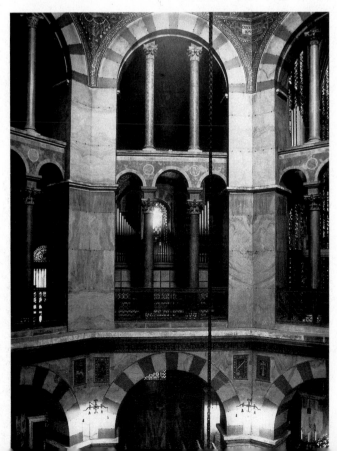

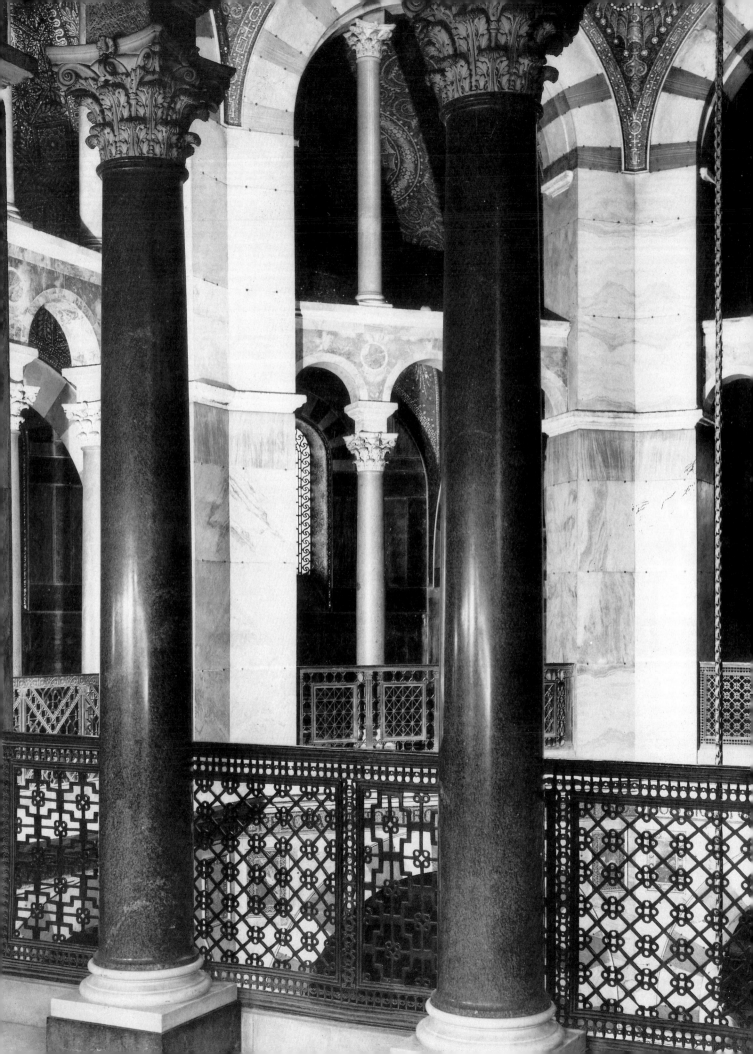

8.34 Tribune of the Palatine Chapel, Aachen.

It was the Palatine Chapel at Aachen (Fig. **8.32**), built to be Charlemagne's tomb-house, that became the jewel in his crown. Further illustrations of the interior (Figs **8.33** and **8.34**) reveal the grandeur and style of this building.

During Charlemagne's reign, then, we find a true renaissance, modified as it may have been to serve the grand design and political ambitions of the emperor. The recreation of antiquity in the arts and humanities made visible and intelligible the dream of a resurrected Roman Empire, with Charlemagne at its head.

SUGGESTIONS FOR THOUGHT AND DISCUSSION

The early Middle Ages and the spread of early Christianity are essentially inseparable. Although we have not seen how early Christian ideas apply directly to the arts, we need now, having completed the survey, to go back and tie early Christian thought, the Roman Church, and the early Christian Church, with its concepts of demons, sin, and hell, to various art forms.

Emotionalism in the arts may reflect the fragmented, frightening, and chaotic world of the early Middle Ages. Emotionalism may also reflect the changing thrust of faith from the logical intellectualism of the classical world to the intuitive abstractions of the Christian world. Emotionalism and symbolism seem to go hand in hand throughout the early Middle Ages, but their presence in the arts is inconsistent. In some cases, emotionalism points to an inability to depict an unknowable, noncorporeal God, in contrast with the more human gods of the classical world. In other cases, symbolism is used to hide meaning from all but the intellectually initiated. For the Roman Christians, symbolism was a purely practical device, which helped them to identify other Christians and protected them from non-Christians. And emotionalism was in many cases a sign of technical inability and the nature of the times. How did the arts express any or all of these concerns?

■ In what ways was the harsh nature of God's judgment apparent in Christian thought and Christian arts?

■ What role did monasticism play in preserving and combining philosophy, tradition, and the arts?

■ How did the Christian Church provide for order and stability in the Medieval world? How was the hierarchy of religious and state organization different from that of the Eastern Empire and how did it reflect western pragmatism?

■ How did Rome establish itself as the principal seat of Christianity?

8.33 (opposite) View into the octagonal interior of the Palatine Chapel, Aachen, from the Tribune.

LITERATURE EXTRACTS

The Confessions

Saint Augustine

Augustine's *Confessions* describe his conversion, around AD 400, to the spiritual life for which he is famous as a Father of the Church. They paint an unusually vivid picture of the delights of his everyday life, thereby making his renunciation of it all the more compelling.

Book VIII

9

Why does this strange phenomenon occur? What causes it? O Lord in your mercy give me light to see, for it may be that the answer to my question lies in the secret punishment of man and in the penitence which casts a deep shadow on the sons of Adam. Why does this strange phenomenon occur? What causes it? The mind gives an order to the body and is at once obeyed, but when it gives an order to itself, it is resisted. The mind commands the hand to move and is so readily obeyed that the order can scarcely be distinguished from its execution. Yet the mind is mind and the hand is part of the body. But when the mind commands the mind to make an act of will, these two are one and the same and yet the order is not obeyed. Why does this happen? What is the cause of it? The mind orders itself to make an act of will, and it would not give this order unless it willed to do so; yet it does not carry out its own command. But it does not fully will to do this thing and therefore its orders are not fully given. It gives the order only in so far as it wills, and in so far as it does not will the order is not carried out. For the will commands that an act of will should be made, and it gives this command to itself, not to some other will. The reason, then, why the command is not obeyed is that it is not given with the full will. For if the will were full, it would not command itself to be full, since it would be so already. It is therefore no strange phenomenon partly to will to do something and partly to will not to do it. It is a disease of the mind, which does not wholly rise to the heights where it is lifted by the truth, because it is weighed down by habit. So there are two wills in us, because neither by itself is the whole will, and each possesses what the other lacks.

10

There are many abroad who talk of their own fantasies and lead men's minds astray.[1] They assert that because they have observed that there are two wills at odds with each other when we try to reach a decision, we must therefore have two minds of different natures, one good, the other evil. *Let them vanish at God's presence as the smoke vanishes.* As long as they hold these evil beliefs they are evil themselves, but even they will be good if they see the truth and

1. Italics indicate biblical quotations.

accept it, so that your apostle may say to them *Once you were all darkness; now, in the Lord you are all daylight.* These people want to be light, not in the Lord, but in themselves, because they think that the nature of the soul is the same as God. In this way their darkness becomes denser still, because in their abominable arrogance they have separated themselves still further from you, who are *the true Light which enlightens every soul born into the world.* I say to them, "Take care what you say, and blush for shame. Enter God's presence, and find there enlightenment; *here is no room for downcast looks.*"

When I was trying to reach a decision about serving the Lord my God, as I had long intended to do, it was I who willed to take this course and again it was I who willed not to take it. It was I and I alone. But I neither willed to do it nor refused to do it with my full will. So I was at odds with myself. I was throwing myself into confusion. All this happened to me although I did not want it, but it did not prove that there was some second mind in me besides my own. It only meant that my mind was being punished. *My action did not come from me, but from the sinful principle that dwells in me.* It was part of the punishment of a sin freely committed by Adam, my first father.

If there were as many different natures in us as there are conflicting wills, we should have a great many more natures than merely two. Suppose that someone is trying to decide whether to go to the theatre or to the Manichees' meeting-house. The Manichees will say, "Clearly he has two natures, the good one bringing him here to us and the bad one leading him away. Otherwise, how can you explain this dilemma of two opposing wills?" I say that the will to attend their meetings is just as bad as the will to go off to the theatre, but in their opinion it can only be a good will that leads a man to come to them. Suppose then that one of us is wavering between two conflicting wills and cannot make up his mind whether to go to the theatre or to our church. Will not the Manichees be embarrassed to know what to say? Either they must admit—which they will not do—that it is a good will which brings a man to our church, just as in their opinion it is a good will which brings their own communicants and adherents to their church; or they must presume that there are two evil natures and two evil minds in conflict in one man. If they think this, they will disprove their own theory that there is one good and one evil will in man. The only alternative is for them to be converted to the truth and to cease to deny that when a man tries to make a decision, he has one soul which is torn between conflicting wills.

So let us hear no more of their assertion, when they observe two wills in conflict in one man, that there are two opposing minds in him, one good and the other bad, and that they are in conflict because they spring from two opposing substances and two opposing principles. For you, O God of truth, prove that they are utterly wrong. You demolish their arguments and confound them completely. It may be that both the wills are bad. For instance, a man may be trying to decide whether to commit murder by

poison or by stabbing; whether he should swindle another man out of one part of his property or another, that is, if he cannot obtain both; whether he should spend his money extravagantly on pleasure or hoard it like a miser: or whether he should go to the games in the circus or to the theatre, when there is a performance at both places on the same day. In this last case there may be a third possibility, that he should go and rob another person's house, if he has the chance. There may even be a fourth choice open to him, because he may wonder whether to go and commit adultery, if the occasion arises at the same time. These possibilities may all occur at the same moment and all may seem equally desirable. The man cannot do all these things at once, and his mind is torn between four wills which cannot be reconciled—perhaps more than four, because there are a great many things that he might wish to do. But the Manichees do not claim that there are as many different substances in us as this.

It is just the same when the wills are good. If I question the Manichees whether it is good to find pleasure in reading Paul's Epistles or in the tranquil enjoyment of a Psalm or in a discussion of the Gospel, they will reply in each case that it is good. Supposing, then, that a man finds all these things equally attractive and the chance to do all of them occurs at the same time, is it not true that as long as he cannot make up his mind which of them he most wants to do his heart is torn between several different desires? All these different desires are good, yet they are in conflict with each other until he chooses a single course to which the will may apply itself as a single whole, so that it is no longer split into several different wills.

The same is true when the higher part of our nature aspires after eternal bliss while our lower self is held back by the love of temporal pleasure. It is the same soul that wills both, but it wills neither of them with the full force of the will. So it is wrenched in two and suffers great trials, because while truth teaches it to prefer one course, habit prevents it from relinquishing the other.

11

This was the nature of my sickness. I was in torment, reproaching myself more bitterly than ever as I twisted and turned in my chain. I hoped that my chain might be broken once and for all, because it was only a small thing that held me now. All the same it held me. And you, O Lord, never ceased to watch over my secret heart. In your stern mercy you lashed me with the twin scourge of fear and shame in case I should give way once more and the worn and slender remnant of my chain should not be broken but gain new strength and bind me all the faster. In my heart I kept saying "Let it be now, let it be now!," and merely by saying this I was on the point of making the resolution. I was on the point of making it, but I did not succeed. Yet I did not fall back into my old state. I stood on the brink of resolution, waiting to take fresh breath. I tried again and came a little nearer to my goal, and then a little nearer still, so that I could almost reach out and grasp it. But I did not reach it. I could not reach out to it or grasp it, because I held back from the step by which I should die to death and become alive to life. My lower

instincts, which had taken firm hold of me, were stronger than the higher, which were untried. And the closer I came to the moment which was to mark the great change in me, the more I shrank from it in horror. But it did not drive me back or turn me from my purpose: it merely left me hanging in suspense.

I was held back by mere trifles, the most paltry inanities, all my old attachments. They plucked at my garment of flesh and whispered, "Are you going to dismiss us? From this moment we shall never be with you again, for ever and ever. From this moment you will never again be allowed to do this thing or that, for evermore." What was it, my God, that they meant when they whispered "this thing or that?" Things so sordid and so shameful that I beg you in your mercy to keep the soul of your servant free from them! These voices, as I heard them, seemed less than half as loud as they had been before. They no longer barred my way, blatantly contradictory, but their mutterings seemed to reach me from behind, as though they were stealthily plucking at my back, trying to make me turn my head when I wanted to go forward. Yet, in my state of indecision, they kept me from tearing myself away, from shaking myself free of them and leaping across the barrier to the other side, where you were calling me. Habit was too strong for me when it asked, "Do you think you can live without these things?"

But by now the voice of habit was very faint. I had turned my eyes elsewhere, and while I stood trembling at the barrier, on the other side I could see the chaste beauty of Continence in all her serene, unsullied joy, as she modestly beckoned me to cross over and to hesitate no more. She stretched out loving hands to welcome and embrace me, holding up a host of good examples to my sight. With her were countless boys and girls, great numbers of the young and people of all ages, staid widows and women still virgins in old age. And in their midst was Continence herself, not barren but a fruitful mother of children, of joys born of you, O Lord, her Spouse. She smiled at me to give me courage, as though she were saying, "Can you not do what these men and these women do? Do you think they find the strength to do it in themselves and not in the Lord their God? It was the Lord their God who gave me to them. Why do you try to stand in your own strength and fail? Cast yourself upon God and have no fear. He will not shrink away and let you fall. Cast yourself upon him without fear, for he will welcome you and cure you of your ills." I was overcome with shame, because I was still listening to the futile mutterings of my lower self and I was still hanging in suspense. And again Continence seemed to say, "Close your ears to the unclean whispers of your body, so that it may be mortified. It tells you of things that delight you, but not such things as the law of the Lord your God has to tell."

In this way I wrangled with myself, in my own heart, about my own self. And all the while Alypius stayed at my side, silently awaiting the outcome of this agitation that was new in me.

12

I probed the hidden depths of my soul and wrung its pitiful secrets from it, and when I mustered them all

before the eyes of my heart, a great storm broke within me, bringing with it a great deluge of tears. I stood up and left Alypius so that I might weep and cry to my heart's content, for it occurred to me that tears were best shed in solitude. I moved away far enough to avoid being embarrassed even by his presence. He must have realized what my feelings were, for I suppose I had said something and he had known from the sound of my voice that I was ready to burst into tears. So I stood up and left him where we had been sitting, utterly bewildered. Somehow I flung myself down beneath a fig tree and gave way to the tears which now streamed from my eyes, the sacrifice that is acceptable to you. I had much to say to you, my God, not in these very words but in this strain: *Lord, will you never be content? Must we always taste your vengeance? Forget the long record of our sins.* For I felt that I was still the captive of my sins, and in my misery I kept crying "How long shall I go on saying 'tomorrow, tomorrow'? Why not now? Why not make an end of my ugly sins at this moment?"

I was asking myself these questions, weeping all the while with the most bitter sorrow in my heart, when all at once I heard the sing-song voice of a child in a nearby house. Whether it was the voice of a boy or a girl I cannot say, but again and again it repeated the refrain, "Take it and read, take it and read." At this I looked up, thinking hard whether there was any kind of game in which children used to chant words like these, but I could not remember ever hearing them before. I stemmed my flood of tears and stood up, telling myself that this could only be a divine command to open my book of Scripture and read the first passage on which my eyes should fall. For I had heard the story of Antony, and I remembered how he had happened to go into a church while the Gospel was being read and had taken it as a counsel addressed to himself when he heard the words *Go home and sell all that belongs to you. Give it to the poor, and so the treasure you have shall be in heaven; then come back and follow me.* By this divine pronouncement he had at once been converted to you.

So I hurried back to the place where Alypius was sitting, for when I stood up to move away I had put down the book containing Paul's Epistles. I seized it and opened it, and in silence I read the first passage on which my eyes fell: *Not in revelling and drunkenness, not in lust and wantonness, not in quarrels and rivalries. Rather, arm yourselves with the Lord Jesus Christ; spend no more thought on nature and nature's appetites.* I had no wish to read more and no need to do so. For in an instance, as I came to the end of the sentence, it was as though the light of confidence flooded into my heart and all the darkness of doubt was dispelled.

I marked the place with my finger or by some other sign and closed the book. My looks now were quite calm as I told Alypius what had happened to me. He too told me what he had been feeling, which of course I did not know. He asked to see what I had read. I showed it to him and he read on beyond the text which I had read. I did not know what followed, but it was this: *Find room among you for a man of over-delicate conscience.* Alypius applied this to himself and told me so. This admonition was enough to give him strength, and without suffering the distress of hesitation he made his resolution and took this good purpose to himself. And it very well suited his moral

character, which had long been far, far better than my own.

Then we went in and told my mother, who was overjoyed. And when we went on to describe how it had all happened, she was jubilant with triumph and glorified you, *who are powerful enough, and more than powerful enough, to carry out your purpose beyond all our hopes and dreams.* For she saw that you had granted her far more than she used to ask in her tearful prayers and plaintive lamentations. You converted me to yourself, so that I no longer desired a wife or placed any hope in this world but stood firmly upon the rule of faith, where you had shown me to her in a dream so many years before. And you *turned her sadness into rejoicing*, into joy far fuller than her dearest wish, far sweeter and more chaste than any she had hoped to find in children begotten of my flesh.

Beowulf

[1–193] Introductory: *history and praise of the Danes, and account of Grendel's attacks on Heorot*

How that glory remains in remembrance,
Of the Danes and their kings in days gone,
The acts and valour of princes of their blood!
 Scyld Scefing: how often he thrust from their
 feast-halls
The troops of his enemies, tribe after tribe,
Terrifying their warriors: he who had been found
Long since as a waif and awaited his desert
While he grew up and throve in honour among men
Till all the nations neighbouring about him
Sent as his subjects over the whale-fields 10
Their gifts of tribute: king worth the name!
Then there was born a son to succeed him,
A boy for that house, given by God
As a comfort to the folk for all the wretchedness
He saw they had lived in, from year to year
Lacking an overlord; and the overlord of Life,
Of Glory, gave the man worldly excelling,
Till his fame spread far, the fame of Beowulf
The son of Scyld, on Scandinavian soil.
So should magnanimity be the young man's care, 20
Rich gifts and royal in his father's household,
That when he is old his ready companions
Will remain with him still, his people stand by him
When war returns; a man shall flourish
By acts of merit in every land.
 Then Scyld departed in the ripeness of time,
Old in deeds, to the Lord's keeping.
They carried him down to the restless sea,
His beloved retainers, as he himself had asked
While words served him, the lord of the Scyldings 30
And their dear king who had ruled them long.
There at the harbour stood the ring-prowed boat,
The prince's vessel, ice-cased, sea-keen;
Deep in the ship they laid him down,
Their beloved lord, the giver of rings,

The hero by the mast. Great treasures there,
Far-gathered trappings were taken and set:
No ship in fame more fittingly furnished
With weapons of war and battle-armour,
With mail-coat and sword; there lay to his hand 40
Precious things innumerable that would go at his side
Voyaging to the distant holds of the flood.
By no means poorer were their rich offerings,
The treasures they gave him, than those given
By the men who cast him at his life's beginning
A child out over the waves alone.
Lastly they put up high above his head
A gold-woven banner, and let the sea bear him,
Gave him to the main; their hearts grieved,
Mourning was in their minds. And whose were the
 shores— 50
Who can say with truth, whether counsellor in hall
Or warrior on earth—where this freight was washed?
 That country then saw Beowulf of the Scyldings
Renowned among the peoples, a beloved king
Ruling many years—his father and lord
Having gone from the world—until there was born to him
Noble Healfdene; war-grim, aged,
Lifelong guardian of the illustrous Scyldings.
By him four children reckoned in all
Were born into this world, princes of men, 60
Heorogar and Hrothgar and the good Halga
And she [.], who was Onela's queen,
The dear consort of the warlike Swede.
To Hrothgar in time came triumph in battle,
The glory of the sword, and his friendly kinsmen
Flocked to serve him till the band of them was great,
A host of eager retainers. And his mind
Stirred him to command a hall to be built,
A huger mead-house to be made and raised
Than any ever known to the children of men, 70
Where he under its roof to young and old
Would distribute such gifts as God gave him,
Everything but the lands and lives of his people.
Not few, we are told, were the tribes who then
Were summoned to the work far throughout this world,
To adorn that dwelling-place. And so in due time,
Quickly as men laboured, it was all prepared,
Most massive of halls; and he called it Heorot
Whose word was authority far and wide.
And his promise he performed, he presented rings, 80
Treasure at banqueting. The hall towered up
Clifflike, broad-gabled: (it awaited flame-battling,
Fire's hostility; and not far off
Lay that sword-hatred ready to be roused
In the deadly feud of father and son-in-law).
 But the outcast spirit haunting darkness
Began to suffer bitter sorrow
When day after day he heard the happiness
Of the hall resounding: the harp ringing,
Sweet minstrelsinging—as the tongue skilled 90
In the distant conception and creation of men
Sang how the Almighty made the earth-fields
Brilliant in beauty, bound by the sea,
Set exulting sun and moon
As lamps for the light of living men,

And loaded the acres of the world with jewelwork
Of branch and leaf, bringing them to life
Each kind of creature that moves and breathes.
—So those retainers lived on in joy
Happy all, till this one spirit, 100
Hell in his mind, his malice began.
Grendel the fiend's name: grim, infamous,
Wasteland-stalker, master of the moors
And the fen-fortress; the world of demonkind
Was for long the home of the unhappy creature
After his Creator had cast him out
With the kin of Cain, the everlasting Lord
Destining for the death of Abel killed;
A joyless feud, for he banished him far,
His Maker for his crime, far from mankind. 110
Progenitor he was of the miscreations,
Kobolds and gogmagogs, lemurs and zombies
And the brood of titans that battled with God
Ages long; for which he rewarded them.
 He went then to visit at the fall of night
That lofty hall, to see how the Danes
Fared as they lay at the end of their carousing.
Within it he found the band of warriors
Sleeping after the feast; they were far from sorrow
And the misery of men. The creature was like pestilence 120
Raging and ravenous, quick at his task,
Savage and unsparing, seizing thirty
Soldiers from their beds; then off again
Glutlusty with booty making for his home,
Seeking his dwelling laden with the slain.
When the dawn broke and day began
And Grendel's battle-strength filled men's eyes,
Then weeping arose where feasting had been,
Loud morning crying. The illustrious king,
The man old in worth sat unrejoicing, 130
Bearing, enduring grief, strong
Sorrow for his soldiers, when they saw the footprint
Of the hated, of the accursed spirit; that strife
Was too strong, too long, and too malignant!
And after no longer than a single night
He went further in murder and mourned none for it,
In hatred, in violence—in these ways too set.
Then it wasn't rare for a man elsewhere
At a greater distance to look for his rest,
For a bed in the outbuildings, when once he knew, 140
Truly told by a sure token,
The hall-haunter's hate; to escape the fiend
Was to keep himself thereafter farther off and safer.
So he held sway and struggled against the right,
Solitary against all, till empty and unvisited
Stood the best of halls. Long was the time,
Twelve years passing, that the lord of the Scyldings
Spent to learn pain, each grief there was,
Each bursting sorrow; and so it became known,
Became open to men, grievously recounted 150
To the children of men, how Grendel fought
That time with Hrothgar, waging his enmity,
His sin-forced feud for many seasons,
His seasonless strife; what peace would he have
With any man of the host of Denmark?
His deadliness was unshakeable: no settling with money:

Nor did any counsellor have cause to expect
Glorious reparation from the killer's hands;
But that was a monster remorseless to persecute,
Dark with death's shadow, both veteran and untried; 160
He lay hid and plotted, he held the moors,
Mist, endless night; and what man's knowledge
Can map the gliding-ground of demon and damned?
 So mankind's enemy, the terrible solitary
Went on accomplishing outrage on outrage,
Heavy humiliations. Heorot was his house,
That treasure-strewn hall through the hours of blackness.
(—No coming openly to the throne or its gifts
Or feeling its favour, forbidden by God.)
It was sharp distress to the lord of the Scyldings, 170
Heartbreak it was; often his chief men
Gathered in council to debate the means
That might seem best to the brave in mind
For combating the panic terror of the raids.
At times in their temples they made pagans' vows,
Sacrifices to their idols, in their speeches beseeching
The destroyer of souls to help the people
In their common affliction. Such was their custom,
The hope of the heathen; it was hell that came
Called back to their minds, of the Creator they knew
 nothing, 180
The Judge of all acts, the Lord God was strange to them,
And indeed they were ignorant of the praise of heaven's
 King,
The Ruler of Glory. O unhappy man
Who will thrust his soul through terrible perversity
Into Fire's embrace, eschewing solace
All unregenerate! O happy the man
To be drawn to the Lord when his death-day falls,
In his Father's embrace to implore his peace!
—So the son of Healfdene's heart was surging
With the cares of that time, nor could the wise man 190
Turn aside his trouble; the strife too severe,
Too long, too malignant, that settled on that people,
Fierce-forcing persecution, night-frightfulness unequalled.

[194–1250] *Beowulf and Grendel*

This Grendel feud became known at home
To Hygelac's warrior, brave among the Geats:
Who at that hour of this earthly life
Was master of manhood of all mankind,
Great-framed, great heart. He had himself prepared
A sound sea-vessel, and said he would visit
The strong king beyond the swan's-way, 200
The illustrious prince desperate for men.
From that expedition he was little dissuaded
By friends and advisers, though to them he was dear;
They urged the hero on, they augured him well.
The good man had picked out from the people of the
 Geats
Soldiers who were the eagerest among those he could
 find,
And with a band of fourteen men collected
He made for the boat, the warrior led the way,
The sea-skilled man to the fringe of the beach.
Not long after was the vessel on the waves, 210
The boat beneath the cliff. The men, alert,

Leapt onto the prow; surf was swirling,
Sand was stirring; soldiers took up
Into the ship-hold glittering trappings,
Splendid battle-arms; and the men cast off,
Eager voyagers, in their tight-timbered boat.
Off over the choppy sea, wind-whipped,
The foam-throated thing went bobbing like a bird,
Till after a space on the second day
The winding prow of the ship had advanced 220
To where the seafarers had glimpse of land,
Could see cliffs gleaming, sheer fall of bluffs,
Ample promontories: they had crossed the sea,
Their voyage was ended. They quickly then
Climbed onto the shore, the men of the Weders,
And moored the ship; mail-coats clashed,
Trappings of battle. They gave thanks to God
For the grace he had shown in their safe seagoing.
 But the Scyldings' coastguard gazing from his rock,
He whose duty was to watch the sea-cliffs, 230
Saw shining shields borne across the gangplank,
Saw bared battle-gear; and his thoughts were pricked
With desire to discover the strangers' business.
So he came to the shore, mounted on horseback,
Hrothgar's man, brandishing with force
A formidable spear, and uttered these words:
"What men would you be, here in your armour,
Mail-coat-protected, in that tall ship
Brought through the paths and acres of ocean
Here, to our land? Long have I been 240
A watcher on these coasts, my vigil the sea,
Lest any enemy with warship-convoy
Should come to plunder the country of the Danes.
Never more openly have shield-armed men
Made harbour here, yet where is your permission,
Pass of any kind from our commanders,
Consent from the court? I never looked on
A finer man living than one of you seems,
He there in his armour: no mere retainer
Tricked out with weapons, unless looks belie him, 250
Looks without equal. Now I must know
Who you are, and from where, in case from this point
You push forward into Denmark and are taken as spies
As you move on inland. So now far-sailers
From homes sea-hidden, bend your attentiveness
To my plain request: promptly to tell me
Where you have come from, in courtesy is best."
 The leader it was who gave him reply,
The commander of the company, from his word-treasury:
"We are men belonging to the nation of the Geats, 260
We are hearth-companions of Hygelac.
Well-known was my father among the peoples,
A princely battle-chief, Ecgtheow his name;
Many many years he lived before he left us,
Went old from our courts; him every counsellor
Happily remembers far and wide.
With friendly purpose we have come to seek
Your own overlord, the son of Healfdene,
Protector of his people; give us fair forwarding!
To that renowned man, ruler of the Danes, 270
We have a great mission; and this not, I may say,
Secret in any way. You know (if indeed

Things have run as rumour has reached us)
How among the Scyldings a certain persecutor,
A mysterious destroying-force in the deep of night,
Unveils to dread a malignity unfathomable,
Murderousness, humiliation. I might in magnanimity
Give Hrothgar advising for the remedy of that,
How he, old and trusted, could overcome this fiend
(If ever again he is to find a reversal, 280
A cure for the care of slaughter and evil),
And affliction's flames become assuaged—
Or else he may suffer ever after
Distress and oppression as long as there stands
On that thronelike site his hall of halls."
 The officer spoke, seated on his horse,
The guard unfearing: "Keen shield-fighter
Of any circumspection must know how to judge
And distinguish the worth of both words and deeds.
You are, as I have heard, a troop loyal 290
To the lord of the Danes; go forward now
With your arms and armour, and I shall be your guide.
Also I shall have my men hold fast
In safe keeping against any enemy
Your buoyant boat, your ship on the sand
Fresh from its tarring, till it carries again
Its beloved man through the winding tides,
The winding prow to the land of the Weders,
With such of the generous and brave as it is given
To survive in safety the storm of battle." 300
 Then they set off: the boat lay at rest,
The broadbreasted ship rode on its mooring,
Its anchor was fixed. Each helmet sparkled
With its glancing boar-emblems: brilliant with gold,
Patterned and fire-tempered, it guarded the life
Of its brave battle-wearer. The men hastened,
They marched together until they could see
A timbered building resplendent with gold:
The most illustrious hell under heaven
For men to move in, and home of a king: 310
Like a lantern illuminating many lands.
Here the soldier showed them the dazzling
Hall of the heroes, pointed the approach
Their steps were to take; and with this the warrior
Wheeled round his horse, and sent back speech:
"Now I must leave you; may the omnipotent
Father hold you in the favour of his keeping,
Your ventures be blessed! I shall be at the shore
To hold watch and ward for war-bent host."
The street was paved with stone, the men 320
Followed on together. War-chains shone,
Strong-linked, hand-locked, glittering ring-mail
Gave iron song-of-arms as they first approached
Marching on to the hall terrible in their battle-trappings.
Their broad shields they laid, the weary seafarers,
Hardest of bucklers at the wall of the building,
And sat at the bench.—The armour rang,
The war-gear of those men; the spears were stacked
Standing all together, weapons of the voyagers,
Ash-cut, grey-tipped; appointed for all fighting 330
That mail-clad band! A nobleman there
Inquired of the warriors their house and kindred:
"Where is it you come from with your gold-laden shields,

Your grey mail-coats and your masked helmets,
Your store of spears? I am Hrothgar's
Personal messenger. Never did I see
Strangers of your number finer than you seem.
The love of arms, I should say, not exile,
Mind's magnanimity brought you to Hrothgar?"
Duly he answered him then dauntless, 340
Hero of the Weders, spoke up in answer
Strong in his armour: "We are Hygelac's
Table-companions; my name, Beowulf.
Let me declare to the son of Healfdene,
To the illustrious prince what my mission is,
Tell it to your king, if he will permit us
To stand before him worthiest of men."
Wulfgar spoke, a man of the Wendels,
Well-known to many in mind and character
For wisdom and valour: "That I shall ask 350
The lord of the Danes, protector of the Scyldings,
Giver of rings, as you make petition,
Ask the great prince concerning your visit,
And quickly report to you what reply
The king in his goodness thinks fit to give me."
He turned then at once to where Hrothgar sat
Aged and grey in the midst of his retinue;
The warrior went and stood facing
The ruler of the Danes in rite of decorum;
Wulfgar spoke to his protector and lord: 360
"Here have arrived, come from far off
Over miles of the sea-flood people of the Geats;
Beowulf is the name these soldiers give
To the man who leads them. They come to ask
That they might, my lord, exchange at this time
Speech with yourself; you should not refuse them
A reply in this, gracious Hrothgar—
For they seem in their armour to be very candidates
For the esteem of kings, and certainly their commander
Who led the men here commands by right!" 370
Hrothgar spoke, defender of the Scyldings:
"Him I knew when he was but a boy;
His father was old, Ecgtheow he was called,
And Hrethel of the Geats gave him in marriage
His only daughter; his son now has come
Here in his strength to a tested friend.
What did seafarers, taking gifts to the Geats
For their pleasure yonder, say of the man—
That he holds in the grip of his hands the strength
Of thirty others, a hero blazoned 380
In valour's report? It is in the favour
Of holy God that he comes to visit us,
Comes to the Danes, comes (as I believe)
For the horror of Grendel. To him in his excellence,
For his fiery purpose, I shall tender treasures.
Now no delay, but invite him in
To the company of my retinue gathered together;
And tell him also that his men are welcome
To this Danish folk." [Wulfgar went then
To the door of the hall] and called from within: 390
"My master, the victorious king of the Danes,
Has ordered me to tell you that he knows your kinsmen,
And that you who have come in your determination
Here over the sea-swell are welcome to him.

Now you may go in your battle-trappings,
War-mask-helmeted, to see Hrothgar.
Let these fighting-spears of yours stay here,
Death-wood, death-shafts, till you have spoken together."
 Then the ruler rose surrounded by his soldiers,
Thick-thronging retinue; some remained there 400
To guard the battle-gear as the brave man required
 them.
They hastened in a group, the warrior leading,
Under Heorot's roof; the hero went in,
Helmeted, grave, till he stood at the hearth;
Beowulf spoke (his war-net shone on him,
Magically chained by skills of smithcraft):
"Your life and health, Hrothgar! I am Hygelac's
Kinsman and retainer; many a hard venture
Has my youth endeavoured. Word about Grendel
Came to me clearly on my native soil: 410
Sea-travellers tell that this hall stands
(Building of buildings for every warrior)
Void and unused when the light of evening
Has been hidden under the hood of heaven.
And then my people, the best of men,
Deliberating well, began to advise me,
My lord Hrothgar, to seek you out,
For they were aware of the force of my strength:
Themselves looked on as I came from battle,
Bloodied from my enemies, where I took five captive, 420
Ravaged giantkind, and on the waves by night
Slaughtered the krakens, suffered sharp stress,
Crushed them in their fierceness, avenged Geats' grief—
They courted their hurts!—; and now I am here
For this fiend, for Grendel, to settle with these hands
The demon's account. Prince of the Danes,
I have now therefore to make you this request,
This single petition, protector of the Scyldings,
Not to forbid me, defender of fightingmen,
Folk-friend endeared, far as I have come, 430
To try with these hands and my company of men,
This unswerving troop, to sweep Heorot clean.
I have found out also that this is a monster
Recklessly bold in refusal of weapons:
So let me despise—and then may Hygelac
Have me his liege in his thoughts with pleasure—
The military assumptions, yellow shields, sword,
Broad-rimmed buckler, and let me rather
Grapple with the fiend in mortal wrestlehold,
Hated against hateful; with submission in him 440
To the will of God who is taken by death.
I am sure that he if he has the power
Will feast unfearing in the warriors' hall
On the Geatish folk as he often has done
On the host of the Danes. Never will you need
Turf for this head, if death takes me,
For I shall be with him crimson-sullied:
He carries off his blood-plunder, its taste is in his mind,
The outcast feeds far from sorrowfully,
Threads the waste dales; you will never be burdened 450
With an hour's anxiety for my body's keeping.
Send off to Hygelac, if battle takes me,
That best of war-coats and my breast's defence,
Most excellent of armour; it is Hrethel's heirloom

And work of Wayland. Fate must be fate!"
 Hrothgar spoke, protector of the Scyldings:
"In the memory of deeds done, in the service of honour
You have come to visit us, Beowulf my friend.
Your father instigated the greatest of feuds;
Heatholaf he killed with his own hands 460
Among the Wylfings; and then the Weder-folk
Didn't dare hold him for fear of invasion.
From there he went to the people of the Danes,
Over the wave-swell to Scylding soil.
I had just succeeded to the Danish throne,
Holding in my youth this far-spread kingdom
With its walled magnificence and its living souls;
Heoragar was dead, dead my brother,
Child of Healfdene, my elder—and my better.
Afterwards I settled that feud with reparations, 470
I sent the Wylfings across the sea-crest
Old precious gifts; and he swore me his oaths.
Misery it is for my mind to be telling
Any living man what Grendel has done
To humiliate me in Heorot by devices of his hate,
What terror-raids made; my hall-warrior-band,
My battle-troop is thinned: doom-swept away
To Grendel and horror. How easily God
Might cut off the blind destroyer from his acts!
Warror after warrior, in the flush of drinking, 480
Has been loud with his boasts above the ale-cup
To be in the beer-hall lying in wait
With daunting blade for Grendel's assault.
—But see this mead-house when morning came,
The rich hall blood-red in the light of day,
The entire bench-space drenched with crimson,
The palace with battle-blood; and my friends the fewer,
My beloved chivalry, for death's theft there.
—Sit now at the banquet, and unbind your thought
To the people of the Danes as your mind may urge you." 490
 Then for the Geats who were gathered together
A bench was cleared within the beer-hall,
Where the warriors went to take their seats
In the joy of the pride of life. An attendant
Was serving, took round the sumptuous ale-flagon,
Poured gleaming mead. Heorot would ring then
To the clear-voiced minstrel. There men had joy,
Danes' joy and Weders' joy, in no puny retinue.
 Unferth spoke, the son of Ecglaf,
Sitting at the feet of the Scylding king, 500
Let out some malice—the coming of Beowulf,
Seafarer and hero, having powerfully riled him
For his own unwillingness to have another man,
Any under the sun, ever attain
More glory on earth than he himself—:
"Are you that Beowulf who challenged Breca
In a proof of swimming-strength on the great sea
When the two of you out of vainglory made trial of the
 waters
And for a foolish vow ventured your lives
On the skin of the abyss? The man was lacking, 510
Either friend or enemy, who could turn you back
From the hazardous undertaking as you swam from the
 shore.
There with your arms you embraced the tide,

Traced out the surging miles and with flailing
Palms thrust flashing through the waves; the swell
Was bridling up with its wintry seethings.
Seven nights' labouring on in the brinehold,
And he outswam you, he had the mastery.
The dawn-flood threw him on a Norway beach.
Dear to his folk, he left there to seek 520
His native soil, the land of the Brondings,
The pleasant fortress where he ruled his people,
The city and the ring-riches. Indeed all his boast
The son of Beanstan had made good against you.
Therefore I expect, in spite of your ardency
In battle-shocks everywhere, in the bitter war-day,
Your fate will be worse if you dare to keep
Your all-night vigil in Grendel's path."
 Beowulf spoke, Ecgtheow's son:
"Now Unferth my friend, you have given us a boxful 530
Of words about Breca, but surely it is the beer in you
Which has voiced his exploit? The truth is this:
It was I who had greater strength in the sea,
Peril in its surges, than any man beside.
It was something the two of us said as boys,
Boasting together—we were then both
Still in our teens—how we should venture
Our lives upon the ocean; and this we did.
We had naked swords, iron to our hands,
When we swam out to sea; we looked to defend
 ourselves 540
Against whale and killer. Not an inch of distance
Could he swim from me in the choppy waterway,
Swifter over the main; never would I leave him.
And so we two were on the sea together
The space of five nights, when a current split us,
A churning of the waters, in the chillest of weathers,
Blackness louring and north wind bending
Hostile against us; the waves were a chaos.
The temper of the sea-fish was stirred and irritated;
My chain-mail then, strong-linked, hand-locked, 550
Furnished me protection in the face of these enemies,
My ring-woven war-dress clung to my breast
Gold from the forge. A raging attacker
Dragged me to the bottom, savage, had me
Fast in his grasp; yet it was given me
To reach and to pierce the monstrous thing
With the point of my battle-sword; storm of conflict
Took the strong beast of the sea by this hand.
So time and again malicious tormentors
Heavily harassed me; and them I served 560
With this good sword, in the law of arms.
By no means did they, agents of hatred,
Enjoy that feasting where I should be fed on,
Sat round as a banquet at the bottom of the sea,
But when morning came they were washed and
 grounded,
Mauled by the sword, on the sands of the shore,
Sword-blade-silenced so that never again
Did they hinder seafarers making their voyage
On the deep acres. Light left the east,
God's bright beacon, and the floods subsided, 570
Until I could gaze on headlands, cliffs
Open to the winds. Fate often saves

The undoomed fightingman when his courage stands!
 —Be that as it may, my sword succeeded
Against nine krakens. Never have I heard of
A harder fight under night and heaven
Or in streaming ocean a more desperate man;
Yet I kept my life from the haters' hold
In the weariness of my going. And so the sea
Drove me, the flood-tide, the milling waters 580
To the land of the Finns. Never did I hear
That you were in any such mortal encounters,
Such sword-blade-terrors. Breca never yet,
Nor you yourself either, in the play of war-weapons
With glancing sword fought out an exploit
So boldly (not that I pause to boast of it)—
Though you did slay your own brothers,
Your own close kinsmen, for which in hell
You shall endure damning, for all your intelligence.
It's the truth I tell you, son of Ecglaf, 590
That Grendel would never have laid such a train
Of terrors for your prince, the fiend-of-frightfulness
Such shame on Heorot, had your own mind been,
Your own heart as war-keen as you yourself claim;
But he has discovered he need not greatly
Fear the hostility, the deadly sword-fury
Of your people here, the Scylding men;
His toll he extorts, not one he spares
Of the Danish folk, but wars on them at will,
Killing, drowning, deeming the Danes 600
Incapable of opposing. But I soon now
Will show him in conflict what the Geats possess
Of strength and courage. Again let any
Go carefree to the mead when the morning-light,
The flame-mailed sun shines from the south,
Tomorrow's day on the children of men!"
 That was happiness to the giver of treasure,
Grey-haired, war-famed; the lord of the Danes
Saw help approaching; the protector of his people
Discovered in Beowulf steadfast intent. 610
There rose the laughter of men, the rejoicing
Resounded loudly, and speech was sweet.
Wealhtheow, Hrothgar's queen, came forward
Careful of the courtesies, gold-brilliant, welcomed
The men in the hall; and the royal hostess
First gave the cup to the guardian of the Danes,
Wished him, dear to his people, gladness
At the beer-banquet; and he took in happiness,
King of victories, hall-cup and feast.
The woman of the Helmings then went round 620
The whole of the retinue, old and young,
Proffering princely cups, till at last
She brought the mead-beaker, she the queen
Ring-bright and distinguished of mind, to Beowulf;
She addressed the Geat, gave thanks to God
In words of wisdom for granting her wish
That she might put trust in some hero's help
Against the disasters. He took the cup,
The war-hardened fighter from Wealhtheow's hands,
And then he declared, in the vision of battle— 630
Beowulf spoke, Ecgtheow's son—:
"I had this in mind at the time I embarked,
Entered the ship with my company of men,

That I should assuredly accomplish the yearning
Of all your people, or else be destroyed
In a fiend's stranglehold. Bravery of chivalry
I shall follow to victory, or else in this mead-hall
Suffer the close of my living days."
The woman was greatly pleased with those words,
With the Geat's war-vow; the folk-queen went 640
Gold-shining, cynosure, to sit by her lord.
 Then there were again in the hall as before
The talk of heroes and the happiness of men,
The hum of an illustrious concourse, till presently
The son of Healfdene was minded to rest,
To retire to his bed; he knew that the truce
In that monster's war on the great hall lasted
From the time when their eyes first saw the sunlight
Till louring night and the forms of the gloomy
Vaults came gliding over man and world 650
Black beneath the clouds. The whole assembly
Rose up. And he turned then to the other,
Hrothgar to Beowulf, wished him good fortune,
Entrusted him with the wine-hall, and spoke these words:
"Never have I committed to any man before,
Since I could wield my hand and shield,
The Danish stronghold, till here now to you.
Keep now and guard the best of homes
In the memory of honour, blaze valour's power,
For the fierce be sleepless! Nothing you may desire 660
Will be lacking if you live through your desperate
 purpose."
 Then Hrothgar went with his troop of retainers,
The protector of the Scyldings, out of the hall;
The war-leader was ready to be with Wealhtheow
His consort and queen. For the King of Kings
Had appointed a hall-guard, as men now knew,
To watch against Grendel: in a special serving
Of the Danish king was his vigil for the giant;
But still the Geat had steadfast trust
In his spirit and strength and in the grace of God. 670
He took off then his war-coat of iron,
His helmet from his head; gave his chased sword,
The choicest of blades, to a hall-attendant,
And told him to hold and guard the battle-gear.
Then the good warrior uttered vaunt and vow,
Beowulf of the Geats, before he went to rest:
"I do not count myself of feebler striking-force
In the works of war than what Grendel boasts;
Therefore not with a sword shall I silence him,
Deprive him of his life, though it lies in my power; 680
Of good arms he knows nothing, of fighting face to face,
Of the shattering of shields, though he stands renowned
For works of violence; but we two shall scorn
The sword tonight, if he dares to join
Weaponless battle, and then let God,
Let the holy Lord decree the glory,
To whichever side may please his wisdom."
The man lay down then, the pillow embraced
The hero's face, and many about him,
Eager sea-venturers, bent to their hall-beds. 690
Not one of them thought he would ever again
Leave there to find his beloved land,
His folk or his fortress, where he once was bred;

For they knew how sudden death had already
Swept from the wine-hall more than too many
Of those Danish men. But the Lord wove them
Fortunate war-fates, solace and support
He gave the Weder-folk, so that they all
Destroyed their enemy through the strength of one,
By his powers alone.—The truth is shown, 700
The great hand of God time out of mind
Moving mankind.
 Gliding at midnight
Came the gloomy roamer. The soldiers were sleeping—
Those who were guarding the gabled building—
All except one. Men well knew
That that malefactor in the forbidding of the Creator
Was powerless to draw them down beneath the shades;
But he, wideawake with heart-pent fury
And anger for the ravager, awaited fight's fortune.
Now by the swirling bluffs from his wasteland 710
Grendel came stalking; he brought God's wrath.
His sin and violence thought to ensnare
One of our kind in that hall of halls.
He moved through the night till with perfect clearness
He could see the banquet-building, treasure-home of
 men
Gold-panelled and glittering. Not his first visit
Was this for attacking the house of Hrothgar;
In no day of his life before or after
Did he find hall-men or a hero more dangerous!
Up then to the building the man came prowling 720
Devoid of all delighting. The door, firm-iron-bound,
Flew at once ajar when he breached it with his fists;
The hall's mouth he tore wide open, enraged
And possessed by his evil. Quickly after this
The fiend stepped over the stone-patterned floor,
Moved with fury; there started from his eyes
Unlovely light in the very form of fire.
Many a soldier he saw in the hall,
The company of kinsmen all asleep together,
The young warrior-band; and his heart exulted, 730
He aimed to divide, before day came,
Monstrous in frightfulness, life from limb
In every man of them, now that he had hope
Of ravening to gluttonousness. But the fate was finished
That could keep him after that night carnivorous
On human kind. The kinsman of Hygelac
Watched in his strength to see how the killer
Would go about his work with those panic hand-grips.
Nor did the monster mean to be backward,
But flashed to seize at the first opportunity 740
A soldier from his sleep, tore him unopposed,
Gnashed flesh from bone, at veins drank blood,
Gulped down the feast of his wounds; in a trice
He had the last of the dead man devoured,
To the feet and the fingers. He stepped farther in,
Caught then with his hand the iron-purposed
Warrior in his bed, the fiend with his fist
Reached out to seize him; he quickly gripped
The spite-filled creature, and rose upon his arm.
As soon as evil's dalesman discovered 750
That never had he known a stronger hand-grasp
In any other man beneath the sun

Throughout earth's acres, his mind began
To fear for his flesh; by that he escaped
None the more readily! He strained to be off,
To strike den and dark, join the devil-covens;
His fate in that place was without a fellow
Among his days before. Then the good warrior,
The kinsman of Hygelac recalled what he had said
That evening, stood up, and grappled him close; 760
Joints cracked aloud; the giant moved off,
The man strode after him. The byword for malice
Was minded, if he could, to slip into the distance
To the shelter of the fens—saw his fingers' force
In the fierce man's fist holds. A bitter coming
The persecutor had of it when he made for Heorot!
The royal hall rang; to all the Danes,
To all the fortress-men, the brave, the warriors
Came panic horror. Both hosts-of-the-hall
Were in rage, in ferocity. The building reverberated. 770
It was more than a marvel that that wine-house
Stood up to the battle-darers, that the splendid walls
Didn't fall to the ground; but it had the solidity,
It was cleverly compacted both inside and out
With its bands of iron. Many were the mead-benches
Sumptuous with gold that were wrenched there from the
 floor,
Beside the antagonists in their epic fury.
—A thing undreamed of by Scylding wisdom
That any man could ever, in any manner,
Shatter as it stood stately and horn-spanned, 780
By sleights disrupt it: till fire's embrace
Should become its furnace. A sound mounted up
Uncouth, unceasing: terror unparalleled
Fell upon the Danes, upon every soul of them
Who listened by the ramparts to the noise of crying,
To the God-hated howling a lay of horror,
Song of lost triumph, the hell-fettered man
In lament for pain. He held him fast
Who at that hour of this earthly life
Was master of manhood of all mankind. 790

 Nothing would make the protector of warriors
Let slaughter's emissary escape alive,
Nor would he reckon many days left to him
Of profit to any man. Then Beowulf's soldiers
Brandished here and there their ancient swords,
Anxious to defend the body of their lord,
Of the illustrious prince, as they might be able—
Ignorant of this, when they moved to fight,
Iron-minded men of arms,
Thinking to strike on every side, 800
To pierce to his spirit: that the lawless ravager
Was not to be reached by any war-blade,
Not by the choicest metal on earth,
For every sword-edge and weapon of victory
He had blunted by wizardry.—Wretched his future
Now at that hour of this earthly life
Cut off from breath: far had the uncanny
Soul to wander into fiends' dominions.
For then he discovered, who often before
Had in his transgressions tormented the mind 810
Of human kind, he God's antagonist,
That his own body would not obey him,

But the kinsman of Hygelac in undaunted encounter
Had him in his grasp; each was to the other
Abhorrent if alive. The appalling demon
Bore flesh-agony; on his shoulder became manifest
A monstrous wound, sinews quivering,
Tendons ripped open. To Beowulf was granted
Triumph in that fight; but to Grendel the flight
In distress to death by the looming marshlands, 820
To his joyless home; he had no more doubt
That the end of his life had arrived in sight,
The lease-date of his light. All the Danes' desire
Was met and fulfilled by bloodshed of that fight.
For he who before had come from afar
In wisdom and singlemindedness had purged Hrothgar's
 hall,
Saved it from persecution. The night's work pleased him,
His deeds had proved him. The man of the Geats
Had carried out his boast in the sight of the Danes,
Just as he had redeemed the sum of that misery, 830
That sorrow in hostility they suffered in the past
And had to suffer, under stress of compulsion,
No small affliction. It was in clear tokening
Of this that the warrior laid down the hand,
The arm and the shoulder—the visible whole
Claw-hold of Grendel—beneath the soaring roof.

The Song of Roland

[c.AD 1130–40] Turold

The poem is based on the attempt by Charlemagne, in
778, to capture Saragossa in Spain, but it is
fictionalized. The hero, Roland, dies in battle, but his
perfect knightly behavior makes him a legend even in
defeat.

1

Charles The King, our Emperor, the Great,
has been in Spain for seven full years,
has conquered the high land down to the sea.
There is no castle that stands against him now,
no wall, no citadel left to break down—
except Saragossa, high on a mountain.
King Marsilion holds it, who does not love God,
who serves Mahumet and prays to Apollin.
He cannot save himself: his ruin will find him there. AOI.[1]

2

King Marsilion was in Saragossa. 10
He has gone forth into a grove, beneath its shade,
and he lies down on a block of blue marble,
twenty thousand men, and more, all around him.
He calls aloud to his dukes and his counts:
"Listen, my lords, to the troubles we have.

1. These three mysterious letters appear at certain moments
throughout the text, 180 times in all. No one has ever adequately
explained them, though every reader feels their effect.

333

The Emperor Charles of the sweet land of France
has come into this country to destroy us.
I have no army able to give him battle,
I do not have the force to break his force.
Now act like my wise men: give me counsel, 20
save me, save me from death, save me from shame!"
No pagan there has one word to say to him
except Blancandrin, of the castle of Valfunde.

3

One of the wisest pagans was Blancandrin,
brave and loyal, a great mounted warrior,
a useful man, the man to aid his lord;
said to the King: "Do not give way to panic.
Do this: send Charles, that wild, terrible man,
tokens of loyal service and great friendship:
you will give him bears and lions and dogs, 30
seven hundred camels, a thousand molted hawks,
four hundred mules weighed down with gold and silver,
and fifty carts, to cart it all away:
he'll have good wages for his men who fight for pay.
Say he's made war long enough in this land:
let him go home, to France, to Aix,² at last
come Michaelmas³ you will follow him there,
say you will take their faith, become a Christian,
and be his man with honor, with all you have.
If he wants hostages, why, you'll send them, 40
ten, or twenty, to give him security.
Let us send him the sons our wives have borne.
I'll send my son with all the others named to die.
It is better that they should lose their heads
than that we, Lord, should lose our dignity
and our honors—and be turned into beggars!" AOI.

4

Said Blancandrin: "By this right hand of mine
and by this beard that flutters on my chest,
you will soon see the French army disband,
the Franks will go to their own land, to France. 50
When each of them is in his dearest home,
King Charles will be in Aix, in his chapel.
At Michaelmas he will hold a great feast—
that day will come, and then our time runs out,
he'll hear no news, he'll get no word from us.
This King is wild, the heart in him is cruel:
he'll take the heads of the hostages we gave.
It is better, Lord, that they lose their heads
than that we lose our bright, our beautiful Spain—
and nothing more for us but misery and pain!" 60
The pagans say: "It may be as he says."

5

King Marsilion brought his council to an end,
then he summoned Clarin of Balaguét,
Estramarin and Eudropin, his peer,
and Priamun, Guarlan, that bearded one,
And Machiner and his uncle Maheu,

and Joüner, Malbien from over-sea,
and Blancandrin, to tell what was proposed.
From the worst of criminals he called these ten.
"Barons, my lords, you're to go to Charlemagne; 70
he's at the siege of Cordres, the citadel.
Olive branches are to be in our hands—
that signifies peace and humility.
If you've the skill to get me an agreement,
I will give you a mass of gold and silver
and lands and fiefs, as much as you could want."
Say the pagans: "We'll benefit from this!" AOI.

6

Marsilion brought his council to an end,
said to his men: "Lords, you will go on now,
and remember: olive branches in your hands; 80
and in my name tell Charlemagne the King
for his god's sake to have pity on me—
he will not see a month from this day pass
before I come with a thousand faithful;
say I will take that Christian religion
and be his man in love and loyalty.
If he wants hostages, why, he'll have them."
Said Blancandrin: "Now you will get good terms." AOI.

7

King Marsilion had ten white mules led out,
sent to him once by the King of Suatilie, 90
with golden bits and saddles wrought with silver.
The men are mounted, the men who brought the
 message,
and in their hands they carry olive branches.
They came to Charles, who has France in his keeping.
He cannot prevent it: they will fool him. AOI.

8

The Emperor is secure and jubilant:
he has taken Cordres, broken the walls,
knocked down the towers with his catapults.
And what tremendous spoils his knights have won—
gold and silver, precious arms, equipment. 100
In the city not one pagan remained
who is not killed or turned into a Christian.
The Emperor is in an ample grove,
Roland and Oliver are with him there,
Samson the Duke and Ansëis the fierce,
Geoffrey d'Anjou, the King's own standard-bearer;
and Gerin and Gerer, these two together always,
and the others, the simple knights, in force:
fifteen thousand from the sweet land of France.
The warriors sit on bright brocaded silk; 110
they are playing at tables to pass the time,
the old and wisest men sitting at chess,
the young light-footed men fencing with swords.
Beneath a pine, beside a wild sweet-briar,
there was a throne, every inch of pure gold.
There sits the King, who rules over sweet France.
His beard is white, his head flowering white.
That lordly body! the proud fierce look of him!—
if someone should come here asking for him,
there'd be no need to point out the King of France.

2. Aachen (Aix-la-Chapelle), capital of Charlemagne's empire.
3. Either September 29 or October 16.

The messengers dismounted, and on their feet 120
they greeted him in all love and good faith.

9

Blancandrin spoke, he was the first to speak,
said to the King: "Greetings, and God save you,
that glorious God whom we all must adore.
Here is the word of the great king Marsilion:
he has looked into this law of salvation,
wants to give you a great part of his wealth,
bears and lions and hunting dogs on chains,
seven hundred camels, a thousand molted hawks,
four hundred mules packed tight with gold and silver, 130
and fifty carts, to cart it all away;
and there will be so many fine gold bezants,
you'll have good wages for the men in your pay.
You have stayed long—long enough!—in this land,
it is time to go home, to France, to Aix.
My master swears he will follow you there."
The Emperor holds out his hands toward God,
bows down his head, begins to meditate. AOI.

10

The Emperor held his head bowed down;
never was he too hasty with his words: 140
his custom is to speak in his good time.
When his head rises, how fierce the look of him;
he said to them: "You have spoken quite well.
King Marsilion is my great enemy.
Now all these words that you have spoken here—
how far can I trust them? How can I be sure?"
The Saracen: "He wants to give you hostages.
How many will you want? ten? fifteen? twenty?
I'll put my son with the others named to die.

You will get some, I think, still better born. 150
When you are at home in your high royal palace,
at the great feast of Saint Michael-in-Peril,
the lord who nurtures me will follow you,
and in those baths—the baths God made for you—
my lord will come and want to be made Christian."
King Charles replies: "He may yet save his soul." AOI.

11

Late in the day it was fair, the sun was bright.
Charles has them put the ten mules into stables.
The King commands a tent pitched in the broad grove,
and there he has the ten messengers lodged; 160
twelve serving men took splendid care of them.
There they remained that night till the bright day.
The Emperor rose early in the morning,
the King of France, and heard the mass and matins.
And then the King went forth beneath a pine,
calls for his barons to complete his council:
he will proceed only with the men of France. AOI.

12

The Emperor goes forth beneath a pine,
calls for his barons to complete his council:
Ogier the Duke, and Archbishop Turpin, 170
Richard the Old, and his nephew Henri;
from Gascony, the brave Count Acelin,
Thibaut of Reims, and his cousin Milun;
and Gerer and Gerin, they were both there,
and there was Count Roland, he came with them,
and Oliver, the valiant and well-born;
a thousand Franks of France, and more, were there.
Ganelon came, who committed the treason.
Now here begins the council that went wrong. AOI.

CHAPTER NINE

THE LATE MIDDLE AGES

Humanity in the late Middle Ages seemed to undergo a spiritual and intellectual revival which had a profound influence on the creative spirit. In the Gothic cathedral, the mystery of faith was embodied in the mystery of space. Stone was transubstantiated into ethereal tracery defining open space, which was flooded by the colored light streaming in through stained-glass windows. The austere and fortress-like massiveness of the Romanesque style was thus transformed, and the human spirit seemed to blossom as attention shifted from the oppressive wrath of God to the sweetness and mercy of the loving Savior and the Virgin Mary. Meanwhile, the vigorous growth of towns and cities accelerated the pace of life. As the focus of wealth and power shifted away from the feudal countryside, the new universities in the cities replaced monasteries as centers of learning.

9.1 Salisbury Cathedral, England, from the southwest, begun 1220.

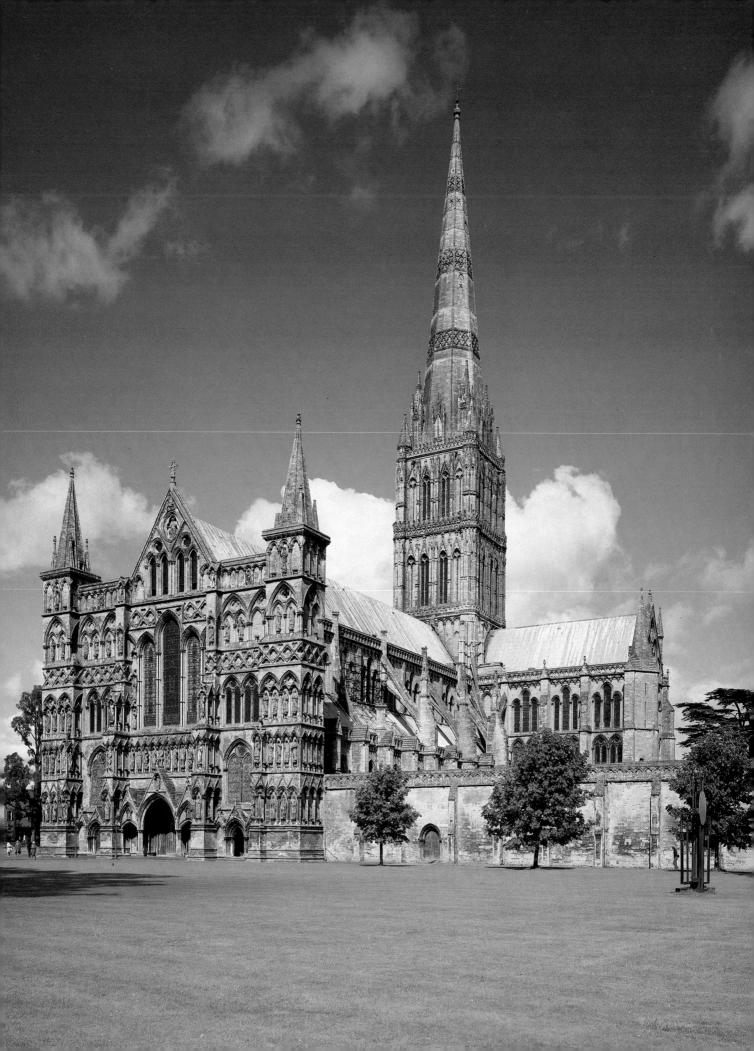

CONTEXTS AND CONCEPTS

The constant search for a better definition of reality yielded some remarkable results in the 12th to 15th centuries, and ushered in a new age, at least in the western world. Perhaps human beings possess certain ideas of what ought to be, and no matter how oppressive the circumstances, these ideas struggle to be fulfilled. Perhaps life is, as some have said, a search for personal freedom. Just whose freedom is concerned, and under what conditions, seems generally to be subject to circumstances.

Circumstance certainly colors a people's image of reality, and the circumstances of the mid-Middle Ages were unique. The effects of the conversion of Europe to Christianity and the approach of the end of the millennium (AD 1000) cannot be underestimated. The desperate conditions of feudal society and faith in a life beyond this vale of tears led to a widespread belief that the Second Coming of Christ and the end of the world would occur at the close of the millennium. One might think that the Second Coming and the end of the world would be a joyous fulfillment for a Christian. However, when Europe awoke to discover that the world had not ended with the millennium, rather than disappointment there seems to have been a great sense of relief. Humankind had been granted a new lease of life here on earth, and this was reflected in significant changes in the climate of feeling and thought.

REFORM IN THE CHRISTIAN CHURCH

The development of western culture, including its artistic institutions in the late Middle Ages, was profoundly affected, if not controlled, by the Christian Church. By the middle of the 11th century, the Church had become very powerful.

Although the tenth-century Church had become feudalized and corrupt, with many of its secular clergy seeking only wealth and power, this corruption did not go unchallenged. Cries for reform came loudest from the monasteries. The founding of the Abbey of Cluny by William of Aquitaine in 910 signalled the start of a major reform movement. The strict discipline and high moral standards of Cluny's Benedictine monks and abbots made Cluny a model of reform, and its influence spread across Europe.

While monastic life was successfully reformed to its original standards, however, the secular clergy changed their behavior very little. Feudal lords and the lesser nobility appointed priests and bishops, often choosing the highest bidder. Bishoprics were treated as family property, and the secular clergy, many of whose priests were married, did not place a high priority on their religious duties.

Conditions were ripe for reform, and the reformers vehemently attacked the evils of the secular clergy. Their objective was to free the Church from lay control and to reduce the secular interests of the clergy. The reform movement crossed national boundaries. Led by the papacy from the mid-11th century onward, it transformed the structure of the Medieval Church. Success depended on the reestablishment of the papacy as a central force in Christendom, and this was a position it had not enjoyed for some time, despite recognition of the primacy of the Roman See.

Circumstances changed in 1046 under Emperor Henry III of Germany. Henry championed the cause of the reformers, and in 1049 he appointed Pope Leo IX, who ruled until 1054. During those five years, Leo introduced a brilliant ecclesiastical reorganization, including the creation of a body of cardinals. Creation of the rank of cardinal made it possible for the papacy to exercise control over those bishops who had been named by lay rulers. After a series of synods in Rome, Leo took a personal tour of the empire, during which he publicized his reforms. As he put them into practice, he both consolidated his program and rid the clergy of many of its most offensive bishops.

Conflict between papacy and laity over the investiture of ecclesiastical office was not solved so easily, however. At the heart of the matter lay the issue of the basis of royal authority. The resulting struggle became known as the "Investiture conflict." Through a series of negotiated settlements with the various monarchs of Europe, the relationships between nobility and clergy, and clergy and papacy, were stabilized. The outcome was a compromise in which kings gave up their ancient claim to represent God's will in appointing senior clergy. They did continue to nominate bishops, but they had greater difficulty in presenting candidates considered unsuitable by the Church. From the 12th century onward, the quality of ecclesiastical appointments improved substantially.

The papacy emerged from the conflict with greatly enhanced prestige, and the importance of the Church in Medieval affairs, artistic and otherwise, continued to grow.

INTELLECTUAL PURSUITS

The 12th century has often been called an "age of humanism." The wave of religious enthusiasm that swept Europe from the second half of the 11th century to the middle of the 12th coincided with a burst of cultural activity and a zestful interest in learning. "The writers of the 12th century reveal themselves to us as living personalities more vividly than those of the earlier Middle Ages. There was a revival of classical literary studies, a vivid feeling for nature in Lyric poetry, a new naturalism in Gothic art."[1] With these exciting intellectual and ecclesiastical developments, new humanist, or "personalist," elements in religious devotion, theology, and philosophy also took hold.

ST BERNARD OF CLAIRVAUX AND MYSTICISM

Many new religious orders were founded during this period, and the status of women in religious and secular thought also grew. The Virgin Mary assumed a new importance in religious life, and the cult of Mary Magdalene spread through Europe. A key figure in the changing religious thought was a young nobleman, Bernard of Clairvaux (1090–1153), who entered the order of Cîteaux, the most influential new monastic movement of the 12th century.

Bernard was an enthusiast, perhaps even a fanatic, having no doubt in his own mind that his views were correct. He entered into eager combat with anyone who disagreed with him, and those individuals included the most influential clerics and philosophers of the times: men such as the scholar and theologian Peter Abelard; the monk and abbot, Suger, of St Denis; and the entire order of Cluny. At the same time, Bernard could show great patience and common sense. He treated his monks with patience and forgiveness, and reportedly turned down the Duke of Burgundy's request to become a monk by saying that the world had many virtuous monks, but few pious dukes.

Bernard had a widespread reputation for holiness and eloquence, and was often asked to solve disputes in the public arena. He also occasionally intervened in public affairs without being asked. He was an advisor to the French king, Louis VII, founded the order of Knights Templar, and took an active role in promoting the Second Crusade. The unfortunate outcome of the crusade was one of the few stains on his public life. Personally, he was also profoundly upset by the fact that his preaching in favor of the crusade led to new and dreadful massacres of the Jews.

His religious teaching set a new tone for 12th-century Christianity through emphasis on a more mystical and personal sense of piety than had existed previously. In his writings he described a way of "ascent to God," consisting of four stages of love by which a soul could gain union with God. In his sermons for the common people, he treated more ordinary themes and vividly retold familiar stories from the New Testament. Rather than treating Jesus, Mary, and the apostles as remote images, Bernard described them as living personalities. He sought to create in his listener an emotional love for the person Jesus. He emphasized the role of Mary as an intercessor who could lead people to Jesus. Recognizing that a sinner might be afraid to approach a sternly just God directly, Bernard created the image of a sympathetic, merciful lady to whom the sinner could turn, in trust and without guilt, for help. During this same time, collections of stories about Mary, called "Miracles of the Virgin," and the Mary-plays became popular. Bernard's preaching was an important stimulant for the spread of the Mary cults.

Bernard's popularity and leadership proved an important stimulant also for the growth and spread of the Cistercian order. In the 38 years between 1115 and Bernard's death in 1153 the order went from five houses to 343. By the end of the 13th century that number had doubled. The number of monks in each house was large too, with some approaching 700 monks.[2]

THE CRUSADES

Many of us have the notion that the crusades featured knights in shining armor setting out on glorious quests to free the Holy Land from Infidels. The crusades were far from a romantic quest, however. Instead, they illustrate clearly a new and practical energy and optimism in Europe in a new millennium and a new era. A strengthened Church leadership emerged from the period of the crusades.

As early as the tenth century, popes had led armies against the Saracens in Italy. By the end of the 11th century, the Church was able to put forward several reasons why a Christian army might march against the Muslims. Constantinople had been rescued from the Turks, and a healing of the east–west schism seemed possible. Furthermore, pilgrimages to the Holy Land as a form of penance had become increasingly popular in this age of religious zeal, and the safety of these pilgrims was ample reason for interference by the popes. A more practical benefit closer to home was the removal of troublesome nobles from the local scene. An opportunity came in 1095 at the Council of Clermont. When envoys of the eastern emperor Alexius Comnenus supposedly asked Pope Urban II for aid, Urban set about mounting a crusading army. The response to his call was astonishing. Thousands came forward to take up the cross. Men, women, and children—even those who were disabled—clamored to

	GENERAL EVENTS	LITERATURE & PHILOSOPHY	VISUAL ART	THEATRE & DANCE	MUSIC	ARCHITECTURE
1000	Henry III of Germany Pope Leo IX First Crusade	Abelard				
1100	Bernard of Clairvaux Muslim conquest of Edessa Second Crusade Muslim conquest of Jerusalem Eleanor of Aquitaine, chivalry Third Crusade		Gothic style West portal jamb statues—Chartres Cathedral (**9.13**)	Courtly tradition Mystery, miracle, morality plays Mansion stages (**9.18**) Antecriste Adam Play Second Shepherd's Play	Ars antiqua Organa Cantilena Motet	Gothic style Abbey Church of St Denis (**9.20–21**) Chartres Cathedral (**9.24–27**) Notre Dame de Paris (**9.22–23**)
1200	Magna Carta	St Thomas Aquinas Dante Roger Bacon	South transept jamb statues—Chartres Cathedral (**9.14**) Psalter of St Louis (**9.6**) Nicola Pisano (**9.16**) David Harping (**9.8**) St John on Patmos (**9.7**) Psalter of Alfonso (**9.32**)	Danse Macabre	Troubadours Minnesänger	Amiens Cathedral (**9.28**) Salisbury Cathedral (**9.1, 9.29–30**) Exeter Cathedral (**9.33**) Westminster Abbey
1300	Hundred Years' War begins The Plague	Chaucer Froissart	Cimabue (**9.11**) Giotto (**9.10**) Jean Pucelle (**9.9**) Pietro Lorenzetti (**9.12**)		Ars nova	Ely Cathedral (**9.35**) Wells Cathedral (**9.34**) Lincoln Cathedral (**9.37**) Gloucester Cathedral (**9.38–39**)
1400			International Gothic	Confrérie de la Passion Everyman		

9.2 Timeline of the Late Middle Ages.

9.3 Europe at the time of the First Crusade.

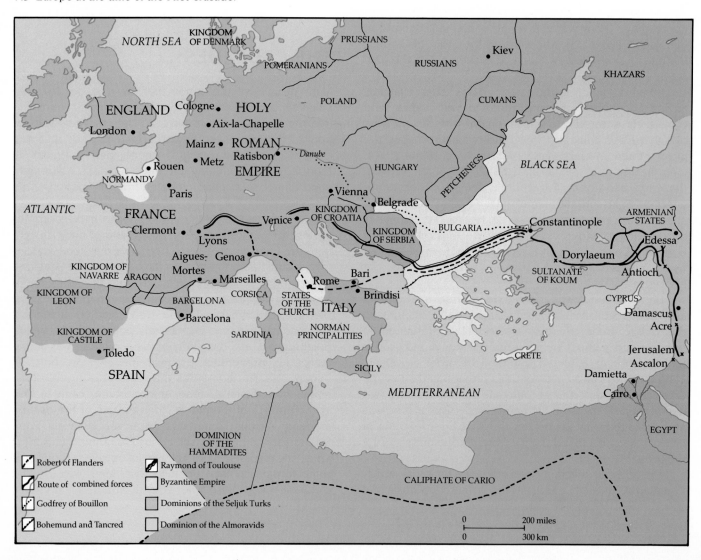

take part, and the aforementioned nobles also went riding off to war.

The reasons for the First Crusade went beyond its political and military objectives. Its impetus came from the religious enthusiasm of those who made up the crusading army. These people were ready to make significant sacrifices for their faith. The idea of a crusade generated such a tremendous emotional response that even the Pope could not control it. Itinerant preachers heralded an upcoming crusade in their revival meetings. No one cared about the practical problems—it was an act of faith and piety. The infidels would scatter in fear before the banner of the cross. The walls of fortresses would tumble down like those of Jericho.

The most famous of these itinerant preachers was Peter the Hermit. At one point he was given entire credit for the movement, although we now know this was not the case. But even if he did not initiate the idea of a crusade, he certainly contributed significantly to its popularity. Mounted on a mule, he wandered through France, preaching crusade to any and all who would listen. His ascetic lifestyle and passionate oratory led many to regard him as a saint. He drew enormous crowds, and by the time he reached Cologne in March 1096, thousands had taken up the cross and followed him.

The First Crusade, which ultimately led to the capture of Jerusalem and a bloody massacre, wound its way through Hungary, Greece, Constantinople, Syria, Nicea, the southern coast of Asia Minor, Edessa, and Antioch (Fig. **9.3**). Beset by infighting and other self-inflicted problems, the crusaders stumbled onward. When they finally conquered Jerusalem, even more problems appeared. What was Jerusalem to become? Was it to be a secular kingdom or Church property, like Rome? How was it to be defended? Most of the crusaders rushed home after their pilgrimages, however, and the wide-ranging Christian conquests proved virtually indefensible. As time went on, closer and closer association with the local people led any Christians who stayed on to adopt the customs of the country. Very little was settled, and no centralized authority was set up. By 1144, the Muslims had reunited and the Christian state was under siege. Edessa fell, sending shock waves through Europe. The clamor for another crusade coincided with the reform movement of St Bernard of Clairvaux. The Second Crusade set out in 1147, but ended in disarray and defeat. After that, Europe lost its enthusiasm for such ventures, for a generation.

In the interim, the Muslims gathered their forces and set about driving out the Christians. On 3 October 1187, led by Saladin, the Muslims conquered Jerusalem, ending 83 years of Christian rule. Again the news shocked Europe, and again the Pope took the opportunity to attempt to make peace among warring nobles in Europe. Henry II of England and his son Richard, Philip Augustus of France, and Frederick Barbarossa of Germany all took

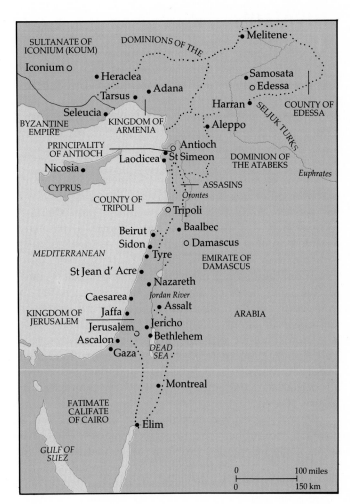

9.4 Areas of the crusades.

up the cross. Well planned, well financed, and led by the most powerful rulers of Europe, the Third Crusade set off in high spirits, with high expectations. But one disaster after another befell the crusaders, and by 1189, only Richard and Philip were still in the field. Their major accomplishment was the capture of Acre after a two-year siege. Philip then returned home to make trouble for Richard, now Richard I of England, as France and England resumed hostilities; Richard did succeed in agreeing a truce with Saladin which allowed pilgrims to enter Jerusalem safely. Another chapter in the conflict of politics and religion had come to a close.

The Third Crusade clearly demonstrated the limitations of the papal program. Although the goals of a crusade gave the Pope a perfect excuse to intervene in the secular politics of Europe, that intervention was largely unsuccessful. Alliances between warring powers during a crusade were only temporary. Once they dissolved, France, England, and Europe in general, went right back to their old quarrels and could not refrain from new ones. Papal hopes for a united Christendom under the military leadership of Rome thus died with the end of the Third Crusade.

341

CHIVALRY

Society was feudal throughout Europe over this period. The Carolingian and Ottonian Empires had suggested that a wider stability and order were possible. But life remained polarized in a rigid class system. The clergy and nobility ruled, and the serf labored. In between, there was a vacuum. Gradually, however, this vacuum came to be filled by the town and the town guild. When this happened, another new age was born.

At the same time, another Medieval phenomenon was born of a change in attitude that permeated society and the arts. Feudalism was a masculine, "men-at-arms" code of behavior. But by the 12th century, a distinctly feminine point of view ruled ethics and personal conduct —that of chivalry and the courtly tradition. Men were away from their homes or castles for long periods of time, whether they were off trading or off warring. It fell to women to run their households and control domestic matters and manners. If Eleanor of Aquitaine (1122–1204) is a representative example, women managed this very well. Society thus took on a gentler, more civil tone than under the rough code of feudalism, and elaborate codes of conduct and etiquette emerged which culminated in "courts of love."

We may speculate that the code of chivalry was a practical and euphemistic way of glossing over illicit love affairs while husbands were away. Most aristocratic marriages were arranged for political convenience, anyway, while those of the lower classes had economic advantages as their goal.

More important than its impact on morals was the impact of the courtly tradition on religious philosophy. The early Middle Ages were fixated on devils and death, faith notwithstanding. As time passed, however, we find a warmer feeling, a quality of mercy. Christ the Savior and Mary, his compassionate mother, became the focal points of the faith. This change in viewpoint is reflected very clearly in the arts of the time.

THE MIDDLE CLASS

Amid the changing values a new and important middle class arose to fill the vacuum between nobility and peasantry. Thousands flocked into emerging towns and cities, which offered a new hope of escape from slavery to the land. The crusades had opened Europe's barricaded mentality to new horizons. Returning soldiers brought tales of the east and of marvelous fabrics and goods that caught the fancy of nobles and commoners alike. The demand for trade goods and services exploded. Response could be almost instantaneous because the Italian trading cities, such as Pisa, Genoa, and Venice, had never fully declined as centers of commerce and shipping.

Within the emerging towns and cities, very powerful guilds of artisans and merchants rapidly developed. No order gives up power easily, and struggles, sometimes violent, pitted burgher against nobleman. The crusades had financially ruined many feudal landholders, and a taste of potential power and wealth strengthened the resolve of the middle-class citizens. They needed a more dynamic society than feudalism could offer, and they threw their wealth and power behind strengthening monarchies that favored them. As a result, administration became more centralized, society was stabilized, and a rudimentary democracy emerged. The 13th century witnessed the *Magna Carta*, which built upon 12th-century English common law, and also, in 1295, the establishment of an English parliament. Democracy began to emerge in Switzerland, and, in 1302, the Estates General were founded in France, igniting a spark of democracy.

INTELLECTUAL LIFE

Many universities gained their charters in the 12th and 13th centuries, for example, Oxford University in England, the University of Salamanca in Spain, the University of Bologna in Italy, and the University of Paris in France. Many had existed previously in association with monasteries, but their formal chartering made the public more aware of them. Medieval universities were not like today's institutions. They had no buildings or classrooms. Rather, they were guilds of scholars and teachers who gathered their students together wherever space permitted. University life spawned people with trained minds who sought knowledge for its own sake and who could not accept a society that walled itself in and rigidly resisted any questioning of authority.

This environment bred new philosophies. As we shall see, St Thomas Aquinas built a philosophical structure that accommodated divergent points of view. Dante suggested a new mix of views in the *Divine Comedy*. Aristotle was rediscovered and introduced throughout Europe, and Roger Bacon began a study of "reality" simply as physical phenomena. As intellectual walls collapsed, light and fresh air flooded into western culture. New freedoms, new comforts, both physical and spiritual, and a new confidence in the future pervaded every level of society. Thirteenth-century philosophy reconciled reason and revelation, the human and the divine, the kingdom of heaven and the kingdoms on earth. Each took its place in a universal, harmonious order of thought.

PHILOSOPHY AND THEOLOGY
Abelard and realism

Abelard (1079–1142) has become a figure of both philosophy and romance. His life-long correspondence and

late-in-life love affair with Héloïse accounts for the romantic element. As for the philosophy, he studied with William of Champeaux and with Roscellinus, but he disagreed with the conclusions of each of his masters. Abelard denied that objects are merely imperfect imitations of universal ideal models to which they owe their reality. Instead, he argued for the concrete nature of reality. That is to say, objects as we know them have *real* individuality which makes each object a substance "in its own right."

Abelard went beyond this, to argue that universals do exist, and comprise the "Form of the universe" as conceived by the mind of God. These universals are patterns, or types, after which individual substances are created and which make these substances the *kinds* of things they are.

Abelard has been called a "moderate realist," or, sometimes, a "conceptualist," even though that term is usually applied to later teaching. His views were adopted and modified by St Thomas Aquinas, and in this revised form they constitute part of Roman Catholic Church dogma today. Abelard believed that philosophy had a responsibility to define Christian doctrine and to make it intelligible. He also believed that philosophers should be free to criticize theology and to reject beliefs that are contrary to reason.

Abelard regarded Christianity as a way of life, but he was very tolerant of other religions as well. He considered Socrates and Plato to have been "inspired." The essence of Christianity was not its dogma, but the way Christ had lived his life. Those who lived prior to Jesus were, in a sense, already Christians if they had lived the kind of life Christ did. An individual act should be understood as good or evil "solely as it is well or ill intended," he argued in his treatise K*now Thyself.* However, lest anyone excuse acts on the basis of "good intentions," Abelard insisted that there should be some sort of standard for judging whether intentions were good or bad. Such a standard existed in a natural law of morality, "manifested in the conscience possessed by every man, and founded upon the will of God." When opinions differed over the interpretation of the law of God, he said, each person must obey his or her own conscience. Therefore, "anything a man does that is against his own conscience is sinful, no matter how much his act may commend itself to the consciences of others."[3]

St Thomas Aquinas and Aristotelianism

The rediscovery of Aristotle in the 13th century marked a new era in Christian thought. With the exception of Aristotle's treatises on logic, called the *Organon,* his writings were inaccessible to the west until the late 12th century. Their reintroduction created turmoil. Some centers of education, such as the University of Paris, forbade Aristotle's metaphysics and physics. Others championed Aristotelian thought. Their scholars asserted the eternity of the world and denied the existence of divine providence and the foreknowlege of contingent events. In the middle were thinkers such as Albertus Magnus who, though orthodox in their acceptance of the traditional Christian faith, regarded the rediscovery of Aristotle in a wholly positive light. Magnus' first pupil was Thomas Aquinas (1227–74).

In his youth, Aquinas joined the newly formed mendicant Order of Preachers (the Dominican Order). This led him to Paris to study with Magnus, who was the master teacher of the Dominicans. A prolific writer, Aquinas produced philosophical and theological works and commentaries on Aristotle, the Bible, and Peter Lombard. His most influential works are the *Summa contra Gentiles* and the *Summa Theologiae.* Aquinas, like Magnus, was a modernist, and he sought to reinterpret the Christian system in the light of Aristotle—in other words to synthesize Christian theology and Aristotelian thought. He believed that the philosophy of Aristotle would prove acceptable to intelligent men and women, and further, that if Christianity were to maintain the confidence of educated people, it would have to come to terms with and accommodate Aristotle. Aquinas was a very devout and orthodox believer. He had no wish to sacrifice Christian truth, whether to Aristotle or any other philosopher.

In dealing with God and the universe, Aquinas carefully defined the fields of theology and philosophy. Philosophy was limited to whatever lay open to argument, and its purpose was to establish such truth as could be discovered and demonstrated by human reason. Theology, on the other hand, was restricted to the "content of faith," or "revealed truth," which is beyond the ability of reason to discern or demonstrate, and "about which there can be no argument." There was, nonetheless, an area of overlap.

Aquinas concentrated upon philosophical proofs of God's existence and nature. The existence of God could be proved by reason, he thought, and Aristotle had inadvertently done just that. The qualities to which Aristotle reduced all the activities of the universe become intelligible "only on the supposition that there is an unmoved . . . self-existent . . . form of being whose sheer perfection sets the whole world moving in pursuit of it."

Beyond this, Aquinas moved the philosophical knowledge of God's nature beyond the Aristotelian viewpoint. He turned, instead, to Plato. Aristotle's view that God knows only his own Form is replaced with the idea that God's self-knowledge comprises a knowledge of the whole formal structure of the universe. On this point, Aquinas follows Augustine in his belief that the formal structure of the universe is a plan in the divine mind in accordance with which the world is created.

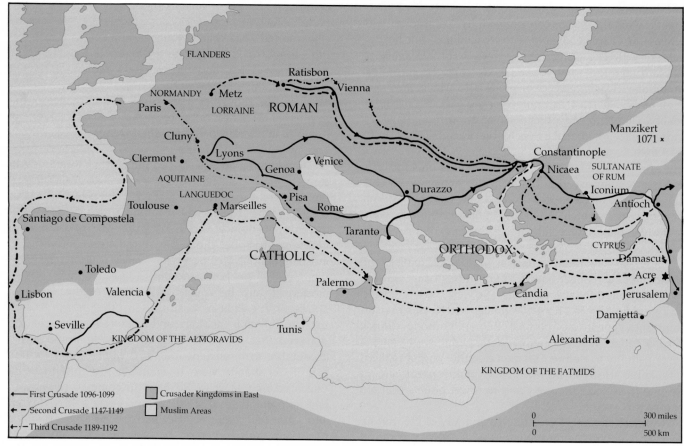

9.5 The crusades.

SECULARISM

By the 14th century, revelation and reason, and God and the state, were considered separate spheres of authority, neither subject to the other. Such a separation, of what had previously been the full realm of the Church, was the beginning of secularism—that is, a rejection of religion and religious considerations. Individual nations (in contrast to feudal states or holy empires) had arisen throughout Europe. Social and economic progress was disrupted by two events, however. The Plague (1348–50) killed half the population of Europe. The Hundred Years' War (1338–1453) was the other disruptive event. During this time, secular arts gained prominence, respectability, and significance. These changes were, of course, gradual, and they reflected a shifting emphasis rather than a reversal of values.

The terms "ebb and flow" and "shifting and sliding" quite adequately describe the manner in which the arts have crossed the centuries. Until this point in our examination, the lack of records has made this difficult to see. From the 12th century onward, we understand most of the arts fairly well. We can at least tell whether characteristics of style may or may not adhere to all forms in all places in the same time. A major style may refer to a rather broad chronological period even though that style may have come and gone in some places or may never have arrived at all in some places or in some art forms.

FOCUS

TERMS TO DEFINE

Abbey of Cluny	Chivalry	Aristotelianism
Humanism	Middle class	Secularism
Mysticism		

PEOPLE TO KNOW

St Thomas Aquinas	Peter the Hermit
Abelard	St Bernard of Clairvaux
Eleanor of Aquitaine	

DATES TO REMEMBER

The First, Second, and Third Crusades

THE ARTS
OF THE LATE MIDDLE AGES

TWO-DIMENSIONAL ART
Gothic style

In the 12th to the 15th centuries, traditional fresco painting returned to prominence. Manuscript illumination also continued. Two-dimensional art flowed from one style into another without any clearly dominant identity emerging. Because this period is so closely identified with Gothic architecture, and because painting found its primary outlet within the Gothic cathedral, however,

we need to ask what qualities identify a Gothic style in painting. The answer is not as readily apparent as it is in architecture and sculpture, but several characteristics can be identified. One is the beginnings of three-dimensionality in figure representation. Another is a striving to give figures mobility and life within three-dimensional space. Space is the essence of Gothic style. Gothic painters and illuminators had not mastered perspective, and their compositions do not exhibit the spatial rationality of later works. But if we compare these

9.6 *Gideon's Army Surprises the Midianites*, from the Psalter of St Louis, c.1250.
4¾ × 3⅝ ins (12.1 × 9.2 cm). Bibliothèque Nationale, Paris.

painters with their predecessors of the earlier Medieval eras, we discover that they have more or less broken free from the frozen two-dimensionality of earlier styles. Gothic style also exhibits spirituality, lyricism, and a new humanism. In other words, it favors mercy over irrevocable judgment. Gothic style is less crowded and frantic —its figures are less entangled with each other. It was a changing style with many variations.

The Gothic style of two-dimensional art found magnificent expression in manuscript illumination. The Court Style of France and England is represented by some truly exquisite works. The Psalter of St Louis (Fig. **9.6**) was produced for King Louis IX of France in about 1250. It was a lavish book containing 78 full-page pictures of scenes from the Old Testament. The figures are gracefully elongated and delicate. Set against gold backgrounds, the compositions are carefully balanced and, while somewhat crowded, show a relaxed comfort in their spatial relationships. Precision and control characterize the technique. Colors are rich. Human figures and architectural details are blended in the same manner that church sculpture both decorated and became a part of its architectural environment.

The artists who made these works were professionals living in Paris. They were influenced by Italian style, and they clearly had a new interest in pictorial space, which begins to distinguish them from their Medieval predecessors. This Parisian style, in turn, influenced English manuscript illumination. Figure **9.7** of *St John on Patmos* was painted for Edward, son of Henry III, and his wife Eleanor of Castile. The elongated figures and small heads reflect the French court influence, as does the heavy drapery. The English painters, however, frequently altered their French models, giving them "more angular treatment of the folds and exaggerated poses and even expressions."[4]

The same characteristics can be seen in Figure **9.8**, *David Harping*. The curious proportions of face and hands, as well as the awkward linear draping of fabric juxtaposed against the curved forms of the harp and chair, create a sense of tension. The layout of the background screen is almost careless. The upward curving arcs at the top are intended to be symmetrical, but their lack of symmetry is reinforced by the imprecision of the diamond shapes. A touch of realism appears in the curved harp string which David is plucking. A rudimentary use of highlight and shadow gives basic three-dimensionality to cloth and skin. And while out of balance in its interior space, the figure, nonetheless, does not appear to crowd the borders. It has space in which to move.

In the later years of the Gothic period, Italian manuscript illuminators experimented with three-dimensional space. The work of Jean Pucelle, the Parisian illuminator, graphically demonstrates this change in his *Book of Hours of Queen Jeanne d'Evreux* (Fig. **9.9**). Here, the Virgin is rendered in a deep space with remarkably accurate linear perspective.

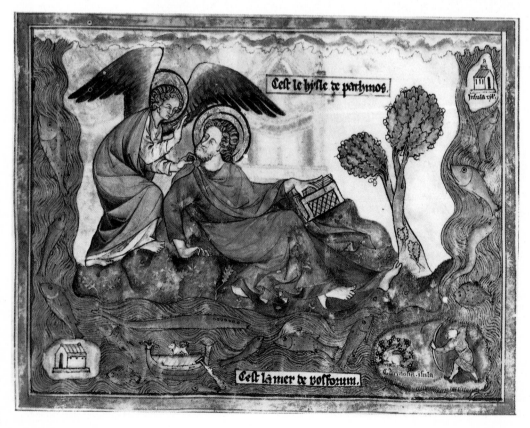

9.7 *St John on Patmos*, from the Douce Apocalypse, before 1272. $12\frac{1}{2} \times 8\frac{5}{8}$ ins (31.75 × 21.9 cm). Bodleian Library, Oxford, England.

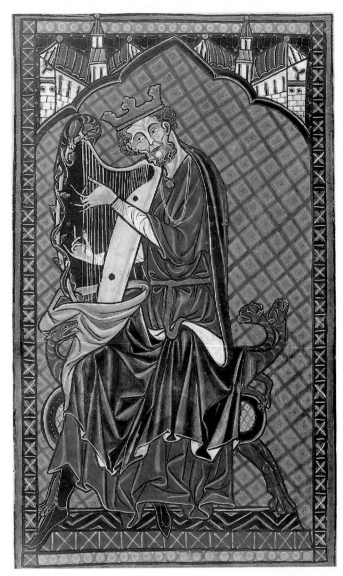

9.8 *David Harping*, from the Oscott Psalter, c.1270. $7\frac{7}{8} \times 4\frac{3}{8}$ ins (20 × 11.1 cm). British Library, London.

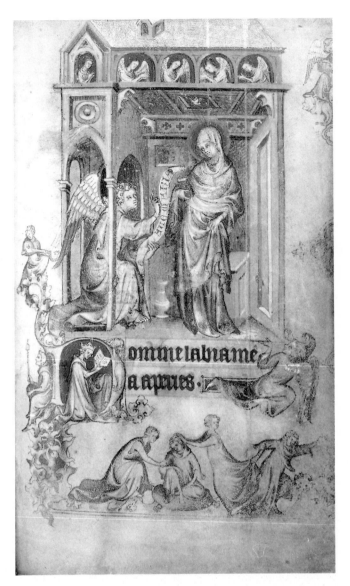

9.9 Jean Pucelle, *The Annunciation*, from the Hours of Jeanne d'Evreux, 1325–28. Grisaille and color on vellum. $3\frac{1}{2} \times 2\frac{7}{16}$ ins (8.9 × 6.2 cm). The Metropolitan Museum of Art, New York (The Cloisters Collection, 1954).

The Gothic style in painting spread throughout continental Europe, but the center of activity and the area of greatest influence was Italy. The new sense of space, three-dimensionality, and mobility are clear in Giotto's masterpiece *Lamentation* (Fig. **9.10**). The figures are skillfully grouped in a simple and coherent scene. Giotto's fabrics retain a decorative quality from an earlier time, but they also show an increased realism. Figures are crowded, but they still seem free to move within the space. For all its emotion and intensity, the fresco remains human, individualized, and controlled. What makes Giotto's fresco so compelling is his unique mastery of three-dimensional space. He employs atmospheric perspective for the background, but unlike other painters who created deep space behind the primary focal plane, Giotto

brings the horizon to our eye-level. As a result, we can move into a three-dimensional scene that also moves out to us.

Pietro Lorenzetti's triptych, the *Birth of the Virgin* (Fig. **9.12**), shows a careful concern for creating three-dimensional space and depicting figures. The figures are lifelike. Highlight and shadow flesh out faces and garments. The treatment of draping fabric in the gowns of the right panel shows precise attention to detail. We have a sense of looking in on a scene in progress, rather than at a flat, frozen rendering. The scene has a relaxed atmosphere, and the eye is drawn across the work in a lyrical sweep. Figure groupings are spaced comfortably, and the whole picture, which continues behind the columns separating the panels, spreads throughout the triptych.

Cimabue's *Madonna Enthroned* (Fig. **9.11**) in its very

form embodies Gothic, upward-striving monumentality. Designed for the high altar of the church of Santa Trinità, the work rises over 12 feet high. Its hierarchical design places the Virgin Mary at the very top center, surrounded by angels, with the Christ child supported on her lap. Below her elaborate throne, four half-length prophets display their scrolls.

The verticality of the composition is reinforced by the rows of inlaid wood in the throne and by the ranks of angels rising, one behind the other, on each side. The figures in the top rank bend inward to reinforce the painting's exterior form and the focus on the Virgin's face. The delicate folds of the blue mantle and dark red robe, which are highlighted with gold, encircle the upper torso, drawing attention in to the Madonna's face and to the child. In a convention appropriate to the theology of the time, the Christ child is depicted as a wise and omniscient presence, with a patriarchal face beyond his infant years. The clean precision of the execution gives the work a delicacy and lightness reflective of the traceries in stone that characterize Gothic architecture.

By the turn of the 15th century, Italian and northern European Gothic had merged into an International Gothic style. The term is applied to elegant courtly art with delicate coloring and beautiful clarity of definition.

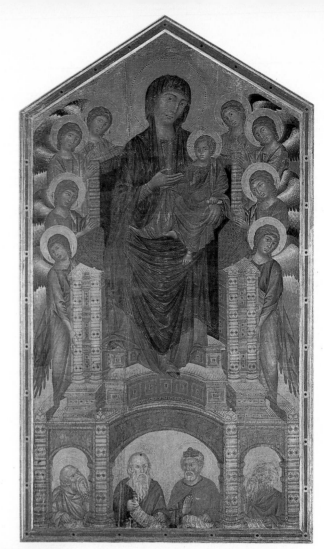

9.11 Cimabue, *Madonna Enthroned*, c.1280–90. Tempera on wood, c.12ft 7½ ins × 7 ft 4 ins (3.84 × 2.24 m). Uffizi Gallery, Florence, Italy.

9.10 Giotto, *The Lamentation*, 1305–06. Fresco. Arena Chapel, Padua, Italy.

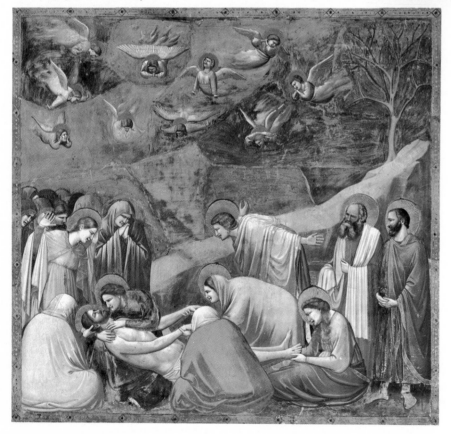

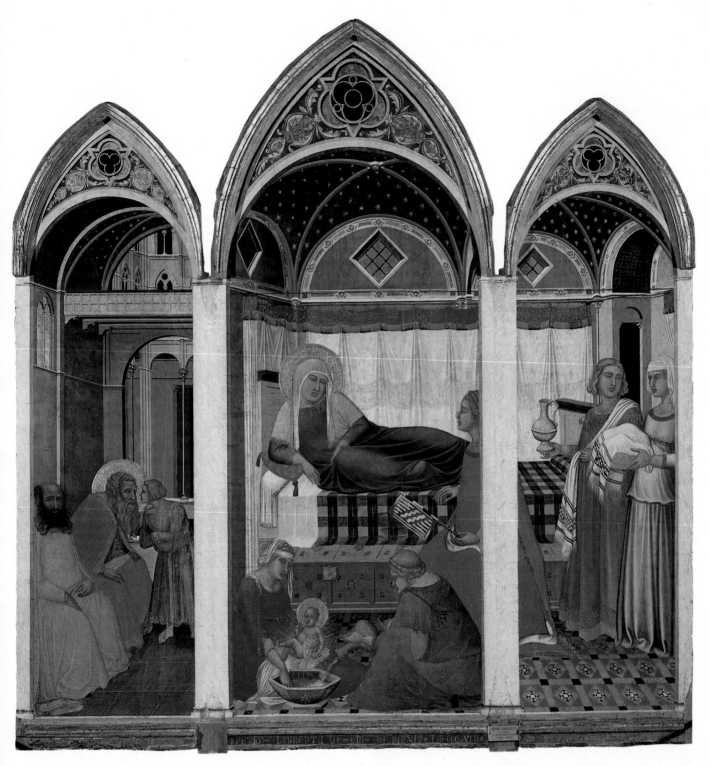

9.12 Pietro Lorenzetti, *The Birth of the Virgin*, 1342. Panel painting, 6 ft 1½ ins × 6 ft ½ in (1.87 × 1.84 m). Museo dell' Opera Metropolitana, Siena, Italy.

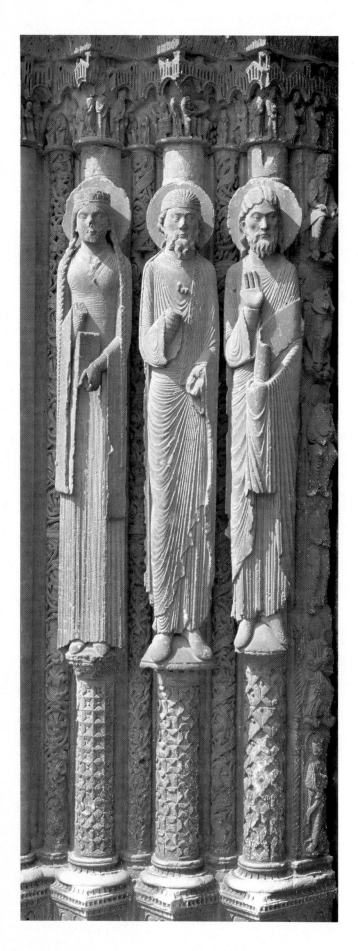

SCULPTURE
Gothic style

Gothic sculpture again reveals the changes in attitude of the period. It portrays serenity, idealism, and simple naturalism. Gothic sculpture, like painting, has a human quality. Life now seems to be more valuable. The vale of tears, death, and damnation are replaced by conceptions of Christ as a benevolent teacher and of God as awesome in his beauty rather than in his vengeance. There is a new order, symmetry, and clarity. Visual images carry over a distance with greater distinctness. The figures of Gothic sculpture are less entrapped in their material and stand away from their backgrounds (Fig. **9.13**).

Schools of sculpture developed throughout France. Thus, although individual stone carvers worked alone, their links with a particular school gave their works the character of that school. The work from Rheims, for example, had an almost classical quality; that from Paris was dogmatic and intellectual, perhaps reflecting the role of Paris as a university city. As time went on, sculpture became more naturalistic. Spiritual meaning was sacrificed to everyday appeal, and sculpture increasingly reflected secular interests, both middle-class and aristocratic. A comparison of the figure of Christ in the central tympanum at Chartres (Fig. **9.15**) with that in the Vézelay tympanum (Fig. **8.11**) illustrates this point. At Chartres, Christ has a calm solemnity, in contrast to the emotion-charged, elongated, twisting figure at Vézelay.

Compositional unity also changed over time. Early Gothic architectural sculpture was subordinate to the overall design of the building. As later work gained in emotionalism, it began to claim attention on its own (Fig. **9.14**).

The sculptures of Chartres Cathedral, which bracket nearly a century from 1145 to 1220, illustrate clearly the transition from early to High Gothic. The attenuated figures of the JAMB statues in Figure **9.13**, from the middle of the 12th century, display a relaxed serenity, idealism, and simple naturalism. They are an integral part of the portal columns, but they also emerge from them, each in its own space. Each figure has a particular human dignity despite its idealization. Cloth drapes easily over the bodies. Detail is somewhat formal and shallow, but we now see the human figure beneath the fabric, in contrast to the previous use of fabric merely as a surface decoration.

As human as these saints may appear, this quality is

9.13 Chartres Cathedral, France, jamb statues, west portal, c.1145–70.
9.14 (opposite) Chartres Cathedral, jamb statues, south transept portal, c.1215–20.

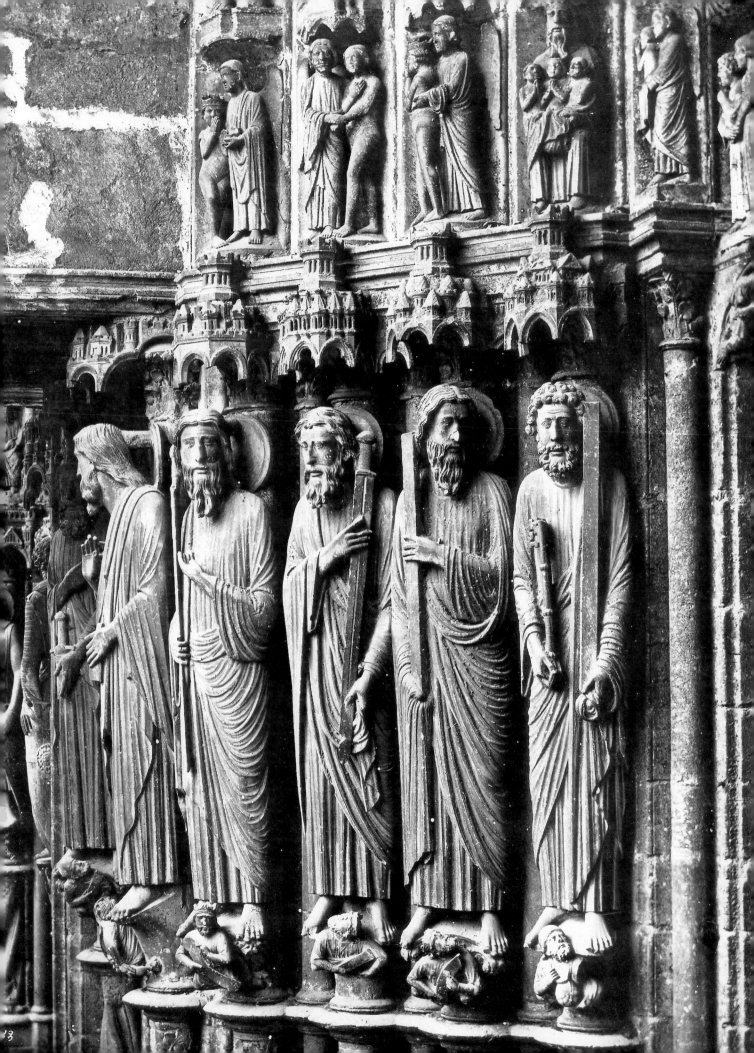

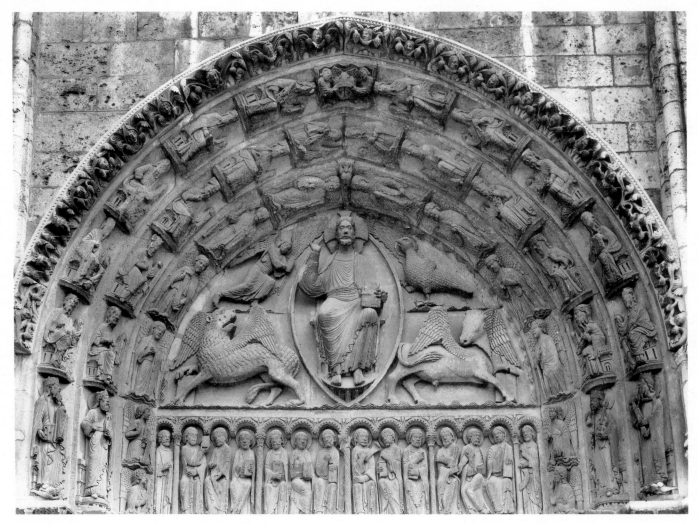

9.15 Chartres Cathedral, central tympanum, west portal, c.1145–70.

even more pronounced in the saints' figures from less than 100 years later (Fig. **9.14**). Here we see the characteristics of the High Gothic style, or Gothic classicism. These figures have only the most tenuous connection to the structural elements of the building. Proportions are more lifelike, and the figures are carved in subtle S-curves rather than as rigid perpendicular columns. The drape of the fabric is much more natural, with deeper and softer folds. In contrast to the idealized saints of the earlier period, these figures have the features of specific individuals, and they express qualities of spirituality and determination.

The content of Gothic sculpture is also noteworthy. Like most Church art, it was didactic, or designed to teach. Many of its lessons are straightforward. Above the main doorway of Chartres Cathedral, for example, Christ appears as a ruler and judge of the universe, along with a host of symbols of the apostles and others (Fig. **9.15**). Also decorating the portals are the prophets and kings of the Old Testament. These figures proclaim the harmony of secular and spiritual rule, and thus suggest that the kings of France are spiritual descendants of biblical rulers—a message much like that of San Vitale, built by Justinian at Ravenna.

Other lessons of Gothic cathedral sculpture are more complex and less obvious. According to some scholars, much of this art was created according to specific conventions, codes, and sacred mathematical calculations. These formulas govern positioning, grouping, numbers, and symmetry. For example, the numbers three, four, and seven (which often appear as groupings in compositions of post-Gothic periods) symbolize the Trinity, the Gospels, the sacraments, and the deadly sins (the last two both number seven). The placement of figures around Christ shows their relative importance, with the position on Christ's right being the most important. These codes and symbols, consistent with the tendency toward mysticism, and finding allegorical and hidden meanings in holy sources, became more and more complex.

The Gothic style was fairly similar in France, Germany, and Spain. In Italy, it was quite different. Italian sculpture

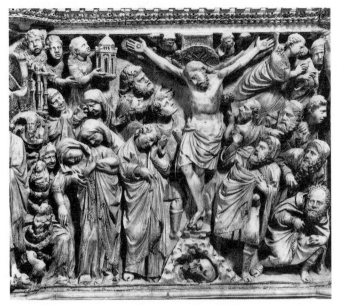

9.16 Nicola Pisano, *The Crucifixion*, detail of pulpit, 1259–60. Marble, whole pulpit c.15 ft (4.6 m) high; relief 34 ins (86 cm) high. Baptistry, Pisa, Italy.

9.17 *The Visitation*, west portal, Reims Cathedral, France, c.1225–45.

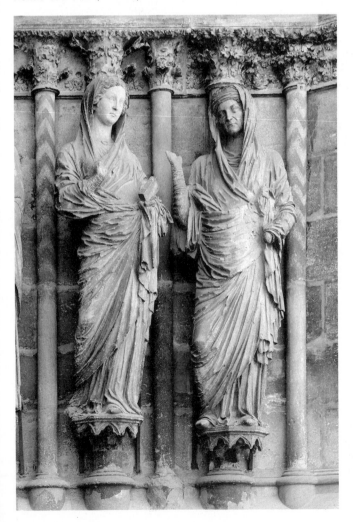

had a classical quality, partly due to the influence of the German Emperor Frederick II, who ruled southern Italy and Sicily. The works of one of the major Italian sculptors of the period, Nicola Pisano, have both Roman and Medieval qualities in their crowded use of space (Fig. **9.16**).

The classical influence in Gothic sculpture can also be seen in *The Visitation* at Reims (Fig. **9.17**). Scholars believe that the sculptor at Reims had studied ancient Roman statues, because the method of carving exhibited in the folds of the garments of the mothers of Jesus and John the Baptist reflects a technique that had not been practiced for nearly a millennium. The pose, with one knee bent, also harks back to classical style. Nonetheless, in this depiction of the discussion between expectant mothers, we see a warm and individual humanity, with great moral weight and dignity.

By the turn of the 15th century, the international style noted in painting dominated virtually all European Gothic art, including the Italian. Like the figures brought forward from deep space in Gothic painting, figures in sculpture were brought even further forward, not by detaching them from their background, but by treating the background as an empty space.

LITERATURE
Dante and other vernacular poets

The greatest poet of the age was Dante (1265–1321). Dante wrote a few lyric poems and the story of his passion for his unattainable love, Beatrice, in *La Vita Nuova*. But the *Divine Comedy* was the major work of his life. It is a description of heaven, hell, and purgatory. It is a vision of the state of souls after death told in an allegory, demonstrating the human need for spiritual illumination and guidance. Part of Dante's significance lies in the fact that he elevated vernacular Italian to the status of a rich and expressive language suitable for poetry. It was no longer necessary for writers to use Latin. The Italian poet Petrarch (1304–74), who created the sonnet form, wrote in both Latin and his native Tuscan dialect. Soon poets all over Europe were following Dante's lead and exploring the poetic resources of their own everyday languages.

A popular genre of literature was the Medieval chronicle. A chronicle is history told in a "romantic" way, and in the contemporary language of the country. The *Chronicles of England, France, and Spain* by Froissart (c.1333–c.1400) is an outstanding example of this genre. Froissart's work covers the history of the 14th century and the wars between England and France. It was not written as a factual account but, in the words of its author, "to encourage all valorous hearts and to show them honorable examples."

Chaucer

Geoffrey Chaucer (c.1340–1400) is the father of English poetry. His best known work, *The Canterbury Tales*, is a collection of stories set in a framing tale about a band of pilgrims on their way from London to the shrine of Thomas à Becket in Canterbury. The framework resembles that of Boccaccio's *Decameron*, with which Chaucer was familiar, but Chaucer's cultivated irony and robust comedy are unprecedented. Each pilgrim tells a tale which is funny or serious, satirical or philosophical, but always insightful. Each tale reveals the character of the pilgrim telling it. Here are the *Cook's Prologue* and *Tale*.

The Cook's Prologue

The cook from London, while the reeve yet spoke,
Patted his back with pleasure at the joke.
"Ha, ha!" laughed he, "by Christ's great suffering,
This miller had a mighty sharp ending
Upon his argument of harbourage!
For well says Solomon, in his language,
'Bring thou not every man into thine house;'
For harbouring by night is dangerous.
Well ought a man to know the man that he
Has brought into his own security. 10
I pray God give me sorrow and much care
If ever, since I have been Hodge of Ware,
Heard I of miller better brought to mark.
A wicked jest was played him in the dark.
But God forbid that we should leave off here;
And therefore, if you'll lend me now an ear,
From what I know, who am but a poor man,
I will relate, as well as ever I can,
A little trick was played in our city."
 Our host replied: "I grant it readily. 20
Now tell on, Roger; see that it be good;
For many a pasty have you robbed of blood,
And many a Jack of Dover have you sold
That has been heated twice and twice grown cold.
From many a pilgrim have you had Christ's curse,
For of your parsley they yet fare the worse,
Which they have eaten with your stubble goose;
For in your shop full many a fly is loose.
Now tell on, gentle Roger, by your name.
But yet, I pray, don't mind if I make game, 30
A man may tell the truth when it's in play."
 "You say the truth," quoth Roger, "by my fay!
But 'true jest, bad jest' as the Fleming saith.
 And therefore, Harry Bailey, on your faith,
Be you not angry ere we finish here,
If my tale should concern an inn-keeper.
Nevertheless, I'll tell not that one yet.
But ere we part your jokes will I upset."
 And thereon did he laugh, in great good cheer,
And told his tale, as you shall straightway hear. 40

THUS ENDS THE PROLOGUE OF THE COOK'S TALE

The Cook's Tale

There lived a 'prentice, once, in our city,
And of the craft of victuallers was he;
Happy he was as goldfinch in the glade,
Brown as a berry, short, and thickly made,
With black hair that he combed right prettily.
He could dance well, and that so jollily,
That he was nicknamed Perkin Reveller.
He was as full of love, I may aver,
As is a beehive full of honey sweet;
Well for the wench that with him chanced to meet. 10
At every bridal would he sing and hop,
Loving the tavern better than the shop.
 When there was any festival in Cheap,
Out of the shop and thither would he leap,
And, till the whole procession he had seen,
And danced his fill, he'd not return again.
He gathered many fellows of his sort
To dance and sing and make all kinds of sport.
And they would have appointments for to meet
And play at dice in such, or such, a street. 20
For in the whole town was no apprentice
Who better knew the way to throw the dice
Than Perkin; and therefore he was right free
With money, when in chosen company.
His master found this out in business there;
For often-times he found the till was bare.
For certainly a revelling bond-boy
Who loves dice, wine, dancing, and girls of joy—
His master, in his shop, shall feel the effect,
Though no part have he in this said respect; 30
For theft and riot always comrades are,
And each alike he played on gay guitar.
Revels and truth, in one of low degree,
Do battle always, as all men may see.
 This 'prentice shared his master's fair abode
Till he was nigh out of his 'prenticehood,
Though he was checked and scolded early and late
And sometimes led, for drinking, to Newgate;
But at the last his master did take thought,
Upon a day, when he his ledger sought, 40
On an old proverb wherein is found this word:
"Better take rotten apple from the hoard
Than let it lie to spoil the good ones there."
So with a drunken servant should it fare;
It is less ill to let him go, apace,
Than ruin all the others in the place.
Therefore he freed and cast him loose to go
His own road unto future care and woe;
And thus this jolly 'prentice had his leave.
Now let him riot all night long, or thieve. 50
 But since there's never thief without a buck
To help him waste his money and to suck
All he can steal or borrow by the way,
Anon he sent his bed and his array
To one he knew, a fellow of his sort,
Who loved the dice and revels and all sport,
And had a wife that kept, for countenance,
A shop, and whored to gain her sustenance.

OF THIS COOK'S TALE CHAUCER MADE NO MORE.[5]

THEATRE

Probably because of their relationship to the Church, major movements in the arts in the 12th to 15th centuries were reasonably unified and widespread. Although local diversity was common, styles were generally alike. The theatre was no exception. As the Middle Ages progressed, drama associated with the Church followed the example of painting and included more and more Church-related material. Earliest Church drama, that is, the trope, was a simple elaboration and illustration of the Mass. The subject matter of later drama included Bible stories (mystery plays), lives of the saints (miracle plays), and didactic allegories (morality plays), which had characters such as Lust, Pride, Sloth, Gluttony, and Hatred.

Theatrical development throughout Europe (including Germany, Italy, and Spain) appears to have followed a similar route, although the dates were different. Tropes were performed in the sanctuary, using niches around the church as specific scenic locations. On special occasions, cycles of plays were performed, and the congregation moved to see different parts of the cycle. It is hard to pinpoint specific developments, even in specific churches, but clearly these dramatizations quickly became very popular.

Over the years, production standards for the same plays changed drastically. At first only priests performed the roles; later laymen were allowed to act in liturgical drama. Female roles were usually played by boys, but some evidence suggests that women did participate occasionally. The popularity of church drama soon made it impractical, if not impossible, to contain the audience within the church building. Evidence also suggests that as laymen assumed a greater role, certain vulgarities were introduced. Comedy and comic characters appeared, even in the Easter tropes. For example, on their way to Jesus' tomb, the three Marys stop to buy ointments and cloths from a merchant. This merchant developed into one of the earliest Medieval comic characters. The most popular comic character of all, of course, was the devil.

Church drama eventually moved outside the sanctuary and, like Church architecture and sculpture, opened up to the common man and woman. As Medieval drama moved out of the Church, various production practices developed in different places. In France and Italy, the stationary stage decoration of the church interior became a mansion stage (Fig. 9.18), so-called because the different areas represented "mansions," or houses. The specific configuration of the mansion stage differed from location to location. In Italy it was rectangular and linear, designed to be viewed from one or two sides. In some parts of France, arena staging, in which the audience completely surrounded the stage area, was introduced. Whatever the specific application, the mansion stage had a particular set of aesthetic conventions that made its style unique. The individual mansions depicted their

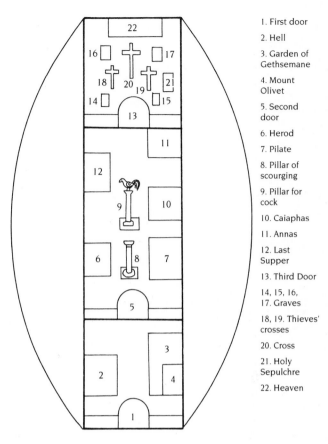

1. First door
2. Hell
3. Garden of Gethsemane
4. Mount Olivet
5. Second door
6. Herod
7. Pilate
8. Pillar of scourging
9. Pillar for cock
10. Caiaphas
11. Annas
12. Last Supper
13. Third Door
14, 15, 16, 17. Graves
18, 19. Thieves' crosses
20. Cross
21. Holy Sepulchre
22. Heaven

9.18 Plan of a Medieval mansion stage, showing the mansions in the Donaueschingen Mystery Play, Germany.

locations realistically. At the same time, areas between the mansions could serve as any location.

The most interesting depiction on the medieval stage was that of hell, or hellmouth (the mouth of hell into which sinners were cast). Audiences demanded more and more realism and complexity in the depiction of hellmouth (compare this with similar changes in Gothic sculpture). Descriptions of devils amidst smoke and fire, pulling sinners into the mouth of hell, often the jaws of a dragon-like monster, are common (Fig. **9.19**). One source describes a hellmouth so complicated that it took 17 people to operate it. Some plays, *Antecriste* and *Domes Daye*, for example, were clearly intended to be frightening. But in the late Middle Ages, even vividly depicted hellmouths seem to have been comic in their intentions, rather than fearsome. Plays of the period are humorous and compassionate, clearly reflecting the cultural change in attitude.

When the action of a play moved away from a specific mansion, the aesthetic became conventional, just as we saw in classical Greek theatre. That is, the stage could represent *any* place, as opposed to the representation of place found in the mansion. The text of the play told the audience where the action was supposed to occur, and the audience then imagined that locale.

9.19 The Valenciennes Mystery Play, 1547. Contemporary drawing. Bibliothèque Nationale, Paris.

In England and parts of France and the Netherlands, another staging style developed. Rather than move the audience or set up all the locations in different places on a mansion stage, theatre was brought to the audience on a succession of pageant wagons, like the floats of a modern parade. Each wagon carried the set for a specific part of the play cycle. Many of these wagons were very elaborate, two stories tall, and curtained for entrances and exits like a modern theatre. In some cases, a flat wagon was combined with an elaborate background wagon to provide a playing area. This type of production was mostly used in cities where narrow wagons were needed to negotiate narrow streets. At intersections where there was more space, wagons were coupled and crowds gathered to watch a segment of the play. When the segment finished, the wagon moved on, and was shortly replaced by another wagon that served as the setting for another short play in the cycle.

As time progressed, theatrical production became more and more elaborate and realistic. Many productions were extremely complicated in detail and direction. Live birds, rabbits, and lambs gave life to the play, as did elaborate costumes that represented specific characters. Bloody executions, wounds, and severed heads and limbs were very common in later Medieval drama.

When drama moved out of the church, local guilds began to assume responsibility for various plays. Usually the topic of the specific play dictated which guild took charge of it. For example, the watermen performed the Noah play, and cooks presented The Harrowing of Hell because things—in this case, sinners—were baked, boiled, and put into and out of fires. Increasing secularization and philosophical division of the 14th-century Church and state gave rise to a separate secular theatrical tradition which led, in the 15th century, to French farce. Even religious drama came under secular professional control in France when King Charles VI granted a charter in 1402 to the Confrérie de la Passion.

A typical mystery play was the Adam of early 12th-century France. It was performed in the vernacular, and began by reminding the actors to pick up their lines, to pay attention so as not to add or subtract any syllables in the verses, and to speak distinctly. The play told the biblical story of Adam, and was probably played in the square outside the church, with the actors retiring into the church when not directly involved in the action.

A play of the 13th century, Le Jeu de Saint Nicholas by John Bodel of Arras, illustrates the expanding subject matter of Christian drama. The play is set in the Holy Land amid the battles between the Christian crusaders and the Infidels. In the battle, all the Christians are killed except a Monsieur Prudhomme who prays to St Nicholas in the presence of the Saracen king. The king is told that St Nicholas will safeguard his treasure, and when St Nicholas actually intervenes to foil a robbery attempt, the king is converted. Similar plays dealing with the conversion of historical figures (usually amidst attempts to ridicule Christianity or vilify Christians) were very popular, as

were plays about the intercessions of Mary, called "Mary-plays." The most famous play of this era is *Everyman*. It is a morality play in which the hero undertakes a journey to his death. He seeks the company of all those earthly things on which he has counted: Fellowship, Kindred, Goods, for example. However, each one refuses. Beauty, Strength, Discretion, and Five Wits all desert him as he approaches the grave. Good Deeds alone accompanies him.

MUSIC

Paris was the center of musical activity in the 12th and 13th centuries. Perhaps in response to the additional stability and increasing complexity of life, music now became more formal in notation and in structure, and also it increased in textural complexity. Improvization had formed the basis of musical composition. Gradually musicians felt the need to write down compositions—as opposed to making up each piece anew along certain melodic patterns every time it was performed. As a result, in the late Middle Ages "musical composition" became a specific and distinct undertaking.

Music was often transmitted from performer to performer or from teacher to student. Standardized musical notation now made it possible for the composer to transmit ideas directly to the performer. The role of the performer thus changed, making him or her a vehicle of transmission and interpretation in the process of musical communication.

As the structure of musical composition became more formal during this period, conventions of rhythm, harmony and mode (similar to our concept of key) were established. Polyphony began to replace monophony, although the latter continued in chants, hymns, and other forms during this time.

Ars antiqua and Ars nova

Each of these developments contributed so distinctly to music that modern scholars refer to the mid-12th and 13th centuries as *ars antiqua*, or the "old art." In the 14th century, music underwent notable change, and came to be described as *ars nova*, or "new art."

Music of *ars antiqua* was affected by the same change of attitude as two-dimensional art and sculpture—a more rational, as opposed to emotional, underlying approach and feeling. A number of forms typify 12th- and 13th-century music. Among these are *organum*, an early sacred form of music, sung in Latin. At first *organum* used two parallel melodic lines, based on a plainsong theme, moving in exactly the same rhythm, and separated by a fixed interval. Later, a third or fourth voice was added. By the 12th century, the various voices were no longer restricted

to singing parallel lines. The plainsong melody remained in long notes in a low voice, as the basis of the music structure. Meanwhile the upper voices had more interesting, freely flowing lines to sing.

Alongside *organum* existed secular songs such as BALLADES and RONDEAUX. These were vernacular songs in set forms, usually easy to listen to and direct in appeal. Some were dance-like, often in triple meter. The tradition of the troubadour and the wandering entertainer continued, and the courtly approach found in music and poetry an exquisite forum for its love-centered philosophy. But the most important new form of the 13th century was the MOTET, whose name probably derives from the French word *mot*, meaning "word." As in *organum*, the motet used a plainsong melody in long held notes in a low voice, while upper parts were more elaborate. Motets were written not only for the Church, but also for secular use, with the upper voices singing non-religious words over the plainsong.

The 14th century witnessed a distinct change in musical style. Music of the *ars nova* was more diverse in its harmonies and rhythms. Passages of parallel fifths, with the bare, haunting sound characteristic of Medieval music, were used less frequently than passages of parallel thirds and sixths, which sound more harmonious to modern listeners. In this period the MADRIGAL began to emerge. It was a poetic form, with texts about love and the beauty of nature. Written initially for two or three voices, it was usually lively and polyphonic, with all the voices imitating each other.

As music, like theatre, moved out of the Church sphere, it reflected the philosophical separation of revelation and reason and the political separation of Church and state. In addition, by the turn of the 15th century, the previously distinct French and Italian Medieval musical styles were starting to merge into an international style.

Instruments

We still have much to learn about the instruments of this period. Their timbres were probably clear and shrill. But about all we can add to our description of early Medieval instruments is the observation that performing ensembles, whether vocal or instrumental, seem to have had few members. Composition was formal, but composers apparently did not indicate on a score the instrument for a given part. Tradition was so strong that composers did not need to write out directions. (Or it could be that several options would have been equally acceptable in a given situation.)

We should note in passing the invention in the 14th century of the first keyboard instruments of the harpsichord variety. These did not come into wide use until a century later, however.

DANCE

Dance was part of Medieval religious and secular activity, but with the exception of pantomime, examples of which have perished, theatre dance was less important than forms of group dancing. Fascinating illustrations survive of the "ring dance," for example, in which 12 dancers representing the apostles and the zodiac danced in a circle. Amid the ravages of the Plague, the DANSE MACABRE, or dance of death, appeared. Whipped by hysteria, people danced in a frenzy until some dropped dead of exhaustion. *Choreomania*, an English version of the *danse macabre*, seems to have expressed a kind of group psychosis in the throes of which the participants engaged in all kinds of demented behavior, including self-flagellation. Numerous folk and court dances also existed.

Within the courtly tradition, theatre dance was reborn. Dances done at court were performed to instrumental accompaniment. A certain degree of expressiveness and spontaneity marked these court dances, but increasingly they conformed to specific rules. Dance that was performed in the course of court theatricals employed professional entertainers. These performances depended to a large degree upon the guiding hand of the dancing master, who was perhaps more like a square-dance caller than a ballet master or choreographer.

Documentation of theatre dance adequate for any detailed discussion of the form, however, must wait for a later age.

ARCHITECTURE
Gothic style

Although Gothic style in architecture took many forms, it is best exemplified by the Gothic cathedral. In its synthesis of intellect, spirituality, and engineering, the cathedral perfectly expresses the Medieval mind. Gothic style was widespread in Europe. Like the other arts it was not uniform in application, nor was it uniform in date. Initially a very local style, on the Île de France in the late 12th century, it spread outward to the rest of Europe. It had died as a style in some places before it was adopted in others. The "slipping, sliding, and overlapping" pattern of artistic development fully applies to Gothic architecture.

The cathedral was, of course, a Church building whose purpose was the service of God. However, civic pride as well as spirituality inspired the cathedral builders. Local guilds contributed their services in financing or in building the churches, and guilds were often memorialized in special chapels and stained-glass windows. The Gothic church occupied the central, often elevated, area of the town or city. Its position symbolized the dominance of the universal Church over all human affairs, both spiritual and secular. Probably no other architectural style has exercised such an influence across the centuries. The story of the Gothic church is an intricate and fascinating one, only a few details of which we can highlight here.

The beginnings of Gothic architecture can be pinpointed to between 1137 and 1144, in the rebuilding of the royal Abbey Church of St Denis near Paris (Figs **9.20** and **9.21**). There is ample evidence that Gothic style was a physical extension of philosophy, rather than a practical response to the structural limitations of the Romanesque style. That is, Gothic theory preceded its application. The philosophy of the Abbot Suger, who was advisor to Louis VI and a driving force in the construction of St Denis, held three main points. Harmony, the perfect relationship of parts, is the source of beauty; divine light is a mystic revelation of God; and space is symbolic of God's mystery. The composition of St Denis and subsequent Gothic churches clearly expressed that philosophy. As a result, Gothic architecture is more unified than Romanesque. Gothic cathedrals use refined, upward-striving lines to symbolize humanity's upward striving to escape the bounds of earth and enter the mystery of space (the kingdom of heaven).

9.20 Exterior of the Abbey Church of St Denis, near Paris, 1140–44.

9.21 Interior of the Abbey Church of St Denis.

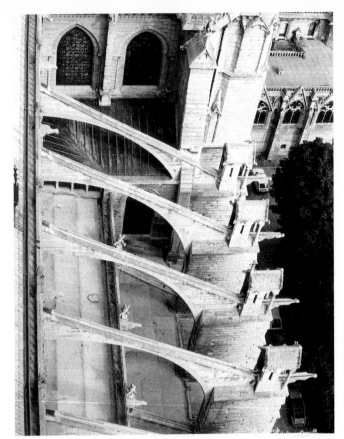

9.22 Notre Dame, Paris, flying buttresses, 1163–1250.

9.23 Notre Dame, Paris, west front, 1163–1250.

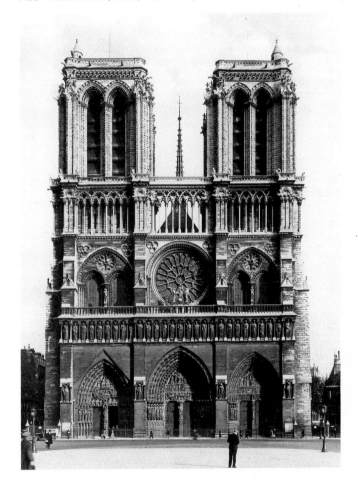

The pointed arch is the most easily identifiable characteristic of this style. It represents not only a symbol of Gothic spirituality, but also an engineering practicality. The round arch of the previous era places tremendous pressure on its keystone, which then transfers thrust outward to the sides. But the pointed arch redistributes the thrust of downward force in more equal and controllable directions. It controls thrust by sending it downward through its legs, and it also makes design flexibility possible. The Gothic arch also increases the sense of height in its vaults. Some have said that Gothic structure actually made increased heights possible, but this is not quite correct. Some Romanesque churches had vaults as high as those in Gothic churches. It is the possibility of changing the proportion of height to width that increases the *apparent* height of the Gothic church.

Engineering advances implicit in the new form made possible larger clerestory windows, which let in more light. And more slender ribbing placed greater emphasis on space, as opposed to mass. On the exterior, the outward thrust of the vaults is carried gracefully to the ground through a delicate network of ribs, vaults, and flying buttresses (Fig. **9.22**). Every detail of the decorative tracery is carefully integrated into a system that emphasizes mysterious space.

Three examples characterize Gothic style and illustrate the marvelous diversity that existed within it. The four-square power of Notre Dame de Paris (Fig. **9.23**) reflects the strength and solidity of an urban cathedral in Europe's greatest city of the age. Its careful design is

highly mathematical—each level is equal to the one below it, and its three-part division is clearly symbolic of the Trinity. Arcs (whose radii are equal to the width of the building) drawn from the lower corners meet at the top of the circular window at the second level. The effect of this design is to draw the eye inward and slowly upward. The exterior structure clearly reveals the interior space, as it did not in Romanesque buildings.

Chartres Cathedral (Fig. **9.24**) stands in remarkable contrast. Chartres is a country cathedral that rises above the centre of a small city. Just as its sculptures illustrate a progression of style (see Figs **9.13** and **9.14**), so does its architectural design. At first glance we wonder why its cramped entry portal is so small in comparison with the rest of the building. The reason is that Chartres was not built all at once. Rather, it was built cumulatively over many years, as fire destroyed one part of the church after another. The main entry portal and the windows above it date back to its Romanesque beginnings. The porch of the south transept (Fig. **9.27**, the portal holding the statues of the warrior saints) is much larger and more in harmony with the rest of the building.

Our biggest question, however, concerns the incongruity of the two unmatched spires. Again, fire was

9.24 Chartres Cathedral, west front, 1145–1220.

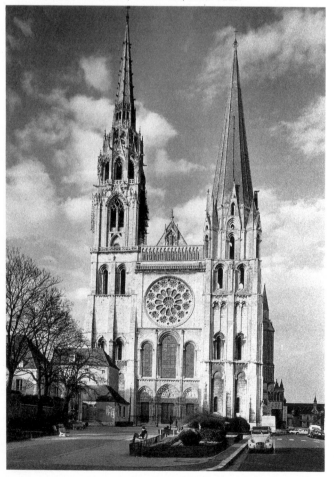

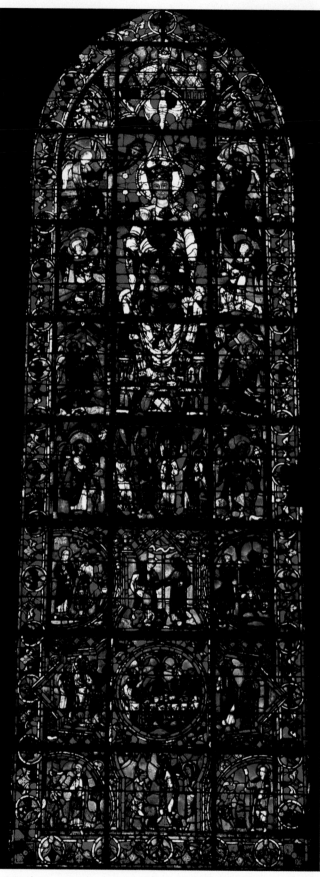

9.25 Chartres Cathedral, *Notre Dame de Belle Verrière*.

9.26 Chartres Cathedral, rose window, north transept, c.1230. Diameter 42ft 8ins (13m).

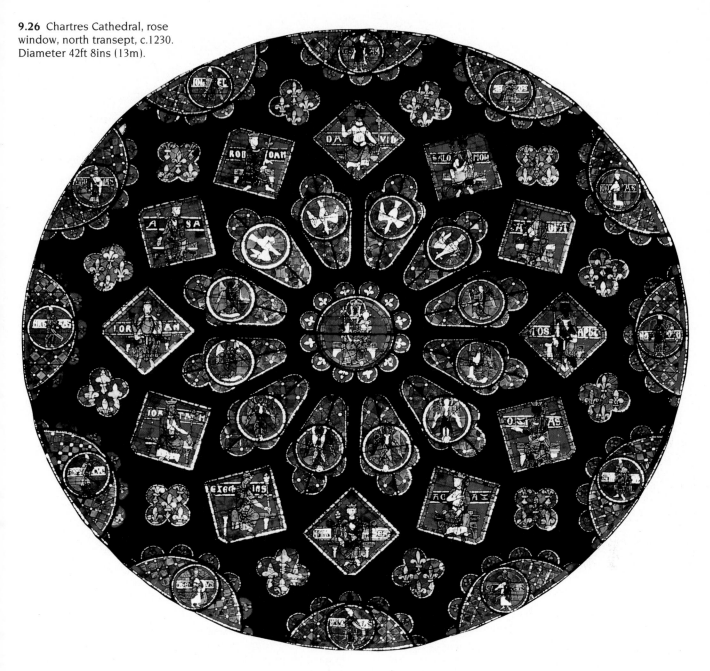

responsible. The early spire, on the right, illustrates faith in its simple upward lines rising, unencumbered, to disappear at the tip into the ultimate mystery of space. The later spire is more ornate and complex. The eye travels up it with increasing difficulty, its progress halted and held by decoration and detail.

A major difference between the Gothic style and the Romanesque lies in the fenestration. Gothic-style walls are pierced by windows that take the form of sparkling jewels of stained glass, such as the *Notre Dame de Belle Verrière* ("Our Lady of the Beautiful Window") of Chartres Cathedral (Fig. **9.25**). Stained-glass windows replaced the wall paintings of the Romanesque and the mosaics of the Byzantine style. Their ethereal, multicolored light further mysticized the spiritual experience of the Medieval worshipper. Light now became a further property for artistic manipulation and design. The loveliness and intricacy typical of the art of Medieval stained glass can also be seen in the magnificent rose window of the north transept of Chartres Cathedral (Fig. **9.26**). In the center, the Virgin Mary sits with the Christ child on her knee. Around her, panels are grouped together in series of 12, an important symbolic number in the Middle Ages. Angels, archangels, and four white doves represent the Gospel and the Holy Spirit. In the squares appear the kings of Israel, named by St Matthew as the ancestors of Joseph, while the prophets sit on the outer edge of the window. Every element in the design leads the eye to the focal center, the Virgin and Child, and, thereby, draws together the Old and New Testaments.

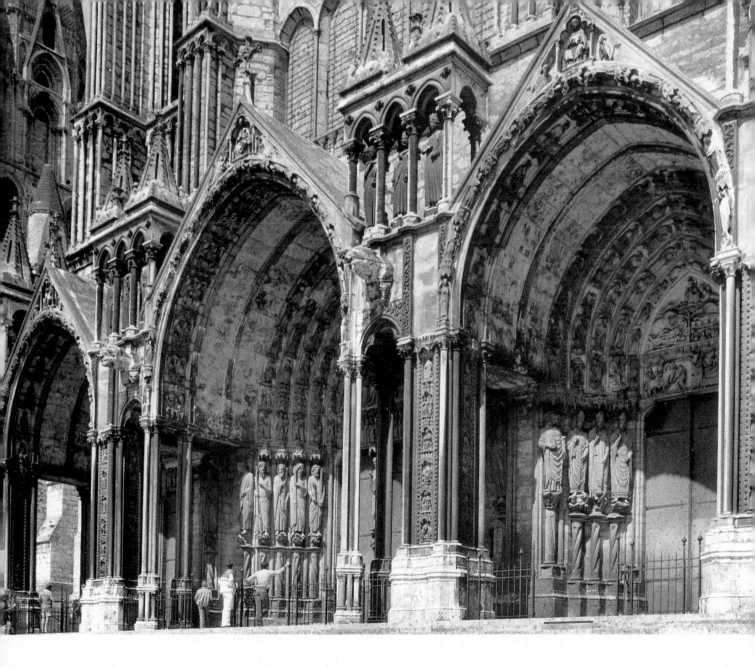

The Cathedral at Amiens (Fig. **9.28**) is similar to Notre Dame. Rather than creating a sense of power, however, it has a delicate feel. Amiens Cathedral illustrates late developments in Gothic style similar to those that appear in the left spire of Chartres. In scale and proportion, however, Amiens is more like Notre Dame. The differences between Amiens and Notre Dame provide an important lesson in the ways design can be used to elicit a response. Amiens is more delicate than Notre Dame, and this feeling is enhanced by the greater detail that focuses our attention on space rather than flat stone. Both cathedrals are divided into three very obvious horizontal and vertical sections of roughly the same proportion. Notre Dame appears to rest heavily on its lowest section, the proportions of which are apparently diminished by the horizontal band of sculptures above the portals. Amiens, on the other hand, carries its portals upward to the full height of the lower section. In fact, the lines of the central portal, which is much larger than the central portal of Notre Dame, combine with the lines of the side portals to form a pyramid whose apex penetrates into the section above. The roughly similar size of the portals of Notre Dame reinforces its horizontality, and this is what gives it stability. Every use of line, form, and proportion in Amiens reinforces lightness and action. Everything about the appearance of Notre Dame reinforces stability and strength. One design is no better than the other, of course. Nevertheless, both cathedrals are unquestionably Gothic, and the qualities that make them so are easy to identify.

The importance of stained-glass windows in Gothic cathedrals cannot be overemphasized. They carefully control the light entering the sanctuary, and the quality of that light reinforces a marvelous sense of mystery. With the walls of the Romanesque style replaced by the space and light of the Gothic style, these windows take the place of wall paintings in telling the story of the gospels and the saints.

9.27 (opposite) Chartres Cathedral, south transept porch, c.1205–50.

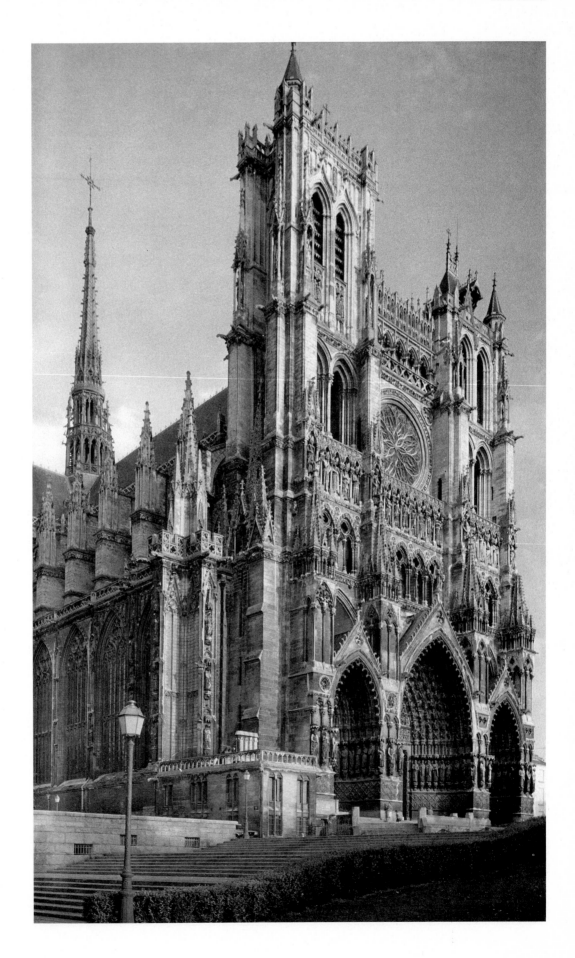

9.28 Amiens Cathedral, west front, c.1220–59.

MASTERWORK
Salisbury Cathedral

The Cathedral Church of the Blessed Virgin Mary at Salisbury (Fig. **9.1**) is famous more for its beauty than for its historical associations. Its breathtaking spire nearly caused the building to collapse when it was added. A graceful work of architecture, it has been celebrated widely, especially in the paintings of John Constable.

The building of Salisbury Cathedral came under the supervision of Canon Elias de Dereham, who is associated with other famous buildings such as the great hall of Winchester Castle. With the exception of St Paul's Cathedral in London, Salisbury is the only English cathedral whose entire interior structure was built to the design of a single architect and completed without a break. This was accomplished in 1265. What is perhaps the most perfect part of the cathedral, however, took another 55 years to complete. The famous spire, built between 1285 and 1310, added an additional 404 feet to a very squat tower which rose only a few feet above the nave. The spire thus became the highest in England and the second highest in Europe. Unfortunately, the piers and foundations were not designed to carry the additional 6400 tons, and masons were forced to add a strong stone vault at the crossing of the nave below the tower, one of the few stylistic modifications in the building. An extensive system of internal stone BUTTRESSES was built into the thickness of the clerestory walls in order to resist the thrust of the main arches on all four sides. An additional group of external flying buttresses was added to the main aisle walls running up the tower. Even so, the spire proved too heavy for the supporting walls, and the pillars began to bend and the walls to shift. In the 15th century, two great stone girder-arches were added at the entrances to the main transepts between the piers supporting the spire. So, although the entirety of Salisbury is designed in the Early English style, the first of the later additions represents the Decorated style while the second addition is in the Perpendicular style. These last corrections succeeded in stabilizing the building after a displacement of only three and one half inches.

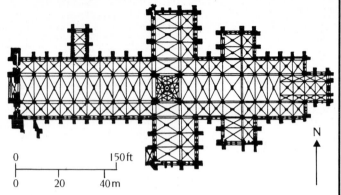

9.29 Plan of Salisbury Cathedral, England.

Compared to the soaring vertical cathedrals of France, Salisbury seems long, low, and sprawling. The west front functions more as a screen wall, wider than the nave, whose horizontal bands of decoration further emphasize the horizontal thrust of the building. The plan of the cathedral (Fig. **9.29**), with its double transept, is reminiscent of the earlier Romanesque style. The same emphasis on the horizontal appears in the interior, where the nave wall looks more like a succession of arches and supports (Fig. **9.30**). Typical of Early English Gothic, the nave vaults curve steeply with their ribs extending down to the TRIFORIUM level, thereby tucking the clerestory windows into the vaults. Also characteristic of the Early English style is the use of dark marble for the COLONNETTES and capitals. The building is free of tracery, and the LANCET WINDOWS are grouped in threes and fives.

Part of the original splendor of Salisbury has been lost due to the replacement of its magnificent stained-glass windows. It seems likely that the windows originally contained mainly glass formed into geometrical patterns with patches of color making part of the pattern. Much of this glass was destroyed during the Commonwealth and Reformation periods of the 16th and 17th centuries. In the 18th century, in an attempt to "restore and beautify" the cathedral, what remained of the stained glass was replaced by plain glass, to increase the available light. Only three windows retain anything but plain glass.

9.30 (opposite) Salisbury Cathedral, nave and choir.

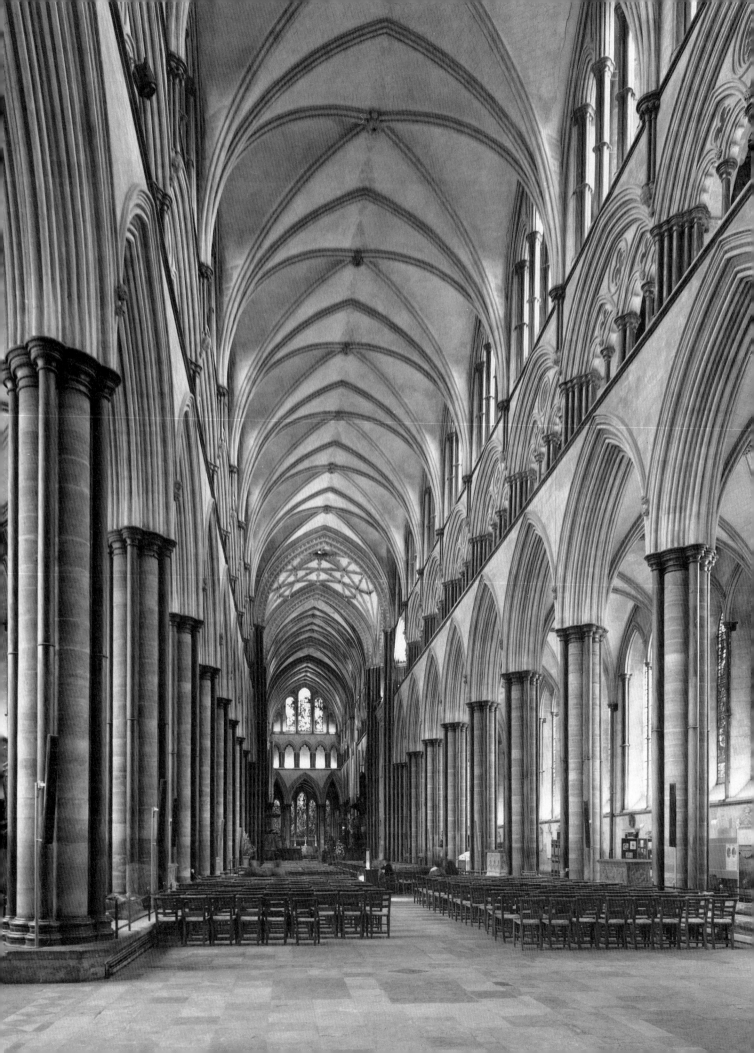

9.31 The Doges' Palace, Venice, Italy, c.1345–1438.

Secular Gothic

A unique version of the Gothic style in architecture developed in Venice in the 14th century. It was used in particularly for non-religious buildings, and one of the most delightful examples is the Doges' Palace (Fig. **9.31**). It represents a direction in architecture developed specifically for the palaces of the rich and powerful merchant class. Begun in the 1340s, the palace was designed to serve the function of a large meeting hall for the *Maggior Consiglio*, the elective assembly of the Republic of Venice. Remarkable for this time is the sense of openness and tranquility the building exhibits. The absence of fortress features and function reflects the relative peace that the republic enjoyed at the time. The solidity of the upper storeys above the open colonnades gives the building an almost top-heavy appearance; the rather squat proportions of the lower arcade detract from the delicacy of the overall design. The treatment of the Gothic arch and style is mixed with an eastern influence in the patterning of the brickwork. The result illustrates a particularly Venetian inventiveness, which one can often find in the city, as European and Moorish influences intermix.

SYNTHESIS
The Gothic temperament in England

In England, as in the rest of the Medieval world, the Catholic Church was the center of the spiritual community and, at least partly, of the secular community as well. It was a time of expanding horizons, a time of greater openness as the Gothic mind let light into the barricaded Romanesque darkness. Into each corner of the European world crept individual national characteristics. And in England, the changing styles and pervasive humor of the English peasant found their way into art.

Peasant restiveness led to a revolt against Richard II, which came to be known as Wat Tyler's rebellion. The attitudes behind that uprising are vividly expressed in the *Second Shepherd's Play*, part of a passion play whose folk spirit is typically English. Hilarious farce exudes from this part of the Wakefield Cycle, as we hear the invented story of Mak, who steals a sheep and hides it in his wife's bed. This is followed by the journey of the shepherds to the manger to see the Christ child. A one-act play, this masterpiece of English farce is full of comic characterizations drawn very realistically. Mak, the sheep stealer, lives by his wits in the hard world and when under pressure simply brazens it out.

Throughout the play the characterizations remain consistent. One of the interesting features of the *Second Shepherd's Play* is the way in which location and "reality" are invented. In the last episode, the very English shepherds journey to Bethlehem—apparently not far from England. Throughout the play is a sense of wonder, of Medieval faith—mystical and unquestioning. Amidst the farce, though, the shepherds grumble amusingly about social injustice and the inequalities of domestic life. Mak complains about poverty, and yet all of his complaints, misbehavior, bad weather, and harsh words seem to melt into the mystery of the nativity. In the end, everything leads to the necessity of redemption from suffering, sin, and evil.[6]

Medieval English humor found another outlet in manuscript illumination, in a form known as *drôlerie*, which began to appear in the margins of books in the 13th century. From these illuminations comes a wealth of information on contemporary costume, customs, social behavior, musical instruments, and even a few individual eccentricities. They show a taste for exaggerated, elongated forms and a love of lavish decorations. These margin drawings also found their way into religious books, for example the Psalter of Alfonso (Fig. **9.32**).

The Gothic spirit found expression in church building here as elsewhere. The architecture of the period between 1280 and 1375 is called the Decorated style. During this time, English buildings evolved exuberant forms that anticipated late Gothic styles in Germany and France.

In Exeter Cathedral (Fig. **9.33**) we see the decorative effect in every detail. Moldings multiply and the ribs of the vaulting proliferate and project boldly. At Wells Cathedral (Fig. **9.34**), 11 ribs spring from each bay boundary, giving an overwhelming richness of linear form and a complex interplay of light and shade. At Wells, four so-called "STRAINER ARCHES" appear between the CROSSING piers. This unusual feature serves a structural purpose

9.32 *Drôlerie*, from the Psalter of Alfonso, 1284. British Library, London.

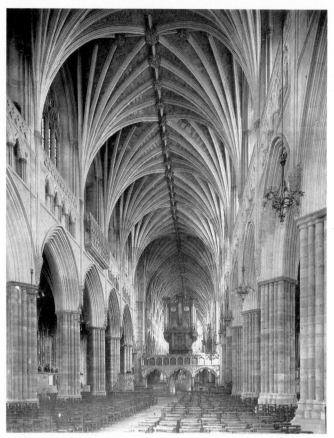

9.33 Exeter Cathedral, England, interior looking toward the east, 1280–1350.

9.34 Wells Cathedral, England, arches of crossing, 1338.

and also adds a striking element to the design.

The crossing tower of Ely Cathedral (Fig. **9.35**) was rebuilt on an octagonal plan in 1323. This was quite a dramatic departure from the rectangular plan of the Romanesque transept and nave. An octagonal LANTERN rises above the crossing, seemingly suspended in mid-air.

A similar tendency toward richness and surprise is shown in a series of English canopied tombs. Here sculpture and architecture complement each other. Canopied tombs originated in France, and illustrate the influence of French sculpture in England. Figure **9.36** shows the tomb of Edmund Crouchback, Earl of Lancaster and youngest son of Henry III. This tomb and others like it feature sculptures of the deceased displayed in rich architectural settings. Every possible surface is covered with lavish decorative sculpture.

We also find increasing complexity in the English Gothic style in the window traceries at Lincoln Cathedral (Fig. **9.37**). In some cases, window traceries extended to cover adjacent wall surfaces, a practice that was strictly decorative. English architects took this decorative device

9.36 Tomb of Edmund Crouchback, Earl of Lancaster, c.1300. Westminster Abbey, London.

9.37 (right) Lincoln Cathedral, England, rose window, southwest transept, 1325–50.

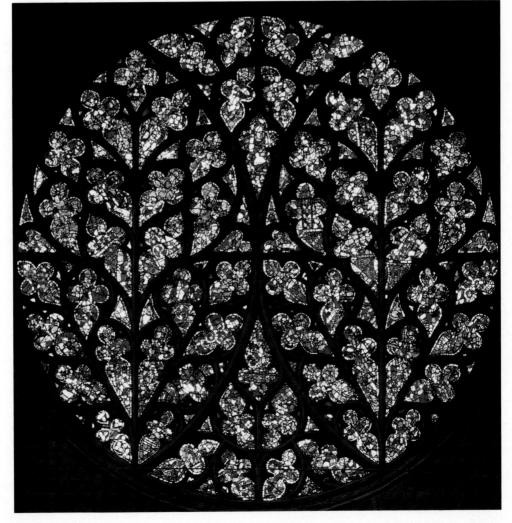

9.35 (opposite) Ely Cathedral, England, interior and lantern of crossing tower, 1323–30.

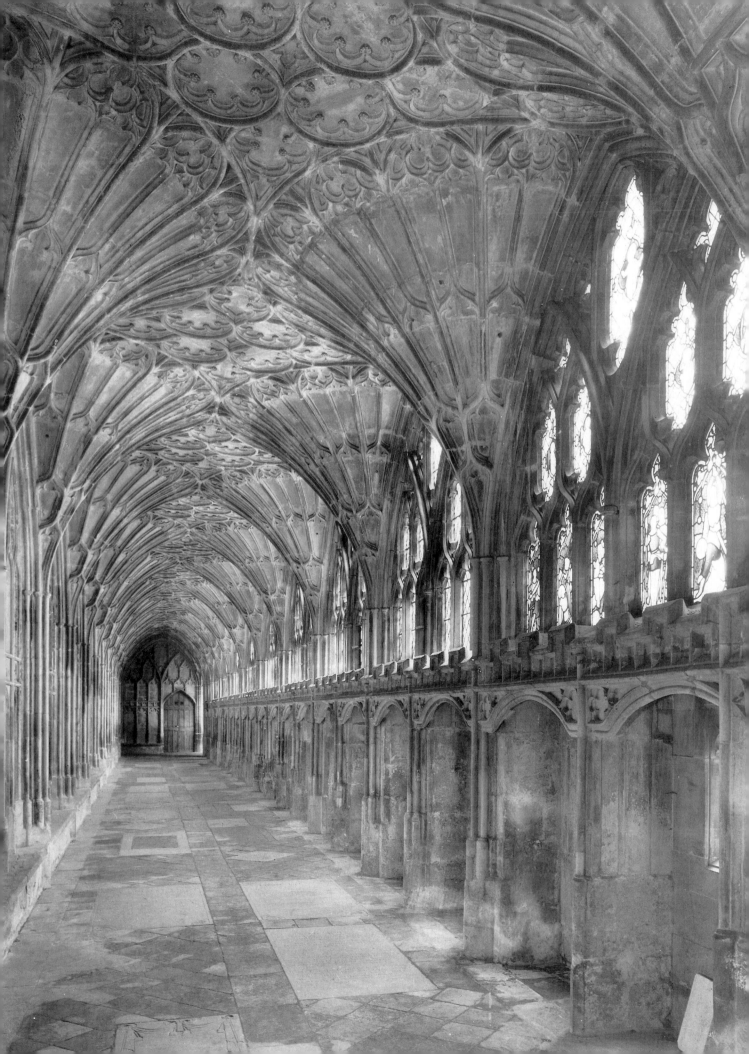

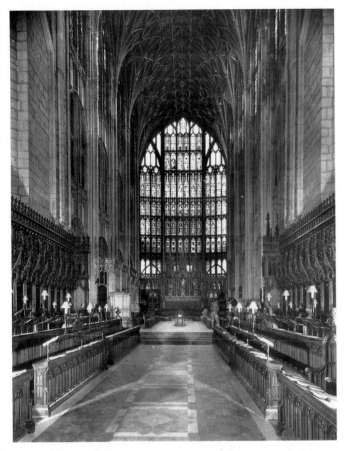

9.39 Gloucester Cathedral, England, interior of choir looking toward the east, rebuilt c.1330.

and developed it into a highly orginal version of late Gothic style known as the Perpendicular style. It began in London and spread elsewhere. For example, the early Romanesque choir of Gloucester Cathedral (Fig. **9.39**) was reshaped in the 1330s according to the new style. The east wall was replaced by a huge window with vertical and horizontal traceries. The solid Romanesque side walls were covered with thin, delicate traceries. The new decorations were even extended high up into the vaulting.

Further examples of the inventiveness of late English Gothic in FAN VAULTING can be found in the south CLOISTER of Gloucester Cathedral (Fig. **9.38**). Here the vault becomes more complex, employing cone-like forms. By the 15th century, the fan vault had been perfected and was used in a number of late Gothic royal buildings.

The Gothic spirit in England, whether written in stone, story, or ink, reflected the awakening of the western world to a new light of faith and expanding horizons. As the Romanesque Middle Ages opened up, life became a positive enterprise rather than a vale of tears from which only death could bring release.

9.38 (opposite) Gloucester Cathedral, south cloister, before 1377.

SUGGESTIONS FOR THOUGHT AND DISCUSSION

The struggle for supremacy between popes and monarchs in the late Middle Ages reflected the increasing division between things secular and things spiritual. The struggle became more intense as an increasingly international Church clashed with growing nationalistic claims. Yet a sense of stability and order was also emerging, and a drastic change in attitude occurred with the transition from the values of feudalism to the code of chivalry. The rise of the middle class became a balancing weight between the aristocracy and clergy on the one hand and the serf on the other.

Space and light replaced the cloistered darkness of the early Middle Ages. An age of greater tolerance and rationalism was fueled by the ideas of Bernard of Clairvaux, Abelard, and Thomas Aquinas. Revelation and reason were seen as alternative ways of knowing, and the search for a synthesis of Platonic and Aristotelian thought with Christian theology dominated intellectual activity.

Mysticism, spirituality, and allegory existed alongside rationality, space, and relaxation in the arts and in late Medieval life in general. Sacred numbers dominated design. A new attempt to comprehend the infinite and to bring humanity together with deity in a comfortable relationship found expression in intellectual life, in the visual and performing art, and, above all, in the Gothic cathedral—the great symbol of Medieval intellect, engineering, and spirituality.

■ What is the difference between cognitive truth and revealed truth?

■ What inter-relationships can you find among the arts, chivalry, and the teachings of Bernard of Clairvaux?

■ How do these concepts differ from the concepts and their artistic reflections of the early Middle Ages?

■ How does Thomas Aquinas further develop Augustine's neo-Platonic ideas? How do these contrast with Aristotelian ideas?

■ How do the new concepts of space and light illustrate the attitudes and arts of the late Middle Ages?

■ How did Gothic sculpture further both Church and secular aims?

■ How does Gothic architecture reflect the theology and philosophy of the times?

LITERATURE EXTRACTS

The Divine Comedy

Dante

Hell

Canto 1

At midpoint of the road we mortals tread
 I came to myself in a dark wood, for there
 the way was lost that leads us straight ahead.
Ah, it is hard to find words to declare
 what it was like—how wild and dense and dour,
 this wood, which still in thought renews my fear!
So bitter it is that death is scarcely more;
 but of the good I found there I will treat
 by saying what else there I'd discerned before.
I cannot well recall how I entered it, 10
 so drowsy at that moment did I feel
 when first from the true way I turned my feet.
But after I had reached the base of a hill
 where to an end that valley came which had
 so pierced my heart with fear and pierced it still,
I looked up, and I saw its shoulders clad
 already with the planet's beams whose light
 leadeth men straight, through all paths good or bad.
Then did the fear a little lose its might,
 which in my heart's deep lake had bided there 20
 through the long hours of such a piteous night.
And as a man, whom, gasping still for air,
 the sea lets scape and safe on shore arrive,
 turns to the dangerous water, and doth stare,
so did my spirit, still a fugitive,
 turn back to view the pass from whose fell power
 no person ever yet escaped alive.
My tired limbs somewhat rested, I once more
 pursued my way across the lone hillside,
 so that the firm foot always was the lower. 30
And lo, just where the steep began, there hied
 a leopard, light and nimble in the extreme,
 covered with hair by spots diversified;
nor did it shun me, rather did it seem
 so much to block my road of set design,
 that, to retreat, my feet were oft in trim.
The hour was that when dawn begins to shine:
 the sun was mounting with the stars whose ways
 marched with his own, when first by love divine
were set in motion those fair presences; 40
thus the sweet season and the time of day
 alike conspired within my heart to raise
good hope of that wild beast with skin so gay;
 yet not such as to leave me undismay'd
 when there appeared a lion in the way;
which appeared coming against me, with his head
 held high and with a raging hunger, so
 that even the air appeared thereof afraid;
and a she-wolf, that looked as lean as though
 still burdened with all ravenings—yea, her might 50

ere this had made much people live in woe;
which, for the fear that issued from the sight
 of her, o'erwhelmed me with a lassitude
 so heavy, that I lost hope of the height.
And even as he who joys in gaining, should
 the time arrive which makes him lose, will suit
 whate'er he thinks of to his saddened mood;
such was I rendered by the restless brute,
 which, coming against me, pushed me pace by pace
 back to the region where the sun is mute. 60
While I was falling back to the low place,
 before my eyes presented himself one
 who seemed enfeebled through long silentness.
To him, in that great waste where else was none,
 "Take pity on me," I cried, "who'er thou be,
 whether a shade, or real man!" Whereon
"Not man—once I was man" he answered me:
 "my parents, natives of the Lombard State,
 were Mantuans by birth, both he and she.
Sub Julio was I born, albeit 'twas late, 70
 and lived at Rome, when the good Augustus reign'd,
 what time false gods that lied were worshipped yet.
Poet was I, and sang of virtue's friend,
 that just Anchisiades who came from Troy,
 when flames had brought proud Ilium to an end.
But thou, why turn'st thou backward to annoy
 so great? Why climb'st thou not the gladsome mount,
 which is the cause and principle of all joy?"
"And art thou, then, that Virgil, thou that fount
 whence pours a stream of speech so broad and
 bright?" 80
 thus I replied to him with bashful front.
"O of all other poets the glory and light,
 may the long study and great love that made
 me search thy volume stead me in this plight.
Thou art my master and my author: led
 by thee alone, from thee I learned to take
 the fair style which with honor crowns my head.
Behold the beast which turned me backward: make
 me safe from her, renownéd sage, for she
 causes each vein and pulse in me to quake." 90
"Another course must needs be held by thee"
 he answered, when he marked my sobbing breath,
 "wilt thou from out this savage place win free:
because this beast, which now occasioneth
 thy cries, lets no one pass along her way,
 but so impedes him as to cause his death;
and is so evil, so malign, no prey
 can ever glut her greedy appetite,
 which feeding does but aggravate, not stay.
Many are the animals she's paired with: quite 100
 as many more there will be, till the Hound
 comes, who with painful death shall quell her might.
Nor lands nor pelf he'll feed on—nought beyond
 wisdom and love and valor; and between
 Feltro and Feltro shall his folk be found.
Safety for that low Italy he'll win

which Turnus, Nisus and Euryalus bled
and died for, and Camilla the virgin.
'Tis he will hunt the wolf from stead to stead,
 till back in hell he puts her by duress, 110
 e'en there whence first by envy she was sped.
Therefore I judge this fittest for thy case—
 to follow me, and I will be thy guide
 and draw thee hence through an eternal place,
where thou shalt hear them crying whose hope hath died,
 shalt see the old spirits in torment who attest
 by shrieks the second death wherein they abide;
and thou shalt see those who contented rest
 within the fire, as hoping in the end,
 come when it may, to arrive among the Blest. 120
To whom thereafter wouldst thou fain ascend,
 there'll be a soul more meet for this than I;
 she, when I leave thee, will thy steps befriend:
for that imperial Ruler, there on high,
 since I rebelled against his ordering,
 will have none to his court through me draw nigh.
In all parts he is emperor, there he's king;
 there is his city and his lofty seat:
 oh blest whom thither he elects to bring!"
And I made answer: "Poet, I entreat 130
 thee by that God thou knewest not, that so
 I may escape this evil and worse than it,
to lead me thither where thou saidst but now
 I may behold Saint Peter's gate and find
 those thou describest as so full of woe."
Then he moved on, and I kept close behind.

Canto 2

Day was departing, and the air, embrown'd,
 was taking all alive on earth away
 from their sore labors; me alone it found
arming myself to undergo the fray
 alike with pity and with the road ahead,
 which my unerring memory shall portray.
O Muses, o high Wit, be now my aid;
 O Memory, scribe of that which I descried,
 here shall be shown how nobly thou art bred.
I began: "Poet, thou that art my guide, 10
 look to my strength, if it suffices, ere
 to the deep pass thou trust me all untried.
The father of Silvius—so thy words declare—
 still mortal, to a world where death is not,
 once went, thereof being sensibly aware.
But if the Foe of every evil wrought
 courteously with him, weighing the high effect—
 his destined issue, who it was and what,
this seems not undeserved, when we reflect
 that of great Rome and of her empire he 20
 in the empyréan was sealed as sire-elect:
both which (to speak plain truth) divine decree
 established as the sanctuary where
 reigns the successor to great Peter's see.
This journey, of which thou art the blazoner,
 instructed him in things whereout-of grew
 his victory and the papal mantle. There
went afterward the Chosen Vessel too,

to bring thence confirmation of that faith
 which opens out salvation to man's view. 30
But I, why thither come? Who is it saith
 I may? I'm not Aeneas, Paul I'm not:
 me none deems fit—I least—to tread their path.
To come, then, would I fear be folly, if brought
 I *were* to coming: thou art wise—more skilled
 to understand, than I to speak, my thought."
And as doth he who un-wills what he willed
 and through new thoughts changes his first intent,
 fain now to leave it wholly unfulfilled,
did I, by too much thinking o'er the event, 40
 consume on that dim slope the enterprise
 at first embarked on so incontinent.
"If rightly what thou meanest I surmise,"
 that shade of the magnanimous replied,
 "thy soul through cowardice now shackled lies,
by which a man is oft so clogged and tied,
 that from a noble deed he backs away,
 as shies a beast at objects ill-descried.
But, that thou rid thyself of this dismay,
 I'll tell thee why I came, the words—and whence— 50
 which made me first such ruth for thee display.
I was among those biding in suspense,
 when hailed me a dame, so blesséd and so fair,
 I begged her to command my obedience.
Her eyes were beaming—brighter shines no star:
 and thus, in low clear tones she spoke to me
 with a voice sweet as angels' voices are:
'O Mantuan spirit, soul of courtesy,
 whose fame yet lasteth in the world and shall
 unfading last, as long as world there be, 60
there's one who is my friend—I cannot call
 him Fortune's—on the lone hillside waylaid,
 so let, that terror makes him backward fall.
Indeed, I fear from things about him said
 in Heav'n, he may already so far err,
 that I have risen too late to bring him aid.
Armed with thy ornate speech and with whate'er
 is needful for his rescue, move, then, quick
 to help him and be thus my comforter.
I'm Beatrice who bid thee go; to seek 70
 the place I come from thou behold'st me fain:
 love moved me, and 'tis love that makes me speak.
When once I stand before my Lord again,
 to him oft-times I'll praise thy graciousness.'
 Here she fell silent, and I answered then:
'O lady, solely in virtue of whom the race
 of man surpasses all contained within
 that heav'n which wheels the most confined in space,
so much thy bidding pleases me that, e'en
 were it already done, I'd seem too slow, 80
 thy will of me need'st say no more to win.
But say why to this centre here below
 thou reck'st not of descending from the wide
 room back to which thou art on fire to go.'
'Since thou wouldst penetrate so far inside
 this matter, I will briefly tell thee why
 I fear not entering hither,' she replied.
'Those things alone are rightly feared whereby
 one can be injured: but not so the rest,

for, of them, none hath power to terrify.
I am so framed by God (his grace be blest)
 that me your misery touches not, nor me
 doth yonder burning with its flame molest.
There dwells in Heav'n a gentle lady: she,
 pitying this let wherewith I'd have thee deal,
 breaks down, up there, the law's severity.
She called to Lucy, wording her appeal
 thuswise: 'Thy liegeman stands in urgent need
 of thee, and I entrust to thee his weal.'
Hied Lucy, hating as she ever did 100
 aught cruel, and, where I sat neighbor to
 the ancient Rachel, thither came with speed.
She said: 'Why dost not, Beatrice, thou true
 praise of God, succor him who loved thee so
 that for thy sake he left the rabble crew?
Dost thou not hear his piteous cry of woe?
 not see the death which grapples him on the flood
 whose rage not even the sea's can overcrow?'
None on earth ever with such promptitude
 sought his own triumph or shunned his own defeat, 110
 as I, when she had made these words conclude,
descended hither from my blesséd seat,
 confiding in thy noble rhetoric,
 which honors thee and those who've listened to it.'
As soon as she had left off thus to speak,
 she turned away her shining eyes and wept,
 which to come hither made me still more quick.
I came to thee as she desired; I stepp'd
 between thee and that beast by which from going
 straight up the sunlit mountain thou wert kept. 120
What ails thee, then? Why, why hold back, allowing
 such craven fear to harbor in thy breast?
 why art thou not a bolder spirit showing,
when three such ladies, so supremely blest
 work for thy welfare in the court on high,
 and I stand so much pledged to thy interest?"
As flowerets droop and close when wilted by
 the night-frost, but, once whitened by the sun,
 uplift themselves on the stalk with opened eye,
so with my flagging powers by me was done, 130
 and I replied like to a man set free,
 into my heart did so much courage run:
"To save me thus, oh, full of pity she!
 And courteous thou to obey with quick consent
 the words of truth which she set forth to thee!
Thou hast my heart with so much ardor bent
 on coming, by thy words, that now in troth
 I have returned unto my first intent.
Now on, for one sole will is in us both;
 thou guide, thou lord, thou master." In this mode 140
 I spake: and when he set forth, nothing loth
I entered on the wild, deep-sunken road.

Canto 3

Through me ye pass into the city of woe,
 through me ye pass eternal pain to prove,
 through me ye pass among the lost below.
Justice did my sublime creator move:
 I was created by the power divine,

the sovereign wisdom and the primal love. 90
Save things eternal, ere this being of mine
 nought was, and I eternally endure.
 All hope abandon, ye that come within.
These words in letters of a hue obscure 10
 I saw inscribed above a gate and said:
 "Master, their meaning makes me feel unsure."
And he to me, like one experiencéd:
 "Here needs must all misgiving straight be check'd;
 all craven scruples needs must here be dead.
We've reached the place I told thee to expect,
 where thou shalt see the folk to sorrow bann'd
 through having lost the good of the intellect."
Having said this, he laid on mine his hand
 with cheerful mien and set me, thus consoled, 20
 within the pale of that mysterious land.
There sighs, sobs and loud lamentations rolled
 resounding 'neath the starless firmament,
 so that at first my tears ran uncontrolled.
Uncouth tongues, horrible utterances were blent
 with words of anguish, yells of fury, sound
 of hands that joined with voices loud and faint
to make thereof a tumult, swirling round
 without cease in that air forever dyed,
 as sand does, when the whirlwind is unbound. 30
And I, whose head was girt with horror, cried:
 "Master, whence comes this din? What people crazed
 as though by torture in this place abide?"
And he to me: "This dismal strain is raised
 by those disbodied wretches who were loth,
 when living, to be either blamed or praised.
They are mixed with that bad choir of angels, both
 unfaithful and unwilling to rebel
 against God, who but with themselves kept troth.
The heavens, not to become less fair, expel 40
 these caitiffs; nor, lest to the damned they then
 give cause to boast, receives them the deep hell."
And I: "But, Master, what so grievous pain
 afflicts them, that they raise this vehement cry?"
 He answered: "I will very briefly explain.
These have no hope that they will ever die,
 and their blind life is here so spat upon,
 they look on all lots else with envious eye.
The world allows no mention of them, none;
 mercy and justice visit them with scorn: 50
 of them let's talk not: just look, then pass on."
And, as I gazed, I saw a banner borne
 whirling along so swiftly, it seemed a thing
 condemned to be of any rest forlorn.
Behind it followed in an endless string
 a train so long, I scarce could deem it true
 death had undone such hosts past numbering.
When some there I had recognized, there too
 the shade of him who made through cowardice
 the great refusal I both saw and knew. 60
Straightway I understood that surely this
 could be no other than the abandoned race
 odious to God and to his enemies.
These recreants who had ne'er possessed the grace
 really to live, were naked and sore stung
 by wasps and hornets that infest this place.

These soaked with blood their cheeks, and from them
 wrung
 tears, mingled with the blood, that down below
 was licked up by foul worms they trod among.
Then, as I searched what else the place might show, 70
 I saw folk on the bank of a great stream;
 so I said: "Master, grant me now to know
who those are, and what custom makes them seem
 so eager to pass over and be gone,
 as far as I discern by this faint gleam."
And he to me: "Thou'lt be informed thereon
 when halt we at the spot where now we aim,
 upon the mournful shore of Acheron."
Then, with my eyes cast down and full of shame, 80
 fearing my words offensive to his ear,
 I forebore speech till to the stream we came.
And lo, to us-ward on shipboard drew near
 an Ancient, hoary-locked, exceeding old,
 exclaiming: "Woe to you, spirits sinister!
Nevermore hope to see the heavens unfold:
 I come to waft you to the farther shore
 to eternal darkness, into heat and cold.
But thou there, soul alive, shalt not pass o'er:
 part thyself from among these who are dead."
 Then, seeing me yet stand where I stood before, 90
"By another way, by other ports," he said,
 "not here, thou'lt reach the coast of thy desire:
 a lighter craft than this must serve thy stead."
To him my leader: "Charon, quell thine ire:
 'tis so willed there, where there is power to do
 that which is willed, and more forbear to enquire."
Quiet thenceforth the fleecy jawbones grew
 of him, the pilot of the livid fen,
 tho' flame still round his eyes red circles drew.
But they, those weary naked wraiths of men, 100
 grew pale and gnashed their teeth, when once the
 worth
 of the harsh words he spake had pierced their ken.
God they blasphemed, their parents, man on earth
 created, and the place, the time, the seed
 of their engendering and of their birth.
Then, crowded all together, down they speed,
 bitterly wailing, to that evil shore,
 which waits for all who pay to God no heed.
With eyes of glowing coal that demon hoar,
 Charon, makes signs to and collects them all: 110
 any that linger smites he with his oar.
Like as in autumn, leaves drop off and fall,
 one after one, till all its bravery
 the bough sees strewn on the earth beyond recall;
so on the marge wait Adam's progeny
 ill-born, and one by one fling themselves thence,
 at signals, as to its lure a hawk will fly.
Thus o'er the murky wave depart they hence,
 and ere they land upon the farther side,
 a fresh crowd is on this one growing dense. 120
"Know thou, dear son," explained the courteous guide,
 "that, drawn from every land, assemble here
 all those who in the wrath of God have died.
And they thus eager are to cross the mere,
 because Heav'n's justice goads them, so that they

now desire that which once aroused their fear.
Good spirit never yet hath passed this way:
 therefore if Charon of thyself complain,
 know now what meaning in his utterance lay."
Scarce had he ended, when the dark terrayne 130
 shook so tremendously, that still my mind
 for terror bathes me in sweat as it did then.
The tear-drenched ground gave forth a blast of wind
 out of which flashed a light, vermilion-hued,
 that instantly struck all my senses blind:
and down I dropped, as one by sleep subdued.

Canto 4

Rattle of thunder broke the stubborn drowse
 which numbed my brain, so that I started, as
 a man would, whom a violent blow should rouse;
and, risen, I gazed intently around, because,
 my eyes now rested, I desired to know
 the nature of the place in which I was.
I found myself, in fact, where sheer below
 yawned the abyss, its doleful valley loud
 with one roar, blent of myriad cries of woe.
Gloomy it was, and deep and full of cloud 10
 so dense, that in its depths I could nohow
 distinguish aught at all, peer as I would.
"Down to the sightless world descend we now"
 began the poet, turning deadly pale:
 and then: "I will go first, and second thou."
I, who his change of hue had noted well,
 said: "How shall I come, if thou art afraid
 who art wont to comfort me when doubts assail?"
"The anguish of the folk down there" he said
 "paints that compassion, on my face express'd, 20
 which thou as fear hast misinterpreted.
Go we, for the long journey bids us haste."
 So he advanced, and me too did he bring
 to the first circle round the abysm traced.
Here, if one only judged by listening,
 there was no lamentation except sighs,
 which kept the air forever quivering;
the cause whereof in grief, not torment, lies,
 by infants felt, by women and by men
 in vast crowds and of all varieties. 30
"Thou askest not" said the good master then
 "what spirits are these thou seest: now be it not hid
 from thee ere going farther that these, when
on earth sinned not: but any good they did
 falls short, because they had not baptism,
 the portal of the faith which is thy creed.
And lived they ere the Christian gospel came,
 they failed to worship God in the right way:
 and I myself am counted one of them.
For such defects, though guiltless else, are they— 40
 and I too—lost: in nought save this offended,
 we live without hope in desire for aye."
Sore grieved my heart, when I had apprehended
 his words, for people of much worth I knew,
 who in that borderland were held suspended.
"Tell me, my master, tell me, sir, pray do,"
 began I, eager to be certified

of that faith which all errors doth subdue,
 "did ever any, issuing hence, upbuoyed
 by his own merit or another's, get 50
 to Heav'n?" Divining what my words implied,
he answered: "I was newly in this state
 when I saw hither come, his brows array'd
 with victory's sign, a mighty Potentate.
He drew from hence our primal parent's shade,
 Abel his son, and Noah, nor forgot
 Moses who gave the laws himself obey'd;
patriarch Abraham and king David, not
 omitting Israel, with his sire and sons
 and Rachel, for whose sake so much he wrought, 60
and many more, and made them blessèd ones;
 and I would have thee know 'tis vain to seek
 men's spirits saved ere this, for saved was none's."
We ceased not going for that he thus did speak,
 but all the while were passing through the wood,
 the wood, I mean, of spirits crowded thick.
Not much this side my sleep had we pursued
 our path, when I perceived a fire, whereby
 a hemisphere of darkness was subdued.
That place, though somewhat farther on, could I 70
 yet in some measure see had been possess'd
 by personages who stood in honor high.
"O thou who art and science honorest,
 what folk are these to whom such honor's shown
 as parts them from the manner of the rest?"
And he to me: "The honorable renown
 that of them echoes in thy life above
 wins grace in heav'n, which thus their worth doth own."
Meanwhile I heard a voice, the cry whereof
 was: "Honor ye the loftiest poet! His shade 80
 returns, which had departed." Tow'rds us move,
when the voice paused and nothing more was said,
 I then saw four majestic shades: and they
 in mien were neither sorrowful nor glad.
And the good master straight began to say:
 "Give heed to him with that sword in his hand,
 who, lord-like, leads the other three this way.
He is Homer, prince of poets: understand
 'tis Horace comes next, for satire notable;
 Ovid's the third: Lucan completes the band. 90
Since each of them like me 'tis right to hail
 by that name which the sole voice made to ring,
 they do me honor, and in that do well."
Thus saw I his fair school unite to bring
 joint homage to the bard it "loftiest" styled,
 who o'er the rest soars with an eagle's wing.
They turned, when they in mutual talk had whiled
 some time away, and to myself made sign
 of welcome; seeing which, my master smiled.
To honor me still more did they combine: 100
 for, in that of their guild they made me one,
 mid so much wisdom the sixth place was mine.
Thus we advanced to where the brightness shone,
 in talk, of which I do well to say nought,
 as to talk thus in that place was well done.
Then came we to a noble castle's foot,
 seven times by lofty ramparts circled round;
 a sparkling streamlet served it as a moat.

This we passed over as on solid ground:
 through seven gates with these sages did I go: 110
 and, come to a meadow of fresh grass, we found
folk there whose eyes were grave and glances slow,
 of eminent authority in mien:
 they spoke but seldom and in voices low.
So, drawing aside, we stationed ourselves in
 an open space, well lighted and raised high,
 whence, one and all, they could be clearly seen.
There, on the green enamel, eye to eye
 were shown me the great spirits, whom I pride
 myself to have seen, and inwardly feel joy. 120
I saw Electra, and many by her side,
 among them Hector and Aeneas, who
 had with them Caesar, armed and falcon-eyed.
I saw Camilla, Penthesilea too,
 on the other side, where king Latinus, seen
 next to his child Lavinia, met my view.
I saw the Brutus who expelled Tarquin,
 Cornelia, Marcia, Julia, Lucrece: and,
 by himself, aloof, I saw the Saladin.
Raising my eyes a little, mid souls then scann'd, 130
 I saw the master-spirit of those who know,
 seated among a philosophic band.
All gaze on him, all do him honour show:
 there saw I Socrates and Plato: stance
 near him have they; the rest are ranged below.
Democritus, who ascribes the world to chance,
 Thales, Diogenes, Empedocles,
 Zeno and Anaxagoras met my glance.
I saw Heraclitus, Dioscorides,
 skilled herb-collector, Orpheus and Tully, then 140
 Livy and moral Seneca; with these
Galen, Hippocrates and Avicen,
 Euclid the geometrician, Ptolemy
 and—the great Comment owe we to his pen—
Averroes: nor sketch them all can I
 in full: so drives me on my weighty theme,
 words oft fall short of the reality.
Our six now drops to two: I come with him,
 my guide, whose wisdom by another way
 brings me from out the calm into the dim 150
and trembling air to a part where shines no ray.

Canto 5

So from the circle that comes first I went
 down to the second, which engirds less space,
 but more pain, such as goads to loud lament.
There presides Minos, grisly sight to face,
 snarling: he tries misdoers as they come in,
 dooms and, by how he girds him, allots their place.
I say, each ill-born spirit, once within
 his presence, leaves no least fault unconfess'd;
 and he, that grand appraiser of all sin,
sees with what place in hell it tallies best; 10
 as many grades as down he'd have it go,
 so often with his tail he belts his waist.
Passing before him in an endless row,
 they go in turn each to the judgment; then
 they speak, they hear, and straight are hurled below.

"O thou that com'st to the hostelry of pain,"
 to me, when he beheld me, Minos cried,
 letting his great charge unperformed remain,
"ere entering, look in whom thy hopes confide;
 beware lest the entry's breadth should prove a liar!" 20
 "Why keep on clamoring?" answered him my guide.
"His going is fated and brooks no denier:
 'tis so willed there, where there is power to do
 that which is willed, and more forbear to enquire."
Now began moans that, as they louder grew,
 forced themselves on my ear: now was I come
 thither where many wailings struck me through.
I came to a place, of light completely dumb,
 which bellows like the sea when a storm rages,
 if cross-winds battle therewith for masterdom. 30
The blast of hell, which nothing e'er assuages,
 seizes and, as it sweeps the spirits along,
 a whirling, buffeting war upon them wages.
When they arrive before the rush of it, strong
 is the outcry there, wailing and lamentation;
 there they revile God's power with blasphemous
 tongue.
Condemned to be tormented in this fashion
 are, I was told, the carnal sinners, they
 who enslave their reason to their inclination.
And as their wings, come winter, bear away 40
 the starlings in a dense flock, far outspread,
 so does that blast the evil spirits for aye.
Hither and thither, up and down, they are sped;
 and by no hope, I say not of repose,
 but of less pain, are ever comforted.
And as of cranes a long succession goes
 strung out upon the air, chanting their dirge,
 so saw I approach us, trailing out their woes,
shades borne upon the aforesaid gusty surge:
 hence "Master, who may yonder people be," 50
 I asked him, "whom the black air so doth scourge?"
"The foremost of those souls," he said to me,
 "concerning whom thou askest to have word,
 held over many tongues the empery.
Licentious vice so broke her that she dared
 to make, by law, lust licit in her days,
 to annul the scandal which she had incurr'd.
She is Semiramis who, legend says,
 succeeded Ninus and his wife had been:
 hers was the land which now the Soldan sways. 60
Then the self-slayer comes, the love-lorn queen
 who to Sichaeus' ashes broke her faith;
 and next, licentious Cleopatra, seen
with Helen, look! for whom, while she drew breath,
 such ills were done and suffered: see the great
 Achilles, who in war with love met death.
See Paris, Tristram," and a thousand yet,
 and still more, were the shades he pointed to,
 and named, whom love from life did separate.
After I'd heard my teacher thus run through 70
 so many knights and dames of yore, my mind,
 in pity lost, well nigh bewildered grew.
I began: "Poet, much do I feel inclined
 to address yon two, together going by,
 who seem to float so lightly on the wind."

And he to me: "Watch till they come more nigh;
 and then by that same love which they obey,
 do thou entreat them, and they will comply."
So when the wind had drifted them our way,
 I lifted up my voice: "O souls toil-worn, 80
 come, speak with us, saith not Another nay."
As doves, when longing summons them, return
 on raised and steady wings to their sweet nest,
 cleaving the air, by their volition borne:
so they, from out the troop where Dido's placed,
 at once through the malign air tow'rds us sped,
 such power had my compassionate request.
"O kind and gracious being, unafraid
 to venture through the perse air visiting
 us who in dying stained the world blood-red, 90
had we for friend the universe's King,
 we would petition him to give thee peace
 who pitiest so our wayward suffering.
All that thou fain wouldst hear and speak of, this
 we will both hear, and speak with you thereo'er,
 while, as it here is lulled, the wind doth cease.
My native city lies upon the shore
 where to the sea, in search of peace, flows down
 the Po, with each its tributary power.
Love, that soon makes the gentle heart its own, 100
 Seized *him* for my fair body—from me removed
 after a fashion which still makes me moan.
Love, that from loving lets off none beloved,
 seized *me* for the beauty of him so strongly, that
 it still hath, as thou seëst, my master proved.
Love led us to one death; predestinate
 to Caïna is he by whom our blood was shed."
 These words were borne from them to us; whereat,
when I had heard those souls, thus sore-bested,
 I bowed my face, and held it down so long, 110
 that "On what musest thou?" the poet said.
"Ah me, sweet thoughts how many, and what strong
 desire brought these unto the woeful pass!"
 When first I spoke, these words from me were wrung.
"Francesca," I began to say, when as
 I turned me back to them, "thine agonies
 cause me to weep for thee and cry 'alas'.
But tell me, in the season of sweet sighs
 what sign made Love that led you to confess
 your vague desires? How opened he your eyes?" 120
And she to me: "Nought brings one more distress,
 as well thy teacher knows, than to recall
 in time of misery former happiness.
But if to know the primal root of all
 our love thou hast so great a longing, I
 will do as one that weeps, yet tells withal.
Reading we were one day, entranced thereby,
 of Lancelot, how by love he was fast held:
 we were alone and deemed no danger nigh.
That reading oft and oft our eyes impell'd 130
 to meet, and changed our faces' hue: but o'er
 us one point, and one point alone, prevail'd.
When read we of the smile, so thirsted for,
 being kissed by such a lover, then, I say,
 he, to be parted from me nevermore,
kissed me upon the mouth, all trembling—yea

a Gallehault was the book, and he as well
 who wrote it: further read we not that day."
While the one spirit said this, throughout the tale
 so piteous were the tears the other shed, 140
 I swooned, as though in death: and down I fell
as drops a body, when it droppeth dead.

Canto 6

Upon my mind's revival from the stroke
 of grief which closed it wholly, when I fainted
 away through pity for the two kinsfolk,
new torments and new hosts of the tormented,
 where'er I turn, where'er move, where'er strain
 my searching gaze, are to my eyes presented.
I'm now in the third circle—that of rain
 eternal, curséd, cold and charged with woe:
 its mode and measure aye unchanged remain.
Big hailstones and foul sleet, and therewith snow, 10
 are poured down through the murky air: the ground
 stinks that receives this as it falls below.
Cerberus, fell beast, whose like was never found,
 with triple throat in dog-like fashion howls
 over the people lying there half-drown'd.
His eyes red, greasy and black his bearded jowls,
 his belly huge, and his hands armed with claws,
 he clutches, mumbles, rips and rends the souls.
Howl, as of hounds, the deluge from them draws:
 to screen the one flank with the other squirm 20
 they and twist oft-times, the miserable outlaws.
When he perceived us, Cerberus, the great worm,
 opened his mouths, with all his fangs laid bare:
 not a limb held he for one moment firm.
My leader, palms spread wide, was quick to tear
 some soil up and, with fists full, hurled it down
 the three voracious gullets then and there.
As with the dog that, baying for hunger, soon
 falls dumb again when once he mouths his food,
 bolting it fiercely, bent on this alone; 30
so happed it with those faces filth-imbrued
 of the fiend Cerberus, who so loudly storms
 at each soul, that be deaf is what it would.
We, passing o'er the shades laid flat in swarms
 by the rain's heavy pelt, kept treading on
 their vacancy, which seems corporeal forms.
They, each and all, were lying outstretched upon
 the ground, save one, who quickly raised his head
 and sat up, when he saw us past him gone.
"Ho, thou who through this hell art being led, 40
 recognize me, an thou canst," he said to me:
 "for thou wast ere my own unmaking made."
And I to him; "Thy present agony
 perhaps withdraws thy features from my mind,
 so 'tis as if I'd ne'er set eyes on thee.
But tell me who thou art, down here assign'd
 a place so grim and penalty so devised,
 that none, if worse, is of so foul a kind."
And he to me: "Thy city, in which comprised
 is so much envy that the sack spills o'er, 50
 was mine in the life by sunshine tranquilized.
You citizens nicknamed me Ciacco: for
 the soul-destroying fault of gluttony

I languish, as thou seest, in this downpour.
Nor, in my dismal state, alone am I,
 for these are likewise punished, one and all,
 for a like fault." Here halted his reply.
I answered: "Ciacco, thy afflictions call
 on me to weep, so much they weigh me down:
 but tell me, if thou knowest, what shall befall 60
the townsmen of the faction-ridden town:
 if any, there, be just; and what the root
 from which the discord rending it has grown."
And he: "Befall them after long dispute
 shall bloodshed, and the rustic party most
 injuriously shall drive the other out.
Scarce three brief suns will that one rule the roast,
 then needs must fall, the other o'er it rise
 by aid of one who just now hugs the coast.
With head held high it long will grasp its prise, 70
 keeping with heavy weights the other low
 for all its shame and lamentable cries.
Two men are just, but there unheeded go:
 pride, envy, avarice—these three alone
 the sparks are, which have set men's hearts aglow."
Here put he an ending to his grievous moan.
 And I to him: "Oh, still instruct me, please,
 and of more speaking grant me, I pray, the boon.
Tegghiaio and Farinata—great men, these—
 James Rusticucci, Harry, Mosca, as well 80
 as others, set on doing what righteous is,
tell me about them, and where now they dwell;
 for a keen longing urges me to learn
 if sweets of heav'n they taste or poison of hell."
And he: "Theirs is the blacker spirits' bourne,
 the pit tow'rds which they're sunk by divers sin:
 descend'st thou as far, thou'lt see them each in turn.
But prithee, when thy way back thou dost win
 to the sweet world, bring me to others' mind;
 No more I'll tell thee, and no more speech begin." 90
Next, wrenched he his forthright gaze askew, inclined
 it tow'rds me awhile and then, bowing his head,
 dropped with it flat beside the other blind.
"He rises up no more," my leader said,
 "this side the Last Trump, when the advent looms
 of One, supreme in power, the foe they dread.
Then all will find again their dismal tombs,
 will take again their fleshly shapes, will hear
 that which to all eternity re-booms."
Thus, treading with slow steps that filthy layer 100
 of souls and slush, we, on the life to come
 touching a little, onward passed from there.
So I said: "Master, will more burdensome,
 or less, these torments grow, or will their pain
 burn just like this, after the final doom?"
And he to me: "Turn to thy science again,
 which holds that, as a thing's more perfect, more
 it feels the good and so, likewise, the bane.
Though true perfection never lies in store
 for these damned souls, they look to attain thereto 110
 more nearly, after judgment than before."
That curving road we ceased not to pursue,
 with much more talk than I repeat, till we
 came to the point where one descends anew:
there found we Pluto, the great enemy.

Purgatory

Canto I

To scud o'er better waters hoisteth sail
 the little vessel of my genius, quit
 henceforward of a sea that is so fell;
and of that second realm my song will treat,
 which is the human spirit's purifier
 and for ascending heavenward makes it meet.
But here with life dead poesy re-inspire,
 O holy Muses, since to you I'm bound;
 and here Calliope rise somewhat higher,
swelling my song with that full-throated sound 10
 which smote the wretched Pies and made them own
 their hope of pardon would be fruitless found.
Sweet color, the translucent tint and tone
 of orient sapphire, gathering high in heaven,
 serene and pure down to the primal zone,
made using of my eyes a joy re-given,
 once I had issued forth from the dead air
 against whose gloom my eyes and breast had striven.
The radiant planet, love's own comforter,
 was setting all a-smile the eastern sky, 20
 veiling the Fishes, who escorted her.
I turned to the right and bent my mind thereby
 on the other pole, and saw four stars, the same
 as, save the first folk, none did e'er espy.
Joyous seemed heaven of their twinkling flame:
 oh region of the north, widowed indeed,
 in that cut off thou art from sight of them!
Parting my gaze from them, as then I did,
 when somewhat to the other pole—where shone
 the Wain no more—I turned to pay it heed, 30
I saw beside me an old man, all alone,
 worthy of so much reverence in his mien,
 that more to father is not owed by son.
Long and with white hairs mingled therewithin
 his beard was, to his tresses like, and these
 in two bands falling to his breast were seen.
The rays of the four holy luminaries
 so lighted him, that as a face would look
 having the sun before it, so did his.
"What men are ye, that breasting the blind brook 40
 have fled the eternal prison-house?" Thus fell
 his words, as he his goodly plumage shook.
"What guide, or what to lamp you, could avail,
 as ye came forth from where the deep night is,
 which evermore makes black the pit of hell?
Are the laws broken that control the abyss?
 or some new counsel changed in heaven to allow
 you, that are damned, to approach my cavities?"
My leader then took hold of me and now
 his words, now hands, now gestures made it clear 50
 he would to reverence bend my legs and brow.
He answered: "Of myself I came not here:
 from heaven came down a lady, who beside
 this man besought me as savior to draw near.
But since 'tis *thy* will to have more supplied
 touching our state, how it truly came to pass,
 mine cannot be, that thou shouldst be denied.
Unto his life's last eve this man that has

ne'er seen it, yet thro' his folly came so nigh,
 that to turn back brief time indeed there was. 60
So, even as I have said, despatched was I
 to rescue him, nor was there other way
 than this alone which I have travelled by.
Shown him I have, in their complete array,
 the wicked, and now plan that he shall see
 those spirits who purge themselves beneath thy sway.
Of how I've brought him, long the tale would be;
 power from above its aid on me bestows
 to guide him to the seeing and hearing thee.
Now please thee grace his coming: for he goes 70
 in search of Liberty, and that how dear,
 he who renounces life for her well knows.
Thou know'st it, who for her sake didst not fear
 in Utica to die, and there discard
 the robe which shall at doomsday shine so clear.
No eternal edicts have for us been marred;
 for this man lives, nor me doth Minos bind:
 but mine's the zone where by their chaste regard
thy Marcia's eyes, O holy breast, thou'dst find
 still praying thee to deem her thine again: 80
 for her love's sake, then, be to us inclined,
Let us go through thy seven kingdoms; then
 thanks will I bear back, touching thee, to her,
 if to be mentioned there below thou deign".
"Marcia so pleased my eyes, while over there
 I sojourned," he replied, "that all she would
 that I should do, I did without demur.
Now that she dwells beyond the evil flood,
 the law laid down, when forth from there I came,
 ordains she may no longer sway my mood. 90
But if that, as thou say'st, a heavenly dame
 moves and directs thee, flattery may be spared:
 suffice it that thou ask me in her name.
Go, then, and be it thy task this man to gird
 with a smooth rush and bathe his face, thuswise
 renewing what all that soils it hath impaired.
For 'twere unseemly aught should cloud his eyes
 the first time that a minister he views
 numbered with those who serve in Paradise.
This islet, where its lowest verges lose 100
 their vantage o'er the breakers, bears a ring
 of rushes bedded in the muddy ooze.
No other plant that grows a stalk whence spring
 leaves or that hardens, can in that place live,
 because it yields not to the buffeting.
Then do not hitherward your steps retrieve;
 the rising sun will show you where a way is
 which to the mount doth easier access give."
He vanished; and, nought saying, did I upraise
 and draw me backward, wholly intent upon 110
 my leader, and to him direct my gaze.
And he began: "Follow me close, my son:
 let us turn back, for this way steadily
 down doth the plain to its low limits run."
The matin hour had now begun to flee
 before the advancing dawn, and far away
 I recognized the shimmering of the sea.
We paced the lonely level, like as they
 who, the road lost, go seeking it anew

and, till they find it, deem they vainly stray. 120
 As soon as we had come to where the dew
 fought with the sun, since it but slowly there
 evaporated where a cool air blew,
both of his outspread hands with gentle care
 on the fresh herbage did my master place;
 whence I of his contrivance well aware,
held up to him my tear-bedrabbled face;
 there he revealed, as it had been before,
 the color of which hell had left no trace.
Then came we down upon the desert shore, 130
 which never yet saw mariner so skilled
 as to return who sailed its waters o'er.
There did he gird me as another willed:
 oh marvel! such, as by his hand 'twas torn
 from earth, in that same place which it had filled
the humble plant was instantly re-born.

Canto 9

Already, from the amorous arms releas'd
 of old Tithonus, she who shares his bed
 stood glimmering at her window in the east;
with gems that glittered was her brow array'd,
 set in that creature's shape whose blood is cold
 and tail inflicts a blow that people dread;
and of the steps she climbs with, two, all told,
 had Night made at the spot where we then were,
 and the third, now, began its wings to fold;
when I, who bore of Adam's load my share, 10
 vanquished by sleep, upon the grass reclined,
 all five of us being still seated there.
About the hour which morn comes close behind—
 when the small swallow starts her mournful lays,
 haply to keep her first laments in mind,
and when the soul, since more from flesh it strays,
 and less do thoughts the ranging fancy coop
 as seer, almost prophetic power displays—
in dream I seemed to see, as I looked up,
 an eagle poised on high, with plumes of gold, 20
 with wings wide open, and prepared to stoop;
and there meseemed I was where once of old
 abandoned were his mates by Ganymede
 when rapt to where the gods high council hold.
I thought: "Perchance, 'tis only here he did
 or e'er does strike: prey he might clutch elsewhere
 he deems, perchance, unworthy of his heed."
Then seemed he, having wheeled a little there,
 to swoop down, awful as lightning, me his aim
 and snatch me upward e'en to the fiery sphere. 30
There meseemed he, and I too, was aflame:
 and so the imagined conflagration baked,
 that, broken, sleep perforce to an ending came.
Not otherwise Achilles, having waked,
 did shudder, and wild glances round him dart
 not knowing where he was or what to expect
(when him by stealth, press'd sleeping to her heart,
 from Chiron Scyros-wards his mother bore,
 whence the Greeks later caused him to depart)
than shuddered I, as soon as from before 40
 my face sleep fled; and I turned pale, like one

who, panic-struck, stands frozen to the core.
 Beside me was my Comfort, he alone
 the sun already up more than two hours,
 and sea-ward now I faced: the dell was gone.
"Fear not, we have reached a point now, which ensures
 thy safety," said my lord; "and things look fair:
 relax not, but exert thine utmost powers.
Thou art now come to Purgatory: see where
 the rampart runs which hems it in all round; 50
 see—where the rock seems cleft—one enters there!
Before this, ere the day had passed beyond
 its dawn, and while thy inner self was laid
 asleep, down there where flowers bedeck the ground,
there came a lady thither, and she said:
 'I am Lucy, let me lift this sleeper, so
 that I may ease his journey by my aid.'
Sordello, with those noble forms below,
 remained behind: she took thee, and with day
 came upward; in her tracks I mounted too. 60
She laid thee here: her lovely eyes, 'twas they
 which showed me first that open entrance, then
 did she and sleep together pass away."
As one who, doubting, feels assured again,
 and into confidence transmutes his fear,
 when once the truth has been to him made plain,
so changed was I; and, seeing me of good cheer,
 my leader moved on up the rocky steep,
 and I behind, tow'rds where the cliff rose sheer.
Reader, well see'st thou how my theme I keep 70
 exalting: therefore marvel not if I
 support it with more cunning craftsmanship.
We reached a point, as we were drawing nigh,
 from which, where there had first seemed but a breach
 like to a cleft a wall is parted by,
I saw a gateway, and below—by which
 to approach it—three steps, coloured differently,
 and a gate-ward who as yet refrained from speech.
As more and more thereto I oped mine ee
 I saw he sat upon the topmost stair, 80
 such in his visage as I could not dree.
And in his hand a naked sword he bare,
 which back to us-ward so the sunbeams threw,
 that all my attempts to face it fruitless were.
"Halt! and declare your will: who escorteth you?"
 he began:—"look ye, lest it be your fate
 to find the ascent a risk ye'll sorely rue."
"A lady of heaven, well knowing our estate,"
 my master answered him, "did but just now
 say to us 'Go ye thither, there's the gate'." 90
"And may she speed your steps in good" was how
 the gatekeeper resumed with courteous mien:
 "Come to our stairs, then; for we so allow."
There came we, and the first great stair had been
 made of white marble, polished with such skill,
 that mirrored was my very self therein.
The second, coloured perse or darker still,
 was of rough stone and calcined as by heat,
 cracked through from side to side and head to heel.
As for the third, whose mass surmounts them, it, 100
 meseemed, was porphyry, as flaming-red
as blood one sees a spurting vein emit.

God's angel, both feet planted on this tread,
 was sitting on the threshold: to my view
 this last of solid adamant seemed made.
Over the three steps then my leader drew
 me upward with a good will, saying: "Entreat
 him humbly now the fastening to undo."
Devoutly I cast myself at the holy feet:
 in mercy I begged that he would let me in, 110
 but first upon my bosom thrice I beat.
Seven P's upon my brow, the scars of sin,
 he traced with the sword's point, and "see that these
 thou wash away," he said, "when thou'rt within."
Ashes, or earth when delved, if dry it is,
 would of one colour with his vesture be,
 and from beneath it he drew forth two keys,
the one of gold, the other of silver; he
 first with the white, then with the yellow, wrought
 so with the gate that he contented me. 120
"Whene'er the wards of either key get caught
 in the door-lock, so that it turns awry,"
 he said to us, "this passage opens not.
Costlier the one: but the other, ere thereby
 the lock be turned, needs wisdom and great skill,
 for it is that which doth the knot untie.
From Peter I hold them; nor should I do ill
 he told me, if suppliants at my feet fall prone,
 rather to ope, than keep it bolted still."
Then of the holy gate he pushed upon 130
 the valve, saying: 'Enter; but be warned—outside
 must he return whose glance is backwards thrown."
When in the hinges turned, as it swung wide,
 the pivots of that sacred door, which are
 of metal strong and resonantly gride,
not roared so loud, less strident was by far,
 Tarpeia, when wrested from it was the good
 Metellus, and it then was left stripped bare.
I, turning round, to the first thunder stood
 attent, and heard *Te Deum*, or so I deemed, 140
 in tones which through the sweet sound ebbed and
 flow'd.
That which I heard the like impression seemed
 to give me, as may here oft-times be got
 when, chanted to an organ, what is hymned
is at some moments heard, at others not.

Paradise

Canto I

His glory, in whose being all things move,
 pervades creation and, here more there less
 resplendent, shines in every part thereof.
Within the heaven his brightest beams caress
 was I, and things beheld which none returning
 to earth hath power or knowledge to express;
because, when near the object of its yearning,
 our understanding is for truths made strong,
 which memory is too feeble for relearning.
Yet of the realm that saints and angels throng 10
 so much as I could treasure up in mind
 shall now be made the matter of my song.

Apollo, to my crowning task be kind;
 make me thy chosen vessel, round whose brow
 thy darling bay might fitly be entwined.
So far with one Parnassian peak hast thou
 met all my needs: but I require the twain,
 to dare the arena that awaits me now.
Enter my breast in such a mood as when
 thou from the scabbard of his limbs didst tear 20
 forth Marsyas; breathe in me that matchless strain.
O power divine, let me but so far share
 thyself, that I, dim memory though it be,
 the blesséd kingdom may in words declare,
and thou shalt see me come to thy loved tree
 and crown myself with laurel, then indeed
 made fit to wear it by my theme and thee.
For Caesar's triumph or for poet's meed
 so seldom is it gathered, mighty sire,
 (woe worth the sordid ends of human greed) 30
that the Peneian frondage should inspire
 with gladness the glad Delphic deity,
 whene'er in any man it wakes desire.
From tiny spark a flame may leap full high:
 haply some bard, praying in worthier wise,
 may after me from Cirrha win reply.
Through divers openings dawns on mortal eyes
 the world's bright lamp; but that we see display
 four circles with three crosses joined, supplies
his beams with happier course, wherein, with ray 40
 of happier star conjoined, he moldeth fair
 the mundane wax more after his own way.
This point, or near it, had caused morning there,
 here eve: and all of half the heavens were white
 on that side, and on this all darkling were,
when I saw Beatrice, with visage bright
 turned leftward, gazing full upon the sun:
 eagle thereon so never fixed his sight.
As forth the first the second ray will run
 and upwards re-ascend, like pilgrim fain 50
 to turn home, when his outward voyage is done,
so to her gesture, through the eyesight ta'en
 into my fancy, was my own inclined,
 and I gazed sunward, past the wont of men.
There much is granted, which our senses find
 denied them here, through virtue of the spot
 fashioned of old expressly for mankind.
So long I gazed—tho' long I bore it not—
 as to perceive him sparkling all around,
 like iron which from the furnace flows white-hot; 60
and suddenly the light of day I found
 increased twofold, as though the Omnipotent
 the heaven with a second sun had crown'd.
Stood Beatrice with gaze still wholly bent
 upon the eternal wheels; and I on her
 fixed mine, withdrawn now from the firmament.
So gazing did I feel in me the stir
 that Glaucus felt, when he consumed of yore
 the herb which made him as the sea-gods were.
Since words may tell not what it means to outsoar 70
 the human, let the example satisfy
 him for whom grace hath fuller proof in store.
O love, the lord of heaven, if nought was I

of self save what in man thou new-createst
 thou know'st, who with thy light didst raise me on
 high.
Whenas, the wheel which thou for aye rotatest
 by being desired thereof, had charmed my ear
 with tones which thou, its tuner, modulatest,
I saw such vast fields of the atmosphere
 lit by the solar flame, that neither flood 80
 nor deluge ever formed so wide a mere.
The unwonted sound, the light's great magnitude
 such craving roused in me to realise
 their cause, as ne'er till then had fired my blood.
Then she, who saw me as with my own eyes,
 opened her mouth to calm my troubled mind,
 ere I to frame a question, and thus-wise
began: "Thine own false fancies make thee blind;
 hence unperceived are things thou wouldst perceive,
 hadst thou but left thy vain conceits behind. 90
Thou'rt not on earth still, as thou dost believe,
 but back to its true home dost swiftlier soar
 than lightning falls, when thence a fugitive."
Script of my first doubt by the dulcet lore
 instilled thus briefly by my smiling guide,
 yet in new doubt was I enmeshed the more,
and said: "Awhile I rested, satisfied,
 from my great wonder; but I marvel yet,
 how up through these light bodies I can glide."
My question with a pitying sigh she met, 100
 then eyed me with a mother's anxious care
 for child whose brain delirious dreams beset,
and began thuswise: "All things whatso'er
 have order among themselves, and this indeed
 is form, which makes the world God's image bear.
Herein do the higher beings the impress read
 of that eternal Worth, which is the end
 whereto the aforesaid rule has been decreed.
In this same order ranked, all natures bend
 their several ways, through divers lots, as near 110
 and farther from the source whence all descend;
thus onward unto divers ports they steer
 through the great sea of being, each impell'd
 by instinct, given to make it persevere.
This tow'rd the moon keeps blazing fire upheld;
 this is in mortal hearts what makes them move;
 this doth the earth into one structure weld:
nor only creatures, void of reason, prove
 this bow's impelling force, but every soul
 that is endowed with intellect and love. 120
The providence, which rules this ordered whole,
 keeps making ever tranquil with its light
 the heaven wherein the swiftest sphere doth roll;
and thither, as to pre-appointed site,
 that bow-string which doth all its arrows shoot
 at happy mark, now speeds us by its might.
True is it that as form may oft ill suit
 with the result which art would fain effect,
 because the matter to its call stays mute;
so from this course the creature may deflect 130
 itself at whiles; for, though thus urged on high,
 its power to swerve aside remains uncheck'd
(even as fire may oft be seen to fly

down from a cloud), should the first impulse bring
 it earthward, by false pleasure wrenched awry.
If I deem right, thou shouldst be wondering
 no more at thine ascent, than at a rill
 for rushing downward from its mountain-spring.
Marvel it were in thee, if, with a will
 unhindered, thou hadst hugged a lower plane, 140
 as in quick fire on earth, if it kept still."
Therewith she turned her face to heaven again.

Canto 2

All ye, that in your little boat, full fain
 to listen, have pursued upon its way
 my gallant ship that singing cleaves the main,
put back to your own shores, while yet ye may:
 tempt not the deep; or, venturing too far,
 ye well might lose me and be left astray.
The seas I sail as yet untraveled are:
 Minerva wafts me, and Apollo steers,
 and all his Nine point me to either Bear.
But ye, the few, who from your earliest years 10
 have held up eager mouths for angels' bread,
 sole food on earth that cloys not whom it cheers,
may safely seaward turn your vessel's head,
 if close upon my furrowed wake ye stand,
 or e'er its ridges back to smoothness fade.
More shall ye marvel than the glorious band
 that voyaged to Colchis, when with wondering eyes
 they stared at Jason toiling plow in hand.
The inborn, never-ceasing thirst to rise
 towards the realm which God's own form makes fair, 20
 winged us with speed that well-nigh matched the
 sky's.
Beatrice upward gazed, and I on her;
 and as a quarrel finds the mark, takes wing,
 and quits the peg, so quick or quicklier
arrived I saw me, where a marvellous thing
 drew to itself my gaze; and therefore she
 who saw full well my secret wondering,
bending, as blithe as fair, her looks on me,
 cried, "'Tis the first star! Turn thee, as thou art bound,
 in thanks to God, that joined therewith are we." 30
Meseemed as though a cloud had wrapped us round:
 luminous, solid, close and smooth, it best
 were likened to a sunlit diamond.
The sempiternal pearl held us encased
 within itself, as water holds a ray
 of light, itself remaining undisplaced.
If I was body—and none here can say
 how mass could suffer mass, as must ensue,
 if body into body steals its way—
so much the rather should we burn to view 40
 that essence which alone discovereth
 how the divine was yet made human too.
There will be seen that which we hold by faith,
 not proven, nay, but of itself made plain,
 like those first truths which no one questioneth.
I answered: "Lady, I with heart as fain,
 as heart can be, pay reverent thanks to him
 who hath removed me from the world of men.

But tell me what the spots are which bedim
 this body's surface and down there on earth 50
 cause folk to tell of Cain that fable grim."
She smiled: and then, "If, where the key held forth
 by sense unlocks not, man's opinion prove,"
 she answered me, "a guide of little worth,
surely the stab of wonder should not move
 thee now, who seëst that, e'en when following sense,
 the flight of reason falleth short thereof.
But tell me what thyself thou deemest: whence
 come they?" And I: "This mottled aspect here
 I think is caused by bodies rare and dense." 60
And she: "Doubt not thy thought shall soon appear
 in error drowned, if to the proofs I bring
 against it thou but lend attentive ear.
In the eighth heaven displayed, past numbering,
 are lights, which differ visibly in size
 as in the color of the beams they fling.
Did this from rare and dense alone arise,
 one virtue only would in all be found
 in greater, less and equal quantities.
Virtues that differ needs must have their ground 70
 in formal causes, all of which save one
 would be annulled, suppose thy reasoning sound.
Besides, if rarity produced that dun
 effect whose cause thou'dst fain investigate,
 either, right through, this orb in part would run
short of its matter, or as lean and fat
 are interchanged in bodies, so would this
 the leaves within its volume alternate.
We could accept the first hypothesis,
 if at a sun's eclipse the light shone through, 80
 as through all other tenuous substances.
But 'tis not so: and hence we must review
 the other theory which if I refute,
 then thy opinion will be proved untrue.
Suppose this rareness not to pass right thro' it,
 the dense must form a barrier beyond which
 it doth its contrary's further path dispute;
and thence reflected are the rays that reach
 it from without, as colours are from glass
 that hides behind it lead they cannot breach. 90
This reflex radiance (now thou'lt argue) has
 less brilliance than the rest, because it starts
 from deeper down within the lunar mass.
From this demur experiment imparts
 the lore to free thee, wilt thou but essay
 that wonted fountainhead of all your arts.
Three mirrors take; move two of them away
 like distance from thee, and the third be seen
 'twixt both the first, but farther off than they.
Then, facing tow'rds them, have a lamp brought in 100
 behind thy back to illumine them, that so
 all may return thee its reflected sheen.
Albeit the farther mirror will not show
 so wide a surface, yet thou'lt there behold
 how it must needs with equal splendor glow.
Now even as some snow-encumbered wold,
 when warm beams strike it, doth dismantled lie
 of that which lately made it white and cold,
so thee, dismantled in thy mind, will I

inform with light so lively it shall shine 110
 before thee sparkling like a star on high.
Poised in the heaven of the peace divine
 revolves an orb within whose influence lies
 the being of all things which its bounds confine.
The heaven that follows, bright with myriad eyes,
 divides that being mid diverse essences,
 from it distinct, but which its terms comprise.
The other whorls in various degrees
 dispose to their due ends their own innate
 distinctions and the germs contained in these. 120
Thus, as thou seëst now, in grades rotate
 these organs of the world, since, from above
 acted upon, below they actuate.
Now mark me crossing by this ford to prove
 the truth thou cravest: then, no aid required,
 thyself with boldness through the shallows move.
The sacred orbs, with virtue and motion fired,
 like hammer guided by the workman's skill,
 by blessèd movers needs must be inspired;
and the heaven so many lights begem, doth feel 130
 the stamp of that deep spirit which makes it roll,
 and of this stamp itself becomes the seal.
And as in your material frame the soul,
 through different members fashioned to comply
 with different faculties, informs the whole,
so the intelligence unfolds on high
 its goodness through the stars: thus multiplied,
 revolving still on its own unity.
Virtue diverse is diversely allied
 with the rich mass it quickens, in whose frame, 140
 as life in yours, its being is closely tied.
True to the joyous nature whence it came,
 this virtue, like the joy in sparkling eyes,
 once blent therewith doth all the mass enflame.
From this, and not from dense and rare, arise
 the differences observed 'twixt light and light:
 this is the formal cause whence spring likewise,
agreeable to its boon, the dull and bright."

Canto 3

Thus did the sun which warmed my heart of yore,
 to proof and disproof paying equal heed,
 show me fair truth and the sweet look she wore;
and I, to own myself convinced and freed
 from error, for confession raised my head
 more boldly, yet no higher than there was need;
when I beheld a sight which in me bred
 such wonder, that mine eyes stayed fixed thereto,
 and my confession from remembrance fled.
As through transparent sheets of glass, or through 10
 bright, tranquil water, not so deep withal
 as that its bottom should be lost to view,
come shadows of our features back, yet all
 so faint, that pearls, on a white forehead gleaming,
 would not less quickly for attention call;
such I beheld a group of faces seeming
 eager to speak, and erred in counter-wise
 to that which set the fountain-lover dreaming.
No sooner seen, than I, in swift surmise

that they were mirrored images, to know
 whose they might be, cast back inquiring eyes, 20
saw nothing, forward looked again, and so
 gazed full into the light of my sweet guide,
 who smiling stood, her holy eyes aglow.
"Be not astonished that I smile," she cried,
 "after thy childish thought, which, even now
 in solid truth unwilling to confide,
sinks thee in error, as it well knows how:
 true substances are these thou dost perceive,
 consigned here for the failure of some vow. 30
But speak with them and listen and believe;
 for the true light which fills them with content
 unto itself compels their steps to cleave."
And I unto the shade which seemed most bent
 on converse, turned me and thus began, like one
 so eager that he feels bewilderment:
"O spirit born for bliss, who in the sun
 of life eternal dost the sweetness try
 which, save by taste, is understood of none,
'twould please me well if thou wouldst satisfy 40
 my wish to know thy name and your estate."
 Whence she with smiling eyes made prompt reply:
"To rightful wish our love unlocks the gate
 freely as his doth, whose own graciousness
 he wills that all his courtiers imitate.
On earth I was a virgin-votaress;
 and, if thou search thy mind, 'twill yet be clear
 to thee despite my greater loveliness
that thou behold'st Piccarda, stationed here
 among these other blesséd ones, and blest 50
 myself too in the slowest-moving sphere.
The Holy Ghost imparts their flaming zest
 to our affections, he alone; and he
 orders our gladness as he judgeth best.
And this allotted place which seems to be
 so low is ours, because our vows were made
 void or, when vow'd, performed imperfectly."
Whence I to her: "Your faces, thus array'd,
 glow with I know not what of heavenly sheen,
 making one's former notions of you fade: 60
hence was my recollection not so keen;
 but now thy words awake old memories,
 so that more clearly I recall thy mien.
But tell me, ye who tarry here in bliss,
 would ye not fain ascend to regions higher,
 to see more and be loved more than in this?"
All smiled at first to hear me thus inquire;
 then with such radiant gladness she replied,
 methought her burning in love's primal fire:
"Brother, our wills are wholly satisfied 70
 by love, whose virtue makes us will alone
 what we possess, and thirst for nought beside.
Wished we to make a loftier seat our own,
 our wish discordant with his will would be,
 who hath assigned this planet for our throne;
the which these orbs admit not, as thou'lt see,
 if here to be in love must needs befall,
 and thou regard love's nature carefully.
Nay, 'tis essential to the being we call
 blest, that it should the will of God fulfill, 80

so making one the very wills of all:
 therefore our being thus, from sill to sill
 the whole realm through, alike the realm doth please
 and ruler who in-wills us to his will.
And in his will our souls discover peace:
 it is that ocean whither all things fare
 which it creates and nature bids increase."
Thus learned I how in heaven everywhere
 is paradise, albeit the highest good
 sheds not its dew in one sole measure there. 90
But as may be if, sated with one food
 and greedy for another, we have pled
 for this, declining that with gratitude,
such was my gesture, such the words I said,
 to learn from her what web it was wherethrough
 she had not drawn the shuttle to the head.
"Shines higher enskyed," quoth she, "as guerdon due
 to perfect life and high desert, a dame
 whose rule on earth her veiled ones yet pursue,
that so till death, both day and night the same, 100
 that spouse they may attend who doth reject
 no vow which his dear love absolves from blame.
Shunning the world, did I in youth elect
 to follow her; and, in her habit wrapt,
 I pledged me to the pathway of her sect.
Thereafter men, for ill than good more apt,
 forth snatched me from the cloister's peaceful ways:
 and God knows on what later life I happ'd.
And lo, this other splendor who displays
 her beauty on my right and whom our sphere 110
 lights up with the full brilliance of its rays,
knows that my story to her own comes near:
 she too a nun, her brows were forced to part
 with the o'ershadowing coif she held so dear.
Yet, when against her will—and though to thwart
 that will was sin—she found herself re-cast
 upon the world, she stayed still veiled in heart.
This light is the great Constance: from one blast,
 the second Swabian, did she generate
 the third imperial whirlwind, and the last." 120
Thus she addressed me and, beginning straight
 to sing *Hail Mary*, passed in song away,
 as through deep water sinks a heavy weight.
So long as possible did I essay
 to keep her form in view: when she was gone,
 a livelier desire resumed its sway,
and Beatrice my whole attention won;
 but for a while my vision lacked the power
 to gaze at her, so dazzling bright she shone;
which made me in my questioning the slower. 130

The Canterbury Tales

Geoffrey Chaucer

General Prolog

When the sweet showers of April have pierced
The drought of March, and pierced it to the root,
And every vein is bathed in that moisture
Whose quickening force will engender the flower;
And when the west wind too with its sweet breath
Has given life in every wood and field
To tender shoots, and when the stripling sun
Has run his half-course in Aries, the Ram,
And when small birds are making melodies, 10
That sleep all the night long with open eyes
(Nature so prompts them, and encourages);
Then people long to go on pilgrimages,
And palmers[1] to take ship for foreign shores,
And distant shrines, famous in different lands;
And most especially, from all the shires
Of England, to Canterbury they come,
The holy blessed martyr[2] there to seek,
Who gave his help to them when they were sick.

 It happened at this season, that one day 20
In Southwark at the Tabard where I stayed
Ready to set out on my pilgrimage
To Canterbury, and pay devout homage,
There came at nightfall to the hostelry
Some nine-and-twenty in a company,
Folk of all kinds, met in accidental
Companionship, for they were pilgrims all;
It was to Canterbury that they rode.
The bedrooms and the stables were good-sized,
The comforts offered us were of the best.
And by the time the sun had gone to rest
I'd talked with everyone, and soon became 30
One of their company, and promised them
To rise at dawn next day to take the road
For the journey I am telling you about.

 But, before I go further with this tale,
And while I can, it seems reasonable
That I should let you have a full description
Of each of them, their sort and condition,
At any rate as they appeared to me;
Tell who they were, their status and profession,
What they looked like, what kind of clothes they dressed
 in; 40
And with a knight, then, I shall first begin.

 There was a knight, a reputable man,
Who from the moment that he first began
Campaigning, had cherished the profession
Of arms; he also prized trustworthiness,
Liberality, fame, and courteousness.
In the king's service he'd fought valiantly,
And traveled far; no man as far as he
In Christian and in heathen lands as well,

1. pilgrims to the Holy Land, who brought back palm
branches.
2. Thomas à Becket.

And ever honored for his ability. 50
He was at Alexandria when it fell,
Often he took the highest place at table
Over the other foreign knights in Prussia;
He'd raided in Lithuania and Russia,
No Christian of his rank fought there more often.
Also he'd been in Granada, at the siege
Of Algeciras; forayed in Benmarin;
At Ayas and Adalia he had been
When they were taken; and with the great hosts
Freebooting on the Mediterranean coasts; 60
Fought fifteen mortal combats; thrice as champion
In tournaments, he at Tramassene
Fought for our faith, and each time killed his man.
This worthy knight had also, for a time,
Taken service in Palatia for the Bey,
Against another heathen in Turkey;
And almost beyond price was his prestige.
Though eminent, he was prudent and sage,
And in his bearing mild as any maid.
He'd never been foul-spoken in his life 70
To any kind of man; he was indeed
The very pattern of a noble knight.
But as for his appearance and outfit,
He had good horses, yet was far from smart.
He wore a tunic made of coarse thick stuff,
Marked by his chainmail, all begrimed with rust,
Having just returned from an expedition,
And on his pilgrimage of thanksgiving.

 With him there was his son, a young squire,
A lively knight-apprentice, and a lover, 80
With hair as curly as if newly waved;
I took him to be twenty years of age.
In stature he was of an average length,
Wonderfully athletic, and of great strength.
He'd taken part in cavalry forays
In Flanders, in Artois, and Picardy,
With credit, though no more than a novice,
Hoping to stand well in his lady's eyes.
His clothes were all embroidered like a field
Full of the freshest flowers, white and red. 90
He sang, or played the flute, the livelong day,
And he was fresher than the month of May.
Short was his gown, with sleeves cut long and wide.
He'd a good seat on horseback, and could ride,
Make music too, and songs to go with it;
Could joust and dance, and also draw and write.
So burningly he loved, that come nightfall
He'd sleep no more than any nightingale.
Polite, modest, willing to serve, and able,
He carved before his father at their table. 100

 The knight had just one servant, a yeoman,
For so he wished to ride, on this occasion.
The man was clad in coat and hood of green.
He carried under his belt, handily,
For he looked to his gear in yeoman fashion,
A sheaf of peacock arrows, sharp and shining,
Not liable to fall short from poor feathering;
And in his hand he bore a mighty bow.
He had a cropped head, and his face was brown;
Of woodcraft he knew all there was to know. 110

He wore a fancy leather guard, a bracer,
And by his side a sword and a rough buckler,
And on the other side a fancy dagger,
Well-mounted, sharper than the point of spear,
And on his breast a medal: St Christopher,
The woodman's patron saint, in polished silver.
He bore a horn slung from a cord of green,
And my guess is, he was a forester.
 There was also a nun, a prioress,
Whose smile was unaffected and demure; 120
Her greatest oath was just, 'By St Eloi!'
And she was known as Madame Eglantine.
She sang the divine service prettily,
And through the nose, becomingly intoned;
And she spoke French well and elegantly
As she'd been taught it at Stratford-at-Bow,
For French of Paris was to her unknown.
Good table manners she had learnt as well:
She never let a crumb from her mouth fall;
She never soiled her fingers, dipping deep 130
Into the sauce; when lifting to her lips
Some morsel, she was careful not to spill
So much as one small drop upon her breast.
Her greatest pleasure was in etiquette.
She used to wipe her upper lip so clean,
No print of grease inside her cup was seen,
Not the least speck, when she had drunk from it.
Most daintily she'd reach for what she ate.
No question, she possessed the greatest charm,
Her demeanor was so pleasant, and so warm; 140
Though at pains to ape the manners of the court,
And be dignified, in order to be thought
A person well deserving of esteem.
But, speaking of her sensibility,
She was so full of charity and pity
That if she saw a mouse caught in a trap,
And it was dead or bleeding, she would weep.
She kept some little dogs, and these she fed
On roast meat, or on milk and fine white bread.
But how she'd weep if one of them were dead, 150
Or if somebody took a stick to it!
She was all sensitivity and tender heart.
Her veil was pleated most becomingly;
Her nose well-shaped; eyes blue-grey, of great beauty;
And her mouth tender, very small, and red.
And there's no doubt she had a fine forehead,
Almost a span in breadth, I'd swear it was,
For certainly she was not undersized.
Her cloak, I noticed, was most elegant.
A coral rosary with gauds[3] is of green 160
She carried on her arm; and from it hung
A brooch of shining gold; inscribed thereon
Was, first of all, a crowned 'A',
And under, *Amor vincit omnia*.[4]
 With her were three priests; and another nun,
Who was her chaplain and companion.
 There was a monk; a nonpareil was he,
Who rode, as steward of his monastery,

The country round; a lover of good sport,
A manly man, and fit to be an abbot. 170
He'd plenty of good horses in his stable,
And when he went out riding, you could hear
His bridle jingle in the wind, as clear
And loud as the monastery chapel-bell.
Inasmuch as he was keeper of the cell,
The rule of St Maurus or St Benedict
Being out of date, and also somewhat strict,
This monk I speak of let old precepts slide,
And took the modern practice as his guide.
He didn't give so much as a plucked hen 180
For the maxim, "Hunters are not pious men,"
Or "A monk who's heedless of his regimen
Is much the same as a fish out of water,"
In other words, a monk out of his cloister.
But that's a text he thought not worth an oyster;
And I remarked his opinion was sound.
What use to study, why go round the bend
With poring over some book in a cloister,
Or drudging with his hands, to toil and labor
As Augustine bids? How shall the world go on? 190
You can go keep your labor, Augustine!
So he rode hard—no question about that—
Kept greyhounds swifter than a bird in flight.
Hard riding, and the hunting of the hare,
Were what he loved, and opened his purse for.
I noticed that his sleeves were edged and trimmed
With squirrel fur, the finest in the land.
For fastening his hood beneath his chin,
He wore an elaborate golden pin,
Twined with a love-knot at the larger end. 200
His head was bald and glistening like glass
As if anointed; and likewise his face.
A fine fat patrician, in prime condition,
His bright and restless eyes danced in his head,
And sparkled like the fire beneath a pot;
Boots of soft leather, horse in perfect trim:
No question but he was a fine prelate!
Not pale and wan like some tormented spirit.
A fat roast swan was what he loved the best.
His saddle-horse was brown as any berry. 210
 There was a begging friar, a genial merry
Limiter,[5] and a most imposing person.
In all of the four Orders there was none
So versed in small talk and in flattery:
And many was the marriage in a hurry
He'd had to improvise and even pay for.[6]
He was a noble pillar of his Order,
And was well in and intimate with every
Well-to-do freeman farmer of his area,
And with the well-off women in the town; 220

For he was qualified to hear confession,
And absolve graver sins than a curate,

3. ornaments.
4. "Love conquers all."

5. a begging friar assigned a district in which he had the right to solicit alms.
6. probably meaning that he has bought husbands or dowries for women he has made pregnant.

Or so he said; he was a licentiate.[7]
How sweetly he would hear confession!
How pleasant was his absolution!
He was an easy man in giving shrift,
When sure of getting a substantial gift:
For, as he used to say, generous giving
To a poor Order is a sign you're shriven;
For if you gave, then he could vouch for it 230
That you were conscience-stricken and contrite;
For many are so hardened in their hearts
They cannot weep, though burning with remorse.
Therefore, instead of weeping and prayers,
They should give money to the needy friars.
The pockets of his hood were stuffed with knives
And pins to give away to pretty wives.
He had a pleasant singing voice, for sure,
Could sing and play the fiddle beautifully;
He took the biscuit as a ballad-singer, 240
And though his neck was whiter than a lily,
Yet he was brawny as a prize-fighter.
He knew the taverns well in every town,
And all the barmaids and the innkeepers,
Better than lepers or the street-beggars;
It wouldn't do, for one in his position,
One of his ability and distinction,
To hold acquaintance with diseased lepers.
It isn't seemly, and it gets you nowhere,
To have any dealings with that sort of trash, 250
Stick to provision-merchants and the rich!
And anywhere where profit might arise
He'd crawl with courteous offers of service.
You'd nowhere find an abler man than he,
Or a better beggar in his friary;
He paid a yearly fee for his district,
No brother friar trespassed on his beat.
A widow might not even own a shoe,
But so pleasant was his In principio[8]
He'd win her farthing in the end, then go. 260
He made his biggest profits on the side.
He'd frolic like a puppy. He'd give aid
As arbitrator upon settling-days,
For there he was not like some cloisterer[9]
With threadbare cape, like any poor scholar,
But like a Master of Arts, or the Pope!
Of the best double-worsted was his cloak,
And bulging like a bell that's newly cast.
He lisped a little, from affectation,
To make his English sweet upon his tongue; 270
And when he harped, as closing to a song,
His eyes would twinkle in his head just like
The stars upon a sharp and frosty night.
This worthy limiter was called Hubert.
 A merchant was there, on a high-saddled horse:
He'd a forked beard, a many-colored dress,
And on his head a Flanders beaver hat,
Boots with expensive clasps, and buckled neatly.
He gave out his opinions pompously,

Kept talking of the profits that he'd made, 280
How, at all costs, the sea should be policed
From Middleburg in Holland to Harwich.
At money-changing he was an expert;
He dealt in French gold florins on the quiet.
This worthy citizen could use his head:
No one could tell whether he was in debt,
So impressive and dignified his bearing
As he went about his loans and bargaining.
He was a really estimable man,
But the fact is I never learnt his name. 290
 There was a scholar from Oxford as well,
Not yet an MA, reading Logic still;
The horse he rode was leaner than a rake,
And he himself, believe me, none too fat,
But hollow-cheeked, and grave and serious.
Threadbare indeed was his short overcoat:
A man too unworldly for lay office,
Yet he'd not got himself a benefice.
For he'd much rather have at his bedside
A library, bound in black calf or red, 300
Of Aristotle and his philosophy,
Than rich apparel, fiddle, or fine psaltery.
And though he was a man of science, yet
He had but little gold in his strongbox;
But upon books and learning he would spend
All he was able to obtain from friends;
He'd pray assiduously for their souls,
Who gave him wherewith to attend the schools.
Learning was all he cared for or would heed.
He never spoke a word more than was need, 310
And that was said in form and decorum,
And brief and terse, and full of deepest meaning.
Moral virtue was reflected in his speech,
And gladly would he learn, and gladly teach.
 There was a wise and wary sergeant-at-law,
A well-known figure in the portico
Where lawyers meet; one of great excellence,
Judicious, worthy of reverence,
Or so he seemed, his sayings were so wise.
He'd often acted as Judge of Assize 320
By the king's letters patent, authorized
To hear all cases. And his great renown
And skill had won him many a fee, or gown
Given in lieu of money. There was none
To touch him as a property-buyer; all
He bought was fee-simple, without entail,[10]
You'd never find a flaw in the conveyance.
And nowhere would you find a busier man;
And yet he seemed much busier than he was.
From yearbooks he could quote, chapter and verse, 330
Each case and judgment since William the First.
And he knew how to draw up and compose
A deed; you couldn't fault a thing he wrote;
And he'd reel all the statutes off by rote.
He was dressed simply, in a colored coat,
Girt by a silk belt with thin metal bands.

7. licenced to hear confession.
8. "In the beginning."
9. member of a monastic order.

10. fee-simple; entail: legal terms meaning, respectively, absolute property, and its opposite, estate secured so that it cannot be bequeathed at will.

I have no more to tell of his appearance.
 A franklin—that's a country gentleman
And freeman landowner—was his companion.
White was his beard, as white as any daisy; 340
Sanguine his temperament; his face ruddy.
He loved his morning draught of sops-in-wine,
Since living well was ever his custom,
For he was Epicurus' own true son
And held with him that sensuality
Is where the only happiness is found.
And he kept open house so lavishly
He was St Julian to the country round,
The patron saint of hospitality.
His bread and ale were always of the best, 350
Like his wine-cellar, which was unsurpassed.
Cooked food was never lacking in his house,
Both meat and fish, and that so plenteous
That in his home it snowed with food and drink,
And all the delicacies you could think.
According to the season of the year,
He changed the dishes that were served at dinner.
He'd plenty of fat partridges in coop,
And kept his fishpond full of pike and carp.
His cook would catch it if his sauces weren't 360
Piquant and sharp, and all his equipment
To hand. And all day in his hall there stood
The great fixed table, with the places laid.
When the justices met he'd take the chair;
He often served as MP[11] for the shire.
A dagger, and a small purse made of silk,
Hung at his girdle, white as morning milk.
He'd been sheriff, and county auditor:
A model squireen, no man worthier.
 A haberdasher and a carpenter, 370
A weaver, dyer, tapestry-maker—
And they were in the uniform livery
Of a dignified and rich fraternity,
A parish-guild: their gear all trim and fresh,
Knives silver-mounted, none of your cheap brass;
Their belts and purses neatly stitched as well,
All finely finished to the last detail.
Each of them looked indeed like a burgess,
And fit to sit on any guildhall dais.
Each was, in knowledge and ability, 380
Eligible to be an alderman;
For they'd income enough and property.
What's more, their wives would certainly agree,
Or otherwise they'd surely be to blame—
It's very pleasant to be called "Madam"
And to take precedence at church processions,
And have one's mantle carried like a queen's.
 They had a cook with them for the occasion,
To boil the chickens up with marrowbones,
Tart powdered flavoring, spiced with galingale. 390
No better judge than he of London ale.
And he could roast, and seethe, and boil, and fry,
Make a thick soup, and bake a proper pie;
But to my mind it was the greatest shame
He'd got an open sore upon his shin;

For he made chicken-pudding with the best.
 A sea-captain, whose home was in the west,
Was there—a Dartmouth man, for all I know.
He rode a cob as well as he knew how,
And was dressed in a knee-length woollen gown. 400
From a lanyard round his neck, a dagger hung
Under his arm. Summer had tanned him brown.
As rough a diamond as you'd hope to find,
He'd tapped and lifted many a stoup of wine
From Bordeaux, when the merchant wasn't looking.
He hadn't time for scruples or fine feeling,
For if he fought, and got the upper hand,
He'd send his captives home by sea, not land.
But as for seamanship, and calculation
Of moon, tides, currents, all hazards at sea, 410
For harbor-lore, and skill in navigation,
From Hull to Carthage there was none to touch him.
He was shrewd adventurer, tough and hardy.
By many a tempest had his beard been shaken.
And he knew all the harbors that there were
Between the Baltic and Cape Finisterre,
And each inlet of Britanny and Spain.
The ship he sailed was called "The Magdalen".
 With us there was a doctor, a physician;
Nowhere in all the world was one to match him 420
Where medicine was concerned, or surgery;
Being well grounded in astrology
He'd watch his patient with the utmost care
Until he'd found a favorable hour,
By means of astrology, to give treatment.
Skilled to pick out the astrologic moment
For charms and talismans to aid the patient,
He knew the cause of every malady,
If it were "hot" or "cold" or "moist" or "dry",
And where it came from, and from which humor.[12] 430
He was a really fine practitioner.
Knowing the cause, and having found its root,
He'd soon give the sick man an antidote.
Ever at hand he had apothecaries
To send him syrups, drugs, and remedies,
For each put money in the other's pocket—
Theirs was no newly founded partnership.
Well-read was he in Aesculapius,
In Dioscorides, and in Rufus,
Ancient Hippocrates, Hali, and Galen, 440
Avicenna, Rhazes, and Serapion,
Averroës, Damascenus, Constantine,
Bernard, and Gilbertus, and Gaddesden.
In his own diet he was temperate,
For it was nothing if not moderate,
Though most nutritious and digestible.
He didn't do much reading in the Bible.
He was dressed all in Persian blue and scarlet
Lined with taffeta and fine sarsenet,[13]
And yet was very chary of expense. 450
He put by all he earned from pestilence;

11. Member of Parliament [an anachronism in the translation].

12. one of the four fluids of the body thought to determine health and temperament. (They were: blood, phlegm, choler, and melancholy.)
13. fine silk fabric.

In medicine gold is the best cordial.
So it was gold that he loved best of all.
 There was a business woman, from near Bath,
But, more's the pity, she was a bit deaf;
So skilled a clothmaker, that she outdistanced
Even the weavers of Ypres and Ghent.
In the whole parish there was not a woman
Who dared precede her at the almsgiving,
And if there did, so furious was she, 460
That she was put out of all charity.
Her headkerchiefs were of the finest weave,
Ten pounds and more they weighed, I do believe,
Those that she wore on Sundays on her head.
Her stockings were of finest scarlet red,
Very tightly laced; shoes pliable and new.
Bold was her face, and handsome; florid too.
She had been respectable all her life,
And five times married, that's to say in church,
Not counting other loves she'd had in youth, 470
Of whom, just now, there is no need to speak.
And she had thrice been to Jerusalem;
Had wandered over many a foreign stream;
And she had been at Rome, and at Boulogne,
St James of Compostella, and Cologne;
She knew all about wandering—and straying:
For she was gap-toothed, if you take my meaning.
Comfortably on an ambling horse she sat,
Well-wimpled, wearing on her head a hat
That might have been a shield in size and shape; 480
A riding-skirt round her enormous hips,
Also a pair of sharp spurs on her feet.
In company, how she could laugh and joke!
No doubt she knew of all the cures for love,
For at that game she was a past mistress.
 And there was a good man, a religious.
He was the needy priest of a village,
But rich enough in saintly thought and work.
And educated, too, for he could read;
Would truly preach the word of Jesus Christ, 490
Devoutly teach the folk in his parish.
Kind was he, wonderfully diligent;
And in adversity most patient,
As many a time had been put to the test.
For unpaid tithes he'd not excommunicate,
For he would rather give, you may be sure,
From his own pocket to the parish poor;
Few were his needs, so frugally he lived.
Wide was his parish, with houses far asunder,
But he would not neglect, come rain or thunder, 500
Come sickness or adversity, to call
On the furthest of his parish, great or small;
Going on foot, and in his hand a staff.
This was the good example that he set:
He practiced first what later he would teach.
Out of the gospel he took that precept;
And what's more, he would cite this saying too:
"If gold can rust, then what will iron do?"
For if a priest be rotten, whom we trust,
No wonder if a layman comes to rust. 510
It's shame to see (let every priest take note)
A shitten shepherd and a cleanly sheep.

It's the plain duty of a priest to give
Example to his sheep; how they should live.
He never let his benefice for hire
And left his sheep to flounder in the mire
While he ran off to London, to St Paul's
To seek some chantry and sing mass for souls,
Or to be kept as chaplain by a guild;
But stayed at home, and took care of his fold, 520
So that no wolf might do it injury.
He was a shepherd, not a mercenary.
And although he was saintly and virtuous,
He wasn't haughty or contemptuous
To sinners, speaking to them with disdain,
But in his teaching tactful and humane.
To draw up folk to heaven by goodness
And good example, was his sole business.
But if a person turned out obstinate,
Whoever he was, of high or low estate, 530
He'd earn a stinging rebuke then and there.
You'll never find a better priest, I'll swear.
He never looked for pomp or deference,
Nor affected an over-nice conscience,
But taught the gospel of Christ and His twelve
Apostles; but first followed it himself.
 With him there was his brother, a plowman,
Who'd fetched and carried many a load of dung;
A good and faithful laborer was he,
Living in peace and perfect charity. 540
God he loved best, and that with all his heart,
At all times, good and bad, no matter what;
And next he loved his neighbor as himself.
He'd thresh, and ditch, and also dig and delve,
And for Christ's love would do as much again
If he could manage it, for all poor men,
And ask no hire. He paid his tithes in full,
On what he earned and on his goods as well.
He wore a smock, and rode upon a mare.
 There was a reeve as well, also a miller, 550
A pardon-seller and a summoner,
A manciple, and myself—there were no more.
 The miller was a burly fellow—brawn
And muscle, big of bones as well as strong,
As was well seen—he always won the ram
At wrestling-matches up and down the land.
He was barrel-chested, rugged and thickset,
And would heave off its hinges any door
Or break it, running at it with his head.
His beard was red as any fox or sow, 560
And wide at that, as though it were a spade.
And on his nose, right on its tip, he had
A wart, upon which stood a tuft of hairs
Red as the bristles are in a sow's ears.
Black were his nostrils; black and squat and wide.
He bore a sword and buckler by his side.
His big mouth was as big as a furnace,
A loudmouth and a teller of blue stories
(Most of them vicious or scurrilous),
Well versed in stealing corn and trebling dues, 570
He had a golden thumb—by God he had!
A white coat he had on, and a blue hood.
He played the bagpipes well, and blew a tune,

And to its music brought us out of town.
 A worthy manciple of the Middle Temple[14]
Was there; he might have served as an example
To all provision-buyers for his thrift
In making purchase, whether on credit
Or for cash down: he kept an eye on prices,
So he always got in first and did good business. 580
Now isn't it an instance of God's grace,
Such an unlettered man should so outpace
The wisdom of a pack of learned men?
He'd more than thirty masters over him,
All of them proficient experts in law,
More than a dozen of them with the power
To manage rents and land for any peer
So that—unless the man were off his head—
He could live honorably, free of debt,
Or sparingly, if that were his desire; 590
And able to look after a whole shire
In whatever emergency might befall;
And yet this manciple could hoodwink them all.
 There was a reeve,[15] a thin and bilious man;
His beard he shaved as close as a man can;
Around his ears he kept his hair cropped short,
Just like a priest's, docked in front and on top.
His legs were very long, and very lean,
And like a stick; no calf was to be seen.
His granary and bins were ably kept; 600
There was no auditor could trip him up.
He could foretell, by noting drought and rain,
The likely harvest from his seed and grain.
His master's cattle, dairy, cows, and sheep,
His pigs and horses, poultry and livestock,
Were wholly under this reeve's governance.
And, as was laid down in his covenant,
Of these he'd always rendered an account
Ever since his master reached his twentieth year.
No man could ever catch him in arrears. 610
He was up to every fiddle, every dodge
Of every herdsman, bailiff, or farm-lad.
All of them feared him as they feared the plague.
His dwelling was well placed upon a heath,
Set with green trees that overshadowed it.
At business he was better than his lord:
He'd got his nest well-feathered, on the side,
For he was cunning enough to get round
His lord by lending him what was his own,
And so earn thanks, besides a coat and hood. 620
As a young man he'd learned a useful trade
As a skilled artisan, a carpenter.
The reeve rode on a sturdy farmer's cob
That was called Scot: it was a dapple grey.
He had on a long blue-grey overcoat,
And carried by his side a rusty sword.
A Norfolk man was he of whom I tell,
From near a place that they call Bawdeswell.
Tucked round him like a friar's was his coat;

He always rode the hindmost of our troop. 630
 A summoner[16] was among us at the inn,
Whose face was fire-red, like the cherubim;
All covered with carbuncles; his eyes narrow;
He was as hot and randy as a sparrow.
He'd scabbed black eyebrows, and a scraggy beard,
No wonder if the children were afraid!
There was no mercury, white lead, or sulphur,
No borax, no ceruse, no cream of tartar,
Nor any other salves that cleanse and burn,
Could help with the white pustules on his skin, 640
Or with the knobbed carbuncles on his cheeks.
He'd a great love of garlic, onions, leeks,
Also for drinking strong wine, red as blood,
When he would roar and gabble as if mad.
And once he had got really drunk on wine,
Then he would speak no language but Latin.
He'd picked up a few tags, some two or three,
Which he'd learned from some edict or decree
No wonder, for he heard them every day.
Also, as everybody knows, a jay 650
Can call out "Wat" as well as the Pope can.
But if you tried him further with a question,
You'd find his well of learning had run dry;
"Questio quid juris"[17] was all he'd ever say.
A most engaging rascal, and a kind,
As good a fellow as you'd hope to find:
For he'd allow—given a quart of wine—
A scallywag to keep his concubine
A twelvemonth, and excuse him altogether.
He'd dip his wick, too, very much *sub rosa*.
And if he found some fellow with a woman, 660
He'd tell him not to fear excommunication
If he were caught, or the archdeacon's curse,
Unless the fellow's soul was in his purse,
For it's his purse must pay the penalty.
"Your purse is the archdeacon's Hell", said he.
Take it from me, the man lied in his teeth:
Let sinners fear, for that curse is damnation,
Just as their souls are saved by absolution.
Let them beware, too, of a "*Significavit*."[18] 670
Under his thumb, to deal with as he pleased,
Were the young people of his diocese;
He was their sole adviser and confidant.
Upon his head he sported a garland
As big as any hung outside a pub,[19]
And, for a shield, he'd a round loaf of bread.
 With him there was a peerless pardon-seller[20]
Of Charing Cross, his friend and his confrère,
Who'd come straight from the Vatican in Rome.
Loudly he sang, "Come to me, love, come hither!" 680
The summoner sang the bass, a loud refrain;
No trumpet ever made one half the din.
This pardon-seller's hair was yellow as wax,

14. *manciple*: buyer of provisions; Middle Temple: one of London's Inns of Court, where lawyers practiced and lived.
15. supervisor for a Lord of the Manor.
16. lawcourt official.
17. "What is the law on this point?"
18. The first word of the writ of excommunication.
19. Before literacy became widespread, inns often used bushes or branches as signs.
20. Person licensed to sell papal indulgences.

And sleekly hanging, like a hank of flax.
In meagre clusters hung what hair he had;
Over his shoulders a few strands were spread,
But they lay thin, in rat's tails, one by one.
As for a hood, for comfort he wore none,
For it was stowed away in his knapsack.
Save for a cap, he rode with his head all bare, 690
Hair loose; he thought it was the *dernier cri.*
He had big bulging eyes, just like a hare.
He'd sewn a veronica[21] on his cap.
His knapsack lay before him, on his lap,
Chockful of pardons, all come hot from Rome.
His voice was like a goat's, plaintive and thin.
He had no beard, nor was he like to have;
Smooth was his face, as if he had just shaved.
I took him for a gelding or a mare.
As for his trade, from Berwick down to Ware 700
You'd not find such another pardon-seller.
For in his bag he had a pillowcase
Which had been, so he said, Our Lady's veil;
He said he had a snippet of the sail
St Peter had, that time he walked upon
The sea, and Jesus Christ caught hold of him.
And he'd a brass cross, set with pebble-stones,
And a glass reliquary of pigs' bones.
But with these relics, when he came upon
Some poor up-country priest or backwoods parson, 710
In just one day he'd pick up far more money
Than any parish priest was like to see
In two whole months. With double-talk and tricks
He made the people and the priest his dupes.
But to speak truth and do the fellow justice,
In church he made a splendid ecclesiastic.
He'd read a lesson, or saint's history,
But best of all he sang the offertory:
For, knowing well that when that hymn was sung,
He'd have to preach and polish smooth his tongue 720
To raise—as only he knew how—the wind,
The louder and the merrier he would sing.
 And now I've told you truly and concisely
The rank, and dress, and number of us all,
And why we gathered in a company
In Southwark, at that noble hostelry
Known as the Tabard, that's hard by the Bell.
But now the time has come for me to tell
What passed among us, what was said and done
The night of our arrival at the inn; 730
And afterwards I'll tell you how we journeyed,
And all the remainder of our pilgrimage.
But first I beg you, not to put it down
To my ill-breeding if my speech be plain
When telling what they looked like, what they said,
Or if I use the exact words they used.
For, as you all must know as well as I,
To tell a tale told by another man
You must repeat as nearly as you can
Each word, if that's the task you've undertaken, 740

However coarse or broad his language is;
Or, in the telling, you'll have to distort it
Or make things up, or find new words for it.
You can't hold back, even if he's your brother:
Whatever word is used, you must use also.
Christ Himself spoke out plain in Holy Writ,
And well you know there's nothing wrong with that.
Plato, as those who read him know, has said,
"The word must be related to the deed."
Also I beg you to forgive it me 750
If I overlooked all standing and degree
As regards the order in which people come
Here in this tally, as I set them down:
My wits are none too bright, as you can see.
 Our host gave each and all a warm welcome,
And set us down to supper there and then.
The eatables he served were of the best;
Strong was the wine; we matched it with our thirst.
A handsome man our host, handsome indeed,
And a fit master of ceremonies. 760
He was a big man with protruding eyes
—You'll find no better burgess in Cheapside—
Racy in talk, well-schooled and shrewd was he;
Also a proper man in every way.
And moreover he was a right good sort,
And after supper he began to joke,
And, when we had all paid our reckonings,
He spoke of pleasure, among other things:
"Truly," said he, "ladies and gentlemen,
Here you are all most heartily welcome, 770
Upon my word—I'm telling you no lie—
All year I've seen no jollier company
At one time in this inn, than I have now.
I'd make some fun for you, if I knew how.
And, as it happens, I have just now thought
Of something that will please you, at no cost.
 "You're off to Canterbury—so Godspeed!
The blessed martyr give you your reward!
And I'll be bound, that while you're on your way,
You'll be telling tales, and making holiday; 780
It makes no sense, and really it's no fun
To ride along the road dumb as a stone.
And therefore I'll devise a game for you,
To give you pleasure, as I said I'd do.
And if with one accord you all consent
To abide by my decision and judgment,
And if you'll do exactly as I say,
Tomorrow, when you're riding on your way,
Then, by my father's soul—for he is dead—
If you don't find it fun, why, here's my head! 800
Now not another word! Hold up your hands!"
 We were not long in making up our minds.
It seemed not worth deliberating, so
We gave our consent without more ado,
Told him to give us what commands he wished.
"Ladies and gentlemen," began our host,
"Do yourselves a good turn, and hear me out:
But please don't turn your noses up at it.
I'll put it in a nutshell: here's the nub:
It's that you each, to shorten the long journey, 810
Shall tell two tales *en route* to Canterbury,

21. Image of Christ, like that supposed to have appeared on St
Veronica's cloth after she wiped Christ's brow as he went to Calvary.

And, coming homeward, tell another two,
Stories of things that happened long ago.
Whoever best acquits himself, and tells
The most amusing and instructive tale,
Shall have a dinner, paid for by us all,
Here in this inn, and under this roof-tree,
When we come back again from Canterbury.
To make it the more fun, I'll gladly ride
With you at my own cost, and be your guide. 820
And anyone who disputes what I say
Must pay all our expenses on the way!
And if this plan appeals to all of you,
Tell me at once, and with no more ado,
And I'll make my arrangements here and now."

 To this we all agreed, and gladly swore
To keep our promises; and furthermore
We asked him if he would consent to do
As he had said, and come and be our leader,
And judge our tales, and act as arbiter, 830
Set up our dinner too, at a fixed price;
And we'd obey whatever he might decide
In everything. And so, with one consent,
We bound ourselves to bow to his judgment.
And thereupon wine was at once brought in.
We drank; and not long after, everyone
Went off to bed, and that without delay.

 Next morning our host rose at break of day:
He was our cockcrow; so we all awoke.
He gathered us together in a flock, 840
And we rode, at little more than walking-pace
Till we had reached St Thomas' watering-place.
Where our host began reining in his horse.
"Ladies and gentlemen, attention please!"
Said he, "All of you know what we agreed,
And I'm reminding you. If evensong
And matins are in harmony—that's to say,
If you are still of the same mind today—
Let's see who'll tell the first tale, and begin.
And whosoever baulks at my decision 850
Must pay for all we spend upon the way,
Or may I never touch a drop again!
And now let's draw lots before going on.
The one who draws the short straw must begin.
Sir Knight, my lord and master," said our host,
"Now let's draw lots, for such is my request.
Come near," said he, "my lady Prioress,
And, Mister Scholar, lay by bashfulness,
Stop dreaming! Hands to drawing, everyone!"
To cut the story short, the draw began, 860
And, whether it was luck, or chance, or fate,
The truth is this: the lot fell to the knight,
Much to the content of the company.
Now, as was only right and proper, he
Must tell his tale, according to the bargain
Which, as you know, he'd made. What more to say?
And when the good man saw it must be so,
Being sensible, and accustomed to obey
And keep a promise he had freely given,
He said, "Well, since I must begin the game, 870
Then welcome to the short straw, in God's name!
Now let's ride on, and listen to what I say."

And at these words we rode off on our way,
And he at once began, with cheerful face,
His tale.

The Prolog of the Wife of Bath's Tale

"Experience—and no matter what they say
In books—is good enough authority
For me to speak of trouble in marriage. 820
For ever since I was twelve years of age,
Thanks be to God, I've had no less than five
Husbands at church door—if one may believe
I could be wed so often legally!
And each a man of standing, in his way.
Certainly it was told me, not long since,
That, seeing Christ had never more than once 10
Gone to a wedding (Cana, in Galilee)
He taught me by that very precedent
That I ought not be married more than once.
What's more, I was to bear in mind also
Those bitter words that Jesus, God and Man,
Spoke in reproof to the Samaritan
Beside a well—'Thou hast had,' said He,
'Five husbands, and he whom now thou hast
Is not thy husband.' He said that, of course,
But what He meant by it I cannot say. 20
All I ask is, why wasn't the fifth man
The lawful spouse of the Samaritan?
How many lawful husbands could she have?
All my born days, I've never heard as yet
Of any given number or limit,
However folk surmise or interpret.
All I know for sure is, God has plainly
Bidden us to increase and multiply—
A noble text, and one I understand!
And, as I'm well aware, He said my husband 30

Must leave father and mother, cleave to me.
But, as to number, did He specify?
He named no figure, neither two nor eight—
Why should folk talk of it as a disgrace?
"And what about that wise King Solomon:
I take it that he had more wives than one!
Now would to God that I might lawfully
Be solaced half as many times as he!
What a God-given gift that Solomon
Had for his wives! For there's no living man 40
Who has the like; Lord knows how many a bout
That noble king enjoyed on the first night
With each of them! His was a happy life!
Blessed be God that I have married five!
Here's to the sixth, whenever he turns up.
I won't stay chaste for ever, that's a fact.
For when my husband leaves this mortal life
Some Christian man shall wed me soon enough.
For then, says the Apostle Paul, I'm free
To wed, in God's name, where it pleases me. 50
He says that to be married is no sin,
Better it is to marry than to burn.
What do I care if people execrate
The bigamy of villainous Lamech?

I know that Abraham was a holy man,
And Jacob too, so far as I can tell;
And they had more than two wives, both of them,
And many another holy man as well.
Now can you tell me where, in any age, 60
Almighty God explicitly forbade
All marrying and giving in marriage?
Answer me that! And will you please tell me
Where was it He ordained virginity?
No fear, you know as well as I do, that
The Apostle, where he speaks of maidenhood,
Says he has got no firm precept for it.
You may advise a woman not to wed,
But by no means is advice a command.
To our own private judgment he left it; 70
Had virginity been the Lord's command,
Marriage would at the same time be condemned.
And surely, if no seed were ever sown,
From what, then, could virginity be grown?
Paul did not dare command, at any rate,
A thing for which the Lord gave no edict.
There's a prize set up for virginity:
Let's see who'll make the running, win who may!
 "This teaching's not for all men to receive,
Just those to whom it pleases God to give 80
The strength to follow it. All I know is,
That the Apostle was himself a virgin;
But none the less, though he wished everyone
—Or so he wrote and said—were such as he,
That's only to *advise* virginity.
I have his leave, by way of concession,
To be a wife; and so it is no shame,
My husband dying, if I wed again;
A second marriage can incur no blame.
Though it were good for a man not to touch 90
A woman—meaning in his bed or couch,
For who'd bring fire and tow too close together?
I think you'll understand the metaphor!
Well, by and large, he thought virginity
Better than marrying out of frailty.
I call it frailty, unless he and she
Mean to live all their lives in chastity.
 "I grant all this; I've no hard feelings if
Maidenhood be set above remarriage.
Purity in body and in heart
May please some—as for me, I make no boast. 100
For, as you know, no master of a household
Has all of his utensils made of gold;
Some are of wood, and yet they are of use.
The Lord calls folk to Him in many ways,
And each has his peculiar gift from God,
Some this, some that, even as He thinks good.
 "Virginity is a great excellence,
And so is dedicated continence,
But Christ, of perfection the spring and well,
Did not bid everyone to go and sell 110
All that he had, and give it to the poor,
And thus to follow in His tracks; be sure
He spoke to those who would live perfectly;
And, sirs, if you don't mind, that's not for me.
I mean to give the best years of my life

To the acts and satisfactions of a wife.
 "And tell me also, what was the intention
In creating organs of generation,
When man was made in so perfect a fashion?
They were not made for nothing, you can bet! 120
Twist it how you like and argue up and down
That they were only made for the emission
Of urine; that our little differences
Are there to distinguish between the sexes,
And for no other reason—who said no?
Experience teaches that it is not so.
But not to vex the scholars, I'll say this:
That they were fashioned for both purposes,
That's to say, for a necessary function
As much as for enjoyment in procreation 130
Wherein we do not displease God in heaven.
Why else is it set down in books, that men
Are bound to pay their wives what's due to them?
And with whatever else would he make payment
If he didn't use his little instrument?
It follows, therefore, they must have been given
Both to pass urine, and for procreation.
 "But I'm not saying everyone who's got
The kind of tackle I am talking of
Is bound to go and use it sexually. 140
For then who'd bother about chastity?
Christ was a virgin, though formed like a man,
Like many another saint since time began,
And yet they lived in perfect chastity.
I've no objection to virginity.
Let them be loaves of purest sifted wheat,
And us wives called mere barley-bread, and yet
As St Mark tells us, when our Savior fed
The multitude, it was with barley-bread.
I'm not particular: I'll continue 150
In the condition God has called us to.
In married life I mean to use my gadget
As generously as my Maker gave it.
If I be grudging, the Lord punish me!
My husband's going to have it night and day,
At any time he likes to pay his dues.
I shan't be difficult! I shan't refuse!
I say again, a husband I must have,
Who shall be both my debtor and my slave,
And he shall have, so long as I'm his wife, 160
His 'trouble in the flesh.' For during life
I've 'power of his body' and not he.¹
That's just what the Apostle Paul told me;
He told our husbands they must love us too.
Now I approve entirely of this view—"
 Up leapt the pardoner—"Now then, madam,
I swear to you by God and by St John,
You make a splendid preacher on this theme.
I was about to wed a wife—but then
Why should my body pay a price so dear? 170
I'll not wed this nor any other year!"
 "You wait!" said she. "My tale has not begun.
It is a different cask that you'll drink from

1. Ephesians 5:25.

Before I've done; a bitterer brew than ale.
And when I've finished telling you my tale
Of tribulation in matrimony
—And I'm a lifelong expert; that's to say
That I myself have been both scourge and whip—
You can decide then if you want to sip
Out of the barrel that I mean to broach. 180
But you had best take care if you approach
Too near—for I've a dozen object-lessons
And more, that I intend to tell. 'The man
Who won't be warned by others, he shall be
Himself a warning to all other men.'
These are the very words that Ptolemy
Writes in his A*lmagest*: you'll find it there."[2]

 "Let me beg you, madam," said the pardoner,
"If you don't mind, go on as you began,
And tell your tale to us and spare no man, 190
And teach all us young fellows your technique."

 "Gladly," said she, "if that's what you would like;
But let no one in this company, I beg,
If I should speak what comes into my head,
Take anything that I may say amiss;
All that I'm trying to do is amuse.

 "And now, sir, now, I will begin my tale.
May I never touch a drop of wine or ale
If this be not the truth! Of those I had,
Three were good husbands, two of them were bad. 200
The three good ones were very rich and old;
But barely able, all the same, to hold
To the terms of our covenant and contract—
Bless me! you'll all know what I mean by that!
It makes me laugh to think, so help me Christ,
How cruelly I made them sweat at night!
And I can tell you it meant nothing to me.
They'd given me their land and property;
I'd no more need to be assiduous
To win their love, or treat them with respect. 210
They all loved me so much that, heavens above!
I set no store whatever by their love.
A wily woman's always out to win
A lover—that is, if she hasn't one.
Since I'd got them in the hollow of my hand,
And they'd made over to me all their land,
What point was there in taking pains to please,
Except for my advantage, or my ease?
Believe you me, I set them so to work
That many a night I made them sing, 'Alack!' 220
No flitch of bacon for them, anyhow,
Like some have won in Essex at Dunmow.[3]
I governed them so well in my own way,
And kept them happy, so they'd always buy
Fairings to bring home to me from the fair.
When I was nice to them, how glad they were!
For God knows how I'd nag and give them hell!

 "Now listen how I managed things so well,

You wives that have the wit to understand!
Here's how to talk and keep the upper hand: 230
For no man's half as barefaced as a woman
When it comes to chicanery and gammon.
It's not for knowing wives that I say this,
But for those times when things have gone amiss.
For any astute wife, who knows what's what,
Can make her husband think that black is white,
With her own maid as witness in support.
But listen to the kind of thing I'd say:

 'So this is how things are, old Mister Dotard?
Why does the woman next door look so gay? 240
She can go where she likes, and all respect her,
—I sit at home, I've nothing fit to wear!
Why are you always over at her house?
She's pretty, is she? So you're amorous!
What did I catch you whispering to the maid?
Mister Old Lecher, drop it, for God's sake!
And if I've an acquaintance or a friend,
You rage and carry on just like a fiend
If I pay him some harmless little visit!
And then you come back home pissed as a newt, 250
And preach at me, confound you, from your bench!
What a great shame—just think of the expense—
To marry a poor woman, so you tell me.
And if she's rich, and comes of a good family,
It's hell, you say, to put up with her pride,
And her black moods and fancies. Then, you swine,
Should she be beautiful, you change your line,
And say that every rakehell wants to have her,
That in no time she's bound to lose her honor,
Because it is assailed on every side. 260

 'You say that some folk want us for our riches,
Some for our looks, and others for our figures,
Or for our sex appeal, or our good breeding;
Some want a girl who dances, or can sing,
Else it's our slender hands and arms they want.
So the devil takes the lot, by your account!
None can defend a castle wall, you say,
For long if it's attacked day after day.

 'And if she's plain, why then you say that she's
Setting her cap at every man she sees: 270
She'll jump upon him, fawning like a spaniel,
Till someone buys what she has got to sell.
Never a goose upon the lake so grey
But it will find its gander, so you say.
Says you, it's hard to manage or control
A thing no man would keep of his own will.
That's how you talk, pig, when you go to bed,
Saying that no sane man need ever wed,
Nor any man who hopes to go to heaven.
Wretch, may your withered wrinkled neck be broken 280
In two by thunderblast and fiery lightning!

 'And then, you say, a leaky roof, and smoke,
And nagging wives, are the three things that make
A man flee from his home. Oh, for God's sake!
What ails an old man to go on like that!

 'Then you go on to claim we women hide
Our failings till the knot is safely tied,
And then we show them—A villainous saying,
A scoundrel's proverb, if I ever heard one!

2. Collection of proverbs attributed to Ptolemy of Alexandria (2nd
century BC). This proverb is not, in fact, his.
3. Couples proving conjugal harmony for a year are awarded a side of
pork (flitch), at Dunmow every year.

'You say that oxen, asses, horses, hounds,
Can be tried out and proved at different times,
And so can basins, washbowls, stools, and spoons,
And household goods like that, before you buy;
Pots, clothes and dresses too; but who can try
A wife out till he's wed? Old dotard! Pig!
And then, says you, we show the faults we've hid.

 'You also claim that it enrages me
If you forget to compliment my beauty,
If you're not always gazing on my face,
Paying me compliments in every place, 300
If on my birthday you don't throw a party,
Buy a new dress, and make a fuss of me;
Or if you are ungracious to my nurse,
Or to my chambermaid, or even worse,
Rude to my father's kinsfolk and his cronies,—
That's what you say, old barrelful of lies!

 'And about Jankin you've the wrong idea,
Our apprentice with curly golden hair
Who makes himself my escort everywhere—
I wouldn't have him if you died tomorrow! 310
But, damn you, tell me this—God send you sorrow!—
Why do you hide the strongbox keys from me?
It's mine as much as yours—our property!
What! I'm the mistress of the house, and you'll
Make her look like an idiot and a fool?
You'll never be, no matter how you scold,
Master of both my body and my gold,
No, by St James! For you'll have to forgo
One or the other, take or leave it! Now,
What use is all your snooping and your spying? 320
I sometimes think you want to lock me in
That strongbox of yours, when you should be saying
"Dear wife, go where you like, go and have fun,
I shan't believe the tales they tell in malice,
I know you for a faithful wife, Dame Alice."
We love no man who watches carefully
Our coming and going; we want liberty.

 'Blessed above all other men is he,
That astrologer, Mister Ptolemy,
Who set down in his book, the Almagest 330
This proverb: "Of all men he is the wisest
Who doesn't care who has the world in hand."
From which proverb you are to understand
That if you have enough, why should you care
A curse how well-off other people are?
Don't worry, you old dotard—it's all right,
You'll have cunt enough and plenty, every night.
What bigger miser than he who'll not let
Another light a candle at his lantern—
He won't have any the less light, I'm thinking! 340
If you've enough, what's there to grumble at?

 'And you say if we make ourselves look smart
With dresses and expensive jewelry,
It only puts at risk our chastity;
And then, confound you, you must quote this text,
And back yourself up with the words of Paul,
As thus: "In chaste and modest apparel
You women must adorn yourselves," said he,
"And not with braided hair and jewelry,
Such as pearls and gold; and not in costly dress." 350

But of your text, and your red-letter rubric, 290
I'll be taking no more notice than a gnat!
 'And you said this: that I was like a cat,
For you have only got to singe its skin,
And then the cat will never go from home;
But if its coat is looking sleek and gay,
She won't stop in the house, not half a day,
But off she goes the first thing in the morning,
To show her coat off and go caterwauling.
That's to say, if I'm all dressed up, Mister Brute, 360
I'll run out in my rags to show them off!
 'Mister Old Fool, what good is it to spy?
If you begged Argus with his hundred eyes
To be my bodyguard—what better choice?—
There's little he would see unless I let him,
For if it killed me, yet I'd somehow fool him!

 'And you have also said, there are three things,
Three things there are that trouble the whole earth,
And there's no man alive can stand the fourth—
Sweet Mister Brute, Jesus cut short your life! 370
You keep on preaching that an odious wife
Is to be counted one of these misfortunes.
Really, are there no other comparisons
That you can make, and without dragging in
A poor innocent wife as one of them?
 'Then you compare a woman's love to Hell,
To barren lands where rain will never fall.
And you go on to say, it's like Greek fire,
The more it burns, the fiercer its desire
To burn up everything that can be burned. 380
And just as grubs and worms eat up a tree,
Just so a woman will destroy her husband;
All who are chained to wives know this, you say.'
 "Ladies and gentlemen, just as you've heard
I'd browbeat them; they really thought they'd said
All these things to me in their drunkenness.
All lies—but I'd get Jankin to stand witness
And bear me out, and my young niece also.
O Lord! the pain I gave them, and the woe,
And they, heaven knows, quite innocent of course. 390
For I could bite and whinny like a horse.
I'd scold them even when I was at fault,
For otherwise I'd often have been dished.
Who comes first to the mill, is first to grind;
I'd get in first, till they'd be glad to find
A quick excuse for things they'd never done
In their whole lives; and so our war was won.
I'd pick on them for wenching; never mind
They were so ill that they could barely stand!
 "And yet it tickled him to the heart, because 400
He thought it showed how fond of him I was.
I swore that all my walking out at night
Was to spy out the women that he tapped;
Under that cover, how much fun I had!
To us at birth such mother-wit is given;
As long as they live God has granted women
Three things by nature: lies, and tears, and spinning.
There's one thing I can boast of: in the end
I'd gain, in every way, the upper hand
By force or fraud, or by some stratagem 410
Like everlasting natter, endless grumbling.

Bed in particular was their misfortune;
That's when I'd scold, and see they got no fun.
I wouldn't stop a moment in the bed
If I felt my husband's arm over my side,
No, not until his ransom had been paid,
And then I'd let him do the thing he liked.
What I say is, everything has its price;
You cannot lure a hawk with empty hand.
If I wanted something, I'd endure his lust. 420
And even feign an appetite for it;
Though I can't say I ever liked old meat—
And that's what made me nag them all the time.
Even though the Pope were sitting next to them
I'd not spare them at table or at board,
But paid them back, I tell you, word for word.
I swear upon my oath, so help me God,
I owe them not a word, all's been paid back.
I set my wits to work till they gave up;
They had to, for they knew it would be best, 430
Or else we never would have been at rest.
For even if he looked fierce as a lion,
Yet he would fail to get his satisfaction.
 "Then I would turn and say, 'Come, dearest, come!
How meek you look, like Wilkin, dear old lamb!
Come to me, sweetheart, let me kiss your cheek!
You ought to be all patient and meek,
And have ever such a scrupulous conscience—
Or so you preach of Job and his patience!
Always be patient; practice what you preach, 440
For if you don't, we've got a thing to teach,
Which is: it's good to have one's wife in peace!
One of us has got to knuckle under,
And since man is more rational a creature
Than woman is, it's you who must forbear.
But what's the matter now? Why moan and groan?
You want my quim just for yourself alone?
Why, it's all yours—there now, go take it all!
By Peter, but I swear you love it well!
For if I wished to sell my pretty puss, 450
I'd go about as sweet as any rose;
But no, I'll keep it just for you to taste.
Lord knows you're in the wrong; and that's the truth!'
 "All arguments we had were of that kind.
Now I will speak about my fourth husband.
 "My fourth husband was a libertine;
That is to say, he kept a concubine;
And I was young, and passionate, and gay,
Stubborn and strong, and merry as a magpie.
How I would dance to the harp's tunable 460
Music, and sing like any nightingale,
When I had downed a draught of mellow wine!
Metallius, the dirty dog, that swine
Who with a club beat his own wife to death
Because she drank—if I had been his wife,
Even he would not have daunted me from drink!
And after taking wine I'm bound to think
On Venus—sure as cold induces hail,
A greedy mouth points to a greedy tail.
A woman full of wine has no defense, 470
All lechers know this from experience.
 "But, Lord Christ! when it all comes back to me,

And I recall my youth and gaiety,
It warms the very cockles of my heart.
And to this day it does my spirit good
To think that in my time I've had my fling.
But age, alas, that cankers everything,
Has stripped me of my beauty and spirit.
Let it go then! Goodbye, and devil take it!
The flour's all gone; there is no more to say. 480
Now I must sell the bran as best I may;
But all the same I mean to have my fun.
And now I'll tell about my fourth husband.
 "I tell you that it rankled in my heart
That in another he should take delight.
But he was paid for it in full, by God!
From that same wood I made for him a rod—
Not with my body, and not like a slut,
But certainly I carried on with folk
Until I made him stew in his own juice, 490
With fury, and with purest jealousy.
By God! on earth I was his purgatory,
For which I hope his soul's in Paradise.
God knows he often had to sit and whine
When his shoe pinched him cruellest! And then
How bitterly, and in how many ways,
I wrung his withers, there is none can guess
Or know, save only he and God in heaven!
He died when I came from Jerusalem,
And now lies buried under the rood beam,[4] 500
Although his tomb is not as gorgeous
As is the sepulchre of Darius
That Apelles sculpted so skillfully;
For to have buried him expensively
Would have been waste. So goodbye, and God rest him!
He's in his grave now, shut up in his coffin.
 "Of my fifth husband I have this to tell
—I pray God keep and save his soul from hell!—
And yet he was to me the worst of all:
I feel it on my ribs, on each and all, 510
And always will until my dying day!
But in our bed he was so free and gay
And moreover knew so well how to coax
And cajole when he wanted my *belle chose*,
That, though he'd beaten me on every bone,
How quickly he could win my love again!
I think that I loved him the best, for he
Was ever chary of his love for me.
We women have, I'm telling you no lies,
In this respect the oddest of fancies; 520
If there's a thing we can't get easily,
That's what we're bound to clamor for all day:
Forbid a thing, and that's what we desire;
Press hard upon us, and we run away.
We are not forward to display our ware:
For a great crowd at market makes things dear;
Who values stuff bought at too cheap a price?
And every woman knows this, if she's wise.
 "My fifth husband—may God bless his soul!
Whom I took on for love, and not for gold, 530

4. screen separating chancel from nave of church, supporting a crucifix, or rood.

Was at one time a scholar at Oxford,
But had left college, and come home to board
With my best friend, then living in our town:
God keep her soul! her name was Alison.
She knew me and the secrets of my heart
As I live, better than the parish priest:
She was my confidant; I told her all—
For had my husband pissed against a wall,
Or done a thing that might have cost his life—
To her, and also to my dearest niece, 540
And to another lady friend as well,
I'd have betrayed his secrets, one and all.
And so I did time and again, dear God!
It often made his face go red and hot
For very shame; he'd kick himself, that he
Had placed so great a confidence in me.
 "And it so happened that one day in Lent
(For I was ever calling on my friend,
As I was always fond of having fun,
Strolling about from house to house in spring, 550
In March, April, and May, to hear the gossip)
Jankin the scholar, and my friend Dame Alice,
And I myself, went out into the meadows.
My husband was in London all that Lent,
So I was free to follow my own bent,
To see and to be seen by the gay crowd.
How could I know to whom, and in what place,
My favors were destined to be bestowed?
At feast-eves and processions, there I was;
At pilgrimages; I attended sermons, 560
And these miracle-plays; I went to weddings,
Dressed in my best, my long bright scarlet gowns.
No grub, no moth or insect had a chance
To nibble at them, and I'll tell you why:
It was because I wore them constantly.
 "Now I'll tell you what happened to me then.
We strolled about the fields, as I was saying,
And got on so well together, he and I,
That I began to think ahead, and tell him
That if I were a widow we could marry. 570
For certainly—I speak without conceit—
Till now I've never been without foresight
In marriage matters; other things as well.
I'd say a mouse's life's not worth a leek
Who has but one hole to run to for cover,
For if that fails the mouse, then it's all over!
 "I let him think that he'd got me bewitched.
It was my mother taught me that device.
I also said I dreamed of him at night,
That he'd come to kill me, lying on my back, 580
And that the entire bed was drenched in blood.
And yet I hoped that he would bring me luck—
In dreams blood stands for gold, so I was taught.
All lies—for I dreamed nothing of the sort.
I was in this, as in most other things,
As usual following my mother's teachings.
 "But now, sirs, let me see—what was I saying?
Aha! Bless me, I've found the thread again.
 "When my fourth husband was laid on his bier
I wept for him—what a sad face I wore!— 590
As all wives must, because it's customary;

With my kerchief I covered up my face.
But, since I was provided with a mate,
I wept but little, that I guarantee!
 "To church they bore my husband in the morning
Followed by the neighbors, all in mourning,
And one among them was the scholar Jankin.
So help me God, when I saw him go past,
Oh what a fine clean pair of legs and feet
Thought I—and so to him I lost my heart. 600
He was, I think, some twenty winters old,
And I was forty, if the truth be told.
But then I always had an itch for it!
I was gap-toothed; but it became me well;
I wore St Venus' birthmark and her seal.[5]
So help me God, but I was a gay one,
Pretty and fortunate; joyous and young;
And truly, as my husbands always told me,
I had the best what-have-you that might be.
Certainly I am wholly Venerian 610
In feeling; and in courage, Martian.
Venus gave to me lust, lecherousness;
And Mars gave me my sturdy hardiness.
Taurus was my birth-sign, with Mars therein.
Alas, alas, that ever love was sin!
And so I always followed my own bent,
Shaped as it was by my stars' influence,
That made me so that I could not begrudge
My chamber of Venus to a likely lad.
I've still the mark of Mars upon my face, 620
And also in another secret place.
For, sure as God above is my salvation,
I never ever loved in moderation,
But always followed my own appetite,
Whether for short or tall, or black or white;
I didn't care, so long as he pleased me,
If he were poor, or what his rank might be.
 "There's little more to say: by the month's ending,
This handsome scholar Jankin, gay and dashing,
Had married me with all due ceremony. 630
To him I gave all land and property,
Everything that I had inherited.
But, later, I was very sorry for it—
He wouldn't let me do a thing I wanted!
My God, he once gave my ear such a box
Because I tore a page out of his book,
That from the blow my ear became quite deaf.
I was untameable as a lioness;
My tongue unstoppable and garrulous;
And walk I would, as I had done before, 640
From house to house, no matter how he swore
I shouldn't; and for this he'd lecture me,
And tell old tales from Roman history;
How one Simplicius Gallus left his wife,
Left her for the remainder of his life,
Only because one day he saw her looking
Out of the door with no head-covering.
 "He said another Roman, Whatsisname
Because his wife went to a summer-game

5. To have a gap between the front teeth was thought to indicate
licentiousness.

Without his knowledge, went and left her too. 650
And then he'd get his Bible out to look
In Ecclesiasticus for that text
Which with absolute stringency forbids
A man to let his wife go gad about;
Then, never fear, here's the next thing he'd quote:
'Whoever builds his house out of willows,
And rides a blind horse over the furrows,
And lets his wife trot after saints' altars,
Truly deserves to be hung on the gallows.'
But all for nothing; I cared not a bean 660
For all his proverbs, nor for his old rhyme;
And neither would I be reproved by him.
I hate a man who tells me of my vices,
And God knows so do more of us than I.
This made him absolutely furious;
I'd not give in to him, in any case.
 "Now, by St Thomas, I'll tell you the truth
About why I ripped a page out of his book,
For which he hit me so that I went deaf.
 "He had a book he loved to read, that he 670
Read night and morning for his own delight;
Valerius and Theophrastus,[6] he called it,
Over which book he'd chuckle heartily.
And there was a learned man who lived in Rome,
A cardinal who was called St Jerome,
Who wrote a book attacking Jovinian;
And there were also books by Tertullian,
Chrysippus, Trotula, and Heloise,
Who was an abbess not far from Paris,
Also the parables of Solomon, 680
Ovid's *Art of Love*, and many another one,
All bound together in the same volume.
And night and morning it was his custom,
Whenever he had leisure and freedom
From any other worldly occupation,
To read in it concerning wicked women:
He knew more lives and legends about them
Than there are of good women in the Bible.
Make no mistake, it is impossible
That any scholar should speak good of women, 690
Unless they're saints in the hagiologies;
Not any other kind of woman, no!
Who drew the picture of the lion? Who?[7]
My God, had women written histories
Like cloistered scholars in oratories,
They'd have set down more of men's wickedness
Than all the sons of Adam could redress.
For women are the children of Venus,
And scholars those of Mercury; the two
Are at cross purposes in all they do; 700
Mercury loves wisdom, knowledge, science,
And Venus, revelry and extravagance.
Because of their contrary disposition
The one sinks when the other's in ascension;

6. *Valerius*: a work by Walter Map (12th century) about not marrying;
Theophrastus: *On Marriage*, a treatise read by St Jerome.
7. A reference to one of Aesop's fables. A lion would paint a lion
killing a man, not the other way around, i.e. all depends on point of
view.

And so, you see, Mercury's powerless
When Venus is ascendant in Pisces,
And Venus sinks where Mercury is raised.
That's why no woman ever has been praised
By any scholar. When they're old, about
As much use making love as an old boot, 710
Then in their dotage they sit down and write:
Women can't keep the marriage vows they make!
 "But to the point—why I got beaten up,
As I was telling you, just for a book:
One night Jankin—that's my lord and master—
Read in his book as he sat by the fire,
Of Eva first, who through her wickedness
Brought the whole human race to wretchedness,
For which Jesus Himself was crucified,
He Who redeemed us all with His heart's blood. 720
Look, here's a text wherein we plainly find
That woman was the ruin of mankind.
 "He read to me how Samson lost his hair:
He slept; his mistress cut it with her shears,
Through which betrayal he lost both his eyes.
 "And then he read to me, if I'm no liar,
Of Hercules and his Dejaneira,
And how she made him set himself on fire.
 "He left out nothing of the grief and woe
That the twice-married Socrates went through; 730
How Xantippe poured piss upon his head,
And the poor man sat stock-still as if dead;
He wiped his head, not daring to complain:
'Before the thunder stops, down comes the rain!'
 "And out of bloody-mindedness he'd relish
The tale of Pasiphaë, Queen of Crete—
Fie! say no more—it's gruesome to relate
Her abominable likings and her lust!
 "Of the lechery of Klytaimnestra,
How she betrayed her husband to his death, 740
These things he used to read with great relish.
 "He also told me how it came about
That at Thebes Amphiarus lost his life:
My husband had a tale about his wife
Eriphile, who for a golden brooch
Had covertly discovered to the Greeks
Where they might find her husband's hiding-place,
Who thus, at Thebes, met a wretched fate.
 "He told of Livia and Lucilia,
Who caused their husbands, both of them, to die; 750
One out of love, the other out of loathing.
Hers, Livia poisoned late one evening,
Because she hated him; ruttish Lucilia
On the contrary, loved her husband so,
That she mixed for him, so that he should think
Only of her, an aphrodisiac drink
So strong that before morning he was dead.
Thus husbands always have the worst of it!
 "Then he told me how one Latumius
Once lamented to his friend Arrius 760
That there was a tree growing in his garden
On which, he said, his three wives, out of dudgeon,
Had hanged themselves. 'Dear friend,' said Arrius,
'Give me a cutting from this marvellous tree,
And I shall go and plant it in my garden.'

"Concerning wives of later days, he read
How some had killed their husbands in their bed,
And let their lovers have them while the corpse
Lay all night on its back upon the floor.
And others, while their husbands slept, have driven 770
Nails through their brainpans, and so murdered them.
Yet others have put poison in their drink.
He spoke more evil than the heart can think.
On top of that, he knew of more proverbs
Than there is grass and herbage upon earth.
'Better to live with a lion or dragon,'
Said he, 'than take up with a scolding woman.
Better to live high in an attic roof
Than with a brawling woman in the house:
They are so wicked and contrarious 780
That what their husbands love, they always hate.'
He also said, 'A woman casts off shame
When she casts off her smock,' and he'd go on:
'A pretty woman, if she isn't chaste,
Is like a gold ring stuck in a sow's nose.'
Now who could imagine, or could suppose,
The grief and torment in my heart, the pain?
 "When I realized he'd never make an end
But read away in that damned book all night,
All of a sudden I got up and tore 790
Three pages out of it as he was reading,
And hit him with my fist upon the cheek
So that he tumbled back into our fire,
And up he jumped just like a raging lion,
And punched me with his fist upon the head
Till I fell to the floor and lay for dead.
And when he saw how motionless I lay,
He took alarm, and would have run away,
Had I not burst at last out of my swoon.
'You've murdered me, you dirty thief!' I said, 800
'You've gone and murdered me, just for my land!
But I'll kiss you once more, before I'm dead!'
 "He came close to me and kneeled gently down,
And said, 'My dearest sweetheart Alison,
So help me God, I'll not hit you again.
You yourself are to blame for what I've done.
Forgive it me this once, for mercy's sake.'
But once again I hit him on the cheek:
'You robber, take that on account!' I said.
'I can't speak any more; I'll soon be dead.' 810
After no end of grief and pain, at last
We made it up between the two of us:
He gave the reins to me, and to my hand
Not only management of house and land,
But of his tongue, and also of his fist—
And then and there I made him burn his book!
And when I'd got myself the upper hand
And in this way obtained complete command,
And he had said, 'My own true faithful wife,
Do as you please from now on, all your life: 820
Guard your honor and look after my estate.'
—From that day on we had no more debate.
So help me God, to him I was as kind
As any wife from here to the world's end,
And true as well—and so was he to me.
I pray to God Who reigns in majesty,

For His dear mercy's sake, to bless his soul.
Now if you'll listen, I will tell my tale."

The dispute between the Summoner and the Friar

The friar laughed, when he had heard all this.
"Now madam," cried he, "as I hope for bliss, 830
That was a long preamble to a tale!"
And when the summoner heard the friar bawl,
"See here!" he cried. "By God's two arms! A friar
Will butt in all the time, and everywhere!
Good folk, they're all the same, these flies and friars,
Falling in people's foodbowls and affairs.
What are you talking of—'perambulation'?
Amble, trot, or shut up and sit down!
This kind of thing is ruining our fun."
 "Oh indeed, Mister Summoner, is that so?" 840
Returned the friar. "My word, before I go
I'll tell a tale or two about a summoner,
And raise a laugh from everybody here!"
 "Try it and see, Friar," said the summoner,
"And damn your eyes! And damn my own as well
If I've not got two or three tales to tell
Concerning friars, that will make you mourn
Before I get as far as Sittingbourne.
For I can see you've lost your temper now."
 "Now you shut up!" our host cried. "Hold your row!" 850
He went on: "Let the lady tell her tale.
You look as if you had had too much ale.
Madam, begin your tale: that would be best."
 "I'm ready, sir," said she, "just as you wish,
That is, if I have leave of this good friar,"
 "Tell on, madam," said he, "and I will hear."

The Wife of Bath's Tale

In the old days, the days of King Arthur,
He whom the Britons hold in great honor,
All of this land was full of magic then.
And with her joyous company the elf-queen
Danced many a time on many a green mead.
That was the old belief, as I have read:
I speak of many hundred years ago.
But now elves can be seen by men no more,
For now the Christian charity and prayers 10
Of limiters and other saintly friars
Who haunt each nook and corner, field and stream,
Thick as the motes of dust in a sunbeam,
Blessing the bedrooms, kitchens, halls, and bowers,
Cities and towns, castles and high towers,
Villages, barns, cattle-sheds and dairies,
Have seen to it that there are now no fairies.
Those places where you once would see an elf
Are places where the limiter himself
Walks in the afternoons and early mornings, 20
Singing his holy offices and matins,
While going on the rounds of his district.
Women may now go safely where they like:
In every bush, and under every tree,
They'll find no other satyr there but he:
And he'll do nothing worse than take their honor.

Now it so happened that this King Arthur
Had in his court a bold knight-bachelor
Who one day was hawking by the river,
And it so chanced, as he was riding home,　30
He met a maiden walking all alone,
And thereupon, though she fought long and hard,
The knight took by main force her maidenhood;
And this outrage occasioned a great stir,
So much petitioning of King Arthur,
That the knight was, in due course of law,
Condemned to death, and would have lost his head
According to the law as it then stood,
Had not the queen and many another lady
Importuned the king so long for mercy　40
That in the end he granted him his life
and gave him to the queen to dispose of:
Either to execute, or spare his life.

The queen gave the king thanks with all her heart,
And some time afterwards spoke to the knight
One day when she saw opportunity:
"Your fate is in the balance still," said she,
"You cannot yet be certain of your life,
But you shall live if you can answer me,
What is the thing that women most desire?　50
Your neck is forfeit to the axe—beware!
And if you cannot tell me here and now
I shall, however, give you leave to go
A twelvemonth and a day, to seek and find
An answer that will satisfy my mind.
And you must pledge, before you can depart,
Duly to yield yourself up in this court."

Sad was the knight; sorrowfully he sighed;
But there! it's not as if he'd any choice.
And so at long last he made up his mind　60
To go, and to come back at the year's end,
With whatever answer heaven might provide;
And so he took his leave, and off he rode.

He visited every house, and every spot
Where he might have the luck to find out what
The thing is that we women most desire;
But could find in no country anywhere
Two people to agree with one another
Upon this subject.
　　　　　　　Some said we love best
Riches and wealth; and others said, honor;　70
Some said, fine clothes; and others, happiness;
Some said it is the pleasures of the bed,
And to be often widowed, often wed.
And others said we're happiest at heart
When complimented and well cosseted.
Which is pretty near the truth, and that's no lie.
A man can win us best by flattery;
And with attentiveness, assiduity,
We're ensnared, one and all.
　　　　　　　　　　Some say that we
Love best to have our own way and be free,　80
To have no one reprove us for our follies,
But say how wise we are, how far from foolish.
If someone touches on a tender spot,
There isn't one of us—indeed there's not—
Who won't kick, just for being told the truth!

Just try it, and you'll find out soon enough.
However faulty we may be within,
We want to be thought wise, and free from sin.
　　And others say that we take great delight
In being thought dependable and discreet.　90
Able to hold steadfastly to one purpose,
Never revealing what a person tells us.
As for that notion, it's not worth a button,
Because we women can keep nothing hidden.
Witness King Midas—would you hear of him?
　　Ovid, among some other trifles, said
That under his long hair King Midas had
Two asses' ears growing upon his head,
Which blemish he kept hid, as best he might,
Most artfully from everybody's sight,　100
So that, but for his wife, none knew of it.
Above all things he loved and trusted her;
And he implored her never to make mention
Of his deformity to anyone.
　　No, not for anything in the world, she swore,
Would she do such a mean and sinful thing,
And bring discredit to her husband's name.
If only for her shame's sake, she'd not tell.
But none the less, she thought that she would die
If she had to keep a secret for so long;　110
So hard against her heart it seemed to swell,
That she must speak or burst; till finally
As she dared tell the secret to no man,
Down to a marsh close by her home she ran—
Till she got there, her heart was all afire—
And, like a bittern when it makes its boom,
Placing her mouth beneath the water's surface,
"Do not betray me, water, with your noise,"
Said she, "to you I tell it, no one else:
My husband has got two long asses' ears!　120
I feel ever so much better now it's out.
I couldn't keep it in another minute!"
Which shows that though we may hold on a bit,
Yet out it must; we can keep nothing secret.
If you'd like to hear the ending of this tale,
Read Ovid's book: and there you'll find it all.
　　Now when the knight, the subject of my story,
Found that he was no nearer the discovery
Of what it is that women love the best,
How heavy was the heart within his breast!　130
And home he went, for he could not remain;
The day was come when he had to return.
On his way home it happened that he rode,
Much troubled, by the borders of a wood
Where he, all of a sudden, caught a glimpse
Of four-and-twenty ladies in a dance;
And eagerly drew nearer, on the chance
That he would hear of something he could use.
Lo and behold! Before he quite got there,
The dancers vanished, he could not tell where.　140
No living creature was there to be seen
Save for a woman sitting on the green—
You couldn't imagine an uglier.
At the knight's coming, this old woman rose.
"There's no road on from here, Sir Knight," she says,
"But tell me what you're looking for. Who knows,

You'll do yourself a good turn, it may be;
We old folks know so many things," says she.
 "My dear good mother," said the knight, "for sure,
I am as good as dead, if I can't tell 150
What the thing is that women most desire.
If you could tell me that, I'd pay you well."
 "Put your hand in mine and pledge your word," said
 she,
"That you will do the first thing I require
Of you, so be that it lies in your power,
And I shall tell it to you before night."
 "Agreed: you have my promise," said the knight.
 "Then," said she, "I'll go so far as to say
Your life is safe: for I will stake my head
That what I say is what the queen will say. 160
Now let's see if the proudest of them all
That wears a handkerchief or jeweled snood
Will have the face to deny or refute
What I'll teach you. Say no more; let's go on."
Then, whispering a few words in his ear,
She told him to cheer up and have no fear.
 The knight, on his arrival at the court,
Said he had kept, according to his word,
His day, and that he had his answer ready.
Many a maiden, many a noble lady, 170
And many a widow (widows are so wise),
The queen herself in the chair of justice,
Had all assembled in the court to hear;
And then the knight was ordered to appear.
 All were commanded to observe silence,
And the knight to tell, in formal audience,
What it is mortal women love the most.
Instead of standing there dumb as an ox,
The knight resolved the riddle there and then
In ringing tones, so the whole court heard him: 180
 "In general, my liege lady," he began,
"Women desire to have dominion
Over their husbands, and their lovers too;
They want to have mastery over them.
That's what you most desire—even if my life
Is forfeit. I am here; do what you like."
In the whole court there was no wife nor maid
Nor widow who'd contradict what he said,
But all declared that he deserved his life.
Upon this, the old woman whom the knight 190
Encountered sitting on the forest green,
Jumped up and cried: "My sovereign lady queen,
Before the court disperses, do me right!
It was I who taught his answers to the knight.
For which he gave his promise on the spot
That he would do the first thing that I asked,
If so be that it lay within his might.
And so before the court I ask, Sir Knight,"
Said she, "that you take me to be your wife.
For well you know that I have saved your life. 200
If this be false, deny it upon oath!"
 "Alas!" replied the knight, "alack, alas!
I know too well that such was my promise.
So for the love of God, choose something else!
Take all my goods and let my body go."
 "Never! A curse on us both if I do!

For though I may be ugly, old and poor,
I'd not, for all the gold and metal ore
That's buried under ground, or lies above,
Be other than your wife, and your true love!" 210
 "My love?" cried he. "You mean my damnation!
Alas! that ever any of my family
Should undergo such foul degradation!"
But it was all for nothing; finally
He was compelled to see he needs must wed;
And, taking his aged wife, goes off to bed.
 Now some of you will say of me, perhaps,
That I don't trouble, out of laziness,
To tell of all the gaiety and joy
Seen at the feast upon that marriage-day: 220
To which I'll give a short and simple answer,
There was no feasting and no fun whatever,
Nothing at all but misery and mourning,
For he married her in secret in the morning,
And all that day hid himself like an owl,
Moping because his new wife looked so foul.
 And now what bitter thoughts oppressed the knight
When he was brought to bed with his aged wife!
He tossed and twisted back and forth, the while
His wife lay there and never ceased to smile, 230
But said, "My dearest husband! Bless me! Do
All knights who marry wives behave like you?
Is this the custom in King Arthur's house?
Is every knight of his so hard to please?
I am your own true love, also your wife,
And I am also she who saved your life.
And surely I have never wronged you yet?
So why behave like this on our first night?
You're acting like a man who's lost his wits.
What have I done? Now tell me, for God's sake, 240
And if I can, I shall soon set it right."
 "Set it right! Never, never!" cried the knight,
"Nothing can ever set it right again!
You are so hideous, so old and plain,
And what is more besides, so basely born,
It's little wonder if I toss and turn.
I only wish to God my heart would burst."
 "Is that," she asked, "the cause of your distress?"
 "Indeed yes, and no wonder," said the knight.
 "Now sir," said she, "all this I could put right 250
Before three days are up,—that's if I liked,
And you were to behave more courteously.
 "But since you talk of such gentility
As is derived from ancient wealth; and claim
On that account to be a gentleman—
Such affectation isn't worth a bean.
Look for the man who's always virtuous
In private and in public, does his best
Always to do what gentle acts he can,
And count him for the greatest gentleman. 260
For Christ wants us to claim nobility
From Him, and not from our rich ancestry,
For though they may have left us all their wealth,
For which we claim to be of gentle birth,
They are by no means able to bequeath
Their goodness, or their virtuous way of life
Which earned for them the name of gentlemen,

401

And points to us to follow in their steps.
 "Upon this Dante, that wise Florentine
Poet, has spoken with great eloquence; 270
Now listen: Dante's verses go like this:
'It's rarely man climbs to excellence by
His own thin branches; God in His goodness
Wills us to claim from Him nobility.'
For from our forebears we can only claim
Material things, which may injure and harm.
 "And everybody knows as well as I,
Were Nature to implant gentility
In any single family, so the line
Inherited it—why then, they'd never cease 280
In private and in public from behaving
Like gentlemen; moreover, they would be
Incapable of villainy or crime.
 "Take fire, convey it to the darkest house
That's between here and coldest Caucasus,
And shut the doors on it, and go away;
As brightly will that fire blaze and burn,
As if a thousand folk were looking on;
I'll stake my life, that fire will perform
Its natural function always, till it die. 290
Thus you can plainly see that nobleness
Has no connection with ancestral riches;
People aren't always on their best behaviour
As fire is—for fire is always fire.
And God knows one can often enough find
A lord's son who behaves just like a fiend.
And he who prizes his gentility
Because descended from a noble house,
From ancestors both noble and virtuous,
Yet who himself performs no noble deed 300
Like his own noble ancestor who's dead,
He is not noble, be he duke or earl;
For churlish actions are what make the churl.
For nobility's no more than the renown
Of your forebears, by their great virtue won,
Nothing to do with you, or your person;
Your nobility comes from God alone.
Thus our true nobility comes by grace,
Is not bequeathed along with our position.
 "And think how noble, as Valerius says, 310
Was Tullus Hostilius, who rose
From poverty to the highest rank of all.
Read Seneca, and Boethius as well,
And there you will find that it's made quite plain
It's noble deeds that make the nobleman.
And therefore, my dear husband, I conclude,
That though my ancestors were rough and rude,
I might be granted yet, by God on high
(And so I hope) grace to live virtuously.
I'm truly noble then, if I begin 320
To live in virtue and to cast off sin.
 "As for my poverty, which you reprove,
The Lord on high, in Whom we both believe,
Willingly chose a life of poverty.
To every man, matron, and maid, surely
It's plain as day that Jesus, Heaven's King,
Would never choose a vicious way of life.
As Seneca and others say, in truth

Cheerful poverty is an honest thing.
Whoever is contented with his lot, 330
Poor as it is, I count him to be rich,
Though he may have no shirt upon his back;
Whoever covets anything is poor,
Because he wants what isn't in his power.
The man with nothing, who would nothing have,
Is rich, though you may count him as a slave.
The nature of true poverty is to sing;
On this Juvenal has a happy saying—
'The poor man, when he goes a-journeying,
Can laugh at thieves.' Poverty's a hated boon, 340
And, as I'd guess, an efficient expeller
Of anxieties; also a great improver
Of wisdom, when it is patiently borne.
That is poverty, hard as it may seem:
It is an asset no one wants to claim.
Poverty will often, if you're humble,
Teach you to know God, and yourself as well.
Poverty's like an eyeglass, I declare,
Through which you can see who your real friends are.
In this I am not harming you; therefore 350
You can't go on complaining I am poor.
 "And as for your reproach that I am old,
Were there no book whatever to uphold
Authority for it, yet all the same
It's said by honorable gentlemen
Just like yourself, that people should respect
An old man, call him 'sir' for manners' sake:
I could find texts that say so, I expect.
 "As for your point that I'm loathsome and old,
You've then no fear of being made cuckold; 360
For ugliness and age, it seems to me,
Are the best bodyguards for chastity.
But, since I know what gives you most delight,
I'll satisfy your sensual appetite.
 "Choose now, choose one of these two things," said
 she,
"To have me old and ugly till I die,
And be to you a true and faithful wife,
And never to displease you all my life;
Or else to have me beautiful and young,
And take your chances with a crowd of men 370
All flocking to the house because of me,
Or to some other place, as it may be.
Choose for yourself which of the two you please."
 He turns it over in his mind, and sighs,
And in this way the knight at last replies:
"My lady and my love, my dear wife too,
I place myself in your wise governance;
Choose for yourself whichever's the most pleasant,
Most honorable to you, and me also.
All's one to me; choose either of the two; 380
What pleases you is good enough for me."
 "Then I've the mastery of you," said she,
"Since I may choose and decide as I wish?"
 "Yes, certainly," said he, "I think it best."
 "Kiss me, and we won't quarrel any more,
For I'll be both to you, upon my honor!
That's to say, beautiful as well as good.
May death and madness be my lot," she said,

"If I am not a wife as good and true
As ever wife was since the world was new. 390
And if I'm not as pretty as a queen,
As any empress that was ever seen
From east to west, before tomorrow's dawn,
Then you can deal just as you like with me.
And now, lift up the curtain: look and see."
 And when the knight saw it was really so,
And that she was as lovely as she was young,
He caught her up in both his arms for joy,
With his whole heart bathed in a bath of bliss;

They kiss; a thousand thousand times they kiss. 400
And she obeyed him in all things that might
Afford him satisfaction or delight.
 To their lives' end they lived in perfect joy;
And may Christ Jesus send us husbands who
Are meek and young, and spirited in bed;
And send us grace to outlive those we wed;
And I pray Jesus to cut short the lives
Of those who won't be governed by their wives;
And as for all old and ill-tempered skinflints,
May heaven rain upon them pestilence! 410

GLOSSARY

a cappella. Choral music without instrumental accompaniment.

abacus. The uppermost member of the capital of an architectural column; the slab on which the architrave rests.

absolute music. Music that is free from any reference to nonmusical ideas, such as a text or program.

abstract, abstraction. Non-representational; the essence of a thing rather than its actual appearance.

absurdism. A style dealing with life's apparent meaninglessness and the difficulty or impossibility of human communication.

academy. From the grove (the Academeia) where Plato taught; the term has come to mean the cultural and artistic establishment which exercises responsibility for teaching and the maintenance of standards.

accent. In music, a stress on a note. In the visual arts, any device used to highlight or draw attention to a particular area, such as an accent color. See also *focal point*.

acoustics. The scientific study of sound and hearing.

action theatre. A contemporary phenomenon in which plays, happenings, and other types of performance are strongly committed to broad moral and social issues with the overt purpose of effecting a change for the better in society.

aerial perspective. The indication of distance in painting through use of light and atmosphere.

aesthetic. Having to do with the pleasurable and beautiful as opposed to the useful.

aesthetic distance. The combination of mental and physical factors that provides the proper separation between a viewer and an artwork; it enables the viewer to achieve a desired response.

aesthetics. A branch of philosophy dealing with the nature of beauty and art and their relation to human experience.

affective. Relating to feelings or emotions, as opposed to facts. See *cognitive*.

aleatory. Chance or accidental. A term used for 20th-century music where the composer deliberately incorporates elements of chance.

allegory. Expression by means of symbols to make a more effective generalization or moral commentary about human experience than could be achieved by direct or literal means.

altarpiece. A painted or sculpted panel placed above and behind an altar to inspire religious devotion.

ambulatory. A covered passage for walking, found around the apse or choir of a church.

amphitheatre. A building, typically Roman, that is oval or circular in form and encloses a central performance area.

amphora. A two-handled vessel for storing provisions, with an opening large enough to admit a ladle, and usually fitted with a cover.

animism. The belief that objects as well as living organisms are endowed with soul.

antiphonal. A responsive style of singing or playing, in which two groups alternate.

anthropomorphic. With human characteristics attributed to nonhuman beings, or things.

apse. A large niche or niche-like space projecting from and expanding the interior space of an architectural form such as a basilica.

arcade. A series of arches side by side.

arch. In architecture, a structural system in which space is spanned by a curved member supported by two legs.

archetype. An original model or type after which other similar things are patterned.

architrave. In post-and-lintel architecture, the lintel or lowest part of the entablature, resting directly on the capitals of the columns.

aria. An elaborate solo song found primarily in operas, oratorios, and cantatas.

art song. A solo musical composition for voice, usually with piano accompaniment.

articulation. The connection of the parts of an artwork. In music or speech, the production of distinct sounds.

artifact. An object produced or shaped by human workmanship.

Art Nouveau. A style of decoration and architecture first current in the 1890s, characterized by curvilinear floral forms.

atonality. The avoidance of tonal centers or keys in musical compositions.

atrium. An open courtyard within or related to a building.

avant-garde. A term used to designate innovators, the "advanced guard," whose experiments in art challenge established values.

balance. In composition, the equilibrium of opposing or interacting forces.

ballad. In folk music, a narrative song usually set to relatively simple music.

ballade. A verse form usually consisting of three stanzas of eight or ten lines each, with the same concluding line in each stanza, and a brief final stanza, ending with the same last line as that of the preceding stanzas. In musical composition, either a Medieval French song, or a lyrical piano piece from the 19th century.

baroque. A 17th- and 18th-century style of art, architecture, and music that is highly ornamental.

barrel vault, tunnel vault. A series of arches placed back to back to enclose space.

basilica. In Roman times a term referring to building function, usually a law court; later used by Christians to refer to church buildings and a specific form.

beats. In music, the equal parts into which a measure is divided, which form the pulse underlying most rhythmic patterns.

bel canto. An Italian baroque style of operatic singing characterized by rich tonal lyricism and brilliant display of vocal technique.

binary form. A musical form consisting of two sections.

biomorphic. Representing life forms as opposed to geometric forms.

bridge. A musical passage of subordinate importance played as a link between two principal themes.

buttress. A support, usually an exterior projection of masonry or wood, for a wall, arch, or vault.

cadence. In music, the specific harmonic arrangement that indicates the closing of a phrase.

cameo. A brief but dramatic appearance of a prominent actor or actress in a single scene in film, television, and stage. Also a gem, hardstone, or shell with two layers of color, the upper of which can be carved in relief while the lower is used as a ground.

canon. A body of principles, rules, standards or norms; a criterion for establishing measure, scale, and proportion. In music, a composition for two or more voices or instruments, where one enters after another in direct imitation of the first.

cantata. A type of composition developed in the baroque period, for chorus and/or solo voice(s) accompanied by an instrumental ensemble.

capital. The transition between the top of a column and the lintel.

carbon-dating. A scientific method of determining the origin or date of ancient objects.

caryatid. A sculpted female figure standing in the place of a column.

cast. See *sculpture*.

catharsis. The cleansing or purification of the emotions through the experience of art, the result of which is spiritual release and renewal.

cella. The principal enclosed room of a temple; the entire body of a temple as opposed to its external parts.

ceremony. A formal act or set of acts performed as prescribed by ritual, custom, or etiquette.

chamber music. Vocal or instrumental music suitable for performance in small rooms.

chiaroscuro. Light and shade. In painting, the balance of light and shade across the whole picture. See also *modeling*. In theatre, the use of light to enhance plasticity of human and scenic form.

chorale. A Protestant hymn, for voices or organ.

chord. Three or more musical tones played at the same time.

choreography. The composition of a dance work; the arrangement of patterns of movement in dance.

citadel. A fortress or a fortified place.

city–state. A sovereign state consisting of an independent city and its surrounding territory.

classical. Adhering to traditional standards. May refer to Greek and Roman art in which simplicity, clarity of structure, and appeal to the intellect are fundamental.

clerestory. A row of windows in the upper part of a wall.

cloister. A covered walk with an open colonnade on one side, running along the inside walls of buildings that face a quadrangle. A place devoted to religious seclusion.

coffer. A recessed panel in a ceiling.

cognitive. Facts and objectivity as opposed to emotions and subjectivity. See *affective*.

collage. An artwork constructed by pasting together various materials, such as newsprint, to create textures, or by combining two- and three-dimensional media.

colonnade. A row of columns usually spanned or connected by lintels.

colonnette. A tall, narrow engaged column; colonnettes are grouped together to form piers which support structural arches in buildings such as Gothic cathedrals.

coloristic. Reflecting the skillful use of color and painterly skills.

column. A cylindrical post or support which often has three distinct parts: base, shaft, and capital.

commedia dell'arte. A type of comedy developed in Italy in the 16th century, characterized by improvization from a plot outline and by the use of stock characters.

composition. The arrangement of line, form, mass, color, and so forth, in a work of art.

compression, compressive strength. In architecture, stress that results from two forces moving toward each other.

concerto. A composition for one or more solo instruments, accompanied by an orchestra, typically in three movements.

concerto grosso. A baroque composition for a small group of solo instruments and a small orchestra.

conjunct melody. In music, melody comprising neighboring notes in the scale. The opposite of *disjunct melody*.

consonance. The feeling of a comfortable relationship between elements of a composition. Consonance may be both physical and cultural in its ramifications. The opposite of *dissonance*.

continuo, basso continuo. In baroque music, a bass line played on a low melodic instrument, such as a cello, while a keyboard instrument (or other chord-playing instrument) also plays the bass line and adds harmonies.

contrapposto, counterpoise. In sculpture, the arrangement of body parts so that the weight-bearing leg is apart from the free leg, thereby shifting the hip/shoulder axis.

conventions, conventional, conventionalized. The customs or accepted underlying principles of an art.

Corinthian. A specific order of Greek columns employing an elaborate leaf motif in the capital.

cornice. A crowning, projecting architectural feature.

corps de ballet. The chorus of a ballet ensemble.

counterpoint. In music, two or more independent melodies played in opposition to each other at the same time.

crosscutting. In film, alternation between two independent actions that are related thematically or by plot to give the impression of simultaneous occurrence.

crossing. The area in a church where the transept crosses the nave.

cross-section. A view of an object shown by cutting through it.

cruciform. Arranged or shaped like a cross.

crypt. A vaulted chamber, wholly or partly underground, that usually contains a chapel. Found in a church under the choir.

curvilinear. Formed or characterized by curved line.

cutting within the frame. Changing the viewpoint of the camera within a shot by moving from a long or medium shot to a close-up, without cutting the film.

danse macabre. Dance of death, popular in the 19th century.

dénouement. The section of a play's structure in which events are brought to a conclusion.

deposition. A painting or sculpture depicting the removal of the body of Christ from the cross.

design. A comprehensive scheme, plan or conception.

diatonic. Referring to the seven tones of a standard major or minor musical scale.

disjunct melody. In music, melody characterized by skips or jumps. The opposite of *conjunct melody*.

dissonance. The occurrence of inharmonious elements in music or the other arts. The opposite of *consonance*.

dome. An architectural form based on the principles of the arch, in which space is defined by a hemisphere used as a ceiling.

Doric. A Greek order of column having no base and only a simple slab as a capital.

drames bourgeois. Pseudo-serious plays utilizing middle-class themes and settings, with an emphasis on pathos and morality.

dynamics. The various levels of loudness and softness of sounds.

echinus. In the Doric order, the round, cushion-like element between the top of the shaft and the abacus.

eclecticism. A combination of several differing styles in a single composition.

empathy. Emotional and/or physical involvement in events to which one is a witness but not a participant.

empirical. Based on experiments, observation, and practical experience, without regard to theory.

en pointe. See *on point*.

engaged column. A column, often decorative, which is part of and projects from a wall surface.

entablature. The upper portion of a classical architectural order above the column capital.

entasis. The slight convex curving on classical columns to correct the optical illusion of concavity which would result if the sides were left straight.

entr'acte. Performance between the acts of a play.

ephemeral. Transitory, not lasting.

epic. A long narrative poem in heightened style about the deeds and adventures of a hero.

étude. Literally, a study, a lesson. An instrumental composition, intended for the practice or display of some technique.

exposition. The introductory material or opening section of a play or a musical composition.

façade. The front of a building, or the sides, if they are emphasized architecturally.

fan vaulting. An intricate style of traceried vaulting, common in the late English Gothic style, in which ribs arch out like a fan from a single point such as a capital.

farce. A theatrical genre characterized by broad, slapstick humor and implausible plots.

ferro-concrete. Concrete reinforced with rods or webs of steel.

fluting. Vertical ridges in a column.

flying buttress. A semi-detached buttress.

focal point, focal area. A major or minor area of visual attraction in pictures, sculpture, dance, plays, films, landscape design or buildings.

foreground. The area of a picture, usually at the bottom, that appears to be closest to the viewer.

form. The shape, structure, configuration, or essence of something.

found object. An object taken from life that is presented as an artwork.

four-part harmony. A standard musical texture, where four tones fill out each chord.

fresco. A method of painting in which pigment is mixed with wet plaster and applied as part of the wall surface.

frieze. The central portion of the entablature: any horizontal decorative or sculptural band.

fugue. Originated in the baroque period from a Latin word meaning "flight." A musical composition in a fixed form in which a theme is developed by counterpoint.

full-round. See *sculpture*.

galliard. A spirited court dance in triple meter.

genre. A category of artistic composition characterized by a particular style, form, or content.

geometric. Based on man-made patterns such as triangles, rectangles, circles, ellipses, and so on. The opposite of *biomorphic*.

Gesamtkunstwerk. A complete, totally integrated artwork; associated with the music dramas of Richard Wagner in 19th-century Germany.

gesso. A mixture of plaster of Paris and glue, used as a base for low relief or as a surface for painting.

Greek cross. A cross in which all arms are the same length.

Gregorian chant. A Medieval form of monophonic church music, also called plainchant or chant, sung unaccompanied, and named for Pope Gregory I.

groin vault. The ceiling formation created by the intersection of two tunnel or barrel vaults.

half cadence. A type of harmonic ending to a musical phrase which does not have a feeling of finality because it does not end on the home or tonic chord.

hamartia. The "tragic flaw" in the character of the protagonist of a classical tragedy.

harmony. The relationship of like elements such as musical notes, colors, and patterns of repetition. See *consonance* and *dissonance*.

Hellenistic. Relating to the time from the reign of Alexander the Great to the first century BC.

heroic. Larger than life-size.

hierarchy. Any system of persons or things that has higher and lower ranks.

hieratic. A style of depicting sacred persons or offices, particularly in Egyptian and Byzantine art.

hieroglyph, hieroglyphic. A picture or symbol of an object standing for a word, idea, or sound; developed by the ancient Egyptians into a system of writing.

homophony. A musical texture characterized by chordal texture supporting one melody. See *monophony* and *polyphony*.

horizon line. A real or implied line across the picture plane which, like the horizon in nature, tends to fix the viewer's vantage point.

hubris. Pride; typically the "tragic flaw" found in the protagonist of a classical tragedy. See *hamartia*.

hue. The spectrum notation of color; a specific, pure color with a measurable wavelength. There are primary hues, secondary hues, and tertiary hues.

humanitarianism. The ideas and philosophies associated with people who are concerned about human need and the alleviation of human suffering.

hymnody. The singing, composing, or study of hymns; the hymns of a particular period or church.

hypostyle. A building with a roof or ceiling supported by rows of columns, as in ancient Egyptian architecture.

icon. A Greek word meaning "image." Used to identify paintings which represent the image of a holy person.

iconography. The meanings of images and symbols.

idealization. The portrayal of an object or human body in its ideal form rather than as a true-to-life portrayal.

idée fixe. A recurring melodic motif representing a nonmusical idea; used by the composer Berlioz.

improvization. Music or other art produced on the spur of the moment, spontaneously.

illumination. The practice of decorating the pages of books—especially Medieval manuscripts—with colorful pictures or motifs.

intensity. The degree or purity of a hue. In music, theatre, and dance, that quality of dynamics denoting the amount of force used to create a sound or movement.

interval. The difference in pitch between two tones.

intrinsic. Belonging to a thing by its nature.

Ionic. A Greek order of column that has a scroll-like capital with a circular base.

jamb. The upright piece forming the side of a doorway or window frame.

key. A system of tones in music based on and named after a given tone—the tonic.

kouros. An archaic Greek statue of a standing, nude youth.

krater. A bowl for mixing wine and water, the usual Greek beverage.

kylix. A vase turned on a potter's wheel; used as a drinking cup.

labanotation. A system of writing down dance movements.

lancet window. A tall, narrow window whose top forms a lancet or narrow arch shaped like a spear.

lantern. A relatively small structure on the top of a dome, roof, or tower, frequently open to admit light into the area beneath.

Latin cross. A cross in which the vertical arm is longer than the horizontal arm, through whose midpoint it passes.

Leitmotif. A "leading motif" used in music to identify an individual, ideal, object, and so on; associated with Wagner.

lekythos. An oil flask with a long, narrow neck adapted for pouring oil slowly; used in funeral rites.

Lieder. German secular art songs. Normally applied to 19th-century solo songs with piano accompaniment; also a term for three-part Early Renaissance songs.

linear perspective. The creation of the illusion of distance in a two-dimensional artwork through the convention of line and foreshortening. That is, the illusion that parallel lines come together in the distance.

lintel. The horizontal member of a post-and-lintel structure in architecture, or a stone bridging an opening.

loggia. A gallery open on one or more sides, sometimes with arches or with columns.

lost-wax, cire-perdue. A method of casting sculpture in which the basic mold is made of wax, which is then melted to leave the desired spaces.

low relief. See *sculpture*.

lyric. A category of poetry differentiated from dramatic or narrative. In music, the use of sensual sound patterns.

madrigal. An unaccompanied musical composition for two to five independent voices using a poetic text.

masonry. In architecture, stone or brickwork.

mass. Actual or implied physical bulk, weight, and density. Also, the most important rite of the Catholic liturgy, similar to the Protestant communion service.

medium. The process employed by the artist. Also the binding agent used to hold pigments together.

melismatic. Music where a single syllable of text is sung on many notes.

melodrama. A theatrical genre characterized by stereotyped characters, implausible plots, and an emphasis on spectacle.

melody. In music, a succession of single tones; a tune.

microtone. A musical interval smaller than a half-step.

mime. A form of ancient Greek and Roman drama in which realistic characters and situations were farcically portrayed and mimicked on stage.

miniature. An artwork, usually a painting, done in very small scale.

mobile. A constructed structure whose components have been connected by joints to move by force of wind or motor.

mode. A particular form, style, or manner. In music, a scale; often used with reference to nonwestern music.

modeling. The shaping of three-dimensional forms. Also the suggestion of three-dimensionality in two-dimensional forms.

modulation. The changing from one key to another in a musical composition.

monody. A style of musical composition in which one melodic line predominates; a poetic form expressing personal lament.

monolith. A large block of stone used in architecture or sculpture.

monophony. In music, a texture employing a single melody line without harmonic support.

montage. The process of making a single composition by combining parts of others. A rapid sequence of film shots bringing together associated ideas or images.

monotheism. The belief that there is only one God.

monumental. Works actually or appearing larger than life-size.

mosaic. A decorative work for walls, vaults, floors, or ceilings, composed of pieces of colored material set in plaster or cement.

motet. A polyphonic musical composition based on a sacred text and usually sung without accompaniment.

motif, motive. In music, a short, recurrent melodic or rhythmic pattern. In the other arts, a recurrent element.

mullions. The vertical elements dividing windows into separate sections.

mural. A painting on a wall, usually large.

musique concrète. A 20th-century musical approach in which conventional sounds are altered electronically and recorded on tape to produce new sounds.

narthex. A portico or lobby of an early Christian church, separated from the nave by a screen or railing.

naturalistic. Carefully imitating the appearance of nature.

nave. The great central space in a church, usually running from west to east, where the congregation sits.

neo-Attic. Literally, "new Greek." A reintroduction of the classical Greek and Hellenistic elements of architecture and visual art.

neoclassicism. Various artistic styles that borrow the devices or objectives of classical art.

niche. A recess in a wall in which sculpture can be displayed.

nimbus. The circle of radiant light around the head or figures of God, Christ, the Virgin Mary, and the saints.

nonobjective. Without reference to reality; may be differentiated from "abstract."

nonrepresentational. Without reference to reality; including abstract and nonobjective.

obelisk. A tall, tapering, four-sided stone shaft with a pyramidal top.

octave. In music, the distance between a specific pitch vibration and its double; for example, concert A equals 440 vibrations per second, the A one octave above that pitch equals 880, and the A one octave below equals 220.

oculus. A circular opening in the top of a dome.

oligarchy. Government by a small, select group.

on point. In ballet, a specific technique utilizing special shoes in which the dancer dances on the points of the toes. Same as *en pointe*.

opus. A single work of art.

oratorio. A large choral work for soloists, chorus, and orchestra, developed in the baroque period.

orchestra. A large instrumental musical ensemble; the first-floor seating area of a theatre; the circular playing area of the ancient Greek theatre.

organum. Singing together. Earliest form of polyphony in western music, with the voices moving in parallel lines.

ornament. Anything used as a decoration or embellishment.

palette. In the visual arts, the composite use of color, including range and tonality.

palmette. A decoration taking the form or abstracting the form of a palm branch.

pantomime. A genre of Roman drama in which an actor played various parts, without words, with a musical background.

pantheon. A Greek word meaning all the gods.

pas. In ballet, a combination of steps forming one dance.

pas de deux. A dance for two dancers.

pathos. The "suffering" aspect of drama usually associated with the evocation of pity.

pediment. The typically triangular roof piece characteristic of classical architecture.

pendentive. A triangular part of the vaulting which allows the stress of the round base of a dome to be transferred to a rectangular wall base.

perspective. The representation of distance and three-dimensionality on a two-dimensional surface. See also *linear perspective* and *aerial perspective*.

picaresque. An artwork referring to the environment of rogues and adventurers.

piers. Upright architectural supports—usually rectangular.

pigment. Any substance used as a coloring agent.

plainsong (plainchant). Medieval liturgical music sung without accompaniment and without strict meter.

plan. An architectural drawing that reveals in two dimensions the arrangement and distribution of interior spaces and walls, as well as door and window openings, of a building as seen from above.

plaque. A decorative or informative design placed on a wall.

plasticity. The capability of being molded or altered. In film, the ability to be cut and shaped. In painting, dance, and theatre, the accentuation of dimensionality of form through chiaroscuro.

pointillism. A style of painting in which the paint is applied to the surface by dabbing the brush so as to create small dots of color.

polyphony. Literally, "many sounds." See *counterpoint*.

polyrhythm. The use of contrasting rhythms at the same time in music.

post-and-lintel. An architectural structure in which horizontal pieces (lintels) are held up by vertical columns (posts).

program music. Music that refers to nonmusical ideas through a descriptive title or text. The opposite of *absolute music*.

proportion. The relation, or ratio, of one part to another and of each part to the whole with regard to size, height, width, length, or depth.

proscenium. A Greek word meaning "before the skene." The plaster arch or "picture frame" stage of traditional theatres.

prototype. The model on which something is based.

psalmody. A collection of psalms.

putti. Nude male children—usually winged—especially shown in Renaissance and later art.

pylon. A gateway or a monumental structure flanking an entranceway.

rake. To place at an angle. A raked stage is one in which the floor slopes slightly upward from one point, usually downstage, to another, usually upstage.

realism. A style of painting, sculpture, and theatre based on the theory that the method of presentation should be true to life.

recitative. Sung monologue or dialogue, in opera, cantata, and oratorio.

reinforced concrete. See *ferro-concrete*.

relief. See *sculpture*.

representational. Art showing objects that are recognizable from real life.

requiem. A mass for the dead.

rhythm. The relationship, either of time or space, between recurring elements of a composition.

rib. A slender architectural support projecting from the surface in a vault volume.

ribbed vault. See *vault*. A vault to which slender, projecting supports have been added. A structure in which arches are connected by diagonal as well as horizontal members.

rite. A customary form for conducting religious or other solemn ceremonies.

ritornello form. A baroque musical form in which a recurrent orchestral theme alternates with solo passages.

rondeau. A Medieval French secular song based on a poetic form.

rondo form. A predominantly classical form of musical composition based around recurrence of the main theme, alternating with contrasting themes.

sanctuary. A holy place or building; a holy place within a building such as the cella of a temple or the area around the altar of a church.

sarcophagus. A stone coffin.

saturation. In color, the purity of a hue in terms of whiteness; the whiter the hue, the less saturated it is.

scale. In music, a graduated series of ascending or descending musical tones. In architecture, the mass of the building in relation to the human body.

scenography. The art and study of scenery design for the theatre and film.

schema. A summarized or diagrammatic representation.

sculpture. A three-dimensional art object. Among the types are 1. *cast*: created from molten material utilizing a mold. 2. *relief*: attached to a larger background. 3. *full-round*: free-standing.

semidome. A roof covering a semicircular space; half a dome.

serial music. A 20th-century musical style utilizing the tone row; can also employ serialization of rhythms, timbres, and dynamics.

sfumato. A smoky or hazy quality in a painting, with particular reference to Leonardo da Vinci's work.

shaft. The main trunk of a column.

shape. A two-dimensional area or plane with distinguishable boundaries.

silhouette. A form as defined by its outline.

skene. The stage building of the ancient Greek theatre.

skyphos. A two-handled ancient Greek drinking pot with an open top, tapering bowl, and flat, circular base.

sonata. Instrumental composition of the 17th through 20th centuries, consisting of a group of movements played in succession.

statuary. Free-standing, three-dimensional sculpture.

stereophonic. Sound reproduction in which two channels are used to simulate a natural distribution of sources.

still life. In the visual arts, an arrangement of inanimate objects used as a subject of a work of art.

strainer arch. An arch in an internal space that prevents the walls from being pushed inward.

strophic form. Form of vocal music in which all stanzas of the text are sung to the same music.

stucco. A plaster or cement finish for interior and exterior walls.

style. The characteristics of a work of art that identify it with an artist, a group of artists, an era, or a nation.

stylized. A type of depiction in which verisimilitude has been altered for artistic effect.

stylobate. The foundation immediately below a row of columns.

suite. A grouping of dance movements, usually unrelated except by key.

summa. An encyclopedic summation of a field of learning, particularly in theology or philosophy.

symbol. A form, image, or subject standing for something else.

symmetry. The balancing of elements in design by placing physically equal objects on either side of a center line.

symphony. A lengthy orchestral composition, usually in four movements.

syncopation. In a musical composition, the displacement of accent from the normally accented beat to the offbeat.

synthesis. The combination of independent factors or entities into a compound that becomes a new, more complex whole.

synthesizer. An electronic instrument that produces and combines musical sounds.

temperament. In music, a system of tuning. Equal temperament—the division of the octave into 12 equal intervals—is the most common way of tuning keyboard instruments.

tempo. The rate of speed at which a musical composition is performed. In theatre, film, or dance, the rate of speed of the overall performance.

tensile strength. The ability of a material to resist bending and twisting.

text painting. See *word painting*.

texture. In visual art, the two-dimensional or three-dimensional quality of the surface of a work. In music, the number and relationship of musical lines in the composition.

theatricality. Exaggeration and artificiality; the opposite of *verisimilitude*.

theme. The subject of an artwork, whether melodic or philosophical.

timbre. The characteristic of a sound that results from the particular source of the sound. The difference between the sound of a violin and the sound of the human voice, caused by different patterns of sound waves, is a difference in timbre, also called color.

toccata. A baroque keyboard composition intended to display technique.

tonality. In music, the specific key in which a composition is written. In the visual arts, the characteristics of value.

tondo. A circular painting.

tonic. In music, the root tone (*do*) of a key.

tragédie bourgeois. See *drames bourgeois*.

tragedy. A serious drama or other literary work in which conflict between a protagonist and a superior force (often fate) concludes in disaster for the protagonist.

tragicomedy. A drama combining the qualities of tragedy and comedy.

transept. The crossing arm of a cruciform church, at right angles to the nave.

travertine. A creamy-colored type of calcium used as a facing in building construction.

triforium. The section of the nave wall above the arcade and below the clerestory windows.

triptych. An altarpiece or devotional picture composed of a central panel and two wings.

trompe l'oeil. "Trick of the eye" or "fool the eye." A two-dimensional artwork so executed as to make the viewer believe that three-dimensional subject matter is being perceived.

trope. A Medieval, dramatic elaboration of the Roman Catholic mass or other offices.

tundra. A treeless area between the ice cap and the tree line of arctic regions, with a permanently frozen subsoil and supporting low-growing vegetation such as lichens, mosses, and stunted shrubs.

tunnel vault. See *barrel vault*.

tutu. A many-layered, stiff, short skirt worn by a ballerina.

twelve-tone technique. A 20th-century atonal form of musical composition associated with Schoenberg.

tympanum. The space above the door beam and within the arch of a medieval doorway.

value, value scale. In the visual arts, the range of tonalities from white to black.

vanishing point. In linear perspective, the point on the horizon toward which parallel lines appear to converge and at which they seem to vanish.

variation. Repetition of a theme with small or large changes.

vault. An arched roof or ceiling usually made of stone, brick, or concrete.

verisimilitude. The appearance of reality or the nearness to truth in works of art; the opposite of *theatricality*.

virtuoso. Referring to the display of impressive technique or skill by an artist or performer.

volute. A spiral architectural element found notably on Ionic and other capitals, but also used decoratively on building façades and interiors.

wash. A thin layer of translucent color or ink used in watercolor painting and brush drawing.

word painting. The use of language by a poet or playwright to suggest images and emotions; in music, the use of expressive melody to suggest a specific text.

FURTHER READING

Anderson, Jack. *Dance*. New York: Newsweek Books, 1974.

Andreae, Bernard. *The Art of Rome*. New York: Harry N. Abrams, Inc., 1977.

Arnott, Peter D. *An Introduction to the Greek Theatre*. Bloomington, IN: Indiana University Press, 1963.

Artz, Frederick. *From the Renaissance to Romanticism*. Chicago: University of Chicago Press, 1962.

Bataille, Georges. *Lascaux*. Switzerland: Skira, n.d.

Bazin, Germain. *The Baroque*. Greenwich, CN: New York Graphic Society, 1968.

Bentley, Eric (ed). *The Classic Theatre* (4 vols). Garden City, NY: Doubleday Anchor Books, 1959.

Bohn, T. W., Stromgren, R. L., and Johnson, D. H. *Light and Shadows*, A *History of Motion Pictures* (2nd ed.). Sherman Oaks, CA: Alfred Publishing Co., 1978.

Booth, Michael. *Victorian Spectacular Theatre 1850–1910*. Boston: Routledge and Kegan Paul, 1981.

Borroff, Edith. *Music in Europe and the United States: A History*. Englewood Cliffs, NJ: Prentice Hall, Inc., 1971.

Brandon, S. G. F. *Religion in Ancient History*. New York: Charles Scribner's Sons, 1969.

Brindle, Reginald Smith. *The New Music: The Avant-Garde Since 1945*. London: Oxford University Press, 1975.

Brockett, Oscar G. *History of the Theatre*. Boston: Allyn and Bacon, Inc., 1968.

Campos, D. Redig de (ed). *Art Treasures of the Vatican*. Englewood Cliffs, NJ: Prentice Hall, Inc., 1974.

Cheney, Sheldon. *The Theatre: Three Thousand Years of Drama, Acting, and Stagecraft* (rev. ed.). New York: Longmans, Green, 1952.

Chujoy, Anatole. *Dance Encyclopedia*. New York: Simon and Schuster, Inc., 1966.

Clarke, Mary and Crisp, Clement. *Ballet*. New York: Universe Books, 1973.

Clough, Shepard B. et al. A *History of the Western World*. Boston: D. C. Heath and Co., 1964.

Cope, David H. *New Directions in Music*. Dubuque, IA: William C. Brown and Co., 1981.

Corrigan, Robert. "The Search for New Endings: The Theatre in Search of a Fix, Part III," *Theatre Journal*, Vol. 36, No. 2, May 1984, pp. 153–63.

Coryell, Julie and Friedman, Laura. *Jazz-Rock Fusion*. New York: Delacorte Press, 1978.

Crocker, Richard. A *History of Musical Style*. New York: McGraw-Hill, 1966.

Diehl, Charles. *Byzantium*. New Brunswick, NJ: Rutgers University Press, 1957.

Drinkwater, John. *The Outline of Literature*. London: Transatlantic Arts, 1967.

Engel, Carl. *The Music of the Most Ancient Nations*. Freeport, NY: Books for Libraries Press, 1970.

Ernst, David. *The Evolution of Electronic Music*. New York: Schirmer Books, 1977.

Fleming, William. *Arts and Ideas*. New York: Holt, Rinehart, and Winston, 1980.

Frankfort, Henri. *Kingship and the Gods*. Chicago: University of Chicago Press, 1948.

Freedley, George and Reeves, John. A *History of the Theatre* (3rd ed.). New York: Crown Publishers, 1968.

Fuller, B. A. G. A *History of Philosophy*. New York: Henry Holt and Company, 1945.

Gardner, Helen. *Art Through the Ages* (8th ed.). New York: Harcourt Brace Jovanovich, 1986.

Garraty, John and Gay, Peter. A *History of the World* (2 vols). New York: Harper and Row, 1972.

Gassner, John (ed). A *Treasury of the Theatre*. New York: Holt, Rinehart, and Winston, 1967.

Gilbert, Creighton. *History of Renaissance Art Throughout Europe: Painting, Sculpture, Architecture*. New York: Harry N. Abrams, Inc., 1973.

Glasstone, Victor. *Victorian and Edwardian Theatres*. Cambridge, MA: Harvard University Press, 1975.

Goethe, Johann Wolfgang von. *Faust: Part I*, trans. Philip Wayne. Baltimore: Penguin Books, 1962.

Grabar, Andre. *The Art of the Byzantine Empire*. New York: Crown Publishers, Inc., 1966.

Graziosi, Paolo. *Palaeolithic Art*. New York: McGraw-Hill, 1960.

Griffiths, Paul. A *Concise History of Avant-Garde Music*. New York: Oxford University Press, 1978.

Grimm, Harold. *The Reformation Era*. New York: Macmillan Co., 1954.

Groenewegen-Frankfort and Ashmole, Bernard. *Art of the Ancient World*. Englewood Cliffs, NJ and New York: Prentice Hall, Inc. and Harry N. Abrams, Inc., n.d.

Gropius, Walter (ed). *The Theatre of the Bauhaus*. Middletown, CN: Wesleyan University Press, 1961.

Gropius, Walter. *The New Architecture and the Bauhaus*. Cambridge, MA: M. I. T. Press, 1965.

Grout, Donald Jay. A *History of Western Music* (rev. ed.). New York: W. W. Norton and Co., Inc., 1973.

Hamilton, Edith. *Three Greek Plays*. New York: W. W. Norton and Co., Inc., 1965.

Hamilton, George Heard. *Nineteenth and Twentieth Century Art: Painting, Sculpture, Architecture*. New York: Harry N. Abrams, Inc., 1970.

Hartt, Frederick. *Art* (2 vols). Englewood Cliffs, NJ and New York: Prentice Hall, Inc. and Harry N. Abrams, Inc., 1979.

Hartt, Frederick. *Italian Renaissance Art* (3rd ed.). Englewood Cliffs, NJ and New York: Prentice Hall, Inc. and Harry N. Abrams, Inc., 1987.

Hawkes, Jacquetta and Wooley, Sir Leonard. *History of Mankind: Prehistory and the Beginnings of Civilization*. New York: Harper and Row, 1963.

Held, Julius and Posner, D. *17th and 18th Century Art*. New York: Harry N. Abrams, Inc., n.d.

Helm, Ernest. *Music At the Court of Frederick the Great*. Norman, OK: University of Oklahoma Press, 1960.

Henig, Martin (ed). *A Handbook of Roman Art*. Ithaca, NY: Cornell University Press, 1983.

Hewett, Bernard. *Theatre USA*. New York: McGraw-Hill Book Company, 1959.

Hitchcock, Henry-Russell. *Architecture: Nineteenth and Twentieth Centuries*. Baltimore: Penguin Books, 1971.

Hofstadter, Albert and Kuhns, Richard. *Philosophies of Art and Beauty*. Chicago: University of Chicago Press, 1976.

Honour, Hugh and Fleming, John. *The Visual Arts: A History* (3rd ed.). Englewood Cliffs, NJ: Prentice Hall, Inc., 1992.

Hoppin, Richard. *Medieval Music*. New York: W. W. Norton and Co., Inc., 1978.

Hornstein, Lillian, Percy, G. D. and Brown, Sterling A. *World Literature* (2nd ed.). New York: Mentor, 1973.

Hubatsch, Walther. *Frederick the Great of Prussia*. London: Thames and Hudson, 1975.

Hubert, J., Porcher, J. and Volbach, W. F. *The Carolingian Renaissance*. New York: George Braziller, 1970.

Jacobs, Lewis. *An Introduction to the Art of the Movies*. New York: Noonday Press, 1967.

Janson, H. W. *A Basic History of Art* (2nd ed.). Englewood Cliffs, NJ and New York: Prentice Hall, Inc. and Harry N. Abrams, Inc., 1981.

Jung, Carl G. *Man and His Symbols*. New York: Doubleday and Co., Inc., 1964.

Karsavina, Tamara. *Theatre Street*. New York: E. P. Dutton, 1961.

Kernodle, George and Portia and Pixley, Edward. *Invitation to the Theatre* (3rd ed.). San Diego: Harcourt Brace Jovanovich, 1985.

Keutner, Hubert. *Sculpture: Renaissance to Rococo*. Greenwich, CT: New York Graphic Society, 1969.

Kirby, E. E. *A Short History of Keyboard Music*. New York: Macmillan Co., 1966.

Kjellberg, Ernst and Saflund, Gosta. *Greek and Roman Art*. New York: Thomas Y. Crowell Co., 1968.

Knight, Arthur. *The Liveliest Art: A Panoramic History of the Movies* (rev. ed.). New York: Macmillan, Inc., 1978.

Kratzenstein, Marilou. *Survey of Organ Literature and Editions*. Ames, IA: Iowa State University Press, 1980.

Kraus, Richard. *History of the Dance*. Englewood Cliffs, NJ: Prentice Hall, Inc., 1969.

Lange, Kurt and Hirmer, Max. *Egypt*. London: Phaidon, 1968.

Lawler, Lillian. *The Dance in Ancient Greece*. Middletown, CT: Wesleyan University Press, 1964.

Leish, Kenneth W. *Cinema*. New York: Newsweek Books, 1974.

Lippard, Lucy R. *Pop Art*. New York: Oxford University Press, 1966.

Lloyd, Seton. *The Archeology of Mesopotamia*. London: Thames and Hudson, 1978.

Lommel, Andreas. *Prehistoric and Primitive Man*. New York: McGraw-Hill, 1966.

Maas, Jeremy. *Victorian Painters*. New York: G. P. Putnam's Sons, 1969.

MacDonald, William. *Early Christian and Byzantine Architecture*. New York: George Braziller, 1967.

Machiavelli, Niccolo. *The Prince*, trans. George Bull. Baltimore: Penguin Books, 1963.

Machlis, Joseph. *The Enjoyment of Music* (3rd ed.). New York: W. W. Norton and Co., 1955.

Mango, Cyril. *Byzantium*. New York: Charles Scribner's Sons, 1980.

Marshack, Alexander. *The Roots of Civilization*. New York: McGraw-Hill, 1972.

Martin, John. *The Modern Dance*. Brooklyn: Dance Horizons, 1965.

McDermott, Dana Sue. "Creativity in the Theatre: Robert Edmond Jones and C. G. Jung." *Theatre Journal* (May 1984), pp. 212–30.

McDonagh, Don. *The Rise and Fall of Modern Dance*. New York: E. P. Dutton, Inc., 1971.

McGiffert, Arthur. *A History of Christian Thought*. New York: Charles Scribner's Sons, 1961.

McLeish, Kenneth. *The Theatre of Aristophanes*. New York: Taplinger Publishing Co., 1980.

McNeill, William H. *The Shape of European History*. New York: Oxford University Press, 1974.

Montet, Pierre. *Lives of the Pharaohs*. Cleveland: World Publishing Co., 1968.

Moortgat, Anton. *The Art of Ancient Mesopotamia*. London: Phaidon, 1969.

Murray, Margaret. *Egyptian Sculpture*. New York: Charles Scribner's Sons, 1930.

Muthesius, Stefan. *The High Victorian Movement in Architecture 1850–1870*. London: Routledge and Kegan Paul, 1972.

Myers, Bernard S. *Art and Civilization*. New York: McGraw-Hill Book Company, Inc., 1957.

Nicoll, Allardyce. *The Development of the Theatre* (5th ed.). London: Harrap and Co. Ltd., 1966.

Nyman, Michael. *Experimental Music: Cage and Beyond*. New York: Schirmer Books, 1974.

Oppenheim, A. Leo. *Ancient Mesopotamia*. Chicago: University of Chicago Press, 1964.

Ostransky, Leroy. *Understanding Jazz*. Englewood Cliffs, NJ: Prentice Hall, Inc., 1977.

Pfeiffer, John E. *The Creative Explosion*. New York: Harper and Row, 1982.

Pignatti, Terisio. *The Age of Rococo*. London: Paul Hamlyn, 1969.

Powell, T. G. E. *Prehistoric Art*. New York: Frederick Praeger Publishers, 1966.

Raphael, Max. *Prehistoric Cave Paintings*. Washington, DC: Pantheon, 1946.

Read, Benedict. *Victorian Sculpture*. New Haven: Yale University Press, 1982.

Read, Herbert E. *Art and Society* (2nd ed.). New York: Pantheon Books, Inc., 1950.

Rice, David Talbot. *The Art of Byzantium*. New York: Harry N. Abrams, Inc., n.d.

Richter, Gisela. *Greek Art*. Greenwich, CN: Phaidon, 1960.

Roberts, J. M. *History of the World*. New York: Alfred A. Knopf, Inc., 1976.

Robertson, Martin. *A Shorter History of Greek Art*. Cambridge, MA: Cambridge University Press, 1981.

Robinson, David. *The History of World Cinema*. New York: Stein and Day Publishers, 1973.

Roters, Eberhard. *Painters of the Bauhaus*. New York: Frederick Praeger Publishers, 1965.

Rotha, Paul. *The Film Till Now*. London: Spring Books, 1967.

Rowell, George. *The Victorian Theatre* (2nd ed.). Cambridge, England: Cambridge University Press, 1978.

Sachs, Curt. *World History of the Dance*. New York: W. W. Norton and Co., 1937.

Sachs, Curt. *The Rise of Music in the Ancient World*. New York: W. W. Norton and Co., 1943.

Sadie, Stanley (ed). *The New Grove Dictionary of Music and Musicians*. Washington, DC: Grove's Dictionaries; London: Macmillan, 1980.

Salzman, Eric. *Twentieth Century Music: An Introduction*. Englewood Cliffs, NJ: Prentice Hall, Inc., 1967.

Sandars, N. K. *Prehistoric Art in Europe*. Baltimore: Penguin Books, 1968.

Schevill, Ferdinand. *A History of Europe*. New York: Harcourt Brace and Co., Inc., 1938.

Schonberger, Arno and Soehner, Halldor. *The Rococo Age*. New York: McGraw-Hill, 1960.

Sherrard, Philip. *Byzantium*. New York: Time Inc., 1966.

Sitwell, Sacheverell. *Great Houses of Europe*. London: Spring Books, 1970.

Smith, Hermann. *The World's Earliest Music*. London: W. Reeves, n.d.

Smith, W. Stevenson. *The Art and Architecture of Ancient Egypt*. Baltimore: Penguin Books, 1958.

Snell, Bruno. *Discovery of the Mind: The Greek Origins of European Thought*. New York: Harper, 1960.

Sorell, Walter. *Dance in its Time*. Garden City, NY: Doubleday Anchor Press, 1981.

Sorell, Walter. *The Dance Through the Ages*. New York: Grosset and Dunlap, Inc., 1967.

Southern, Richard. *The Seven Ages of the Theatre*. New York: Hill and Wang, 1961.

Sperry, Roger. *Science and Moral Priority: Merging Mind, Brain, and Human Values*. New York: Columbia University Press, 1983.

Spitz, Lewis (ed). *The Protestant Reformation*. Englewood Cliffs, NJ: Prentice Hall, Inc., 1966.

Sporre, Dennis J. *The Arts*. Englewood Cliffs, NJ: Prentice Hall, Inc., 1985.

Sporre, Dennis J. *Perceiving the Arts*. Englewood Cliffs, NJ: Prentice Hall, Inc., 1981.

Stamp, Kenneth M. and Wright, Esmond (eds). *Illustrated World History*. New York: McGraw-Hill Book Company, 1964.

Strayer, Joseph and Munro, Dana. *The Middle Ages*. Pacific Palisades: Goodyear Publishing Company, 1970.

Tierney, Brian and Painter, Sidney. *Western Europe in the Middle Ages*. New York: Alfred A. Knopf, 1974.

Tirro, Frank. *Jazz: A History*. New York: W. W. Norton and Co., Inc., 1977.

Ucko, Peter J. and Rosenfeld, Andree. *Paleolithic Cave Art*. London: World University Library, 1967.

Ulrich, Homer. *Music: A Design for Listening* (3rd ed.). New York: Harcourt, Brace and World, Inc., 1970.

Van Der Kemp, Gerald. *Versailles*. New York: The Vendome Press, 1977.

Vidal-Naquet, Pierre (ed). *The Harper Atlas of World History*. New York: Harper & Row, 1986.

Wheeler, Robert Eric Mortimer. *Roman Art and Architecture*. New York: Frederick Praeger Publishers, 1964.

Wilkins, David G. and Schultz, Bernard. *Art Past Art Present*. Englewood Cliffs, NJ and New York: Prentice Hall, Inc. and Harry N. Abrams, Inc., 1990.

Zarnecki, George. *Art of the Medieval World*. Englewood Cliffs, NJ: Prentice Hall, Inc., 1975.

NOTES

See **Further Reading** for full bibliographical details of cited works:

Introduction
1 Warren S. Smith in *Perceiving the Arts*, Dennis Sporre
2 Roger Sperry, *Science and Moral Priority: Merging Mind, Brain, and Human Values*

Chapter 1
1 Marshack, *The Roots of Civilization*
2 Marshack, op. cit., p.34
3 Marshack, op. cit., p.275
4 Marshack, op. cit., p.276
5 Powell, *Prehistoric Art*
6 Marshack, op. cit., p.274

Chapter 2
1 Garraty and Gay, *A History of the World*, p.49
2 Revised Standard Version Bible

Chapter 3
1 Murray, *Egyptian Sculpture*, p.23
2 Lange and Hirmer, *Egypt*
3 Freedly and Reeves, *A History of the Theatre*, pp.5–6
4 Montet, *Lives of the Pharaohs*, pp.38–40
5 Sachs, *The Rise of Music in the Ancient World*, p.33

Chapter 4
1 *The Harper Atlas of World History*, p.40
2 Lawler, *The Dance in Ancient Greece*, p.12
3 Homer, *The Iliad*, Book XX, trans. Richmond Lattimore. Chicago: University of Chicago Press, 1962, p.404. Used by permission of the University of Chicago

Chapter 5
1 Snell, *Discovery of the Mind: The Greek Origins of European Thought*, p.247
2 In each tragic contest a playwright was required to present four plays in succession—three tragedies and a satyr play
3 The chorus was a distinctive feature of Greek drama, carrying out the dual function (in the same play) of narrator and collective character—responding to the actors
4 Arnott, trans., in *An Introduction to the Greek Theatre*, pp.76–7
5 Robertson, *A Shorter History of Greek Art*, p.123
6 Hamilton, trans., in *Three Greek Plays*
7 Wm Arrowsmith, trans., in *The Complete Greek Tragedies*, Vol. VI (New York: Random House, 1958)

Chapter 6
1 B. A. G. Fuller, *A History of Philosophy*, p.266
2 Ibid.
3 Hofstadter and Kuhns, *Philosophies of Art and Beauty*, pp.140–1
4 Andreae, *The Art of Rome*, p.71
5 Virgil, *The Aeneid*, trans. Theodore C. Williams. New York: Houghton Mifflin Co., 1938, p.1
6 Garraty and Gay, op. cit., p.209
7 "Rings around the Pantheon," *Discover* (March 1985), p.12
8 Andreae, op. cit., p.109

Chapter 7
1 Garraty and Gay, op. cit., p.431
2 Roberts, *History of the World*, p.321

3 Diehl, *Byzantium*, p.286
4 Mango, *Byzantium*, p.234
5 Mango, op. cit., p.235
6 Mango, op. cit., p.251
7 Nicoll, *The Development of the Theatre*, p.48
8 Freedly and Reeves, op. cit., p.177
9 MacDonald, *Early Christian and Byzantine Architecture*, p.43
10 Sherrard, *Byzantium*, p.56

Chapter 8
1 McGiffert, *A History of Christian Thought*, p.7
2 Fuller, op. cit., p.353
3 Ibid.
4 Hofstadter and Kuhns, op. cit., p.172
5 AOI: these three mysterious letters appear throughout the text. No one has ever adequately explained them, though every reader feels their effect
6 *The Song of Roland*, trans. Frederick Goldin. New York: W. W. Norton and Co., Inc., 1978
7 St Augustine, quoted in Grout, *A History of Western Music*, p.19

Chapter 9
1 Tierney and Painter, *Western Europe in the Middle Ages*, p.257
2 Tierney and Painter, op. cit., pp.259–60
3 Fuller, op. cit., p.377
4 Zarnecki, *Art of the Medieval World*, p.406
5 Chaucer, *The Canterbury Tales*, trans. J. Nicolson. Garden City: Doubleday and Co., 1934, pp.120–3. Used by permission of the publisher
6 Gassner, ed, *A Treasury of the Theatre*, p.187

LITERATURE EXTRACT CREDITS

Calmann & King, the author, and the literature researcher wish to thank the publishers and individuals who have kindly allowed their copyright material to be reproduced in this book, as listed below. Every effort has been made to contact copyright holders, but should there be any errors or omissions, Calmann & King would be pleased to insert the appropriate acknowledgement in any subsequent edition of this publication.

For the sake of consistency, it has been necessary to adapt spelling in some cases. The policy followed has been to present all translations into the English language with American spelling, but each British original maintains the author's spelling. A number of common Greek names have been standardized to avoid confusion, but the less familiar ones have been left as they appear in the editions from which they were drawn.

Chapter 2

From *Gilgamesh Epic*, Tablet I, trans. John Gardner and John Maier. © 1985 by the Estate of John Gardner and John Maier. Published by Alfred A. Knopf, Inc.

The Bible, Genesis I and Job from the Revised Standard Version Bible. © 1946, 1952, 1971 by the Division of Christian Education of the National Council of the Churches of Christ in the USA. Used by permission.

Chapter 4

Homer, from *The Odyssey*, trans. Robert Fitzgerald (Vintage Books, New York).

Sappho, "An Absent Friend," from C.M. Bowra, *The Greek Experience*. Published by permission of George Weidenfeld and Nicolson Ltd, London, and Frederick Praeger Publishers, New York.

Sappho, "The Orchard," from A.R. Burn, *A Traveller's History of Greece*, Hodder and Stoughton Ltd, London, 1965. Published as *The Pelican History of Greece*, Penguin Books, Harmondsworth, 1966.

Chapter 5

Sophocles, *Oedipus the King*, trans. Stephen Berg and Diskin Clay. © 1978 Oxford University Press, Inc.

From *The Republic of Plato*, trans. F.M. Cornford (1941). Reprinted by permission of Oxford University Press.

Chapter 6

Horace, from *The Art of Poetry*, in Allan H. Gilbert, *Literary Criticism: Plato to Dryden* (1962). Reprinted by permission of Wayne State University Press.

The Bible, Matthew 5 from the Revised Standard Version Bible. © 1946, 1952, 1971 by the Division of Christian Education of the National Council of the Churches of Christ in the USA. Used by permission.

Chapter 8

St Augustine, from *Confessions*, trans. R.S. Pine-Coffin (Penguin Classics, 1961). © R.S. Pine-Coffin, 1961. Reprinted by permission of Penguin Books Ltd.

Beowulf, from *A Verse Translation in Modern English* by Edwin Morgan (Berkeley: University of California Press, 1962). Reprinted by permission of Edwin Morgan.

"The Song of Roland" from *The Song of Roland*, trans. Frederick Golding. © 1978 by W.W. Norton and Co., Inc.

Chapter 9

Dante, from *The Divine Comedy*, trans. G.L. Bickersteth (Blackwell, 1981). Reprinted by kind permission of Miss U.M. Bickersteth.

Geoffrey Chaucer, "The Prologue" and "The Wife of Bath's Tale and Prologue" from *The Canterbury Tales*, trans. David Wright (Oxford University Press, 1985). Reprinted by permission of Peters Fraser & Dunlop Group.

INDEX